cover design: Karen Salsgiver
cover photographs: David Vine

# Photography

# Photography

**A Handbook of History, Materials, and Processes**

**second edition**

**Charles Swedlund**
*Southern Illinois University, Carbondale*

**with**
**Elizabeth Yule Swedlund**

Holt, Rinehart and Winston
*New York Chicago San Francisco*
*Dallas Montreal Toronto*

To Elizabeth,
Heather, and Alison

Photograph acknowledgments and credits appear
on page 410.

**Editor-in-Chief: Judith Rothman**
**Publisher: Rita Pérez**
**Developmental Editor: Karen Dubno**
**Special Projects Editor: Pamela Forcey**
**Picture Editors: Joan Scafarello, Joan Curtis**
**Production Manager: Nancy Myers**
**Designer: Karen Salsgiver**

**Composition and camera work: York Graphic Services, Inc.**
**Color separations: Lehigh/Electronic Color**
**Printing and binding: W. A. Krueger Company, Inc.**

**Library of Congress Cataloging in Publication Data**

Swedlund, Charles.
   Photography, a handbook of history, materials,
   and processes.

   Bibliography: p.
   Includes index.
   1. Photography—Handbooks, manuals, etc.
I. Swedlund, Elizabeth Yule, joint author.  II. Title.
TR146.S93    1981        770        80—25030

**ISBN: College paperback edition: 0-03-056699-1**
**ISBN: General Book hardcover edition: 0-03-059236-4**

*Photography* introduces students to the principles and processes of photography in such a way that they can soon begin to concentrate on the art of making images. Basic techniques are illustrated step by step with clear, attractive drawings; there are also many photographic images that introduce the sensitive use of these techniques without being prescriptive about composition. The text is designed primarily for beginners of all ages in black-and-white photography, whether in academic or less formal situations, but many sections will also be useful for students at the intermediate level. Complex or advanced topics are clearly set apart by headings or in separate chapters; thus they can easily be located when they are needed.

This second edition of *Photography* has been entirely rewritten, and most of the illustrations are new (including many more by well-known photographers). The information has been updated and rearranged to present ideas in a more logical order, for which intent five new chapters have been added. For example, information on large-format photography formerly scattered throughout the text has been brought together into a single comprehensive chapter. Artificial light and the Zone System, important subjects that were only briefly discussed and difficult to find because they were relegated to an appendix or a section of a larger chapter, are now full chapters. "The Darkroom" is a new chapter that consolidates information on equipment, papers, and chemicals. "Beyond Basics" is another new chapter that brings together into a single logical location some older and much new material on more advanced techniques. Further, the "Portfolio" of contemporary photographs has been expanded, and all its images are new. In addition to the images, which were selected by the individual photographers, there are accompanying statements that were either written or chosen by the photographers for this book.

The more logical arrangement of this edition is supported by a striking new design that achieves a number of goals: information is easier to locate and text and illustrations complement each other, eliminating the duplication of material in text and captions; most topics and subtopics begin and end on a single page or spread; the more open format permits images by well-known photographers to be reproduced as large as possible. Other new features are the outline of subjects that begins each chapter and the extensive system of cross references throughout the text.

Chapter 1 is a pictorial guide to our photographic past. It highlights the processes and work of early photographers and contrasts photographers who use the photograph for social documentation or advertising with those who pursue their own personal visions, free of editorial influence. The chapter concludes with a brief discussion of some of the trends and new technology that will affect future photographers.

Seven chapters, 2 through 8, introduce the principles and basic techniques needed to produce a photograph. The subject of Chapter 2 is the camera itself. A thorough discussion of the basic components of all cameras leads to an extensive exploration of differences between cameras, considerations when choosing a camera, and advice on buying used equipment. The goal is to make students aware of what is available so their buying decisions are based on knowledge rather than emotion or sales pressure. The chapter ends with the proper way to clean a camera and suggestions on how to hold a camera to minimize camera movement.

Chapter 3 introduces light and the way a lens controls it to produce an image suitable for photography. Such topics as depth of field and lens size, speed, and focusing ability are discussed in practical terms for the photographer. A description of the unique visual qualities of lenses of various focal lengths is followed by suggestions for buying a lens.

Chapter 4, "Film and Filters," describes the components and characteristics of black-and-white film, the theory of film exposure and its relation to density, proper procedures for loading film into 35mm cameras, and correct methods for storage. It also presents the types of filters and various ways they may be used for corrective and interpretive purposes.

The next logical step in making a picture—exposure—is covered in Chapter 5 with a thorough discussion of light meters, both handheld and built-in. The chapter describes their types, operation, advantages, disadvantages, and their effective use in varying situations. Exposure charts with suggested settings for situations where a meter reading may be hard to get are also included.

Film processing is explained and illustrated step by step in Chapter 6, beginning with removing various types of film from cassettes or cartridges and loading film on different types of developing reels. Photographs clearly illustrate processing mistakes. An explanation of the relationship between development and exposure is followed by discussion of corrective processing to compensate for exposure problems.

Chapter 7, "The Darkroom," is a new chapter that concentrates on the home darkroom and its equipment and supplies (since each academic institution has its own setup and procedures). It discusses thoroughly the parts of the enlarger and various enlarger types. Supplies such as printing paper—both graded and variable contrast—are also covered, as well as the necessary chemicals for processing.

The final chapter on basic techniques is Chapter 8, "The Print." The procedures for exposing and developing prints and the various ways of presenting them are described step by step. There is much emphasis on ways to evaluate the visual qualities of a print and then alter them by varying exposure and development. A more advanced procedure—archival processing—supplements and concludes this chapter.

The next five chapters broaden the scope beyond the basics. Chapter 9, "Artificial Light," explains how photographers use studio lights and electronic flash to increase their capabilities. It also includes more advanced techniques, such as copying, duplicating color transparencies, and copying with black-and-white transparencies.

Chapter 10, "The Zone System," is not merely a description of this well-known method for determining accurately and consistently how tonal values in a scene will be rendered in the print. It is also a presentation of a simple, logical method for actually practicing the system. Although the Zone System is more often taught in intermediate or advanced classes, it can be used by beginners to find out what they are doing wrong during exposure and/or development and how to correct their mistakes. Using it can also give an overall understanding of the sensitivity characteristics of photographic materials.

"Large-Format Photography" is the subject of Chapter 11. It describes exposing and processing sheet film step by step, as well as operating a view camera and controlling view camera movements.

Chapter 12, "Beyond Basics," introduces other ways of producing and printing photo-

*v*

graphs, including nonsilver processes. The chapter stresses imagery over process—taking advantage of the capabilities of each process to produce sensitive and meaningful photographs, rather than depending on an unusual technique to transform an inadequately conceived idea.

Chapter 13 introduces color theory and the history of color photography; it also gives an overall view of the characteristics, exposure, development, and printing of color transparency and color negative film. Filtration and evaluation are covered in some detail. The chemicals and equipment for color photography are discussed in general terms, but detailed processing techniques are not included, since these processes are constantly being modified, and manufacturers provide specific guidelines.

The "Portfolio" concludes the book, but it is actually a starting point meant to provoke discussion and suggest further study. Following it are a thorough glossary of technical photographic terms and an up-to-date bibliography that includes, among other kinds of entries, listings for well-known photographers of the past and present.

## Acknowledgments

**M**y first acknowledgment must be to the students whose questions prompted me to undertake this project. Their comments and reactions helped me to formulate two early versions of the book, then the first edition, and now this revision. Many fellow instructors of photography from coast to coast offered their advice in the form of responses to a survey organized by my publisher and more detailed analysis of various drafts of the manuscript. In particular, suggestions and comment by the following

proved enormously helpful: Stanley Bowman, Cornell University; Vernon Cheek, Purdue University; Daryl Curran, California State University, Fullerton; Marianne Gellman, formerly North Texas State University; Peter Glendinning, Michigan State University; David Read, University of Nebraska, Lincoln; Chris Simons, Shoreline Community College, Seattle; Michael Smithson, San José State University.

Others have helped me, too. I am grateful to Barbara Gore Suter for her assistance in preparing a first draft of part of the material now appearing in Chapters 1 through 8. David Gilmore, associate professor, Southern Illinois University, Carbondale, deserves a special note of gratitude for generously and enthusiastically sharing his knowledge and methods in preparing the manuscript for the Zone System chapter. The technical assistance of William C. Nickell, professor, Southern Illinois University, Carbondale, and Timothy Wilbers was also warmly welcomed.

I am grateful to Jay Bender for his initiative and dependability when printing a large number of the illustrations. I also appreciate the assistance I received from Herb Nelson in the production of some of the illustrations. In additon, helpful information about equipment was given me by Allen Sue, Helix, Chicago; and Howard Silver, Vern Stinson, and Allen Mals, Standard Photo Supply, Chicago. The following generously lent me equipment for illustrations: Jim Bair, Agapé, Carbondale; Frank Hemphill, Photo Nest, Carbondale; John Richardson, Southern Illinois University, Carbondale; Bill Branson, Richard Lawson, Kevin Mooney, and Jeffery D. Trilling.

I also express my gratitude to the many photographers who allowed us to use their work and lent us excellent prints and to the

museums and galleries, both in this country and abroad, that graciously granted us permission to reproduce photographs from their collections. They and the photographers are credited individually at the back of the book. Although I cannot list them by name, I would also like to thank all the wonderful people who acted as models for many of the illustrations and for the cover. Without all these people, we would have had fewer ideas and even fewer illustrations.

Warm thanks go to the dedicated people at Holt, Rinehart and Winston who worked so untiringly to prepare this edition. Rita Gilbert not only initiated and coordinated the revision, but kept it on schedule. She was supported by Karen Dubno, who must receive a large share of the credit for bringing this edition to its final form. The work of Pamela Forcey, who refined the final manuscript and shepherded it through its various production stages, was indispensable. The enormous task of obtaining and coordinating the illustrations was efficiently performed by Joan Scafarello and Joan Curtis. Nancy Myers ably supervised the physical production of the book. Karen Salsgiver is responsible for the beautiful new design and layout of this edition. Sandra Popovich brought her intelligence as well as artistic talent to the step-by-step drawings of technical procedurés.

To honor the special place she occupies in my life, I direct these last expressions of gratitude to Elizabeth, who became a vital part of this edition by bringing light to very dark moments, transforming my ideas into coherent text, typing the manuscript, and organizing many of the illustrations.

C.S.

*Cobden, Illinois*
*November 1980*

# Contents

# Photography

*. . . a knowledge of photography is just as important as that of the alphabet. The illiterates of the future will be ignorant of the use of camera and pen alike.*

*László Moholy-Nagy*

This chapter is a pictorial guide to photography. It covers the work of the early photographers whose particular insights and talents have led to photography as it is now. It also highlights the work of some of the modern photographers who have made photography a versatile and expressive art form. (There are many full-length histories of photography. See the bibliography.)

The more you become involved with photography, the more you are likely to want to know about how it evolved. You may decide to begin your investigations with this history. Or you may decide to begin by experimenting on your own. Either way is good. In any case, you are now part of the continuing story of photographers who both record history and make history with their photographs.

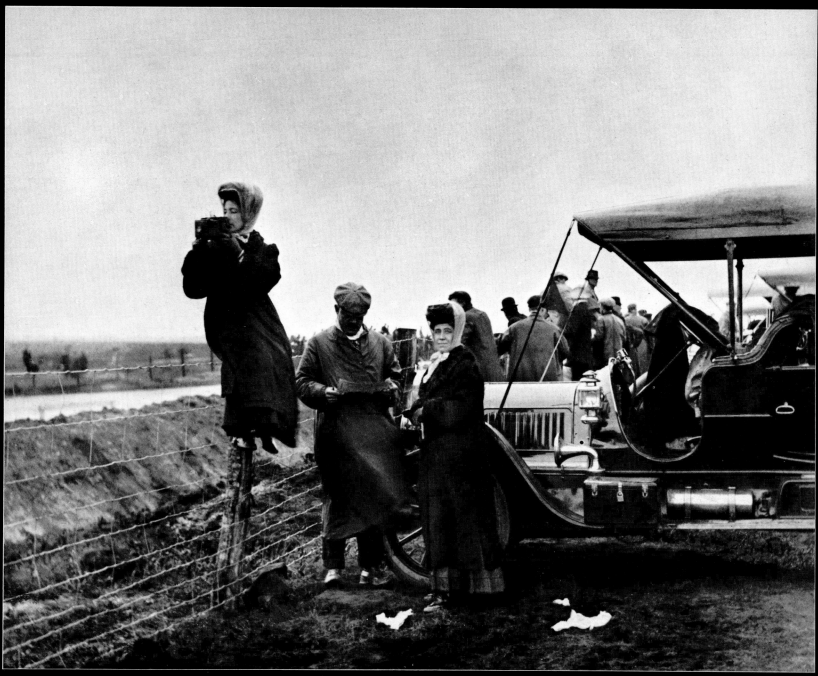

Alice Austen, photographing automobile speed trials, perches on a fencepost.   c. 1910.

## Capturing and Fixing Images

By the late 19th century, *photography*, a word derived from the Greek *phos* "light" and *graphein* "writing," had become almost a household word. No one knows who constructed the first device that would produce images by means of light, but we do know that by the 16th century Renaissance painters were very concerned with painting a scene "realistically" and that the earliest camera, the camera obscura, helped them to achieve correct perspective in their painting. As Leonardo da Vinci sketched the camera obscura (literally, "dark room"), light was admitted into a darkened room through a tiny pinhole in one wall; an upside-down image of the scene outside the room appeared on the opposite wall. The artist merely placed a sheet of translucent paper over the image and traced its outlines.

Modifications of the camera obscura were made gradually. In 1568 Danielo Barbaro of Padua recommended substituting a lens for the pinhole to create a sharper, brighter image. Over the years the camera obscura gradually shrank until, by the 18th century, it usually consisted of a box about 2 feet square that was fitted with a lens to focus the light and a sheet of ground glass to receive the image. The device was extremely popular with artists of the period.

The logical next step was to make the image permanent without tracing it. To do so involved putting to use the fact that certain substances are chemically altered when exposed to light. Heinrich Schulze (1687–1744), a German physicist, is credited with the discovery in 1727 of the light-sensitive qualities of silver salts. Thomas Wedgwood (1771–1805), son of the famous British potter, published in 1802 his similar discoveries of the light-sensitive qualities of paper that had been soaked in nitrate of silver. Although Schulze never tried to fix the images of nature and Wedgwood was stymied by the impermanence of the images that he produced on paper, both men had suggested a way toward making permanent light-created images.

In 1826 Joseph Nicephore Niepce (1765–1833), a French inventor, discovered that a certain type of bitumen became insoluble in lavender oil after it had been exposed to light, whereas the same substance could be dissolved in lavender oil if light were prevented from striking it. Through the action of these chemicals, Niépce was able to transfer an engraving to a pewter plate—an accomplishment that paved the way for lithographic reproduction. Next he turned his attention to the images of nature or, as he called them, "view points." A thin pewter plate coated with bitumen of Judea was exposed in the camera obscura. The image became visible after being washed in oil of lavender and white petroleum. It resulted in a direct positive image with the light areas having a coating of bitumen and the shadow areas being the bare pewter. Niépce's first successful experiment in what he termed *heliography* (from the Greek *helios* "sun" and *graphein* "writing") was a view from the photographer's window at Gras, made with an exposure of eight hours. Although it was the first successful image, it was pale and not substantial enough to be practical for commercial use.

2

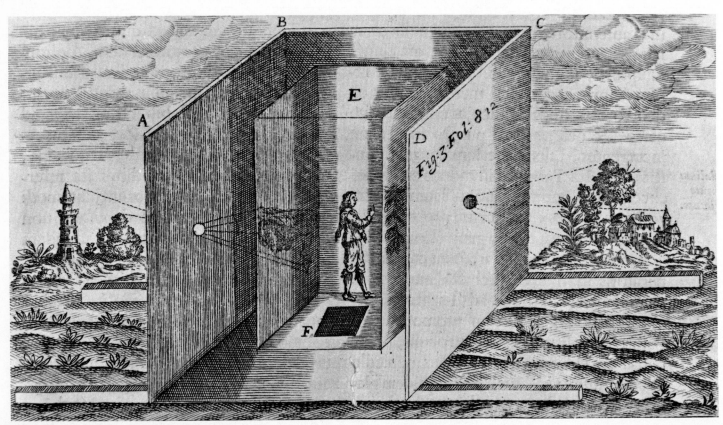

Camera obscura, a "cutaway" view. Engraving. 1646.

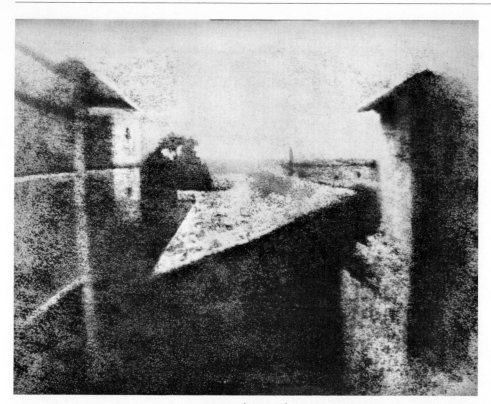

JOSEPH NICÉPHORE NIÉPCE. *View from Window at Gras*. Heliograph. 1826.

## Daguerreotypes

**A**n unusual correspondence developed when a Frenchman named Daguerre was informed by their mutual lensmaker in Paris that Niépce was working along the same lines as he was with light-sensitive materials. Louis Jacques Mandé Daguerre (1787–1851) was a painter and entrepreneur who had experimented with the camera obscura to produce the diorama, an extraordinary display of immense landscapes painted on semitransparent theatrical gauze illuminated from behind to produce a scene as impeccably detailed and as realistic as possible.

Niépce and Daguerre corresponded for three years, neither wishing to reveal the fruits of his research, until finally, in 1829, ill health and discouraging results forced Niépce to suggest a partnership. When Niépce died four years later, Daguerre continued his partnership with Niépce's son Isidore. Several more years of experimentation followed, and then came Daguerre's first successful photograph, *The Artist's Studio,* which was signed and dated 1837. Convinced that the method he had perfected was sufficiently different

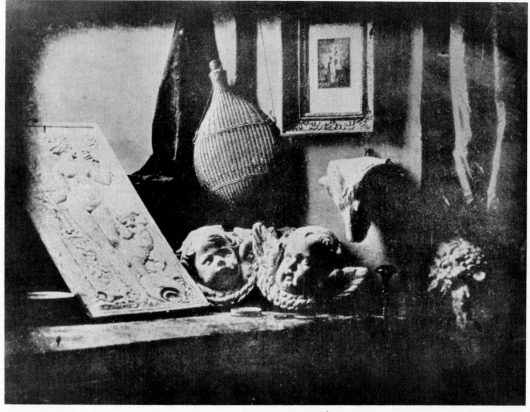

LOUIS JACQUES MANDÉ DAGUERRE. *The Artist's Studio*. Daguerreotype. 1837.

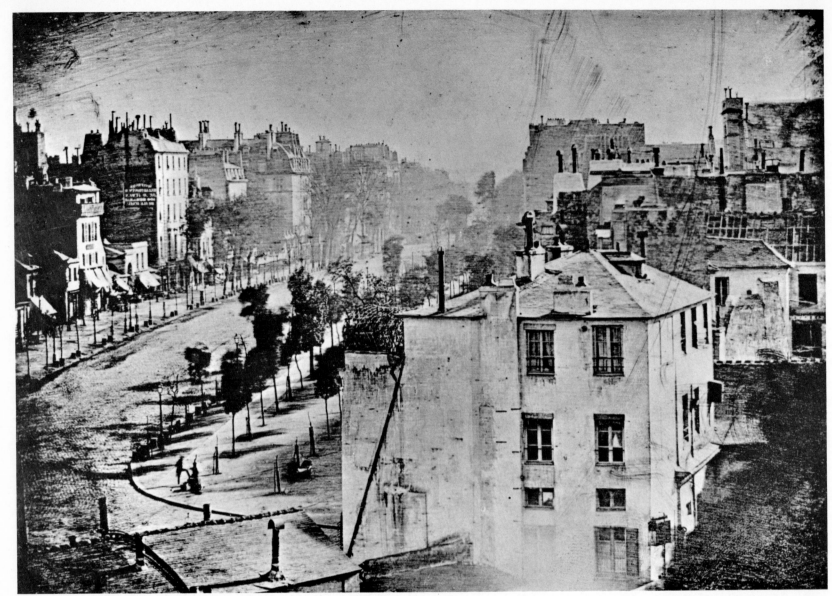

LOUIS JACQUES MANDÉ DAGUERRE. *Boulevard du Temple, Paris*. Daguerreotype. 1839.

4

from Niépce's earlier work, Daguerre called his efforts *daguerreotypes*. In 1839 when the French government bought his invention, details of the procedure were made available to the public.

To demonstrate the daguerreotype process, Daguerre used a sheet of copper that had been silverplated on one side. After a buffing with pumice, the plate was subjected to the fumes of iodine and then exposed in the camera obscura. When the required exposure time had elapsed, the plate was removed and developed with fumes from heated mercury, which gradually brought out the image. Finally the image was made permanent by soaking it in a salt solution. (This solution was later replaced by sodium thiosulphate, which Sir John Herschel [1792–1871] had discovered was a fixing agent.) The resulting photograph, extraordinary for its detail and luminosity, was difficult to look at because the mirrorlike surface reflected the viewer's own features, and from certain angles the image appeared in negative form, with dark and light tones reversed. Moreover, the daguerreotype image was so delicate it had to be mounted behind glass and sealed.

By 1839 Daguerre had so perfected the process that he could record more complicated scenes, but the long exposure time—from 5 to 40 minutes—still precluded photographing people. *Boulevard du Temple* was the first photograph to include a human being, but that happened by chance—a man stayed motionless because he was having his shoes shined. Although the demand for portrait photographs was considerable, Daguerre could not find a way to reduce the exposure time enough to make them feasible. By the time of his death he had all but abandoned photography and returned to painting. ☐

# The Era of Portrait Photography

Within a few months of Daguerre's original announcement, word of his invention had spread throughout Europe and the United States. The initial excitement soon passed when people realized that the daguerreotype was not a quick and easy substitute for portrait painting. But improvement did not take long. By 1841, better lenses and methods of preparing the light-sensitive plate had reduced the necessary exposure time for an image to less than a minute. The experience of being photographed was therefore possible, if not particularly comfortable.

The first American "daguerreotype gallery for portraits" was opened in New York in 1840; by the mid-1850s that city boasted 86 such studios, and there was one in every major city and town in the United States. At a price of two-for-a-quarter, including the frame, daguerreotypes were affordable by a large number of people, who flocked to the galleries, where they were required to sit motionless and unblinking for half a minute or more. The resulting very stylized, rigid postures and stiff expressions have come to be associated with daguerreotypes. Because the plate had to be processed immediately after exposure, processing facilities had to be readily available. As a result, most daguerreotypes were studio portraits; outdoor scenes were particularly rare.

In spite of its initial overwhelming popularity, the daguerreotype had a few serious flaws that eventually led to more efficient types of portraiture. The surface was extremely delicate and without the protective frame and glass was easily damaged or ruined. The mirrorlike face made it difficult to look at. Also, the image was reversed from left to right (unless a mirror or prism was used on the camera). Furthermore, there was no way to duplicate the one-of-a-kind image except by rephotographing the image or the scene.

## The Invention of the Negative

It often happens with inventions that more than one person works to reach the same goal at the same time, but usually one person's name becomes associated with the idea. An English scientist and mathematician, William Henry Fox Talbot (1800–1877), had begun his research in photographic processes in 1833, six years before Daguerre's original announcement, which Talbot claimed took him totally by surprise. Talbot rushed to make his perfected method public in 1839. He first called it *calotype* (from the Greek *kalos* "beautiful" and *typos* "impression"), but eventually was persuaded by friends to rename it *talbotype*.

Talbot used light-sensitized paper, rather than silver-coated copper plates. His use of paper led Talbot to invent both the negative-positive system and contact printing, which became essential parts of photography.

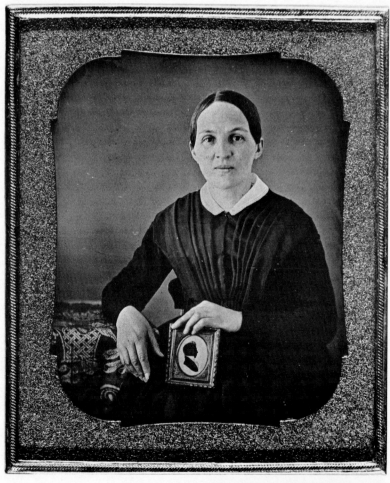

Daguerreotype portrait. One-sixth plate. c. 1850.

Talbot announced that multiple copies of an image could be made from what he called a "negative." After a calotype was exposed, the paper appeared to have no visible image. When it was chemically developed, an image would appear, with dark and light tones reversed and left and right reversed. In making copies, Talbot invented contact printing. A fully developed paper negative, waxed to make it translucent, was placed in contact with another sheet of sensitized paper, and both were exposed to light. The result was a positive image, with tones in their actual values and left and right in their actual positions—a contact print, as we now know it.

Calotypes were never as bright or as sharply detailed as daguerreotypes, but the soft charcoal-like image of the calotype lent itself well to recording architecture, landscapes, and sculpture. Talbot made many prints for the first book ever to be illustrated with photographs. From 1844 to 1846 he published a six-volume work, *The Pencil of Nature,* each copy of which included twenty-four pasted-in calotypes.

Landscape painter David Octavius Hill (1802–1870) and photographer Robert Adamson (1821–1848) collaborated successfully on employing the calotype process for portraits. In 1843 Hill was commissioned to execute a canvas that would include a total of 450 individual portraits! Adamson assisted him in making calotype studies for the work, and for five years a seemingly endless train of sitters made their way to Hill and Adamson's outdoor studio.

6

DAVID OCTAVIUS HILL AND ROBERT ADAMSON. *Portrait of a Minister.* Calotype. c. 1845.

WILLIAM HENRY FOX TALBOT. Negative and positive calotypes. c. 1844.

## Wet-Plate Photography

Since neither the daguerreotype nor the calotype was a completely satisfying solution to portraiture—the former because it could not be duplicated and the latter because it created too fuzzy an image—yet another area of photography was left open to an ambitious inventor. The challenge was to find a substance that would cause silver salts to adhere to a glass surface, which would permit sharp imagery and easy duplication. The magical substance proved to be *collodion,* a gluey mixture of gun-cotton, alcohol, and ether that had been developed in 1847 as a means of protecting wounds. It was first used in 1851 by Frederick Scott Archer (1813–1857) to coat glass plates that were dipped in light-sensitive chemicals (silver ni-

trate solution) and then exposed, while wet, in the camera. These negatives were then contact printed onto paper. The three variations of collodion, or "wet-plate," photography that were invented eventually displaced the daguerreotype and remained in use until the development of the gelatin dry plate three decades later.

James Ambrose Cutting (1814–1867) of Boston was the first to patent Archer's technique in 1854, and so the name *ambrotype* became associated with it. Like the daguerreotype in that each image produced was unique, the ambrotype consisted of a sheet of glass coated with collodion emulsion, purposely underexposed (or normally exposed and then bleached). When viewed against white, the resultant image resembled a pale negative; but backing the glass with black

material, or producing the image directly on dark red (amber) glass revealed a properly exposed positive. Because of the great demand for inexpensive portraits, the ambrotype became very popular in the United States.

The second variation of collodion photography, the *tintype,* utilized a black or dark-brown metal plate instead of glass. Invented by Hamilton L. Smith (1819–1903) and introduced in 1856, the tintype process was immediately embraced by an enthusiastic public because tintypes were cheaper than ambrotypes, could be developed very quickly, and were not fragile, so they could even be sent through the mail. Most of the portraits made by this process were quite informal, even delightfully naive. Although the image produced tended to be dark because the col-

One-sixth plate, presented against a dark ground, left, and a white ground, right. Ambrotype.  c. 1860.

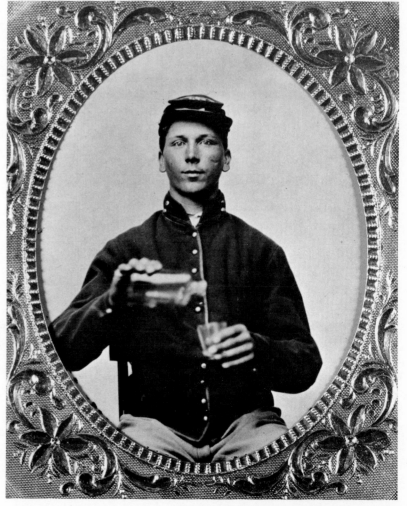

Civil War soldier. One-sixth plate. Tintype.  c. 1861.

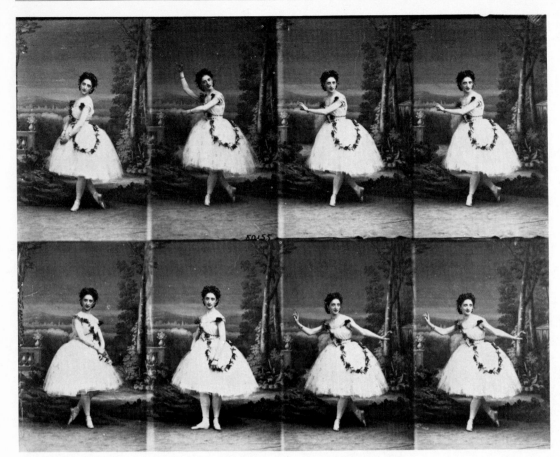

ADOLPHE EUGÈNE DISDÉRI. Sheet of uncut carte-de-visite photographs of Martha Muravieva, Paris Opéra dancer, in poses from the ballet *Neméa*. 1864.

Cabinet photograph of a child. Late 19th century.

lodion, transparent on a dark piece of metal, made a pure white impossible, the tintype was enormously popular between the early 1860s and the late 1880s; it eventually became associated with the penny arcade.

The tintype had an even more prolific cousin, the *carte-de-visite,* so called because each print was mounted on a card 4 × 2½ inches (10 × 6 cm), the standard size for calling cards. Patented in 1854 by Adolphe Eugène Disdéri (1819–1890?), the process differed from both the ambrotype and the tintype in that the camera was equipped with four lenses. As many as eight or twelve separate exposures could be made on a single glass-plate negative by shifting the plate in the camera. The result was a negative that could be duplicated in an infinite number of positives. Carte-de-visite portraits were a great success with the public and were eagerly exchanged during the Victorian era by friends and relatives, who kept them at home in family photo albums.

The popularity of the carte-de-visite fostered a desire for even larger images that could be produced just as readily. To meet this demand, the *cabinet photograph* was introduced in 1866. Printed from an individual negative that measured 6½ × 4½ inches (17 × 11 cm), the cabinet photo could be retouched to eliminate imperfections such as freckles, moles, or wrinkles. It was also grander than its predecessors; often the subject would be posed with fake scenery, elaborate drapery, and other studio props. The cabinet photograph was the ultimate step in idealized portraiture.

Within a few decades of its introduction, then, photography had more than gratified the desires of those who could not afford a painted portrait but who nonetheless longed to have their images recorded for posterity. Photographers then turned their attention to ways in which they could elevate the art of photography above simple documentary portraits.

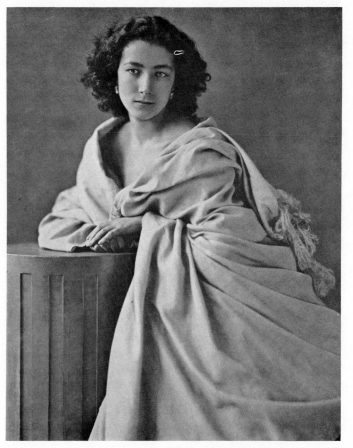

NADAR. *Sarah Bernhardt*. Collodion plate. 1859.

## The Fine Art of 19th-Century Photography

Daguerreotypes, ambrotypes, tintypes, cartes-de-visite, and cabinet portraits were made by photographers eager to please the mass market. The finest portraits were produced in larger formats by more serious photographers, both amateur and professional. Foremost among these 19th-century photographers was Nadar (Gaspard Félix Tournachon, 1820–1910), whose portraits of actress Sarah Bernhardt and other notables are still famous. The "naturalness" of the subject became a sought-after characteristic of early portraits. To achieve this, Nadar usually posed a sitter without artificial props and other devices that might prevent capturing an intimate record of the sitter's personality.

Portrait photographer Julia Margaret Cameron (1815–1879), who was personally acquainted with many of the illustrious personalities of her time, took advantage of her social position to photograph such celebrities as Lord Tennyson, Charles Darwin, Henry Wadsworth Longfellow, Robert Browning, and Sir John Herschel. Like Nadar, she was concerned with recording the innate character of her subject; she deliberately used soft-focus lenses to subdue detail while photographing her sitters from very close range, their heads often filling most of the composition. Relatively unconcerned with the complexities of the photographic process, she used whatever methods were necessary to achieve her desired end—the permanent recording of her sitter's essential spirit.

Unlike Julia Margaret Cameron, who photographed the famous, Charles Lutwidge Dodgson (1832–1898), better known as Lewis Carroll, preferred photographing little girls dressed in fancy clothes. He, too, sought naturalness. He even photographed his small subjects in the nude, which brought him some measure of disapproval in the Victorian era.

9

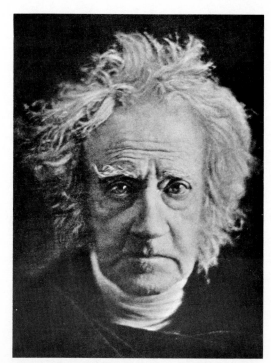

JULIA MARGARET CAMERON. *Sir John Herschel*. Collodion plate. 1867.

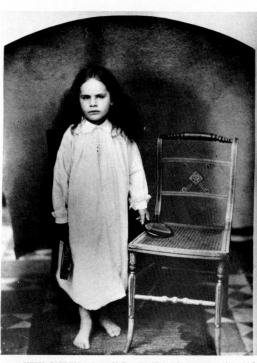

LEWIS CARROLL. *Irene McDonald: "It won't come smooth."* 1863.

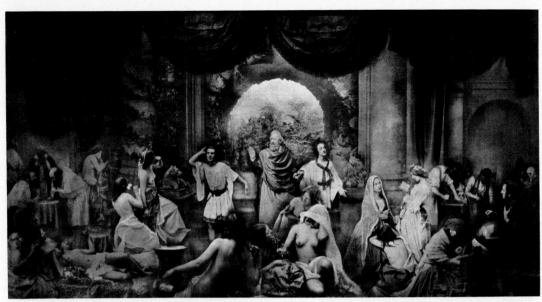

OSCAR G. REJLANDER. *The Two Ways of Life*. Composite photograph. 1857.

10

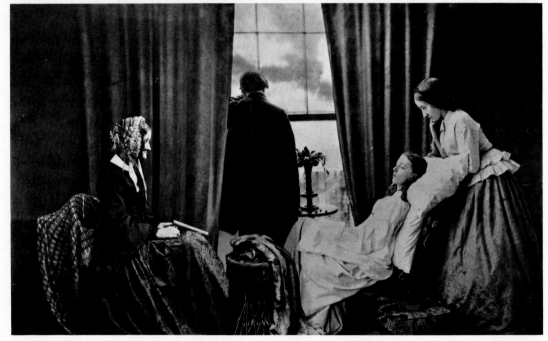

HENRY PEACH ROBINSON. *Fading Away*. Composite photograph printed from five negatives. 1858.

Some of these early photographers who had a previous background in painting did not photograph people as individuals but instead incorporated them in composite photographs that had a strong relationship to traditional allegorical painting. These photographers, in their desire to emulate paintings in subject matter and effect, turned to *combination printing,* or the use of several negatives to produce a single print. In 1857 Oscar G. Rejlander (1813–1875) exhibited an allegorical photograph called *The Two Ways of Life*. He photographed each figure group in sections, then masked the negatives together to produce a single composite print that measured 16 × 31 inches (40 × 79 cm). Although the photograph may seem melodramatic to the modern viewer, it was generally popular with the public; in fact, the original was purchased by Queen Victoria herself. On the other hand, a composite photograph in which Henry Peach Robinson (1830–1901) portrayed the death of a young girl was thought excessively morbid. Although death was often a theme in the paintings of the time, photography made it seem too real.

Obviously, photography could cause strong reactions in people. Thus it was beginning to be accepted as a forceful medium of expression in its own right. ☐

## The Photojournalist-Explorers

**R**oger Fenton (1819–1869), an Englishman who was commissioned by Queen Victoria to cover the Crimean War in 1855, was the first photographer actually to focus on the scene of battle. He returned with more than three hundred negatives that presented a rather selective view of the war: they ignored the brutal realities of camp conditions. Also, because of the relatively long exposure required by the collodion process, there were no images of action. Though Fenton's photographs were considered to be less exciting than painted battle scenes, the public was intrigued by their element of truth.

Harsh realities were not ignored by the early photojournalists who felt impelled to portray the American Civil War. Mathew Brady (1823–1896), a New York photographer, stated, "I felt that I had to go. A spirit in my feet said 'go' and I went." Initially he personally photographed the events and at Bull Run was nearly killed. Realizing that the project was beyond one photographer's capacity, he hired more than twelve others, including Alexander Gardner (1821–1882) and Timothy H. O'Sullivan (1840–1882), and supplied them with the necessary materials. These photographers entered the thick of conflict to record battlefields littered with the dead, exhausted soldiers, wrecked ships and railroads, and ruined cities.

By the end of the war, Brady and his associates had produced more than seven thousand negatives. But the public was not yet ready for the stark and brutal scenes of war depicted by these photojournalists, and Brady never realized much profit.

The lure of the unexplored American West attracted many of the early photojournalists, who frequently joined government expeditions to travel to faraway places. For their work the public showed much more enthusiasm. Timothy O'Sullivan, making use of his war photography experience, became one of the best known of these early adventurer-photographers. In 1870 William Henry Jackson (1843–1942) joined an expeditionary party led by the explorer-scientist Ferdinand Vandiveer Hayden, and the following year he made the first photographs of the area now known as Yellowstone Park. Jackson's stunning photographs of the unspoiled magnificence of the Western landscape were an essential factor in the controversial decision of Congress to create national parks.

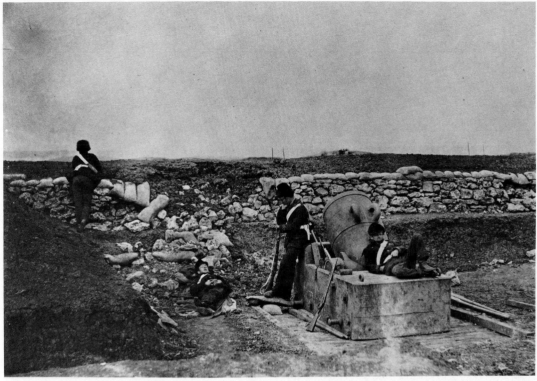

ROGER FENTON. *A Quiet Day at the Mortar Battery.* 1855.

*11*

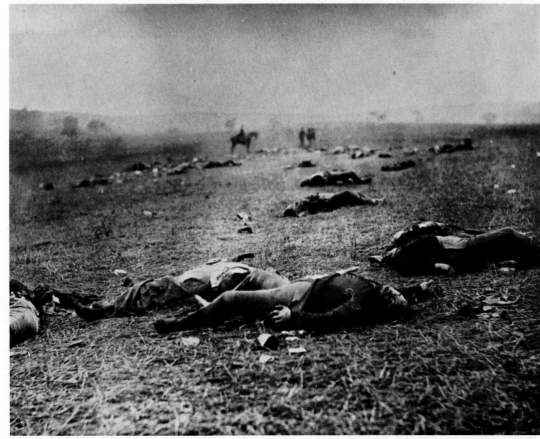

TIMOTHY H. O'SULLIVAN. *A Harvest of Death, Gettysburg.* 1863.

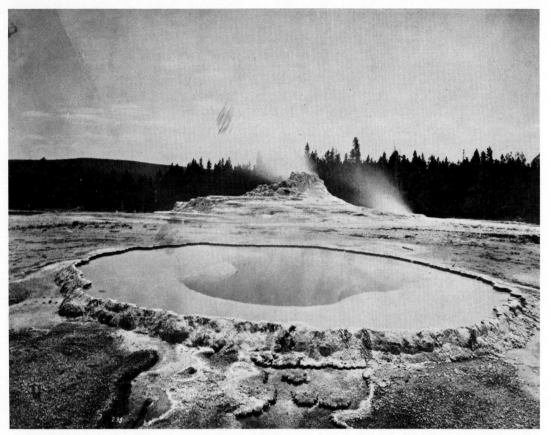

WILLIAM HENRY JACKSON. *Hot Springs and Castle Geyser, Yellowstone.* c. 1895.

12

These photojournalist-explorers had to contend with three limiting characteristics of early photography. For one thing, the wet-plate collodion process required that each negative be processed as soon as it had been exposed, forcing photographers to carry their unwieldy darkrooms with them. Another problem was that the size of the print was still determined by the size of the negative (enlarging did not become practical until the 1920s); thus photographers also had to carry cumbersome large cameras on their often perilous expeditions. The third limitation was that the exposures were long and prevented the capturing of action.

The problem of motion was solved in an ingenious, though complicated, way by Eadweard Muybridge (1830–1904), one of the first photographers to produce photographs that stopped fast action. Commissioned to settle a bet that a galloping horse has all its feet off the ground at some point, Muybridge took a series of photographs with a series of cameras. The photographs proved that all four feet are indeed off the ground at once, when they are bunched together. Thus they also proved that a galloping horse never assumes the rocking-horse position—two legs stretched forward and two back—which had always been shown in paintings of galloping horses. Muybridge went on, using new and faster emulsions and special multi-lens cameras, to photograph other animals and human beings in motion—an invaluable collection of motion studies that forced painters to reevaluate their portrayals of action.

## Dry-Plate Photography and the Advent of Roll Film

**B**y the late 1870s considerable progress had been made toward solving the need for immediate processing with the invention of readymade dry plates that could be processed at the photographer's convenience. The first of these plates had too little sensitivity to be of much use, but acceptable dry plates were perfected in 1879 and almost universally adopted. The dry plates could be bought in stores, exposed at leisure, and developed within any reasonable time—either by the photographer or by a commercial processing firm. Though the first dry plates were oversensitive to blue and insensitive to red, orange, and yellow, these inconsistencies were gradually corrected. (Modern film is equally sensitive to all colors.)

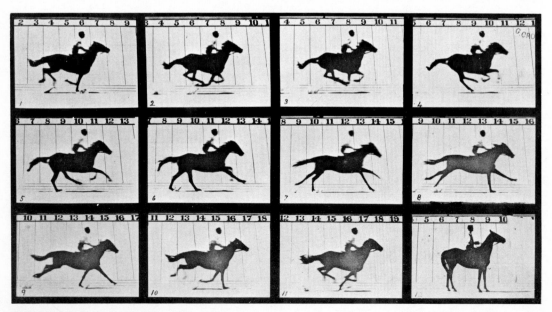

EADWEARD MUYBRIDGE. *Galloping Horse.* 1878.

Until the last decade of the 19th century photography was left largely to determined people willing to cope with the heavy glass plates and unwieldy camera equipment. Alice Austen (1866–1952), who began to record her surroundings in the 1880s and left thousands of photographs, was one of these (see page 1). But in 1888 George Eastman (1854–1932), an American dry-plate manufacturer, did for the camera what Henry Ford would do for the automobile a generation later: he made it possible and practical for more people to own and use one. In that year Eastman introduced the box camera, which he called a *Kodak* because the name was easy to pronounce and remember. The Kodak camera was small, relatively light-

weight, and easy to operate; its faster shutter speed eliminated the need for a tripod.

Essential to the success of the box cameras was another Eastman invention, the so-called American Film, a roll of paper (transparent nitrocellulose from 1889 on) coated with a thin gelatin emulsion. As purchased, the camera was equipped with a roll of film capable of taking one hundred round negatives each $2\frac{1}{2}$ inches (6.4 cm) in diameter. When the roll was used, the camera was shipped to the Eastman company in Rochester, where the film was removed and processed. The customer received back in the mail one hundred individually mounted prints and the camera, reloaded with a new roll of film. Although somewhat expensive

(the camera was \$25 and each reload \$10, considerable amounts at the time), the Kodak system paved the way for amateur photography.

By the turn of the century, Eastman was marketing much cheaper cameras and film, and Americans were beginning to make their own photographic records. Tourists carried their new box cameras with them on their travels and brought back snapshots to prove to the folks at home that they had really been there. At home, people took pictures of each other and their surroundings. Many families could now have their own photographic archives. The slightly more ambitious amateur could buy a kit that included a tripod and developing chemicals.

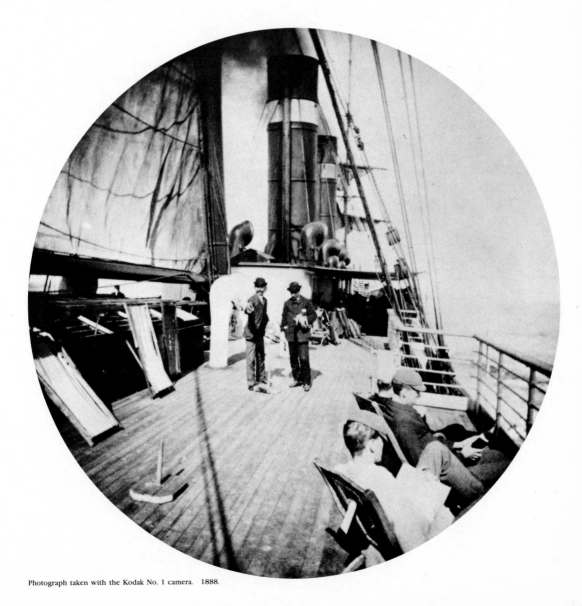

Photograph taken with the Kodak No. 1 camera.  1888.

13

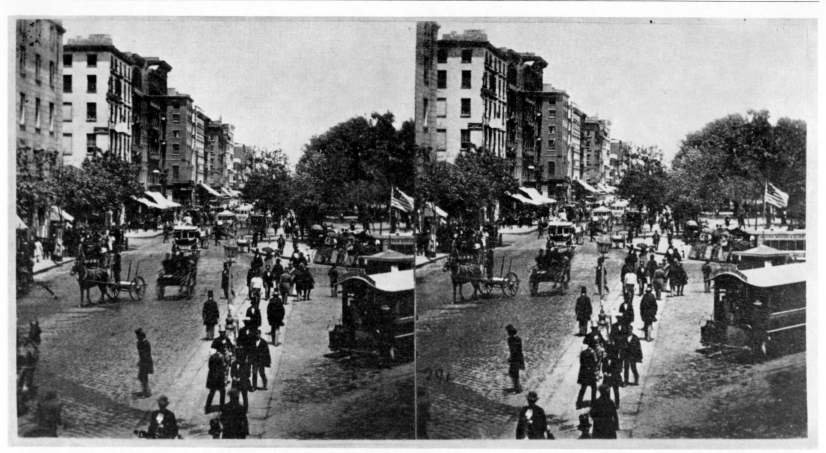

14

EDWARD ANTHONY. *Broadway, New York.* Stereograph card. 1859.

## Stereoscopic Photography

**F**rom the earliest days of photography there had been interest in stereoscopic pictures—two nearly identical views of the same scene taken from points about 2 inches (5 cm) apart. Thus photographers imitated the stereo vision of the human eyes, a major factor in the perception of three-dimensional space. In the early 1900s stereoscopic photographs of scenic points, architectural wonders, and street scenes became all the rage. They were made either by moving the camera laterally a short distance between exposures or with a double-lens camera. Then the results were viewed through a *stereoscope,* a device that blended the two images to produce the illusion of spatial depth. Stereoscopes became the "home movies" of the early 20th century as street scenes once silent and empty in earlier photographs became filled with people and their daily activities.

Finally, the turn of the century ushered in yet another facet of photography. The 20th century brought a new era of "art" photography as serious professionals began to explore the camera's aesthetic potentials. □

# The Photographer as Artist

## A Challenge to the Pictorialists

**T**hroughout the history of photography two basic but conflicting views concerning the photographic image have coexisted. In one camp are the "pictorialists," who in their imagery seek to imitate paintings and art prints. They used to set up fictitious sentimental allegorical situations; now they often suppress detail by means of soft focus, emphasize soft, flat tonalities, and sometimes hand-manipulate the resulting negatives or prints to produce as artistic a photograph as possible. These photographers think of themselves as artists first and photographers second. This approach is challenged by those photographers known as realists, or "straight" photographers, who do not believe in any degree of manipulation of the photographic image. Perhaps the first champion of straight photography was Daguerre, who wrote: "Nature has the artlessness which must not be destroyed."

Photographic exhibitions in the late 19th century were dominated by the pictorialists' sentimental genre scenes, idealized landscapes, and rather artificial portraits. But a strong challenge came from Peter Emerson (1856–1936), an Englishman who was an established photographer. Emerson set forth his aesthetic theories in a textbook, *Naturalistic Photography,* published in 1889. The most controversial of Emerson's ideas was his contention that only the principal elements in a photograph should be in sharp focus, with the background and often the foreground somewhat blurred. This was an attempt to imitate the vision of the human eye, which does not focus with equal clarity on everything it sees. Emerson's theory of graduated focus is evident in *Taking Up the Eel-Net,* in which the foreground figures and the boat are sharply defined against a soft background. Although Emerson later recanted some of his earlier ideas, the spirit of the straight photograph he had fostered continued to influence other photographers.

## Stieglitz and the Photo-Secessionists

**A**lfred Stieglitz (1864–1946) as a young man set out to prove that the hand camera was perfectly capable of achieving professional results. With borrowed equipment, he began to photograph deliberately under adverse conditions—in snow, in rain, and at night. Stieglitz became an ardent propagandist for photography as an independent art medium which could be used to produce pictures free from imitation of other arts. With lectures and periodicals he attempted to present the best available work to the public. In 1902 he started the Photo-Secession, a loosely structured group dedicated to advancing photography "as applied to pictorial expression." *Camera Work,* a handsome quarterly of which Stieglitz was in charge, helped to further this goal. In the fifteen years of its publication, *Camera Work* adhered to the highest possible standards of excellence, both in the works selected for presentation and in quality of reproduction.

In 1905 the Photo-Secession group opened the Little Galleries at 291 Fifth Avenue in New York. The "291" gallery became famous for presenting the most daring, innovative work in the visual arts—not only photography, but also painting, sculpture, and drawing. Through "291" Stieglitz introduced to the United States such European masters as Pablo Picasso, Paul Cézanne, Henri Matisse, Georges Braque, and Auguste Rodin, as well as many progressive young American artists.

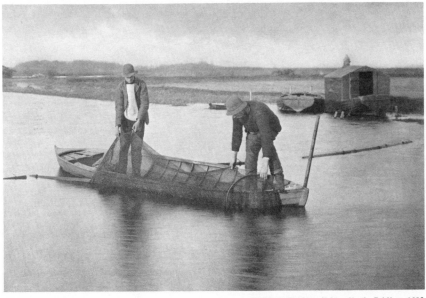

PETER EMERSON. *Taking Up the Eel-Net.* 1885.

ALFRED STIEGLITZ. *The Terminal.* 1893.

## Straight Photography

**A**lthough Stieglitz often presented pictorialist photographs and even experimented with a few such prints himself in his early work, he became much concerned with straight photography. *The Steerage* is a straight photograph Stieglitz made hurriedly when he noticed the striking composition of human figures and bold diagonal forms on the lower decks of the *Kaiser Wilhelm II.* Stieglitz himself considered this to be his finest photograph.

In the late 1920s, Stieglitz began work on an extensive series of photographs called "Equivalents," all featuring clouds. By choosing a subject that was "there for everyone" he hoped to silence those who maintained that his success with other subjects was attributable to his own forceful personality. In addition, Stieglitz intended to demonstrate what he had "learned in forty years about photography." He used an ordinary camera and had all the film processed in the same way that was available to amateurs. The resulting photographs are indeed "straight," yet they illustrate Stieglitz' mastery of form in the sensitive relationships of twisting and swirling clouds with the horizon, the trees, or the circular shape of the sun. Each photograph could be viewed as an independent image or as part of the whole series.

Stieglitz' contribution to photography goes far beyond his own efforts; in *Camera Work* and at "291," he introduced many previously unknown photographers who later earned international recognition. One of these photographers, Edward Steichen (1879–1973), after a number of years of close association with Stieglitz became the chief photographer of Condé Nast Publications. Combining a gift for design with the ability to characterize a personality in portraiture, he had much influence on magazine illustration in publications such as *Vogue* and *Vanity Fair.* Toward the end of World War II he directed combat photographers for the U.S. Navy Photographic Institute. From 1947 to 1962 he was the director of photography at the Museum of Modern Art in New York and organized more than fifty photography exhibitions, of which "The Family of Man" was perhaps the most famous.

Another photographer who exhibited at "291" was Gertrude Käsebier (1852–1934). Selected for her painterly representations of light, shade, tone, and texture, Käsebier was

16

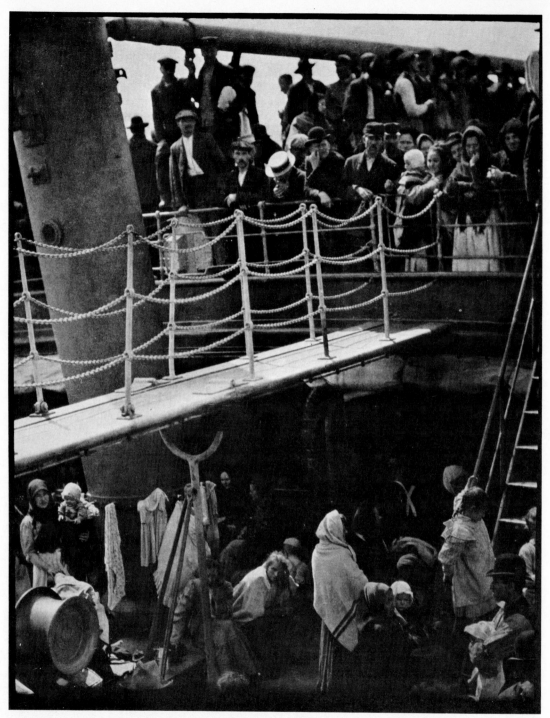

ALFRED STIEGLITZ. *The Steerage.* 1907.

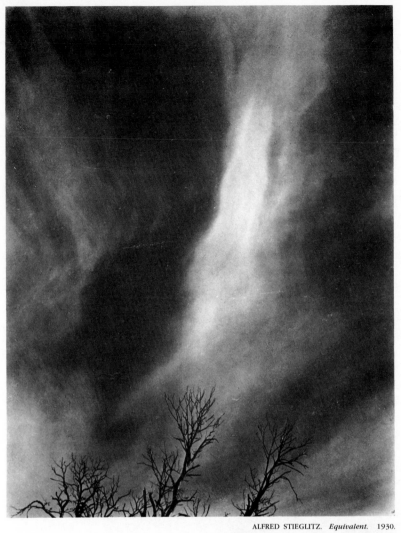

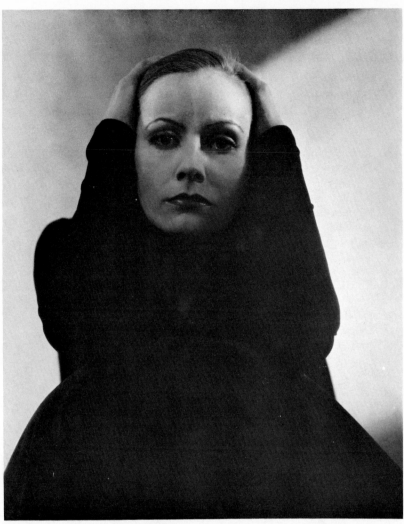

ALFRED STIEGLITZ.  *Equivalent.*  1930.

EDWARD STEICHEN.  *Greta Garbo, Hollywood.*  1928.

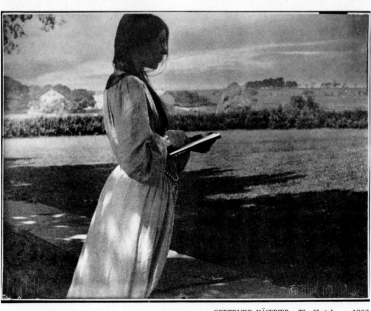

GERTRUDE KÄSEBIER.  *The Sketch.*  c. 1902.

a serious romanticist who eventually broke away from the Stieglitz group when Stieglitz proclaimed himself to be an advocate of the straight style of photography.

The last issue of *Camera Work* in 1917 featured Paul Strand (1890–1976), a young American who pushed straight photography to a point that Stieglitz called "brutally direct." Many of Strand's early photographs were closeup abstractions of fruit, machines, and roads. His later photos of people revealed a bare-boned simplicity. His extraordinary perception of subject matter, combined with his meticulous attention to craftsmanship, contributed much to the development of photography as a respected art form.

While some straight photographers located their visions in abstractions, others discovered the intensely beautiful forms of natural objects and the significance of documenting daily life. Jean Eugène Auguste Atget (1856–1927), by choice not a member of any photographic or artistic movement, made a

life work out of photographing almost anything and everything that he considered "picturesque and artistic" about life in Paris from 1900 to 1925. Having no patience with any of the soft techniques used to imitate paintings, Atget was firmly committed to making photographic documents; these revealed an innate sense of how great realistic photography could be.

Inspired initially by the artful photographic work of Gertrude Käsebier, Imogen Cunningham (1883–1975) produced early work that was also of the soft-impression, romantic type. She gradually evolved, however, toward a more "straight" approach espoused by such notable photographers as Edward Weston, Ansel Adams, and others who, as members of the "Group f/64," believed in sharp-focus photography. While her photographs reflect the "bare truth" of an object, they also convey a sense of excitement in seeing a familiar object in an unexpected context.

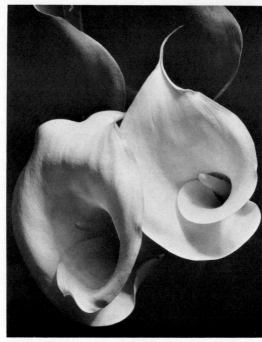

IMOGEN CUNNINGHAM. *Two Callas.* c. 1929.

18

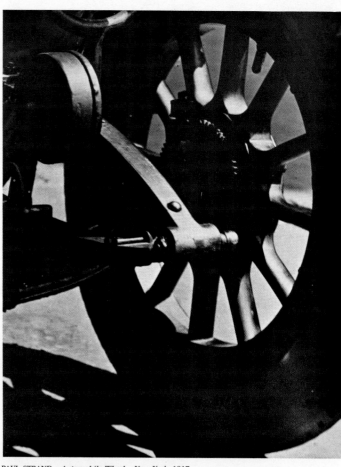

PAUL STRAND. *Automobile Wheel.* New York, 1917.

JEAN EUGÈNE AUGUSTE ATGET. *Men's Fashions.*

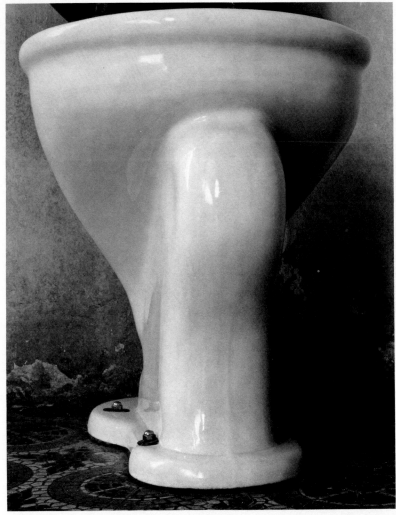

EDWARD WESTON. *Excusado.* 1925.

ANSEL ADAMS. *Moon and Half-Dome, Yosemite National Park.* 1960.

19

### *In Search of the Perfect Photograph*

**T**he work of two photographers in particular, Edward Weston and Ansel Adams, came to exemplify the movement that carried the idea of the direct and unmanipulated image one step further toward the creation of the photograph as a visual symbol. Edward Weston (1886–1958), who was influenced early in his career by photographers such as Stieglitz and Strand, personified this approach that dominated photography from the 1930s to the 1950s. A perfectionist about detail, Weston felt that a closeup could be much more powerful than a vague overall view. His closeups are striking studies of form—almost abstractions. Weston's attitude toward photographic materials, plus a personal passion for his subject matter, crystallized in the idea that a scene should be "previsualized"—that all decisions should be made before the shutter is opened.

The photographs of Ansel Adams (b. 1902) are symbolic in that they demonstrate his conception of the beauty of unspoiled nature. Although Adams has a great love for nature and a concern for conservation, he is more loyal to the photograph, transforming tones and departing from reality to create the perfect photograph and not the perfect record of the scene. Adams obtains the tones he wants by manipulating the relationship between exposure and development. He has written extensively on this relationship, which he named the Zone System (see Chapter 10).

By the 1920s, then, photography had largely cast off its image as a device to enhance the range of painting. It seems particularly appropriate, therefore, that in the same period the aesthetic possibilities of photography began to be expanded by serious painters. □

In 1917 Alvin Langdon Coburn (1882–1966), another member of Photo-Secession, created and exhibited a series of photographs called *Vortographs,* made by focusing a camera through a triangle of mirrors onto small objects. Coburn, who had set out to prove that photography could be just as abstract as painting, wrote that the patterns he had created "amazed and fascinated" him.

In the early 1920s two artists began independently to make "cameraless images" by placing three-dimensional objects on light-sensitive paper and then exposing the whole to light. Man Ray (1890–1976), an American painter who was connected with the Dada circle in New York and Paris, called his efforts *rayographs.* The Hungarian László Moholy-Nagy (1895–1946), an instructor at the Bauhaus school of design in Germany, called his photographic abstractions *photograms.* In both cases the resultant image revealed the contours of the object as well as the shadows it cast. Although both men used the same method, their emphasis was different. For Man Ray the original identity of the objects was part of their meaning; for Moholy-Nagy the way light transformed objects was more important than the objects themselves.

Many other experimental techniques were investigated during this same period. Both Man Ray and Francis Bruguière (1880–1945) created numerous abstract photographs by means of a technique commonly known as *solarization.* When either a negative or a print is momentarily reexposed to light during the processing, the result is a partial reversal of tones, especially of sharp edges or lines, creating an exciting negative-positive visual quality.

As more and more photographers were experimenting with distorting photographic images, others concentrated on producing unembellished, often painful, photographic images of reality. The camera as an instrument of social conscience came into its own in the late 19th century. □

20

ALVIN LANGDON COBURN. *Vortograph of Ezra Pound.* 1917.

LÁSZLÓ MOHOLY-NAGY. *Photogram.* 1926.

FRANCIS BRUGUIÈRE. *Untitled.*

# The Social Documenters

## Immigrants and Industry

**T**he camera has an unparalleled ability to document scenes of poverty, cruelty, brutality, and despair. Although the photographs of the very earliest photo-commentators, such as T. H. O'Sullivan's of the Civil War, were unpopular with a public not prepared to face the stark truth of war, other photographers followed their lead in recording other harsh realities: the life of the poor.

In the late 1800s Jacob Riis (1849–1914), a Danish immigrant in New York, set out to prove to an indifferent nation that intolerable living conditions existed for many among the "huddled masses" who had recently arrived in the United States. Riis worked for a time as a police reporter, an occupation that regularly took him into the worst sections of the city. His pictures of tenement slums and a disreputable alley known as Bandits' Roost evoked a sordid reality that was far removed from the genteel image cherished by late-19th-century New Yorkers. Unfortunately, photographic reproduction was still in its infancy, and Riis' pictures appeared in the newspapers merely as facsimile drawings. His 1890 book, *How the Other Half Lives,* which contained seventeen photographic reproductions, had greater impact, and ultimately Riis' photo-journalistic campaign led to many housing reforms.

Similar reform motivations inspired Lewis W. Hine (1874–1940), a trained sociologist, to carry his camera along on field trips into factories, sweatshops, and slums. Photographs like *Little Spinner in Carolina Cotton Mill* were carefully calculated in terms of scale to prove that the factory workers were actually quite small children. In 1900 nearly two million children under the age of sixteen were employed, often in wretched conditions. Hine's photographs helped to create a climate for the child labor laws that were passed after 1911.

21

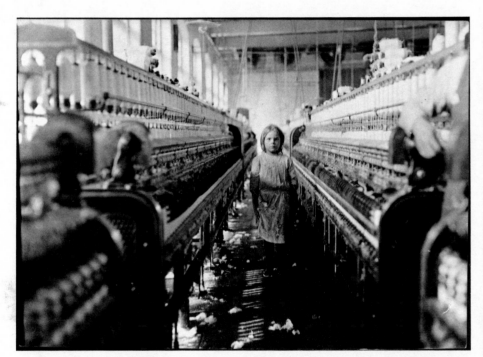

LEWIS W. HINE. *Little Spinner in Carolina Cotton Mill.* 1909.

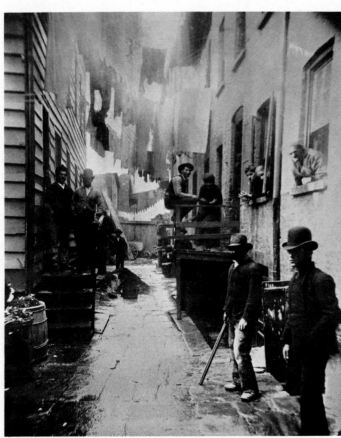

JACOB RIIS. *Bandits' Roost, Mulberry Bend.* c. 1888.

*The Depression Years*

**S**ocial conscience on a governmental level blossomed during the years of the Great Depression. In the hope that photographic documentation would serve an educational purpose, the U.S. Government, through the Farm Security Administration (FSA), headed by Roy E. Stryker, sent many photographers to record rural conditions brought about by the Depression and the severe drought of the mid-1930s. One of these photographers, Dorothea Lange (1895–1965), concentrated on the plight of migrant farm workers who traveled back and forth across the country trying to find enough work to feed their families. Walker Evans (1903–1975) lived among sharecroppers in the South, documenting their marginal existence through pictures of their farms, their schools, and their homes. The seven-year FSA project yielded thousands of negatives, most of them strong and straightforward, many of them shocking. When the project was finally disbanded, several of the photographers applied the experience they had gained to the new field of photojournalism, finding a ready market in *Life* and *Look* and other pictorially oriented magazines.

22

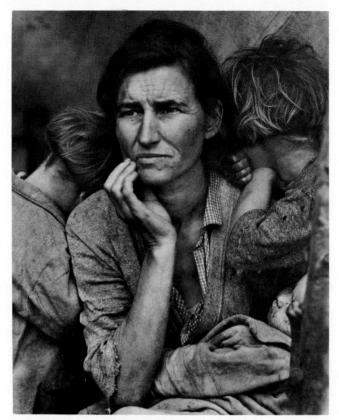

DOROTHEA LANGE. *Migrant Mother, Nipomo, Calif.* 1936.

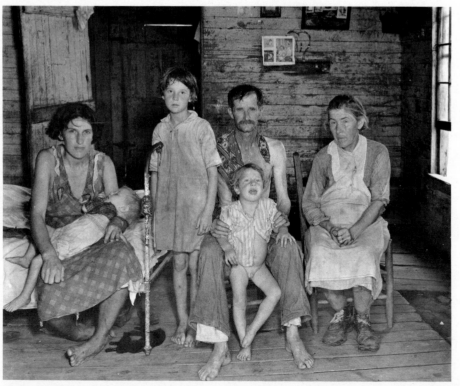

WALKER EVANS. *The Bud Fields Family at Home, Alabama.* 1935.

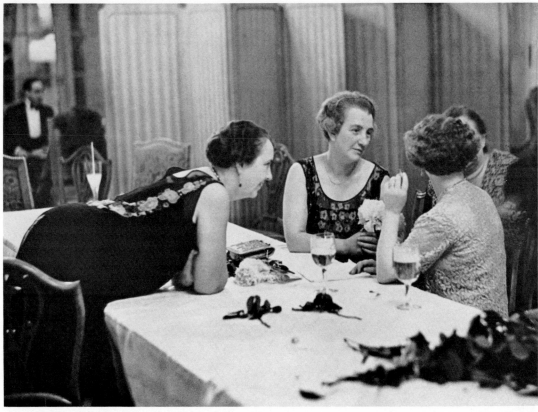

ERICH SALOMON. *Two Female Politicians of 1930: Katharina von Kardoff-Oheimb, Wife of a Reichstag Deputy, and Ada Schmidt-Beil.* 1930.

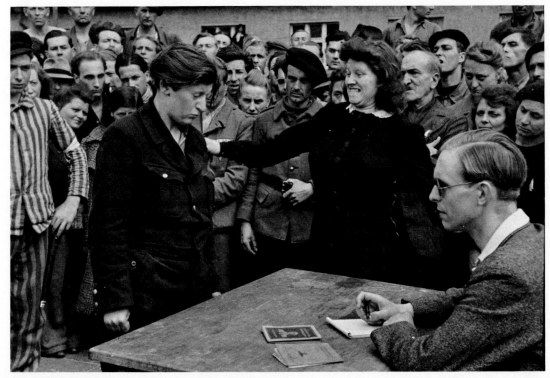

HENRI CARTIER-BRESSON. *Gestapo Informer Accused, Dessau.* 1945.

## Photojournalism

**A**lthough the efforts of early photojournalists were thwarted by poor representations of their work in the newspapers of the time, in 1897 a method was perfected for printing photographs as halftones on high-speed presses; thus for the first time the mass production of photos was possible. By the turn of the century, people had already become accustomed to seeing photographs in their daily newspapers. This printing innovation opened up the field of journalism to photographers and allowed people to see, by proxy, all sorts of national and world events that before they could only have read about. The photo-essay, or picture story, an important outgrowth of photojournalism, was evolved in the 1930s in magazines such as *Life,* which were devoured by a public anxious to be amazed by photos.

Erich Salomon (1886–1944), who worked for various German newspapers and magazines during the 1920s and 1930s, used a small camera and great initiative to obtain pictures in places normally forbidden to photographers. Salomon managed to gain admittance to courtroom trials, a Hague conference, the United States Supreme Court, the British Foreign Office, and meetings of the German Reichstag and proved that neither he nor his camera would disturb the proceedings. All of his photographs were made with available light and shot as unobtrusively as possible. In some instances he concealed the camera in a briefcase or a hat and once operated it by remote control. Rarely posing his subjects, Salomon was the first to have his work described as "candid photography."

A masterful photographer, Henri Cartier-Bresson (b. 1908) has a particular genius for capturing what he calls the "decisive moment." In 1945 he recorded the dramatic scene that unfolded in a camp for displaced persons when a refugee exposed a Gestapo informer. By remaining inconspicuous and at the same time knowing instinctively just when to open his shutter, Cartier-Bresson— who had himself spent three years in a German prison camp—caught the precise instant when the refugee's rage burst forth. The angry yet controlled faces of the watching crowd, the clenched fists of the accused, and the ready pen and pencil of the recorder all heighten the photograph's impact. Not only can Cartier-Bresson capture the tension

23

created by a moment; he also has an uncanny ability to structure a moment into a perfect organization of its separate elements. Once he has pressed the shutter, his work is done; someone else can print the picture, but it is an entity, and cropping or retouching is forbidden.

Alfred Eisenstaedt (b. 1898), one of the original staff photographers of *Life,* has traveled extensively over the past forty-five years, and his pictures alone could almost chronicle the period. Eisenstaedt was among the first to develop the concept of the picture story. He photographed activities in the United States during the 1930s, the rise and fall of the Nazi and Fascist governments in Europe, the defeat of Japan, and the postwar years in Africa. In the course of covering national and global events, Eisenstaedt has never lost sight of basic human values or preoccupations.

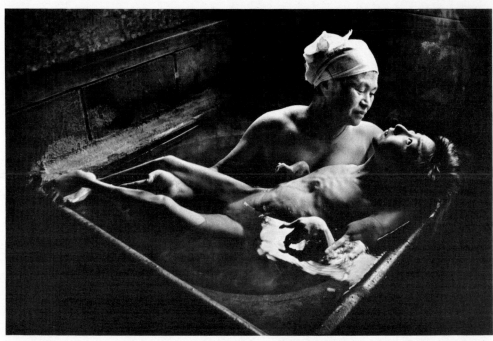

W. EUGENE SMITH. *Tomoko and Mother.* Minamata, 1972.

24

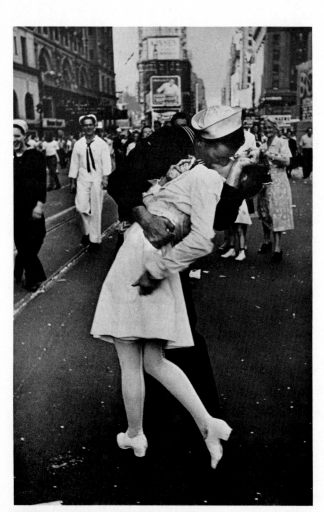

ALFRED EISENSTAEDT. *V-J Day: Sailor Kissing Girl.* 1945.

IRVING PENN. *Dior Hat and Dry Martini. Vogue,* 1952.

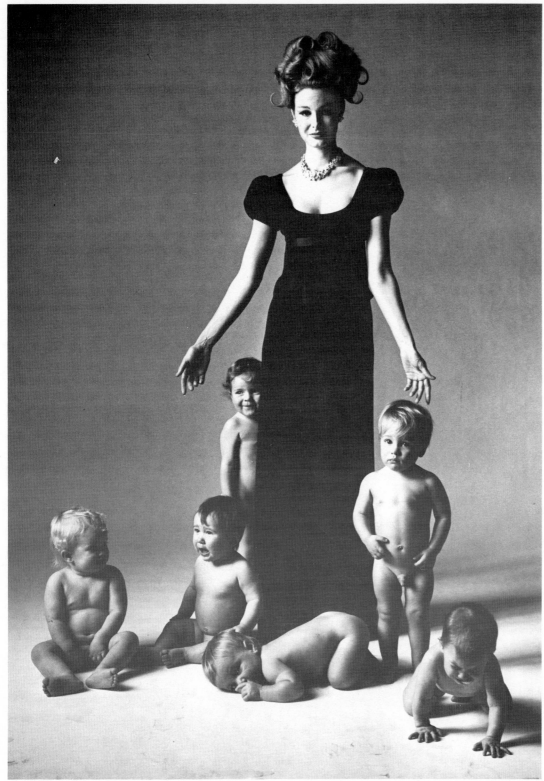

BERT STERN. *Monique Knowlton and Babies.* Vogue, 1962.

W. Eugene Smith (1918–1978) also produced an enormous number of picture stories for *Life* but was more at odds with the group-journalism concept because of his profound personal sense of mission. Exposing social evils became his central aim. On one assignment he lived for a year in a poor Spanish village, becoming almost a member of the community in order to photograph its essence. His pictures, while focusing on the particular, display a universal quality that supports his intent to increase the viewers' sympathy with other human beings. Later he documented the effects of industrial pollution in a Japanese village. Photographs such as the one of a mother bathing her daughter born with irreparable genetic defects identify Smith as one of the new breed of social commentators who record history with a conscience.

Although not photojournalists in the strict sense, there have been many photographers who have contributed to the mass media through illustration photography. A history as brief as this one cannot deal properly with the many specialized branches of the craft, such as food, fashion, and advertising photography. A few photographers, most notably Richard Avedon (b. 1923), Irving Penn (b. 1917), and Bert Stern (b. 1929), have brought such sensitivity and technical mastery to the realm of fashion and illustrative photography as to create virtually a new art form. Even more demanding are certain types of industrial and scientific photography, which require a sophisticated knowledge of the subject matter and, often, modified photographic equipment. For example, Lennart Nilsson (b. 1922), a Swedish medical photographer, produces amazing documentations of the human body (see page 26). Nilsson uses sophisticated devices for viewing internal organs as well as dramatic methods of lighting to show specimens removed from the body. These images are not only informative for the medical profession but also strikingly beautiful.

25

By the mid-20th century it seemed that cameras had been everywhere on earth. Then, in July 1969, the spacecraft *Eagle* landed on the moon, and its two passengers, astronauts Neil Armstrong and Edwin Aldrin, set foot on the surface. Their first steps were recorded by news photographers throughout the world who photographed television screens. The astronauts themselves made photographs with a specially modified, motor-driven Hasselblad 70mm camera and, for photographing the surface of the moon, a special Kodak stereo camera. These photographs and the many others from other space explorations indicate the unlimited potentialities of photography: not only can it document new frontiers; it can even discover them.

*Individual Insights*

**M**ost photojournalists' projects are assigned by an editor or editorial board rather than chosen by the photographer as an individual. Other photographers have decided to document what interested them personally, with little concern for the mass-media audience. Their photographs seldom show human suffering or political events. Rather, they often deal with everyday occurrences and surroundings, seen by the camera as an extension of the photographer's personality.

Brassaï (Gyula Halász, b. 1899), a French photographer, journalist, sculptor, set designer, and filmmaker, photographed the "night people" of Paris of the 1930s. His images of pimps, prostitutes, opium smokers, and dancers are not social documents so much as warm responses that reflect the photographer's presence as a participant, rather than as a spectator.

Josef Sudek (1896–1976) was a Czech photographer who explored and documented the city of Prague, the "world of his choice." He was indifferent to financial success and fame; in fact, his photos were not mass reproduced. His main desire was to take enough time to pursue his photographic projects, which included panoramic photographs, landscapes, and studio still lifes. His motto was "hurry slowly." Sudek's photos express a very delicate sensibility. They also show a thorough knowledge of light: objects in his photos emerge from or recede into darkness and are illuminated not by reflected light but rather by light that falls gently on them.

26

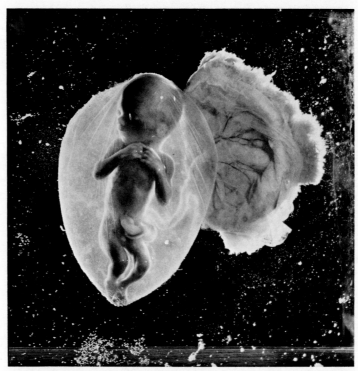

LENNART NILSSON. *Eighteen-week-old Embryo.* 1965.

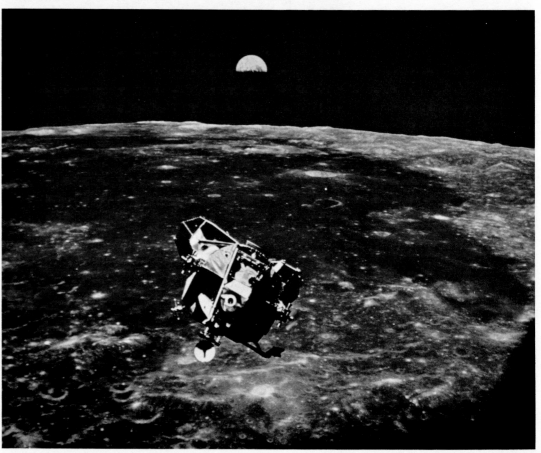

*Earth Rise.* 1969.

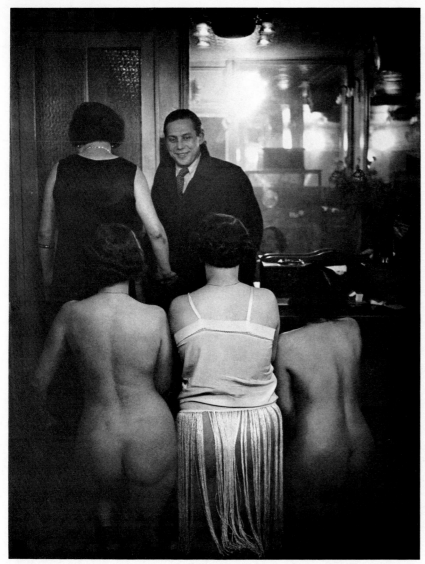

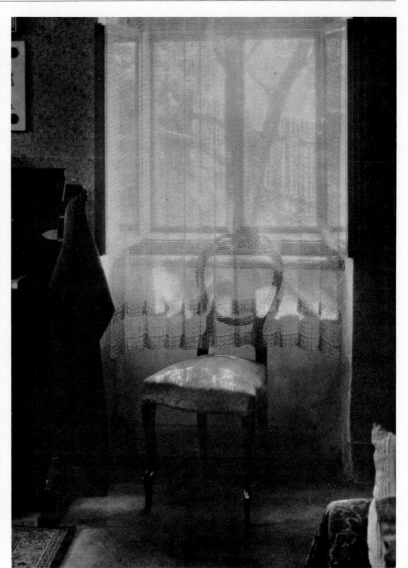

27

BRASSAÏ. *Chez Suzy, Introductions.* c. 1932.

JOSEF SUDEK. *At the Janáčeks'.* 1948.

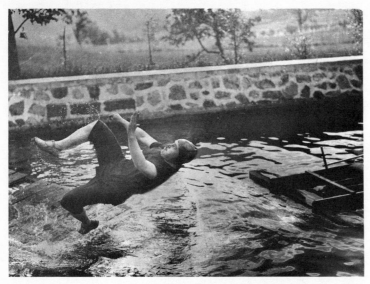

JACQUES-HENRI LARTIGUE. *Jean Haguet, Château de Rouzat.* 1910.

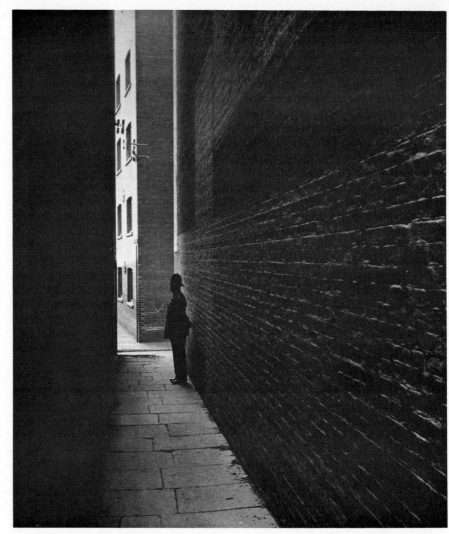

BILL BRANDT. *Policeman in a Dockland Alley, Bermondsey.* 1930s.

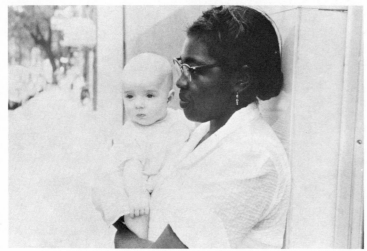

ROBERT FRANK. *Charleston, S.C.* 1956.

28

Jacques-Henri Lartigue (b. 1896) is a painter who started as a child to chronicle his family and friends with a camera. Lartigue was much interested in the camera's ability to stop movement, and his family and friends gave him ample opportunity to exploit this ability. His humorous, yet straightforward, photos included people diving into water, jumping off porches, and trying out new inventions. He also photographed rich, elaborately dressed men and women watching horse races and promenading on the boulevards of Paris. These intriguing photographs provide a sensitive documentation of the life of the affluent in the Edwardian era.

Bill Brandt (b. 1904), born in London, studied with Man Ray and returned to England to specialize in documentary photography. He photographed the depression in England in the 1930s and the Nazi raids on London in the 1940s, and he produced a series of portraits of famous English writers. His photographs often have large rich black areas that reveal the subject in a familiar fashion and yet are quite strange. His later distorted images of the nude figure made with a special antique wide-angle camera often seem dreamlike.

Robert Louis Frank (b. 1924) drove throughout the United States in the 1950s photographing places, people, and events. Supported by a Guggenheim grant, and therefore free from any journalistic or commercial considerations, he was able to pursue his private vision of "the American way of life." The resulting book, *The Americans,* published in France in 1958, demonstrated that Frank had established a new way of making pictures. His photographs were shockingly unconventional in that they gave a view of America the way it *was,* not the idealized vision Americans wanted to see. His work has had a profound influence on many contemporary social commentators, such as Garry Winogrand and Lee Friedlander.  □

# Personal Visions

Before World War I and especially after it, a number of photographers began to develop their own personal visions, making photographs more for their own satisfaction than for financial gain. Their work explores a vast variety of technical and aesthetic directions, not all of them easily understood by the general public. Some of these photographers have used photographic techniques and processes that are considered "experimental." Others have worked loosely in the tradition of the documentary photograph, commenting on the social scene more critically and more idiosyncratically than the photojournalists. Still others use private symbols, totems, and special exhibition arrangements to communicate their ideas.

Harry Callahan (b. 1912), basically a self-taught photographer, originally pursued his private vision while teaching at the Institute of Design of the Illinois Institute of Technology and at the Rhode Island School of Design. Callahan is a very complex photographer in that he does not limit himself to one area but has explored many different styles. Some of his photographs, such as the extremely sensitive studies of his wife Eleanor (see pages 119, 127), are in the straight tradition. Others, such as his images of the city and its inhabitants and of the patterns made by nature, explore the multiple images produced by multiple exposures, the exaggerations of perspective and proportion made possible by the wide-angle lens, and

the deletion of tonalities made possible by high-contrast methods. Primarily, however, his concern is to explore abstract qualities. He often emphasizes a particular aspect of his subject, whether its shape or texture, in order to reveal it in a new way. Callahan's photographs have strongly influenced contemporary photography by unifying and refining some of the early photographers' experiments, making them an integral part of a photographer's vocabulary for reproducing images.

Aaron Siskind (b. 1903) was an English teacher when he began to make documentary photographs with the Photo League in New York from 1932 to 1941. In 1940 his work changed radically and became non-

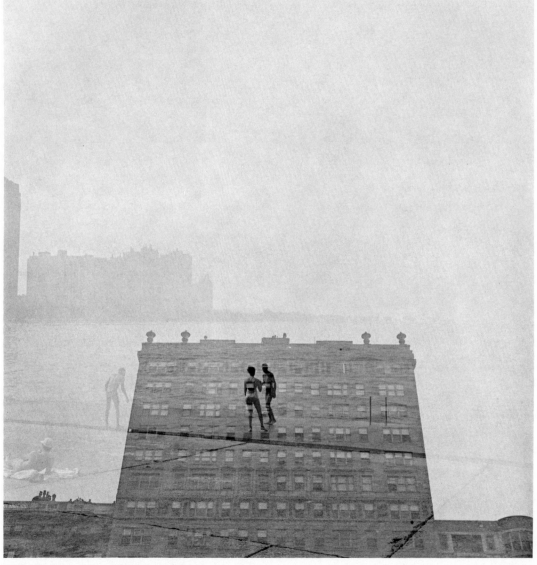

HARRY CALLAHAN. *Chicago, 1954.* Multiple exposure.

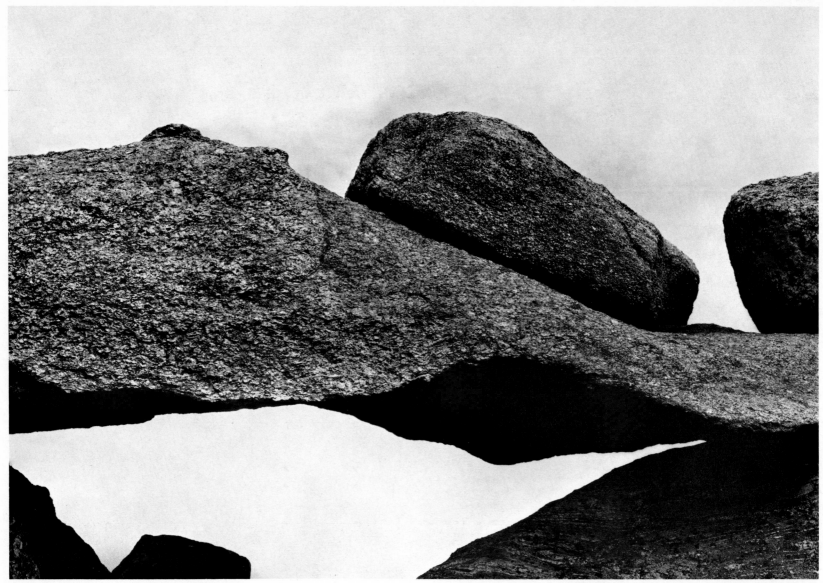

AARON SISKIND. *Martha's Vineyard, Mass.* 1954.

representational. Forms, tonalities, relative scale, and the way elements were ordered became more important than subject matter. His work has sometimes been compared to the paintings of the abstract-expressionists, because of the way he has reduced objects such as rocks to elemental shapes that express his personal response to them.

Minor White (1908–1976) influenced photography as much by his teaching, writing, and editing—he was founder and chief force behind the quarterly review *Aperture* for many years—as by his personal photography. His interest in self-analysis and, at different times in his life, Catholicism, Gestalt psychology, and Zen perhaps accounts for

his belief that photographers project themselves into and identify themselves with everything they see in order to know and feel it better. White's work consists of sensuous closeups of natural forms, stark and often surreal landscapes, and portraits. Like Siskind, he often made his subjects scarcely recognizable. White felt that many of his photographs were aesthetically related and that they should be arranged in a "sequence" with a definite order for viewing (see pages 135, 267).

Wynn Bullock (1902–1975) worked as a commercial photographer for eighteen years until in 1953 he decided to concentrate on his own private photography. During this

time he became an authority on reticulation, double exposure, multiple printing, and solarization (on which he held patents). His photographs show his interest in the juxtaposition of opposites through such images as gently rolling hills above a harshly eroded bank. The visual content of his photographs often suggests a hidden message, as here: hooded monks, faceless and anonymous, stand below the surface of the earth.

Frederick Sommer (b. 1905), originally a landscape architect and city planner, was intrigued by the lure of surrealism and, after a period of illness, decided to explore drawing, painting, and photography. Many of his early 8 × 10-inch (20 × 25-cm) contact

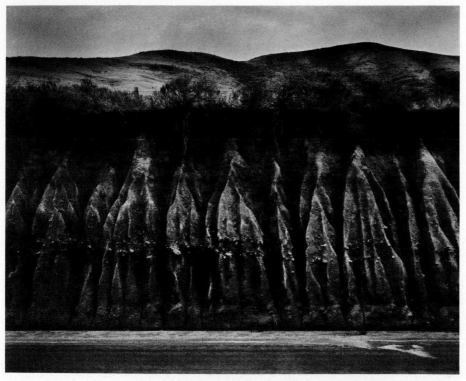

WYNN BULLOCK. *Erosion.* 1959.

prints offended viewers because of their subject matter, which included dead animals and a severed leg from a train accident. He speaks of his arrangements of found objects and the entrails of chickens as "constituting a miniature metaphysical inventory." Sommer has also explored cameraless images produced with negatives made by painting on cellophane or scratching on smoked glass; photographs of classical sculpture made with camera movement and slow shutter speeds; out-of-focus images produced with the enlarger; and light modulations from cut paper. His extremely selective and unique vision of the world creates a new reality.

Clarence John Laughlin (b. 1905) has tied together with photography his interests in painting, poetry, psychology, and especially architecture. He speaks of his incentives as "the mystery of time, the magic of light, and the enigma of reality—and their interrelationships." His photographs of buildings, especially in New Orleans, "animate the life of architecture." The series of people placed in ruins or graveyards are not photographs of a place, but rather constitute a symbol of his inner life. The relationship between the real world and what Laughlin calls "total reality" may be seen in his use of negative tonalities or multiple imagery (see page 285). Laughlin often accompanies his photographs by extensive captions. □

*31*

FREDERICK SOMMER. *Lee Nevin.* 1965.

Despite many improvements in the speed, quality, and dependability of cameras, there have been only two really basic changes in photographic technology over the last few decades: the development of color films and the invention of instant-developing cameras and materials.

The desirability of color photographs was apparent from the beginning, and many hand-coloring techniques were employed. The first practical color film to be developed was Kodachrome in 1935, followed shortly by Anscochrome, Ektachrome, Fujichrome, and Kodacolor. So vast and important is the subject of color that Chapter 13 is entirely devoted to it.

A problem that has always plagued photographers—the delay in time between exposure and the examination of the finished photograph—was eliminated in 1947, when Edwin H. Land introduced Polaroid film materials. It wasn't until 1963, however, that color film packed in a cartridge was introduced. The Polaroid camera dominated the field of both black-and-white and color instant photography for nearly three decades until 1976 when Eastman Kodak Company

brought out its own version of the instant color camera. The newest of these cameras now simply ejects a picture which develops almost instantaneously before your eyes.

The growth of photography has been enormous in the last ten to fifteen years as reflected in the expansion of undergraduate and graduate programs and the increase in the number of exhibitions in major art museums and in the number of galleries devoted exclusively to photography. In addition, a large number of people from a wide variety of backgrounds have become involved in photography, greatly expanding its role and making it impossible to define clear-cut styles and categories. Thus it is difficult to predict which of the current attitudes will still be of interest twenty years from now— whose work will seem merely curious and whose work will influence the paths that future photographers take. A general survey such as this one can only point to a few of the many avenues currently being explored. The Portfolio (pages 378–393) offers additional examples of recent trends as well as statements about the work by the photographers and others.

The straight photographic tradition, with its concern for describing places and objects, continues in works of Paul Caponigro (b. 1932) and George Tice (b. 1938)—see page 141—among others. Other photographers, while still describing the social landscape, are more concerned with design—that is, the spatial relationships of shapes and forms. Two photographers working in this way are Lewis Baltz (b. 1945) and Lee Friedlander (b. 1934). Baltz' uncluttered photographs are composed of inanimate, mostly geometric structures. Friedlander's arrangements seem very haphazard in the way they capture the motion of modern city life so that it seems to spill out of the confines of the print. A closer look reveals a very high degree of order in the relationship of forms.

People continue to be a favorite subject of contemporary photographers. The present liberal atmosphere, which has existed for a decade or so, enables photographers to pursue and publicly show projects which in earlier decades would have been confined to more private situations if tolerated at all. An example is the work of Diane Arbus (1923–1971), who often photographed

32

LEWIS BALTZ. No. 5 from *The New Industrial Parks near Irvine, California.* 1974.

LEE FRIEDLANDER. *Chicago, 1968.*

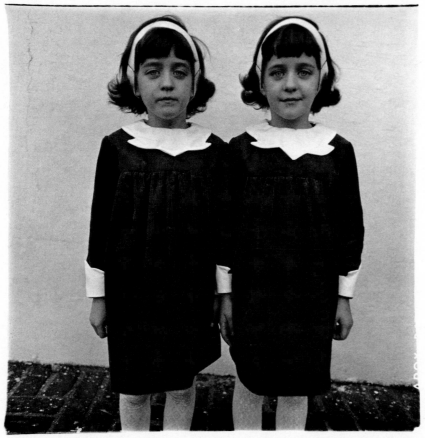

DIANE ARBUS. *Identical Twins, Roselle, N.J.* 1967.

socially "unique" people, such as identical twins, middle-aged nudists, and circus performers. Les Krims (b. 1943) has fabricated often disturbing and rather controversial situations utilizing incongruous or symbolic objects. Many photographers take a seemingly more realistic view. Notable among these is Garry Winogrand (b. 1928), whose photographs of people in apparently ordinary activities and settings are actually interpretations of human foibles that can evoke strong emotions (see page 55).

No longer are magazines such as *Life* and *Look,* with their group-journalism concept, the main outlet for photographers concerned with documentation. The book, rather than the article, is now the major means of presentation. The resulting photographs are not subservient to a larger concern but reflect the personal intentions of individual photographers. The areas documented in these photographic books range from California suburbia to Harlem, from teenagers to transvestites, from a Texas prison to an insane asylum. The bibliography at the end of this book includes publications by many photographers who present their work in books, such as Bill Owens and Bruce Davidson (see pages 391 and 389).

Manipulation of photographic techniques in relation to imagery has been intensely investigated in recent years. These techniques include special ways of exposing the film, making the print, and assembling the final presentation. A major aspect of this investigation is to discover new relationships produced with multiple imagery. Some photographers, such as Ralph Eugene Meatyard (1924–1972), prefer to produce their multiples in the camera. Jerry Uelsmann (b. 1934) reassembles a number of images in the darkroom, creating a new reality from pieces of others (see page 177). In this way he can control scale, tonalities, negative-positive relationships, and overlapping. Tetsu Okuhara (b. 1942) assembles small photographs into large mosaics. The relationship of one image to another image or many images in some type of order has produced a new vision—the sequence, providing an important extension of the meaning of a single image.

The climate of exploration has carried over into new ideas about making negatives and prints. Some photographers ignore the long tonal range of the traditional photograph, preferring the graphic qualities of high contrast. This area has become so

33

important in contemporary photography that a section of Chapter 12 is devoted to it (page 320). For many years reticulation, solarization, and excessive toning were not considered to be appropriate in serious photography; now many photographers are able to control these techniques and sensitively relate the imagery in their photographs to the unique qualities the techniques produce.

In addition to manipulating the procedures or processes, a number of photographers alter the negative by hand, either eliminating information or adding to it; or they change the surface of the print by perhaps drawing on it or placing materials on it.

A new definition of what constitutes a photograph evolved when sculptors and photographers began relating the photographic image to other materials. The tactile, tonal, reflective, and structural characteristics of materials such as wood, cloth, ceramic, metal, and Plexiglas, among other materials, were used to make three-dimensional photographic objects. Photographic sculpture extends photography into the actual third dimension, producing an interesting visual exchange between the illusion of solid form set in deep space and its actual presence. It also involves the viewer with photography in a different way, requiring the consideration of more than a single surface in order to see the entire work. The photographic sculptures of Doug Prince (b. 1942) consist of small Plexiglas boxes containing transparencies, which although overlapping visually are physically separated, producing interesting spatial relationships.

Some photographers, artists, and printmakers are using photography as a means to present an idea, a relationship, a concept. These "conceptual" artists work in different ways: they get their photographs from the picture files of large corporations or hire a photographer or personally photograph specific places or events; or they design, organize, construct, and then photograph an arrangement. To them, the presentation is secondary to the original idea, so the photograph is merely used as a means to document a concept.

The exploration of color photography has become popular in large part because of the relative ease of many of the modern processes, the introduction of Polaroid's SX-70, and its acceptance by museums. In the 1950s only a few serious photographers chose to

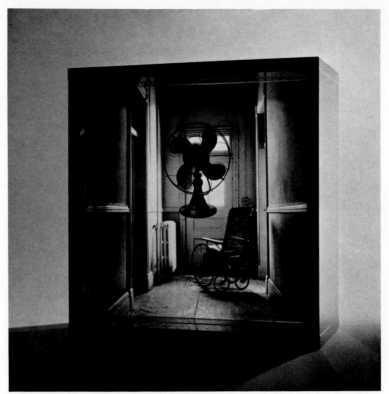

DOUG PRINCE. *Floating Fan.* 1972.

34

NAOMI SAVAGE. *Catacomb.* Photoengraving: 3/8-inch (1-cm) magnesium, silver-plated, oxidized, black acrylic paint. 1975.

work primarily in color. Among these were Ernst Haas (b. 1921), Eliot Porter (b. 1901), Arthur Siegel (1913–1978), and Henry Holmes Smith (b. 1903). Some younger photographers, such as Joel Meyerowitz (b. 1938)—see page 335—and William Eggleston (b. 1939), use the regular color-separation processes, seeking to duplicate in their photographs the colors found in the original scene or subject. Others prefer more arbitrary and synthetic color relationships and thus use processes that require the application of photo oils, opaque paint, or dyes and toners by hand to the surface of the photograph.

The materials that photographers use have changed drastically since Daguerre first introduced his invention. Nevertheless, most photographic processes are based on the principle that certain silver salts compounds are light-sensitive. Because the consumption of silver for photographic purposes is enormous and the price very high, scientists have begun to explore techniques that require less silver or none at all. One of these is Xerox, which works on the principle of static electricity. Some photographers have been successful in their image-making experiments with this and similar processes. Charles A. Arnold, Jr. (b. 1922) creates "xerographs" by exposing electronically charged selenium plates in a view camera, using the Haloid (Xerox) process. Though Xerox and similar processes are at present suitable only for reproducing high-contrast copy, rather than images with a full range of tones, they promise eventually to challenge the existing methods of photography.

A major trend is the shift from conventional materials toward nonsilver methods and techniques for primarily aesthetic reasons. Among these are dislike of the plastic quality of regular photographic materials, desire for the soft tonalities and colors inherent in certain processes, the ability to manipulate the imagery easily by hand, and archival permanency. Printmaking processes such as etching, lithography, silkscreen, collotype, gravure, and offset lithography have been utilized. So photographers have become printmakers, while printmakers have adopted photographic methods. Such cross-fertilization is a hallmark of contemporary art. Naomi Savage (b. 1927) actually uses the printing *plate* as the end product instead of as a means to obtaining a print. There is also a renewed interest in historical nonsilver processes such as cyanotype, gum bichromate, platinum, and carbon-carbro. Betty Hahn (b. 1940) has worked with found images from magazines or books and her own photographs with the gum bichromate process, presenting these images on both paper and fabric backings (see page 332).

The new photography is indebted to imagination as much as it is to reality. The new photographer is as eager to exploit processes as to transcend them. The new public seems more willing than ever to accept the widest possible spectrum of photographs in museums, art galleries, and private collections; and photographers are more willing than ever to produce them. Throughout the history of photography, each photographer has sought a unique expression, but perhaps all photography is a combination of human perception, a documentarian's eye, an artistic notion, and a dreamer's vision.  □

35

CHARLES A. ARNOLD, JR. *Reflection*. 1979.

Despite striking differences in appearance, all cameras have similar systems for viewing and recording images—as all human eyes do. The eye and the camera have a rigid outer covering, are lighttight, and provide a sensitive surface capable of registering an image projected by light (eye: retina; camera: film). There is also a lens system in each, as well as a mechanism for regulating the amount of light that enters (eye: iris; camera: diaphragm). Muscles surrounding the lens of the eye change the curvature of the lens to make it focus on objects at various distances; the photographer focuses the camera by adjusting the position of the lens instead. In both eye and camera, the image is registered upside down and laterally reversed on the light-sensitive surface. It is turned right side up and left to right by the brain in one case and during developing and printing in the other case. The major similarities between the eye and the camera are diagramed on the opposite page.

To understand fully how the eye functions, you would need to learn a great deal about its various component parts. Similarly, to understand how to use the camera to make photographs that express your own ideas, you need to become familiar with its various systems and how they function.

There are five basic systems inside a camera, as shown opposite. The *viewing system* allows the photographer to view and compose the picture. The *focusing system* adjusts the distance between the lens and the *focal plane* (or film plane), where unexposed film rests, to bring the subject into clear outline. The *shutter system* controls the length of time light reaches the film. The *aperture* consists of a diaphragm that controls the amount of light that reaches the film by changing the opening size. (The diaphragm also controls a critical measurement in photography called *depth of field*—see page 49.) The *lens* is the glass optical mechanism that admits light into the camera.

This chapter describes all the camera systems except the lens. Lenses are so complex that all of Chapter 3 is devoted to them. The latter part of this chapter describes many of the different types of cameras, their uses, and their care, among other things.

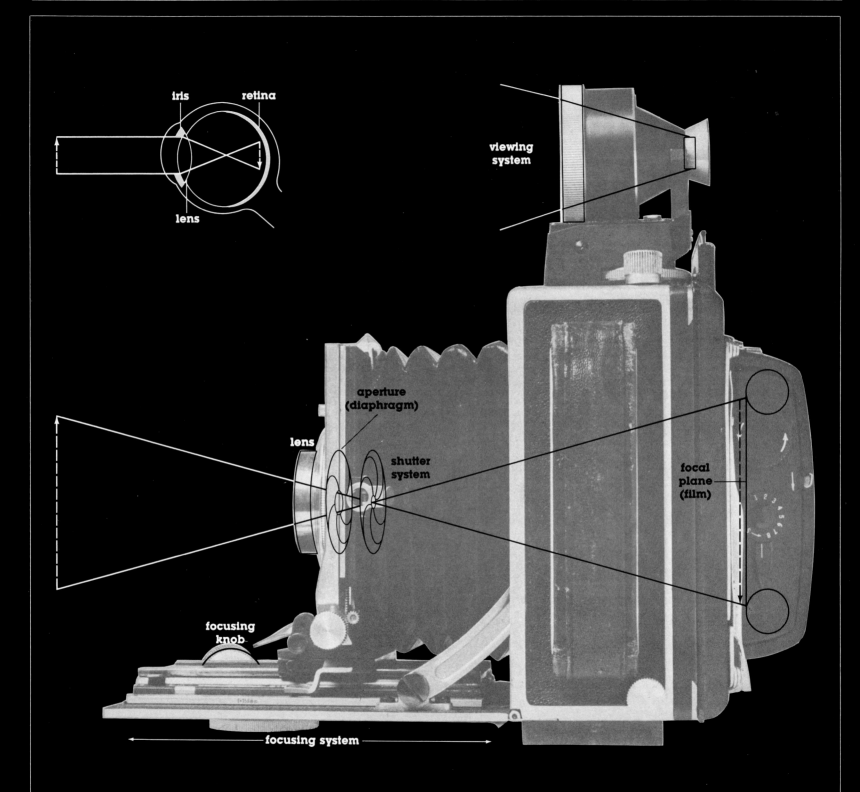

iris    retina

lens

viewing
system

aperture
(diaphragm)

lens

shutter
system

focal
plane
(film)

focusing
knob

focusing system

37

Your first concern as a photographer is the means by which the camera lets you see and compose the scene it will record. This is so important that cameras usually are classified according to their viewing systems. All cameras fit into one of four basic viewing-system classifications: viewfinder, twin-lens reflex (TLR), single-lens reflex (SLR), and view camera. The illustrations show how each of the four types of viewing systems would "see" an antique stereoscope.

Using a *viewfinder camera,* you see the scene directly. The viewing system is a simple optical device that gives the effect of looking through a small window directly on the scene in miniature.

The *twin-lens reflex camera* has two lenses, one mounted above for viewing and the other below for picture-taking. Light traveling from the viewing lens is reflected upward by a mirror and projected onto the bottom of a ground-glass screen that has been etched to a translucent, milky appearance and set into the top of the camera. By looking down through the viewing hood onto the other side of the viewing screen, you see the image in reverse. The hood helps keep out unnecessary light, making it possible to examine the ground-glass image with a built-in magnifier for proper focus. Other advantages of this system are that you can hold the camera upside down over the heads of people in a crowd, at the waist to photograph inconspicuously, or at ground level for exaggerated viewpoints.

Because the reflection on the ground glass is reversed, you must move the camera in a direction opposite to that of the subject when photographing a moving object—at a sports event, for example. Most twin-lens reflex cameras are therefore equipped with a sports viewfinder, a small opening in the back of the viewing hood lined up with a larger one at the front. The photographer can view roughly the area being photographed through these openings while swinging the camera with a moving subject. This supplementary system is not as accurate as the ground-glass method, naturally. Another problem with the twin-lens reflex viewing system is that a human subject who looks into the focusing lens rather than the exposing lens will have a strange faraway expression.

Unless specifically corrected, viewfinder and twin-lens reflex cameras can present a viewing problem called *parallax error*—a discrepancy between what the photographer sees and the area actually recorded by the camera lens. As shown in the illustration below, this happens because the viewing lens and the camera lens do not sight from the same position. Thus light comes from the subject into the viewing lens and the picture-taking lens at different angles. When the camera is 3½ feet (1 m) or closer to the subject, parallax error increases.

In more costly, sophisticated viewfinder and twin-lens reflex cameras, parallax error is corrected to permit accurate sighting if the

camera is at least 3 feet (90 cm) from the subject. In less sophisticated twin-lens reflex cameras a device known as the Mamiya Paramender can be used to compensate for the distance between the viewing and picture-taking lenses by raising the camera 1½ inches (3.8 cm) for the exposure after the scene has been focused. The same effect can be achieved by using a tripod to raise the camera for the exposure after composing and focusing.

In the *single-lens reflex camera* light passing through the picture lens is reflected from a mirror in front of the focal plane and projected up through a viewing screen into a five-sided prism that turns the image vertically and horizontally so that it is seen as it actually is. This viewing system eliminates parallax error because the photograph is composed through the picture lens. It is especially well-suited to closeups, that is, photography of subjects less than 3 feet (90 cm) away, because out-of-focus elements (see page 317) are easily visible.

The ground-glass viewing screen of a *view camera* is located on the same plane as the film and therefore receives light directly from the picture-taking lens. Thus the image on the translucent screen shows exactly what the film will record, including a reversed and upside-down image. The view camera's large size and accurate reflection of what the lens sees enable the photographer to inspect the focus closely throughout the picture, even to going over every bit of the large image with a magnifying glass. □

38

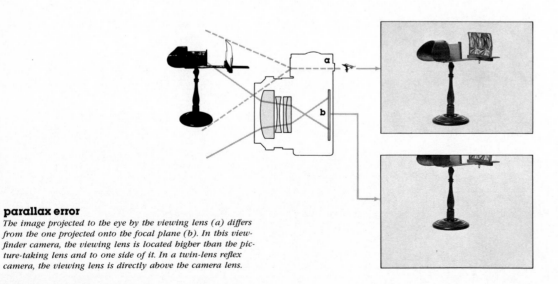

**parallax error**
*The image projected to the eye by the viewing lens (a) differs from the one projected onto the focal plane (b). In this viewfinder camera, the viewing lens is located higher than the picture-taking lens and to one side of it. In a twin-lens reflex camera, the viewing lens is directly above the camera lens.*

*The antique stereoscope in the photograph is shown below as it would be seen through four different viewing systems.*

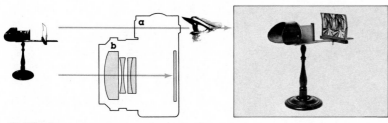

## viewfinder

*In the viewfinder view system, light from the subject enters the viewfinder (a) and the lens (b) entirely separately. Thus it is possible to shoot a whole roll of film without knowing the lens was covered.*

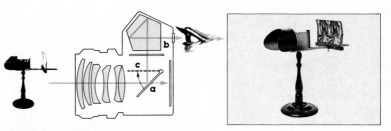

## single-lens reflex

*In the SLR camera, light from the subject strikes a mirror (a) and is reflected up through a pentaprism (b), which turns the image two ways and conveys it to the photographer's eye. When the shutter is activated the mirror flips up (c) so that the film can be exposed.*

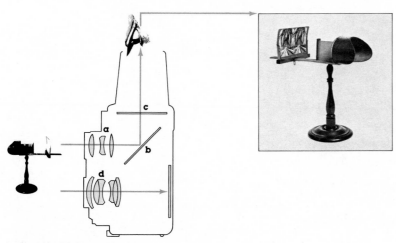

## twin-lens reflex

*In the TLR camera, light from the subject is reflected through the upper lens (a) onto a mirror at a 45° angle (b) and from there to a viewing screen (c). At the same time the lower lens (d) conducts light to the focal plane.*

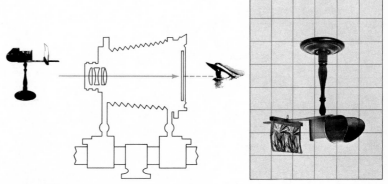

## view camera

*In the view camera, light from the subject reaches the photographer's eye directly and thus the subject appears upside down and reversed. View cameras are equipped with hairline grids to aid in composing the picture. After composing and focusing are done, sheet film is inserted in the camera for the exposure.*

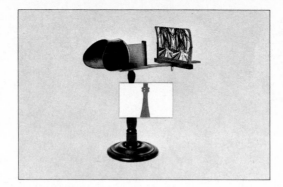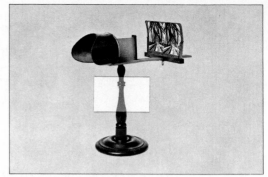

Early box cameras and some inexpensive models are designed to produce a relatively sharp image as long as the subject is at least 6 feet (1.8 m) from the camera. Other cameras have manual focusing mechanisms which require that the photographer estimate or actually measure the distance between camera and subject and then set the camera accordingly. In order to achieve sharp images in pictures, a dependable means for *focusing*—that is, relating the distance between camera and subject to the distance between lens and film—is essential. The two focusing mechanisms in most sophisticated contemporary cameras are the rangefinder and the ground-glass viewing screen.

The *rangefinder,* an optical mechanical device used in viewfinder cameras, produces a double image in the viewfinder until the subject is brought into focus. When the two images coincide exactly, the camera is said to be *in focus.* In the viewfinder is a semitransparent mirror. Mounted a short distance away, on the other side of the camera, is a prism (or a glass block or mirror) with its own window. Light reflected from a subject strikes the prism and is reflected to the semitransparent mirror and from there to the photographer's eye. At the same time, the light from the subject passes directly through the mirror to the eye. Thus there are two images. The rangefinder works on the principle of angles of light. Light reflected from a distant subject strikes both the viewfinder mirror and the prism in parallel waves. The prism is set to give two coinciding images at that point. Light reflected from a nearer subject strikes mirror and prism at an angle, producing two split images. As the prism is turned to compensate for the angle, it brings the two images together and simultaneously focuses the picture-taking lens.

This coupled rangefinder system tremendously improves the capability of the simple viewfinder camera. Because the rangefinder does not use a lens that produces an image on ground glass, it presents a bright image, uniformly sharp. This makes focusing in dim light feasible. However, even parallax-corrected rangefinders cannot focus at less than 3 feet (90 cm).

In 1932 Leica introduced the first 35mm rangefinder camera. For many years the rangefinder was the usual means of focusing 35mm cameras. Most 35mm cameras now have ground-glass focusing, but the rangefinder is still preferred by many people.

*40*

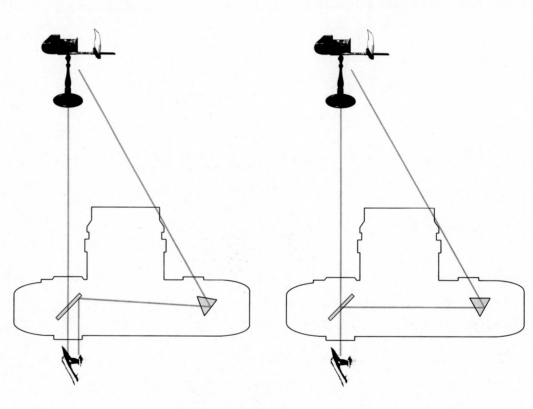

**rangefinder focusing**
*The rangefinder shows two images* (left) *of the same subject from different angles. By rotating the prism at the right of the viewfinder, the photographer sets the prism at an angle that aligns the two images as one* (right). *The lens is then automatically in focus.*

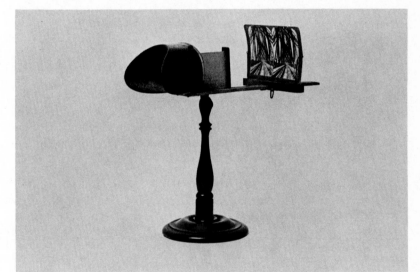

**ground-glass focusing**
*In the ground-glass focusing system of the SLR, the image as seen through the viewing hood* (above) *is focused by rotating the lens* (below). *The lens is then in focus.*

The *ground-glass viewing screen* is the focusing system in twin-lens reflex, single-lens reflex, and view cameras. In this system, light reflected from the subject passes through the camera's picture-taking lens (or, in the TLR, through a separate lens) and is projected onto a piece of ground glass to produce an image which the photographer sees from the reverse side. Except in TLR cameras that have not been corrected for parallax, you see what the lens "sees." You bring the image into focus by watching it while manipulating the focusing mechanism of the lens. When the image is clear, the camera is in focus.

The ground-glass mechanism functions slightly differently in TLR, SLR, and view cameras. In the TLR, light gathered by the top lens is reflected by a mirror to a piece of ground glass. As the image on the ground glass is brought into focus, the lower exposure lens is also focused because the upper viewing lens and the lower exposing lens are mounted to move back and forth in tandem.

In 1936, with the introduction of the first SLR camera (the Kine Exakta) and with the later improvements by Nikon, the ground-glass focusing system of the SLR began to challenge the rangefinder and then surpassed it. The reason is that SLR cameras enable the photographer both to compose and to focus through the picture-taking lens. There is a drawback, however. The light that projects the image on the little viewing screen in the SLR travels by an indirect route. Thus the image is darker than the rangefinder image and may be hard to focus in dim light.

In the view camera, a bellows—an accordion-pleated, lighttight, collapsible unit connecting the lens to the focal plane—enables the photographer to move the lens backward and forward until the maximum focus of the image on the ground-glass screen is achieved. Some SLR and TLR cameras also have bellows.  □

# The Shutter System

## Shutter Types

The shutter is the light-switch of the camera. Pressing the shutter release is like turning on a light. The shutter speed setting determines the *length* of time the shutter is open and thus how long the light is "on" and entering the camera. When you press the shutter-release button, light enters the camera at the preset speed, measured in fractions of a second—1/60 of a second, 1/125 of a second, etc. The longer the shutter is open, the more light the film is *exposed* to. By adjusting the shutter speed and the aperture size, you vary the exposure of the film according to the needs of the situation—whether a sunlit room or a dark forest—and the desired artistic content of the photograph. Thus, shutter speed and aperture setting function together to control light.

Early cameras did not have shutters because the photographic materials then available were relatively slow in reacting to exposure and a careful regulation of timing was unnecessary. Today all cameras use either the leaf shutter or the focal-plane shutter.

The *leaf shutter* is also called a *between-the-lens shutter,* because it is always located in the lens itself. Several tiny metal leaves or blades overlap, when closed, to prevent light from entering the camera and, when opened, move outward in a star-shaped pattern. The leaves are controlled by a gear and a taut-spring mechanism. For the shutter to open the spring must be cocked—that is, put in a taut position. In some cameras the spring is cocked automatically by the film advance lever; others are cocked manually.

When the spring is released, the leaves move away from the center of the lens, permitting a tiny amount of light to enter the camera. This movement continues until the leaves have opened to their fullest extent and the maximum amount of light pours in. They remain in this position according to the preset timing of the exposure and then begin to close. After the leaves have closed completely, the exposure is finished.

The *focal-plane shutter* operates directly in front of the camera's focal plane—the film. Because it is in the camera, rather than in the lens, the focal-plane shutter functions with whatever lens is put on the camera and permits viewing through the lens. Placing the shutter inside the camera, as in 35mm single-lens reflex cameras, makes economically feasible the manufacture of a wide variety of interchangeable lenses which would be too expensive if each had to include a shutter.

The focal-plane shutter moves in a single direction—unlike the leaf shutter, which both opens and closes. The advantage of one-direction movement is that it permits speeds as great as 1/2000 of a second. This shutter, however, is noisier than the leaf shutter. Focal-plane shutters in current use are the curtain focal-plane shutter and the blade focal-plane shutter.

The *curtain focal-plane shutter* consists of two "curtains" operated by a spring and gear mechanism, cocked automatically as the film is advanced. The two curtains, each with a cut-out section, move in the same track in front of the film. The cut-out sections coincide to produce a slit. The width of the slit is controlled to produce a full range of shutter speeds. A wide slit gives a slow shutter speed and a narrow slit gives a fast shutter speed. When the shutter release button is pressed, the first curtain moves horizontally, followed by the second curtain. The length of time before the second curtain starts to move determines the width of the slit and thus determines the shutter speed. Both curtains move for speeds faster than 1/60 of a second; at 1/60 and slower only the lower curtain moves.

In the last few years a newer type of focal-plane shutter, the *blade focal-plane shutter,* or *Copal Square shutter,* has become popular. It operates like the older model except that it moves vertically rather than horizontally. In a normal position, the top set of metal blades extends and prevents the film from being exposed. When the shutter is operated, the top set moves up and is followed by the bottom set moving up after it. The Copal Square shutter may eventually replace the curtain type for these reasons: it is easier and faster to repair, more compatible with electronic controls, more compact and thus appropriate to smaller cameras; also because it enables electronic flash units to be synchronized at 1/125 instead of 1/60 (thus eliminating occasional "ghost" images caused by exposure to existing light in addition to the flash).

## analogy of the water faucet and the shutter

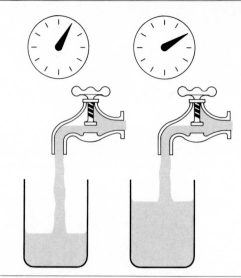

*A popular way to explain the functions of the shutter and aperture is to compare them to the controls of a faucet through which water flows into a container. In this analogy, the water is light; the valve on the faucet, which determines the amount of water permitted to flow, is the aperture; and the length of time the valve is held open to permit a flow of water is the shutter speed. A certain amount of water flows into the container when the wide-open valve is held open for 5 seconds, and twice as much flows in when the wide-open valve is held open for 10 seconds. Similarly, the shutter of the camera controls the length of time during which light is permitted to enter the camera. If the timing of the shutter opening is doubled, the amount of light the film is exposed to also doubles. (See page 49 for the Analogy of the Water Faucet and the Aperture.)*

▶ *The leaf shutter (a) in all cameras is located in the lens itself. The illustrations show the positions of the leaves in order as the shutter opens and closes and the relative amount of light that reaches the film at each position. The leaf shutter allows light to spread evenly over the whole film, building up to peak intensity when the shutter is open at its widest and then diminishing as the shutter closes.*

▶ *The focal-plane shutter (a) is located directly in front of the focal plane (b). The illustrations show the positions of the slit in order as the curtains move across the film and the segment of film exposed to light at each position. Since each segment receives the same amount of light in turn, the film is uniformly exposed throughout, from one end to the other.*

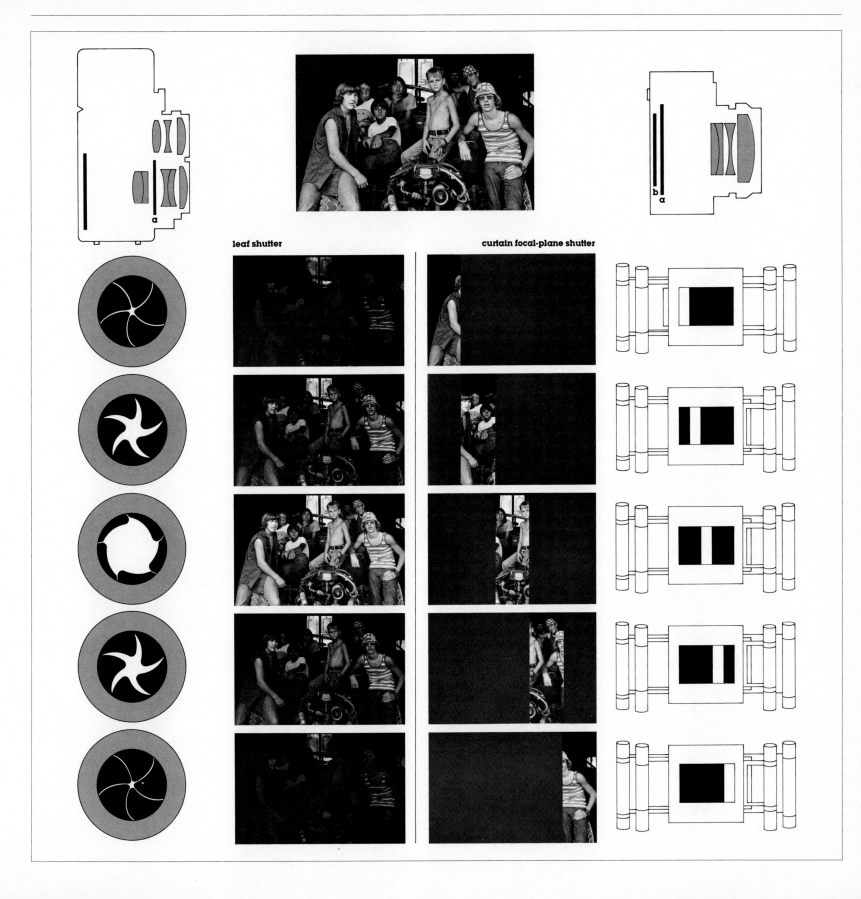

leaf shutter

curtain focal-plane shutter

43

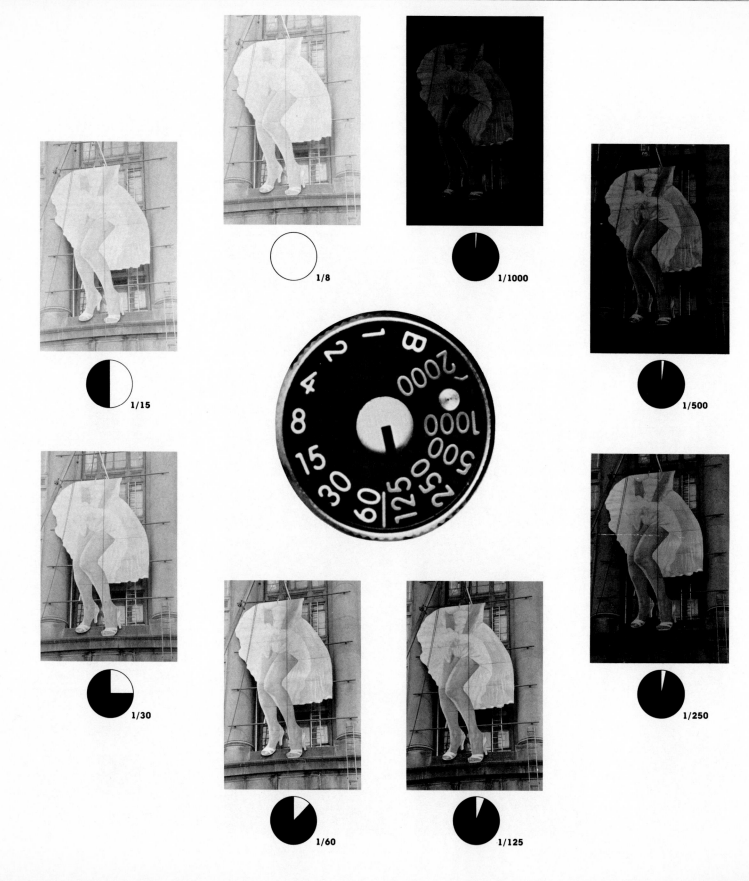

44

## Setting Shutter Speed

**A**ll shutters are geared to remain open for a period of time set by the photographer; the setting controls the time of the exposure. Most shutter speed dials have settings from 1 second up to 1/1000 or 1/2000 of a second. The time of each shutter setting is approximately half as long as the time of the one before it, and twice that of the one after it. For example, a setting of 125 (1/125 of a second) allows only half the exposure time of 60 (1/60 of a second). The illustration shows how different shutter settings affect a finished photograph, ranging from dark to light.

Most shutters also have either a B (bulb) setting or a T (time) setting, and some have both. When the shutter is set on B, light is admitted for as long as the shutter release is pressed down; the shutter closes when pressure is removed. The B setting is suitable for exposures of more than 1 second and less than 30 seconds. The T setting is more efficient for longer exposures. It keeps the shutter open until the shutter release is pressed again or the shutter-speed knob is rotated.

When setting your shutter speed always be sure the setting is precisely opposite the indicated reference point. In-between settings can ruin your photographs and even damage the shutter mechanism.

When photographing stationary subjects, usually you determine the shutter speed setting by measuring the amount of available light and relating it to the type of film and the depth of field desired (see page 49). Thus a rock in a field can be photographed with a handheld camera at 1/60, provided your hand is steady enough to prevent the camera from moving while the shutter is open.

When you photograph moving subjects, setting the shutter speed can be more complex, because the shutter setting critically affects the appearance of motion in the photograph. If you photograph a moving subject at a relatively slow shutter speed, the subject's movement will be recorded on film and the photograph will appear blurred. For a sharp outline of a moving subject the speed of the shutter must be fast enough to "stop" the subject's motion. However, photographers can obtain striking effects by manipulating shutter settings to advantage to produce deliberately blurred photographs, as in Paul Himmel's photograph.

45

◄ **shutter speeds**
*The circles indicate the relative exposure times at the indicated shutter speeds. The photographs show the range, from darkest at the fastest speed to lightest at the slowest speed.*

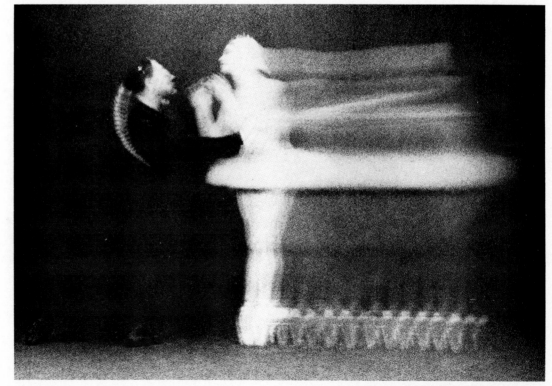

PAUL HIMMEL. *Swan Lake* (from *Ballet in Action*). 1953.

In choosing the correct shutter speed to stop the action of a moving subject, three variables must be considered: the *speed* of the subject's movement; the *angle* of the subject's movement in relation to the camera; and the *distance* between subject and camera. Swinging the camera in an arc to follow the movement of the subject—a technique called *panning*—is another option. The illustrations show how the three variables and the use of panning affect the selection of shutter speed and the quality of photographs. □

OSCAR BAILEY. *Waterfall I.*

46

OSCAR BAILEY. *Waterfall II.*

### speed of movement

*The more rapidly a subject is moving, the faster the shutter speed must be to "stop" or "freeze" it. A speed of 1/1000 of a second was needed to stop the flow of water in* Waterfall I. *A slower speed of 1/2 second blurred the flow of water and softened the image in* Waterfall II. *If a subject is moving very fast, even a speed of 1/1000 may not be fast enough to stop it.*

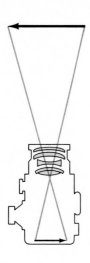

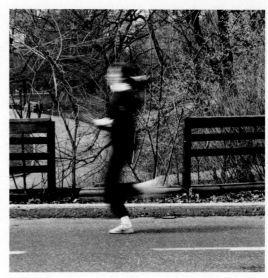

## angle of movement

*A subject traveling at a right angle to the camera requires a much faster shutter speed to stop action than a subject moving directly toward the camera. The jogger in the two photographs above was photographed from a right angle at 1/500 and then at 1/30; the differences in sharpness of detail are obvious. The jogger in the two below was photographed head-on, also at 1/500 and then at 1/30; here there is very little difference in clarity, showing that a slower shutter speed can be used for head-on motion.*

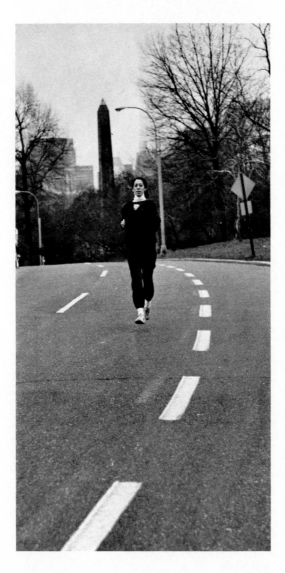

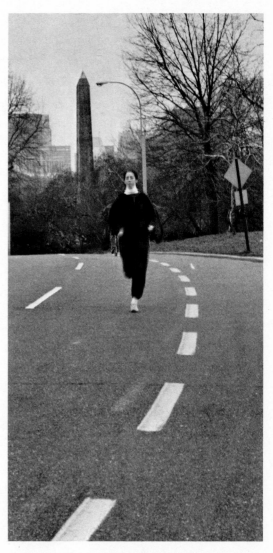

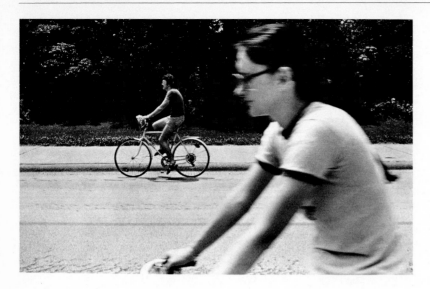

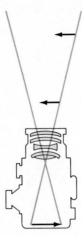

### distance of subject

*The farther away the subject, the less its apparent speed becomes. This photograph was shot at a shutter speed fast enough to stop the action of the bicyclist in the background; to stop the action of the bicyclist closer to the camera, who now is blurred, the photographer would have had to use a much faster shutter speed.*

### panning

*To pan a subject in motion, move the camera along an arc in the direction taken by the subject, as the diagram shows. This reduces the effect of the subject's speed (blurring). A fast shutter speed of 1/500 was used at right and a much slower speed of 1/125 was used below while panning. Though all bicyclists are sharp, there is a striking difference in the backgrounds. At 1/500 the bicyclist seems to be standing still; at 1/125 the racing bicyclists are clear but there is an effect of motion. Start panning before you release the shutter.*

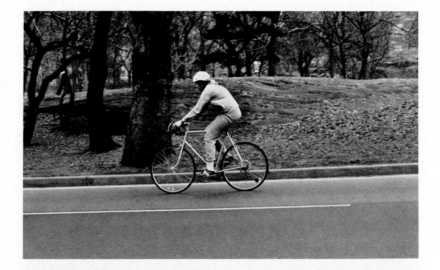

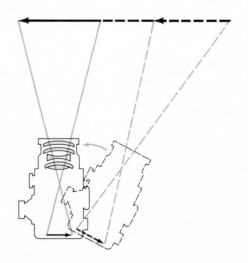

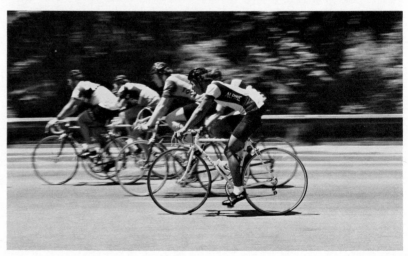

# The Aperture

**analogy of the water faucet and the aperture**

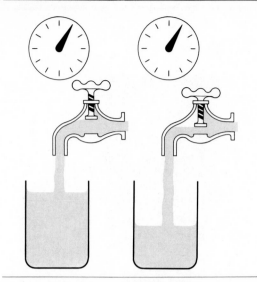

*As with the shutter (page 42) the analogy of the faucet valve is useful in understanding how the aperture works. The length of time the faucet valve is open is the shutter speed; the degree to which the faucet is open is the aperture size. A wide-open faucet valve permits twice as much water to flow into the container in 5 seconds as one that is only half open. Similarly, if the size of the aperture opening is doubled, the amount of light the film is exposed to also doubles.*

The aperture of a camera functions with the shutter to control the amount of light that reaches the film. Located inside the lens, the aperture consists of overlapping thin metal leaves that form a circle called the diaphragm. By turning an adjustment on the lens, the photographer moves the leaves toward the outside of the circle. This widens the diameter of the aperture and permits more and more of the available light to enter. When the diaphragm is adjusted in the opposite direction, less available light enters.

A standard scale of numbers called f-stops, measured from f/1.0 to f/64, is used to indicate aperture size. The maximum opening, admitting the most light, is f/1.0. The smallest, admitting the least, is f/64. Each succeeding f-stop is one-half the size of the previous f-stop and decreases the amount of exposure by half. Thus an f/4 aperture admits half as much light as f/2.8. (It is easier to remember that larger numbers mean smaller openings if you think of the f-numbers as fractions, which they actually are. The reason is explained in Chapter 3.) The diagram on the next page shows the relative aperture sizes for a selected number of f-stops.

In early cameras the aperture size was controlled by pieces of metal with holes of various sizes in them that were inserted behind the lens; they were called Waterhouse stops. Even though aperture size is now controlled by adjusting the diaphragm, the process of decreasing the aperture opening is still called "stopping down." Thus, a change from f/2 to f/4, even though 4 is larger numerically than 2, is stopping *down*. (Increasing the opening is called "opening up.")

Be careful, too, not to confuse the numerical value of the f-stop numbers with the size of the aperture. A common mistake, for example, is to suppose that because f/4 is numerically twice f/2, the amount of exposure for f/4 will be half that of f/2. Actually, as the diagram illustrates, the aperture set at f/2.8 is half as large as that at f/2, and the one set at f/4 is only one fourth as large. Remember, regardless of the numerical value of an f-stop, each succeedingly higher numbered f-stop lets in half as much light as the one before it.

Although the possible f-stop range is f/1.0 to f/64, no lens has a full range of possible f/stops. The lens on a 35mm camera generally has a maximum aperture of f/1.4 and a minimum of f/16. The range on twin-lens reflex cameras is f/3.5 to f/22; on view cameras it may be f/5.6 to f/45.

Unlike the shutter, where great care must be taken to set speed accurately, the aperture scale is continuous, and a setting need not be precisely on the f-stop mark. You can set the aperture anywhere between the reference points. Interim settings are commonly used with color film, but they are seldom necessary for black-and-white photography.

## Aperture and Depth of Field

In addition to affecting the amount of light entering the camera, the aperture size also helps to determine depth of field. Depth of field is the measurement in a scene of the area between foreground and background in which subjects will be in sharp focus. To determine how much depth of field may be necessary you must take account of aesthetic as well as technical considerations. *A large aperture produces very little depth of field, while a small aperture produces a large amount of depth of field.* For instance, if you want to have only the foreground, only the background, or only the middle ground of a scene in focus, then you must choose a large aperture in order to limit the depth of field. If, on the other hand, you decide to have all three areas as sharply focused as possible, then you must close down the aperture to expand depth of field. For further discussion of depth of field, see pages 84–87 (Chapter 3).

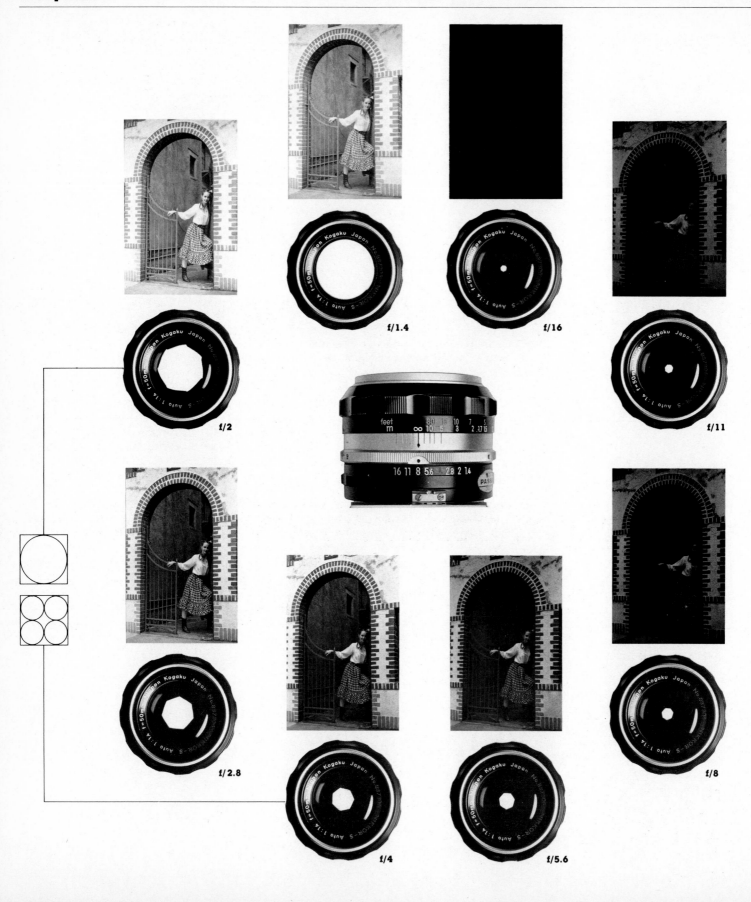

f/1.4

f/16

f/2

f/11

f/2.8

f/4

f/5.6

f/8

50

### ◀ aperture sizes

*At successively higher aperture settings, or f-stops, the size of the diaphragm opening of a camera decreases. Thus the opening at f/1.4 is largest, half as large at f/2, half again as large at f/2.8, and so on. This means that a setting of f/2.8 lets in half as much light as a setting of f/2 and that f/4 lets in one fourth as much.*

▶ Right: *The photographer used a large aperture of f/2.8. The images in the foreground are in focus and those in the middle ground and background are beyond the shallow depth of field. The shutter speed was 1/500. Far right: The photographer stopped down the aperture to f/16 for maximum depth of field. The images in all three planes—foreground, middle ground, background—are in focus. However, the slower shutter speed of 1/15 that was needed did not freeze the motion of the flag.*

▼ *Aperture and shutter speed combinations that give the same exposure are shown in the diagrams. If you stop down the aperture from f/5.6 to f/8 to improve depth of field, you cut the light in half. Thus you must also decrease shutter speed from 1/500 to 1/250 of a second to compensate by doubling the time of the exposure. In the same way, if you further stop down the aperture to f/11, you must further slow the shutter speed to 1/125.*

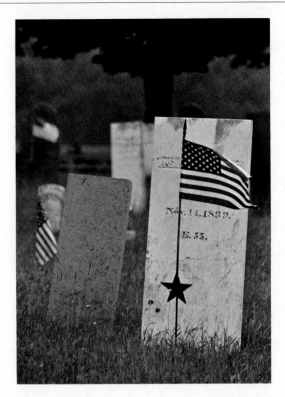

51

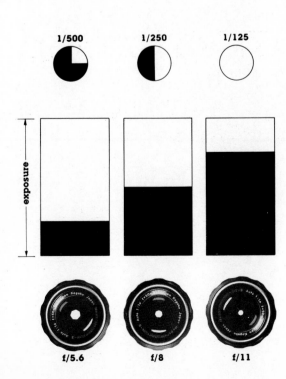

| 1/500 | 1/250 | 1/125 |
| --- | --- | --- |

f/5.6    f/8    f/11

## Aperture and Shutter Speed

**S**ince aperture and shutter function together to control the amount of light entering the camera, you must correlate aperture setting and shutter speed to achieve a satisfactory exposure. Remember, smaller aperture sizes give greater depth of field, so that once you know the amount of light needed to expose the film properly, you may want to decrease the aperture size to improve depth of field. But when you decrease the aperture, you must also decrease the shutter speed. In other words, you must compensate for the decreased amount of light coming through the aperture by increasing the amount of time during which light is permitted to enter. Because consecutive shutter speeds are related to one another in the same way as f-stop numbers—each consecutive lower number giving twice the exposure as the preceding number—the exposure will be correct as long as the two factors are correctly correlated, as in the diagram. Failure to correlate the f-stop number and the shutter speed can result in a film that is either overexposed or underexposed.

Besides achieving a properly exposed film, use of these correlations will produce various visual qualities. The large aperture that limited depth of field in one photograph above was used with a fast shutter speed that stopped the motion of the flag. The longer exposure in the other photograph, needed to compensate for the small aperture opening, blurred the motion. With some cameras, it is difficult to stop action and retain great depth of field, although this is usually not a problem with 35mm cameras and fast film. Properly correlating aperture and shutter speed to light conditions, motion of the subject, and depth of field is always an important element in getting the photographs you want. □

## Cartridge-Film Cameras

**C**ameras are divided into types not only by their viewing systems but also by the format and size of the film they use and, as in the case of special-purpose cameras, by the functions they serve. The serious photographer is concerned with film size because the quality of the final print depends heavily on the size of the negative from which it was made and the degree of enlargement from that negative. (See page 78 for further discussion of film sizes.) Indeed, *the larger the negative the higher the quality of the final print.*

Today, the simplest cameras use cartridge film, which has the convenience of needing only to be dropped into the camera, eliminating failures from improper loading. These cameras are generally small, lightweight, and require few if any adjustments because many of the camera controls are set during manufacture. They are thus extremely popular with amateur photographers. The most commonly used cartridge film cameras are the 126 cartridge camera, the 110 pocket camera, and the Minox. They produce rather small negatives—29 × 29 mm, 13 × 17 mm, and 8 × 11 mm, respectively. They are described and illustrated here.

52

◀ *The inexpensive 126 cartridge camera is typical of nonadjustable cameras. Such cameras have certain drawbacks: the price for the film per exposure is slightly higher than for other cameras and the types of film are limited; slow shutter speed makes stopping fast action impossible; focus flexibility is limited; parallax error is pronounced in closeups.*

▼ *The 126 cartridge camera is a favorite with the casual amateur and quite suitable for introducing photography to young children—such as the 5-year-old who took this photograph—because it is simple to operate and rugged.*

*110 pocket cameras are small, light, and easily carried in a pocket or handbag. They are designed primarily for making color slides or color prints; Verichrome Pan is the only black-and-white film available. The image size is very small (13 × 17 mm), but special slide projectors produce acceptable sharpness. The quality of the color prints is good at the normal snapshot size, but enlargements to 5 × 7 or 8 × 10 inches (12.5 × 17.7 or 20 × 25 cm) may look fuzzy and grainy. New models have such features as automatic built-in exposure system, built-in closeup lens, choice between a normal and moderate telephoto lens in the same camera, zoom lens, built-in rangefinder or SLR system, built-in warning light if available light is too dim for good exposure or if the flashbulbs are used up, and built-in electronic flash.*

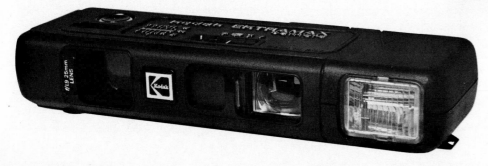

The well-designed Minox is made with great precision. Smaller than the 110 pocket camera, it usually is used by professionals who need a tiny camera only 4¼ inches (10.8 cm) long; it is shown actual size. The shutter is automatically controlled by the built-in light meter, but can be manually set from 1/30 to 1/2000 second. There is no aperture setting, since the aperture is fixed wide open. A built-in neutral-density filter can be slid over the lens for very bright scenes. The lens is 15mm, f/3.5. A measuring chain calibrated to match the distance scale is provided for closeups from 8 to 24 inches (20–60 cm). Accessories include flash unit, tripod, copying stand. Cartridge film comes in various color and black-and-white emulsions. The film is held on a curved plane under pressure during the exposure for maximum sharpness. Great care is needed in exposing, developing, and printing the small film: 8 × 11 mm image. John Nagel's photograph was made with a Minox.

JOHN WM. NAGEL. *Untitled.* 1972.

## 35mm-Film Cameras

The 35mm camera—including range-finders, such as the Leica, and single-lens reflexes, such as the Nikon—gets its name because it uses 35mm motion-picture film. The film is relatively inexpensive, allows up to 36 exposures per roll, and is available in many different types, including a full range of black-and-white, several kinds of color, and even special film like infrared. Because the film is available worldwide, the 35mm is a good choice for travelers, as well as for the photographer interested in producing color slides. The image size is small, $1 \times 1\frac{1}{2}$ inch ($25.4 \times 38.1$ mm), which means that any technical error will be magnified and readily visible in the print. However, when 35mm negatives are exposed correctly, processed with care, and enlarged with quality enlarging lenses, excellent prints are possible. The small size of 35mm film permits the camera to be compact and light, and also makes financially practical the manufacture of a wide-aperture lens that can produce successful photographs even in rather dark places. The shutter is cocked automatically as the film is advanced, permitting a rapid succession of exposures.

An especially popular and widely advertised 35mm camera, the fully automatic SLR, can be highly useful on some occasions; on others, however, its automatic features can be undesirable. For example, in a situation of very uneven lighting, the automatic camera tends to set an exposure that *averages* the contrasting light. If you wish to base your exposure on one subject in the picture, you need a semiautomatic or manual exposure feature, which many of the more expensive cameras have. These manual options usually give a choice between shutter and aperture priority. The aperture-priority camera allows you to set the lens opening as you wish; the shutter-priority camera allows you to control the shutter speed; the complementary adjustment, shutter or aperture, is made automatically. The quite new *multimode*

54

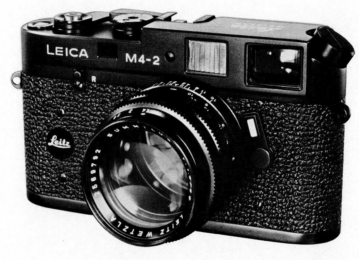

*Compact 35mm cameras, smaller than regular 35mm cameras (such as Leica and Nikon), are rapidly becoming quite popular because they combine the features of 35mm and pocket cameras. They usually have zone focusing (see page 86) or a rangefinder; a few models have automatic focusing with an electronic exposure control operating the shutter. Most have a built-in flash unit with automatic exposure.*

*The only high-quality 35mm rangefinder camera with interchangeable lenses is now the Leica. Many professional photographers prefer it because the bright image is easier to focus than the SLR and because the quiet shutter enables them to be less noticeable. 35mm rangefinders have become less popular partly because the newer compact 35mm cameras have been extensively advertised. With the rangefinder, charts and scales must be used to determine depth of field, and soft-focus effects cannot be visualized. Even parallax-corrected rangefinders cannot focus at less than about 3 feet (1 m) without parallax error. Special equipment and methods are available to adapt rangefinders to closeup photography (see pages 317–318), but they are not very satisfactory. Garry Winogrand's photograph was taken with a Leica.*

*35mm rangefinders cannot accept lenses longer than 135mm. When a long-focal-length lens (see page 91) is used on a rangefinder, an additional piece of equipment, a reflex housing, is needed instead of the normal lens. The long-focal-length lens is attached to the reflex housing, converting the rangefinder camera into a single-lens reflex camera.*

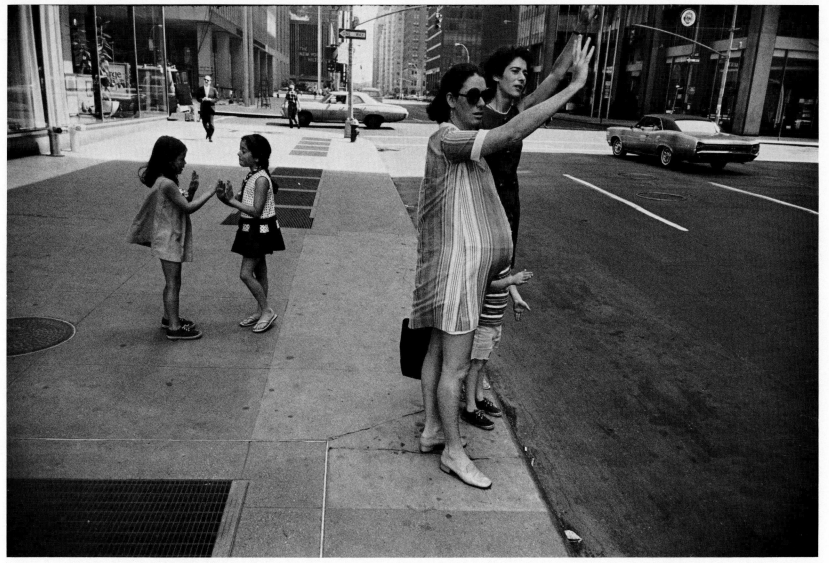

GARRY WINOGRAND. *New York City.* 1969.

55

automatic 35mm SLR allows you to choose *between* aperture and shutter priority, depending on whether you need to determine depth of field or whether speed is the important factor for your picture.

In addition to cameras with automatic exposure control, there now are cameras—most of them 35mm—with automatic focusing. The mechanisms differ. Polaroid uses a sonar (sound-beam) system in one model of the SX-70. The Canon Autofocus beams infrared light from the camera that reflects off the

subject and back to a sensor on the camera, which activates the focusing mechanism. Other manufacturers, such as Konica, have an optical system combined with electronic sensors that focus the lens.

The 35mm is a favorite camera today for the amateur and the serious photographer alike, because of the advantages of its film size and because it offers convenience and control in picture taking. There are many different types; some are illustrated and discussed here and on the next page.

*Many brands of 35mm single-lens reflex cameras are available; they are all similar. The Nikon F3 is typical. Prices differ little among SLR models (unlike other 35mm types). Direct viewing through the camera lens makes the 35mm SLR ideal for closeup photography at distances less than 3 feet (1 m). Composing is simple. Focusing also is simple, as out-of-focus images are visible. The built-in light meter is an important reason for the increasing popularity of the SLR. Some are semiautomatic: while looking into the camera, the photographer must align a needle to reference points by manually adjusting either the shutter or the aperture. The fully automatic SLR computes and sets the correct exposure for each photograph almost instantaneously; thus this kind of camera is desirable for a photographer who must react very quickly.*

Only a few cameras with automatic focusing are now available, and they are primarily for the amateur market. The trend is toward increased growth in this area.

56

*A complete "system"—not just a camera and a few lenses—is now offered by many 35mm SLR camera makers. A system includes not only a wide variety of lenses, but also motor drives for fast succession of exposures and time-lapse photography and remote-control mechanisms. Special camera backs permit 350 or 750 exposures, and date-recording backs print the day, month, and year of each exposure. Other accessories enable the SLR to photograph a tiny insect or be attached to a microscope or telescope. (The Leica system is shown.)*

Half-frame 35mm cameras *accept regular 35mm film but produce twice as many exposures per roll because each negative is half the size of a normal 35mm negative. These cameras are fairly inexpensive, but the small negative cannot produce high-quality enlargements. They are popular with photographers who often want sequential images. Some photographers print two half-frames together as one picture—see Ray Metzker's here.*

RAY K. METZKER. *Untitled.* 1968.

57

▲ *The 120/220 twin-lens reflex camera, originally designed in Germany by Rolleiflex, is very dependable. Rolleiflex still makes them, but Japanese companies now also make excellent but less expensive models, such as the Yashica, shown here. The camera may look difficult to operate, but it is actually simple, convenient, and versatile; as it is also relatively inexpensive, it is a good choice for beginners.*

58

▶ *120/220 rangefinders are the Rapid Omega 200, shown here, and the Mamiya Universal. These are modern versions of the old "press camera." Commercial photographers use them for aerial photography, publicity, weddings, sports, and other situations when much maneuverability and high picture quality are required. Both cameras have interchangeable lenses ranging from moderate wide angle to telephoto. The viewfinder is large for easy viewing, contains a built-in rangefinder, and is corrected for parallax. The Mamiya has interchangeable backs, permitting the use of sheet film, film packs, and Polaroid film.*

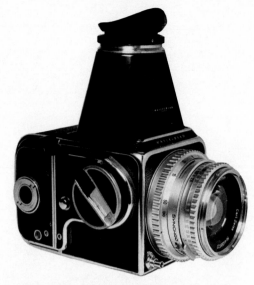

▲ *The main advantages of the 120/220 single-lens reflex camera are interchangeable film magazines (in some models), interchangeable lenses, and (in some models) magnifying hoods and prismfinders. The Hasselblad, shown here, is one of the several brands of this type. The greater cost of these cameras is offset by their extreme versatility. The interchangeable film magazines allow removal of the film without harm to it when it is only partially exposed; the film can be reinserted later for exposure of the rest. Thus black-and-white and color film can be used alternately in the same camera. The interchangeable lenses give the same options as 35mm SLR cameras. Some manufacturers offer the "system" concept; they provide equipment ranging from closeup adapters to underwater housings.*

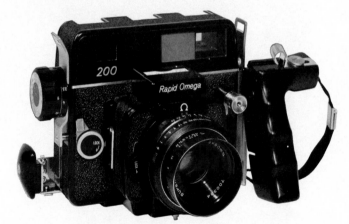

▲ *For many years the twin-lens reflex camera was criticized because it provided only a normal lens. Now there is one TLR roll-film camera with interchangeable lenses, the Mamiya C33f, shown here. This camera has not only an 80 mm normal lens, but also 55mm and 65mm wide-angle lenses and 105mm, 135mm, 180mm, and 250mm longer lenses. The focusing system accommodates the longer lenses and also closeup photography. An exposure-increase factor for the extra bellows extension is clearly indicated. The image as seen in the regular viewing hood is automatically corrected for parallax. This hood may be replaced with an accessory Porrofinder (similar to the pentaprism in the 35mm SLR camera), with or without a light meter.*

## 120/220 Roll-Film Cameras

There are three types of 120/220 roll-film cameras: the twin-lens reflex, the single-lens reflex, and the rangefinder. These cameras take either 120 film or 220 film; 220 is twice as long as 120 and therefore gives twice as many exposures in the picture size of a specific camera. The outstanding feature of the 120/220 camera is that it has a negative size about four times the size of 35mm negatives. A full range of black-and-white and color film is available for all three types, but the color film for slides is considerably more expensive than 35mm color film for slides, and the projector for the larger slides also is expensive.

The variety of film formats available in 120/220 single-lens reflex cameras is somewhat confusing at first. The two primary formats are square or rectangular. Some 120/220 SLRs produce twelve (120 roll) standard $2\frac{1}{4}$-inch (6-cm) square negatives; this shape can be inconvenient, as photographic paper usually is rectangular. The Mamiya RB 67 and the Pentax 6X7, however, produce eight (120 roll) $2\frac{1}{4} \times 2\frac{3}{4}$-inch ($6 \times 7$-cm) negatives, the proper proportion for $8 \times 10$-inch ($20.3 \times 25.4$-cm) prints. The Mamiya M 645, which is considerably less expensive than other 120/220 SLRs, produces fifteen (120 roll) $1\frac{5}{8} \times 2\frac{1}{4}$-inch ($4.5 \times 6$-cm) negatives.

Examples of the three types of 120/220 roll-film cameras are shown and described on this page.

## Sheet-Film Cameras

**T**here are two basic types of *sheet-film cameras*—view cameras and press cameras. They are called sheet-film cameras because film for them comes in sheets, which are loaded into special holders, rather than in rolls. The bulky, heavy view cameras are generally used by advanced amateurs, fine-art photographers, and professional photographers. They require a tripod; this and their slow operation mean that the photographer must preplan the work.

Though somewhat cumbersome to use, the view camera provides a great deal of control and flexibility. It has interchangeable lenses, and the bellows unit makes possible accurate closeup photography. Adjustments called "movements" permit the photographer to control perspective. For example, when the camera is pointed up at a building the lines of the building can be kept parallel instead of converging. The depth of field may

also be increased or decreased by using these movements instead of by varying the f-number. Since none of these controls is possible with roll-film cameras, the view camera is a unique piece of equipment.

Each film holder for the view camera accommodates two sheets of film. Common film sizes are $4 \times 5$, $5 \times 7$, and $8 \times 10$ inches ($10.1 \times 12.7$, $12.7 \times 17.8$, $20.3 \times 25.4$ cm). A wide variety of film is available, including some special-purpose graphic arts films. Each sheet may be developed individually, which gives complete control in processing. In addition to sheet film, the camera can accommodate film packs, roll film, and Polaroid packs. A full discussion of sheet-film photography can be found in Chapter 11.

The early view cameras were primarily the "flat-bed" type, but in recent years the "monorail" design has become dominant. In all these cameras the front and back are connected by a bellows. The front and back of the flat-bed camera move back and forth on

a flat surface—hence the name. The front and back of the monorail camera move along a round or square pipe—hence its name. Some monorail cameras are modular in design: the different parts—front, back, bellows, and monorail—are interchangeable; the resulting versatility greatly increases both control and flexibility.

A complete system for a monorail modular view camera is extremely expensive. Although the degree of movements is greater than that possible with a flat-bed camera, the monorail modular view camera is not very compact and may be rather difficult to carry when photographing in rough terrain.

One of the expenses of a view camera is the lenses, since the shutter is in the lens. One brand, Sinar, has a "universal shutter" which makes possible the purchase of less expensive lenses without shutters. This universal shutter is especially useful in the studio because it has speeds ranging from 1/50 to 8 seconds.

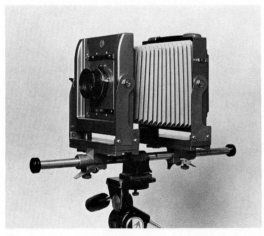

a

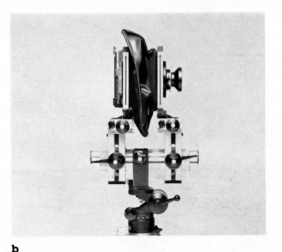

b

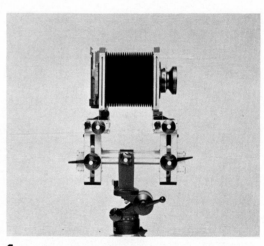

c

*The least expensive monorail view cameras, such as the Calumet* (a), *are not modular in design. More expensive monorail cameras, such as the Sinar* (b–e), *are modular, offering systems that include rails of different lengths, bellows of various types and sizes, backs that take various sizes of sheet and roll film, and other options.* b: *With a wide-angle lens, a bag bellows is used with the regular rail.* c: *With a normal lens, the regular bellows is used.* d: *For extreme closeups, another bellows and another standard are added, mounted on a longer rail.* e: *With the appropriate back and bellows, the camera takes $8 \times 10$-inch ($20 \times 25$-cm) film.*

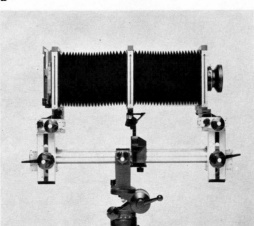

d

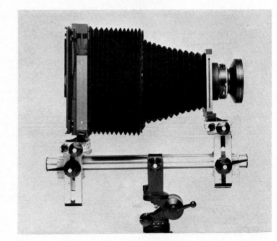

e

▶ *The flat-bed view camera, or "field camera," such as the Deardorff, has always been known for its high level of craftsmanship and its use of natural wood. Field cameras are lightweight and compact, but they do not have as many movements as monorail modular view cameras. For a number of years the field camera seemed to be becoming obsolete, but it has become more popular in recent years with the growing interest in large-format negatives.*

▼ *Press cameras are now made in Japan by Horseman, the kind shown here, and in Germany by Linhof. The Horseman has a 2¼ × 3¼-inch (6 × 8.2-cm) negative. The Linhof produces negatives of either 2¼ × 3¼ or 4 × 5 inches (10 × 12.5 cm). These cameras are considerably more complex than the press cameras once made in the United States. Some models have almost all the capabilities of flat-bed view cameras. They have a range of interchangeable lenses. Ground-glass focusing is provided, but a rangefinder is usually used to save time. Each lens has a special "cam" that synchronizes the lens to the rangefinder and ensures accurate focusing. Made of metal, not wood, these cameras are heavy, but they are rugged. With the appropriate accessory back, they may be used with 120/220 roll film.*

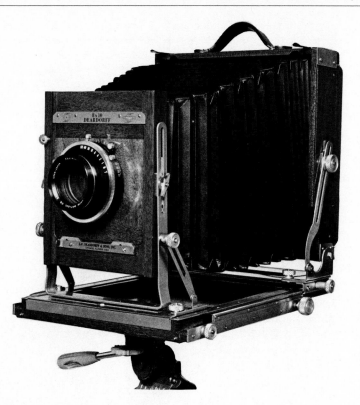

The *press camera* was for many years the symbol of the newspaper photographer. This camera produces the largest size negative (4 × 5 or 2¼ × 3¼ inches; 10 × 12.5 or 6 × 8.2 cm) of all the handheld cameras. Early press cameras had limited movements but extra-long bellows to accommodate telephoto lenses or make closeup photography possible. The classic American-made press camera, the Speed Graphic, is no longer manufactured, but used ones are often bought by photography students eager to begin work with sheet film. The camera may be used for simplified studio photography, portraiture, landscape photography, and copying. These days press cameras are often used in commercial situations where one camera is needed to fulfill many functions, from portrait to product photography.

The monorail system and press camera, as well as a field camera and a handmade view camera, are pictured and described on page 59 and this page.

60

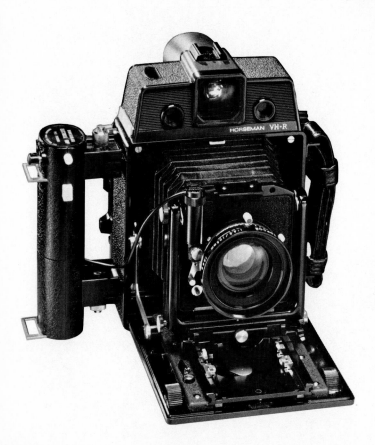

▶ *As an alternative to buying an expensive view camera, you can design and construct your own at much less cost. Jay Bender made this one. Some handmade view cameras are made entirely from raw materials; others are made from "repair parts" bought from camera manufacturers. Instructional articles in photography magazines have shown how to build a view camera or listed sources of kits.*

*The Polaroid SX-70, shown here, was the first "integral processing" camera. All delicate parts are protected when it is folded up. Because it is a single-lens reflex camera, subjects can be correctly focused as close as 10.4 inches (26.4 cm). One model, the Polaroid SX-70 Sonar, has automatic focusing, produces a 3⅛-inch (8-cm) square photograph, and has an attachable flash. The versatility of the SX-70 is increased with such accessories as closeup lenses, a telephoto 1.5 lens that magnifies the image 50 percent, a self-timer, a tripod clamp, a lens hood, and an electrical cable release.*

*The Colorburst, Eastman Kodak's "integral processing" camera, is newer than the Polaroid SX-70, and it is less complex because a viewfinder is used for composing the scene. The camera is focused by sliding the focusing tab back and forth, which varies the size of a gold circle seen in the viewfinder; when the gold circle is the same size as the subject's head, the camera is correctly focused. The limit of close focusing is 3½ feet (1 m). The photograph is 2⅝ × 3⁹⁄₁₆ inches (6.7 × 9 cm.). One model has a built-in electronic flash. The Colorburst has only a few accessories and is basically suited to the amateur.*

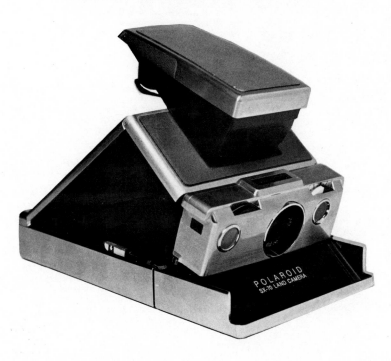

61

## Instant-Picture Cameras

In 1947 a new concept in photography, the *instant-picture camera,* which used black-and-white (and, later, color) film for "instant" pictures, was introduced. There are now two types of film which produce these instant pictures: "peel-apart" and "integral processing."

Polaroid "peel-apart" film is in two parts: the film proper and a sheet of specially prepared paper. As the film tab is pulled, the film is brought into contact with the special paper and passed between two rollers. A jelly-like developing reagent in the film (or in the paper) is squeezed out by the rollers and spread evenly between film and paper. A negative image forms and unused silver salts migrate to the paper, producing the positive image. At present, the process takes 30 seconds for black-and-white and 60 seconds for color, after which the negative is stripped from the print and the photograph is fin-

ished. A wide assortment of film is available, including high-contrast film and a continuous-tone film that produces a reusable negative.

In "integral processing," a multi-layered sheet of color film (black-and-white is not available), upon exposure, is squeezed between two rollers and automatically ejected from the camera. The squeezing activates chemicals contained in the film which, in turn, produce the image on the picture. At first the picture appears blank, but gradually the colors become visible until the photograph is finished. There is no negative image to discard as with the "peel-apart" system. Instant picture cameras for "integral processing" are manufactured by Polaroid and Eastman Kodak.

The simple-to-operate instant-picture cameras for the amateur market are zone focused (see page 86) and have automatic exposure control. Polaroid has recently introduced the Polaroid 600 SE camera for the professional market. This camera has manual

adjustable shutter speeds from 1 second to 1/500 of a second, a manual adjustable aperture range from f/4.5 to f/45, interchangeable lenses (normal, wide-angle, telephoto), and a synchronized shutter for electronic flash. It produces a 3¼ × 4¼-inch (8.2 × 10.8-cm) picture.

Because of the increased demand for instant-picture capability, some manufacturers now produce special backs to accommodate Polaroid film to 120/220 roll-film cameras, view cameras, and press cameras. Even larger Polaroid color prints are now available with the Polaroid 8 × 10 system, which uses 8 × 10-inch (20.3 × 25.4-cm) Polacolor 2 Land film, a special filmholder, and an electrically powered film processer. It is ideal for studio work, but the requirement of electrical processing hinders its use outdoors. Recently, Polaroid has introduced another system to produce 20 × 24-inch (50.1 × 60.1-cm) color pictures, but it is not yet portable and must be used in a Polaroid studio.

## Special-Purpose Cameras

**S**pecial-purpose cameras have been developed for any number of situations where none of the standard types suit the purpose. Some of the more well-known special-purpose cameras are panoramic, stereo, underwater, and aerial cameras. For even more particular purposes, both amateur and professional photographers have designed and made their own cameras. Several special-purpose cameras are pictured and described on pages 62–64.

The *panoramic camera* was developed to photograph crowded interiors, sports, parades, landscapes, or large groups of people, where extremely wide-angle coverage is desired. There are three types, distinguished by their use of either a fixed lens, a swinging lens, or a rotating lens.

*Stereo* has periodically been in vogue, but because special viewers or complex projection systems are required to see stereo photos, it has never become standard. In fact, no stereo cameras are currently manufactured, although they are readily available on the used market. Stereo attachments are available, however, for most 35mm SLR cameras.

◀ *The* fixed-lens panoramic camera *gives wide-angle coverage in a camera that is simple to operate and has a relatively large image size. It records "rectilinear perspective"; that is, it records straight lines in a subject as straight lines in the image, as a normal camera does. A built-in level is usually included because if the camera is not level, vertical lines in the subject, particularly at each end of the image, will lean in or out. Such convergence, when intentional, can produce exciting pictures. The Brooks Veriwide 100, shown here, uses 120/220 roll film; it produces a 2¼ × 3¼-inch (6 × 8.2-cm) negative; it covers 82° of a scene. The shutter is fully synchronized for flash; the speeds range from 1 to 1/500 second, with a B setting. There is an optical viewfinder.*

◀ *The Widelux is a swinging-lens panoramic camera with a short-focal-length lens (26mm) mounted to swing from side to side during exposure. The film, rather than being held against a flat surface, is set against the inside of a cylinder. Like the Brooks Veriwide 100, this camera must be level to keep the images of verticals parallel to the sides of the image. In this case, also, interesting visual qualities may be achieved by aiming the camera up or down or tilting it sideways. This camera uses 35mm film; the image area is 1 × 2¼ inches (2.5 × 6 cm); it covers 140° of a scene. The camera is not synchronized for flash and has a limited number of shutter speeds. There are a focusing scale and an optical viewfinder.*

▼ *Unlike the fixed-lens panoramic camera, the Widelux records "panoramic perspective." That is, when the camera is level, only the image of a horizontal line in the center of the picture is rendered parallel to the bottom edge of the frame; the images of all other lines above and below the center are rendered as bent toward each end of the center line. A building, for example, seems to bend at the right- and left-hand sides of the picture, making the center of the building seem to come forward. Because the lens moves during exposure, the rendition of moving objects is also changed. If an object is moving in the same direction as the swing of the lens, its form is elongated, as here. If it is moving against the direction of the swing, it is compressed.*

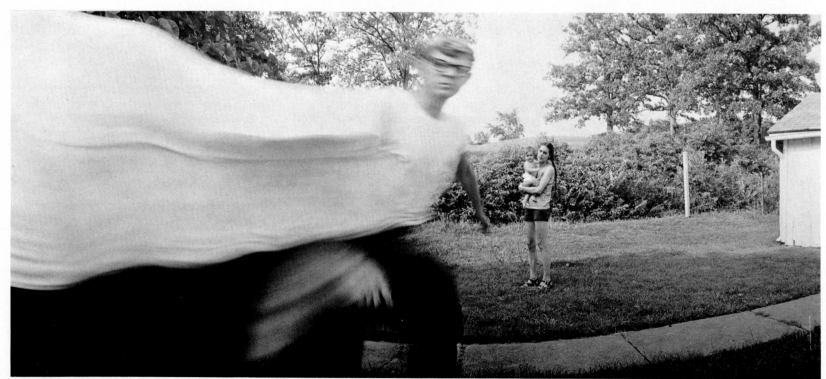

CHARLES SWEDLUND. *Untitled.* 1972.

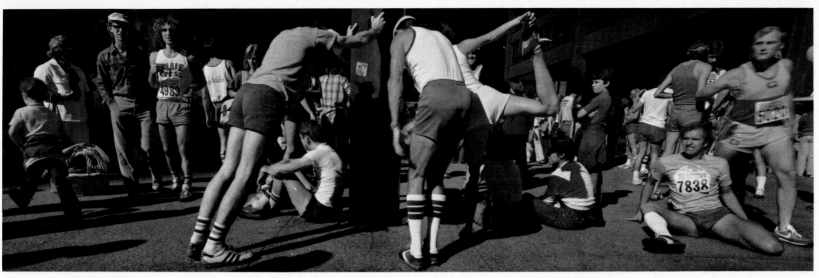

DAVID AVISON. *Chicago Marathon.* 1978.

63

▼ *A few years ago, David Avison wanted to make long-format, wide-angle photographs with standard rectilinear perspective. He tried to use cropped images produced by several conventional cameras but found that they were technically inadequate. Also, these cameras provided poor control over aesthetic factors and were cumbersome to use in this way. So Avison designed and constructed a fixed-lens camera with an extremely wide-angle lens which produces an image three times as long as its height. This camera, completed in 1972, uses 120/220 roll film; the image area is $2\frac{1}{4} \times 6\frac{3}{4}$ inches ($6 \times 17$ cm); it covers 98° of a scene. A photograph made with this camera is shown above. (Since Avison made his camera, Linhof has begun marketing the Technorama, similar to Avison's but lacking some of its special features.)*

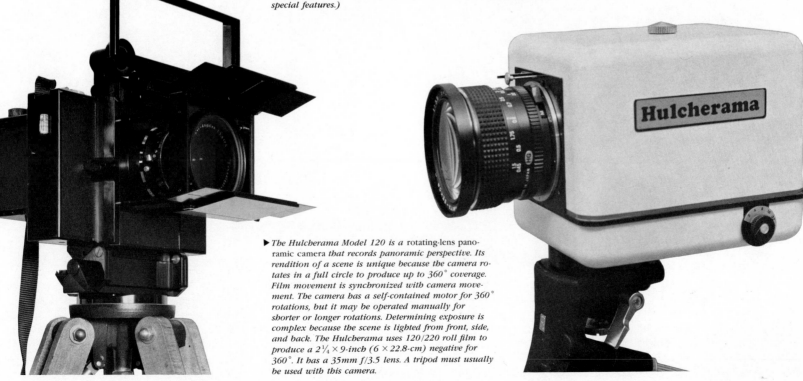

▶ *The Hulcherama Model 120 is a rotating-lens panoramic camera that records panoramic perspective. Its rendition of a scene is unique because the camera rotates in a full circle to produce up to 360° coverage. Film movement is synchronized with camera movement. The camera has a self-contained motor for 360° rotations, but it may be operated manually for shorter or longer rotations. Determining exposure is complex because the scene is lighted from front, side, and back. The Hulcherama uses 120/220 roll film to produce a $2\frac{1}{4} \times 9$-inch ($6 \times 22.8$-cm) negative for 360°. It has a 35mm f/3.5 lens. A tripod must usually be used with this camera.*

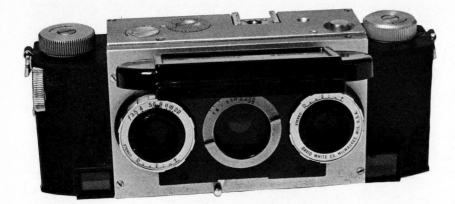

◀ *A stereo camera, such as the Stereo-Realist, shown here, is really two cameras in one, with two lenses mounted side by side, much like a pair of human eyes. The lenses operate in unison to produce two images from slightly different viewpoints on 35mm film. The same effect can be obtained by using a 35mm single-lens reflex camera with a stereo attachment. The attachment contains a beam splitter that produces two images side by side on a single piece of film. In either case, the resulting images are blended into one apparently three-dimensional image by a special viewer or projection system.*

◀ *The detail provided by an aerial camera depends a great deal on the size of film. The Linhof Aero Technika 45, shown here, is an expensive camera specifically designed for aerial photography; it gives the best detail possible with handheld cameras. Its shutter and aperture are easily set, and it fits snugly in both hands; it produces 150 exposures with a negative size of 4 × 5 inches (10 × 12.5 cm).*

▼ *The Nikonos is a versatile, moderately priced 35mm underwater camera designed to be used up to a depth of 150 feet (45 m). It has interchangeable 15mm, 28mm, 35mm, and 80mm lenses. An electronic flash completes the unit. This camera also is practical whenever accidental wetting is possible, such as on a canoe trip or in a heavy rainfall.*

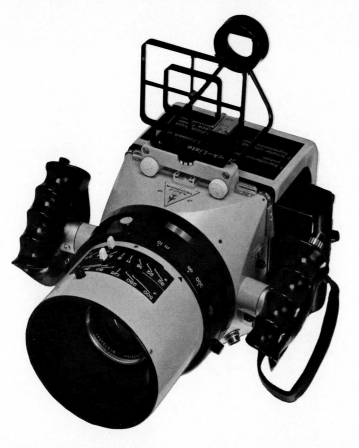

64

Many manufacturers market a variety of equipment for underwater photography. There are *underwater housings* for inexpensive nonadjustable cameras, for sophisticated cameras such as the Hasselblad, and even for the Polaroid SX-70. There is also a camera, the Nikonos, designed specifically for underwater use.

Obviously, the underwater camera or housing must be watertight. It is important to know its depth limits to prevent leakage; it is also important to be sure construction mate-

rials are resistant to the corrosion of salt water. The operation of the camera must be simple because time is an important consideration when diving; thus, shutter speed, aperture, film advance, and counter mechanism should be easily visible. A wide-angle lens (35mm or 28mm) is generally preferred underwater because of the limited range of vision. An electronic flash is essential, especially when using color film, since the light is never very bright or clear underwater and may be quite dim.

*Aerial cameras* fall into two groups: those permanently installed in a plane, and smaller, handheld models. The former are most commonly used by the military. Only one handheld camera, the Linhof Aero Technika, is specifically designed for aerial use. Other cameras normally used on the ground can also be used for aerial photography; these include the 35mm single-lens reflex cameras with motor-drive and the Hasselblad 500 EL. The Hasselblad gives more detail than a 35mm camera. □

Just as no single tool does every job, no *one* camera is suitable for every photographic situation. As we have seen, some cameras are quite versatile, while others have been designed for specific functions. Furthermore, modifications are constantly being made in current models and new models are being introduced. The camera you choose should neither baffle you with its complexity nor limit you with its simplicity. When buying a camera you may find yourself confused by the number of options available, especially by the competing claims of manufacturers' "systems." Since a camera represents a considerable investment, your choice should be made carefully, with a clear understanding of your own requirements and minimum influence from advertising or sales pressure.

Each camera type is suitable for different photographers on different occasions. The 126 cartridge camera and the 110 pocket camera are wholly adequate for black-and-white or color souvenir-type snapshots. For better quality results, a 35mm camera should be considered. When even higher image quality is desired, one of the cameras that produces negatives larger than 35mm is indicated. These are considerably more expensive than 35mm cameras but are an ideal compromise between weight and image quality, and fine quality black-and-white prints and color prints from color negatives are possible with them. However, if the end product is to be color transparencies, a 35mm camera is the less expensive choice because of the cost of the projector for 2¼-inch (6-cm) slides.

On the principle that *the larger the negative, the higher the quality of the final print,* an 8 × 10-inch (20.3 × 25.4-cm) view camera gives the best results, since with it an 8 × 10-inch print can be made from an 8 × 10-inch negative and nothing is lost in enlargement. This camera provides a great deal of control, but requires planning and a dedicated commitment to photography.

Buying a used camera is a valid way for you to acquire equipment inexpensively. The condition of a used camera is the most important factor in determining its price. Once you have decided on the type of camera you want, do some comparison shopping to determine the condition and the current prices of available used cameras.

Often you can save money by buying "last year's" model. Changes made in many new models may be cosmetic rather than functional, and even functional changes are usually for the convenience of "fail-safe" procedures. With some patience, the older model cameras are perfectly adequate, or even superior. Multiple-exposure prevention is an example of a "fail-safe" function which, if it cannot be overriden, hinders the versatility of the camera. Older cameras often offer a level of craftsmanship superior to that of newer ones because better craftsmanship prevailed when they were manufactured.

A rough rule for the purchase price of a used camera is that it should cost about 50 percent of the retail price for a currently available camera. Verify the current retail price and be sure that the new camera is not available for only slightly more than the used one. A used camera may not be a good choice if the saving amounts to only a few dollars, especially if the warranty is not available or transferrable from the original owner. Some camera stores issue their own warranties, but their prices on used equipment are a little higher. If you are considering buying a camera from a "collector," remember that a collector purchases cameras as examples of an historical period or because of their rarity, rather than for use. As a result, prices of these cameras are often greatly inflated.

There is a wide variety of accessories available for most cameras. Some are virtually essential and others are quite specialized for specific situations. Some of these accessories are shown and described on the next page. A serious amateur or a professional photographer may have several cameras for several different needs and own a great many accessories that extend the picture-making capabilities of these cameras.

The main point to keep in mind, however, is that it is not expensive equipment that produces a good photograph—it is a good photographer. No amount of money, gear, or technical expertise can create a photographic idea. □

65

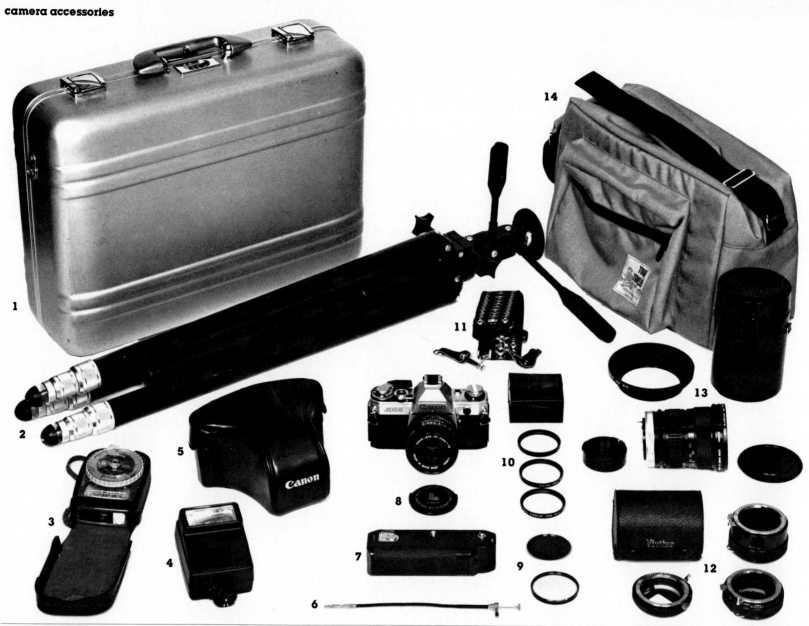

**a Canon 35mm single-lens reflex camera surrounded by accessories**

**1 travel case** *Needed for maximum protection of equipment when traveling. Usually made of aluminum or fiberglass with foam inserts to protect equipment from damage. Some brands have locks and are watertight. See Chapter 9.*

**2 tripod** *Three-legged support that holds the camera at a fixed position; often useful, sometimes necessary. The correct size for a specific camera must be used. Some brands have a center shaft that moves up and down; others have a gear mechanism that permits very delicate adjustments.*

**3 handheld exposure meter** *Helps determine correct exposure by measuring light. A necessity if not built into the camera. See Chapter 5.*

**4 electronic flash unit** *Necessary for photography in very dark places. May also be used with existing available light. These units are small, lightweight, and fairly inexpensive. See Chapter 9.*

**5 camera case** *Helps protect the camera from weather and jarring. Most models permit the camera to be used without removal from the lower section of the case.*

**6 cable release** *Flexible shaft for operating the shutter without touching and possibly jarring the camera. Necessary for time exposures. For very long exposures, a locking mechanism to prevent premature closing of the shutter is recommended.*

**7 motor drive unit** *Permits exposures in rapid succession by advancing the film electronically. Attached to the bottom of the camera; powered by small batteries.*

**8 front lens cap** *It is advisable to buy a metal screw-on cap to protect the lens (caps that come with cameras are easily knocked off). Also available: rear lens caps for storage and lens cases; see 13 here.*

**9 filters** *With black-and-white film, filters enhance tones; with color film, they correct colors. Filters are also available for closeup lenses. See Chapters 4 and 13.*

**10 three closeup lenses and case** *Attached to a normal lens for very close subjects. Such lenses can be combined for varying degrees of magnification. See Chapters 3 and 12.*

**11 neck strap** *For carrying the camera.*

**12 three extension tubes and case** *Attached between camera and closeup lens for closeup photography. May be used singly or combined for varying degrees of magnification. See Chapter 12.*

**13 wide-angle lens and four accessories** *Left: rear lens cap. Right: front lens cap. Above left: lens hood; helps keep excessive light from striking the lens and creating flare; if the hood is too small, corners of the picture are vignetted; if too large, light is not reduced enough. Above right: carrying case. See Chapter 3.*

**14 accessory bag** *Some are soft and collapsible; others are rigid; others designed for specific cameras have built-in partitions. Useful in the field but not strong enough for carried or checked traveling luggage.*

## Cleaning a Camera

**Y**ou don't need to be obsessive about cleaning your camera and lens, but it is well worthwhile from time to time to check the camera inside and out for tiny dirt or dust particles that may scratch your negatives, and for smudges on the lens.

The covering on a camera may be gently buffed with a soft cloth. A very soft brush may be used to clean out the inside of the camera. Be very careful with the mirror inside a single-lens reflex camera, for it is easily scratched or streaked if damp. Avoid cleaning this mirror unless absolutely necessary. A cotton swab is handy for cleaning out the crevices and corners around the viewfinder. Cleaning the lens is more critical. The proper technique for cleaning a lens is described on this page.

## Holding a Camera

**T**o prevent camera movement from ruining a picture, it is important to hold the camera steady while making the exposure. The shutter release button should be pressed gently to eliminate the possibility of jerking the camera. Stand in such a way that your weight is distributed evenly. Lean against a support whenever possible to help prevent body movements such as swaying back and forth. The exact way to hold a camera depends on the particular type of camera you use and the point of view desired. Whenever possible, however, place the camera against a stationary object. This will help a great deal to reduce camera movement. The following guidelines for specific instances should prove helpful.

- For horizontal pictures, tuck in your elbows and rest the camera against your cheek.
- For vertical pictures, use the same arm placement and your forehead for support.
- When kneeling, rest the muscular part of your upper arm against your knee. This is better than having your elbow resting on your knee because the two hard, bony surfaces coming together could cause vibrations.
- For low-viewpoint pictures, lie flat on the ground and use your elbows for support.
- When using a twin-lens reflex camera at waist level, pull down on the neck strap while holding the camera against your body with arms tucked in.
- When using the magnifier on a twin-lens reflex camera, brace the camera against your chest.
- Holding the twin-lens reflex camera upside down above your head is not a position for steadiness, but is often useful and necessary when trying to photograph over the heads of a crowd of people.

### cleaning a lens

- *To remove lint or dust from a lens, turn it upside down and gently brush with a soft camel's hair brush, so that loosened pieces of debris will fall away.*
- *Compressed air from an ear syringe may also be used to blow away dust.*
- *If you use lens-cleaning tissue especially made for photographic lenses, roll the tissue into a tube and tear it in half to produce a ragged edge. Clean the lens with this edge in a circular motion. Do not use eyeglass cleaning paper, which may have ingredients that could harm the coating on the lens.*
- *Photographic lens-cleaning fluid may be used if further cleaning is necessary. Place the fluid very sparingly on the lens and gently wipe with a piece of photgraphic lens tissue. Holding the lens upside down prevents the fluid from collecting at the edges of the lens. Do not use lens-cleaning fluid made for eyeglasses.*

67

The most important part of the camera is the lens. The lens collects light rays from a scene or object in front of the camera and projects them onto the film at the back of the camera as an image. Any lens has certain characteristics of size, speed, and optical precision, all of which influence the manner in which the lens controls light. A good modern lens can produce a sharp and accurate image on the film. Such a lens is ingeniously constructed of several layers of different kinds of optical glass combined to adjust mechanically and smoothly for exact focusing. Many types of lenses are now available, each designed to have specific capabilities. Your ability to produce the photograph you want will depend in large degree on your knowledge of the way light behaves and how the lens you are using controls it. Further, it will depend on your ability to use the capabilities of your lens to specific effect, even to making inherent lens defects serve your own purposes. This chapter tries to give you this knowledge.

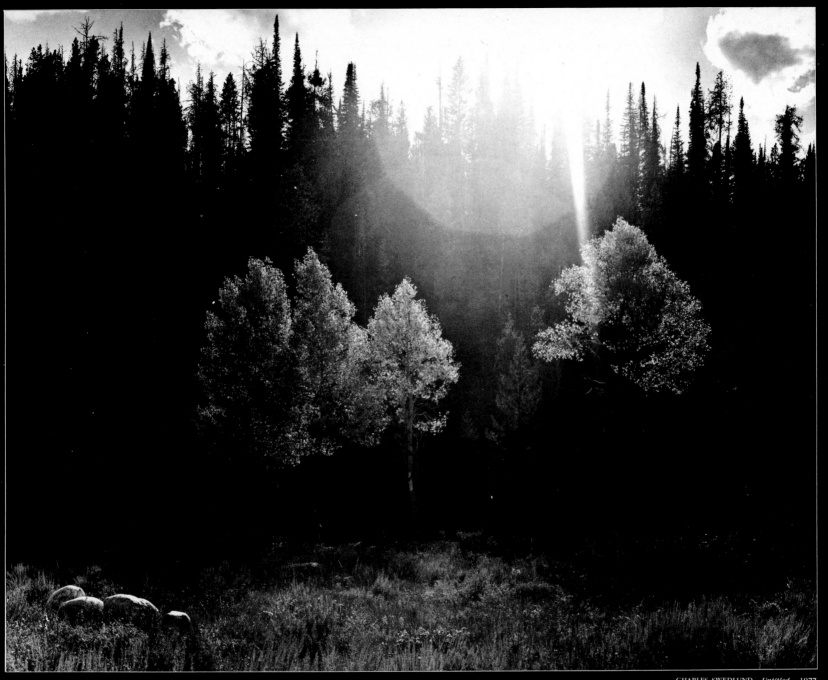

69

CHARLES SWEDLUND. *Untitled.* 1977.

Light has been defined as energy making visible anything that produces it. Light producers include the sun, an electric-light filament, or the wick of a lighted candle. As energy, light is the visible part of the electromagnetic spectrum whose wave-like pulsations come from the sun. This spectrum ranges from X rays and gamma rays at one extreme to radio waves at the other. What distinguishes each type of energy is its wavelength. Energy waves that are visible to the human eye, called light, are found halfway between X rays and gamma rays (which measure only about .00000000004 inch) and radio waves (which can be as long as 6 miles). The visible energy waves of light differ in length according to color, from .000016 inch for blue to .000028 inch for red. (See illustration, page 337.) Shorter waves immediately beyond the visible rays are called *ultraviolet*; longer rays immediately beyond the visible rays on the other end are called *infrared*.

Waves of light contain particles called *photons,* but light traditionally has been defined not as particles but as energy. Contemporary quantum mechanics says light has properties of both particles and energy. In photography, we are mostly concerned with the behavior of light as energy or waves, but its behavior as particles is also important: When a photon strikes a molecule of silver bromide in the surface of photographic film, it disrupts it, thus exposing the film. (See Chapter 4, page 98.)

Light radiates in all directions from its point of origin; the radiation travels in straight lines, as shown in the diagram of the light bulb. Light not only makes visible anything that produces it but also anything that receives and is illuminated by it, such as the moon and virtually any other object we see. Any non-light-producing object is illuminated by reflecting the light that strikes it. The way an object reflects light depends on its color, surface characteristics, and degree of transparency. A white shiny surface reflects a good deal of light, while a black mat surface absorbs most of the light reaching it and reflects very little. Light on its way to an object is called *incident light*; light leaving, or

bouncing off, an object is called *reflected light.* As shown, the angle of incident light equals the angle of reflected light.

White light, which appears colorless to our eyes, contains all the colors of the visible spectrum; each color is distinguished by its own group of wavelengths. When white light is passed through a prism, which bends light, each color, because it has its own wavelength, is bent, or *refracted,* differently; these separate colors together produce a *spectrum*—all the visible colors of light.

Light that strikes a transparent medium at a right angle passes straight through, as shown. But when light strikes such a medium at another angle, it is *refracted*. Refraction explains why a straight stick placed at an angle in water looks bent below the water surface. As shown, after light is refracted, it travels in a straight line again from the point of refraction, but on a path parallel to the original path. This property of light, refraction, is fundamental to the principle of a lens, because a lens is a device for bending light in special ways. □

70

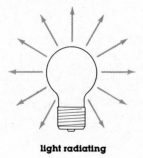

light radiating

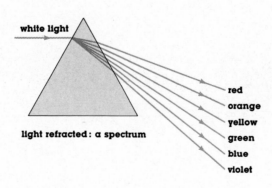

white light

light refracted: a spectrum

red
orange
yellow
green
blue
violet

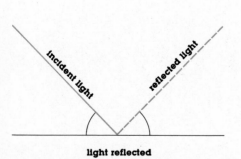

incident light

reflected light

light reflected

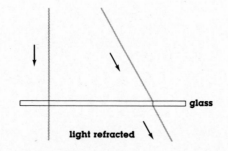

glass

light refracted

# How a Lens Forms an Image

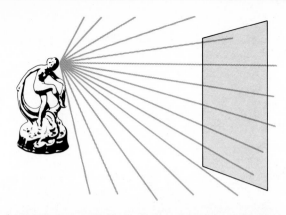

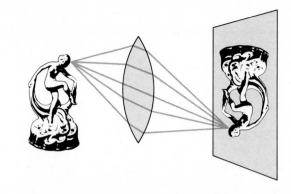

*When light rays striking the figurine bounce off in all directions they do not create a coherent image on a piece of ground glass. When the light is made to pass through a lens, which sorts and directs the rays, it projects a sharp image of the figurine on the ground glass.*

As light strikes an object, such as the figurine in the photographs and diagrams, its rays bounce off from all points and scatter in all directions. A piece of photographic film placed in front of a subject will not record the subject's image because light rays strike the film everywhere and at random—not in the ordered fashion that will produce an image. To form an image of a subject on film, light rays reflected from the subject must be selected and controlled so as to strike the film in a coherent order that reproduces the form from which they came. In the early camera obscura, a pinhole served as the controlling point for light rays coming from the subject (see Chapter 12, page 312). In modern cameras the lens gathers light rays to form an image with far more accuracy and speed. A lens selects and sorts out light rays and directs them, ray by ray, to reproduce on film, point by point, the photographer's subject.

The function of the lens in making photographs is critical. There are many types of lenses. This chapter covers lens structure and function, the means of controlling light with the lens, and types of lenses.  □

# The Simple Lens

To understand the design and function of the lens, start with the *prism,* a crystal with identical ends (usually triangles) that are parallel to each other and lateral faces that are parallelograms. A prism refracts (bends) light rays. Diagrams *a–h* show prisms, their relationship to lenses, and types of lenses. In all these diagrams, assume that the light rays are coming from a great distance (infinity) and thus are parallel when they enter the prisms and lenses. When two prisms are arranged as in *a,* light rays passing through them converge at a single point on the other side.

When two prisms are arranged the opposite way, as in *b,* the light rays diverge.

A simple lens is a solid piece of glass that is a refinement of two prisms. There are two basic types of lenses: positive and negative. The *positive lens* is like the two prisms arranged to cause light to converge: it bends light rays in an inward (convergent) direction so that eventually the rays meet as in *c.* The *negative lens* is like the two prisms arranged to cause light to diverge: it bends light rays in an outward (divergent) direction, as in *d.* A positive lens is thicker at the

center and has at least one convex surface. A negative lens is thicker at the edges and has at least one concave surface. Within the boundaries of these determining features, positive and negative lenses can take many possible shapes, as in *e* and *f.* The actual picture-taking lens of a camera is always positive. Negative lenses often serve as one element in a lens composed of several parts and help to correct image defects (see page 75).

Diagrams *g* and *h* show how a positive lens brings together light reflecting from

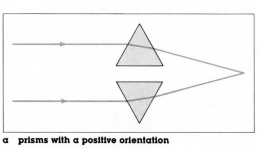

a   **prisms with a positive orientation**

72

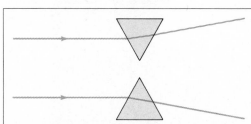

b   **prisms with a negative orientation**

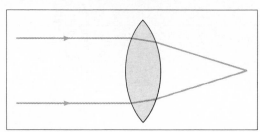

c   **positive lens**

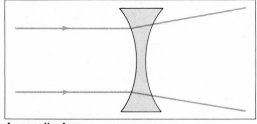

d   **negative lens**

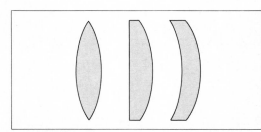

e   **positive lens shapes**

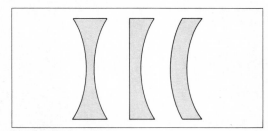

f   **negative lens shapes**

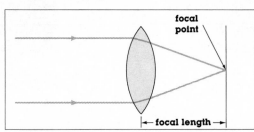

g   **thick positive lens**

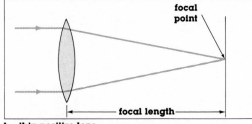

h   **thin positive lens**

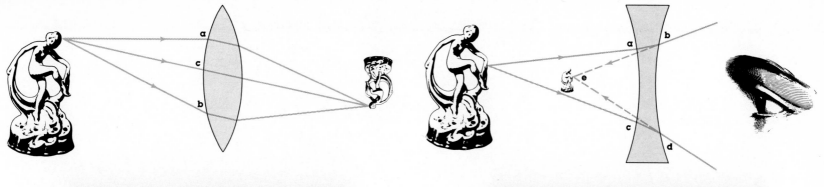

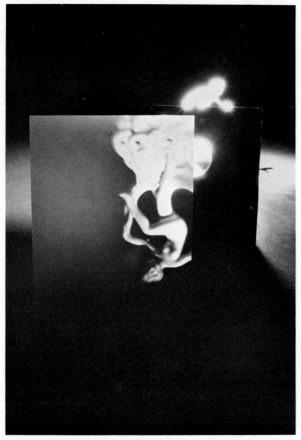

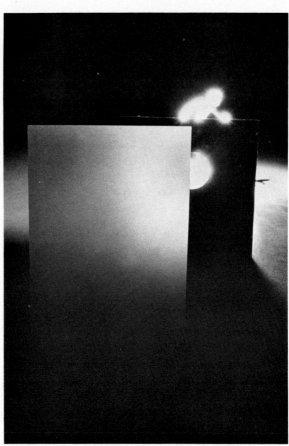

various points on the subject into a single image. The point at which all the rays from the subject meet is where the image is formed. This point is called the *focal point*. The image formed is called a *real image:* it can be seen, upside down and reversed from left to right, on a sheet of ground glass in the view camera. Thickness and degree of curvature are among the properties of a positive lens that determine the distance from the lens to the point of focus of a distant object. This distance is called the *focal length* (FL) of the lens when focused at infinity. A

thick lens causes the light rays to converge closer to the lens (*g*) than a thin lens (*h*).

Because the light rays do not converge with a negative lens, no image can be formed on ground glass. However, a negative lens produces a kind of illusion that makes it ideal for a viewfinder. When looking through such a lens, you perceive the light as if it were coming in a straight line from the other side of the lens. What you see is called a *virtual image:* it is right side up, not reversed, smaller than the subject, and always in focus. □

*Positive and negative lenses in operation. Above left: Convergence of light rays occurs when one ray hits the top part of a positive lens (a) and is bent downward; another ray reflected from the same point hits the bottom of the lens (b) and is bent upward; a third ray hits the center of the lens (c) and continues in a straight line. The photograph shows the real image on the ground glass. Above right: Divergence of light rays occurs when one ray hits the negative lens (a), is refracted by the first surface of the lens and again by the second surface (b), and then travels outward; another ray hits the lens (c), is refracted by the first surface and the second surface (d), and also travels outward. The negative lens did not form an image on the ground glass in the photograph. However, this lens projects a virtual image (e) to the eye; this is the effect that is used in a viewfinder.*

Focus depends on the distance between the lens and the *focal plane*. This distance is determined by the focal point where light rays from the lens converge. In the camera, film is placed on the surface of the focal plane to receive converging light rays from each point on the subject. Every light ray that strikes the film creates a tiny circle, called a *circle of confusion*. The photographic image is composed of countless numbers of these circles in clusters. The smaller, more concentrated and distinct these circles are, the sharper the focus of the image. The larger these circles of confusion, the more they impinge on and overlap one another and produce a blurry image. A simple experiment with a magnifying glass shows this.

By holding a magnifying glass, which is a lens, over a sheet of paper on a sunny day, you can project a circle of light onto the paper. The distance between the magnifying glass and the paper determines whether or not the circle is in focus. Similarly, in the camera, if the distance between the lens and the focal plane is too long or too short, the image will be out of focus. A sophisticated combination of tighter and looser circles of confusion, however, can produce dramatic photographic effects, such as the glistening drops of dew in David Cavagnaro's photograph.  □

74

DAVID CAVAGNARO. *Dew on a Lupine Leaf.* 1971.

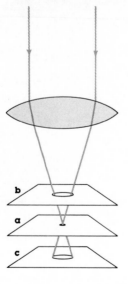

*The circle of light projected through a magnifying glass by the sun varies with distance. At a, the circle is very small, almost a point, and the sun is so intensified that the paper smokes and even catches fire. In other words, the sun is in focus at a, which is a certain critical distance from the glass. At b and c, either too close or too far from the magnifying glass, large and fuzzy circles of confusion are formed. Similarly, the dewdrops on the large veins of the leaf in the photograph are in focus because they were a certain critical distance from the focal plane in the camera. They were formed on the film by tightly clustered circles of confusion. The dewdrops in the foreground and background are at lesser and greater distances from the focal plane and thus are blurred because the circles of confusion are larger and overlap.*

Although the simple lens was a great improvement over earlier methods of gathering light rays, it distorts and does not produce the sharpest image of the subject. Stopping down the aperture can improve picture sharpness, but it does not solve the problem of distorted images, since a lens can produce many image defects. Among possible lens distortions are: tiny dots in a subject that appear tear-shaped on film; certain colors in focus while others are not; the center of an image in focus while the edges are fuzzy, or vice versa; and the perspective of a straight line, such as the edge of a building, appearing bent on film. The most common—chromatic aberration, spherical aberration, coma, astigmatism, curvature of field, and curvilinear distortion—are defined in the chart on page 76. Most camera lenses are constructed to overcome these optical problems, but understanding the problems will help you understand how a lens functions.

The modern compound lens is a sophisticated mechanism designed to counteract lens distortions and to create as nearly perfect an image as possible under a wide range of light conditions. Since both the curvature and the glass of which a lens is made determine how the lens bends light, lensmakers counterbalance, in a series, lenses of various shapes, each made of a special type of glass and placed in a special relationship to the other elements (see page 95). They try to make compound lenses that cancel optical errors and project sharp and true images on film. Such lenses can include up to twenty elements, as a zoom lens does (see page 93). The three photographs show the comparative sharpnesses of image produced by a simple lens and a compound lens.

75

Top: *A simple lens with aperture set at f/5.6 was used. The center of the flat circus poster is in sharper focus than the edges.* Center: *The simple lens with the aperture stopped down to f/45 was used. The restricted light greatly improved sharpness, but a pincushion effect was created (see curvilinear distortion, page 76).* Bottom: *A compound lens with aperture set at f/5.6 was used. Though exposure factors were the same as for the first photo, the compound lens produced a much sharper image that also is not distorted.*

One way of measuring the capacity of a lens to produce a sharp image is its *resolving power,* its ability to distinguish between closely spaced lines. The more lines per millimeter a lens can accurately distinguish, the higher its resolving power and the greater its ability to discern fine detail in the subject. Measurement of resolving power is used to determine the potential of a new lens design and later for quality control.

Light as it passes through the numerous elements in a compound lens reflects off the various surfaces inside the lens. This internal reflection can cause ghost images or excessively light areas in a photograph, called *flare.* Almost all manufacturers coat the various lens elements with a material that helps reduce internal reflection. As with many other lens peculiarities, however, flare can be used to advantage for aesthetic effects— as in the photograph on the opening page of this chapter. □

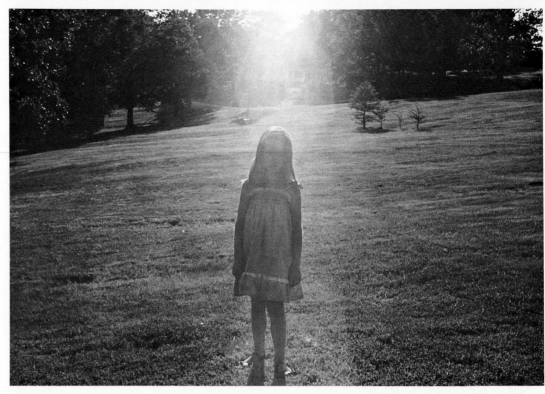

*Light reflecting off the various surfaces inside a compound lens produced the excessively bright areas: flare.*

## lens aberrations

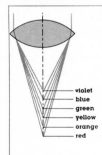
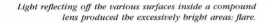

**chromatic aberration** *The lens is like a continuous prism, which, depending on adjustable variables, controls the point at which a color comes into focus. Different colors come into focus at different points because of their different wavelengths (see page 337). Blurring may result in a color photograph from colors coming into focus at different points. Image sharpness may be improved by stopping down the aperture. The inclusion of various aberration-correcting types of glass in modern compound lenses usually corrects chromatic aberration.*

violet
blue
green
yellow
orange
red

**spherical aberration** *Spherical aberration results when light rays entering the outer portions of a lens fail to reach the same focal point as those entering the center of the lens. This can cause a general out-of-focus softness. The problem can be partially overcome by stopping down the aperture, but a good lens contains the elements necessary to prevent spherical aberration.*

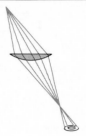

**coma** *Coma is similar to spherical aberration. In coma the lens produces unequal magnification in different areas. Light rays thus pass through the lens obliquely instead of parallel to the lens axis. This results in poor marginal definition. For example, light coming from a dot creates a tear-shaped image with a bright center and a dim outer edge.*

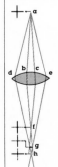

**astigmatism** *If the subject of a photograph is not on the lens axis, astigmatism may result. A lens with severe astigmatism could not produce a plus sign ( + ) in perfect focus, for when the horizontal line is brought into focus, the vertical line is out of focus, and vice versa. In the diagram, vertical light rays from source a, represented by lines b and c, come into focus at a different distance (f) from the lens than the horizontal light rays d and e, which meet at b. Thus the image at g is not a sharp point of light but a rather generalized circle of confusion. The use of special "rare earth" glass and the spacing of elements in most compound lenses tend to eliminate this problem.*

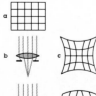
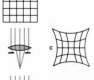

**curvature of field** *A simple lens has a certain degree of curvature, called curvature of field. Because the lens is curved, it cannot form an image of, for example, a wheel in sharp focus on a flat piece of film. If one point is clearly defined in the image, another, the light from which strikes a different point of lens curvature, is not. At a the outer rim of the wheel is in focus but the hub is out of focus; the opposite occurs at c. Point b is a compromise: both rim and hub are moderately sharp. Most complex lenses are designed and constructed to avoid this problem.*

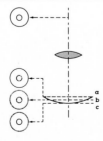

**curvilinear distortion** *When subect a is photographed through an aperture diaphragm placed in back of a lens (b), a pincushion-shape distortion (c) can result. Placed in front of the lens (d), the diaphragm causes a barrel-shape distortion (e). In a complex lens placement of the diaphragm between the elements helps to reduce curvilinear distortion.*

The f-number of a lens is an accurate, standard method for identifying its light-gathering capacity. Marked on the inside rim of any lens, this number also tells how "fast" or "slow" the lens is—a very critical factor in choosing and using a lens.

The intensity of light reaching film depends on two factors: the diameter of the lens and the focal length of the lens (the distance between it and the focal point when the lens is focused at infinity). An f-number for any lens that indicates its relative speed can be calculated from these variables, using the following formula:

$$\frac{FL}{D} = f/N$$

In this formula, FL stands for the focal length of the lens; D stands for the effective diameter of the lens; and f/N stands for the f-number, which represents the light-gathering capacity of the lens. The shorter the focal length, the smaller the quantity of light lost traveling to the ground glass or film. The larger the lens diameter, the more light it is capable of gathering. The diagrams on the next page show the relationship of these variables—focal length and diameter—to the f-number.

It is helpful to remember that the f-number is actually a fraction. For example, f/2 means that the diameter of the lens is ½ of the focal length of the lens; f/3.5 means that the diameter is about ⅓ of the focal length; f/8 means that the diameter is ⅛ of the focal length. (And when a lens is stopped down to f/22, the aperture in this case is only ½₂ of the focal length.) So, just as ½ is larger than ⅛, an f/2 lens is larger than an f/8 lens. Thus the f/2 lens gathers more light. Beginning photographers sometimes make the mistake of thinking that an f/8 lens or aperture is larger than f/2, when it is not. Keeping the fraction concept in mind will prevent this mistake.

A lens with a large diameter is called a "fast" or "high-speed" lens. The faster the lens, the easier it is for you to take pictures in low-light situations, because more light reaches the film. The first diagram and photographs on the next page show how a larger diameter lens yields a brighter image.

Two view cameras are focused on the same subject. The focal length of both lenses is the same, but one lens has a much larger diameter than the other. By applying the f-number formula, we find that the larger lens has a lower f-number and therefore gathers more light, producing a brighter image, as in the corresponding photograph.

Focal length is the second variable in the f-number formula. If light rays originating from a distant object are gathered and bent by the lens so that they converge at a point 12 inches (300mm) from the lens, the lens has a 12-inch (300mm) focal length. Focal length is generally measured in millimeters for short lenses and in both inches and millimeters for long lenses. The shorter the focal length, the brighter the image and thus the wider the range of light conditions in which the camera can function. The f-number formulas in the second diagram on the next page show that although the diameters of both lenses in the view cameras are the same, the shorter focal-length lens has the lower f-number and thus gives the brighter image. The photographs confirm this.  □

77

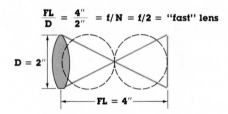

$$\frac{FL}{D} = \frac{4''}{2''} = f/N = f/2 = \text{"fast" lens}$$

D = 2"

FL = 4"

$$\frac{FL}{D} = \frac{8''}{1''} = f/N = f/8 = \text{"slow" lens}$$

D = 1"

FL = 8"

*The f-number derives from the focal length of a lens divided by its diameter. The shorter the focal length and the larger the diameter, the greater the power of the lens to project light on film—and the smaller the f-number. "Faster" lenses have smaller f-numbers.*

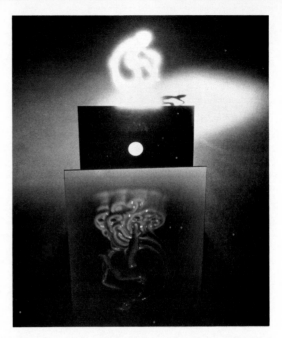

Lens diameter is one of the two variables in the f-number formula. The two cameras are each equipped with a lens whose focal length is 8 inches (200mm). The one with a lens 4 inches (100mm) in diameter (left), an f/2 lens, can throw sixteen times as much light on film as the one with a lens 1 inch (25mm) in diameter (right), an f/8 lens. The photographs show the brighter image produced by the larger diameter lens.

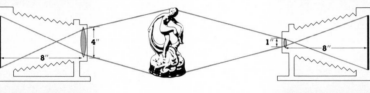

$$\frac{FL}{D} = \frac{8''}{4''} = f/N = f/2 \qquad\qquad \frac{FL}{D} = \frac{8''}{1''} = f/N = f/8$$

78

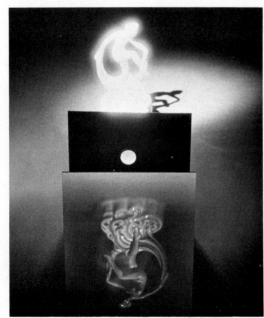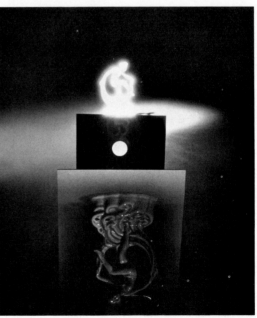

Focal length is the other variable in the f-number formula. The two cameras are each equipped with a lens 2 inches (50mm) in diameter. The one whose lens has a focal length of 4 inches (100mm) (left), an f/2 lens, can throw four times as much light on film as the one whose lens has a focal length of 8 inches (200mm) (right), an f/4 lens. The photographs show the brighter image produced by the shorter focal length lens.

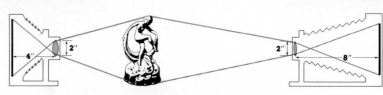

$$\frac{FL}{D} = \frac{4''}{2''} = f/N = f/2 \qquad\qquad \frac{FL}{D} = \frac{8''}{2''} = f/N = f/4$$

# Image Size

**120 film:
normal 75mm lens**

**35mm film:
normal 50mm lens**

**35mm film:
long 150mm lens**

*A lens produces a circular image. The image must extend beyond the corners of the film, but it must not be too large. The normal images for 120 film and 35mm film are shown. But a long 150mm lens on a 35mm camera produces an image so large that the film can record only a small portion, giving an effect of great magnification, as shown. The opposite effect is illustrated at right.*

**4 × 5 film: normal 150mm lens**

*The circular image produced by a lens must not be too small for the film. The square or rectangular film must easily fit inside the circle. The normal image for 4 × 5 film is shown. But a short 50mm lens on a 4 × 5 view camera produces a circular image about 2 inches (50mm) across, leaving the rest of the film blank. However, this image area is much larger than the 35mm frame normally used with a 50mm lens—the white outline.*

The lens on a camera is usually designed to photograph the area that you can see clearly when standing at a specific spot. For example, if you must stand 10 feet (3 m) from a subject in order to see as much of your subject as you wish, obviously the camera must also be 10 feet from the subject. The lens that sees what you see with your naked eyes is considered a "normal" lens for that particular camera. A lens with a 50mm focal length is normal for a 35mm camera, while a 4 × 5 view camera requires a 6-inch (150mm) lens. The 150mm lens will form an image three times larger than the 50mm lens. This is because the longer the focal length, the greater the image area the lens will capture, and thus the larger the film size must be. The normal focal length for a given film size is usually equal to the diagonal measurement of the film size. A camera that uses sheets of 8 × 10 film, for example, requires a lens of from 12 to 14 inches (300–350mm) in focal length because the diagonal of the film is about 13 inches (330mm). □

**4 × 5 film: short 50mm lens**

The angle of view of a lens is the amount of any given subject or scene that the lens includes. Lenses of various focal lengths produce quite different angles of view. A 24mm wide-angle lens on a 35mm camera covers 84°, while a 400mm lens on the same camera covers only 6°. The angles of view for various focal-length lenses are shown in the diagram on the opposite page.

While standing at one spot you can quite dramatically change the angle of view by using a wide-angle or long-focal-length lens not considered normal for your camera. The photographs on these pages were made in that way. They were taken with a 35mm camera that was kept in the same position. The photos show how lenses of eight different focal lengths changed the angle of view. The image of the man varies greatly in size and detail, depending on the focal length of the lens used in each case—ranging from very long to very short.

It is interesting to compare the image produced by the normal 50mm lens with the seven others. □

**800mm lens (3°)**

**400mm lens (6°)**

**50mm lens (46°)**

**24mm lens (84°)**

80

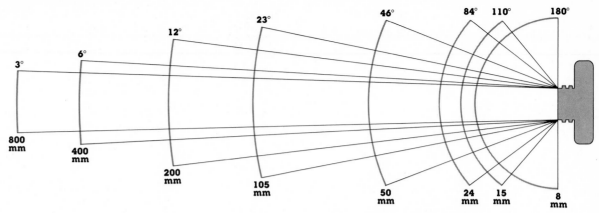

*The shorter the focal length of a lens, the greater the angle of view.*

81

**200mm lens (12°)**

**105mm lens (23°)**

**15mm lens (110°)**

**8mm lens (180°)**

# Perspective

The distance between lens and subject critically affects *perspective* in a photograph. Perspective refers to the relationship of objects in a photograph to each other—their relative positions and sizes and the spaces between them. The first two photographs here were made with the same lens at distances of about 250 feet (75 m) and 1250 feet (380 m). In the photograph taken at the closer distance, the subject is larger in relationship to objects in the background than it is in the photograph taken from farther away.

If the focal length of the lens is changed but the distance between lens and subject remains constant, there is a change in the size of the objects in the photograph but no change in perspective. Compare the second photo made with a 24mm lens with the third photograph, made with a 400mm lens, also at 1250 feet (380 m) from the subject. The two pictures look quite different because of the contrast in the size of the various objects in each. But see the fourth photo: When a small section of the negative produced by

the 24mm lens at 1250 feet is enlarged to match the same area covered in the photo taken with the 400mm lens at 1250 feet, it is obvious that the perspective is the same.

When lens-subject distance *and* focal length are changed, the relationship between objects may be radically altered: perspective is changed. In taking the second group of photographs, the photographer held the sign on the fence at the same size by changing the position of the camera when using each lens. The photograph made with a

82

**24mm lens: 250 feet**

**24mm lens: 1250 feet**

**400mm lens: 1250 feet**

35mm lens has a great feeling of space between the sign and the two basketball backboards. The sign in front looks considerably larger than the backboards. In the photo made with a 200mm lens the space seems more compressed and the rear shapes are now almost the same size as the front one. In the photo made with a 300mm lens space is so compressed that the three shapes seem to be in the same plane. The rear backboard shapes are now larger than the closer white sign. ☐

**35mm lens**

83

**200mm lens**

**300mm lens**

**24mm lens: 1250 feet (detail, enlarged)**

## Aperture

**A**s mentioned on page 49, aperture is one of the controls of depth of field, that area in a photograph between the foreground and background which is in sharp focus. Now that the lens and circles of confusion have been discussed, it is easier to see *why* this is true: *The larger the aperture, the less the depth of field.* A large aperture permits a relatively large number of light rays to enter the camera from each point on the subject. Released into the camera by the lens, they converge toward the focal plane to form a cluster that, on striking the film, covers a small circular area. Because of their greater size, these circles of confusion formed by a large aperture overlap and impinge upon one another, which produces the blurriness of an out-of-focus photographic image. A small aperture admits fewer light rays from each point on the subject, and by striking the film in tighter clusters, these rays create circles of confusion that remain distinct (not overlapped), thus making possible a more precisely defined photographic image.

84

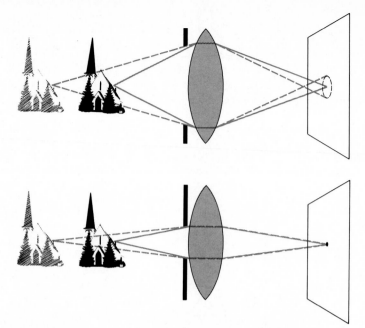

Above: *The large amount of light admitted by a wide aperture permits a greater number of large and overlapping circles of confusion and thus less depth of field.* Below: *The reduced amount of light admitted by a narrow aperture results in smaller, tighter circles of confustion. The broken lines represent light rays from a single point on objects located beyond the point of sharpest focus; the solid lines represent light rays from objects at the point of sharpest focus.*

## reading depth of field

lens-subject distance scale

depth-of-field scale

aperture setting

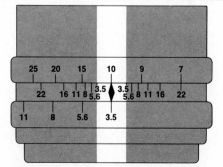

*With the focus set at 10 feet (3 m) on the lens-subject distance scale opposite an aperture setting of f/3.5, the depth of field is only 3 feet (90 cm). This is the distance between 9½ feet and 12½ feet marked off by the duplicated f/3.5 numbers on the depth-of-field scale.*

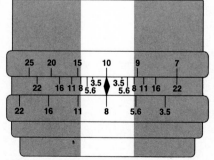

*With the focus remaining at 10 feet and the aperture setting now f/8, the depth of field increases to almost 6 feet (1.8 m). This is the distance between just over 9 feet and just under 15 feet marked off by the duplicated f/8 numbers on the depth-of-field scale.*

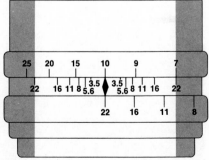

*With the focus remaining at 10 feet and the aperture stopped down to f/22, the depth of field increases again to 16 feet (4.8 m). With this combination, the duplicated f/22 numbers show that everything from 7 feet to 23 feet from the lens will be in sharp focus.*

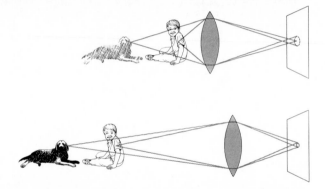

## Lens-Subject Distance

**A**perture is the major means by which a photographer controls depth of field, but lens-to-subject distance is also a factor. *The closer the lens to the subject, the less the depth of field.* This principle is illustrated photographically and diagrammatically here. Both photographs were made at the same f-number; the first one was photographed with a camera set a mere 3 feet (90 cm) from the subject, the second from a distance of 10 feet (3 m). Obviously, the greater distance between camera and subject yielded a more extensive and therefore more inclusive depth of field.

Another way of saying that aperture and distance affect depth of field is to state that focal length affects depth of field. *The longer the focal length, the less the depth of field.* This is because the actual size of the aperture opening on a long lens is larger than the same f-number opening on a wide-angle lens. The longer focal length requires a larger "actual" aperture opening to compensate for the amount of light lost traveling to the focal plane. At the same distance, the image size of a long lens is larger than the image projected by a short lens. Using a short lens, if you move the subject or the camera so that the image is equal in size to the image of the long lens, the depth of field becomes the same as the long-lens depth of field. The short-focal-length lens gives greater depth of field only if its smaller image size is acceptable.

## Using the Depth-of-Field Scale

**A**fter focusing, you can use a depth-of-field scale (opposite) to determine what areas will be sharp. Most cameras have such a scale, which must be related to the lens-subject distance scale. At the center of the scale are duplicated maximum f-numbers, indicating the widest aperture for that particular lens. Arranged to duplicate one another on either side are succeeding f-numbers, one to indicate the closest point in focus and the other the most distant point in focus. To determine your depth of field, find the two f-numbers on this scale that correspond to the f-stop being used. Then read the numbers on the lens-subject distance scale, the focusing ring (by which you adjust lens-subject distance), to find out how many feet in front of the subject and in back of the subject will be

*Above: When the lens is in focus 3 feet (90 cm) from the child, light rays from a point on the child arrive on the focal plane in a circle of confusion with the concentrated nature of a dot. Rays from a point on the dog, only slightly more distant than the in-focus child, converge too far from the focal plane and therefore fan out to make a large and unfocused circle of confusion. The closer the in-focus subject to the lens, the larger the circles of confusion made by light rays from points in the scene that are out of focus. This tendency toward larger circles of confusion, inherent in focusing at close range, results in shallow depth of field. Below: When the lens is in focus 10 feet (3 m) from the child, there are smaller circles of confusion and thus there is greater depth of field. The dog is now sharp.*

in focus. The diagrams on page 84 show how to read depth of field for three f-stop and focusing combinations.

A depth-of-field scale is indispensable if your camera cannot show depth of field visually. It must be used for all cameras requiring manual focusing, including rangefinder cameras. It must also be used for twin-lens reflex cameras in spite of their visual focusing because the viewing lens does not show depth of field on the ground glass. The scale is included on most single-lens reflex cameras as well, even though the single lens does show depth of field visually. You usually compose and focus an SLR at the largest aperture, for better visibility. Thus many SLR cameras have a "preview" button; when you press the button, the lens stops down to the aperture setting you have chosen, so you can make your depth-of-field judgment.

### Zone and Hyperfocal Focusing to Control Depth of Field

**Z**one focusing means presetting the depth of field in order to be able to react quickly in a picture-taking situation—for instance, to catch a subject whose high speed can be anticipated, as in a sports event, or to photograph people in public places without having to take time to focus. You set the camera for a distance and aperture reasonable for the situation and then by checking the depth-of-field scale you know within what zone or range you can photograph. As long as you make photographs within the preset depth-of-field zone, you can be reasonably sure your subjects will be in focus.

When you are taking a photograph showing near and far subjects and you want extra depth of field in the foreground, *hyperfocal focusing* can be used. This technique can best be applied to outdoor scenes with bright light, when the aperture can be stopped down. The procedure involves the *hyperfocal distance,* which is the distance from the lens to the nearest point of the depth of field—the nearest point that is in focus—when the lens is focused at infinity. Normally, when a typical 50mm lens is set at infinity, this point is about 30 feet (9 m) from the camera; everything nearer than that point will be out of focus in the image. In hyperfocal focusing, you make use of the hyperfocal distance to re-focus the camera for a specific point slightly nearer than infinity. The procedure gives you sharp focus from about 15 feet (4.5 m) to infinity.

To achieve hyperfocal focusing for a given f-stop, first determine the hyperfocal distance by setting the distance scale on infinity. Match the depth-of-field scale to the distance scale as you ordinarily do to determine depth of field. Hyperfocal distance is the distance shown by the distance mark corresponding to the aperture number on the depth-of-field scale. To set hyperfocal focus, move the distance setting back from infinity to the distance setting of the hyperfocal distance. You then have an effective depth of field from *half* that distance to infinity. (Therefore, a quick way to achieve hyperfocal focusing is to set the infinity mark opposite the number on the depth-of-field scale of the aperture setting you are using. The new near depth-of-field distance then shows opposite the duplicate aperture setting.)

The diagrams give an example of hyperfocal focusing. The photographs show visually how the principle works. For the first photo, the focus was set at infinity. Even the small aperture used did not produce enough depth of field to register the details of the pump in the foreground in sharp focus. For the second photo, hyperfocal focusing was used with the same aperture. Here the foreground details are in sharp focus. □

**hyperfocal focusing**

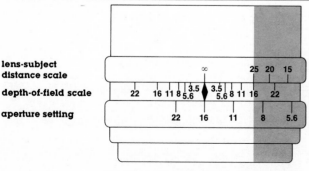

*The aperature is set at f/16. The lens is focused at infinity (∞). The hyperfocal distance—the point of the closest in-focus object—shows opposite f/16 as 25 feet (7.6 m).*

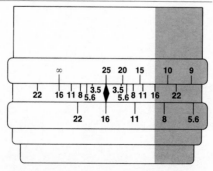

*When the distance setting is changed to the hyperfocal distance of 25 feet, hyperfocal focusing increases the depth of field by one-half of 25 feet to begin at 12½ feet (3.8 m), now showing opposite f/16, and still continues into infinity. (Note that the infinity mark is now opposite the duplicate aperture setting.)*

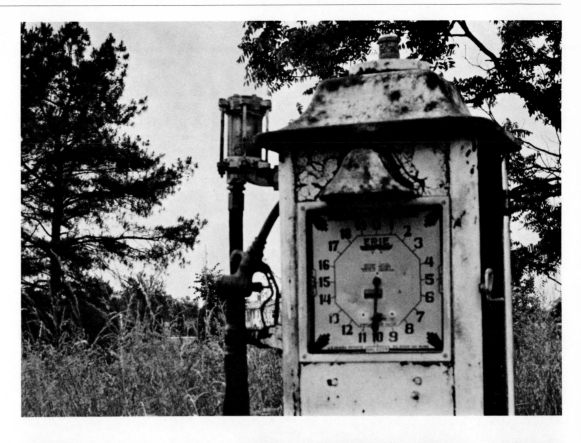

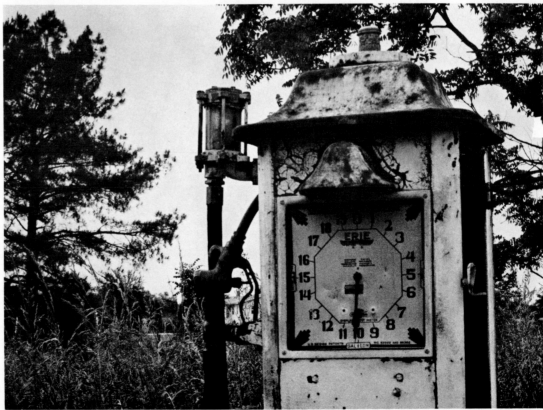

Above: *Focus set at infinity. Numbers and letters and other details in the foreground are not sharp.* Right: *Hyperfocal focusing. Both foreground details and background trees are sharp.*

## Short-Focal-Length Lenses

**A** short-focal-length lens in usually called a *wide-angle lens.* Such a lens covers the same area as a normal lens from a position much closer to the subject than the normal lens. If, for example, a normal lens must be 10 feet (3 m) from the subject in order to see it in its entirety, a typical wide-angle lens needs to be only 7 feet (2 m) away to accomplish the same thing. This can be important if an obstruction prevents standing far enough away from the subject to photograph it with a normal lens.

An uncorrected wide-angle lens would produce an image that lacks rectilinear perspective. The horizontal and vertical lines at the edges of a scene would appear to be curved if wide-angle lenses were not de-signed to correct this type of distortion. As focal length is shortened, such distortion becomes a very complex problem. The shortest wide-angle lens currently available for a 35mm single-lens reflex camera which maintains rectilinear perspective is 15mm, and it is rather expensive. Other wide-angle lenses with a less drastic coverage are more moderately priced.

A wide-angle lens can produce other distortions, depending on the angle between it and the subject. If the lens and subject are perfectly parallel to one another, the perspective is exaggerated, but the relative sizes of objects in the scene are in proportion to each other. If the lens is not parallel but at an angle, objects nearer the lens appear larger and out of proportion to the ones farther away. This distortion may be exciting in some photographs, but grotesque in others.

The wide-angle lens can help the photographer increase the feeling of space in a photograph. This can be useful in some situations, as when photographing architecture. The spatial relationships of objects in a scene also appear more pronounced in a picture produced with a wide-angle lens close to the subject, and near objects often seem almost to emerge from the picture, as in the photograph by Geoff Winningham. The sense of immediate presence given by a wide-angle lens is often used for its dramatic effect by photographers when shooting, for example, crowd scenes. A 35mm lens produces some feeling of space. A 28mm or 24mm lens increases this distortion and a 17mm, 18mm, or 19mm lens produces an even more drastic impression of expanded space.

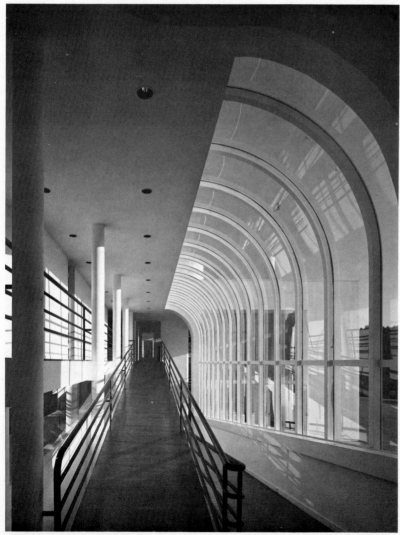

EZRA STOLLER. *House in Old Westbury.* 1971.

*A wide-angle lens increased the feeling of space between the walls of a windowed walkway.*

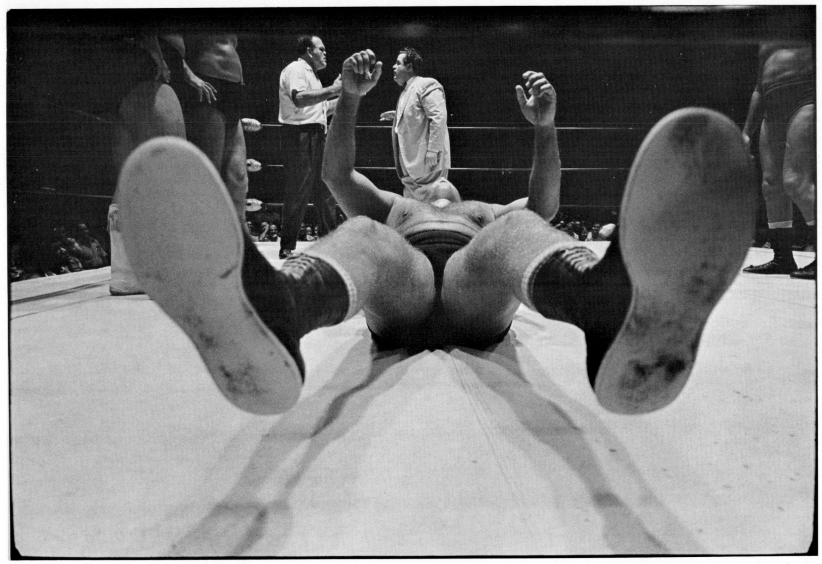

GEOFF WINNINGHAM. *Untitled* (from *Friday Night in the Coliseum*). 1971.

Because the short-focal-length wide-angle lens produces very good depth of field, it is not generally suitable for portraits or other situations when you want the background to be out of focus. When photographing fast action close to the camera, the wide-angle lens is useful, because clear focusing is more easily achieved than it is with a normal lens.

An extreme wide-angle lens is called a *fisheye*. There are two basic types: one produces a circular image in the center portion of the negative, such as that of the dog on the next page; the other produces a full-frame image, such as the 15mm photo on page 81. The circular one is not corrected for rectilinear perspective, while the full-

frame fisheye is. Lenses shorter than 15mm all have the circular format. The angle of view with a fisheye lens is enormous. An angle of 180° means that, for example, you literally have to be careful not to include your feet in the picture. There is even one lens which, because of its 220° angle of view, actually "sees" behind itself.

The extremely short focal length of these lenses (8mm, 7.5mm, 6.5mm) produces great depth of field. The front elements on fisheyes are so large that filters cannot be accessories but must be built in. The distortion produced by this type of lens is minimized if you are careful to place the horizon in the middle of the picture, but, even then, the

pictures have a circular feeling. In many cases the image produced by a fisheye lens is so exaggerated that the subject can hardly be recognized. A picture taken with a fisheye lens may even seem to have a strong element of fantasy.

Fisheye lenses are expensive, but a fisheye attachment will produce acceptable results for a more modest sum. The attachment fits over the front of the normal lens and produces a small circular image with 180° coverage. Closing the lens down to f/8 or f/11 generally produces acceptable sharpness. Another device, the bird's eye attachment, also attaches to the front of a normal or moderate wide-angle lens and produces 360°

coverage. Closing the aperture down to f/11, f/16, or f/22 gives the maximum depth of field and sharpness.

The perspective-control lens or *shift lens* is a wide-angle lens (28mm or 35mm) made for 35mm single-lens reflex cameras. It has a small knob and micrometer lead-screw which enables the lens to be shifted off its optical axis but remain parallel to the film plane. This movement permits pictures of buildings to be made free of the distortion produced when pointing a camera up at an angle. A tripod is convenient, but not absolutely necessary, when using this lens. The shift lens may also be rotated for horizontal movements to produce "wide-field" semi-panoramic pictures, and some models have a "tilt" movement that permits some depth-of-field control (see Chapter 11, page 299).

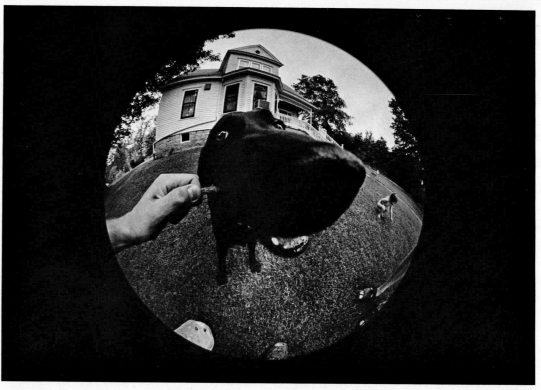

*An 8mm fisheye lens distorted the subject so drastically that it can barely be recognized as a dog. But the result is more humorous than grotesque. This is an example of the creative possibilities of extreme wide-angle lenses.*

*Photographing a building with a shift lens.* a: *Tilt the camera so that the building fills the frame.* b: *Then lower the camera, keeping it parallel with the ground, so that the opposite sides of the building become parallel.* c: *Turn the knob on the lens to raise it so that the entire building fills the frame, free of distortion.*

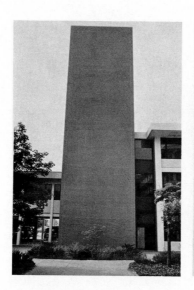
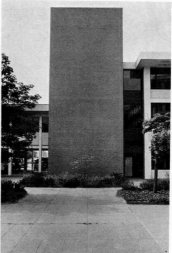

a          b          c

### Long-Focal-Length Lenses

**I**n some situations you cannot get near enough to a subject to use a normal lens effectively. When you are photographing animals or birds in their natural habitat, for example, you can seldom get close enough for good images with a normal-focal-length lens. Often this is the case with sports events, too. A long-focal-length lens is the answer. A lens twice the normal focal length for the camera can be very useful, for it will increase the image size without making the camera unwieldy. Many photographers, however, prefer lenses in the range between normal and twice normal. Such a lens makes possible photographing from a slightly greater distance than normal.

A long-focal-length lens renders perspective differently from a normal lens when there is a corresponding change in the distance from lens to subject, as shown on page 83. In such cases, the longer the lens, the more difficult it is to see the real distances between objects in a photograph. The limited depth of field does let you photograph with the background entirely out of focus to separate objects optically.

Because a long lens adds weight at the front of the camera, it is more difficult to hold the camera steady. This is especially important since long lenses are generally rather slow; few are faster than f/4. As a result, the long-focal-length lens requires either a fast shutter speed or a tripod or, better still, a combination of the two. A general guide for shutter speed for long-focal-length lenses is that the slowest reasonable shutter speed for a 250mm lens is 1/250.

Atmospheric haze is often a problem when using a long lens. Suitable yellow, orange, or red filters help penetrate atmospheric haze, but the resulting negatives still often lack contrast. Extremely long lenses (600mm, 800mm, 1000mm) are highly specialized; movement, depth of field, compression of space, and contrast become even more critical with these lenses.

Rangefinder cameras are not well suited for long lenses, and in fact most do not accept them. To view and focus with a long lens, you can convert some 35mm rangefinder cameras to single-lens reflex with a reflex housing (see page 54). However, SLR cameras are preferable for long lenses because they accommodate them easily.

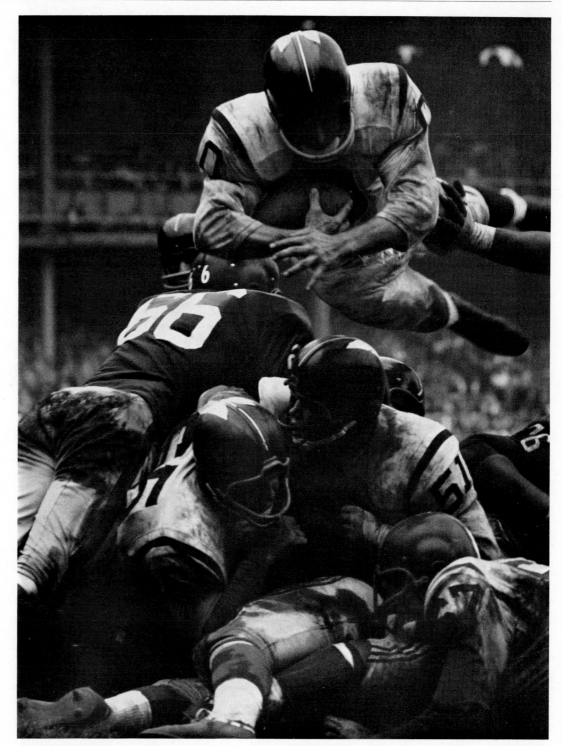

91

ROBERT RIGER. *Touchdown over the Top.* Washington at New York, 1960.

*To emphasize the pileup in a football play, the photographer used a telephoto lens. The real distances between the players are impossible to judge; the telephoto lens makes all the players seem to be on one plane, a flat wall of bodies.*

Although any long-focal-length lens is often called a "telephoto" lens, a real telephoto lens is a lens made with magnification capacity greater than the actual focal length of the lens. The shapes of the various elements in the true telephoto lens are designed to make the long lens slightly lighter and less cumbersome than it would otherwise be.

An accessory to increase the focal length of a lens has recently been introduced. This device, called a teleconverter, attaches to the camera, and the long-focal-length lens is fastened to it. For example, a 200mm lens effectively becomes a 400mm lens with a 2X converter. However, the teleconverter requires additional exposure and generally cuts down the relative sharpness of an image, so its use involves a compromise between maximum image quality and cost of equipment.

In recent years, the techniques of mirror optics (long used for telescopes) have been employed to make *mirror lenses,* which serve the same purpose as long lenses. The accompanying diagram illustrates how such a lens works. A mirror lens, though thicker than a long-focal-length or telephoto lens, is shorter and lighter in weight, and it causes fewer problems with color aberration. A diaphragm cannot be used with a mirror lens. You must rely on neutral-density filters (see Chapter 4) and the shutter in the camera to regulate exposure. At these long focal lengths, the apertures of about f/8 or f/11 allow very little depth of field. Tiny dots of light that are out of focus, such as reflections in the photo, appear as dots with black centers (like doughnuts). (See circles of confusion, page 74.)

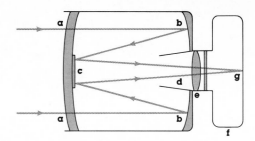

*A mirror lens. As light enters the lens, it passes through the glass at a, refracts off mirror b to mirror c and then refracts again through tube d to the camera lens (e); it then enters the camera (f) and strikes the film (g). A mirror lens looks strange from the front because the small mirror in the center shows as an opaque circle. Some mirror lenses have additional elements in the tube and can accept neutral-density filters.*

*This photograph taken with a mirror lens shows the characteristic limited depth of field. The reflections in front of and beyond the plane of focus are doughnut-like in shape, in contrast to the circles of confusion produced by an optical lens.*

**80mm**

**200mm**

**changing a zoom lens from 80mm to 200mm (slow shutter)**

## Variable-Focal-Length Lenses (Zoom)

**A** *zoom lens* is one with variable focal lengths. Camera manufacturers, responding to the recent popularity of zoom lenses, are producing them in a great variety of focal-length ranges at many different prices.

The zoom lens is attractive because it enables you to vary image size without having to change your position. Pulling or pushing the focusing ring on the lens will automatically change its focal length. One basic available zoom range is from a semi-wide-angle lens (35–40mm) to a semi-telephoto (80–100mm) lens, a popular range because it provides the visual qualities of three lenses in one. Another range is semi-telephoto (80mm) to telephoto (200mm)—see the photographs. One model has a range from 50mm to 300mm. Some newer models also have a "macro" setting, which enables you in a simple motion to focus the lens within inches of the subject. Most, however, cannot photograph closer than a few feet.

The complex construction of zoom lenses (some have as many as twenty elements) makes them considerably more expensive than single lenses. They are not very fast (f/3.5 or slower) and are heavier and larger than many lenses, but they allow much versatility. The sharpness of the image produced with a zoom lens is sometimes less than with conventional lenses.

93

## Special-Purpose Lenses

**A**lmost all manufacturers who endorse the "system" concept make a *macro lens* for their 35mm single-lens reflex cameras. These lenses, which are relatively slow at f/3.5, are specifically designed for closeup photography. They are also excellent for copying two-dimensional subjects (book pages, slides, etc.) because their aberrations are highly corrected for producing a flat field. Originally the macro lens was a 50mm focal-length lens, but there are now also a few in the 84–100mm range. They differ from regular long lenses in that their focusing capacity is from infinity to 9 inches (22 cm). When the macro lens is focused at 9 inches, a 1-inch (2.5 cm) object in the scene is recorded on the film as half its real size. An accessory extension tube makes possible a 1:1 ratio for an image the same size as the actual object. Additional exposure is required for closeup focusing, and some macro lenses automatically compensate for this. Other brands have exposure-increase factors that must be considered to set proper exposure. The accessory extension tube always requires one f-stop increase in exposure. A camera with a built-in exposure meter helps to solve these exposure problems. Closeup photography is discussed at length in Chapter 12.

The very expensive *process lens* is used on large-copy (process) cameras which have lenses of more than 12 inches (300mm) focal lengths and are used to copy art work for printing reproduction. Process-lens aberrations are corrected for photographing flat copy and for color. These corrections make this a rather slow lens (f/5.6, f/8), but this is seldom a problem because of the camera's usual stationary installation and accompanying lighting system. Some photographers use a process lens with sheet-film cameras because they feel it produces the sharpest image. See Chapter 9 for copying.

The *soft-focus lens* is most often used by portrait photographers, because it retains the sharpness of a subject's eyes while allowing other areas such as wrinkles and freckles to be slightly out of focus and thus less obvious. It can also be used for creative effects. The relative amount of softness is determined by the choice of f-number or by adjusting internal components in the lens. A currently available soft-focus lens for 35mm single-lens reflex cameras has different degrees of soft focus. The soft quality produced with these lenses is generally more appropriate for photographs of people than of objects. □

94

*John Brook used a soft-focus lens that he designed himself (with positive spherical aberration; see page 76) to produce the softness that suggests warmth and intimacy.*

JOHN BROOK. *Before You Leave Me.* c. 1960.

# Choosing a Lens

A lens represents a considerable investment and therefore should be chosen with care. Each focal length and special type of lens has certain advantages and disadvantages. Keep in mind when choosing a lens that a camera, whatever the quality of its other features, is only as good as its light-gathering mechanism, the lens.

A new camera will generally come with a normal-focal-length lens for that camera (see page 79). A normal-focal-length lens is usually considerably less expensive than a short- or long-focal-length lens, and it provides the greatest flexibility. The perspective produced by a normal lens helps make the photograph seem an authentic likeness of reality. A short-focal-length lens allows you to get closer to your subject and still cover a sizable area. A long-focal-length lens allows you to be "invisible"—to capture a subject on film while remaining at a distance from it. For the photographer with special needs there are other lenses to choose from, including the ones we have discussed: the pop-ular zoom lens, closeup lenses (macro), process lenses for professional copywork with large-format cameras, and soft-focus lenses for pictorial effects.

Lenses come in two different kinds of mounting arrangements—the *screw mount* and the *bayonet mount*. As the name implies, the screw-mounted lens has threads at the back to screw the lens right onto the body of your camera. Most lenses mounted in this way can be removed easily by placing the camera with the lens pointing up on your lap and twisting the lens clockwise or counterclockwise until it comes off. To remove the bayonet-type lens, simply depress the lens-release button and twist the lens slightly. The ease of this mount makes it especially popular with professional field photographers, such as photojournalists, who require much speed and flexibility in using their equipment. The screw-mount lens is perfectly adequate for most situations.

All the information you need about any lens is engraved on its inside front rim. This information includes the brand name, the speed of the lens, the size or focal length, the name of the manufacturer, and the serial number. On many lens types manufacturers offer a choice between a fast but more expensive lens and a slightly slower but considerably less expensive lens. Often people buy the faster lens when they are getting only one or two more f-numbers, which they really do not need. This is not only a waste of money, but may also mean accepting poorer image quality, since sometimes the fast lens is not able to produce as sharp an image as the slower lens. Similarly, when considering the purchase of a long- or a short-focal-length lens, you should seriously consider how much magnification or coverage you need. Too often, inexperienced photographers buy lenses much longer or shorter than they will actually use.

The general recommendation concerning lenses, then, is to avoid impulse buying, which may leave you with a costly lens for which you have little real use. □

95

**lenses in cross section**

*Light comes from the left. The dashed lines indicate the location of the diaphragm in each case.*

**24mm wide-angle lens**
**(f/2.8)**

**50mm normal lens**
**(f/1.4)**

**105mm long-focal-length lens**
**(f/2.5)**

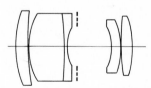

Film can be thought of as the canvas on which light is directed by the lens to form an image. Early versions of film took the form of photographic plates, which were awkward to work with and produced less than perfect results. Modern film is one of the wonders of photography. It is available in many types, generally classified by speed according to their relative sensitivity to light. The image recorded on film by light after it has been in a camera has two salient properties. For one thing, it is *latent,* invisible until it has been subjected to developing procedures. For another, except for slides, it is in *negative* form, capable of being printed into any number of *positives.* Filters, like film, also interact with light. Because they are selective in their effect on light, they can be used at the discretion of the photographer who is familiar with the particular effect attributable to each type.

How light interacts with various types of film and filters to produce certain pictorial qualities is what this chapter is about. The photographer aware of and capable of exploiting these interactions is likely to produce superior photographs.

*To produce a dramatic rendition of the sky, the photographer used a strong red filter, which absorbs blue and thus darkens blue areas in the print.*

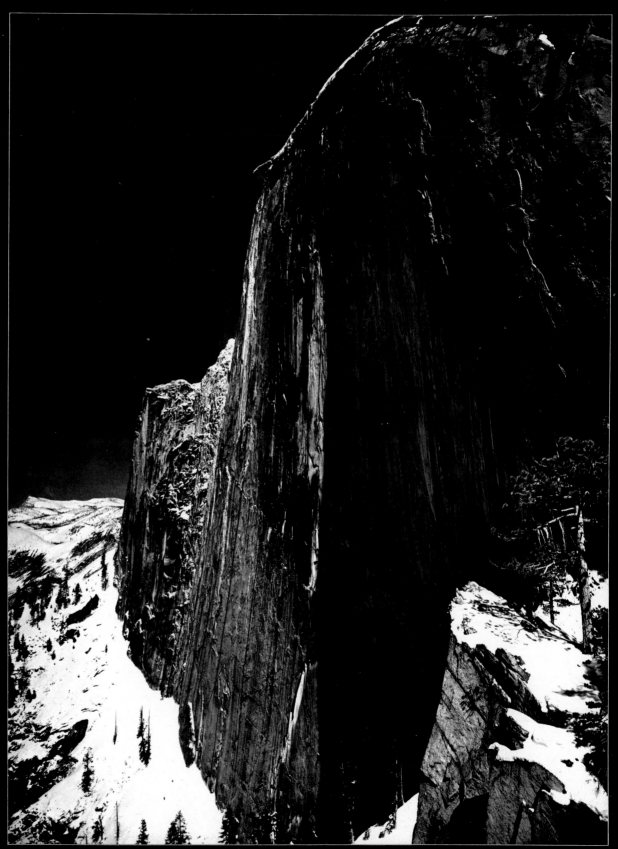

ANSEL ADAMS. *Monolith, the Face of Half Dome, Yosemite.* 1926.

# The Interaction of Light with Film

Most black-and-white roll and sheet film has six separate layers, as shown below: (1) the *top coat,* a protective layer of hard gelatin to prevent scratches on the emulsion; (2) the *emulsion,* a layer of gelatin containing light-sensitive crystals of *silver halides,* which, during development, turn black in proportion to the amount of exposure they have received; (3) the *subbing,* a special glue-like gelatin that adheres the emulsion to the support; (4) the *support,* a strong but flexible transparent plastic; (5) a *second subbing* layer; (6) the *antihalation backing,* a coating (absent from some special-purpose films) that contains dye (dissolved by fixer during the development process). The antihalation backing prevents light from reflecting off the support or the camera itself and back through the film during exposure because such reflections would reduce the sharpness of the image. The top coat and the antihalation backing are the same thickness in order to minimize curling of the film when it is dried after processing.

*Photography is the product of a reaction between light and the silver halide crystals present throughout the emulsion layer of film.* As shown in the second diagram, each silver halide crystal is a combination of silver and bromide ions held together by electrical charges as well as free silver ions and irregularly shaped particles called sensitivity specks.

The reaction that produces a photograph takes place when a submicroscopic crystal, as shown in the next diagram, is struck by as few as two of the photons of light passing through the lens to the film. The reaction of many photons with many silver halide crystals produces a *latent* (that is, invisible) image in exposed film. When film is developed, chemicals react with the film emulsion. In the reaction process the metallic silver specks of the latent image act as hooks to which the rest of the silver becomes attached. By these chemical processes the negative, the transparent image from which photographic prints are made, is formed.

Where a photographic negative is dark, the exposure and development process have converted millions of light-sensitive crystals into metallic silver. Dark areas of the negative are actually dense with blackened silver; the darkness and density are proportionate to the amount of light that struck the silver halide crystals in that area of the film. Because of the density of metallic silver, the passage of light is blocked through that portion of the negative. You can see this by holding a developed negative up to the light. Where more light passes through the negative, little or no silver is present. These areas of the negative have less metallic silver in them.

Light and film interact in the same way in all types of film—both black and white and color. (Color film is discussed in Chapter 13.) Black-and-white film now exists in many types, each of which can be distinguished according to six basic characteristics: color sensitivity, contrast, light sensitivity, grain, resolving power, acutance. □

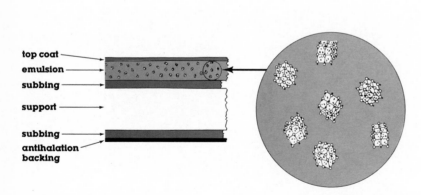

Black-and-white film consists of six layers, together measuring about .005 inch (.127mm) in thickness.

The second layer, the emulsion, is where the image forms when film is exposed to light. It contains hundreds of thousands of microscopically small light-sensitive silver halide crystals.

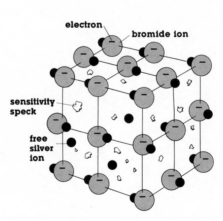

Each silver halide crystal in a film's emulsion layer consists of electrically charged atoms of silver (small black balls) and bromide (large gray balls), called ions. The bromide ion has one more electron (black line) than an uncharged atom; this gives it a negative charge. The silver ion has one less electron than an uncharged atom; this gives it a positive charge. Negative and positive charges attract each other and thus hold the silver and bromide ions together. The emulsion layer also contains free silver ions, which are unattached to bromide ions, as well as many irregularly shaped particles called sensitivity specks.

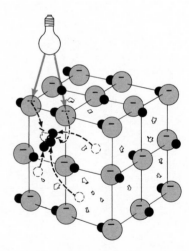

When photons of light strike a silver halide crystal, they cause the extra electrons in bromide ions to move until they reach a sensitivity speck. Then electrical attraction of their negative charges draws the positively charged unattached silver ions and the sensitivity specks into small clumps. The electrical charges in these clumps balance one another and react to form atoms of silver metal. These atoms are the latent image in film.

# Basic Characteristics of Black-and-White Film

**Kodak Commercial Film**

**orthochromatic film**

**panchromatic film**

**infrared film with red filter**

*The wedge spectrogram below each photo shows the color sensitivity of each film to various wavelengths in the electro-magnetic spectrum. The wavelengths from different parts of the visible spectrum had strong effects on Kodak Commercial, orthochromatic, and panchromatic film. The wavelengths from the invisible infrared part of the spectrum had the primary effect on the infrared film because of the red filter, which reduced the film's normal sensitivity to wavelengths from the visible part.*

## Color Sensitivity

**E**arly film had little *color sensitivity*—that is, ability to respond to certain wavelengths of light in the visible portion of the electromagnetic spectrum—and was therefore unable to represent the various tones of colors effectively in black and white. In other words, even though a photograph of a group of vegetables is in black and white, you should be able to tell by the shade, or tone, of gray that there is a distinct difference in color between a red tomato and a green pepper. The four photographs of a basket of vegetables, each made with a different type of black-and-white film, but with the same white background for contrast, illustrate the gradual improvement in color sensitivity of black-and-white film. The accompanying diagrams are *wedge spectograms,* which show the relative color sensitivity that each film has to light waves of various wavelengths in the electromagnetic spectrum.

The first photo was made with Kodak Commercial Film. This film is oversensitive to blue wavelengths, much as early photographic films were. The red tomato is the same tone as the green zucchini; there is also little or no difference in tone between the dark purple eggplant and the yellow squash next to it. The blue in the checked tablecloth is reproduced as a very light tone. Thus the picture does not really capture the various color tones of the objects.

The second photo was made with orthochromatic film (Kodak Tri-X Ortho), which was an improvement over earlier film because of a dye added to the emulsion. As indicated in the spectogram, this film is sensitive to green as well as blue, but is still insensitive to red. Thus, although the tone of the green zucchini is better differentiated from the tones of the eggplant and the squash, and the yellow squash next to the eggplant is lighter than in the previous picture, where they were almost equally dark, the red tomatoes are still abnormally dark. The overall appearance of this photograph is not so dark as the previous one, but the tones are still unnatural. Orthochromatic films were used for many years. Old snapshots made with this type of film have some bizarre tones, such as apparently black lipstick on women. Because this film makes skin tones look dark and rugged, it is still sometimes used for portraits of men.

The third photo on page 99 was made with newer panchromatic film (Kodak Super-XX), which is sensitive to the wavelengths of all colors. Consequently, the print has more natural and subtle tones than the previous two.

The last photo was made with infrared film (Kodak Infrared), which is sensitive to invisible ultraviolet, visible blue and red, and invisible infrared radiation. A red filter was used to reduce the film's sensitivity to visible light rays and, as a result, its exposure is primarily by the infrared radiation from the objects in the scene. Though infrared radiation consists of lightwaves slightly longer than those for red, infrared waves do not behave the same way as the waves of the visible spectrum. Objects radiate varying amounts of infrared energy. Synthetic ones, such as buildings, generate very little radiation and therefore appear dark in pictures taken with infrared film. Natural objects, such as plants and the vegetables in the photograph, generate considerable radiation and thus appear very light, and even unreal, in photographs, because a great deal of infrared light exposes the film. Because of infrared film's sensitivity to natural objects, it has practical applications; for example, the armed forces use it to detect camouflage, and conservationists use it to survey trees. It is also popular with photographers who like its unusual effects. (See Chapter 12 for further information on infrared photography.)

100

**continuous-tone film**

*The image produced with continuous-tone film has a full range of gray tones, as well as black and white. The image produced with high-contrast film has no tones of gray—only black and white.*

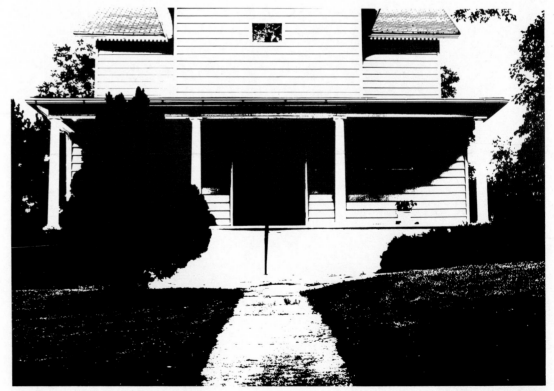

**high-contrast film**

## Contrast

The term *contrast* describes a film's ability to record distinctions in value, from deep black through degrees of gray to white. In black-and-white photography, all elements of form, color, light, and texture are registered on film as variations in value or degrees of lightness and darkness. Such variations are created by the original lighting of a scene or subject. Films that record a wide range of tones are called *continuous-tone films.* Some of these continuous-tone films have a longer tonal range than others. Films that record a very limited number of values are called *high-contrast films.* Very-high-contrast film such as litho film (Kodalith, an Eastman Kodak product) records only black and white tones. A high-contrast film is normally used by printers to copy printed materials and to make negatives for black-and-white photomechanical reproductions. Also, the very sharply delineated images this film gives are sometimes desired by photographers for certain effects that cannot be achieved with the full range of tones produced by ordinary film.

The way high-contrast film images differ from continuous-tone film images is shown on the opposite page.

*High-contrast film gives this winter scene an overall feeling of starkness and coldness.*

101

J. SEELEY. *Trees and Fence.* 1969.

*Light Sensitivity*

**D**ifferent films have different degrees of *light sensitivity,* determined by the size of the silver halide crystals in a film's emulsion. The larger the crystals, the greater the sensitivity, and vice versa. A film's light sensitivity is indicated by its ASA number, established by the American National Standards Institute (formerly American Standards Association), which tests films. (The European counterpart is the DIN number, for Deutsche Industrie Norm.) Each time the ASA number doubles, the speed of the film doubles, so that a film of 200 ASA is twice as fast as a film of 100 ASA. The major classifications of film speed, by average ASA (and DIN) ratings:

- *slow films:* 100 ASA or less (21/10 DIN); require a high light level

- *medium films:* 100–200 ASA (21/10 DIN–24/10 DIN); the most commonly used in average or normal light situations, such as outdoors on a sunny day
- *fast films:* about 200–400 ASA (24/10 DIN–27/10 DIN); needed when the light level is low—for example, on a very cloudy, rainy day or indoors under available light—or when a fast shutter speed is required to stop action
- *extra-fast films:* 400 ASA and up (27/10 DIN); used only when the other types of film are too slow—under the dimmest light conditions or when the fastest possible shutter speeds are necessary

The table below lists the speeds of black-and-white films currently available. (Sheet films are discussed in Chapter 11, color films in Chapter 13.)

The manufacturer's assigned ASA number is not an absolute for a film; the actual speed may vary, depending on your methods and equipment. In addition, manufacturers are usually conservative when assigning ASA numbers, because they feel that slight overexposure is less of an evil than underexposure. In other words, many films carry a slightly lower ASA number than they might; they are slightly more light-sensitive than the assigned ASA number indicates. Moreover, the ASA can be altered in processing the film by manipulating variables such as temperature of solutions, developing time, type of developer, and method of agitation. These methods are discussed in Chapter 6.

The light sensitivity of film can also be manipulated even before the developing procedure by "pushing" the film. Pushing means deliberately assigning the film a higher

**common varieties of black-and-white roll and cartridge film**

| speed | ASA | size |
|---|---|---|
| **slow** | | |
| Adox KB-14 | 20 | 35mm |
| Adox R-14 | 20 | 120 |
| Adox KB-17 | 40 | 35mm |
| Adox R-17 | 40 | 120 |
| Agfapan | 100 | 120, 35mm |
| Ilford Pan F | 50 | 35mm |
| Kodak Panatomic-X | 32 | 120, 35mm |
| H & W Control VTE Pan | 50 | 120, 35mm |
| H & W Control VTE Ultra-Pan | 16 | 35mm |
| Agfapan | 25 | 120, 35mm |
| **medium** | | |
| Adox KB-21 | 100 | 35mm |
| Adox R-21 | 100 | 120 |
| Agfa Isopan ISS | 100 | 120, 35mm |
| Ilford FP 4 | 125 | 120, 35mm, 126 cartridge |
| Kodak Plus-X Pan | 125 | 120, 35mm |
| Kodak Verichrome Pan | 125 | 120, 110 cartridge, 126 cartridge |
| Fujipan K 126 | 125 | 126 cartridge |
| Neopan SS | 100 | 120, 35mm |
| Luminos Lumipan | 100 | 120, 35mm, 126 cartridge |
| **fast** | | |
| Agfa Isopan Ultra | 200 | 120, 35mm |
| Ilford HP 5 | 400 | 120, 35mm |
| Kodak Tri-X | 320 | 126 cartridge |
| Kodak Tri-X Pan | 400 | 120, 35mm |
| Neopan SSS | 200 | 35mm |
| **extra fast** | | |
| Agfapan | 400–2,000+ | 120, 35mm |
| Kodak Royal-X Pan | 1,250 | 120 |
| Kodak 2475 Recording | 1,000–3,200+ | 35mm |
| **special-purpose black-and-white films** | | |
| Kodak High-Contrast Copy | 64 (tungsten) | 35mm |
| Kodak High-Speed Infrared | varies | 35mm |
| Kodak Kodalith Ortho Film | 8 (tungsten) | 35mm |

*Portions of three 35mm negatives greatly enlarged (20×) to show differences in grain with different speeds of film. With extra-fast film, the features are virtually obscured. With fast film, the skin looks rough. With slow film, the image is clear and well defined, with very little grain.*

**extra-fast film—1000 ASA**

**fast film—400 ASA**

**slow film—32 ASA**

exposure rating than that assigned by the manufacturer. Tri-X film, for example, can be pushed from 400 ASA to 800 or 1200 ASA. (The usual procedure is to double or triple the ASA setting on the light meter.) Pushing does not alter the actual light sensitivity of a film, of course; it simply results in underexposed film. This must be compensated for when the film is developed. Thus, when using roll film, the entire roll must be pushed and not just one exposure. Although pushing film tends to result in grainy negatives with loss of detail and excessive contrast, it is often the only way to take pictures when there is not enough light.

If you use commercial film processors, remember to tell them if you have made an adjustment in the ASA. Otherwise, your film will be processed for its normal ASA rating, and the results will be inaccurate.

*Grain*

In addition to speed, the size of the light-sensitive crystals in a film's emulsion (along with the type of developer, print size, and the distance between viewer and print) determines the nature of its *grain*. Grain is the textural quality of tones in a print, produced by the clumping together of microscopic particles of silver during development. To the viewer's eye the grain of a photograph may be so fine that it is imperceptible or so prominent that it looks coarse. A fast film, though highly sensitive to light, is considerably grainier and hence renders less sharply defined detail than a slow film. When choosing the best film for a particular situation, then, you should consider not only whether it will give satisfactory exposure under the conditions of available light but also the grain of the image it will create. Unless you specifically want a grainy image, it is usually best to buy the slowest possible film for the anticipated light conditions. Since it is impossible to obtain both maximum speed and the most sharply defined detail, for general-purpose photography photographers often compromise between speed and grain by using a medium-speed film.

The photos clarify the relationship of speed and grain. The same subject is shown photographed with three different kinds of film: an extra-fast, grainy film; a fast, moderately fine-grain film; and a slow, fine-grain film. A comparison reveals differences in the qualities of each film. The extra-fast film

103

gives the face a mottled, indistinct appearance and makes the smooth skin seem rough. The image lacks sharpness because the grain obscures fine detail. The slow film produces a very clear image with little grain, while the visual quality created by the fast film falls midway between the two extremes.

The less a negative is enlarged—that is, the closer in size the prints made from a film are to the size of the negatives—the less the grain will be noticeable. With small film sizes like 35mm, the negatives require such extreme enlargement, even to make fairly small prints, that grain may interfere with the clarity of the image. The poor quality of the enlargement of a child's face illustrates this point.

Sometimes a beginning photographer tries to create an image by isolating and enlarging what seems to be a promising portion of a negative. Unfortunately, this often makes prints of poor quality because of the grain, which is too pronounced in overmagnification. It is usually better to spend time on creating the images you want before exposing the film.

Nevertheless, extreme graininess is sometimes deliberately produced. For the photograph of the nude, made with a subminiature camera (Minox) loaded with fast film, the photographer composed the picture in such a way that the figure occupied only a small portion of the tiny negative. The combination of grainy film and drastic enlargement produced the heavily textured image the photographer wanted.

104

Top: *The overall print is not grainy, but the child is too far away for a portrait.* Center: *When the negative was enlarged enough to make a portrait, there was so much grain that the face looks textured and the features are indistinct.* Right: *When the camera was moved closer to the child, a sharp portrait with very little grain was the result.*

**distance photo**

**enlargement**

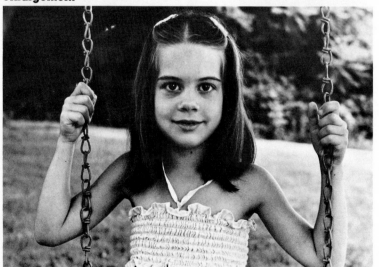

**closeup photo**

*Grainy texture can serve aesthetic purposes. This photograph was much enlarged intentionally.*

CHARLES SWEDLUND. *Untitled.* 1960.

## Resolving Power and Acutance

**T**he *resolving power* of a film is its ability to distinguish between closely spaced lines. Resolving power is usually determined by photographing a chart of parallel lines, ranging by degrees from rather far apart in some areas to very close in others. At some point on the negative the lines can no longer be distinguished as lines, but run together as a tone of gray. This point is the resolving power for a particular film.

The term *acutance* describes the image sharpness of a film. It is gauged by placing a knife edge on film, then exposing and developing it. The silhouette of the knife edge on the negative is examined with a microscope. Because light scatters when it strikes the silver halides in film emulsion, there is always some gray between white and black areas. The narrower this gray area is, the higher the acutance. In general, slower films have higher acutance and resolving power and therefore produce sharper images. □

The quality of the negative you will get depends largely on how you expose your film. The amount of black silver that forms in various areas of a negative, or what is termed the *density* of a negative, is basically proportional to the intensity of the light that strikes the film during exposure. A properly exposed negative has an ample deposit of black silver particles in its emulsion and therefore has good density. An overexposed or "thick"

negative has too much density; an underexposed or "thin" negative has too little.

The relationship between exposure and density of a specific film can be shown graphically by its *characteristic curve*. This curve is often called the *H & D curve* (named for F. Hurter and V. C. Driffield, who did the initial research in this field in the 1890s). It is used to show contrast variations in a particular film as a result of changes in

exposure and development and also contrast and sensitivity among films generally. The negatives opposite illustrate the relationship between degree of exposure and density shown on the curve. The twenty-three different exposures range from very little exposure (1/1024 of normal) through normal to a great deal of exposure (4096 times normal). For comparison, the unnumbered first and last exposures are normal.  □

The H & D curve. *The vertical scale indicates the deposit of silver—the density of the negative. The horizontal scale indicates the degree of exposure. On the exposure scale, each number from 2 through 23 represents twice the exposure of the previous number. Between points 1 and 4 on the curve an increase in exposure produces no change in density; between points 4 and 8 there is a slight change. The part of the scale between 1 and 8 is called the* toe. *From 8 through 16 the curve rises in direct proportion to the increase in exposure. After point 16, an increase in exposure fails to increase the density of the negative at the same rate, and the curve begins to level off to form the* shoulder *from points 16 through 23.*

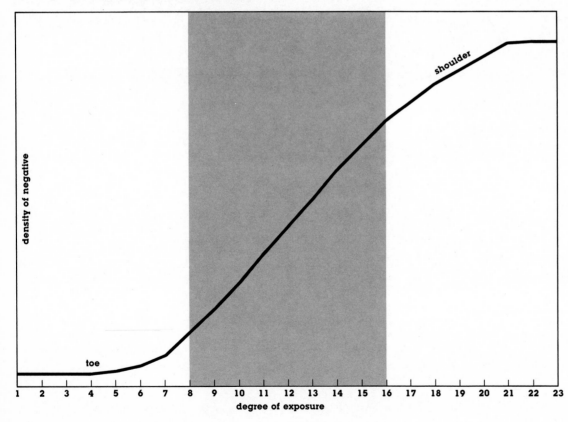

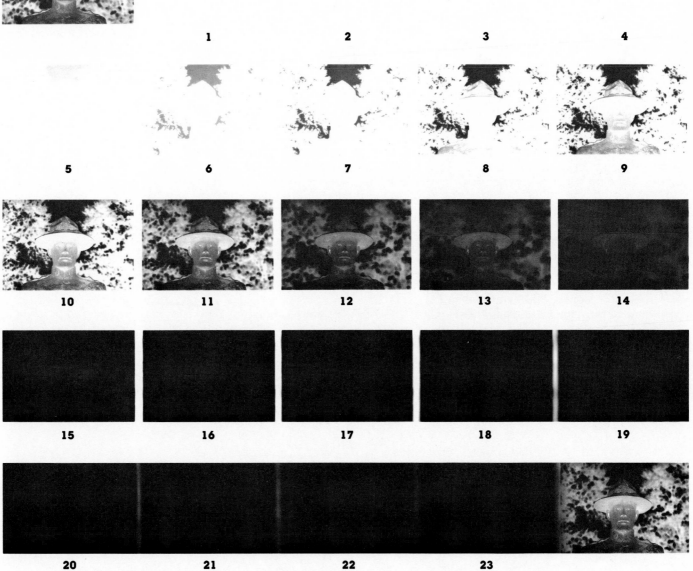

**1** **2** **3** **4**

**5** **6** **7** **8** **9**

**10** **11** **12** **13** **14**

**15** **16** **17** **18** **19**

**20** **21** **22** **23**

*These negatives show the effects of different exposures, from underexposed (thin) negatives with little blackened silver to overexposed (thick) negatives with much blackened silver. A densitometer was used to "read" the density of each negative at the face of the statue. These densities were then plotted on the graph to produce the curve shown. Before and after certain points in the series changes in exposure have little effect on negative densities. These negatives fall in the toe and shoulder of the curve.*

All film is perishable; after a certain period of time, its components break down, causing the film to lose quality and speed. Usually, "surplus bargains" should be avoided, since film on sale is often out of date. Excessive heat and moisture are especially detrimental to any film. If you have a large quantity of film, storing it in a freezer ensures maximum preservation, but it cannot be used until it has been completely thawed for several hours. While it is thawing, leave the original wrapping intact to prevent moisture from condensing on the film and ruining it. Film also keeps well in the refrigerator, where the temperature is low enough to aid in preservation but high enough so that it needs warming for only half an hour to an hour.

## Loading and Unloading 35mm Roll Film

**L**oading and unloading film in an adjustable camera is a simple procedure once you have done it a few times. Unless you bulk-load your own film (see the next page), the roll film you purchase will already be loaded onto a *film cassette* (a type of film cartridge), with one end of the film, the *film leader,* protruding from the cassette. The first step in loading a camera with a built-in light meter is to set the ASA rating according to the type of film you are using. Do it *first* and you will always remember to do it before you start shooting.

Open the back of the camera and place it face down on your lap or on a flat surface. Pull up on the film *rewind knob* (on the top lefthand side of the camera) so that the film cassette can be inserted into the *film chamber*. With the film cassette in place and the film leader facing toward the *takeup spool* on the righthand side of the camera, release the rewind knob to lock in the film cassette. Next, take the film leader gently between your fingers and pull it across the threading sprockets, toward the takeup spool. Slide the film leader into one of the slots on the takeup spool and wind the film onto the spool by advancing the film several (3–4) turns of the film-advance lever. Be sure that the top *and* bottom sprockets are engaged and that the film is winding easily on the threading sprockets as it advances, as shown in the illustration. When the film is securely wound onto the takeup spool (it will be fairly taut against the shutter curtain), close the camera.

To make certain that the film is properly loaded, observe the rewind knob as you continue to advance the film several more turns to provide yourself with fresh (unfogged by light) film for your first picture. (The exposure counter should read "1" or "0," depending on the type of camera you are using.) *If the rewind knob turns as you advance the film, the film is properly loaded.* If it fails to turn, rewind the film until you hear a springing sound from inside the camera and feel less resistance. This will indicate that the film leader is disengaged from the takeup spool. *Do not continue to rewind the film or you will rewind the film leader inside the cassette.* If for any reason you are not certain that the film has been properly loaded, start the loading procedure over again. It's better to be too cautious than to lose an entire roll of pictures because your film was improperly loaded. To practice loading and unloading your camera, try using an old roll of film.

When you have come to the end of a roll of film and the film advance can no longer be moved easily, do not apply force. This resistance means that all the film has been exposed. To rewind the film, push the rewind button *in* or (with other cameras) move the switch from "A" for advance to "R" for rewind. Pull up on the film rewind knob and turn it clockwise. (You'll hear the film disengaging from the takeup reel.) Rewind the film leader *completely* into the cassette. You will know when this has happened because there will no longer be any tension in the rewind knob. You can now open the camera and remove the film cassette.

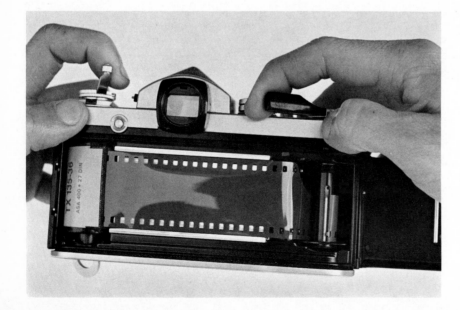

*After several turns of the film-advance lever at right, the film is engaged in both top and bottom sprockets.*

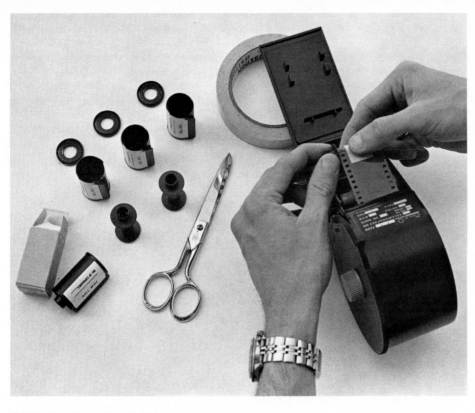

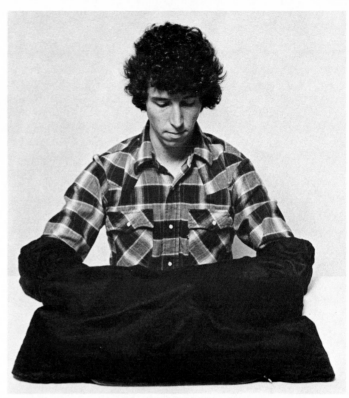

*Bulk-loading film requires a bulk-loader and reusable film cassettes, which are fairly inexpensive. Away from a darkroom, a changing bag must be used.*

### Bulk-Loading 35mm Film

**A**lthough most professional photographers do not bulk-load their film because they cannot afford to take the time to do so, bulk-loading is recommended as an option for those who have 35mm cameras and wish to take many pictures at the least expense. It is a fairly reliable procedure and can also come in handy if, for example, you want to make fewer than the twenty or thirty-six frames on commercial roll film. A bulk-loader, which can be bought for a very reasonable price, allows you to load bulk film onto cassettes. Most Kodak and Ilford black-and-white films, Kodak Ektachrome (color), and Kodalith and other high-contrast films are available in bulk quantities. Bulk film is available in 27½-, 50-, and 100-foot rolls, providing five, ten, and twenty 36-exposure rolls,

respectively. To bulk-load you also need reusable film cassettes, which can be bought at relatively low prices. These are *not* the same as the cassettes purchased already loaded, which are usually not reusable.

The bulk-loader has to be loaded in total darkness, either in a darkroom or in a light-tight *changing bag,* a sort of portable darkroom. The latter method is clumsier, but with practice it works well. Instructions for loading film onto the bulk-loader come with the loading device. A word of caution: the greatest risk with this method is accidentally exposing the film to light. *Be certain that absolutely everything—changing bag, darkroom, film cassettes—is lighttight throughout the process to avoid partially or completely exposing the film.* Once your film is in the bulk loader, film can be loaded into the cassettes with the lights on. □

Filters work by absorbing—that is, excluding—certain light rays. A filter, which is made of glass, sheet gelatin, or acetate in various colors and densities, is placed in front of the lens. To attach a filter to the lens, screw an adapter ring into the threads on the front part of the lens, place the filter in the adapter ring, and hold it in place with the lens hood. The lens hood is very important because without it the filter is not protected from extraneous light, which often produces glare. If a lens hood is not available, you may use your hand or, better, a

piece of black paper to shield the filter during the exposure. But be careful not to let it vignette the picture.

Filters come in different sizes. The size designation of a filter derives from its diameter; a number 4 filter is smaller than a number 8 filter. A filter must physically and optically match the lens it is intended to supplement. In certain situations, a filter may suit a lens in diameter, yet be too small to cover the lens completely. The result is a vignetted image. To avoid this problem, carefully check the information given by filter

manufacturers, consult the salesperson, and test the filter-lens combinations suggested.

With large-format cameras, some photographers remove the lens board from the camera and tape a gelatin filter to the back of the lens board with black masking tape. The filter must be taped flat to prevent internal reflections. The lens board with the attached filter is then replaced, and the exposure is made. This method is inexpensive: no adapter ring or filter holder is necessary; and it prevents glare that may occur when a gelatin filter is used in front of the lens.

110

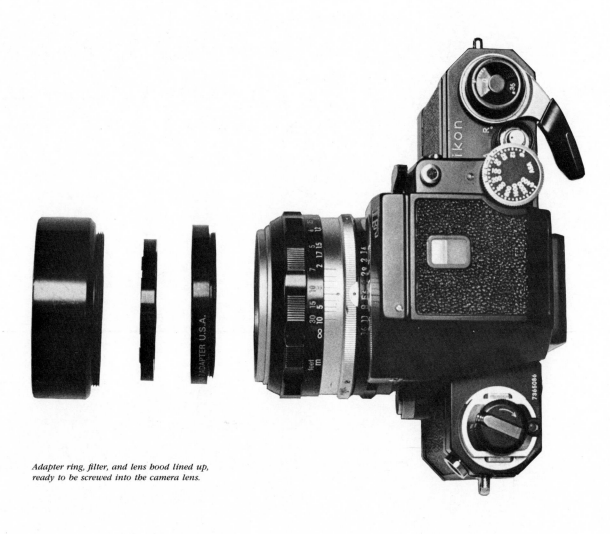

*Adapter ring, filter, and lens hood lined up, ready to be screwed into the camera lens.*

A vignetted image produced by a filter the wrong size for the lens.

## color wheel

*Colors opposite each other are* complements. *Larger type: primary colors. Smaller type: secondary colors. (Cyan: bluish green. Magenta: purplish red.) Color is discussed in detail in Chapter 13.*

### Correction and Contrast Filters

Correction and contrast filters alter the tonal rendition of a scene by decreasing or increasing the amount of light waves of a specific color that reach black-and-white film. When too much of a certain color reaches the film (in relation to other colors), objects of that color become overexposed, and they look lighter in a black-and-white photograph than they do to your eyes. When too little of a specific color reaches the film (in relation to other colors), objects of that color look darker than they look to your eyes. Filters correct such situations by modifying the value relationships in a photograph.

The filter colors most typically used for correction and contrast in black-and-white photography are yellow, red, orange, green, and blue. Each filter color absorbs light waves of its opposite color, its *complement,* and usually also colors near the complement (see the color wheel). Red absorbs blues and greens; yellow absorbs blue; blue absorbs

red, yellow, and green, etc. When a yellow filter is used in photographing a blue sky, it absorbs many of the blue lightwaves. Thus fewer of them reach the film and the sky is lighter in the negative, making it darker in the print. A general rule that is helpful in remembering the effect of filters is: in the print, a filter darkens its complement and lightens its own color.

A *correction filter* controls light in such a way that film renders colors in the value relationships that human vision accepts as normal. The panchromatic film we now have is designed to be sensitive to all visible colors. Nevertheless, it is actually more sensitive to the shorter wavelengths of cool colors, such as blue, than to the longer wavelengths of warm colors, such as red. In daylight, blue light rays dominate, while in artificial light from a tungsten source (a light bulb), red light rays dominate. Panchromatic film is "corrected" to compromise between sunlight and artificial light, so that it can be used in either light without any filter, but filters

**no filter**

**red filter**

*The diagram explains the photograph taken with the red filter. The filter absorbs its complement, green, which does not reach the film; thus the green clothes appear darker in the print. The photograph also shows how a filter appears to lighten its own color; the woman's red clothes are lighter with the red filter than with no filter.*

112

further improve its tonal renditions. Outside, a light-yellow filter corrects the dominance of blue and thus prevents the sky and other blue subjects from being overexposed and looking washed out in the print. Indoors, if you want a truer tonal rendition with panchromatic film, you can use a green correction filter. This absorbs some of the dominant red and thus prevents red-toned objects from looking too light in the print.

A *contrast filter* controls light in such a way that different colors have strongly contrasting tonal values. In other words, contrast filters cause specific colors to be rendered either lighter or darker.

Two photographs of a man dressed in green and a woman dressed in red are shown. The first photo was taken with no filter. The tonal values of green and red are not very different. For the second photo, a red contrast filter was used, and here the green-dressed man's clothes are definitely darker.

The photographs of a white building against a blue sky with white clouds show how a filter can change one tone in a picture without affecting another. The first photo was made with no filter. The sky is light gray, with little separation between it and the clouds. For the second photo, a yellow filter was used, and the sky is darker, with separation between it and the clouds, but the tonal value of the white building remains unchanged.

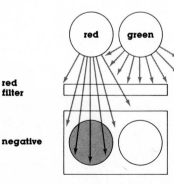

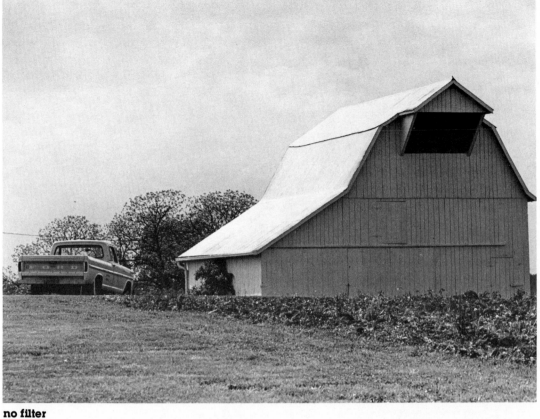

**no filter**

The diagram explains the photograph taken with the yellow filter. The filter absorbs its complement, blue, which does not reach the film; thus the blue sky appears somewhat darker in the print. The filter does not affect the white barn.

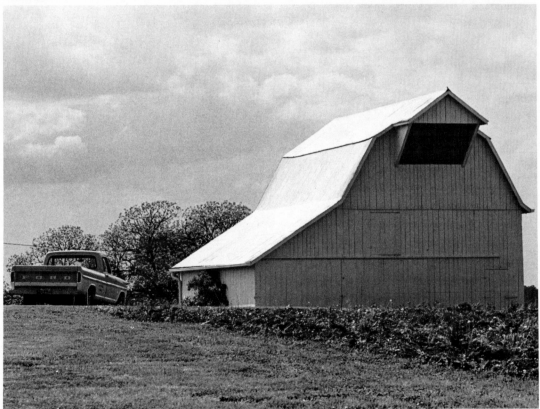

**yellow filter**

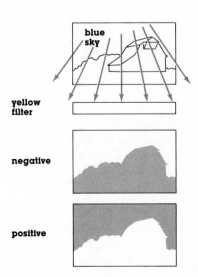

blue sky

yellow filter

negative

positive

When you look at a hazy landscape, the haze reduces the contrast among objects. Yellow, deep yellow, and red filters, which increase contrast, help reduce atmospheric haze in photographs. Often they are especially useful with long-focal-length lenses (see page 91), since the more distant the landscape, the more likely it is that haze will interfere with the photograph. For extremely hazy conditions, you may need to use infrared film with a red filter; this is because infrared waves, unlike visible light waves, are not dispersed by smoke or water particles in the air. The photographs show how infrared film with a red filter penetrates haze. (For further discussion of infrared photography, see Chapter 12.)

The table below lists the color filters that produce certain effects in some of the most common landscape situations. The specific names and numbers—Wratten 8, Wratten 15, etc.—refer to Kodak-manufactured filters.

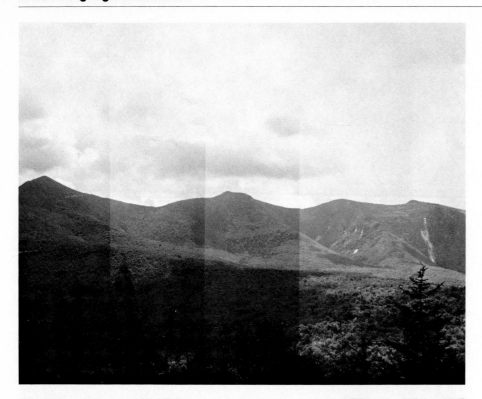

Top: *This photograph was taken on a hazy day, using panchromatic film with no filter. This test print was made in a sequence of different exposures to see which printing exposure might produce acceptable contrast. In the lightest strip at right the sky is featureless. Even in the darkest strip, though the sky is slightly darker, it still lacks detail, and the trees and shadows in the foreground merge in darkness. Thus even if a print is made darker, it cannot show detail that haze has kept from the negative. Above: This photograph was made at the same time, but with infrared film and a red filter. The atmosphere is dramatically clarified: there is definite contrast of sky and clouds. But the trees look strangely light.*

### filters for landscape photography

**clouds against a blue sky**

| | |
|---|---|
| *most accurate rendition* | yellow (Wratten 8) |
| *sky darker than natural* | deep yellow (Wratten 15) |
| *sky very dark* | red (Wratten 25) |

**water and blue sky**

| | |
|---|---|
| *most accurate rendition* | yellow (Wratten 8) |
| *darker than natural* | deep yellow (Wratten 15) |

**landscape**

| | |
|---|---|
| *most accurate rendition* | yellow (Wratten 8) |
| *reduction of haze* | deep yellow (Wratten 15) or red (Wratten 25) or UV |
| *elimination of haze* | infrared film with red (Wratten 25) |
| *accentuation of haze and fog* | blue (Wratten 47) |

**foliage**

| | |
|---|---|
| *most accurate rendition* | yellow (Wratten 8) |
| *lighter than normal* | dark yellowish green (Wratten 13) |
| *darker than normal* | red (Wratten 25) |

**beaches, snow**

| | |
|---|---|
| *natural with texture* | yellow (Wratten 8) |
| *enhanced texture* | deep yellow (Wratten 15) or red (Wratten 25) |

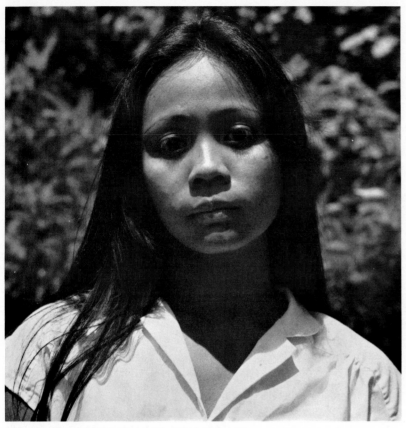

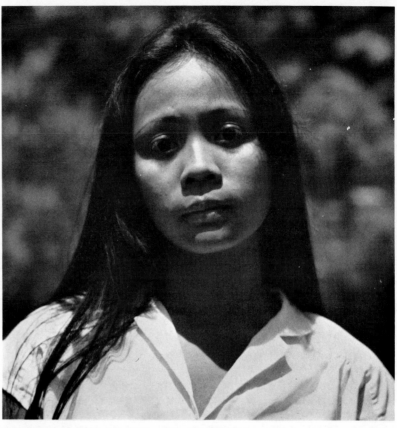

*With a fast film and bright light, depth of field could not be limited enough, and the background is distracting.*

*A neutral-density filter cut the light, making a more limited depth of field possible.*

### Neutral-Density, Polarizing, and Ultraviolet Filters

**N**eutral-density, polarizing, and ultraviolet filters have no inherent color, but they help the photographer realize the most out of certain types of photographic opportunities. Neutral-density (ND) filters reduce brightness generally. Polarizing filters absorb glare, thereby clarifying imagery and darkening skies. Ultraviolet filters help to cut through atmospheric haze.

A *neutral-density filter* absorbs the light rays of all colors. These filters, which look gray, are available in a graduated range of strengths (.10 ND, .30 ND, .60 ND, .90 ND, and so on, up to 4.0). For both color and black-and-white film they reduce the amount of light of all wavelengths entering the lens. The stronger the filter, the more light it ab-

sorbs. ND filters are useful when you have to photograph in bright light with fast film. In this situation, the camera's shutter and aperture systems may not be able to control the brightness enough to prevent overexposure. A neutral-density filter of the appropriate strength absorbs enough of the extra light to correct this.

A neutral-density filter can also be used to limit depth of field when you cannot do it by using a slower film or increasing aperture. If your camera is loaded with medium-speed film, on a bright day you may not have a shutter speed fast enough to compensate for the aperture needed to restrict depth of field. An ND filter limits the light reaching the film enough to allow you the wide aperture you need, while at the same time preventing overexposure. Neutral-density filters are sometimes used to photograph

*When the axis of a polarizing filter is properly positioned at a right angle to the single direction of polarized light, the glare cannot pass through.*

116  *Glare from plate glass obscured the mannequins inside the window.*

*A pola filter blocked most of the glare but let all other lightwaves into the camera to record the mannequins clearly.*

architecture on a busy street because they allow exposures so long that only stationary objects are recorded. They also permit long exposures in bright light, to blur motion.

The light in reflections from glass or water, though not from metal, is *polarized;* that is, lightwaves in such reflections are oriented at one angle rather than many angles. This creates *glare.* Polarized light, or glare, can be controlled by a *polarizing filter,* usually called a *pola filter.* Such a filter looks transparent but actually contains parallel submicroscopic crystals, aligned like the pickets in a fence. You turn the filter until it absorbs—blocks—the single-angle waves of the polarized light. Since the properly adjusted pola filter blocks only the waves arriving from one angle, all other lightwaves pass through to reach the film. With a pola filter you can photograph through glare on glass and photograph water plants when glare from the water would otherwise make it impossible.

To use a pola filter, hold it up and look through it, rotating it until the glare disappears. Then place it on the lens, being careful to keep the orientation exactly the same as it was when you adjusted it. With a single-lens reflex or view camera, you can see the effect through the lens, so you can attach it to the lens before you adjust it.

The *ultraviolet filter* (UV) penetrates haze by allowing invisible ultraviolet waves reflecting off objects in a landscape to pass through the lens and improve the image on the film. Since the UV is a clear filter, it can be used for both black-and-white *and* color photography and requires no additional exposure. Some photographers place a UV filter permanently over their lenses, because if the UV filter is scratched it can be replaced easily, saving the lens from damage.

## Exposure Compensation for Filters

**A**ll filters absorb a specific portion of the light reflected from a subject. Thus any filter (except the UV) reduces to some degree the brightness of the image conveyed to the film by the filtered light. Therefore, when you add a filter to the lens, you need to increase the exposure to be sure that a sufficiently bright image will reach the film. The reduced exposure caused by the filter must be compensated for by slowing shutter speed, increasing aperture, or both. The degree of compensation needed is called the *filter factor.* Because filters differ in the amount of light they absorb, each has a different filter factor.

The filter factor is a number by which normal exposure must be multiplied in order to obtain correct exposure. Different light sources produce different color balances. Thus there are separate filter factors for daylight and for normal indoor (tungsten) illumination. The table below lists the most commonly used filters, with their filter factors for black-and-white film in daylight and normal indoor light. For example, a 2X filter factor means that compensation requires twice normal exposure. If normal exposure for a light situation is $\frac{1}{60}$ at f/8, a filter with a factor of 2X requires that exposure to be doubled, either to $\frac{1}{60}$ at f/5.6 or to $\frac{1}{30}$ at f/8. As the table indicates, each increase of .30 in the strength of a neutral-density filter doubles the filter factor. The UV filter requires no increase in exposure.

The choice of slowing the shutter speed or expanding the aperture depends on the subject and the photographer's intentions. Usually, the most convenient modification is to change the f-number. The f-number increases given in the table show how many f-stops you need to increase the exposure to compensate for the filter. Thus, for a 4X filter factor in daylight you need to increase two f-numbers. If the normal f-number is 5.6, you need to increase it two f-numbers to 2.8. Most cameras with through-the-lens meters do not require exposure corrections because they automatically correct for the filter. ☐

*117*

### filter factors for black-and-white film

| filter | daylight | | tungsten | |
|---|---|---|---|---|
| | filter factor | f-number increase | filter factor | f-number increase |
| yellow (Wratten 8) | 2X | 1 | 1.5X | $\frac{2}{3}$ |
| dark yellowish green (Wratten 11) | 4X | 2 | 3X | $1\frac{2}{3}$ |
| red (Wratten 25) | 8X | 3 | 4X | 2 |
| deep yellow (Wratten 15) | 3X | $1\frac{2}{3}$ | 2X | 1 |
| blue (Wratten 47) | 8X | 3 | 16X | 4 |
| ND .30 | 2X | 1 | 2X | 1 |
| ND .60 | 4X | 2 | 4X | 2 |
| ND .90 | 8X | 3 | 8X | 3 |
| polarizing | 2.5X | $1\frac{1}{3}$ | 2.5X | $1\frac{1}{3}$ |
| ultraviolet | 1X | 0 | 1X | 0 |

Exposure is the amount of light that you allow to reach the film by controlling the variables of aperture and shutter speed. Light meters quickly, accurately, and conveniently measure light in almost any photographic situation and help you to determine the appropriate aperture and shutter-speed combination. The development of light meters and faster, more sensitive films makes it possible for contemporary photographers to use illumination from any direction—back, side, diffused through the atmosphere, or front. Light can also be used to produce many different aesthetic effects. For example, the silhouette on the opposite page was created by beaming intense light on a white background and photographing a nude figure against it.

Most black-and-white films have some exposure latitude built into them, but other films, such as color slide film, have practically none, making careful exposure more critical. Even the best film can register only some of the many different tones your eyes can see. Some tones, and therefore some detail, are lost in all photographs. Thus in every situation you have to choose between tones to emphasize and tones to neglect. Accurate measurement of light with a light meter tells you how to set the aperture and shutter to get both the best detail the film can register and the aesthetic effect you want.

Many modern cameras have built-in light meters, and the latest models have fully automatic ones. A number of photographers, however, prefer a handheld meter because of its greater accuracy and versatility. This chapter explains how to use many types of light meters to determine exposure in various lighting situations.

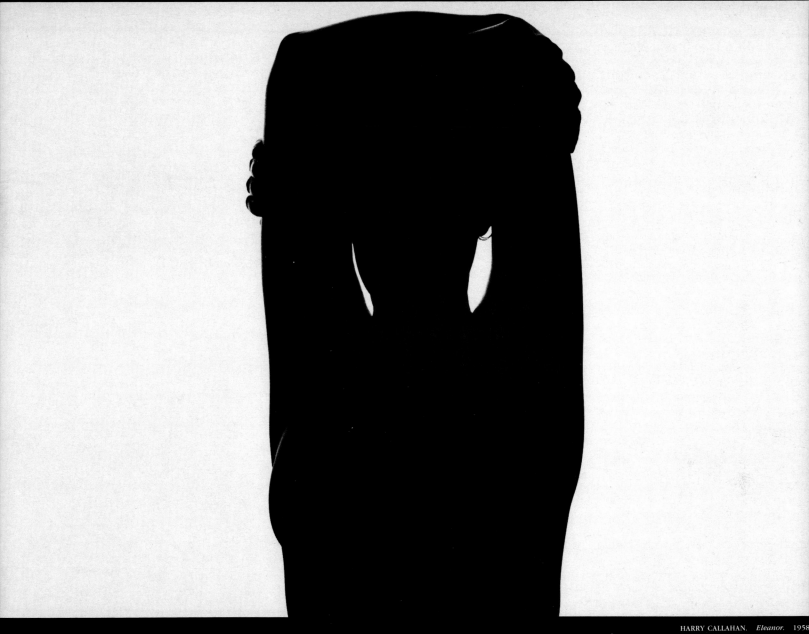

HARRY CALLAHAN.  *Eleanor.*  1958

Three negatives are shown to demonstrate differences in exposure. The first negative lacks detail in the areas that are shadows in the normally exposed negative. Underexposure produced a small range of tones between the light and middle shades of gray; the negative is thin, light, and featureless. The overall appearance of the negative is light, so that it is difficult to see the door at all. The normally exposed negative is rich in detail in the dark, middle, and bright areas; its separation of gray tones makes all the shadows and details visible. A print made from it would have a well-balanced appearance. The overexposed negative lacks detail in the bright areas of the scene (dark in the negative). The middle gray and light areas are poorly separated; the negative is thick, dark, and featureless. A print made from it would have an overall flat and "washed-out" appearance.

Over- or underexposing sometimes produces interesting aesthetic results. The standing subject on the opposite page was posed in direct sunlight, to receive an enormous amount of light. The figure seems to be glowing mysteriously. But in most situations of this kind—for example, photographing a bride in white—the stark-white effect would be far from welcome.

There is an old photographer's maxim: *expose for the shadows and develop for the highlights.* That is, if you must choose between over- and underexposure, it is better to overexpose to bring out the detail of the shadow areas than to underexpose, especially since most film has a higher tolerance for overexposure than for underexposure. In other words, it may be possible to correct for some degree of overexposure in printing the negative (see Chapter 8, page 220), but no printing technique can supply detail that is not in the negative, as the fourth photograph in the portrait series on page 131 shows.  □

120

**underexposed negative (negative print)**

**normally exposed negative (negative print)**

**overexposed negative (negative print)**

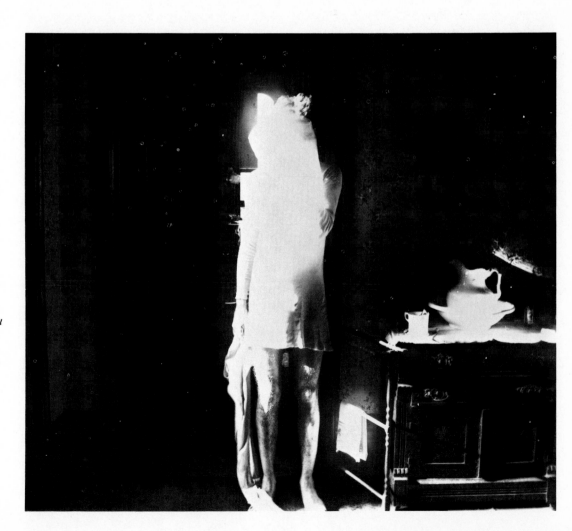

*Extreme overexposure of the area that was in bright sunlight produced this "ghost."*

In the early days of photography, a photographer had to develop each wet plate immediately after the exposure. If the exposure was unsatisfactory, the photographer could try again. Gradually, charts based on previous experience were developed and used with wet plates and then dry plates. The charts were not very reliable, however.

The development of the photoelectric cell finally allowed photographers to measure light and determine exposure accurately. The four common types of photoelectric cells are selenium, cadmium sulfide, silicon blue, and gallium-arsenic phosphide. When buying a light meter, it is important to know which type of photoelectric cell it uses, since each kind has advantages and disadvantages.

In a meter with a *selenium* cell, light produces an electrical current that causes a needle to move across a gauge. More light generates more current and pushes the needle higher. Selenium-cell light meters are accurate for most daylight situations but can be insensitive at low light levels.

The *cadmium sulfide* (CdS) cell is the type most often used today. This kind of meter, which works on a semiconductor principle, consists of a small battery in a series circuit with a gauge and the cadmium sulfide cell. When light strikes the cell, the resistance in the circuit changes and affects the gauge. This type of meter requires a battery, but it is considerably more sensitive to low light than the selenium-cell meter. The

CdS cell does, however, have a tendency to read low-light levels slowly and may take up to a few seconds to give an accurate reading. It also has a "memory," which means that you may have to wait for a minute or so to get an accurate reading when you go from a dark to a light situation or vice versa.

The *silicon blue* (Sbc) cell produces very low amounts of electricity. This cell has no "memory"—it reacts very quickly and sensitively to varying light levels. It, too, requires a battery.

The *gallium-arsenic phosphide* (GAP) cell, which also requires a battery, is quite similar to the Sbc cell, except that it is not especially sensitive to infrared radiation. The CdS and Sbc cells need special filters to prevent them from registering infrared radiation; the GAP cell does not.

All meters that use batteries are reduced in efficiency when cold, which may be a problem in winter. The life span of these batteries does not diminish gradually, but ends rather abruptly with no prior warning. Thus you should always carry an extra battery. You should also check batteries for corrosion, which could ruin your meter.

The different types of photoelectric cells are used in various types of handheld and built-in light meters. The three most commonly used handheld meters are *reflected-light meters,* which measure light reflected by (or "off") the subject; *incident-light meters,* which measure light falling on the subject;

and *spot meters,* which measure reflected light from a very small portion of the subject. Each of these three types has a different angle of coverage. Reflected-light meters cover an angle of from 30° to 50°, slightly less than the angle of a normal camera lens. Incident-light meters cover about 180°. Spot meters cover a very small angle, from 1° to 10°. Each type of measurement has advantages in particular situations, but reflected-light meters are used more often than the other two types.

Some handheld meters can be adjusted to measure both reflected and incident light. Others, generally the reflected-light type, are part of a system. With accessories they may be used to determine exposure for microscopic photography and electronic-flash photography and also while making prints. This type of system meter may also be converted into a spot meter or an incident meter.

Many cameras—such as the compact 35mm cameras and the filmpack Polaroids—contain built-in meters capable of automatically adjusting the camera for proper exposure. There are also many built-in through-the-lens meters in 35mm single-lens reflex cameras, with varying degrees of automatic features. Although built-in meters are becoming very popular because of their convenience, the handheld meter still gives the most flexibility. Whichever type you choose, familiarity with the meter and practice in using it are essential. □

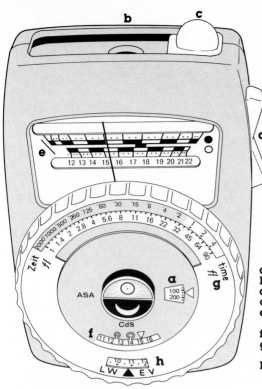

a **ASA speed indicator**
b **reflected-light opening**
c **incident-light diffuser**
d **high-low light-level switch**
e **light gauge (below: high level; above: low level)**
f **light scale**
g **shutter-speed aperture combinations**
h **EV exposure scale**

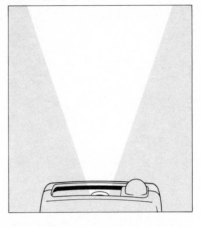
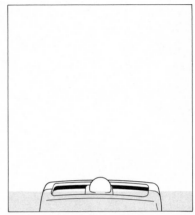

*To set an adjustable meter to measure reflected light, expose the light-admission opening. If read at close range, the 30°–50° angle of light is from a small area of the subject. To set the meter to read incident light, slide the "mushroom cap" light diffuser over to cover the light-admission opening. The meter now measures light coming toward the subject within a broad angle of about 180°.*

123

Different brands of light meters operate slightly differently, and it is important to read the manufacturer's instructions for a meter carefully. However, most meters work in essentially the same way; the adjustable meter in the diagram is fairly typical. The first step in using a light meter is to set the ASA speed indicator (a)—DIN in some meters—to the ASA (or DIN) rating of the film you are using (or the ASA or DIN speed you have chosen if you are pushing the film—see Chapter 4, page 102). The meter here is set on 125 ASA. As this is an adjustable meter, the second step is to set the adjustment for either reflected or incident (b or c) light.

Then, as shown in the two photographs on the following page, point the meter directly at the subject if you are measuring reflected light or point the meter in the general direction of the camera if you are measuring incident light. Next assess the general light condition and press either the high-level or low-level end of the switch (d)

on the side of the meter. This activates the light meter's measurement needle. Where it comes to rest on the light gauge (e) is the measurement of light, which you read against the high-level scale below or the low-level scale above (numerals now covered).

Next set the light scale (f) by rotating the dial on the face of the meter until the light measurement from the gauge is opposite the pointer. Setting the light scale causes the numbers (g) around the meter dial—one scale marked "time" for shutter speed and the other scale marked "f/" for aperture—to adjust in relation to each other. The paired numbers of the two scales are then aligned to show the various combinations of shutter speeds and f-stop numbers that will give the proper exposure.

In the diagram the high-level light measurement is between 15 and 16, and the light scale is set between 15 and 16. The resulting normal exposures range from f/1 at 1/2000 second to f/32 at 1/2 second. Any of the paired

combinations will produce the same exposure. Your choice of a combination will depend on the speed of movement, if any, of your subject; the depth of field you want (see Chapter 2, page 49, and Chapter 3, page 84); and the aperture and speed capabilities of your camera.

In addition to individual settings for aperture and shutter speed, some cameras have what is known as the *Exposure Value System.* This system simplifies the determination of aperture-speed combination, because it combines the f-stop number and the shutter speed into a single unit, ranging from 2 to 18 on the EV exposure scale (h). Under this system, 2 is a low reading, and each successive number gives half the exposure of the previous one. For example, EV 10 (Exposure Value 10) gives half the exposure of EV 9. Most light meters have an EV scale to give proper exposures for EV cameras. If your camera has the EV system, read the instructions carefully for most effective use. □

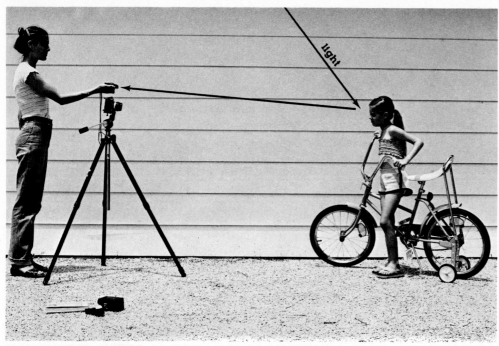

**measuring reflected light**

124

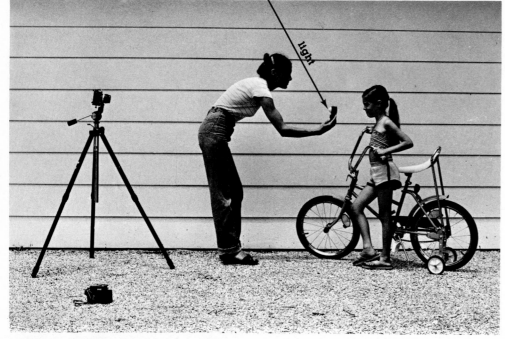

**measuring incident light**

*A Kodak Neutral Test Card, or "18 percent gray card," gives the average degree of reflectance of natural outdoor scenes.*

Different objects reflect different amounts of light. A white object reflects 90 percent of the light falling on it, but a black object reflects almost none, only 3 percent. In natural outdoor scenes all of the different colors of the spectrum, plus white and black, average out to an approximate 18 percent degree of reflectance. An urban scene with buildings often has a different average reflectance.

A reflected-light meter is designed so that when light reflected from areas in a scene is measured with it, it gives the speed and aperture combinations that will cause these areas to be rendered in the photograph as a particular tone of gray in the final print. This specific gray tone is called *18 percent gray*. A card of this gray value (opposite page) is available. Always keep in mind as you use a reflected-light meter that a portion of the area will be reproduced as 18 percent gray and that other tones will be lighter or darker in relation to that gray.

In the usual photographic situation, you are making a black-and-white photograph of a scene with many different colors. One of those colors will be rendered 18 percent gray in the final print and the other colors will be rendered as many subtle shades of gray. Because a reflected-light meter is designed to produce an exposure that will render any specific brightness in the scene as 18 percent gray, it will produce a reading that will result in gray off a black or white area in a scene. The simple scene used here to show this contains three main values— white railings and wall, gray steps, and black door. For the first photograph the meter was pointed at a white railing. The meter indicated an exposure that caused the white to be rendered as 18 percent gray—the white railings in the scene are gray in the photograph. When the reading was taken off the black door, it also turned into 18 percent gray. The print that most accurately reproduces the tonalities as they appear to the human eye is the third one. Here the reading was taken off the stairs, which actually were gray. The other tones in a photograph are determined in relation to the 18 percent gray area, which is why the railings now look white and the door black.

Thus where you point a reflected-light meter and how you interpret its reading are very important, as in the photograph by Dorothea Lange on the next page. Different ways to use reflected-light meters are discussed on the following pages. (Incident-light meters then follow.)

**reflected light measured from white railing**

**reflected light measured from black door**

**reflected light measured from gray steps**

125

DOROTHEA LANGE. *Andrew.* 1959.

*The glowing quality of the lightest tone, with its absence of detail, contributes to the striking quality of this photograph. Bright light fell on the child from the side and was reflected from his hands onto his face. A photograph like this can be made by taking a closeup reading off the shadowed face; this gives a normal skin tone in those areas and renders all other tones in relation to it. The background thus becomes black—in this case, particularly effective in setting off the subject.*

126

## Taking an Overall Reading

**T**aking an overall reading of the light in a scene is perhaps the simplest and most commonly used method of reading reflected light. Most reflected-light meters read about the same areas as a normal camera lens. Thus, in many circumstances, you can stand at the position from which you wish to photograph and obtain readings of various values in the scene by pointing the meter at various areas. The usual method for taking an overall reading is to point the meter at a portion of the scene which you wish to see as 18 percent gray in your final print. The most common error in using a reflected-light meter is inaccurate pointing. The meter can only read light from what it is pointed at. If you aim the meter too high—at the sky in a landscape for instance—your exposure reading for the sky will give you 18 percent gray sky and underexposed ground area. This is

*Afternoon light streamed from behind the photographer. Taking an overall reading is appropriate in such a situation, where there are no extremely bright or extremely dark tones.*

127

HARRY CALLAHAN. *Eleanor.* 1952.

**reflected-light meter pointed at sky**

**reflected-light meter pointed at ground**

shown in the first photograph of a cow standing in a field, which came from a negative exposed according to a reading taken from an extremely bright sky. The negative for the second photo was exposed according to a reading taken from the ground. Here there is full range of tones, and the cow in the field is sharply rendered. Because the meter reading for exposure of the first negative was taken from a very bright tonal value—the sky—the negative was underexposed.

Since reflected-light meters are designed to read gray, any reading from a source *brighter* than an average gray will produce an underexposed negative; a reading from a source *darker* than an average gray will produce an overexposed negative. When the

meter was pointed at the sky above the cow, it indicated an exposure of f/22 at $^{1}/_{500}$ of a second; pointed at the ground, it indicated f/11 at $^{1}/_{125}$ of a second. The difference between the two readings is four f-stop numbers. There are also four shades of difference between 18 percent gray of a standard gray card and an extremely bright sky. In the second photo the tonal value of the grass and the cow is approximately 18 percent. Comparing the gray value of these areas with a gray card shows that the negative used to produce that print was exposed to represent the true tonal values of the scene accurately. Reading from the ground by the overall-reading method was appropriate in this situation, because the scene did

not include any excessively bright or dark areas. In fact, green grass has a degree of reflectance of about 18 percent, roughly equivalent to an 18 percent gray.

The overall reading of the values in a scene is appropriate for any scene of medium tonal contrast and for many scenes where light is coming from behind the camera. In the photograph by Harry Callahan on page 127, for instance, the evenly diffused afternoon light came from behind the photographer and there were no very bright or dark tones. In situations of extreme tonal contrasts, however, an overall reading does not work well. For such scenes, averaging tonal values, discussed next, usually produces a more accurate exposure.

**W**hen there are extreme tonal contrasts, such as a black object surrounded by a white area, an overall reading tends to render either the white or black area as 18 percent gray, and the result is not realistic. A more accurate way to expose a scene of extreme tonal contrasts is to measure the bright and dark values in the scene separately and determine the exposure by averaging the measurements. If, for example, you get a meter reading of 18 in a bright area and 14 in a dim area, set the meter scale at 16 to get the speed and aperture combinations best suited for the whole scene. Averaging bright and dark values is necessary when photographing a small object of one tone against a large area of a contrasting tone.

The three photographs show the result of averaging bright and dark values. The subject is a man dressed in black standing against a white wall. First, the meter was pointed at the subject from the position of the camera. Following the exposure indicated caused the negative to be underexposed—the print is dark and lacks details in the shadow areas. Next, the reading was taken from the black

**reflected light measured from camera's position**

**reflected light measured from dark subject**

**averaged readings from light wall and dark subject**

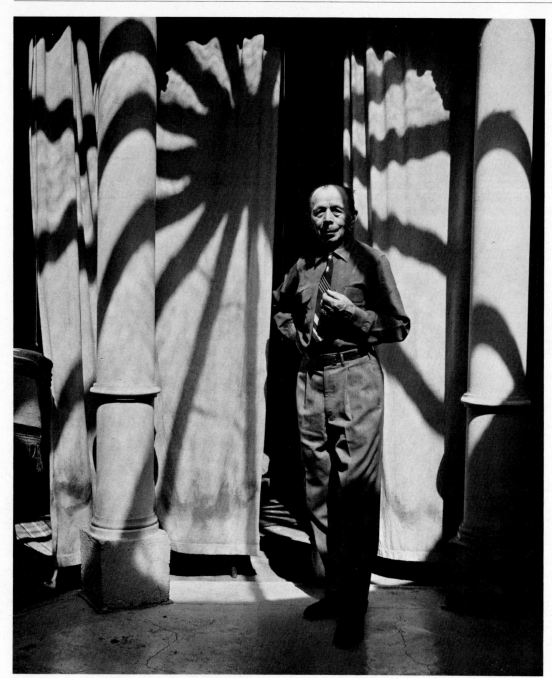

*A meter reading would not have been taken off the black area above the subject because this area was to remain black. But readings taken off the shadow area of the right-hand column and the brightly lit left-hand column could have been averaged to determine an exposure that would produce detail in both these areas, emphasizing the aesthetic pattern of the shadows.*

IMOGEN CUNNINGHAM. *John Winkler, Etcher.* 1958.

figure. This print is considerably lighter—in fact, too light, for it looks washed out. In the first example, the meter interpreted the large white wall area, considerably brighter than 18 percent gray. But the meter "saw" the wall as gray and indicated an exposure accordingly. Similarly, in the second photo, the black figure is rendered as an average gray.

Finally, the readings from the white wall and the black-clothed man were averaged. The resulting print, which shows detail in both light and dark areas, looks quite like the actual scene.

The averaging technique also works well in situations of contrasting light. It is important then to decide which tones should have

detail in a photograph and which should not. The photograph by Imogen Cunningham is a good example.

Another situation of contrasting light in which averaging tonal values can work well is when making a portrait of a subject lighted from behind. Backlighting, as this is called, can be very effective in portraiture,

for the soft-light quality of a face in shadow is attractive, and furthermore the sitter has no need to squint. However, because back-lighting usually results in more light behind the person than on the person's features, to obtain the effect you want, you need to plan exposures with care. A method of achieving satisfactory results is shown in the four photographs.

For the first picture, the light meter was pointed at the background; the result is that the background is well exposed, but the figure is recorded as a silhouette. Details of the face are lost, because the whole face area is underexposed. Next, since the difference in value between the flesh tones and 18 percent gray was slight, a reading was taken from the face. Now the face and figure are clearly defined and have a pleasing tonal quality, but they are in sharp contrast to the light, featureless background. As a compromise between the two extremes, readings from face and background were then averaged for the exposure for the third photo, in which both face and background are clearly defined.

Differences in tonal value can sometimes be corrected in the darkroom. As an experiment, the photographer made a much lighter print of the underexposed negative used to print the first image; the result is shown in the fourth photo. The technique obviously failed here—the print lacks both a proper range of tones and the soft quality shown in the third photo. Thus even though some correcting for exposure can be done in the darkroom, there are limits; this fourth photo shows that the tonal quality of a print depends primarily on the exposure.

The photographer in this case wanted the girl's features to be visible. On the other hand, deliberately exposing for background light can produce desirable silhouettes—see the photograph by Harry Callahan opposite the opening page of this chapter. The result you get in a particular photographic situation depends on how you wish to use the information the reflected-light meter gives you.

Sometimes there is no area or object in a scene equivalent to an 18 percent gray that you can use to determine a correct exposure. In these cases, you can use a reflected-light meter to take a number of readings of various parts of the scene, both brightly illuminated and shaded. Usually when the highest and lowest of these readings are averaged they produce a realistic exposure.

*131*

**reflected light measured from background**

**reflected light measured from face**

**averaged readings from face and background**

**lighter print from underexposed negative**

Several readings were taken before the photograph of the barn was made. The side of the barn in direct sunlight produced the highest reading (19 on the light gauge), while the grass in the shade gave the lowest (15). The average of the highest and lowest readings was used for exposure, with emphasis on "exposing for the shadows," that is, toward overexposure rather than underexposure. How far you should go in "exposing for the shadows" depends on how much contrast there is in the scene. The more contrast there is, the more most photographers expose for the shadows.

A quick and easy way to get an averaged reading is to hold an 18 percent gray card so it receives the same lighting as the scene and take a reading off it. This method is not as reliable as averaging the highest and lowest of several readings, since a specific scene cannot really be standardized. Different factors arise in different situations so that the averaged reading from a scene could be higher or lower than the average indicated by the gray card.

*Varying the Exposure
to Alter Specific Tones*

**T**he bright sand of a sunny beach scene is not equivalent to 18 percent gray—a meter reading from it would be quite high and would produce an underexposed negative. The result would be a beach apparently photographed on a dark day or in the early evening. An increase in exposure of two or three f-stops above the meter's recommended f-stop would help to overcome this problem. The reverse situation, darker than average—for example, a forest scene—would produce a low meter reading and an overexposed negative. The result would be a forest that looked light and gay instead of somber and dark. A reduction in exposure of one or two f-stops would help in this case.

*Varying the exposure to alter specific tones* means increasing or decreasing the f-stop in order to render a certain tone lighter or darker than 18 percent gray. The rendition of all the tonalities of objects in a scene is then also altered. For example, in portrai-

ture, the 18 percent gray meter reading obtained from a very light-skinned face produces a rather dark skin tone (like a suntan) in the picture. Though this skin tone may be accurate for some subjects, it will not be accurate for very light skin. To make the skin tone lighter, increase the exposure by one f-stop. But if a darker skin tone would be more accurate, decrease the exposure by one f-stop.

The first series of contact prints opposite shows how exposure variation changes the rendition of a black door with peeling paint. In the first print, when the meter was pointed at the black door, it indicated an exposure that reproduced it as gray. A one-stop decrease in exposure rendered a slightly darker gray in the second print. A two-stop decrease started to produce the true black in the third print. A three-stop decrease resulted in more black but left enough gray to show the texture of the door—the most realistic tonality. A four-stop decrease showed a black area but eliminated the textural detail of the door.

**reflected-light readings**

**from gray to black**

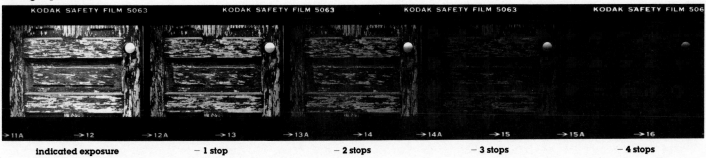

indicated exposure     − 1 stop     − 2 stops     − 3 stops     − 4 stops

**from gray to white**

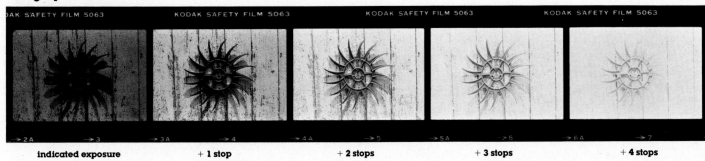

indicated exposure     + 1 stop     + 2 stops     + 3 stops     + 4 stops

A gray rendition may be changed the other way to white with increases in exposure, as shown in the second series. When the meter was pointed close up at a white wall for the first print, the indicated reading rendered the wall as gray. A one-stop increase in exposure produced a slightly lighter rendition. A two-stop increase lightened the wall considerably. A three-stop increase rendered the wall as white, while still maintaining detail—the most realistic tonality. A four-stop increase showed a white area with almost no detail.

Bear in mind as you decrease f-stops to get a darker tone or increase them to get a lighter tone in one specific area of a photograph, that you will affect the other tones in the scene accordingly. For this reason it is essential to alter only the most important and dominant element in the picture. The final decision about which tone is the most suitable for a particular picture is yours. In some cases your decision may be based on the desire for a realistic rendition, but in other cases you may have abstract or interpretive criteria in mind.

## Using Substitute Readings

In some situations, such as a parade or animals or birds in the wild, it is impractical to get a close enough meter reading. Take a substitute reading off the palm of your hand. Generally, a reading from the palm is about one f-stop brighter than 18 percent gray, and you will need twice the indicated exposure, but this factor varies with skin tone. The substitute reading should be considered average; the tonal range should be assessed before setting your exposure.

An 18 percent gray card may also be used for a substitute reading. It is commonly used in the studio, especially for determining the exposure necessary for copying, in photography-studio setups, and in balancing studio lights. In extremely dark situations, a white card with a 90 percent degree of reflectance (the reverse side of the 18 percent gray card is ideal) may be used for a substitute meter reading. However, the indicated exposure must be increased five times (two and one-third f-stops) to equal the one that would be obtained from a gray card. □

The incident-light meter measures the intensity of light falling on a subject. Unlike the reflected-light meter, it is pointed *away* from the subject (see illustration on page 124), so that the light striking the exposure meter is the same as that striking the subject. Most incident-light meters can accept an attachment enabling them to measure reflected light as well.

With a reflected-light meter, direct light enters the light-admission opening to strike the light-sensing cell in much the same way as light enters a normal camera lens. However, the incident-light meter is equipped with a shell-like diffuser over the meter opening which diffuses light as it passes to the sensing cell (see illustration on page 123), just as light falling on the subject is diffused. This device enables the photographer to measure a wider angle of light (approximately 180°) than would be possible with a reflected-light meter. With the incident-light meter, all the light falling on a subject from the direction of the camera is measured.

Light striking the diffuser must be of the same intensity as that falling on the subject. A reading for a subject to be photographed in sunlight must be taken in sunlight. A partially shaded subject requires that the light-diffuser be held half in shade and half in light to get an average reading. If the subject is lighted from the back, the incident-light meter must be held in the shadow of the subject and pointed toward the camera. The basic assumption is that the varying degrees

of light reflected from different areas and objects in the scene and measured in the 180° arc will average out, and the reading obtained will be equivalent to that taken by a reflected-light meter from an 18 percent gray card. Thus an incident-light reading always represents an average.

The incident-light method of exposure lets a photographer take an average reading from subjects that are often difficult to read by the reflected-light system. For instance, though beaches and snow scenes are bright in value, with light tones predominating, they nearly always include portions of average or darker than average tonality as well. Yet because the lighter tones overwhelm the others, the reflected-light meter cannot easily take an average reading. Incident-light meters can be more efficient for such situations.

On the other hand, the incident-light meter's averaged reading is of little value in determining exposure for extreme darks or brights on the tonal scale. In such cases, you can often compensate for the incident-light meter's limitations by adjusting the camera aperture. For extremely bright subjects it is usually enough to decrease the exposure by half an f-stop or a full f-stop. With dark subjects, such as dark bronze sculptures, it is more difficult to estimate the exposure increase.

The incident method of measuring light originated in color motion picture work, where an average exposure is generally required. It is often employed for commercial

black-and-white photography, general color photography, or product photography, and is especially useful for copying.

A spot meter reads light reflected from a very small portion of a subject or a scene. Most reflected-light meters can read light from an angle of about 30° to 50°; by contrast, the spot-meter angle may be 10°, 3°, or even 1°, depending on the brand. The advantage of this extremely narrow angle is that small, key areas of a scene—a small patch of snow, a shadow area, the light reflected from one side of a subject's face—can be singled out for special measurement, so that the exposure will give these elements the desired emphasis. When it is very carefully pointed, a spot meter will read distant objects that cannot be approached for closeup measurement. To determine the best exposure in such a situation, average readings taken from several objects.

Because the spot meter focuses on such a small area, the photographer's aim is critical. The spot meter is equipped with an eyepiece to ensure precision. Looking through it, you see a magnified image of the field read by the meter, with a circle inscribed in the center. The particular area to be measured must fall within the circle. A spot meter is a rather expensive, specialized piece of equipment, but it can be useful in certain situations, as when it is not possible to get close enough to a subject to take readings with a reflected-light meter—see Minor White's photograph. □

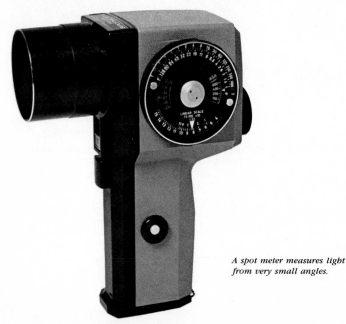

*A spot meter measures light from very small angles.*

MINOR WHITE. *Sun in Rock, Devil's Slide, California.* 1947.

*The strong contrast between areas in direct sunlight and areas in shade is typical of backlighting. Such contrasting areas require separate meter readings. When they are physically unapproachable, as here, a spot meter would be useful.*

135

Many cameras have built-in metering systems, usually of the averaging type, that enable the photographer to determine correct exposure quickly, accurately, and conveniently. Built-in meters are very popular because a separate meter is not needed. These meters are of several types. Some read light from the area that the lens covers; others read light coming directly through the lens. Some are fully automatic; others are semiautomatic and allow the photographer to control shutter or aperture or both. Each type of meter is discussed in detail below.

A *built-in, fully automatic light meter* reads reflected light from the same area of a scene that affects the camera lens, determines an "average" reading, and sets the shutter speed automatically. Because it is so easy to use, this kind of meter is popular on cameras primarily used by amateurs, such as some models of the 110 pocket camera and compact 35mm camera and all Polaroid cameras. Even though the photograph may be a little too light or too dark, the amateur photographer is usually satisfied with the results and the convenience of the system.

Though the fully automatic system of exposure determination is quite adequate for ordinary situations, it does not always guarantee accurate exposure where there are extremes of tonal contrast. Backlit scenes are especially difficult for an automatic meter to read, and the negative will usually be much underexposed. When photographing a landscape with this type of meter, direct the meter away from a bright sky to get adequate exposure of the ground areas. Another deficiency of the fully automatic system is that the aperture is not adjustable; thus you cannot control depth of field. Since the shutter speed is used to regulate the exposure, a bright scene produces a faster shutter speed than a dark one; thus you cannot control stopping subject motion, either.

Even when you are using an automatic light meter, you still need to analyze the situation because there are certain modifications in exposure you can make that compensate for the limitations of a fully automatic meter. These modifications depend on the brand of the camera and the specific controls it has. Some cameras have a "hold" button that maintains an exposure reading even though the photographer changes position. Other models can be switched from automatic to manual control. In some models the meter can be set for an ASA rating that differs from the one of the film actually in use. If more exposure is required, the meter is set for a lower ASA rating; if less, it is set for a higher rating. (Other models have no ASA indicator.) Some cameras have a light and dark adjustment that may be used to help correct exposure. If you are aware of the "averaging" tendencies of the fully automatic light meter and know how to compensate for them, you will be able to minimize exposure problems and produce the pictures you want with such cameras.

A *through-the-lens (TTL) light meter* is designed to alleviate some of these exposure problems by restricting the area of sensitivity of the meter. This kind of meter is provided on 35mm single-lens-reflex cameras. The area of sensitivity of through-the-lens meters varies according to the type of meter. There are six types currently in use. Each is described and its pattern is shown on the opposite page.

Because of the variety of TTL meters, it is very important to read the instruction booklet furnished with a camera in order to understand its method of metering. There may be a "best" meter for any specific photographic situation, but there is no general agreement among manufacturers or photographers on which design is best for all kinds

**averaging meter** *The averaging meter has two CdS cells, one on either side of the eyepiece. Each cell measures light reflected from one-half the picture area, and a linkage between the cells automatically averages the two readings. They read almost the entire picture area and would be accurate if every scene were uniform in tonality. In scenes of contrasting tonalities, compensating methods are needed. Photographing a vertical picture can also be a problem. If the bottom cell reads a dark ground and the top cell reads a bright sky, the brilliance of the sky may cause underexposure unless the meter is pointed toward the ground for the reading.*

**center-weighted meter** *The center-weighted meter also has two CdS cells, arranged so that the areas read by each overlap in a symmetrical pattern, similar to a "bull's-eye"; the pattern is the same for both horizontal and vertical pictures. This design was developed on the assumption that most photographers tend to place their principal subject matter near the center of the composition and that this region should therefore be given priority in determining proper exposure. It is an ideal metering system for portraits and helps to solve the problems of bright skies and backlit scenes.*

**bottom-weighted meter** *The bottom-weighted meter also has two CdS cells. Its sensitivity pattern is a refinement of the center-weighted meter; it is less sensitive to the top portion and more sensitive to the center and bottom-center portions of the area. Specific patterns vary quite a bit among the various manufacturers. This meter reduces the problem of bright sky and is therefore useful for general landscape photography. The photographer must remember, when using the camera for vertical-format pictures, that one side of the picture is being read differently from the other. Failure to remember this can cause serious exposure problems.*

137

**spot meter** *The spot meter has only one CdS cell and measures light reflected from a very limited area of a scene. Usually, this area is the center circle or square seen in the viewing screen, and the surrounding areas are not read. This type of meter produces highly accurate readings but requires a very careful meter-reading procedure to ensure that the meter is reading a tone equivalent to 18 percent gray. A recommended procedure is to use an averaged exposure of bright and dark readings. This meter may be used vertically without any additional adjustments. In spite of its accuracy, the spot meter is not now being used by many camera manufacturers, since they feel it is too complicated for the amateur photographer. Some newer camera models include the spot meter in conjunction with a center- or bottom-weighted meter.*

**dual meter** *The dual meter combines a spot meter with either a center- or bottom-weighted meter. The center circle in the diagram shows the spot-meter coverage and the dotted lines show the bottom-weighted coverage. By turning a switch, the photographer has a choice of metering depending on which method is most useful for a particular situation.*

**off-the-film metering** *All of the previously described through-the-lens meters are "blinded" when the shutter release is pushed and the mirror flips up. If the subject's tonality changes during the interval between exposure determination and the actual exposure—which may occur with fast-moving objects or in the illumination level of a scene during longer exposures— the final exposure may be wrong. A recent-model camera has an off-the-film (OTF) metering system in addition to the regular TTL system. When the mirror flips up and blinds the TTL system, the OTF system is activated. The OTF system uses two CdS cells, which take their reading from reflective chips on the shutter curtain and from the actual film. The exposure determination is actually made "off the film" while it is being exposed. This system of metering is ideal for motor drives and for flash pictures.*

of situations. In any case, the design of through-the-lens meters is so competitive that a great many changes and improvements are constantly being made.

In the viewfinder of earlier semiautomatic through-the-lens models the photographer saw two needles on one side next to the picture area. The needles were aligned to set correct exposure by changing the aperture or shutter. In many newer camera models the shutter-speed and aperture scales along the picture area are illuminated by LED (light-emitting diode) indicators. The manual exposure adjustment has been replaced with varying degrees of automation. Current semiautomatic exposure systems for 35mm SLR cameras have shutter priority, aperture priority, or a dual mode.

With the *shutter-priority system,* you set the shutter speed you want and the through-the-lens meter automatically adjusts the aperture. The chosen shutter speed and the resulting aperture number are visible in the viewfinder, so that you can see if the f-stop is suitable for the desired depth of field. If the meter runs out of f-numbers, a red LED blinks (one model has a "beep"), indicating that the shutter speed needs to be changed. The shutter-priority system is useful for all situations when shutter speed is the most

important factor, as in such fast-moving events as sports or news. It is not a very good system for photographic situations where aperture is more important, such as closeup photography.

With the *aperture-priority system,* you set the aperture you want, and the correct shutter speed is automatically set. An advantage of aperture priority over shutter priority is that with electronic shutters the shutter settings are not limited to $\frac{1}{60}$ or $\frac{1}{120}$, but can be anywhere in between—at $\frac{1}{97}$, for example. The exposure-warning signals are the same as with the shutter-priority system. Aperture priority is ideal for closeup photography with extension tubes or bellows, mirror lenses, microscopes, and other extension devices (see Chapter 12, page 317). You must be careful, however, to check that the shutter speed is fast enough to prevent blurring from subject or camera movement.

The choice between shutter priority and aperture priority depends largely on how you intend to use the camera. A few cameras with *dual-mode metering systems* offer both. One of these has "programmed auto exposure," that is, a minicomputer that automatically selects both shutter speed and aperture. In a situation of normal lighting, the shutter speed is automatically selected to be fast

enough to freeze both camera and subject movement, and the aperture is selected to provide adequate depth of field. In darker situations, the shutter speed and aperture change progressively until they reach $\frac{1}{8}$ of a second at f/1.4. As the aperture must then remain constant, the shutter speed continues to change until it reaches an exposure of 30 seconds at f/1.4. In brightly lit situations, the shutter speed and aperture automatically change the other way until they reach $\frac{1}{1000}$ at f/16. The particular mode the exposure meter is programmed for, the shutter speed, and the f-number are visible as digital numbers in the viewfinder. There are also warning signals for underexposure.

Most shutter-priority, aperture-priority, or dual-mode cameras include the option of manual adjustments, since with some scenes you may require a slightly darker or lighter rendition than the one set by the automatic meter. Most models also have a "correction factor," which permits you to adjust from one to two f-stops. The meter is still active, but it is biased by your adjustment toward a greater or lesser exposure. You have to remember to remove the correction factor after the picture is taken, or other photographs will be exposed at the adjusted f-stop. □

# Determining Exposure Without a Meter

## suggested exposure settings for outdoor scenes

| film | bright sun, beach, snow | bright sun, strong shadows | light overcast, no shadows | heavy overcast, open shade | deep shade |
|---|---|---|---|---|---|
| **Eastman Kodak film** | | | | | |
| Pan-X (32 ASA) | f/16 1/60 | f/11 1/60 | f/8 1/30 | f/5.6 1/30 | f/4 1/30 |
| Verichrome Pan (125 ASA) | f/16 1/250 | f/11 1/250 | f/8 1/125 | f/8 1/60 | f/5.6 1/60 |
| Plus-X Pan (125 ASA) | f/16 1/250 | f/11 1/250 | f/8 1/125 | f/8 1/60 | f/5.6 1/60 |
| Tri-X Pan (400 ASA) | f/22 1/500 | f/22 1/250 | f/8–11 1/250 | f/8 1/125 | f/5.6 1/125 |
| **Ilford film** | | | | | |
| FP-4 (50 ASA) | f/16–22 1/60 | f/11–16 1/60 | f/8–11 1/30 | f/5.6–8 1/30 | f/4–5.6 1/30 |
| HP-5 (400 ASA) | f/22 1/500 | f/22 1/250 | f/8–11 1/250 | f/8 1/125 | f/5.6 1/125 |

## suggested exposure settings for dark scenes

*recommended for indoor or night photography: Tri-X or HP-5 film; both are very light-sensitive*

| subject matter | f-stop | shutter speed |
|---|---|---|
| boxing, wrestling ringside | f/5.6 | 1/125 |
| movie marquees, neon signs | f/8 | 1/30 |
| campfires | f/5.6 | 1/60 |
| television, bright pictures | f/5.6 | 1/30 |
| store windows | f/5.6 | 1/30 |
| brightly lit interiors, offices, restaurants, etc. | f/5.6 | 1/30 |
| main street, very bright | f/4 | 1/30 |
| wet streets | f/4 | 1/30 |
| floodlit buildings | f/16 | 1 sec. |
| fireworks | f/16 | 1 sec. |
| rainy night | f/11 | 4 sec. |
| snowy night | f/11 | 15 sec. |
| skylines | f/8 | 10 sec. |
| landscape, full moon | f/8 | 1 min. |
| landscape, snow | f/11 | 1 min. |

If you do not have a light meter with you, there are other ways to determine exposure, including exposure charts, which usually come with film, and *bracketing* exposures. The tables on this page give suggested exposures in common situations. However, you are nearly always confronted with a mixture of lighting conditions, since bright, average, and dark areas reflect light in varying degrees. When there are no extreme contrasts, the light reflected can be thought of as average. The accuracy of the tables depends on how closely actual conditions match the examples. Another method on a bright, sunny day is simply to use the film's ASA as the shutter speed with f/16, as approximately shown in the second column of the table. Fortunately, the exposure latitude of modern black-and-white film helps to reduce the margin of error.

When you doubt the accuracy of a suggested exposure setting, you can increase your chances of achieving the exposure you want by a method known as *bracketing.* In dark situations, after you have exposed one negative at the recommended setting, make a second at twice the exposure and a third at four times the exposure. In very bright situations, after you have made one exposure at the recommended setting, make a second at half the exposure. Sometimes an even more drastic bracketing range is necessary. Though it takes more film and therefore may cost a bit more, bracketing can give you a good exposure when you are in doubt. □

For time exposures the camera must be held absolutely still. It is usually mounted on a tripod for any exposure longer than $\frac{1}{30}$ of a second, but if a tripod is not available, an improvised support—such as a fence, a tree, or a chair—can be used.

A cable release that allows you to open and close the shutter without touching the camera is another requirement for time exposures. If the shutter-release control is operated manually, any slight movement of the hand can jar the camera. A cable release is inexpensive and most cameras accept one.

On cameras without a T (time) setting, you have to use the B (bulb) shutter-release setting. The shutter must be kept open by hand at this setting. If the exposure is prolonged, there is a tendency to relax or change the position of the fingers, causing the shutter to close prematurely. To avoid this, many cable releases have locks.

A fact that is important in making time exposures is that the sensitivity of any film to light, and therefore its ability to record differences in exposure, diminishes after a specific length of exposure. This phenomenon (a law of physics) is called *reciprocity failure*. Under normal circumstances, an increase in exposure produces a proportionately darker value in the negative. However, as the shoulder of the H & D curve demonstrates (page 106), after a certain period of time—generally about 1 second—the degree to which a film responds to light levels off. Light-meter scales do not take this factor into account. Consequently, *reciprocity-failure factors* (or RF factors) have been worked out for each type of film, indicating the amount by which shutter speeds, as determined by the meter, must be multiplied to obtain proper time exposures. For example, if the RF factor of a certain film is 4 at an indicated shutter speed of 30 seconds, the shutter speed must be set for 4 times 30 seconds, or 120 seconds, to produce a satisfactory negative. Failure to take reciprocity failure into account can result in an underexposed negative. Information on the RF factors of all types of film is available from the manufacturers. For most black-and-white film, the following factors can be used:

| shutter speed | RF factor |
|---------------|-----------|
| 1–2 secs. | 1.4 |
| 2–6 secs. | 2.0 |
| 6–16 secs. | 2.8 |
| 16–35 secs. | 4.0 |

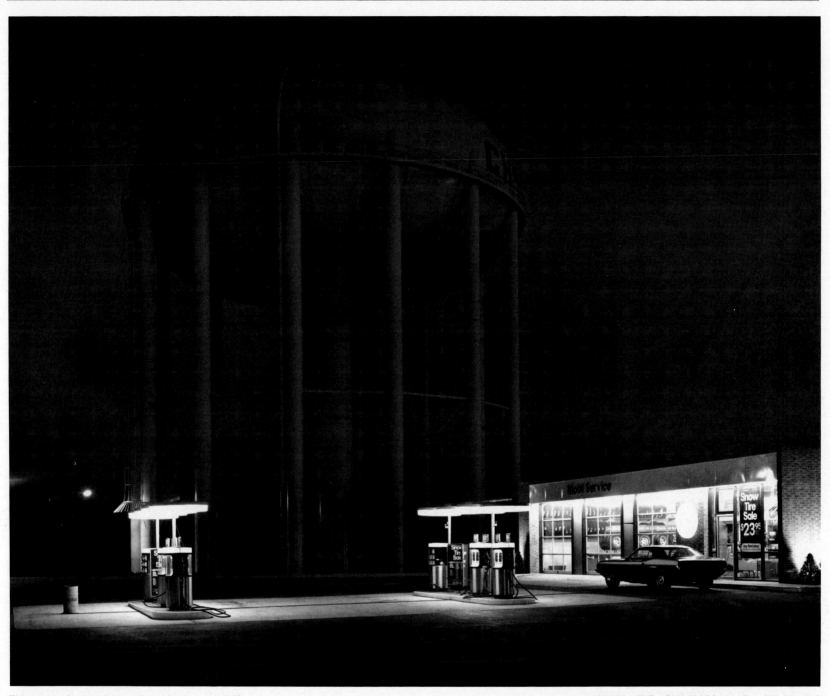

*The exposure for this photograph was 2 minutes at f/22 on Tri-X film.*

GEORGE A. TICE. *Petit's Mobil Station, Cherry Hill, N.J.* 1974.

**6**

A finished photograph is produced in a three-step process. The first step is exposing the film. The second is processing, or developing, discussed in this chapter. The third is printing, discussed in Chapter 8. The photographer controls and coordinates the three steps to produce the desired results.

Film is manufactured to include some latitude for development. The degree of latitude depends on the type of film. High-contrast (litho) and color reversal (transparency) films, for instance, have considerably less latitude for development than regular black-and-white film. In other words, in processing these films, temperature control, strength of solution, and timing of film in the solution are considerably more critical.

Choice of developer is also a factor in the quality of the finished product. Photo-finishing labs use general-purpose developer because they try to return "acceptable" negatives even though the film may be old or poorly exposed or one of any number of brands and types. General-purpose developer, however, gives excessive contrast and grain and thus usually is not acceptable to the more discriminating photographer. Such a photographer uses specific developers to produce the quality desired.

The development method is another important factor. When large quantities of film are developed it is impossible to accommodate the needs of any individual roll. For maximum control and finest quality, individual rolls are developed.

143

WYNN BULLOCK. *Pebble Beach*. Negative print. 1970.

# What Is Normal Development?

Just as proper exposure is essential for producing a negative with an appropriate amount of density and detail, so proper development is essential to making the most of that image. When a normally exposed negative is underdeveloped or overdeveloped, a realistic rendition of the subject or scene is impossible. The three negative prints on this page illustrate the effects of underdevelopment, normal development, and overdevelopment on normally exposed film.

An underdeveloped negative has adequate density in the darkest shadow but very little separation between the other tones and very little density in the highlight areas. It appears weak and has little contrast. A print made from such a negative has little separation between the shadow areas and highlights.

Normal development gives adequate density in the shadow areas, and the highlights are denser than in an underdeveloped negative but still have ample detail. This detail, plus the additional contrast, produces the best separation of tones in all three areas: shadow, middle, and highlight. A print made from such a negative gives the most realistic rendition of the subject or scene.

An overdeveloped negative has adequate shadow detail, but the darker highlight areas are very dense and there is little separation of highlight tones. Lack of detail in these highlight areas causes excessive contrast. A print made from such a negative does not present the tonalities of the subject or scene in a realistic manner and is too contrasty.

Most film is packaged with a brochure that gives the manufacturer's recommendations for processing. By following these directions for a normally exposed film, you will usually produce a normally developed negative with good density and detail. In certain situations, however, you may want to manipulate the developing process to achieve greater or lesser contrast. This chapter explains the steps and procedures for normal development of roll film as well as alternative development processes and ways to manipulate development for other than normal situations. □

144

**underdeveloped negative**

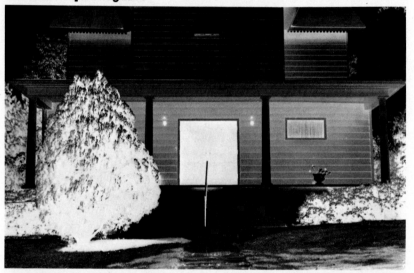

**normally developed negative**

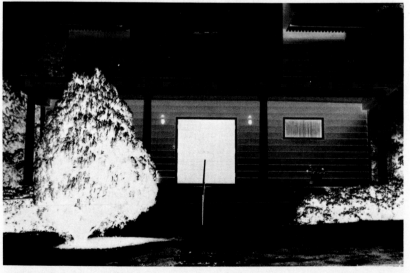

**overdeveloped negative**

# The Chemical Process of Film Development

## safety precautions with photographic chemicals

*The chemicals used for processing film are not explosive; nor are they extremely poisonous. Still, as with any other chemicals, it is wise to follow basic safety precautions. When preparing solutions from powdered chemicals, mix them in a well-ventilated room, pour powder into water carefully to avoid creating dust, and avoid breathing dust or fumes.*

*The most dangerous photographic chemical is glacial acetic acid, used to mix stop bath. It is a concentrated acid which can burn you or damage your equipment. Proper procedures for mixing stop bath with glacial acetic acid are given on page 147.*

*Some people find they have skin allergies to developers, especially the Metol ones. If you have a skin reaction to Metol, wear rubber gloves or use special protective hand creams. If you should have persistent or extreme reactions to any of the photographic chemicals, see a doctor.*

When exposed film is subjected to the chemical compounds in a solution called the *developer,* the exposed silver halide crystals in the film emulsion are changed to tiny metallic silver clumps, producing a visible image. The actual changing—or reducing—of exposed silver halide crystals to visible metallic silver clumps is done by a *reducing agent* such as Metol (Elon). Some developers use only one reducing agent, but most add hydroquinone to help with contrast; these are called *MQ developers.*

To activate the developer solution, an alkaline called an *accelerator* is added. Borax or sodium carbonate is often used. However, the resulting mixture would be so active that it would react not only with the exposed silver crystals, but also with the unexposed ones to produce a dense "chemical fog" over the entire area of the film. To avoid this, a *restrainer,* usually potassium bromide, is added. Finally, sodium sulfite is included as a preservative, to help prevent the developer from oxidizing with room air while being handled, stored, or used in a tray or tank.

Film remains in the developer for an allotted developing time and is then placed in a *stop bath* solution to halt the developing process. Stopping development quickly is essential to ensure consistency and to keep streaks from forming. Experts differ on the best type of stop bath. Some use a water rinse, but most prefer a mild acetic acid solution, which neutralizes the alkaline solution of the developer.

After the stop bath, the film is placed in a *fixer* solution containing sodium thiosulfate or ammonium thiosulfate. These chemicals remove the unexposed, undeveloped silver halide crystals and make the image insensitive to further light. The fixer solution usually also includes a preservative and some acid to neutralize any developer left over from the stop bath. Because the film's gelatin emulsion becomes soft from expansion in the solutions, the fixing bath generally includes potassium alum to harden it.

After fixing, the normal procedure for many years was to wash the film in running water to remove any of the residual chemicals, but it was found that certain sulfur compounds were not removed even with lengthy washing. Thus *washing aids* were developed to make the stubborn sulfur compounds more soluble; these aids make possible shorter final wash periods and greater image permanence.

After the final wash, a *wetting agent* is applied to reduce the surface tension of water on the film, thus preventing water beads from forming. If a drop of water in one area dries differently from a drop in another, the negative can be permanently marked.

## Developer

**S**o many different film developers are available that you may be confused about which one to choose. Generally, developers fall into three categories: general purpose, extra fine grain, and high energy. Some of the available brands are listed in the table below. These, however, are by no means all. Many developers appear on the market, enjoy a brief popularity, and then disappear. Those listed have been popular for many years and are likely to endure. Each type is used for a specific purpose; therefore, you should analyze your own needs and choose the appropriate developer for them. It is a good idea to learn processing by using one developer until you get consistently dependable results before trying a different one.

## developers

| general-purpose developers | extra-fine-grain developers | high-energy developers |
|---|---|---|
| Acufine (replenisher) | Beseler Ultrafin FD 1 (one-shot) | Kodak DK-50 (replenisher) |
| Agfa Rodinal (one-shot) | Edwal Minicol (one-shot) | Acufine (replenisher) |
| Panthermic 777 (replenisher) | Edwal Super 20 (one-shot) | Diafine (two-bath) |
| Edwal FG7, A&B (replenisher, one-shot, or two bath) | Ethol TEC (one-shot) | |
| Kodak HC-110 (replenisher or one-shot) | Kodak Microdol-X (replenisher) | |
| Kodak D-76 (replenisher or one-shot) | Ilford Perceptol (replenisher) | |
| Ilford Microphen (replenisher) | | |
| Diafine (two-bath) | | |
| Ethol UFG (replenisher) | | |

The most commonly used developers are produced in the form of powder that must be mixed with water. When making the solution, carefully follow the instructions provided by the manufacturer. Typically, you first mix the developer powder with enough hot water to dissolve all dry particles into a liquid suitable for storage in airtight containers. The temperature of the water is extremely important. If the water is too cold, it is extremely difficult to dissolve the powder. Water that is too hot tends to oxidize the developer, reducing its effectiveness and shortening its life. When the developer is required for actual processing, you may need to dilute the liquid to make a working solution.

Darkroom chemicals must be kept free of contamination. This is especially important in a shared darkroom. Film that is processed in contaminated developer will be blank—a total loss. To check a developer for contamination, insert a piece of litmus paper into the solution. If the paper turns bright green, the solution is pure; if it turns orange, the developer is spoiled. Litmus paper is available from chemical supply houses.

Be especially cautious when using a developer that has been stored for a period of time. A full bottle of unused developer with no air on top will last about three months if properly stored; half full, it will be good for only a month. If a developer has turned brownish in color, do not use it, especially if it is an MQ developer such as D-76, for this means it has oxidized.

Keeping the strength of the developing solution consistent is a major consideration with any developer. To achieve consistency, developers are used according to the replenishing system or the one-shot system. Some brands of developers may be used with either system; others are definitely of one type.

In the *replenishing system* of development, you add a replenisher solution to the developer in proportion to the number of rolls developed so as to increase its developing capacity. One quart (or 1 liter) of developer may be able to accommodate six or eight rolls of film before it weakens to the extent that developing time must be increased. However, when a quart of replenisher is added, the same solution can be used to develop ten to thirty rolls of film.

The replenishing system is not entirely reliable, for even when the developer is consistently replenished according to the manufacturer's instructions, the amount of replenisher may be too little or too much, depending on the exposure of the film. If the subject matter has a lot of white areas, more replenisher is needed than if it consists mainly of darker areas, and there is no practical way to correlate the subject matter to the rate of replenishment. It usually takes a really experienced eye to see the very gradual shift in contrast in the development of succeeding rolls of film.

Another problem with the replenishing system is that a freshly mixed developer solution is apt to have an "edge" (caused by hyperactivity), which causes excessive contrast in the first few rolls of film for which it is used. Some photographers sacrifice an unwanted roll or two of film to remove this edge. Others mix some of the old developer in with the new to help even out the solution.

The *one-shot system* is the other method for maintaining consistent developer strength. It is recommended for the beginner, because the solution for one-shot developing is simple to prepare and gives very reliable results. A concentrated stock solution is mixed with water, used once, and then discarded; thus the solution is always fresh. One-shot developers yield very satisfying, nicely separated tones with no excessive contrast. The ratio of developer to water may be varied to manipulate contrast. Some one-shot developers have quite fine dilution rates, so accurate measurement is crucial. Rodinal, for example, has a ratio of one part developer to 50 parts water, which may be difficult to measure accurately when only a small quantity of solution is needed.

Most developers require different developing times for different films. Diafine, a *two-bath developer,* is unique in that it has the same developing time for all films, regardless of speed. It can be used within a temperature range of 70°–85° F (21°–30° C), with a minimum developing time of 2 minutes and a maximum of 8 minutes. Furthermore, there is no prescribed time period for any particular temperature, and the solution never needs replenishing. Immerse the film in the first solution (A), then drain but do not rinse and immerse it in the second solution (B). Be careful not to allow any B solution to contaminate the A solution. Finally, drain the film and place it immediately in fixer, without the usual 15-second stop bath; then wash and dry it normally. The combination of high-energy Diafine and fast film results in a negative without excessive contrast or grain (see page 169).

Another type of solution is the one-shot *monobath developer* (packaged as liquid), which develops and fixes in one operation. A monobath developer gives lower quality than other developers but is useful when extremely rapid processing is needed. For a

146

variety of reasons, monobath developer is not readily available.

Many school darkrooms and other shared darkrooms provide a single general-purpose developer, such as Kodak's D-76, which is economical and available in bulk. Although it does not produce the finest grain with slow film, it is good for average photographic conditions. Depending on the type of film being processed, D-76 often is diluted for use once and then discarded. Another versatile developer is Kodak HC-110, which can serve as a one-shot developer—a useful feature when there could be contamination.

When both roll and sheet films are to be developed, good developer choices are D-76, HC-110, Ethol UFG, or Edwal FG-7, which give ample processing time for the tray method of developing sheet film (see page 294). Other developers are not so flexible—they function best with a single type of film.

If you want extremely fine grain and if the general light level is high enough to use slow film, try a combination of Kodak Panatomic-X or Ilford Pan F film and an *extra-fine-grain developer.* Some extra-fine-grain developers, specifically the concentrated liquid developers, are also "semi-compensating" developers when greatly diluted. This means that the developer becomes exhausted rapidly in the highlight areas but continues to develop in the shadow areas, which helps to reduce contrast. This is useful, as slow film has a tendency to be excessively contrasty.

Extremely fast films, such as Royal-X Pan (120) and 2475 Recording film (35mm), require a *high-energy developer,* such as Kodak's DK-50, Acufine, or Diafine. DK-50, which heightens grain and contrast, is not recommended for normal roll film. It is often used commercially to develop fast film

in large negatives, when enlargements will not be of a scale to make the grain noticeable. Acufine and Diafine produce adequate development and yet keep the grain to a tolerable size. For further discussion of high-energy developers, see page 168.

## Other Photographic Chemicals

**S**top bath, which chemically neutralizes the developer, can be used for several rolls of film. It is prepared either from glacial acetic acid or a 28 percent acetic acid solution, which is less caustic.

To minimize the number of times they have to work with the strongly caustic glacial acetic acid, many photographers prepare a weaker solution of 28 percent glacial acetic acid, which they then use to prepare working solutions of stop bath. To prepare a 28 percent solution, mix three parts (9 oz) glacial acetic acid to eight parts (24 oz) water. (Or mix 280 ml glacial acetic acid with 720 ml water.) As a safety precaution, it is a good idea to wear gloves and safety goggles while mixing. In a well-ventilated room, pour the acid slowly into the water and stir. Never pour water into acid, for acid spatters can cause burns. Avoid breathing the fumes. Store the 28 percent solution in a plastic bottle. To prepare 1 quart of stop bath with the 28 percent solution, mix one part 28 percent solution (1 oz) with thirty-one parts water (31 oz). (Or to prepare 1 liter of stop bath, mix 30 ml 28 percent solution with 970 ml water.) Eastman Kodak markets a 28 percent acetic acid with an "indicator" that turns the solution blue-violet when it is exhausted, but it is more expensive than mixing your own.

*Fixer* is available in powder or liquid concentrate. (Fixer and fixer solution are

commonly called *hypo,* even though the term is now inaccurate because it comes from sodium hyposulphate, the name for sodium thiosulfate in 1819.) Liquid concentrate fixer is used more often than powder because it is easier to mix. If the water is too warm or the A solution (the larger bottle) is not mixed thoroughly, the addition of the B solution (the smaller bottle), which is the hardener, may cause the solution to become cloudy. The cloudiness may disappear in time, but it is not advisable to use a cloudy fixer. Fixer is used for processing both film and prints (see Chapter 8), but solution strengths are *not* the same for both procedures. A working solution of fixer will process several rolls of film. Edwal's Hypo Chek is a solution that can be used to find out if fixer is still working or has become exhausted.

*Washing aids* are available in both powder and liquid form. Storage lives of the working solutions vary among brands. The liquid types are generally mixed, used once, and discarded. Two popular washing aids are Hypo Clearing Agent (Kodak) and Permawash.

*Wetting agents,* such as Kodak's Photo-Flo or Edwal LFN, are highly concentrated and must be diluted for use. Be careful to follow the manufacturer's recommendations for sufficient dilution of the wetting agent, because a too highly concentrated solution may produce oily streaks on the film. To guard against impurities, in hard-water areas photographers often use distilled water for preparing the wetting agent. A prepared solution accommodates many rolls of film. When the recommended number of rolls has been processed, the solution must always be discarded. □

*147*

# Facilities and Equipment for Processing Film

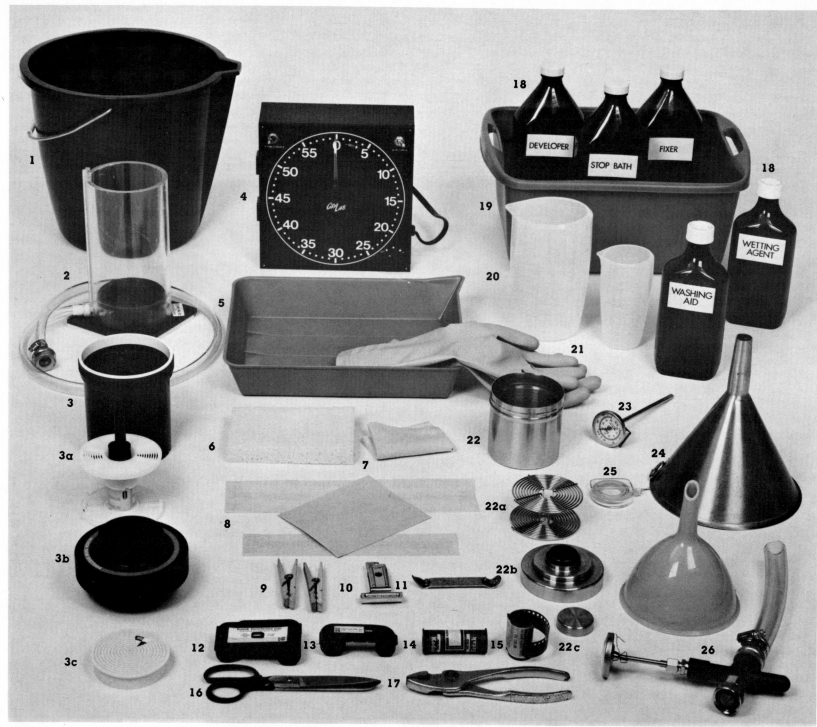

1 bucket
2 film washer
3 plastic developing tank
  a reel and agitator
  b lid
  c cap
4 timer
5 8 × 10 tray for temperature control

6 photographic sponge
7 photographic chamois
8 film storage envelopes
9 clothespins
10 film clip
11 bottle opener
12 126 cartridge film
13 110 cartridge film

14 120 roll film
15 35mm film
16 scissors
17 pliers
18 processing chemicals
19 temperature-control pan
20 graduates: large and small
21 rubber gloves

22 stainless steel developing tank
  a reel
  b lid
  c cap
23 thermometer
24 funnels: large and small
25 litmus paper
26 flo-temp thermometer with hose

You do not need an elaborate darkroom to process your own film. A sink in the kitchen, bathroom, or basement will do. The basic materials and equipment for processing roll film are shown here and described below.

A *sink* with a single faucet that mixes hot and cold water together is essential to regulate the temperature of chemicals during mixing, maintain proper temperature of the solutions during processing, do the final wash, and provide water for removing spilled chemicals before they stain. A kitchen sink with a single regular faucet will work, but the addition of a piece of hose will usually make the water supply handier. For some faucets, a simple rubber adapter with an attached hose works well. If it tends to slip off or leak, you can remove the faucet's aerator or filter and install a suitable adapter and plastic hose obtained from a photographic supply store. Another option is to buy a duplicate faucet filter from a hardware store, remove the filter mechanism, and solder a short piece of copper tubing to it. Then place a piece of plastic hose over the copper tubing and tighten it in place with a small radiator clamp. These hose units are easily removed and do not harm the faucet.

Because consistent temperature of solutions is critical in film developing, most photographers use a *temperature-control pan* and a *photo tray* to help maintain consistent temperature of all solutions during processing. Water of the correct temperature is placed in this pan and tray to surround the chemical solution bottles and the developing tank, thus maintaining the proper temperature of the solutions.

For the most precise temperature control, a *heating recirculator* may be used. This device, primarily marketed for color processing but equally useful for black and white, is either built into a pan similar to the temperature-control pan or bought as a separate unit, consisting of hose, pump, heater, and adjustable thermostat.

Keeping wash water temperature constant can be difficult because of fluctuations in the water-heating system. Especially in winter, if the tap water is excessively cold (40° F or 5° C), it is a good idea to connect a *"flo-temp" thermometer* to the sink faucet with appropriate adapters (available in large photographic supply stores), in order to monitor the temperature constantly. Though expensive, a *water-temperature regulator*—a built-in device that regulates the temperature of the water accurately and consistently—is very useful in a permanent darkroom with a photographic sink.

The quality of tap water varies, depending on the local system and the age of the pipes in a building. There may be fine particles of sand or rust in the water that can become embedded in film emulsion and produce white specks on prints. A portable *water filter,* which can easily be attached to the faucet, will alleviate this problem. If you have a permanent photography sink, you may wish to install separate filters, with replaceable inner filters, in both the hot- and cold-water lines.

Roll-film *developing tanks* are made of stainless steel, plastic, or a combination of both. Developing reels, onto which the film is wound before being placed in the tank, are also made of stainless steel or plastic. Though some plastic reels are adjustable for different film sizes, no stainless steel reels are adjustable; therefore, a different reel is needed for each film size. Tanks vary in size depending on their capacity: a tank can accommodate one, two, or more rolls at once.

The choice between stainless-steel and plastic tanks and reels depends on cost and various other factors. Unbreakable stainless-steel tanks are more expensive than plastic ones. However, the metal, a faster conductor of heat or cold than plastic, helps in maintaining constant solution temperature. The lid and cap of a steel tank are essentially watertight; thus you can easily invert the tank completely to promote even development. On the other hand, after some use, the stainless-steel lid tends to leak or to stick on the tank. Some stainless-steel lids have a filler hole that is rather small, sometimes causing exiting air to bubble. These bubbles can slow down filling of the tank and may cause uneven development. Combination tanks, with a stainless-steel body and a plastic lid and cap, are now available at lower cost than the all-stainless-steel models.

Stainless-steel reels dry faster and more easily than plastic ones; this is very convenient when you are processing a number of rolls of film separately. It is also easier to load wet film onto a stainless-steel reel, because the film will not stick, as it has a tendency to do with plastic reels.

Though plastic tanks and reels are less durable, they are considerably less expensive. A main advantage of some plastic tanks is the large filler hole, which allows air in the tank to exit easily while it is being filled, so that chemicals can be poured in quickly. One of the available plastic tanks has a screw-on lid with a plastic cap; this prevents leaking when the tank is inverted, though all the plastic tanks are relatively leakproof. Some plastic reels are adjustable to a variety of film sizes, but the nonadjustable plastic reels are the least expensive. One manufacturer now makes plastic reels that will tolerate heat up to 250° F (125° C), so you can easily dry these reels with a portable dryer and reuse them almost immediately.

The choice between *glass* and *plastic bottles* for storing chemicals depends primarily on your working habits. If you develop a lot of film within a short period of time and immediately discard the developer, plastic bottles are adequate. If, however, you develop small quantities of film over a longer period of time, storing developer or replenisher in plastic bottles can result in oxidation that will ruin the solutions. All plastic is porous, and air slowly seeps into even a tightly capped bottle. Dark amber glass storage bottles with plastic caps, available at drug stores, give the best protection from oxidation and light. Stop bath, fixer, washing aid, and wetting agent are not subject to oxidation. Clean and reuse glass bottles only if the former contents were not highly acidic or basic (alkaline). Trace amounts of acid or base could ruin new solutions.

Polyethylene bottles for storing chemicals are available at photographic supply outlets. Previously used plastic bottles are not recommended, since the plastic will have absorbed residues of the previous contents which could contaminate new solutions. A flexible plastic container is particularly useful for developer, because you can squeeze the bottle until the level of developer reaches the top and pushes out all the air. A bottle with "concertina" sides enables you easily to force the liquid to fill the entire bottle before capping it. These bottles come in 1-quart, ½-gallon, and 1-gallon sizes (1, 2, and 4 liters).

To avoid contamination, clearly label each bottle, whether glass or plastic, and mark it with the date the solution was mixed and use it for one solution only. A single bottle should never be used, for example, to hold developer, then fixer, then again developer, for a very small quantity of residual fixer will ruin the developer.

Another solution to the oxidation problem is a *heavier-than-air gas*. Several brands are marketed, such as Prolong and XDL spray. You shake the can, place the nozzle in the opening of the bottle of developer or replenisher, and then spray. Inert gas replaces the air in the bottle and effectively seals the solution from oxidation.

*Graduates* are containers calibrated to show both fluid ounces and milliliters. You

will need at least two different sizes—small (1 or 2 oz, 50 ml) and large (32 oz, 1 liter)—for measuring and transporting large and small quantities of solutions.

Since the development of film is a chemical process highly dependent on proper temperature, precise reading of temperatures is critical. Your *darkroom thermometer* should be accurate and easy to read, and it must register quickly. Suitable thermometers are the stainless-steel "stem" type, the more expensive but very accurate "process" type, and the electronic digital type. Most cheap thermometers are not accurate enough.

An ordinary pair of *scissors* about 4 inches long is adequate for cutting film and most other darkroom needs.

You will need two sizes of stainless-steel or plastic *funnels*—a small one for pint or quart (500 ml or 1 liter) bottles and a large one for gallon bottles (4 liters). The smaller one should be large enough to allow the contents of the developing tank to be emptied rapidly back into its bottle. One brand has a built-in fine-mesh screen that filters out lint or other particles.

The timing of the film in the developer is critical, for a variance of half a minute, or less, can produce noticeable differences in image quality. A wristwatch or clock is not very convenient or accurate, since you must start timing in total darkness and because

you would have to remember both start and stopping times. Some type of *interval timer* with a bell is recommended. The least expensive is a windup timer. You activate it by pulling down a lever, and the bell rings when the set time has elapsed. The more accurate electric GraLab timer is easier to reset in total darkness. The newest highly accurate timers are electronic with digital numbers. Some models may even be programmed so a series of beeps indicates when to drain a chemical, when to pour in the next solution, and when to agitate.

A 2-gallon (8-liter) *plastic bucket* is useful for mixing a 1-gallon-(4-liter) size package of chemicals. Separate mixing containers should be used for acid and basic solutions.

35mm film cassettes can be opened with conventional pliers, a bottle opener, or a special *35mm film cassette opener*. One model can be permanently wall-mounted; another is held in the hand and squeezed.

You can choose your *film washer* according to your budget. The developing tank may be used, but it must be drained constantly. A separate plastic film washer is more convenient because it does not require constant supervision. Or you can modify an ordinary plastic juice container to make a film washer by punching holes in it very close to the bottom, an arrangement that requires only intermittent attention.

After using the wetting agent and before drying, most photographers use a *film wiper* to remove particles of dirt. You may use a Kodak Photo Chamois, a rubber wiper blade, or a special cellulose sponge. The chamois is recommended for 35mm film because it is the appropriate size. For sheet film some photographers use a rubber wiper blade or a device with two wiper blades between which the film is drawn. Others, who are strongly opposed to wiping gelatin with a rubber blade, use a photographic cellulose sponge. Household chamois and sponges are not recommended; they are not soft enough.

Stainless-steel *film clips* may be used to hang up film and weight it while it dries. Or use ordinary pinch-type clothespins.

For safety, it is important to store negatives in appropriate *film envelopes*. Brown craft-paper envelopes should not be used, since their sulfur content and their glue can damage negatives stored for long periods. Even glassine envelopes can cause trouble over a long time. Use either a folder made of rag paper with low sulfur content or a type of plastic envelope produced by the Print File Company for storage if you are concerned about the permanence of your negatives. Many photographers store their negatives in bank safe-deposit boxes, where the environment is controlled and the threat of fire is eliminated.  □

*151*

Starting on page 156, the entire process of developing roll film is described step by step. First, however, practice two steps that must be performed in total darkness. Use junked rolls of film for this practice before you begin to process your exposed film. The two steps are: removing film from its carrier and inserting it into the developing reel.

Exposed film is still entirely sensitive to light. Even a very small amount of light can further expose it and impair or ruin your negatives. This is why light must not reach exposed film during processing. If you are using a darkroom area that provides total darkness, you may remove the film from its carrier and insert it onto the reel and place it in the tank there. If total darkness is inconvenient or impossible to achieve in your darkroom area, perform these steps in an-

other area, such as a closet or a windowless bathroom. Whatever area you use, stay in it for several minutes first to let your eyes adjust, so that you can be sure there are no minute cracks of light. You may have to put a towel across the bottom of the door.

The procedures for removing roll film from its carrier and inserting it into developing reels vary with the type of film and the type of reel. Step-by-step instructions are given here for the most common types of roll film and reels. Practice the steps first with the lights on and then in darkness. The techniques may feel awkward in the beginning, but with practice they will become comfortable. Do not begin processing exposed film until you are confident that you can open your film carrier and remove the film and then load the film onto the reel

entirely by feel. *Handle exposed film at all times only by its edges; smudges from your fingers can ruin negatives.*

## Removing Roll Film from Its Carrier

**M**ethods for removing roll film from its carrier depend on the type of film. The general characteristics of 120/220, 35mm, and 110 and 126 cartridge film are described below. Techniques for removing each type from its carrier are illustrated.

A roll of 120 film consists of the spool, the film itself, and an opaque paper backing which prevents exposure while the camera is being loaded or unloaded. The paper also acts as a leader to guide the film through the camera. 220 film is quite similar to 120 except that it is twice as long and has paper

*152*

### key to lighting conditions

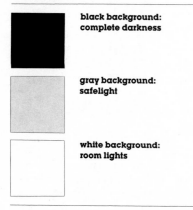

**black background: complete darkness**

**gray background: safelight**

**white background: room lights**

### removing 120 and 220 film from spool

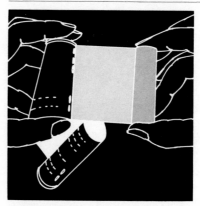

**1 unroll the film**

*To unroll the film, pull the short extension of paper backing, which will bring forward the film and cause it to unwind from the spool. As the film unwinds, let the paper backing curl away from it, and handle the film only by its edges.*

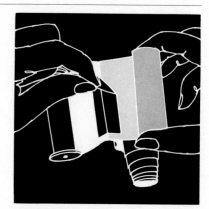

**2 remove the tape from the film**

*Remove the tape that attaches the film to the paper backing at the end of the roll. Sometimes there is a spark caused by static electricity; this may be a bit startling but does not harm the film. If you are removing 220 roll film, there is no paper backing, so cut off the paper leaders at each end of the film.*

leaders only at the beginning and end of the roll, with no backing between these points. It is taken from its spool in the same way as 120 and the paper leaders are cut off.

35mm film has no paper backing. The top of its cassette must be pried off with a tool and once it is unloaded its irregularly shaped "tongue" must be cut off.

In 110 and 126 cartridges the exposed film is contained on a spool in the right-hand portion of the cartridge. To be certain in the dark which part of the cartridge contains the exposed film, feel for the bump on the 110 cartridge or the gear mechanism on the 126 cartridge which engages with the camera to advance the film. The exposed film is in the side with the bump or gear mechanism; the empty side of the cartridge is smooth.

## removing 35mm film from cassette

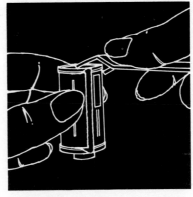

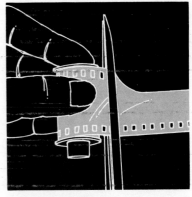

**1 open the film cassette**

*Hold the cassette with the end from which the film spool protrudes down; open the other end with pliers, bottle opener, or 35mm cassette opener. Slide the film spool out.*

**2 cut off the film tongue**

*Cut off the tongue (the protruding odd-shape end of the film), at a straight right angle to the film. If the cut is not made straight, you may have trouble loading the film onto the reel. Keep the film coiled on the spool for easier handling.*

## removing 110 or 126 film from cartridge

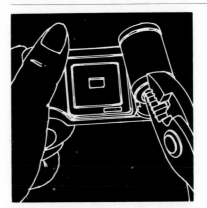

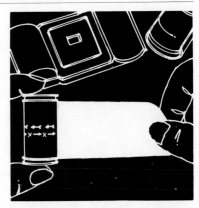

**1 open the film cartridge**

*Feel for the bump or gear mechanism to be sure which end the film is in. Break the cartridge apart by twisting it (110) or by using pliers to pry it apart (126). Remove the film spool.*

**2 remove the paper backing from the film**

*Usually some of the paper leader sticks out. Pull it to produce the film. Then separate the film from the paper backing by removing the tape at one end, as for 120 film.*

## Loading Roll Film onto Developing Reels

**E**xposed film is loaded onto a reel, threaded in spiral grooves in such a way that no part of the film touches any other part. Methods for loading exposed film onto reels differ, depending on whether you are using a stainless-steel or a plastic reel. Study the manufacturer's instructions, and be sure the reel you have takes your film size. The two major types of stainless-steel reel—spring clip and slotted—are loaded differently, but all plastic reels are loaded in the same general way.

Sometimes during the loading process, the film tends to balk. With plastic reels, this may be because the reel is not thoroughly dry, since moisture causes film to stick. In this case the film must be removed and the reel thoroughly dried before a second attempt is made. With stainless-steel reels this jamming occurs when one side of the film slips into a nonparallel track. If this happens, unwind the film for a few rotations and begin again.

Difficulty in loading can also be caused by wrinkles in the film. These wrinkles occur with 35mm film if you have attempted to advance it beyond the last exposure or to rewind it without using the rewind control. Some wrinkles you can merely smooth out with your finger along the sprocket holes, being careful not to scratch the film. An alternative is to reverse the film and load from the opposite end, as this will sometimes reduce its tendency to jam.

Procedures for loading the two types of stainless-steel reels and plastic reels are described and illustrated in step-by-step illustrations on these pages.

154

### loading a plastic reel

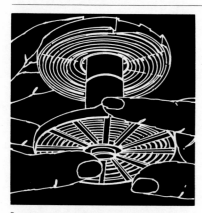 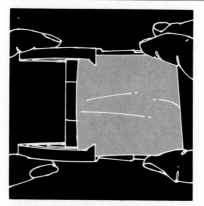  

**1 hold the reel in the proper direction**

*If you are using an adjustable reel, make certain it is adjusted for your film size. Holding the reel in your left hand, use your right hand to find the "ledge." Rotate the reel until both points on the inside edge of the reel face each other. Hold them together to form the entrance to the reel. If you do not hold them together, you may have problems when loading the film.*

**2 push the film into the entrance**

*Holding the reel in your left hand and the film (handling by the edges) in your right, gently push the film into the entrance of the reel until it stops.*

**3 position your thumbs**

*Hold the reel with the left thumb gently touching the film where it enters the reel, and with the right thumb touching the film on the right side where the film enters the reel.*

**4 advance the film onto the reel**

*Keep a relaxed pressure on the film with your left thumb while using your right thumb to rotate the right side of the reel clockwise. This will move some of the film onto the reel. Then press with your left thumb and relax your right thumb, rotating the right side of the reel counterclockwise to its original position. This coordinated series of movements advances the remaining film onto the reel. If you are using 35mm film, you will need to cut the spool off at the end of the roll of film.*

## loading a stainless-steel spring-clip reel

  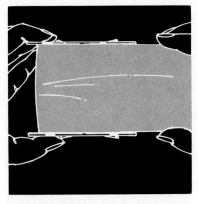

**1 hold the reel in the proper direction**

*Pick up the reel in your left hand and, with your right hand, feel the end of the metal spiral. When the reel is properly oriented, the end of the wire faces right and the spiral runs clockwise from the center.*

**2 insert the film into the clip**

*Hold the center of the reel with the thumb of your left hand and press the spring clip down with the thumb. With your right hand, insert the end of the film into the clip, making certain that the film is centered smoothly between the two sides of the reel. (Remember to hold film only by the edges!) Make the film bend slightly between your fingers as it enters the reel.*

**3 rotate the reel**

*With your left hand, rotate the reel to wind the film into the grooves between the wires of the spiral. Use your right hand to hold the film, slightly arching the film as it moves into the reel. Be careful not to bend the film so much as to cause wrinkles, since these can ruin your negatives. Continue rotating and feeding until the film has been completely threaded into the grooves of the reel.*

155

## loading a stainless-steel slotted reel

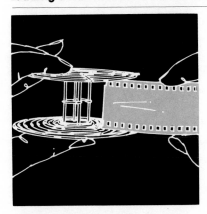 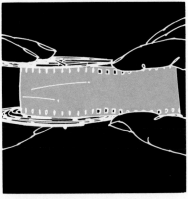 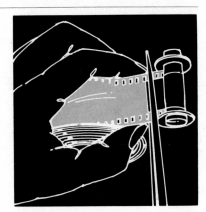

**1 insert the film into the slot**

*Feel the direction of the metal spiral, making sure it is clockwise. Gently arch the film (handling by the edges) and insert it into the slot in the center of the reel.*

**2 rotate the reel**

*To ensure that the film does not slip out of the slot, continue to arch it slightly with your right hand as you rotate the reel with your left. If the film does slip during loading, you may find extra film at the end of the roll with no space for it on the reel. Rotate the reel slowly and carefully at first, then faster until the entire roll is loaded.*

**3 cut the film**

*When the film has been completely wound on the roll, cut the end of the film from the spool.*

*Guidelines for Processing Roll Film*

The diagrams and accompanying captions illustrate and describe the steps for processing roll film. You may have to make some alterations if your facilities differ slightly.

Most of the steps are standardized—they are always used for normal development of roll film in a general-purpose developer. However, photographers disagree about one of the steps, and there are alternative ways of accomplishing some of the steps.

*Before you begin processing* prepare all your chemicals and have them ready and together in a single spot. Any delay in processing may cause damage to your film. Particularly, be sure there is enough developer on hand to fill the tank completely, since a partially filled tank can ruin your film.

Some photographers advise a water presoak of the film in the developing tank before processing begins, believing that this helps to prevent streaks and air bubbles. If you decide to presoak your film, pour water into the loaded tank at the same temperature as your processing chemicals, let it sit a few seconds, and then pour it out.

The guidelines assume that you will be able to remove your film from its carrier, load it onto the reel, and place the reel in a tank *already filled with developer* in total darkness. If you cannot do this, you may remove the film from its carrier, load it onto the reel, place the reel in the *empty* tank, put the lighttight cover on the tank, and then turn the lights on. You then use the tank's

**processing roll film**

156

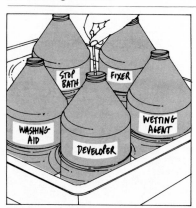

**1 prepare the chemicals**

*After assembling all processing chemicals, bring them to the same temperature, preferably a constant of 68° F (20° C), either by holding the bottles under a tap running mixed hot and cold water or by setting them in a temperature control pan in water of the proper temperature. The higher the temperature, the shorter the developing time. Check the temperature of all solutions with a thermometer. To avoid contamination of the solutions, rinse the thermometer in cool water before you put it into each solution. You may check developer for contamination with litmus paper (see page 146). If normal developing temperature cannot be achieved, as in the summer with no air conditioning, refer to the time-temperature chart provided with the film.*

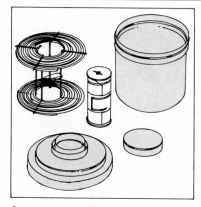

**2 prepare the dry area**

*Be sure that the reel and all parts of the tank are arranged for easy use in the darkroom. Also have on hand the necessary equipment (pliers, scissors, etc.) for removing and loading the film.*

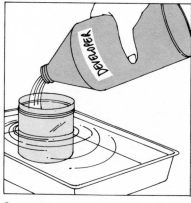

**3 fill the tank with developer**

*Set up a separate 8 × 10-inch (20 × 25-cm) temperature-control tray. Place the tank in it and fill the tank with developer of the right temperature. Be sure the water level in the tray is below the top of the tank. Recap the developer storage bottle and return it to the temperature-control pan prepared for the chemicals.*

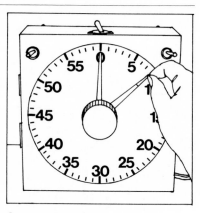

**4 set the interval timer**

*Set the interval timer for the recommended developing time so that it will be ready to start the instant the film is immersed in the developer solution.*

pouring hole to fill it with developer. There are three disadvantages to this procedure: there is some risk of not filling the tank completely; there is some risk of air bubbles, which can mar your negatives; there is some risk of uneven development because filling the tank in this way takes longer.

Correct and constant temperature, accurate timing, and proper agitation are the keys to successful processing of film. All chemical solutions and wash water should be brought to the same temperature and maintained

there throughout the developing process. Drastic changes in temperature cause excessive grain in negatives and, in extreme cases, cracking and wrinkling of the emulsion, which ruins the images on the negatives. The generally suggested temperature range is between 68° F (20° C) and 75° F (24° C), but a constant of 68° F (20° C) is best.

The length of time that film should remain in any of the chemical solutions, whether developer, fixer, or washing agent, depends on the type of film, the brand of

solution, and the temperature of the solution. *Be sure to read the information packaged with the film and the chemicals for specific instructions.* For instance, a specific amount of time is required for each gradation of temperature at which developer may be used; the higher the temperature, the shorter the developing time.

Film should never be left in a chemical solution longer than the specified period. Excessive immersion in fixer, for instance, will remove some of the exposed metallic

157

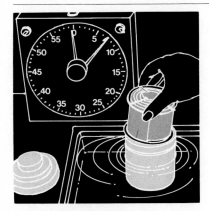

**5 load the film on the developing reel and place the reel in the tank**

*In total darkness (following the instructions on pages 152–155), remove the film from its carrier and load it onto the developing reel. Then lower the loaded reel into the developing tank. Lower it smoothly to avoid generating bubbles, but also rapidly enough so that the part of the film that enters the solution first will not develop significantly longer than the part that enters last. The instant the reel strikes the bottom of the tank, press the timer to start timing development. Use your index finger to agitate the reel up and down to dissipate air bubbles that may have clung to the film. Secure the tank with its lighttight cap and turn on the lights.*

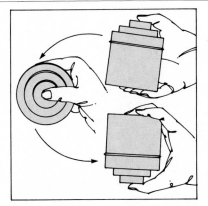

**6 agitate the tank**

*To begin the crucial step of agitation, hold the bottom and the top of the tank together, to prevent the top from accidentally falling off, and turn the tank upside down. Right it, then tap it down hard either in the palm of your hand or on the bottom of the sink. Keep inverting the tank vigorously two or three times in about 4 to 5 seconds. Then place it in the tray until the following periods of agitation, which should not be as vigorous or as long (3–4 seconds). Be sure you have read the information packaged with the film for specific data on the agitation intervals required by your film and developer. Between all agitations, keep the tank in the temperature-control tray.*

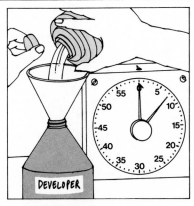

**7 drain the developer**

*About 20 to 30 seconds before the developing time is to expire, remove the cap from the developer solution bottle. About 10 to 15 seconds before the timer sounds, uncover the pouring hole of the tank and rapidly drain all solution into the developer storage bottle through a funnel. (If you are using a developer replenisher, pour the replenisher into the developer storage bottle before draining the tank. Thus, if the bottle overflows, only used developer spills, rather than replenisher.) When the developer has been emptied, return the tank to the temperature-control tray.*

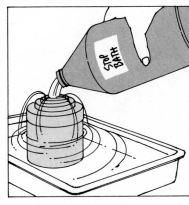

**8 pour, agitate, and drain the stop bath**

*Pour stop bath of the proper temperature through the developing tank's pouring hole until it is full. Place the cap on the tank. Agitate for 10–15 seconds, remove the cap, and empty the stop bath back into its storage bottle. Place the bottle in the temperature-control bath.*

silver and cause loss of detail in the image; also, if the film becomes overly saturated with fixer, the final wash will not remove all of it, jeopardizing image permanence.

Film should be agitated in a consistent way when it is immersed in any solution, to be sure that fresh solution constantly reaches all areas and that all areas get equal coverage. For this reason, agitation is especially critical when film is in the developer. The tank should be agitated vigorously at first to dislodge air bubbles, which cause spots on the negative. The intervals between agitation

periods depend on the film and developer being used. If the manufacturer specifies more than 5 minutes of developing time, you usually have to agitate once each minute. If the developing time is less than 5 minutes, agitation every 30 seconds is usually required. Again, be sure to familiarize yourself with the information included with your film and chemicals.

Photographers disagree about wiping. Some believe it is better, after processing, simply to hang film up to dry. Others wipe it before or after hanging it. The first argue

that the benefits of wiping the film are not worth the risk, inherent in wiping, of scratching the film. The others argue that a gentle wiping is necessary to prevent water spots and to remove dust or dirt that would mar the negatives. The guidelines include wiping, but you will have to make your own decision about whether or not to do it.

When processing is completed, dry the film in a room or cabinet that is dust-free, not subject to extremes of temperature, and preferably away from heavily traveled areas. You can also use a bathtub or shower stall

## processing roll film (continued)

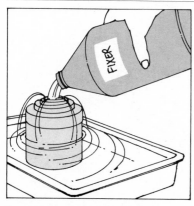

**9 pour, agitate, and drain the fixer**

*Pour fixer into the developing tank until it is full. Place the cap on the tank. Agitate periodically, according to the manufacturer's instructions. Usually after 3 minutes you can take the lid off the developing tank; check the instructions that come with your film to be sure. If the film is on a stainless-steel reel, you can now remove it to check the results, because stainless steel permits reloading wet film. Plastic reels do not permit reloading, but you can check the outside part. When film has first been fixed, it has a cloudy appearance which disappears in a few minutes. A common practice is to fix it for twice the length of time it takes this cloudy appearance to clear. After examining your film, return it to the fixer for the remaining fixing time. Fixer is reusable and should be poured back into its container.*

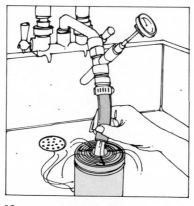

**10 rinse in water (first rinse)**

*You may use a film washer (see step 12) or the developing tank for this rinse, which should be a brief (about 2 minutes) rinse in running water controlled at 68° F (20° C). This rinse, which precedes immersion in the washing aid, helps to remove excess fixer and thus helps prolong the life of the washing aid if it is used for many batches of film. If you are using a washing aid that is discarded after one use, the first water rinse, by removing excess fixer, helps increase the effectiveness of the washing aid and thus helps increase the permanence of the image.*

*If you are using the developing tank for washing, put it in the sink. Also, in this case empty it periodically during the washing period because fixer-laden water is heavier than pure water and tends to settle at the bottom of the tank, impairing the washing effectiveness.*

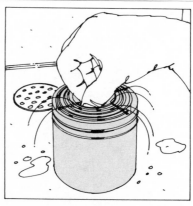

**11 pour, agitate, and drain washing aid**

*Take the reel out of the film washer and put it in the tank (or leave it in the tank if you washed in it). Fill the tank with washing aid and gently agitate the reel in the tank from time to time by moving the reel up and down. The exact time in the washing aid depends on the brand. (Pour the washing aid back into its bottle or discard it, depending on its type.)*

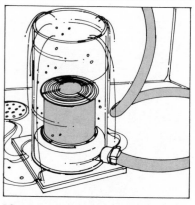

**12 rinse in water (final rinse)**

*Put the reel in a film washer. Use a lot of water at 68° F (20° C) for the final rinse. Rinsing time varies from 10 to 20 minutes, depending on the washing aid used in step 11 (see manufacturer's instructions). A film washer is recommended because it distributes water constantly and automatically through the reel. If you put the reel in a modified juice container with holes punched near the bottom or if you use the developing tank, be sure to fill, agitate, and drain often to remove the fixer-laden water from the bottom. Regulate the drainage so that some water always flows over the top of the film, covering it at all times. Especially in winter, air bubbles are likely to form when warmer water is added to cooler. If the bubbles are not removed, areas of the film they cover will not be sufficiently washed; raising and lowering the reel periodically in the container or tank helps to dislodge them.*

with the curtain drawn to keep out dust. Elimination of dust is important, because if any impurities do dry on a negative, they become embedded in the emulsion and print as white spots. They are almost impossible to remove, even by resoaking in wetting agent.

As soon as the film is dry, remove it from the drying area to prevent accidental damage. If water should accidentally splash it, wet the entire negative immediately in wetting agent, wipe off the excess, and hang it up to dry again.

Cut the dry film into strips. Six-exposure-length strips are suggested for 35mm film and four-exposure-length strips for 120 or 220 film. Do not cut each negative individually, because such tiny segments are difficult to handle. Store negatives in appropriate envelopes (see page 151).

Negatives are easily wrinkled and highly susceptible to scratches. Dirt or lint can be brushed or blown off a negative before it is printed, but fingerprints are hard to remove without damaging the film. Always handle film by its edges. If you do accidentally get finger-

prints on a negative, wipe with a wad of cotton moistened with a commercial film cleaner or pure alcohol.

After processing, be sure to rinse the developing tank and reel in very hot running water so that no wetting agent will carry over into future batches of developer and contaminate them. Don't forget to clean the lid and pouring hole of the developing tank. Make sure that all the other items used for processing are well rinsed and placed in a clean place to dry. Wipe chemicals off the timer, light switch, and sink.

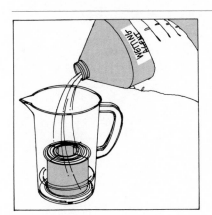

**13** soak the film in wetting agent

*You can soak the film in the wetting agent either on the reel, at this step, or after removing it from the reel, step 14. Photographers who wipe their film before drying it apply wetting agent at this step by placing the reel in a beaker, pouring in the wetting agent at 68° F (20° C), leaving it for 30 seconds, and then draining it back into the storage bottle. Photographers who do not wipe their film usually remove it from the reel at this stage, then place the film and wetting agent in a photo tray.*

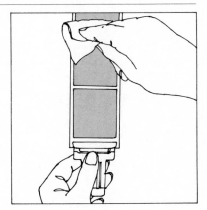

**14** wipe and dry the film

*Remove the film gently from the reel, remembering to handle it carefully and only by the edges. Then attach it to a line by a film clip or clothespin. Place another clip or clothespin on the bottom to weight it and prevent curling, which could cause one area of wet emulsion to dry against another and form a permanent bond. Above all, be sure the film is clipped securely—if damp negatives fall on the floor, they almost always become dirty beyond repair.*

*To wipe film with a photo chamois, thoroughly soak the chamois in wetting agent and squeeze out. Fold the chamois into a pad and hold the film taut at the bottom while gently wiping off the excess water with the pad. When the pad gets damp, resoak and squeeze it out again. Wipe gently and carefully and keep your wiping aid thoroughly clean, since any minute debris could scratch the film.*

## *What Went Wrong?*

**I**f your film is removed from its carrier properly and loaded properly and otherwise processed according to instructions, your negatives should faithfully reflect exposure conditions. But processing mistakes can be made—even the most experienced photographers occasionally make them. Different mistakes produce different defects in negatives and the prints made from them. The photographs on pages 160–164 illustrate some of the more common processing errors and the captions discuss how to avoid them.

160

**film improperly loaded onto reel**
*Creased or wrinkled film results in a print spoiled by crescent shapes where the negative was damaged. Such defects are caused by forcing film to bend too much while loading it onto a stainless steel reel. To prevent this kind of damage, arch the film slightly while loading, but do not bend it.*

**film improperly threaded on reel**
*Improper threading of film onto a reel may cause certain areas of the film to touch each other and therefore remain undeveloped because the chemical solutions cannot reach them. The central area of this negative was not developed.*

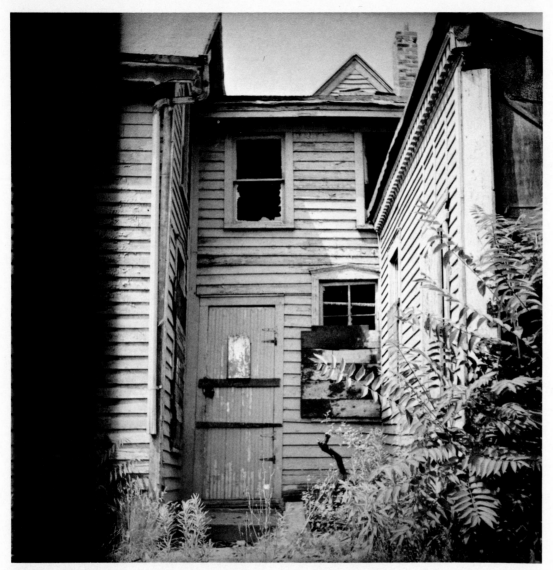

*162*

**too little developer**

*When the developing tank is not filled to the top with developer, partial development results. This print came from a tank only three-quarters full of solution. The dark streak runs vertically because the negatives were positioned so that the image was side down in the reel.*

**drastic change in solution temperature**

*Drastic changes in solution temperatures during processing cause reticulation, a cracking of the emulsion that ruins the film, as shown in this print, which is an enlargement of a section of such a negative. Most modern films tolerate slight changes in solution temperature, but constant temperature control is the only way to prevent such accidents. Less drastic temperature changes can produce negatives that are too grainy.*

**air bubbles not dispersed in developer**

*Air bubbles sticking to film in the developer cause clear (undeveloped) spots on the negative, which print as dark spots. This is why the developing tank must be agitated vigorously at first, as described on page 157.*

164

**too little agitation in developer**

**proper agitation in developer**

**too much agitation in developer**

▲ Too little agitation causes undesirable tonal variations. In this print it caused the light gray areas in the middle (to the right of the black squares), the darker gray area between the two signs, and the mottled tones of the letters on the right. These distortions are caused by "bromide drag," which results when developer is exhausted. As it is heavier than fresh developer, it sinks to the bottom of the tank, if not agitated, producing streaks, usually in areas where black is next to white.

▲ Proper agitation, as described on page 157, causes all areas of the film to develop equally and consistently. The result is evenly distributed tones, which reflect the real tones in the scene.

◄ Too frequent and too vigorous agitation causes the edges of the film to develop more than the center. Thus the edges are darker in the negative and lighter in the print—not noticeable in some photographs but a problem in scenes with light tones. Sometimes you can compensate for excessively developed areas during printing (see burning in, page 222), but proper agitation will prevent the problem.

*Other Methods for Processing Roll Film*

**W**hen extremely even development is required, you may decide to use a special developing procedure called the *roll and unroll method*. This method is suitable for 120 roll film, but not for 35mm or 220 roll film because of their long lengths. It is an ideal method when you want to inspect a roll during the processing in order to determine the best developing time (see below).

The roll and unroll method requires four 8 × 10-inch (20 × 25-cm) developing trays arranged in this order: water, developer, stop bath, fixer. There should be at least ½ gallon (2 liters) of solution in each tray.

The same rolling and unrolling action—described and illustrated in steps 1, 2, and 3—is repeated throughout the process in each of the trays. After rolling and unrolling the film through the water, as described, drain the film and insert it in the developing tray in the same way it was inserted in the

water (step 1). Since the film is now softened by the water, it is easier to immerse in the developer. The rolling and unrolling motion agitates the film throughout the process.

After development, drain the film briefly, then roll and unroll it through stop bath and fixer. A minute or so after immersion in the fixer, the film will be sufficiently fixed so that you can turn on the lights.

Place the film on a stainless-steel reel for rinsing, washing aid, and wetting agent. □

165

**the roll and unroll method for processing 120 roll film**

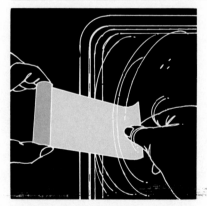 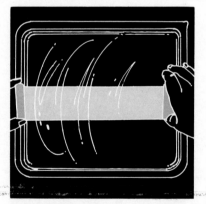 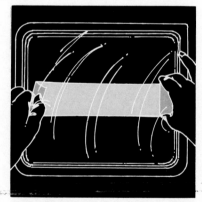

**1 unroll and immerse the film**

*Unroll the film by separating it from the paper leader and letting the film roll back on itself. Then, as shown, hold the roll in your left hand and use your right hand to lead it out for about 6 inches (15 cm). The direction of the curl should be up, so that the emulsion side faces you. Then, with your right hand, place the end of the film in the tray of water at the far left-hand side of the tray.*

**2 roll the film**

*After a few seconds in the water the film becomes limp. Move your right hand to the right-hand side of the tray while feeding more film into the water with your left hand. This gradual immersion of the film prevents it from sticking to itself. When all the film has been immersed, keep it under water and use your right hand to roll it up into a small coil. Be very careful when rolling it not to touch the emulsion; handle it only by the edges. Often, the sharp lead and tail edges of the film scratch the first and last exposures. For this reason, most photographers who use this method do not use the first and last exposures.*

**3 reroll in the opposite direction**

*Keeping the coil immersed, start unrolling at the other end; reroll the film in the opposite direction. Repeat this steady and consistent rolling and unrolling motion during the entire processing time. Keep the roll stretched to the full length of the tray while rolling or unrolling, in order to permit the longest length of film to come into contact with the solutions.*

# The Relationship Between Exposure and Development

**underdevelopment by 50 percent**

**underexposure
by two stops**

a

**normal exposure**

d

**overexposure
by two stops**

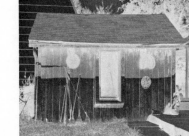
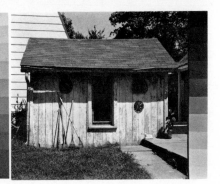

g

Both exposure and development control the degree and quality of contrast in a negative. Contrast is determined by the different densities of metallic silver in adjacent areas of the negative. The rule is: *expose for the shadows and develop for the highlights.* The film should receive enough exposure to get detail in the shadow areas. If not enough light enters the camera to render these areas of the scene, no amount of development will "bring out" detail. Development controls the highlight areas—that is, the brighter portions—since it determines how opaque a white area in the scene will be on the negative. Development should make the highlight area in the negative dark, but not so dark that there is no detail. If there is too much development, the highlight area will be so dark that light cannot penetrate it; the highlights will be stark white in the print.

The nine pairs of negative and positive prints reproduced here show how exposure and development affect contrast in the same scene. The top row shows underexposure (two f-stops less than normal); the center row shows normal exposure; the bottom row shows overexposure (two f-stops more than normal). Each exposure was developed differently. The left column shows underdevelopment (50 percent less development than normal); the center column, normal development; the right column, overdevelopment (100 percent more than normal).

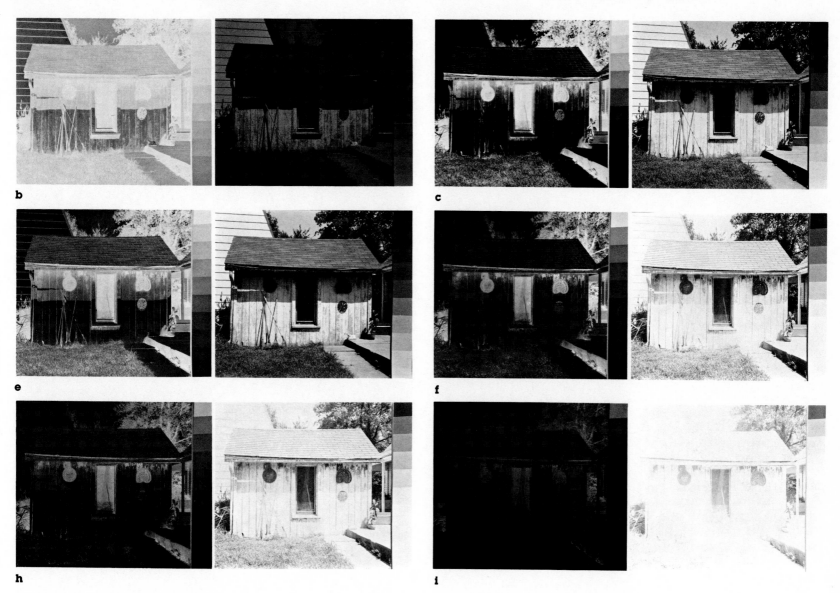

b

c

e

f

167

h

i

The normally exposed and developed negative and its corresponding positive (*e*) have a full range of tones with well-defined detail in both the shadows and highlights. The underexposed and underdeveloped negative (*a*) is almost clear, but the resulting print is dark overall. Because all detail is missing, the entire scene is obscured. The shadows did not get enough exposure and the highlights did not get enough development. In the overexposed and overdeveloped negative (*i*), tonal information is lost in the shadows and highlights, as in *a*, but the negative is very dense, producing a washed-out print. The shadows received so much exposure that they are rendered as a light gray, while overdevelopment filled in the highlight areas.

Underexposure and overdevelopment (*c*) produces greater than normal contrast. Underexposure did not give as much detail as normal exposure in the shadow areas, and overdevelopment reduced details in the highlights. Overexposure and underdevelopment (*g*) gives just the opposite effect—a flatter than normal rendition with very little difference between the various grays on the scale. Underdevelopment gave so much detail in the highlights that they became gray instead of white. All these results are shown also on the gray scale at the right of each image, where 18 percent gray is the fifth frame from the top.   □

## Processing Underexposed Film

**T**aking pictures in available light, that is, in light found at the scene without aid of flash or floodlights, often produces accidentally or intentionally underexposed negatives. An accident may occur, for example, if you have forgotten to set the meter for the appropriate film speed. However, when you are forced to compromise because there is not enough available light for a normal exposure, underexposure may be intentional. In a dark situation, for example, the light meter may indicate an exposure of $\frac{1}{30}$ at the maximum f-stop of the lens being used. If the action of the scene cannot be adequately stopped at $\frac{1}{30}$, you may decide to use a $\frac{1}{125}$ setting, thereby underexposing the negative, and then use the developing process to compensate for the underexposure.

The general rule in compensating for underexposure by overdevelopment is: increase the developing time by 50 percent for a one-f-stop change and by 100 percent for a two-f-stop change. A two-stop underexposure is usually the limit for this compensation method. The stop bath, fixing, and wash steps remain normal.

An alternative processing method for underexposed film is to use a high-energy developer, such as UFG, Acufine, or Diafine. Follow the manufacturer's instructions for developing time. A high-energy developer generally produces a slightly better result in such cases than increasing developing time with a general-purpose developer. The negative and positive prints compare results using different processing methods for underexposed film with a normal negative.

Increasing developing time or using a high-energy developer are often spoken of as procedures to "push" film (see page 102). For example, Tri-X film, which has a manufacturer's rating of 400 ASA, may be "rated" at 800, 1200, 1600, and even 2400 when you plan to develop it with a high-energy developer. Do not be misled, however, by these "increases" in film speed. The actual ASA of a film cannot be changed by changing the developer or the processing time. If a film has an ASA of 400, a negative exposed at 1600 will be underexposed by two f-stops.

This becomes evident when comparing the shadow detail in the four negatives. The shadow detail in the normally exposed and developed negative is ample because it had ample exposure. There is less shadow detail

168

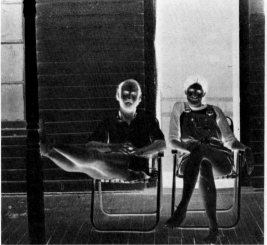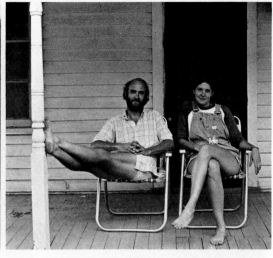

**normal exposure, normal development**

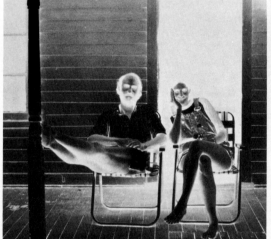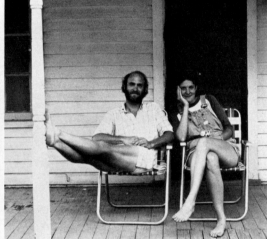

**underexposure by two stops, doubled development time**

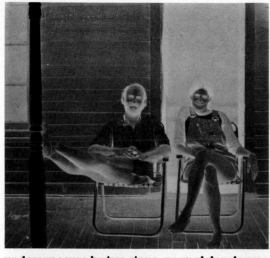

**underexposure by two stops, normal development**

**underexposure by two stops, high-energy development**

in the other three because of underexposure, and it does not change much from one to the other, even though different developing techniques were used. If the speed of the film had really been changed, the density in the shadow areas would also have changed. *Extended developing time or high-energy developer do not change the film speed; they do increase the contrast.* Contrast is harsher when general-purpose developer is used with extended developing time than it is with a high-energy developer, which produces a little more detail in shadow areas, less contrast, and finer grain. Thus, if a higher ASA number than the film's normal ASA is used, and if a high-energy developer is used, the resulting photographs will be slightly different in tonality than they would have been if normally exposed and developed.

*These negative and positive prints show how tonal qualities can be changed by variations in developing time or high-energy development. The normally exposed and developed negative and its print show a full range of tonal contrast. The underexposed, normally developed negative is thin, with little contrast; its print is gray and lacks detail. The underexposed negative developed for twice the normal time has more contrast than the second negative and even more than the normally exposed one, but the print lacks much of the subtle detail of the normal print. The underexposed negative developed in a high-energy developer (Acufine) is closer to the normally exposed and developed negative than to the others. It has somewhat more detail in the shadow areas and considerably more in the middle and highlight areas without being too contrasty.*

*This photograph was taken at night with only a distant street light for illumination, using an extremely fast film. The high-energy developer used to develop the film produced the graininess and contrast.*

170

Increase in contrast when using a high-energy developer is even further compounded when photographing in artificial light. Because fewer objects in the scene reflect light into the dark areas, contrast is greater. Many available-light photographs are made in artifical-light conditions; they usually are grainy and contrasty. In naturally lit scenes, where a greater number of objects reflect light, the shadows are seldom as dark and the photographs do not look as contrasty.

*Processing Extreme-Contrast Exposures*

Increasing development time usually increases contrast. The reverse is also true: decreasing development time usually decreases contrast and may help to improve the tonal range in contrasty scenes. Another method for bringing out greater tonal range and detail in a scene marked by *extreme* contrast—such as only bright sun and dark shadows—is the two-bath developer technique. This method may be used with either a specially mixed developer, such as Kodak's D-23, or a general-purpose developer, such as D-76.

D-23 consists of two developer solutions that you mix yourself from chemicals in the proportions given in the Formula for Two-Bath Developer. Make sure the water is hot enough and that the chemicals are dissolved in the order in which they are listed in the formula. Agitate the film in the first solution for about 3 minutes at 68° F (20° C), beginning with an agitation period of 30 seconds and then with one of 5 seconds every 30 seconds thereafter. Next, transfer the film to the second solution at 68° F (20° C) for 3 minutes with no agitation. Increasing the time in the first solution to as much as 8 minutes will affect the contrast. Keep the time for the second solution the same.

To use the two-bath method with D-76, follow a first solution bath of D-76 with a plain water bath. Develop the film at 68° F (20° C) for 1 minute, agitating for the first 30 seconds. Then place the film carefully in the water bath at 68° F (20° C) and leave it there without agitation for 2 minutes. After this, return it to the developer for another 30 seconds with a 5-second agitation and then return it to the water bath. Continue alternating between developer and water until the desired contrast is achieved.

If you are developing roll film with either of the two-bath solution combinations, you should carefully raise, turn over, and replace the reel in the tank after each second solution bath in order to prevent streaks. With either method, you will need to do tests (or make a number of duplicate exposures if using sheet film) to establish the timing that produces the results you want.

The two-bath method works because the first solution saturates the film with developer, but depending on the thickness of the film, little or no development occurs in this solution. Placing the film in the second solution activates the developer, causing the highlight portions of the film rapidly to exhaust the developer in these areas, so that density ceases to build. The shadow areas do not exhaust the developer as quickly, and so they continue to build density. This compensating action results in a more even distribution of tones and a reduction of contrast. Because of the way this method works it is more suitable for a thick film such as Tri-X than for a thin film such as Panatomic-X.

**formula for two-bath developer**

| first bath | second bath |
|---|---|
| water (125°F, 51°C)   750 ml | Kodalk   10 grams |
| Kodak Elon (Metol)   7.5 grams | water   1,000 ml |
| sodium sulfite, desiccated   1,000 grams | |
| water   1.0 liter | |

*171*

The two photographs of a dark interior flooded with brilliant sunlight show the different tonal values of negatives developed by the normal and the two-bath methods. In both photographs the standard adopted for measuring contrast was the light tone of the sidewalk in direct sunlight. Thus evaluated, the second print seems to offer a greater range of tones.   □

172

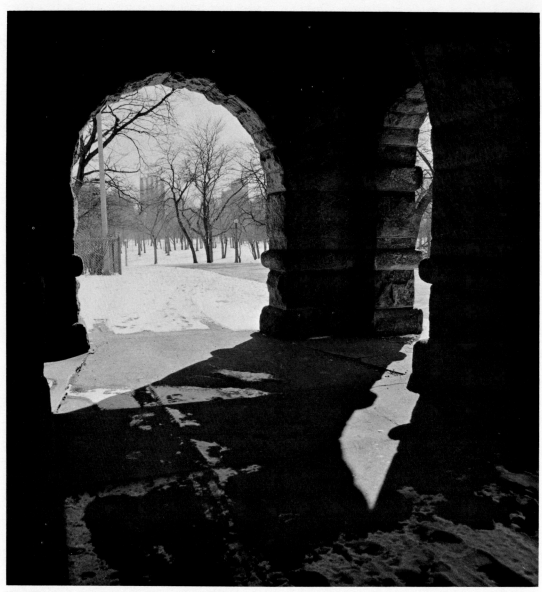

*This photograph, developed normally, shows a very high degree of contrast.*

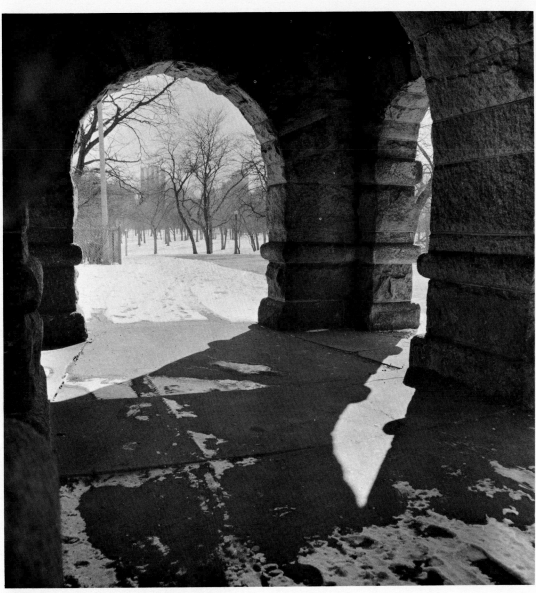

*The two-bath developer technique brought out a range
of intermediate tones.*

173

# Altering the Quality of Negatives

Nearly every photographer has at one time or another made errors in exposure or development. When these errors result in negatives that are too poor in quality to yield satisfactory prints, the negatives can sometimes be salvaged with an intensifier or a reducer. A thin, underdeveloped negative needs intensification and a thick, opaque one needs reduction. These procedures are difficult and not always successful and should be resorted to only if there is no chance to make a new exposure.

*Intensification* increases the opacity of a negative by depositing tiny particles of a metal such as chromium on the image. These particles compensate for underdevelopment and offer a slight correction for underexposure. There are three types of intensifiers. *Subproportional* improves opacity in the shadow areas. *Proportional* helps to correct deficiencies in both shadows and highlights and is therefore most commonly used. *Superproportional* strengthens opacity in highlights and enhances contrast.

174

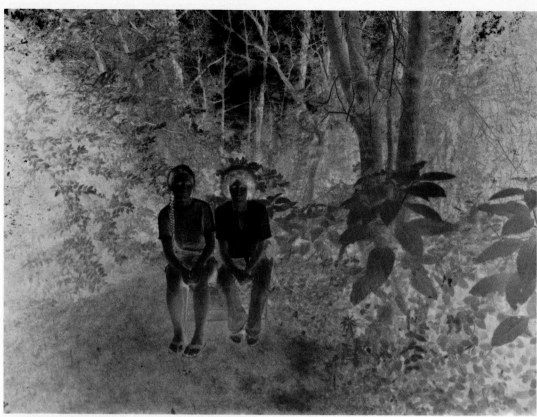

**before intensification**

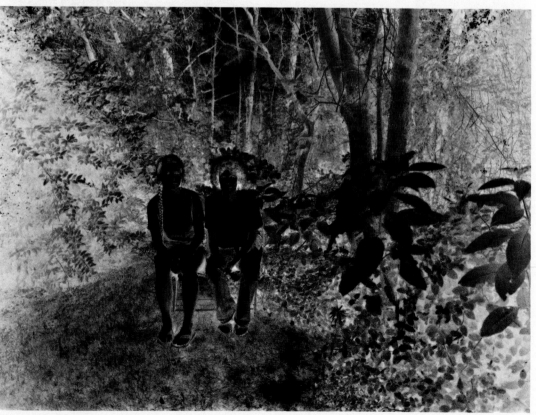

**after intensification**

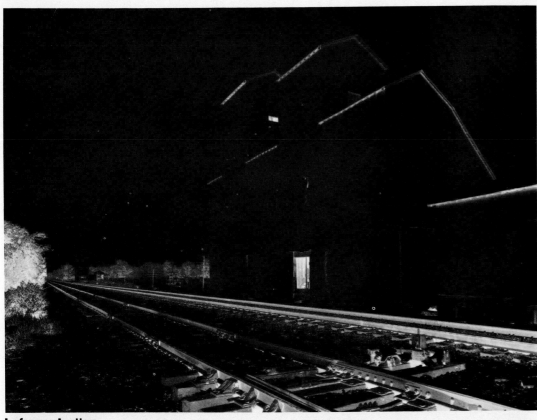

**before reduction**

*Reduction* decreases the opacity of a negative. Kodak offers easily mixed preparations, of which there are three types. *Subtractive,* or *cutting,* counteracts overexposure by diminishing silver density equally over the whole negative, so that contrast is not affected. *Proportional* reduces both contrast and overall density and is used when a negative is too opaque for enlarging. *Superproportional* tones down highlights and decreases contrast. The last of these is rather difficult to control.

Before intensification or reduction can be attempted, a negative must be thoroughly fixed and washed. This makes observation difficult, since a wet negative appears somewhat different from a dry one. You should treat one negative at a time, and wash it immediately afterward. Complete instructions accompany the packaged intensifiers and reducers.

The illustrations here compare negatives before and after intensification and reduction.  □

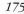

**after reduction**

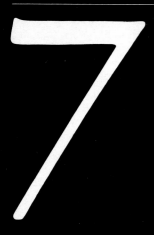

Ideally, every photographer has a personal darkroom for developing and printing. Though it is possible to develop film without a darkroom (see Chapter 6), printing film does require a *dark* room—a lighttight space big enough to hold the equipment and supplies discussed in this chapter and Chapter 6. The requirements for a school or other darkroom that will be shared by a number of photographers are different from the requirements for a home darkroom for use by one or two people.

This chapter concentrates on home darkroom facilities, equipment, and supplies. It orients you to the darkroom, so that it will be easier for you to follow the discussion of print processing in Chapter 8. To equip a darkroom completely, you will need to combine the supplies and equipment for film processing that were described in the last chapter with the additional items discussed in this chapter.

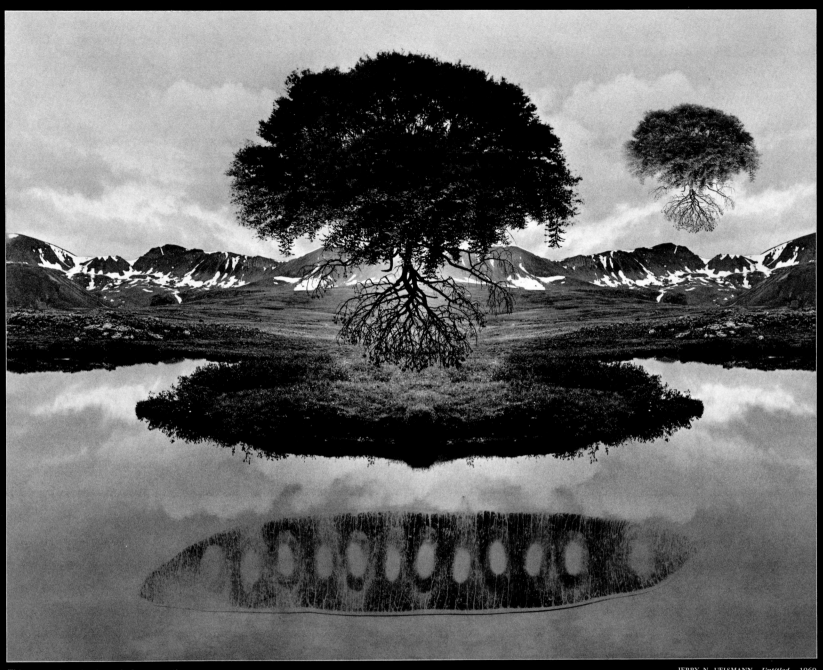

*This composite print is made from negatives in a series of enlargers.*

177

JERRY N. UELSMANN. *Untitled.* 1969.

The ideal home darkroom is a permanent space where equipment can be set up and left for use whenever it is needed. A darkroom space must have enough room for the orderly arrangement of equipment and supplies and for separate wet and dry areas for film processing and printing. It must be made completely dark. It must have adequate ventilation. It also should have a source of water and must have electrical outlets. Each of these requirements is discussed in detail below.

*Space* is a primary consideration in a darkroom. For maximum efficiency, the room should be large enough to contain the necessary equipment but not so large that you will get tired walking back and forth between areas that are too far apart. The diagram shows the size and shape of a well-organized and well-equipped darkroom and the efficient placement of its contents. (This darkroom is an ideal one. In most homes, various modifications and adaptations would be necessary.)

*Total darkness* is essential to a darkroom. If the room you intend to convert to a darkroom has windows, they must be made lighttight. You may cut mount board or cardboard to the inner dimensions of the glass and tape it around the perimeter with black plastic electrical tape. Or you may drape black plastic sheeting, the kind used to cover construction equipment, over the windows. Plastic sheeting is more lighttight than any woven fabric because it is a continuous, unperforated material. When it is first installed and heated by the sun this material may give off an unpleasant odor, but it eventually diminishes. Or you may cover the windows with black "darkroom cloth," rubber-laminated on one side, which you can tack or tape to the window frame. This same lighttight material is used in camera bellows.

When you have blocked off the windows, check to see how lighttight the room is by sitting in its darkness for a few minutes. If any small cracks are visible, cover them. The door to the darkroom should be weather stripped or draped to prevent light from entering at the bottom. If more than one person will be using the darkroom, you may

want to construct a light-trap or sliding-door entrance.

The darkroom walls and ceiling can be any color. Even if the room has white walls, if it is lighttight, it will be dark enough when the lights are off. Only the area immediately surrounding the enlarger should be painted flat black to prevent reflectance or glare from the enlarger lamp.

Because a darkroom is sealed off from outside air, an alternative means of *ventilation* is important. An exhaust fan is usually enough, but an air conditioner helps make a darkroom a pleasant and productive place to work in. It not only lowers the temperature in summer, but also can be used year-round to recirculate air and bring in fresh air, to filter out dust and dirt particles, and to remove the humidity caused by evaporation from solutions and running water.

The darkroom should be divided into two areas: a *dry area* for handling negatives and paper and a *wet area* for development and print processing. Having separate dry and wet areas prevents accidental splashing of water or chemicals on dry negatives. The dry area should have a counter or tabletop large enough to lay out negatives and printing paper and to hold a paper cutter and the enlarger. The wet area should have a counter or tabletop (or sink) large enough for a successive arrangement of five processing trays. To protect the wet area and to make cleaning up easier, this surface should be waterproofed by giving it two or three coats of a polyester resin or epoxy enamel or by covering it with Formica or linoleum.

If you convert a room without a sink into a darkroom you will have to transport chemical solutions and water to and from the room in buckets. This is rather inconvenient, but many productive photographers do manage quite well with such an arrangement, using the bathroom or kitchen for washing film and prints. However, for greatest efficiency a darkroom should have running hot and cold water installed in it.

A *photographic sink with running water* is very convenient because with such a sink you can rinse prints between fixing them and washing them. This is better than having

them sit in a tray of water, where residual chemicals can accumulate, before washing. Depending on your finances and your desire for permanence, you may build a sink yourself or you may buy a stainless-steel or fiberglass sink. If you build it yourself of wood, paint it with epoxy resin, cover it with fiberglass cloth, and coat it with other layers of resin. While pouring chemicals into the sink, always be sure to run the tap water so the pipes will not corrode.

The ideal darkroom provides plenty of *work space* and *storage.* In addition to space for equipment, there should be an area for sorting negatives and reviewing proof sheets and plenty of shelving, drawers, or cupboards for the clean and safe storage of lenses and condensers. There should also be definite areas for storing developing tanks, thermometers, and other small items of darkroom equipment. Permanent storage areas save time when you are locating items in darkness or low light.

Many *electrical outlets* are needed for the safelights, timer, clock, enlarger, and print-viewing light. Do *not* use cheap extension cords or multiple three-way plugs; both can cause fires. A "plug strip" available at most hardware stores is good because it contains four, six, or eight outlets in one metal unit with a switch to control them. Electric darkroom appliances do not need much wattage individually, but when combined they may overload the circuit, so be sure the power supply is adequate.

The light fixture that may already be installed in the ceiling of a room is usually not suitable for examining prints because its light level may be low and because it may cast shadows. A light near the fixing tray is better. Some photographers use a regular frosted light bulb in a photo-flood reflector. Others prefer a light on a swivel mount in order to vary the angle of light. The special photographic safelights needed for processing prints are discussed on page 185.

*Cleanliness* is especially important in a darkroom, for dust and dirt and chemical contamination make clean prints impossible. Washable work and storage surfaces and a washable floor help control dirt. □

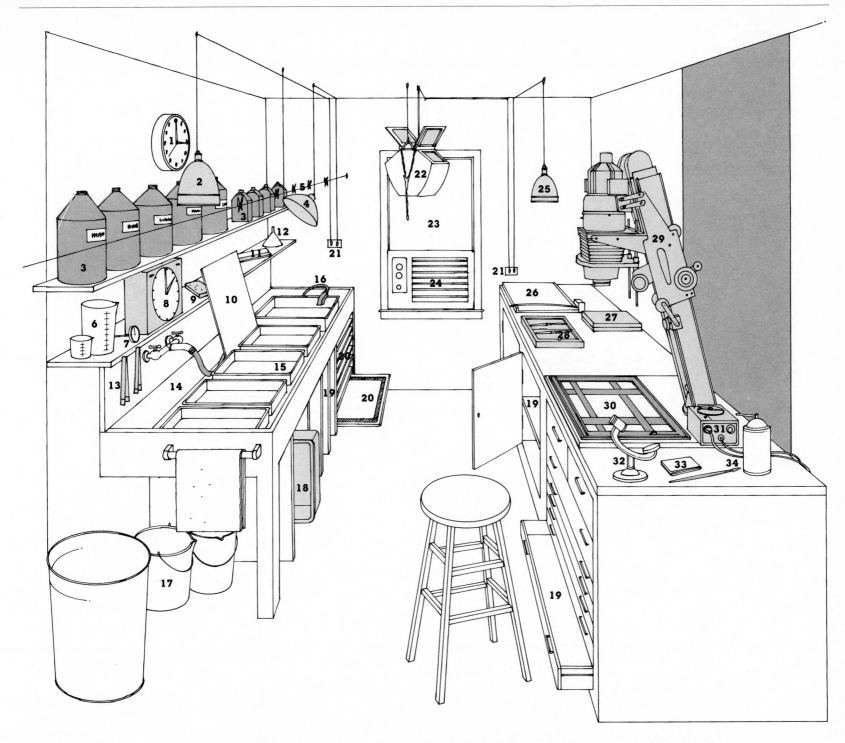

179

1 sweep-second timer
2 safelight with filters
3 chemicals for film and print development
4 print-viewing light
5 clothesline and clothespins
6 graduates
7 thermometer
8 interval timer
9 sponge
10 Plexiglas viewer
11 squeegee
12 funnel
13 tongs
14 sink with faucet and drainage
15 trays (5)
16 siphon print washer
17 pails (2)
18 temperature-control pan
19 drawers, cabinets, shelves
20 drying frames with blotters
21 electrical outlets
22 indirect light safelight
23 darkened window
24 air conditioner
25 contact printing or flashing light
26 paper cutter
27 printing paper
28 contact-printing frame
29 enlarger
30 enlarger easel
31 enlarger timer
32 focusing magnifier
33 lens tissue
34 negative cleaning devices

# The Enlarger

An enlarger is a height-adjustable projector mounted on a supporting column so that it beams light through a negative and on through an enlarging lens. The lens bends light rays from the negative image to fall on and focus as an enlargement on the printing paper. The paper is held in an easel at the base of the supporting column. Adjusting the height of the enlarger head controls the distance from the lens to the image it forms on the paper; this distance scales the image and determines the enlargement size.

The enlarger head houses the enlarger's principal working parts. Its height is adjusted by sliding or cranking it up and down the supporting column. The enlarger light source is usually an incandescent bulb.

The light from the lamp passes through the condenser system: two convex lenses that distribute light uniformly over the negative in order to prevent dimness around the edges of the print. The negative carrier, positioned over an opening between the condenser system and the lens below, holds the negative flat and level. The focusing knob brings the image into focus on the printing paper by moving the lens up and down to make fine adjustments in the distance between lens and paper. The bellows makes this focusing possible.

The lens functions just as the camera lens does; it bends light rays and conveys them to the focal plane where light-sensitive photographic paper rests. Like the camera dia-

phragm, the enlarger diaphragm is calibrated in f-stops; each succeeding larger f-stop doubles the exposure and each succeeding smaller f-stop halves it. On most enlargers the adjustment of the diaphragm produces clicks so that in the dim light of the darkroom the photographer can tell when an adjustment has been made.

The device for adjusting the height of the enlarger head varies with the brand of enlarger. It is usually either a hand crank (as on the large Omega enlarger) or an electric motor (as on the large Beseler enlarger). At the base of the enlarger column is a baseboard to support both the superstructure of the enlarger and the easel, which holds the photographic paper.

180

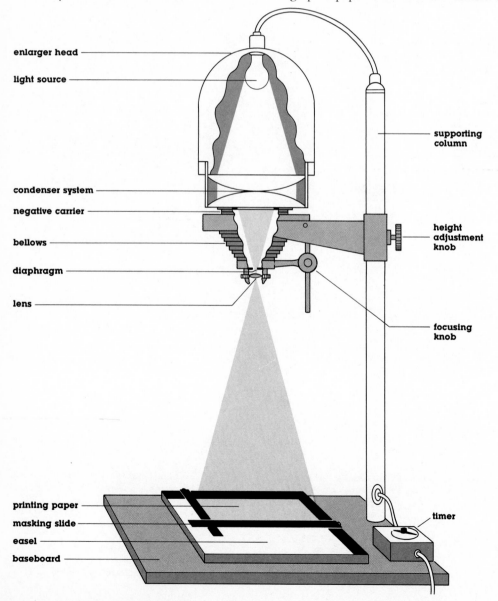

enlarger head

light source

condenser system

negative carrier

bellows

diaphragm

lens

supporting column

height adjustment knob

focusing knob

printing paper

masking slide

easel

baseboard

timer

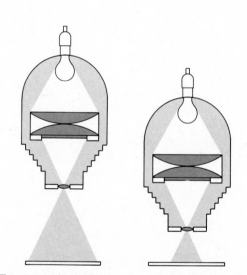

*The amount of magnification of an enlarger depends on lens-to-paper distance. The longer the distance, the larger the image projected on the easel.*

## Types of Enlargers

**E**nlargers may be classified according to the system used to distribute light evenly over the entire surface of the negative. The two basic systems are diffusion and condenser. A number of enlarger lighting systems use either condenser or diffusion distribution, but one (the dichroic lighting system) can use both. Five of these lighting systems are illustrated and discussed here.

In general, prints made from normal-contrast negatives with a *diffusion* enlarger tend to have softened details and a rather diffused appearance, an effect frequently preferred in portraiture. The tonality is soft and low in contrast.

The focused directional light in the *condenser* enlarger makes sharper prints because the grain of the film is rendered more clearly. Such intense illumination and sharp resolution generally produce the best results with small films, such as 35mm.

Although it is often assumed that the illumination system affects the contrast of a photograph, it is the *negative* that controls contrast. Either a diffusion or a condenser enlarger can be used to make prints with the contrast you want. However, to make prints with the diffusion system that have the same contrast as with the condenser system, you need negatives with somewhat greater than normal contrast. In general, the contrast of negatives should be adjusted to the type of

illumination system that you will use to print them.

The *dichroic* enlarger was designed to print color negatives and color transparencies, but it may also be used with black-and-white negatives and variable-contrast paper (see page 190). Most dichroic enlargers have diffusion lighting, but some use condensers. Dichroic heads are available to convert some condenser enlargers to a dichroic system; other cheaper enlargers are exclusively dichroic and are limited to small-film formats.

The illumination requirements for color negatives and transparencies are different from those for black-and-white negatives. A black-and-white image is formed by clumps of tightly packed silver particles, but a color

## enlarger light systems

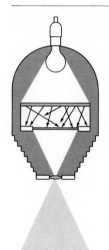

**the diffusion system**
*A sheet of frosted or cloudy glass intercepts the light rays beamed from the lamp and, by refraction, diffuses—spreads—them generally. Because refraction scatters light rays randomly in many directions (as shown by the arrows), some light rays never reach the negative while others overlap. The result is an overall loss of light before it enters the main lens.*

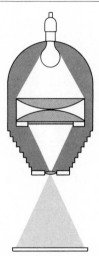

**the condenser system**
*Light passes through two convex lenses, called condensers, placed as shown. This arrangement gathers light and controls it to spread the beams uniformly and project them directly through the negative. The condenser system loses little light, transmitting most of it to the paper. The straight line of the projection minimizes the overlapping of light rays.*

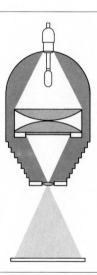

**the point-source system**
*Condensers are used in this system, but the regular lamp is removed and replaced by a special small bulb that produces directional light. The aperture is kept wide open at all times, and a transformer controls the intensity of the light. The bulb is moved up and down in the housing to maintain even light distribution when the enlarger is raised or lowered.*

181

cold-cathode lamp tube     diffusing screen

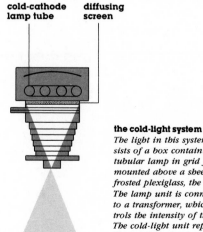

**the cold-light system**
*The light in this system consists of a box containing a tubular lamp in grid form, mounted above a sheet of frosted plexiglass, the diffuser. The lamp unit is connected to a transformer, which controls the intensity of the light. The cold-light unit replaces the regular enlarging lamp housing.*

light-integrating chamber     infrared dichroic filter

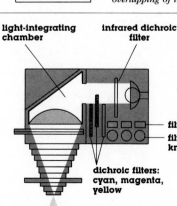

filtration indicator scales
filter control knobs

dichroic filters: cyan, magenta, yellow

**the dichroic system**
*The light source is a bulb with a built-in reflector (similar to those used in slide projectors). Its light passes through pieces of glass (filters) coated with a very thin layer of metal compounds. An infrared filter absorbs infrared light rays. The light is then reflected into the light-integrating (color-mixing)*

*chamber, which is necessary to mix the light, since some of it has already been filtered and some has not. Next, light passes through a condenser or diffusion system. After passing through the negative or transparency, it then passes through the lens to the photographic paper on the easel.*

image is formed by layers of colored dye. These layers do not scatter light and absorb only some of it. Thus color printing does not require as intense a light source as black-and-white printing. Because the dichroic enlarger is primarily for color work, it includes a series of colored filters. The metal compounds on these filters reflect rather than absorb light, as regular gelatin filters do. Different metal compositions determine whether a filter reflects red, green, or blue light. Dichroic filters last longer than gelatin because they do not fade, and since they are self-enclosed they cannot be easily handled, which reduces the risk of breakage and scratches. They provide a large and continuous range of color filtration densities, making possible many subtle color corrections. If you are using a dichroic enlarger to print black-and-white negatives on variable-contrast paper, follow the paper and enlarger manufacturers' instructions for the filter combinations that will give you the contrast grade you want.

The even light distribution of the *cold-light system* is preferred by many photographers, because they feel it helps to ensure that the tones they see in a contact proof sheet will be retained in enlargements. Early model cold-light systems used circular fluorescent tubes that were not very bright; the resulting long exposures restricted their use. Newer cold-cathode lamps are much brighter and are available in many sizes to accommodate different brands of enlargers. One model of cold-light system incorporates two grids of different colors so that it can be used with variable-contrast papers. This system is not usually used for color printing.

The *point-source system* is generally used only for extreme enlargements from small negatives, for excessively dense negatives, or for extreme sharpness.

Dust is always an important consideration in the use of an enlarger, since dust on the

negative will mar the print. In general, condenser-type enlargers require cleaner working habits than diffusion enlargers. The lighting system in a dichroic enlarger is specially designed to help prevent dust or dirt on a color negative or transparency from appearing on the resulting print. With color negatives these spots are white on the print and are difficult to eliminate; with color transparencies, they are black and even harder to eliminate. The quality of light in the cold-light system reduces the effect of dust and dirt.

Another problem with some enlargers is "popping" of the negative. If a negative gets too hot from the heat of the light source, it may expand and "pop" out of focus. One of the advantages of the cold-light system is that it eliminates the possibility of popping.

## Choosing an Enlarger

**I**f you are planning to buy an enlarger, first analyze your current and future needs. If you will be using only 35mm film, you can buy an enlarger that takes only this size, but if you also use or expect to use 120/220 and $4 \times 5$-inch ($10 \times 12.5$-cm) film, you will need an enlarger capable of handling all three film sizes. The most flexible choice is an enlarger that accommodates the largest film size you will use, because it can be adapted to smaller sizes. An enlarger designed for small-film formats cannot be adapted to larger ones.

Price is important. Some inexpensive enlargers are adequate for occasional use, but would wear out quickly in a commercial or shared darkroom. The type of illumination also depends on your needs. The standard condenser enlarger is generally used in schools and by commercial photographers who do no portrait work. This enlarger is a good choice for beginning black-and-white photography students. If you often make

large prints, you can get an enlarger with an extra-long column. Remember, however, that in a darkroom with a low ceiling (as in a basement), an extra-tall enlarger may be too tall. You could construct a lower table, but working at it would probably be uncomfortable. Some models can be turned horizontally to make large prints.

The enlarger should be sturdy enough so that it will not wobble. Its height-locking device should be easy to use and dependably tight. The enlarger head should be easy to raise and lower. The fine-focusing adjustment should be smooth; the lamp housing should have adequate ventilation; and the enlarger should accept bulbs of varying wattage.

Versatility is desirable. Some enlargers are part of a system concept that makes possible additions to or changes in parts. Some enlargers are easily converted to another type of illumination system merely by changing the lamp housing. If you will be using your enlarger for color printing, it should have a filter drawer. All these factors should be taken into account before you make a substantial investment in a piece of equipment you may be using for many years.

Used enlargers can often be bought at considerable savings, and the same factors should be considered as with a new enlarger. In addition, you should inspect a used enlarger carefully. If it has been heavily used or abused, it may have worn parts. Such an enlarger is less rigid, and its focusing and raising and lowering mechanisms may be too loose to be dependable. Sometimes cleaning and tightening the parts is enough, but if new parts are needed they may be difficult to get if the enlarger is an old model or one that is no longer made. Check with a level to be sure that the negative plane, lens plane, and baseboard are all parallel to each other. Examine the lens and condenser carefully for scratches and tiny chips. If possible, ask the seller for a trial period.

*An enlarging lens for small film cannot cover the entire area of a large negative, even with the enlarger head lowered to its lowest point and the easel raised.*

*An enlarging lens for larger film cannot magnify a small negative enough, even with the enlarger head raised to its highest point.*

183

## Enlarger Equipment

**T**he *enlarging lens* you buy for your enlarger should match the quality of your camera and enlarger. The best negatives in the world will not yield fine prints if the enlarger lens is inferior. The *focal length* of the enlarging lens determines the degree to which an enlarger can accommodate film of a given size. As shown, an enlarger lens that is right for small negatives cannot cover the entire area of a larger negative; nor can a lens intended for larger negatives magnify a small negative enough. The table relates film sizes to the focal lengths of the enlarger lenses needed to cover them adequately.

**corresponding film and enlarger lens sizes**

| film | enlarging lens |
|---|---|
| 35mm, 110, 126 | 50mm |
| 2¼ × 2¼(120/220) | 75 or 80mm |
| 2¼ × 3¼(120/220) | 90–100mm |
| 4 × 5 | 135–150mm |

If you are on a limited budget, you may wish to buy a 75mm or 80mm lens for use with both 120/220 and 35mm film. Though this lens is most appropriate for 120/220 film, the enlarger can usually be raised enough to accommodate 35mm film. The greater height will require longer exposures, but you will be able to make 8 × 10-inch (20 × 25-cm) prints from 35mm film.

Some manufacturers of enlarging lenses offer two different models of lenses with the same focal length. The less expensive one is designed only for black-and-white printing. The more expensive one is excellent for black-and-white printing but it is also optically corrected for color aberrations—a necessity for color printing.

Enlargers for use with a variety of film sizes have interchangeable lenses. With condenser enlargers the condenser lenses must also be modified when the enlarging lens is changed. For some enlargers a specific set of condensers must be installed to match the focal length of the selected lens, to prevent light from concentrating at the center of the negative. For others, the condensers are repositioned or supplemented with additional condensers. Follow the manufacturer's modification instructions.

*Negative carriers* for enlargers are available with or without glass. Most enlargers come with the nonglazed type, and the glazed type must be bought separately. Glazed or not, the negative carrier consists of two pieces of metal hinged to close over and hold the negative in place during enlarging. A negative carrier of the right size must be used with each negative. One that is too small covers only part of the image; one that is too large lets light escape around the edges of the negative. Some photographers prefer glazed carriers because these prevent the negative from popping out of focus; the clear glass is, however, hard to keep clean. A glazed carrier takes the largest film size possible with a particular enlarger. If you want to use it with a smaller film size, you place the negative in the center and mask the surrounding areas with black paper to prevent extraneous light from exposing the paper.

The *enlarging easel* holds the paper down flat during the enlarging exposure. Some easels are designed for one size of paper; others have adjustable blades, or masking slides, for use with a variety of paper sizes. The four-blade easel is expensive but it offers the greatest choice in ways to position the image.  □

# Other Darkroom Equipment

Equipment used for film processing, such as graduates, trays, funnels, the thermometer, mixing buckets, and the timer (see Chapter 6), is also used for print processing. However, in addition to the enlarger and its equipment, other items are needed for printing in the darkroom.

Safelights are needed for both areas. The additional dry-area equipment includes an exposing timer, contact-printing frame or proofer, printing paper, paper cutter, focusing magnifier, and negative cleaning aids. The additional wet-area equipment includes five trays for chemical solutions needed in processing prints, a sweep-second-hand clock, and tongs. These additional equipment items are described below.

Because photographic printing paper is sensitive to certain colors of light, it must be handled under a *safelight*. The safelight must be of a color and intensity that will give enough light so that you can find what you need but not enough light to expose the paper. Check the instructions packaged with a printing paper for information on the correct safelight for it. The Kodak OC (amber) safelight filter used with a standard frosted 15-watt bulb at a distance of 4 feet (1.2 m) is usually safe for most brands of paper.

*Direct-* and *indirect-illumination safelights* are shown in the darkroom on page 179. Direct-illumination safelights are located in various places, such as over the enlarger, the paper cutter, and the developing area. Several are usually needed for one darkroom. Indirect illumination bounces off the ceiling and walls and gives more even and brighter distribution of light. Fixtures for indirect illumination are considerably more expensive than direct-illumination fixtures.

Five *trays* are needed for processing prints. Mark the trays: *developer, stop bath, fixer 1, fixer 2, wash.* The same tray may be used for both film and paper developer. Trays are available in sizes from 4 × 5 to 20 × 24 inches (10 × 12.5 to 50 × 60 cm). An 8 × 10-inch (20 × 25-cm) tray is suitable for smaller prints, but developing an 8 × 10-inch print in an 11 × 14-inch (28 × 35-cm) tray is easier and the print will be more consistently developed because the tray holds more solution. If the developer tray turns black from deposits of silver, the deposits can be largely removed with Kodak tray cleaner.

Whether or not to use *tongs* during print processing is an individual decision. Some photographers use their hands to agitate the paper and move it between solutions. However, *tongs are strongly recommended* because they make contamination and allergic reactions to chemicals unlikely. Tongs are available in stainless steel, plastic, and wood. Tongs with rubber tips are less likely to scratch the prints. To prevent contamination, use different tongs for different solutions. Labeling them to match the tray labels will help prevent mistakes.

The typical *exposing timer* has two switches: one to turn on the enlarger light so that the image can be projected for scaling, composing, and focusing; the other to make the exposure for a preset duration. The first light must be turned off manually, but the second is usually connected to the electrical supply of the enlarger so that it automatically turns off when the exposure is completed. Some of the newer electronic darkroom timers are designed for both developing and printing, but most timers are specifically either for film processing or enlarging. If you do not have an automatic timer, you may turn the enlarger lamp on and off while watching the second hand on a clock or counting to yourself to time printing; however, a separate enlarger timer is more reliable. In addition to the timer, you will need a large (10–12-inch or 25–30-cm diameter)

185

## testing safelights

*Test safelights when you set up the darkroom. The "coin method" of testing is popular, though not entirely reliable. Place a coin on a sheet of photographic paper and expose them both to the safelight for 4 or 5 minutes. Develop the paper and examine it. If the area covered by the coin is white and the surrounding area is gray, the light has exposed the paper and is unsafe. This test only shows a drastic level of fogging; it does not show slight fog, which darkens the white in the highlights and still is not obvious in the white border area of the print.*

*There is a more reliable safelight test. Make a good print (following the instructions in Chapter 8) with an extra-wide border (at least ½ inch or 15mm) with the safelights on. Develop this print and mark it No. 1. Expose and develop a second print in total darkness; mark it No. 2. Expose a third print in total darkness, but, before development, place it on a piece of cardboard under the safelight that is over the developing tray to test that specific light. Take another piece of cardboard and move it across the print to reveal increasingly larger segments; expose it in increments of 0, 1, 2, and 4 minutes to safelight illumination; the result is a test strip with exposures of 7, 3, 1, and 0 minutes. Develop this print with the safelights off and mark it No. 3. If there are no differences between the three prints, specifically in the highlight areas, the safelights are safe. If No. 1 is flatter than No. 2, it was fogged, and the safelights should be adjusted. If any strip of the No. 3 is flatter than No. 2, it was fogged by the light over the developing tray. The problem of too much illumination can usually be solved by moving the safelight farther from the work area or reducing the wattage of the safelight bulb or projecting the light on the ceiling.*

*sweep-second-hand clock* near the developer tray to time the developing period.

A *paper cutter* is used for cutting large sheets of photographic paper into smaller ones for test strips and small prints. Either a guillotine or a rotary blade cutter is suitable, though the rotary type usually cuts a more precise edge—useful when trimming prints before mounting them (see page 235).

A *contact-printing frame,* a *proofer,* or a sheet of ¼-inch (6mm) plate glass is needed to produce contact prints and proof sheets. The 8 × 10-inch (20 × 25-cm) frame is suitable for most needs.

With a *focusing magnifier,* you can examine the grain of the image being projected on the easel to be sure the image is in focus. There are many types of magnifiers at varying prices; read the manufacturer's instructions carefully to learn how to operate yours.

Like film, prints must be washed free of all chemical residue for permanence. A workable arrangement for print washing is a tray with a hose attachment. Be sure that enough water can be supplied, that the temperature range can be checked and controlled, and that the prints can be hand-rotated throughout the washing period. The tray should be larger than the prints being washed.

A photographic *print washer* is an excellent investment. Models range in price from ten or so to several hundred dollars; the amount spent should depend on the volume of work anticipated. A tray siphon can handle as many as six prints, and a circular stainless-steel washer (the type most often used in schools) takes many more. A commercial studio may need a floor-model washer. An *archival print washer* gives the best protection from deterioration of the image. Either by water pressure or an electric motor, water circulates constantly in a print washer to prevent the prints from sticking together and to wash over all surfaces. Just as in a film washer, good drainage of heavy fixer-laden water is important for proper print washing.

The type of *print dryer* you choose depends on which print-drying method best suits your budget and available space, the number of prints you make, and the type of printing paper you use—some papers take longer to dry than others. Print dryers vary from a simple line and clothespins to the large drum dryer used by commercial studios. Print dryers and drying methods are discussed on pages 206–207.

Negatives often have static electricity, which attracts dust or lint. A soft camel-hair brush, an antistatic cloth, compressed air, or a safe film cleaner will remove dust before printing. *Antistatic brushes* and *cloths* are helpful in eliminating the static electricity.

Other useful darkroom items include a *squeegee* or windshield wiper to wipe excess water off the prints; a *sponge* for wiping up spills; and *black construction paper* and *black wire* for dodging and burning in areas of pictures (see pages 220–227). ☐

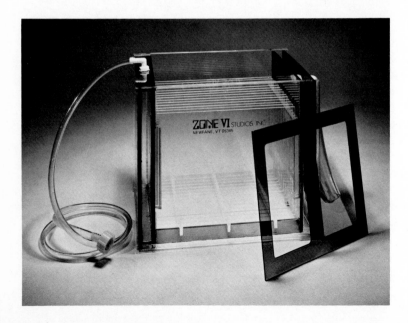

*An archival print washer holds each print in a separate compartment. Thus no prints can overlap and water can freely wash all surfaces of all prints.*

# Photographic Printing Paper

Printing papers are made with various light-sensitive emulsions, which make possible a number of tones and surface finishes. By choosing a particular emulsion you can make black-and-white images look golden or silvery, crisp or soft.

Except for panchromatic paper for printing black-and-white photographs from color negatives, the emulsions on paper are deliberately made *orthochromatic,* that is, insensitive to a certain color of light, so that you can work by the illumination of a colored safelight. The emulsions on printing paper do not react as fast as film emulsion.

The immense variety of tones, colors, and surface finishes available in photographic printing paper may tempt you to experiment broadly with various types. To avoid confusion it is better to learn to control printing with one paper before trying another. Each photographic paper is characterized by its own *paper base and coating, image tone, base color, surface luster, speed, contrast, weight,* and *size.* Each of these qualities is discussed below.

Photographers have used many materials to make prints, including albumen, platinum, and carbon. Silver is now used. A fiber base, that is, actual paper, was the support material for all these types of prints. The fiber base is now used for two quite different kinds of printing paper. *Fiber-based papers,* as they are called, have a baryta coating to prepare them for the emulsion. *RC papers* (resin-coated papers) are newer; they have a fiber-based support but are coated on both sides with a polyethylene resin. This coating makes it possible to use less emulsion; also, as the emulsion cannot soak into the base (as it does with fiber-based papers), a lower quality, thinner paper base can be used.

The range of available fiber-based papers has diminished in recent years, because of decreasing demand and increased production expense. One exception is a new fiber-based Ilford paper called "Ilfobrom Galerie."

Many commerical photographers prefer RC papers because prints may be developed in 1 minute, fixed for 2 minutes, washed for 5 minutes, and dried in a few more minutes. The amount of time saved over printing with traditional fiber-based paper increases productivity. However, RC papers are generally not used by photographers who wish to produce museum-caliber prints; they are still too new to have been tested for permanency.

Depending on the size and form of the silver granules in the emulsion, photographic papers have different kinds of *image tones,* ranging from reddish brown to black. A paper with a brown or brown-black tonality is said to be "warm," a quality that comes from an emulsion of silver bromides. A "cold" blue-black tonality comes from an emulsion that is almost entirely silver chloride crystals. Most photographic papers are neutral, with a slightly warm, brown-black tonality. Some photographers feel that the tonal qualities of RC papers are not as good as those of fiber-based papers.

The *base color* of the paper supporting an emulsion varies from off-white through cream and ivory to pure, gleaming white. The color quality of a print is a combined effect of the paper base color and the emulsion tonality. An off-white color, for example, yields a warm tonality; such paper usually has a warm emulsion. Typically, a cold emulsion is used to coat paper with a stark white base color. Brighteners, which glow slightly under ultraviolet light and transmit a brilliant white quality to paper, are added to some papers for the whitest effect.

*Surface luster* refers to both the texture and the finish of photographic paper. Like color and image tonality, luster has a pronounced effect on the ultimate appearance of a print. The texture can be rough or smooth, resemble burlap, linen, or silk, and have either a highly reflective *glossy* finish, a medium *semi-mat* finish, or a nonreflective, dull *mat* finish. The mat finish dims highlights, suppresses details, and generally reduces the tonal range of photographs, compared with photographs printed on paper with a glossy surface. RC paper is available in gloss and semi-gloss finishes.

The *speed* of photographic paper varies; some papers are more sensitive to light than others and can be printed faster. There are two general classifications according to speed: contact-printing paper and projection (or enlarging) printing paper. The first reacts to light more slowly. In contact printing the paper is closer to the light source; thus this

187

slower paper can produce high-quality images without the speed necessary for projection paper. Projection-printing paper is also used for making contact prints.

Papers have a variety of *contrast* qualities that enable the photographer to suppress, exploit, change, or otherwise control the degrees of lightness and darkness that were in the original scene during the printing process. Low-contrast paper tends to reduce value variations and unify all elements of a picture within a limited value range. Its smoothed tonal ranges and flattened contrast are often preferred in portrait photography. High-contrast paper dramatizes the blacks and whites in a photograph. Medium-contrast paper produces the broadest range of tones.

RC papers come in only one *weight,* or thickness, but fiber-based papers come in three: light weight, single weight, and double weight. Kodak Type A is one brand of lightweight paper, used primarily for making paper negatives and such purposes as passport photos. Single-weight paper is the least expensive and most frequently used. Double-weight paper is twice the thickness of single weight and works better for enlargements measuring 11 × 14 inches (28 × 35 cm) or more. It is less likely to wrinkle when a number of prints are washed and dried simultaneously. A wrinkle breaks the emulsion and ruins the print, since it cannot be repaired. Because double-weight paper is expensive, it is more economical for the beginning photographer to work first with single-weight paper.

Paper is available in different sizes. Precut sheets come in sizes from 2½ × 3½ to 20 × 24 inches (6 × 9 to 50 × 60 cm). Larger sheets may be cut from rolls 20 or 40 inches (50 or 100 cm) wide and 10, 30, or 100 feet (3, 9, or 30 m) long. The small sheets, up to 8 × 10 inches (20 × 25 cm), come in packages of 25, 100, or 250.

Since paper is light-sensitive, it should be stored in a lighttight container and in a cool, dry place; emulsion deteriorates rapidly if exposed to heat or moisture.

*188*

*Two prints of a photograph of a gray scale that shows a full range of tones from black to white.*

**low-contrast Kodak grade 1 paper**          **high-contrast Kodak grade 5 paper**

### *Graded and Variable-Contrast Papers*

**P**hotographic papers are numbered according to *grades* of contrast—from 0, for soft or low contrast, though 2 or 3, considered normal, to 5, which has the most contrast. Many photographers routinely stock their darkrooms with 100-sheet boxes of the medium-contrast grades and 25-sheet packages of the low- and high-contrast grades.

The lower the contrast grade of the paper, the greater the potential of the paper for producing a wide range of tonal variations. High-contrast paper deepens blacks and brightens whites and thus removes details that gradations in between would produce. Note the greater number of gray tones in the gray scale printed on low-contrast paper. The choice of which contrast grade to use for an image is yours. In some cases you may prefer extreme contrast, in others the widest possible range of tones.

A sheet of *variable-contrast paper* can be used within a range equal to paper grades 1 to 4. This paper is coated with a mixture of two emulsions separately sensitized to yellow and blue-violet light. You vary the contrast in a print by exposing the paper with light projected through a colored filter. A yellow filter produces a low-contrast image characterized by a wide tonal range; a blue-violet filter produces higher contrast.

The filters used with variable-contrast paper are graded in half-steps from 1 to 4, providing a total of seven different grades of contrast. The number 2 filter produces the closest to normal contrast, but the highest number filter (4) usually does not produce as high a contrast as the highest graded paper (5). The main point is that the difference between the lower grades and the higher grades is considerable. For example, when a normally exposed and developed negative of a normal-contrast scene is

**range of contrast
with variable-contrast paper and filters**

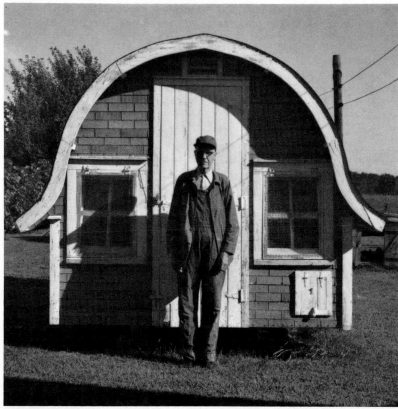

**filter number 1**

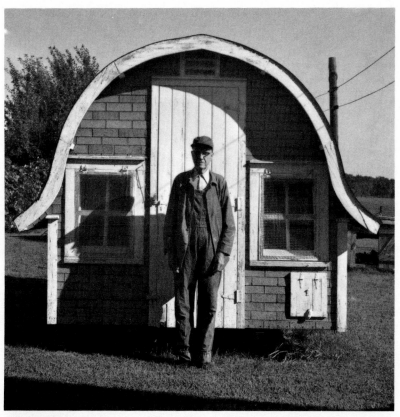

**filter number 1.5**

190

**filter number 2**

**filter number 2.5**

printed on number 1 or number 2 graded paper or on variable-contrast paper with a number 1 or number 2 filter, it has a greater range of tones than when it is printed on number 5 graded paper or on variable-contrast paper with a number 4 filter.

Image density varies according to the color of the filter. Thus exposure must be changed to compensate for a change in filters. Exposure computers that come with the filters have scales that show how to change the correct exposure used with one filter to the correct exposure for another filter.

The photographs on pages 189–191 show the interpretations possible with a single negative when printed on variable-contrast paper with filters in the seven contrast grades.

You need to add an OC (amber) safelight filter to the safelight for variable-contrast paper. This paper is sensitive to a wide range of tones, and the safelight must be made safer than for graded papers. It is a good idea to install an OC safelight filter in any case in order to use both kinds of papers.

An enlarger for use with variable-contrast paper must accept filters. Enlargers that hold filters above the condensers are more practical than the ones that hold filters below the lens, where the holder can obstruct both the passage of light and access to the aperture-adjustment control. Another problem with below-the-lens filters is maintenance. Filters must be kept scrupulously clean to prevent dust, dirt, or lint from softening the image, and this is more difficult for filters positioned outside the enlarger head.

Both variable-contrast paper and filters are manufactured by Eastman Kodak and Ilford. Kodak offers both fiber-based (Polycontrast and Polycontrast Rapid) and RC paper (Polycontrast Rapid II RC). Ilford offers only RC variable-contrast paper (Multigrade).

## Special Printing Papers

In addition to the papers already described, there are several types of special papers for particular purposes. Three of the more common types—printing-out paper, stabilization paper, and rapid-processing paper—are discussed below.

When *printing-out paper* is used, the image appears as soon as the paper is exposed, without any processing. However, if the prints are not toned in a gold toner and fixed, they will continue to darken. A beautiful red-brown image can be formed by intense exposure to sunlight or an artificial light source high in UV radiation (such as carbon arcs) or UV fluorescent bulbs.

*Stabilization paper* and *rapid-processing paper* are used when speed is the most important factor and permanency is not essential. Stabilization paper, such as Kodak's Ektamatic SC paper, has developing agents in its emulsion and is processed in a special stabilization processor. After exposure, the print is fed into the machine where an "activator" solution develops the image almost instantly. It is then transported to the "stabilizer," which helps reduce the print's sensitivity to light. The print comes out damp dry

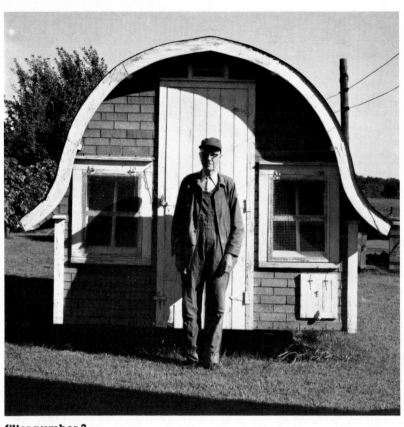

**filter number 3**

**filter number 3.5**

in about 15 seconds. These prints are not permanent and should not be kept with properly fixed and washed prints. The stabilization processing machine is very portable, since all it requires is an electrical outlet and two solutions.

A rapid-processor machine requires a more permanent installation, with running water. Paper for this type of machine, such as Kodak's Kodabrome II RC, has developing agent in its emulsion. A rapid processor develops the image and stops, fixes, and washes it. The print comes out dry in 55 seconds. This is a more permanent print than a stabilized print, which has not been fixed or washed. The processor is very useful for commercial photography because it requires only a small amount of space, can produce as many as 720 8 × 10-inch (20 × 25-cm) photographs an hour, and is simple to operate. The papers for stabilization and rapid processing are not interchangeable, but both types may be processed normally in trays with regular solutions. □

**filter number 4**

The chemicals for developing photographic prints are somewhat similar to those for developing film into negatives. There are important differences, however. Developer suitable for film is too weak for paper, most of which develops in 1 to 2 minutes, while film takes about 5 to 20 minutes. Stop bath and fixer can be the same strength for both film and paper, but fixer is usually less concentrated for paper and contains less of the hardener that helps to strengthen the gelatin component of film. The hardener is sometimes omitted if the prints are going to be toned (see page 232).

The chemical solutions for print processing are made by a number of companies, and there are subtle differences among brands. It is a good idea to become used to the results with one brand before trying another. Some manufacturers publish formulas for photographers who would rather mix their own developers from raw chemicals. Follow the instructions of solution and paper manufacturers in making solutions for print processing.

The differences among brands of print developer are less marked than among brands of film developer. Fundamentally, there are only two types of print developer: one for a warm, soft tone and another for a cold, hard tone. A warm-tone paper developed in a warm-tone developer, such as Kodak's Selectol, gives prints with the warmest tonality. A cold-tone paper developed in a cold-tone developer, such as Kodak's Dektol, gives prints with the coolest tonality.

In print processing, development is sometimes stopped by flushing the print with water rather than stop bath. However, because stop bath neutralizes the developing agent instead of merely washing it away, it is better to use it.

Stop-bath solution can be used for many prints. It is exhausted when it fails to remove the slippery coat that developer leaves on the surface of the print. Solution no longer up to full working strength should be thrown out. Do not try to revive exhausted stop bath by adding acetic acid to it.

A washing aid is helpful in print processing because it cuts washing time in half. After washing prints in water for a few minutes, transfer them to the washing aid. Such a washing aid is especially useful in winter, when the supply of warm water may run out during a long washing time. □

193

Wilbers produced this photograph with two devices of his
own design. The first attached the camera to the tripod in
such a way that a series of exposures could be made 24°
apart on the horizontal axis and 36° apart on the vertical
axis. The second device was used for printing. All 36 nega-
tives in the series were exposed sequentially with a specially
designed printing easel that allowed all of the exposures to
be printed on a single sheet of printing paper. The resulting
photograph has a very interesting feeling of space.

TIMOTHY A. WILBERS.   *Polyspheroid Water Tower.*   1980.

# The Print

Printing—the third stage of the photographic process—converts a negative image on transparent film into a positive image on opaque printing paper. This is done by projecting light through the negative onto paper coated with a light-sensitive emulsion. During the exposure of the paper, black areas of the negative block the light, thus preventing certain areas of the paper from being exposed; after the paper is developed, these unexposed areas are white. On the other hand, clear areas of the negative allow light to pass through and expose certain areas of the paper; after the paper is developed, these areas are dark. The photographs on the opposite page show this reversal of lights and darks between a negative and its positive, the photographic print.

After the paper is exposed, the procedure for developing a print follows in a general way the steps described in Chapter 6 for developing film into negatives. During the printing process, however, you can *see* the various stages of development and make decisions about your handling of the print accordingly. An exposed print is first placed in developer, an alkaline solution that converts the exposed silver halide crystals in the emulsion of the paper into metallic silver. Next, it is placed in stop bath, an acid solution that arrests the chemical action of the developer. Then the print is placed in a fixer that removes all unexposed (and therefore undeveloped) silver halide crystals. Finally, it is washed to remove all residual chemicals and dried. Then, when appropriate, it is prepared for presentation.

In this chapter, procedures for exposing and developing prints and various ways of presenting them are discussed.

negative image

positive image

The first step in producing a photographic print is exposure of photographic paper to light beamed through a negative. Procedures for exposure differ depending on whether you are making contact prints or projection prints (enlargements). These are discussed below. When paper has been exposed it is developed according to the development procedures on pages 203–207.

## Contact Printing

**I**n *contact printing* the negative is placed in direct contact with the printing paper. Contact printing is commonly used to print large negatives and to produce a *contact sheet* (also known as a *proof sheet*), a single sheet on which all the frames from a given roll of film are grouped. A contact print gives the sharpest image possible from a negative because it is a direct print from the negative, in the same size.

A contact sheet is a valuable intermediate stage in the process leading to final prints. When you examine the small prints, you can see much more easily than by looking at negatives which images you wish to enlarge. A contact sheet is particularly useful when you have various exposures of the same subject. Each frame on a roll of film is numbered on the film, and the numbers show on the contact sheet. You find a particular negative by first noting its number on the contact sheet and then locating it by number among the negatives of that roll. Contact sheets are useful also for filing negatives, since each roll of negatives and its corresponding contact sheet can be given a number. This method is more efficient than trying to see the images on the negatives, and it also reduces the risk of damage to a whole collection of negatives by searching through them.

In contact printing the emulsion side of the negative, which is dull, and the emulsion side of the paper, which is usually shiny, must contact each other. The curl of both film and fiber-based paper is usually toward the emulsion side. With flat RC (resin-coated) papers, the shiny emulsion side can be seen under the safelight. The name is printed on the back of Kodak RC papers—a help in determining which side is which.

Both contact printing paper and enlarging paper may be used to make contact prints. Contact paper needs more exposure

196

*A contact sheet enables you to identify the negatives you want to enlarge from a given roll of film. Examine the prints with a magnifying glass and mark the ones you want with a grease pencil.*

*Four ways to make contact prints. The least expensive way is to use ¼-inch plate glass (center front). A print proofer (left) is a piece of glass hinged to a metal back that is covered with a thin sheet of sponge foam. A contact-printing frame (right) is a wood or metal frame fitted with a spring back that holds the negatives and paper together under a glass lid. A contact printer (center rear) is an entirely self-contained device for making contact prints. It has its own lights and timer.*

than enlarging paper. Which paper to use depends on your printing method and your aesthetic preference for one type of paper or the other.

In making contact prints, you can choose from four ways of holding the negatives and paper in contact during the exposure. These are: a piece of ¼-inch (6mm) plate glass (with ground edges for safety); a print proofer; a contact-printing frame; a contact printer.

For any method of making contact prints, use only the correct safelights for the paper. Also, for any method, always clean the glass before making prints.

To use *plate glass,* place the printing paper on a table under the exposing light source with its emulsion side up. Place the negatives on top of the paper, emulsion side down. Place the glass on top so that it presses paper and negatives together flat against the table.

To use a *print proofer,* place the paper emulsion side up on the sponge foam of the proofer. Place the negatives on the paper with the emulsion side down. Bring down the glass for a firm contact between paper and negatives.

For the *contact-printing frame,* see below.

The contact-printing frame and the print proofer work better than the piece of plate glass because negatives do not slip around as easily.

## making a contact sheet with a contact-printing frame

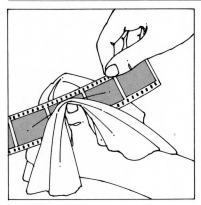

**1 clean negatives**

*Use a negative cleaning aid (see page 186) to clean dust from negatives.*

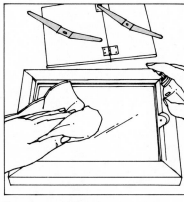

**2 clean the printing frame**

*Place the frame glass side down and remove the back of the frame by turning and pushing down on the spring clips. Clean both sides of the glass.*

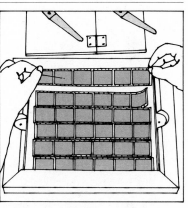

**3 place the negatives**

*Place negatives on the inside of the glass, emulsion side up. Turn off the room lights, leaving only the safelight.*

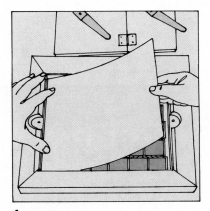

**4 place the paper**

*Take the paper out of its box and place it, emulsion side down, over the negatives.*

**5 prepare frame for exposure**

*Replace the back of the frame and lock it in position. Turn over the frame and expose, using the enlarger or a bare bulb; see page 198. (To determine the exposure, use the test-print procedures, page 202.)*

197

The exposing light source for contact printing can be either a bare incandescent bulb or the enlarger lamp. A bare bulb works better with contact paper than with enlarging paper, but the light from the enlarger can be used with either paper. To use the enlarger as the exposing light source, leave the empty negative carrier in the enlarger and raise the head until the beam of light makes a rectangle about 11 × 14 inches (28 × 35 cm) on the baseboard. Turn off the room lights for better visibility, leaving only a safelight. Focus the enlarger light by making its edges sharp. Close down the aperture on the lens to f/8 or f/11. Turn off the enlarger light. Arrange the sandwich of paper, negatives, and glass and place it on the baseboard. Turn on the enlarger light again for the exposure. Exposure time will vary with the strength of the light source, the distance between the light and the paper, and the type of paper. (Mark the enlarger column at the proper height for contact prints and you will be able to return it to that position quickly every time you make a contact sheet.)

A *contact printer* is more expensive than the three devices already discussed, but it has its own light sources and thus is more efficient. To use one, turn out the room lights and work by the room safelights and the red safelight that is in the printer.

Place the negatives on the glass, emulsion side up, and place the paper on the negatives, emulsion side down. You should be able to see the negatives through the paper clearly enough by the safelight in the printer to be able to position the paper properly over them. Next, put the lid down; lock it with the catch, if the printer has one. Activate the contact printer with the light switch, which times the exposure.

Many contact printers have more than a single bulb; some have many small bulbs that can be turned on or off independently to make selected areas lighter or darker. These enable you to dodge (hold back light from certain portions of the negative) or to burn in (give more light to specific areas) Dodging and burning in are discussed on pages 220–228.

Most contact printers have bulbs of the proper brightness for use with contact paper. To use a contact printer with enlarging paper you may need to replace the bulbs with others of a lower wattage. You can also reduce the light by placing sheets of clean white paper on the glass between the light and the negatives.

*198*

*A bare bulb is a good light source for making contact prints, as here with plate glass.*

## Enlarging

**E**nlarging, also known as *projection printing*, produces prints scaled larger than negatives. An enlarged print obviously does not correspond exactly to the negative, as a contact print does. But modern enlargers transform the small negative images produced by good cameras into sharp, high-quality enlargements.

Cleanliness is essential to all operations in photography, but it is most important during enlarging. Like the image itself, fragments of lint or specks of dust, even barely visible ones, will be enlarged along with the image and recorded in the print. The dust problem is usually worse in winter because low humidity leads to static electricity, which holds dust against a negative. Use a static-neutralizing cleaning aid.

The sharpness of a print is affected not only by negative size and the amount of relative enlargement, but also sometimes by improper operation of the aperture on the enlarger lens. Beginning students may forget to open the aperture all the way before focusing, and a dim image is difficult to focus. But failure to close the aperture down for the exposure will also result in loss of sharpness because the image produced with the lens wide open will not be as sharp as one produced with the lens closed down.

Another cause of lack of sharpness is vibration. Make sure the table for the enlarger does not wobble. Do not touch the enlarger table or walk around (especially on a wood floor) during the exposure.

To make an enlargement, first examine a contact sheet and choose a negative you wish to print. Next, be sure the enlarger is

**enlarging** ▶

**1 remove the negative carrier from the enlarger**

*Raise the lamp housing and remove the negative carrier, the framelike device that holds a negative flat, level, and in position over an opening between the condenser or diffusing glass and the enlarging lens.*

**2 put the negative in the carrier**

*Insert the strip of negatives, emulsion side down, into the carrier so that the chosen image is centered within the window of the frame. When the emulsion side is down, the image has the correct left-to-right orientation.*

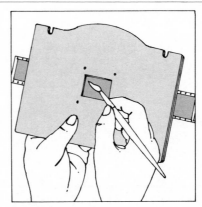

**3 clean the negative**

*If you are using a glassless carrier, hold it at an angle under a strong light, such as the enlarger lamp, and inspect the framed negative for dust. Clean it with a soft brush, an ear syringe, or compressed air. Do not blow on the negative because your breath could deposit moisture, which would produce swollen, raised spots on the negative; these would appear as blemishes and distortions in the print.*

*If you are using a glass carrier, be sure the glass is clean before you insert the negative. A negative already inserted in a glass carrier can sometimes be cleaned by gently opening the carrier and blowing the dust off with compressed air from an aerosol can.*

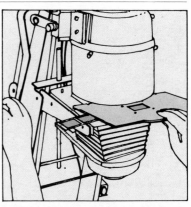

**4 return the negative carrier to the enlarger**

*Replace the carrier in the enlarger and lower the lamp housing to clamp the negative into position. Turn on the safelight and the enlarger lamp too and turn off the room lights to see the image projected by the enlarger clearly.*

equipped with a lens of the correct focal length for the size of film you are enlarging (see page 183). With a condenser enlarger, you may need to change the condensers (see page 184). Always check the enlarger lens for dust; if necessary, clean it with lens tissue or a soft brush.

Specific instructions about lighting are given in the step-by-step guidelines, but this is a good place to summarize the general principles. Turn on the safelights, particu-larly the indirect type, at the beginning of a printing session and leave them on throughout. (Don't turn them off when you turn the room lights on periodically.) Some photographers prefer total darkness when composing and focusing the image on the easel (particularly with very dense nega-tives), but others leave the safelights on during this procedure.

Step-by-step guidelines for enlarging begin on page 199.

## enlarging (continued)

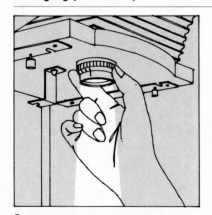

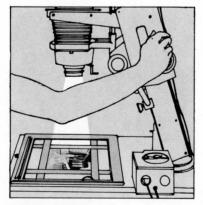

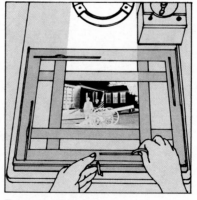

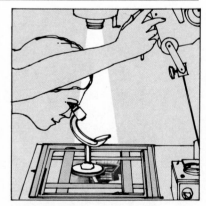

**5 adjust the aperture of the enlarger lens**

*Adjust the aperture of the lens to wide open for maximum light. Be careful not to touch the lens surface with your fingers. At this stage, before printing paper has been in-serted, the image falls on the enlarger's base-board. If the baseboard or easel does not have a white surface, place a sheet of plain paper under the easel's masking slides. The underside of photographic paper works well, because it is the same thickness as the print-ing paper. Keep a piece of paper to use just for this purpose.*

**6 scale the image**

*To get the amount of enlargement you want, raise or lower the enlarger head until the projected image fits the size you have de-cided on. To help balance the weight of the lamp housing, most enlargers have a spring mechanism that you must unlock before the head will move; do not try to force the head when it is locked, as this might break or damage the mechanism.*

**7 compose the image**

*Move the easel and use the inch-marked, ad-justable masking slides to compose and frame the image in the final size and shape.*

**8 focus the image**

*Bring the image into sharp focus by turning the focusing knob. You can use a special magnifying device on fine detail areas of the image to help you see the clearest focus. If focusing adjustments change the image size, change the height of the enlarger head slightly, adjusting back and forth between height and focus until both image size and focus are correct.*

201

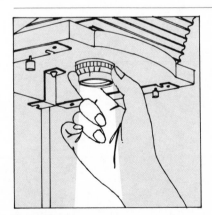

**9** **stop down the aperture**

*Stop down the aperture of the lens by two or three clicks from wide open to a smaller f-stop (f/8 or f/11). Reducing the size of the aperture gives longer exposing times, so that print controls (see page 220) may be used. If you used a sheet of paper for focusing, remove it now. Turn off the enlarger lamp.*

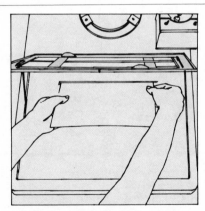

**10** **place the printing paper in the easel**

*Take a sheet of printing paper from its box; be sure to close the box. Place the paper, emulsion side up, into position under the masking slides of the easel.*

**11** **set the timer and make the exposure**

*Set the timer to the time you have decided to use. Make the exposure by pressing the button on the timer that activates the enlarger lamp. Or turn on the lamp if you are using an enlarger not connected to an automatic timer and time the exposure by a clock with a second hand. How long the exposure should be is best determined from a test print (see the guidelines for making a test print, page 202).*

*Making a Test Print*

How long to expose the paper to light is important in enlarging. The proper exposure period depends on both the paper you are using and your aesthetic intentions for a particular print. The way to determine exposure for a particular negative is to make a *test print,* which will show the exact effect of different exposure times with a specific paper and a specific negative.

To make a test print, use paper of the same type you will use for the final print. A test print can be made with a full sheet of 8 × 10-inch (20 × 25-cm) paper. However, the most efficient and economical way to make a test print is to cut only a strip from the paper; this strip should be wide enough to include all the important tonal areas of the image to be printed. The strip can be placed on the easel in whichever position—

vertical, horizontal, or diagonal—will expose it to the greatest range of tones; thus for most negatives a 1-inch (2.5-cm) wide test strip is wide enough for an 8 × 10-inch print. Diagonal placement usually gives the most inclusive range. The step-by-step guidelines show how to make a test print.

As you gain experience, you will be able to estimate what the initial exposure for the test print should be. An image that looks bright on the easel needs less exposure than a darker one. A test print can show as many as six or eight different exposure times, but four times are used in the guidelines: exposures at 5-second intervals from the shortest, 5 seconds, to the longest, 20 seconds. You may have to make more than one test strip to include enough exposure intervals to find the best one for a specific print.

For more on evaluating the test print, see pages 210–217. □

**making a test print**

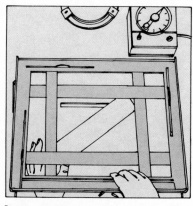

**1 place the strip and set the timer**

*Under safelight only, place the strip of printing paper on the easel in the position you want. Set the enlarger timer for the desired interval—in this case, 5 seconds.*

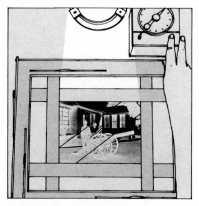

**2 expose the entire strip**

*Expose the entire strip for one interval (5 seconds).*

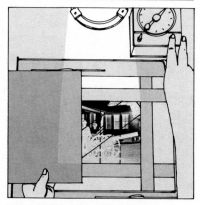

**3 make the remaining exposures**

*Using a piece of black opaque paper, such as black construction paper, cover three-quarters of the strip and expose the other quarter for another interval (5 seconds). Then move the paper to the left to expose half the strip for another interval (5 seconds) while the other half stays covered. Finally, move the paper again to the left to expose three-quarters of the strip for a final interval (5 seconds).*

## General Guidelines for Print Processing

**I**n processing a print you move the exposed sheet of paper from developer to stop bath to fixer, then through a first wash, a washing aid, and a final wash. The alkaline-based developer and the acid stop bath and fixer can contaminate each other when processing is repeated over and over for many prints. Though it would take a large amount of developer to contaminate stop bath or fixer, a mere trace of either of these could ruin developer. This is why you must take great care to avoid contamination. Use separate tongs for each solution to avoid accidents.

If the developer tongs fall into the stop bath or fixer trays, rinse them off thoroughly before returning them to the developer. The same tongs can be used for both stop bath and fixer, but it is safest to use separate tongs for each.

Developer in the developing tray, exposed to air, gradually loses strength and within a few hours can turn brown with oxidation. This happens more rapidly when prints are immersed in it. Therefore, prepare working solutions of print developer only when you intend to use them immediately. Put enough developer in the tray to make it ½–¾ inch (12–18mm) deep. Throughout the time you are using the working solution, check it periodically, with the room lights on, for brownish color. You can detect the color more easily in a white tray. You can also count prints to know when developer is exhausted—no more than twenty-five 8 × 10-inch (20 × 25-cm) prints per quart (or liter) of developer. Prints processed in exhausted developer lack deep, rich tones.

The temperature of paper developer is not as critical as that of film developer. It should be within two or three degrees of 70° F (21° C) (room temperature). Hotter developer shortens developing time and may cause low contrast and uneven development, especially if the print is removed from the developer too soon. Colder developer causes some chemicals in the developer to be less active and may produce exaggerated contrast.

The developing time you prefer may differ slightly from the paper and developer manufacturers' recommendations. The main point is to be consistent, so that your test strip and final print are coordinated. Some photographers feel that extended development times of up to 4 to 6 minutes produce more contrast and richness in the dark areas of a print. This may be true for some papers, but lengthening development can also cause chemical or safelight fogging, which reduces the whites of the highlights.

You have to make an approximate judgment about the tonality of a print while it is

**print processing**

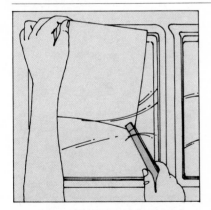

**1 immerse exposed paper in developer**

*With safelight only, as soon as the printing paper has been exposed, use the developer tongs to immerse it quickly, gently, and completely in the developer, either upside down or face up. Turn the print face up eventually in order to watch the image develop. Be sure it is always covered with developer.*

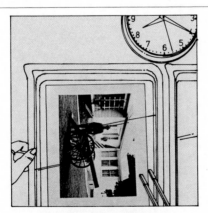

**2 agitate the print in the developer**

*To keep fresh developer solution washing over the print constantly, hold the paper under the developer with the tongs and gently rock the tray back and forth. Agitate lightly enough to avoid splashing chemicals and use as little pressure as possible with the tongs to avoid making dents in the print. Time the immersion by a clock with a large second hand, according to the developer and paper manufacturers' recommendations (usually 1 to 2 minutes).*

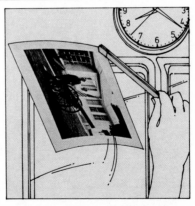

**3 drain the print into the developing tray**

*When the developing time is over, hold the print by one corner with the tongs and suspend it above the developer for a few seconds to let excess solution drain back into the tray.*

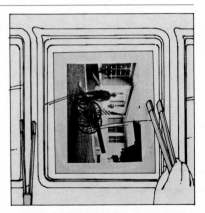

**4 immerse and agitate the print in stop bath**

*Hold the print above the stop-bath solution and let the tongs open to let the print fall into the stop bath. Do not lower the developer tongs into the stop bath. Immediately return the developer tongs to the edge of the developing tray. Immerse the print in the stop bath with the stop-bath tongs and agitate the print with the tongs. If there is a slight sizzling sound when fiber-based paper is immersed in stop bath, this merely means the stop bath is fresh. Fiber-based paper needs about 30 seconds of agitation; RC paper needs only about 5 seconds. Lift the print by one corner with the stop-bath tongs and let excess solution drain back into the tray.*

being developed. If dark areas of the image turn black in 30 seconds (with fiber-based paper), it was overexposed. If the print is still very light after 2 minutes, it was under-exposed. Under the safelights a print usually looks darker than it actually is. The only correct and accurate method for judging tonality is to examine the print in normal room light after about 1 minute of the allotted fixing time has passed.

The method you use to examine the print depends on your facilities. Most photographers place a print on a large over-turned white tray or on a piece of opaque white Plexiglas. The tonalities of a wet print are usually slightly lighter than those of a dry

one, but examining the print out of the fixer does give you a much better view than when it is in the fixer tray covered with liquid.

If you are working in a shared darkroom and you cannot turn on the room lights, place the print in an empty tray to avoid dripping fixer on the floor and take it out of the darkroom into a room with normal light. (Spilled fixer can cause respiratory problems when it has dried and been shuffled about.)

When you have returned the print to the fixer, do not fix it any longer than recommended. If the print is fixed too long, the lighter areas will bleach out and the darker areas will turn pinkish. If the print is left in fixer for hours, the image can disappear.

**print processing (continued)**

**5 immerse and agitate the print in fixer**

*Drop the print in fixer and return the stop-bath tongs. Agitate the print periodically for the time recommended by the fixer manufacturer, usually between 5 and 10 minutes for fiber-based paper and about 2 minutes for RC paper. Do not fix longer than recommended.*

**6 examine the print, if desired**

*After about 1 minute in fixer, the print can be examined in light. Drain the print briefly, place it in an empty tray or on the bottom of a tray turned over, and examine it under normal room light. Return the print to the fixer for the remaining fixing time.*

**7 rinse the print in water**

*Hold the fixed print by one corner with the fixer tongs, lift it from the fixer, and let it drain. Then transfer it to a water rinse at 65°–80° F (18°–27° C) and let it remain with water circulating around it for about 10 minutes.*

**8 immerse the print in a washing aid**

*In a shared darkroom, transfer the print to the washing-aid tray; in a private darkroom, drain the rinsing tray and pour in the washing aid. Follow the manufacturer's recommendation for time, usually from 2 to 5 minutes.*

You can process the greatest number of prints in the least amount of solution with two trays of fixer, moving the prints from the first tray to the second. The times for a common fixer (such as Kodak Rapid Fix) are about 3 minutes in the first tray and about 5 minutes in the second for fiber-based papers. For RC papers, 1 minute in each fixer tray is enough.

The solution in the first tray will become exhausted after about 150 8 × 10-inch (20 × 25-cm) fiber-based prints or about 350 RC prints in a gallon (or 4 liters) of solution. (The first tray becomes exhausted more quickly than the second). Discard the first tray of solution then and move the second tray to first position, adding a new tray of fresh solution as the second tray. This procedure can be repeated until the first fixer has been replaced four times. Both solutions should be thrown out after a week of use, no matter how many prints have been made.

In darkrooms where a number of people use the same washer, prints must be given a final wash in batches. If one print from a fixer or washing aid batch is mistakenly added to a batch in the final wash cycle, contamination results, and the final wash period must be started again.

Step-by-step guidelines for print processing begin on page 203.

205

**9 give the print a final wash in water**

*The period of time in the final water wash (65°–80° F or 18°–27° C) recommended by washing-aid manufacturers ranges from 5 to 20 minutes. Most photographers, however, wash their fiber-based prints 1 hour or even 2 hours. If you do not use a washing aid, a wash of at least 2 hours for double-weight paper is recommended. For RC paper, a 4-minute single wash without a washing aid is enough. (See page 186 for a discussion of print-washing equipment.)*

**10 remove excess water from the print**

*To prevent wrinkles, place the print face down on a piece of plate glass, Plexiglas, stainless steel, or the back of a tray and smooth the back with your fingers. Being careful not to wrinkle the surface, squeeze out excess water by wiping the back of the print with a squeegee or windshield wiper. Turn the print over and do the same thing again. When all excess water has been removed, the print is ready for drying.*

## Print Drying

**T**he method for drying prints depends on your facilities, the type of printing paper, and the number of prints to be dried.

Prints on RC paper are simpler to dry than fiber-based paper prints because RC paper dries in about half an hour and does not curl. These are all effective drying methods for RC prints: the *laundry method*—hang them up with clothespins attached to a taut wire or line; use a conventional hair dryer; place them face up on tables covered with towels; use a commercial RC print dryer. Do *not* use a conventional print dryer for RC prints. It is too hot, and both prints *and* dryer will be ruined.

Generally, prints on fiber-based paper take much longer to dry—48 hours is not unusual—and tend to curl when dry. The curl can be flattened in a dry-mount press (see page 238). There are several different methods for drying prints on fiber-based paper; the laundry method is one; four others are described below.

If you lack space to use the simple laundry method, you may use *photographic blotters.* Do not use ordinary desk blotters because they have lint that will mar the surfaces of the prints. Photographic blotters are 19 × 24 inches (48 × 60 cm) and hold, between pairs, one 16 × 20-inch (40 × 50-cm) print, two 11 × 14-inch (28 × 35-cm) prints, or four 8 × 10-inch (20 × 25-cm) prints.

A *blotter roll* is another simple way to dry prints on fiber-based papers. Until they are mounted the prints will have a slight curl from being rolled, however. A *blotter book,* made of blotting paper interleaved with a special nonsticking paper, can dry prints flat, but it holds only a few prints at a time.

An improvement on the blotter methods is a *drying frame* made of wood or metal and covered with *plastic* (not metal) window screening. The standard dimension for such a frame is 24 × 30 inches (60 × 75 cm). You can order a frame from a hardware store or make one or more yourself with 1 × 2-inch (2.5 × 5-cm) wood. For air circulation, support each frame on 2-inch (5-cm) legs. If you are drying a number of prints, you can use several frames stacked on top of one another.

A large *drum dryer* can take the volume of prints handled by institutional and commercial processors, but it has disadvantages. The cloth carrier may impress itself on the

*In the laundry method of print drying, hang RC prints singly by one corner. Hang fiber-based prints back to back by both upper corners; attach clothespins also to the bottom corners to prevent the paper from curling too much.*

*To use photographic blotters, place the prints face down between two blotters. Then place corrugated cardboard between the layers of blotters. The cardboard gives free air circulation for faster drying and also stiffens the blotters, so that to dry a number of prints you can build a stack of layered blotters and sheets of cardboard. Weight the stack with books, leave for several days, and the prints will come out flat and smooth.*

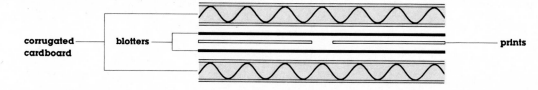

corrugated cardboard — blotters — prints

prints it conveys over the drum and leave them embossed with a cross-hatch pattern, especially pronounced in dark areas. Avoid the pattern by adjusting the dryer for less pressure (if it is adjustable) or adding more hardener to the fixing solution. You can usually salvage a valuable print that has been marked by the dryer by resoaking it in water and then drying it by a different method. Another risk in using a drum dryer is that fixer that may remain in a print can soak into the dryer's cloth apron, thus contaminating prints dried afterwards. To prevent this, change the apron frequently.

*To use a blotter roll, place the prints face down on the flat blotter, roll it up, and leave for a couple of days.*

207

*Before using a drying frame, wipe the screen with a damp sponge to remove dust or lint. Place the prints face down on the screen. Some photographers prefer to cover the prints with a photographic blotter; a standard 19 × 24-inch (48 × 60-cm) blotter works well with a 24 × 30-inch (60 × 75-cm) frame. The prints will dry in about 12 hours (depending on humidity). Frames may be stacked, as here, or in a more permanent installation they may be slid on rails, as in the illustration on page 179.*

## What Went Wrong?

**P**rints can be accidentally damaged during processing. Different processing errors produce different defects. Some of the more common processing errors are shown in four photographs, and the captions tell how to avoid them.   □

**tong scars**
*The black streaks in the sky were caused by scratches from tongs while the print was moved during processing. Use the least possible pressure with tongs—only enough to get a firm grip before lifting the print so the tongs will not slip across the surface.*

208

**marks from contaminated fingers**
*This print was touched before development by fingers contaminated with fixer. The fixer not only ruined the print but probably also contaminated the developer. Use separate tongs for processing solutions to prevent such problems.*

**inadequate development**

*A print removed too soon from the developer looks mottled and muddy and has a very limited range of tones. Adjust the exposure to allow enough developing time.*

**excessive fixing**

*If a print is left in fixer too long, the fixer dissolves out exposed silver as well as unexposed silver, resulting in a bleached image.*

Black-and-white photography records images in terms of their tonal relationships in a range that extends from dense black through many grays to white. Throughout the printing process, you have to plan constantly to get the tonal qualities you want in a print. This is not so obvious as it sounds because you need to take account of the fact that some tonal qualities are lost merely by transferring an image from film to paper. Transparent film cannot register the entire tonal range of objects in a natural scene, but it does register one-third more tones than opaque printing paper. Because of this inherent limitation of printing paper, you need to do whatever you can when printing to produce the quality you want in a print. The final print always results from two factors; your interpretation of a scene and the controls you use to achieve this interpretation. To produce a print that expresses your own interpretation of tonal qualities you need to combine craftsmanship with aesthetics.

When you have made a print, ask questions about it: Is it too light? too dark? Does it have too little contrast? enough? too much? The best way to answer these questions is to examine the exposure and the contrast. At first, evaluate only one variable at a time—exposure *or* contrast. You will quickly become experienced enough to evaluate both variables at the same time.

When you examine the tones in a photograph for exposure or contrast, you need standards for comparison. You can tell whether a print is underexposed or overexposed or whether it is flat with low contrast or has normal contrast for a particular paper by judging its black areas. Gradually, you will become experienced enough to tell flat black from rich black, but until then, use a strip of *test black* to compare with the black in any specific print.

To make a test-black strip for a particular paper, expose a piece of the paper to a bare bulb or the enlarger lamp for various lengths of time by the test-print method. Then develop it for 2 minutes. The strip with the maximum black should be washed, dried, and kept for comparison with the black tones of actual prints made on that paper.

210

*This photograph has a wide range of tonalities. Dense black, many grays, and white are combined to render the scene.*

## Examining Exposure

**H**ow dark or light a photograph will be is controlled by how long the photographic paper is *exposed.* The appropriate exposure is decided by the naked eye. The three photographs of the house show the varying effects of different exposure times. All three were printed from the same negative on paper with identical characteristics for contrast. The first print was made with an exposure that gave a literal interpretation of the scene. The second print received more exposure. Here the clouds are more defined against the darker sky, and the shadows are deeper. In all, the picture seems to have a heavier, more dramatic mood. The third

**10-second exposure (normal)**

**15-second exposure**

*The length of exposure during enlargement can dramatically change the mood of a photograph.*

**25-second exposure**

print received the longest exposure. Now the picture seems to have an ominous, even hostile, mood.

The best way to determine exposure time for a specific image is to examine a test print to find the exposure that best satisfies your intentions. Three test strips are shown. In the top strip, even the lightest section is too dark—too long an exposure. In the bottom strip, even the darkest section is too light—too short an exposure. The center strip, in the normal range, gives a better selection of exposures.

A negative of average density should produce satisfactory prints with exposures of about 15 to 20 seconds. With an underexposed (thin) negative, the print exposure might be too short to control. You can

lengthen the exposure by stopping down the diaphragm of the enlarger lens to make a smaller aperture. With an overexposed (very dense) negative, you might have to open up the diaphragm to prevent the exposure time from becoming excessive.

When exposures are longer than 40 seconds, heat from the enlarger lamp can expand a negative in a glassless carrier until it is out of focus. To avoid this, first insert the negative in the enlarger and turn on the lamp to let the negative expand. When the negative has heated up, focus the enlarger with the aperture open, stop down the aperture, and switch off the lamp. Then, before the negative can contract with cooling, quickly place the paper in the easel and make the exposure.

## Examining Contrast

**J**ust as important as exposure for the final appearance of a print is *contrast.* Both exposure and contrast result from basic qualities in a negative. When a negative has a great deal of contrast, its values can be expanded and balanced by printing it on low-contrast paper. The wide range of values in a flat negative can be narrowed by printing it on high-contrast paper. (See pages 187–191 for a discussion of photographic papers.) The negatives and prints show how negatives with various contrast qualities can be printed on complementary papers to bring out certain qualities.

When three varying contrast negatives are printed on contrast-grade 2 paper, as here,

**too dark**

**normal range**

**too light**

*By examining test prints, you can find the exposure you want for a given print. Twelve different exposures are shown in the three strips.*

**high-contrast negative**

**normal-contrast negative**

**flat negative**

**high-contrast negative on grade 2 paper**

**normal-contrast negative on grade 2 paper**

**flat negative on grade 2 paper**

*213*

**high-contrast negative on grade 1 paper**

*The five prints show the effects of papers of different contrast grades with negatives of different contrasts. Often, prints from negatives of contrast higher or lower than normal can be made more normal by printing them on paper of the contrast grade opposite to their own—for example, a flat (low-contrast) negative on high-contrast paper.*

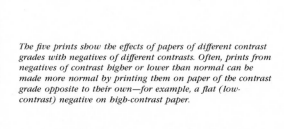

**flat negative on grade 3 paper**

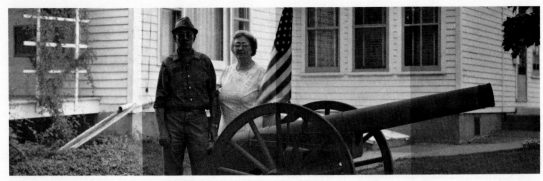

**low-contrast paper**

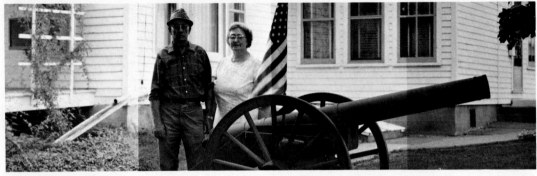

**normal-contrast paper**

*214*

**high-contrast paper**

*By examining test prints, you can judge the effects of different contrast grades of paper. The center strip was the one the photographer chose as the basis for the final print, opposite.*

the print from the normal-contrast negative has the most normal contrast. The print made from the high-contrast negative has extreme contrast, and the print made from the flat negative is quite flat.

When a flatter than normal paper (contrast grade 1) is used with the high-contrast negative, a more normal print results. A higher than normal contrast paper (contrast grade 3) used with a flat negative also results in a more normal print.

You may not always want to change the paper to get a "normal" range of tones. Actually, you may find that a normal negative printed on lower-graded or higher-graded paper may be just what you want for a certain image. In other words, base your decision about contrast on your intention.

A normal-contrast negative was used for the three test print strips here, which show the use of test prints on different contrast grades of paper to evaluate contrast. The top

strip was made on low-contrast paper; it shows a gray tonality, deficient in both brilliant white and dense black—an overall flat and muddy appearance. The center strip was made with normal-contrast paper, which produced a balance between black and white, as well as good clear detail throughout the tonal range. The bottom strip was made with a high-contrast paper; it shows high contrast, almost totally devoid of middle gray tones. The final print was based on the center strip.

**final print**

215

*Evaluating contrast becomes easier with practice. These two test strips are quite similar at first glance, but a close look shows that the lower strip is more contrasty. When a test print is as light as the upper strip, make a new, darker test print before trying to decide how much contrast you want.*

The differences among various degrees of contrast are often quite subtle. Comparing tests on different contrast grades of paper or on variable-contrast papers (see page 229) can help you to evaluate tonal ranges as you decide what interpretation you want. Such evaluation is especially useful when dealing with an objective or abstract subject, when there is no preconceived idea about what the photograph "should" look like—for example, a plant as opposed to a skin tone.   □

*There are no rights and wrongs when evaluating contrast. In any specific case, you may prefer a flatter rendition or a more contrasty one. Decide on the basis of your taste and how you want the photograph to look. For example, some people prefer the lower-contrast print above. Others prefer the higher-contrast one at right. In general, the more objective the subject (like this one), the more subjective you can be in using contrast manipulation to produce the interpretation you think is the right one.*

## contrast in portraiture

*Contrast is especially crucial for realistic skin tones in portraits. These three prints were all made from the same normal-contrast negative. The extreme contrast between light and dark in the first print shows the subject starkly and two-dimensionally; detail is suppressed and the boy's face lacks the roundness of youth. In the middle print, contrast is reduced; the face is more rounded and there are more details in the deeper tones. The low contrast of the third print renders the boy's face in shades of gray that are unlike the true skin tones of the subject.*

217

# Altering Contrast with Developer or Overall Flashing

In addition to altering contrast with different contrast grades of paper or variable-contrast papers (see page 229), you can alter contrast by the type of developer you use or by a procedure called "overall flashing."

A paper *developer,* such as Kodak's Selectol Soft, that normally is used for warm-tone papers reduces contrast slightly when used with cold-tone papers. Dilution of the developer may also change contrast slightly. Used instead of the normal 1:2 (1 part developer to 2 parts water) ratio, a 1:3 ratio produces slightly less contrast. There is also a formula (Beers formula) for mixing a two-solution (A and B) paper developer that can be used to alter contrast by about three contrast grades by mixing in different ratios.

Another way to vary contrast with developer is to mix two different kinds of developer. Kodak's Selectol Soft, for example, may be used as solution A, mixed with a cold-tone developer, such as Kodak's Dektol, as solution B. For normal contrast, use 10 oz A, 6 oz B, 16 oz water to make 1 quart of solution (or 310 ml A, 190 ml B, 500 ml water to make 1 liter). For high contrast, use 3 oz A and 29 oz B to make 1 quart (or 90 ml A and 910 ml B to make 1 liter). Subtle variations of contrast may be achieved by changing the dilution ratios. Some photographers also add extra amounts of certain chemicals, such as hydroquinone, to increase the contrast, or Elon (Metol) to decrease it.

*Overall flashing* is exposing the paper to light—a deliberate fogging—for a short time without the negative. The brief exposure produces a slight veiling over the entire print that has the effect of reducing the contrast from one to three grades. This method may be used to tone down areas in a picture that are too complex for burning in (see page 222) or when a lower-contrast paper is desired, but unavailable.

A relatively dim light source must be used for flashing, and the exposure must be accurately controlled. One method is to hang a darkroom safelight lamp (without the safelight filter) from the ceiling and diffuse it with a piece of frosted plastic. Some photographers first expose the paper through the negative, then remove the negative, raise the enlarger as high as possible, close down the aperture, and flash the paper with the enlarger lamp. Sometimes a neutral-density filter is needed to dim the enlarger light. Using the enlarger is very time-consuming and thus not really practical.

The photographs show contrast quality in prints made from a high-contrast negative with and without flashing.  □

*The print above was given normal exposure. The paper for the print at right was flashed before it was exposed to the negative. Note the increased detail and decreased contrast in the background window of the flashed print.*

Because film can record many more tones than paper, details visible in a negative are often lost in the print made from it. During the printing exposure, there are various techniques—dodging, burning in, using variable-contrast papers or chemicals—that can help to bring out details of the negative in the print that would otherwise be lost. These special techniques control and correct distortions that result during normal printing and help to bring a final print closer to its negative or closer to the photographer's interpretation of the image—or both. Each of the techniques is discussed in detail below.

Evaluating a test print will help you decide where print controls are needed. In the test print you will be able to see which exposure times produced the tonal qualities you prefer in different areas of the print. An exposure of 5 seconds may have produced the desired tones in a dark area; an exposure of 12 seconds may have produced the desired tones in a medium area; an exposure of 16 seconds may have produced the desired tones in a light area, such as the sky. When you make the final exposure, you can use a combination of dodging and burning in to hold back light from or give more light to specific areas that the test print has shown need less or more light than the overall exposure.

## Dodging

**D**odging lightens and often brings out detail in dark areas of a print. It does this by blocking light from these portions during exposure. Thus these deep shadow areas receive a shorter exposure and are lightened and clarified. For example, pictures shot on very bright days typically have such deep shadows that detail is lost in them in a print. A subject taken under high noonday sun may have very dark shadows under the eyes and chin in a print. By shortening the exposure time for such areas, dodging can usually improve the image.

Dodging requires a dodging tool. To make one, attach a piece of reasonably stiff black paper (like the paper used to package photographic paper) to the end of a dull black wire (shiny wire could reflect light onto the image), so that the black paper can be extended out over the image projected onto the printing paper. The shape and size of the tool depend on the shape and size of the area to be dodged. The tool should be held well above the easel and moved constantly during the dodging process, so that the dodged area will blend with the tones of the rest of the print. If held still, the dodging tool is likely to produce its own distinct lines in the printed image. The dodging is done during part of the normal exposure. The three photographs on the facing page show the effects of different degrees of dodging.

220

In dodging, *move a small black dodging tool back and forth during part of the exposure to block light from a dark area in a print and thus lighten it.*

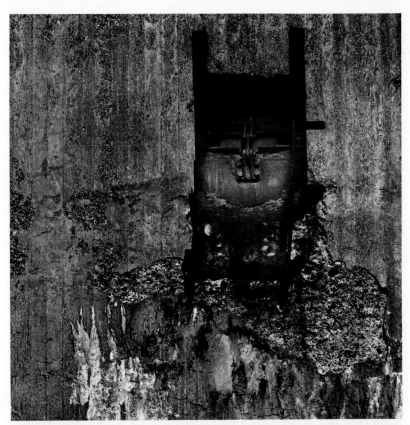

*Dodging a light area of a projected image helps to bring out more detail. In the negative used for these three prints quite a lot of detail could be seen in the interior of a coal chute. Above: Detail is lost in the undodged print. Above right: Dodging the print brought out the interior detail, creating a mysterious image of a face. Right: Excessive dodging created an imbalance between the dodged area and the rest of the print; the mysterious quality is lost and the print looks manipulated.*

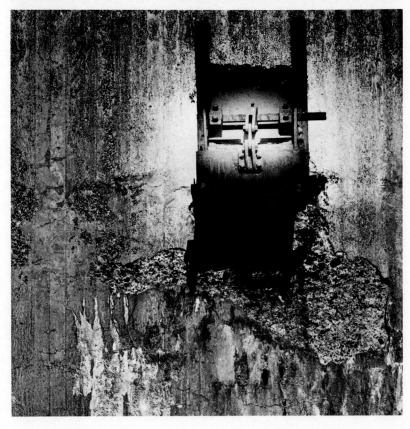

## Burning In

**T**he darkest areas in a negative often have detail that does not show in the corresponding light areas of a print. Burning in, the reverse of dodging, brings out this detail in the final print. Burning in gives a longer exposure to the light areas of a print while blocking light from all other areas. The lens aperture may have to be stopped down enough to allow the extra exposure time for burning in.

To burn in, cut black paper in the shape of the area to be protected from light. Make a normal exposure for the overall image.

Then move the black paper back and forth over the area to be protected while the light area in the print is receiving the additional exposure. Keep the paper moving throughout the burning-in process to avoid making lines that would look artificial in the print. Only slight parallel motion was needed in the second of the two photographs opposite, because the horizon line sharply isolated the sky area that needed burning in. In prints that need more detail in less well defined areas, movement must be broader. In general, burning in is especially useful for landscape photographs, which often are enhanced by more detail in the sky.

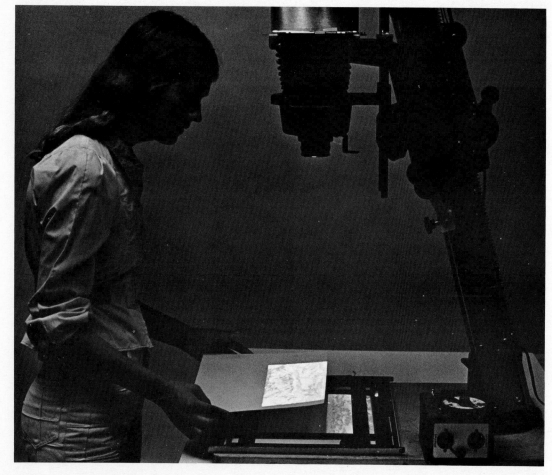

*In* burning in, *move a piece of black paper back and forth after the overall exposure to block light from darker areas of the print so that the remaining, lighter areas receive extra light.*

*Burning in a dark area of a projected image helps to bring out more detail. In the negative used for these prints, quite a lot of detail could be seen in the sky.* Right: *In the print made with normal exposure the detail is lost.* Below: *Burning in gave form to the clouds and tone to the sky.*

223

For burning in a small area in a print, cut a hole the proper size in a sheet of black opaque paper and let light pass through the opening. The shape of the cut opening should relate closely to the area being burned in. In this case a square shape was appropriate. A circular or irregular shape might be appropriate in other cases. The size of the hole should be considerably smaller than the area to be burned in because when the paper is held above the easel the area of light projected onto the easel is larger than the actual opening size. Keep the paper moving during the burning-in exposure. The effects are shown in the photograph of the window in the wall.

The burning-in exposure may be a frac-tion of the initial exposure (25–50 percent) or several times the initial exposure. Be care-ful not to give the area so much exposure that it becomes obvious that the print has been manipulated. If even long burning-in exposures are not bringing out detail, check the negative. An area of a negative may be so far overexposed that it may not contain de-tail; no amount of burning in can bring out detail missing from the negative.

For more drastic burning in, use a pen flashlight with opaque black paper wrapped around it to restrict and direct the beam of light. The bright white light gives a pure black tone in less time than other burning-in techniques. The effects are shown in the photographs on page 226.

*When an area to be burned in is fairly small, a piece of black paper with a hole cut in it makes a good tool.*

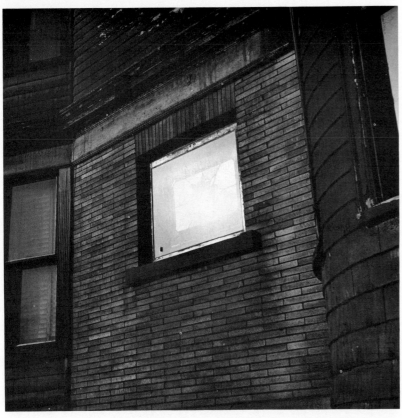

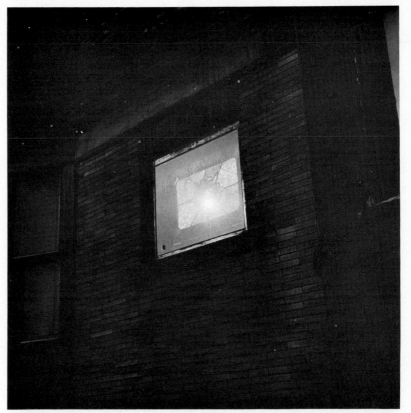

*Burning in a small light area of the print can sometimes be effective. In the negative used for these prints, quite a lot of detail could be seen in the window. Above: In the print made with a normal exposure, the window detail is lost.*
*Above right: An overall increased exposure brought out detail in the window but lost it in the wall. Right: The window was burned in through a hole in black paper. Here both window and wall have detail.*

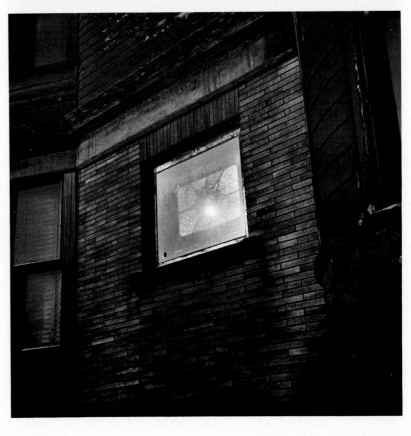

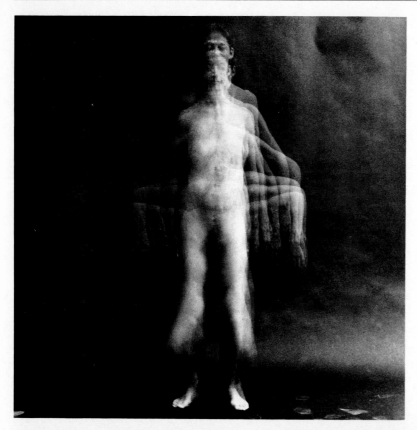
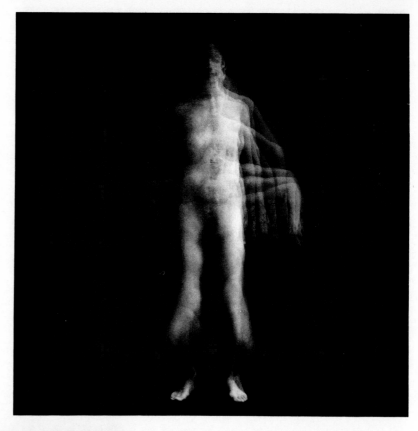

226

▲ *Drastic burning in can enhance aesthetic effects.* Above left: *With a normal exposure, the model's footprints and the wrinkled paper backdrop show.* Above: *The background was burned in with a pen flashlight to produce a pure even black.*

◀ *When an area to be burned in needs drastic treatment, a pen flashlight with black paper wrapped around it works well.*

*Vignetting,* another type of burning-in technique, is a way to isolate one part of an image in order to print it as a separate photograph. It is often used to produce an image of one person taken from a group photograph. Here the group was blocked with a sheet of black paper with a hole in it while only the face was given exposure. In this case the photographer chose a white ground, but a black background could have been produced by dodging. One way to do this is: hold a fist over the exposed image, close to the lens, and shake it back and forth after the overall exposure, at the same time gradually lowering it toward the paper. Another way to produce a black background is to dodge the face area while drastically burning in the surrounding area with a pen flashlight.

Below: *This old photograph was severely damaged in one area, but some good portraits remained. The photographer copied (see pages 261–262) the photograph and enlarged a portion of the negative, vignetting the subject by exposing it through a hole cut in a sheet of black paper.* Below right: *The portrait emerges from soft gradations of tone on a white ground.*

227

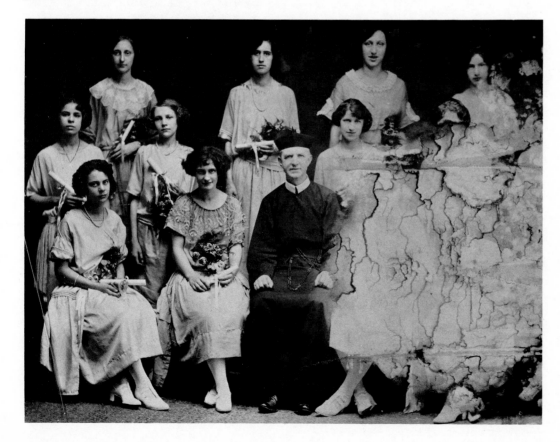

overall exposure with a number 2 filter

foreground exposed with a number 3 filter;
mountains and sky dodged during this exposure

*228*

mountains exposed with a number 2 filter;
foreground and sky dodged during this exposure

sky exposed with a number 1 filter to reduce contrast;
rest of print dodged during this exposure

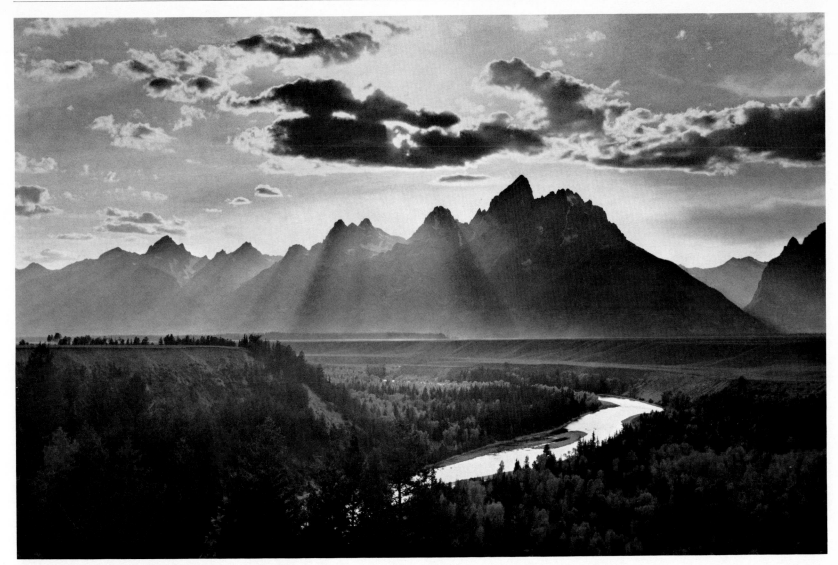

**final print made from all three selective exposures**

229

## Print Control with Variable-Contrast Paper

**A**nother way to control specific areas of a print is to use variable-contrast paper and filters (see pages 189–190). By covering and uncovering variable-contrast paper so as to expose it sequentially through a series of filters, you can enhance contrast in low-contrast areas and soften the image in high-contrast areas.

Variable-contrast papers are, in general, more efficient for area control than burning in or dodging graded papers, since the con-trast of the paper can be controlled at the same time as exposure. Tones blend more gradually and less noticeably with variable-contrast papers. This technique is especially useful for printing high-contrast negatives.

The prints here show the use of variable-contrast paper to control the rendition of a high-contrast negative. The first photograph is printed on variable-contrast paper with a number 2 filter; the foreground is dark and lacks detail, and there is no detail in the sky. Dodging the foreground to lighten it would produce a lighter, but still flat rendition. Burning in the sky would darken the print harshly and cause excessive contrast to ob-scure the subtleties of the clouds.

A more suitable method of printing this negative was to use variable-contrast paper and different filters to alter the contrast of specific areas. This was done by exposing one area at a time with an appropriate filter while dodging the other areas, as shown in the next three prints. In the final print, made from all three exposures, the foreground gained detail—the added contrast separated the trees from each other. The sky has more detail, but the softness of the clouds is maintained.

## Chemical Controls

Chemical controls can also be used to lighten or darken specific areas of a print. Sometimes areas too small for dodging need lightening. They can be chemically bleached. A *reducer,* such as Kodak's Farmer's Reducer, a two-part solution that is easily mixed, can be used. The two solutions (A and B) will keep for weeks, tightly sealed in their separate bottles. Mix equal amounts of A and B shortly before use, as the mixture will then last for only about 10 to 15 minutes.

If the print to be bleached is dry, first soak it in water for a few minutes and then place it on a smooth, firm support, such as the bottom of a photo tray. Squeegee the entire print and then wipe dry the areas to be reduced. Apply the reducing solution sparingly with a cotton-tipped stick or a small brush. Do not use a brush with a metal band, as the band can cause stains. The reducing action is fast, and its results are hard to predict, because it continues even during the rinse. Reducer may be diluted to help slow down the reaction.

When the desired effect has been achieved, rinse the print for a few minutes, then submerge it in fixer for 5 minutes and wash for 30 minutes. If you repeat the procedure more than once, you will be less likely to over-reduce. In fact, because of the unpredictability of reducing, it is a good idea to make several prints to work with in case one is ruined.

Chemical darkening of an area is not very practical, and it is not recommended. It is used mainly by commercial photographers preparing prints for reproduction, when permanency is not important. Such darkening can be done only while the print is being developed, never after it has been in the stop bath or fixer. A container of concentrated developer, often heated, is placed near the developing tray. While the print is developing, the heated developer is applied with a piece of cotton or a brush to the area to be darkened. The accelerated development darkens this area slightly, but it also often stains the print. Darkening an area of a print by extending its exposure is more dependable.

*A reducer can lighten small areas.* Opposite: *This print was normally exposed.* Below: *A reducer was applied to the tops and sides of the rocks, increasing the dramatic quality of the print.*

## Toning

**B**y toning you can alter the color of a print, increase the richness of its tonalities, make the image more permanent (see page 244), or prepare it for handcoloring. You can tone the entire print for an overall color change or tone only local areas. In general, when you want to make image color changes, toning is more effective with warm-tone papers than cool-tone ones.

The specific steps for toning vary according to the type of toner and the desired tonalities. Toners are available in powdered form or as liquid concentrates. They may also be prepared from formulas listed in Pittaro's *Photo-Lab-Index* (see bibliography). Since some toners have strong odors, you need adequate ventilation when working with them. Preferably, wear rubber gloves, since some toners are toxic. Stains are often a problem; prevent them by cleanliness and careful work procedures. Thoroughly fix and wash prints before toning. The fixer should not contain any hardener, because it prevents the emulsion from absorbing toner. Because many toners continue to work during the time they are being washed away, it is hard to predict the final quality of the print. Make several prints to work with in case of mistakes.

To use a toner for local color changes, first remove any excess water from the print. Then apply the toner locally with a brush or cotton swab. It is often hard to maintain definite borders while toning. To avoid this problem, you can paint rubber cement or "Maskoid" onto the areas of the print you do not want to tone.

There are three types of toners: direct, two-step, and dyes. *Direct toners* react chemically with the silver in the print. Their effects are more apparent in the shadow and middle areas, and they slightly increase contrast. The length of time they should be left on the print and the ratio of toner to water are factors in determining the colors produced. Selenium toner is a direct toner that acts slowly to intensify the image in a print by cooling the color, as from a greenish black to a more neutral bluish black. It also makes the image more permanent (see page 245). Kodak's Poly Toner, depending on dilution, produces shades from a warm black to a reddish brown.

*Two-step toning*, which works especially well with papers that have cold tones, consists of first bleaching out the image and then redeveloping it. The bleaching changes the silver into a barely visible compound which redevelopment converts into a visible toned image. The amount of bleaching may be varied, but redevelopment may not. Sepia toner is a popular two-step toner; making a sepia-toned print for later handcoloring is a traditional photographic practice.

The third type of toner is *dyes*. Dyes color the base of the paper and have little effect on the silver in the print. They are available in many colors. Dyes often are used when a more drastic color change is desired. The technique for using dye is simpler than that for other toners, since the print is merely placed in the dye.  □

A frequent print defect is white or black spots that detract from the overall appearance of the image. White spots result from the enlargement of dust, lint, or dirt on the negative or from scratches on the base of the negative. They can be eliminated by *spotting*, a technique using dyes that are absorbed into the gelatin of the print's emulsion. Dyes get darker gradually, as repeated applications and time let the gelatin absorb enough.

Spotone dye that is used for spotting is available in pure black or in black tinged with red (to make it warm) or blue (to make it cool). Select the tonality that harmonizes with the color quality of the photograph.

For spotting to work effectively, the prints must be completely dried. Assemble the spotting materials on a clean table, lit by a strong white nonglare light. Mix the dye and water by dipping an eyedropper first in the dye and depositing it in a series of little pools on the nonporous palette. Next, dip the dropper in water and mix it in graduated amounts with the several pools of dye to provide a range of dye tones, from light to dark. Choose a tone slightly lighter than the area around the white spot. Dip a watercolor brush (00 or finer) into the tone and brush it over the blotter until it is almost dry on

the surface and pointed at the tip. If the brush is too saturated, it may spread the dye beyond the white spot and darken the surrounding area, making a worse black spot. Test the value of the dye by touching the tip of the brush to a scrap of white border trimmed from the print. If the tone is slightly lighter than the tone surrounding the white spot, you can begin to work on the print.

Use the tip of the brush and apply the dye in small dots from the center of the white spot to its outside edge. As you proceed, blend dye and water on the palette as needed, soaking the brush each time and blotting it almost dry. To deepen tonality, pause between applications to let the emulsion dry and then treat the spot again with a freshly moistened brush. To match really dark areas, a brush charged with full-strength dye should be poised on the emulsion surface for a few seconds with each stroke. Since the emulsion can absorb only so much moisture at any one time, allow enough time between applications for absorption.

Black spots result from transparent areas on the emulsion side of the negative, often caused by scratches and air bubbles produced during the processing of film. Because of its small size, the negative usually cannot

be effectively treated with Spotone. Thus the spots must be remedied in the print.

The technique for lightening large black spots is relatively complicated and risky, but small black spots on the print can be bleached with iodine, available from a drug store, or a solution of potassium ferricyanide (Farmer's Reducer 1:10) or Spot Off, made by the Spotone Company. To lighten a black spot, use a toothpick with cotton wrapped around the tip. After dipping it into the bleaching solution and blotting all excess solution on absorbent paper, apply it to the black spot. Be careful not to let bleach come into contact with any other area of the print. Several such applications will make the spot yellow. The yellow stain can be removed by fixing, applying a washing aid, and washing the print. After drying the print, spot the whitened area.

If the black spots are very tiny and are on a white area of the photograph, they may be etched off with a sharp mat knife. Hold the knife so that you use only a tiny portion of the blade and gently scrape off the black spot. Use short, gradual strokes and be very careful not to dig deep into the emulsion because that will produce a visible blemish in the print surface. □

233

**materials for spotting**

1 spotting dye
2 water container
3 eye dropper
4 mat knife
5 cotton editing glove
6 blotting material (paper towels or tissues)
7 spotting brush
8 nonporous palette

In the first print (left), the white spots detract
from the power of the image. In the second print
(below), spotting has corrected the problem.

234

Attractive presentation and safe storage of photographs are integral parts of the craftsmanship of photography. For both effective display and preservation and also to counteract the tendency of fiber-based prints to curl, prints are generally affixed to, or "mounted" on, a piece of stiff paper board, called *mount board.*

Earlier photographers used wheat paste to attach prints to mount board, and many prints mounted that way are still in fine condition. Later, photographers often used rubber cement and other adhesives that contain chemicals that were eventually discovered to have ruined the prints. Now, the most common way to mount photographs is to use adhesive sheets activated by either heat or pressure. Heat-activated mounting is the most efficient method, but a special piece of equipment, an electric dry-mount press, is needed. A sheet of dry-mount tissue, coated with an adhesive, is placed between the photograph and the mount board; this "sandwich" is placed in a dry-mount press, which produces heat that activates the adhesive to form a tight bond. Pressure-activated sheets are an alternative when a dry-mount press is not available.

A third way to mount prints is the *window-mat* method. A window mat is made of two sheets of mount board cut to the same size. The photograph is attached to the bottom board by a heat- or pressure-activated adhesive sheet or by special photo corners, and a window for viewing the photograph is cut out of the top board. The two boards are taped together along one edge to form a unit.

Step-by-step guidelines for the three mounting methods are given separately on pages 237–241. The materials and equipment for mounting are listed in the table below.

The quality of mount board has improved in the last few years. Many early prints deteriorated because the mount board used was made from wood pulp that had residual acids. These acids attacked the photographic image. Moreover, the mount board also became discolored and brittle. A new type of mount board, called Conservation Board, is acid-free and buffered with calcium carbonate to help prevent chemical contamination. Another new type of board, Museum Quality 100% Rag Board, is more expensive but is considered even more permanent.

Mount board comes in various colors and textures and in several weights, designated by the term "ply." A 4-ply board is thicker than a 2-ply board. Each sheet must be cut to exact size. You may buy mount board already cut by the supplier or hire a printer with a large commercial paper cutter to cut it. If you try to cut it yourself, especially heavier board, you will find it almost impossible to do properly. Standardizing the size of the boards you use makes handling, storage, shipping, and framing easier. White board is used most often, but some photographers prefer buff or other colors or textures. Board for a given print should be heavy enough to give the print firm support. Thus, a 2-ply board may be adequate for a small print, but a 4-ply board would be needed for a larger one. If mount board becomes smudged by fingerprints or adhesive during the mounting process, you can usually clean it with an art-gum eraser.

Positioning the print on a board is important in presentation. Most photographers prefer to place a print on a board large enough to give pleasing border proportions. For example, an 8 × 10-inch (20 × 25-cm) horizontal photograph usually looks crowded on a

*235*

## materials and equipment for print mounting

| pressure-activated mounting | heat-activated mounting | window-mat mounting |
| --- | --- | --- |
| mat knife | mat knife | mat cutter |
| non-skid metal straightedge | non-skid metal straightedge | non-skid metal straightedge |
| mount board | mount board | mount board† |
| pica stick or ruler | pica stick or ruler | pica stick or ruler |
| film-editing gloves | film-editing gloves | film-editing gloves |
| art-gum eraser | art-gum eraser | art-gum eraser |
| cutting board* | cutting board* | cutting board* |
| hard rubber roller or plastic squeegee | heat-activated adhesive tissues | acid-free linen tape |
| pressure-activated adhesive sheets | tacking iron | burnishing bone |
| | dry-mount press | hard-lead pencil (3H or 4H) |
| | interleaving tissue | scissors |
| | clean paper | sponge |
| | weights | Permalife paper† |
| | | interleaving tissue† |

*A cutting board can be a piece of mount board, corrugated cardboard, or foam-core board.
†The window-mat method may be used with any type of mount board, paper, and tissue. For the most permanent protection of the image, however, these materials should all be acid-free. If acid-free materials are not available locally, they may be ordered from suppliers.

10 × 12-inch (25 × 30-cm) board, better on an 11 × 14-inch (28 × 35-cm) board, best on a 14 × 17-inch (35 × 43-cm) board—and perhaps too small on a 16 × 20-inch (40 × 50-cm) board. Generally, a 2- to 4-inch (5- to 10-cm) border is thought to be most pleasing. Some photographers mount their prints with equal borders on all sides, but most prefer that the bottom border be 25 to 30 percent wider than the other borders. The extra width gives space for the date and signature. Vertical photographs may be positioned in the same way as horizontal ones. When mounting a small horizontal print on a larger vertical board, it is generally thought to be most pleasing when sides and top are the same width and the bottom border is the same width as the width of the print being mounted. When mounting a small vertical print on a large horizontal board, keep the two side borders the same and the top border slightly smaller than the bottom border.

Prints can also be given a *flush mount,* also called a *bleed mount.* Mount the photograph by either the pressure- or heat-activated method, and then trim off all the borders of the mount board even with the image of the photograph. This style of mounting 16 × 20-inch (40 × 50-cm) prints is especially popular with commercial photographers for presentation of their work to clients. It is not a very permanent form of presentation, however, because the actual print surface is unprotected during handling. Also, if the print is dropped, a corner of the image may be damaged. An acrylic spray may be sprayed over the print to help protect the emulsion. Step 6 of the guidelines for pressure-activated mounting shows how to finish the edges for a flush-mounted print.

Mounted photographs are usually exhibited with a covering of glass or Plexiglas. Nonglare glass is not recommended because it is actually translucent, not transparent, and thus it obscures detail in the picture. Regular glass is usually used, but Plexiglas is more common for traveling exhibits because it weighs less and is unbreakable. A special type of Plexiglas, ultraviolet-filtering UF-3, is recommended for color photographs because it absorbs ultraviolet light, which is harmful to the colors. Plexiglas is more expensive than regular glass and more susceptible to scratches. It also attracts dust.

The wood used for picture frames often is bleached. This bleaching leaves residual fumes, which can harm the print. Natural wood frames are less likely to have this problem. The safest frames are anodized aluminum, and they have become the standard for exhibitions. They are available in various colors and finishes. Insertion or removal of the photograph is simple with these frames.

Excessive heat, humidity, or dryness is harmful to prints; they should be stored in an environment that does not subject them to these conditions. For long-term storage, place them in lighttight, acid-free boxes. The boxes that photographic paper comes in are not appropriate, because the paper they are made of is not acid-free.

## Pressure-Activated Mounting

**T**he bond formed by pressure-sensitive adhesive sheets is considered permanent, but it may be removed with an appropriate solvent. There are several brands of pressure-sensitive adhesive sheets. Scotch Positionable Mounting Adhesive Sheets #572 are typical. Manufacturers claim the adhesive does not contain any residual acids that would adversely affect the print. These sheets are used for all kinds of prints, but especially for mounting RC (resin-coated) color prints, which are easily damaged by heat. Mounting with pressure-sensitive sheets is a relatively simple procedure, illustrated here.

**pressure-activated mounting**

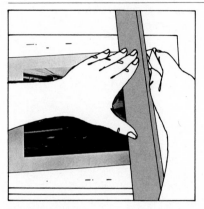

**1 trim the print**

*Place the print on a cutting board (see table of materials and equipment, page 235). With a paper cutter or a straightedge and mat knife, trim the print to the desired size.*

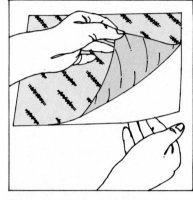

**2 clean the print and prepare the adhesive sheet**

*Peel the release paper from an adhesive-coated sheet of the appropriate size. (Adhesive does not stick to release paper, which is why release paper is used in step 3.)*

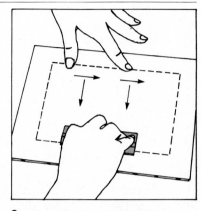

**3 make a three-part "sandwich"**

*Place the release paper on the table. Place the print (dashed lines) face down on the release paper and wipe off the back. Then place the adhesive-coated sheet on the print with the adhesive down. Either roll it with a hard rubber roller or squeegee it with the plastic squeegee that is supplied with most brands of pressure-activated sheets.*

237

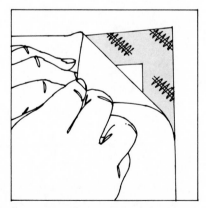

**4 peel the adhesive-coated sheet from the photograph**

*Slowly peel the adhesive-coated sheet off the back of the photograph; this leaves the adhesive layer on the back of the photograph, which is lying on the release paper.*

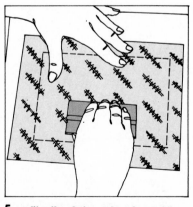

**5 position the photograph and mount it**

*Pick up the photograph and position it over the mount board, adhesive side down. Lower it to the board. When positioned, cover the photograph with the release paper for protection and squeegee it, using slight pressure. This pressure will help ensure a firm bond between the photograph and the mount board.*

**6 to flush mount, cut and finish the edges**

*If you want to flush mount the print, use a metal straightedge and a mat knife, as in step 1, to cut off the mount board at the edges of the image. If the cut edges seem rough, wearing a glove to protect the print, smooth the edges with fine sandpaper wrapped around a block of wood, sanding with small one-way strokes (back-and-forth strokes can break the emulsion). If chips appear near the edges, they can be corrected by spotting (see page 233).*

## Heat-Activated Mounting

**H**eat-activated adhesive sheets, or tissues, are made in sizes that correspond to the standard dimensions of most photographic papers; for large prints, rolled tissue is available. A sheet of tissue should be the same size as the print it will mount. Some brands, such as Seal's Fusion 400, can be spliced together if necessary without creating any problems, but most brands should not be spliced because of the ridges, bumps, or cracks that are likely to be produced on the front of the photograph where two pieces of adhesive join together. (This is not a problem with pressure-activated mounting.)

Dry-mount presses for heat-activated mounting come in a range of sizes for different sizes of prints. Ideally, you should use a press large enough to cover the entire print at one time, but if you must use a small press to mount a large print, shift the print around in the press from time to time to avoid a crease in the print caused by being left too long in one position.

The temperature of the press must be set to the temperature required for the adhesive. The Seal Company provides temperature-indicator strips, with complete instructions for testing press temperature. Newer dry-mount presses have more accurate thermostats and heat control than the older models,

but even they should first be tested with rejected prints before using good photographs. Temperature control is especially critical with RC prints, because if they are overheated, they will melt. Some photographers never use heat-activated adhesive with RC prints because of the risk of the print melting and making a mess that is extremely difficult to clean from the press.

Heat-activated adhesives for RC paper usually require a temperature of about 180°–190° F (82°–87° C). The adhesives for fiber-based papers require a temperature of about 225°–250° F (107°–121° C). Many photographers use the low-temperature adhesives for fiber-based prints, because they believe the higher temperatures are not good for prints.

Before using a dry-mount press, check to make sure the platen (the actual press area) is clean. Dirt particles on the press can make irreparable dents and dimples on the print's surface. A platen cleaner kit is available from the Seal Company, with complete instructions. Alcohol usually dissolves spots of dry adhesive on the press, but if it does not work, use some very fine steel wool. Clean the platen very thoroughly afterward with soap and water to remove any left-over alcohol or pieces of steel wool.

Procedures for heat-activated mounting are illustrated on the facing page.

## heat-activated mounting

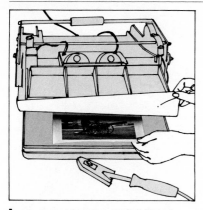

**1  remove moisture from materials and equipment**

*Preheat the tacking iron. Preheat the dry-mount press by setting it at the correct temperature for the type of printing paper and adhesive being used. Close the platen for a few minutes, open it, close it again. Repeat until the rubber cushion is completely dry. To remove moisture from the print, place it face up on the rubber cushion of the press, cover it with a clean piece of paper, and close the press for a few seconds; open it, and repeat. Remove the print, place it face down on a clean piece of paper and cover it with a weight—a piece of ¾-inch (18mm) plywood covered with several layers of brown paper. If there is any possibility of moisture in the mount board, place it in the press for a few seconds, remove it, and place it under weights to flatten it.*

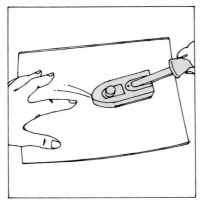

**2  secure the adhesive to the print**

*Place the photograph face down on a clean, smooth surface. Place an adhesive tissue over it, either side up, squaring it at the top of the print. Touch the tissue at the center only with the tacking iron, using just enough pressure to cause the tissue to stick.*

**3  test the adhesion**

*To test that the tissue and print are secured to each other, carefully lift the tissue. It should carry the weight of the print. If it does not, recenter it and tack again, using only a very light stroke.*

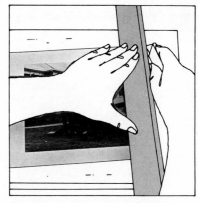

**4  trim the extra adhesive tissue from the print**

*Place the print with the attached adhesive tissue face up on a cutting board, which prevents damage to the table underneath. Using a metal straightedge as a guide, cut the adhesive tissue and print border off, flush with the image area of the print. Hold the straightedge firmly to prevent slipping. An alternative cutting method is to use a rotary-blade paper cutter, which makes a very neat edge and has a light attachment enabling you to see through the print for an accurate trim. Do not use a guillotine cutter; its blades are likely to break the print's emulsion.*

*239*

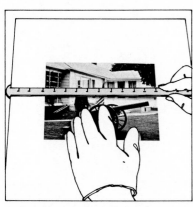

**5  position the print on the mount board**

*Measure the placement for the print. A printer's pica stick is an efficient tool for determining exact placement because the hook at one end holds the stick at the edge of the board, making quick and accurate measurement easy. Place the trimmed print face up on the mount board. Look carefully at the placement; this is your last chance before mounting to make changes.*

**6  tack the print to the mount board**

*Wearing a film-editing glove to prevent finger smudges on the print, hold the print securely in position with the last three fingers of one hand. Using the thumb and forefinger of that hand, lift one corner of the print only, not the adhesive tissue. With the other hand, lower the tacking iron onto the adhesive tissue and touch it lightly to make it stick at this point to the mount board. Do not let the tacking iron touch the print's emulsion at this or any other time; such contact will spoil the print.*

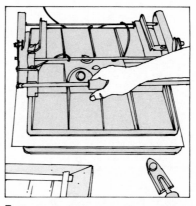

**7  place the board in the press and close it**

*Place the mount board with the attached print in the dry-mount press and cover it with a clean piece of paper for a cover sheet. (With some heat-adhesive tissues, such as Seal's Fusion 400, the use of Seal Release Paper is recommended to help protect the platen.) Close the platen and time the heating period. The time will depend on the type of paper and adhesive and the thickness of the board. Lift the platen after about 30 seconds to see if the print is secured to the board. If it is not, heat longer.*

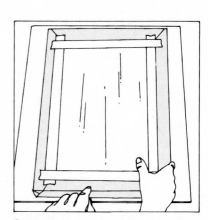

**8  remove the mounted print and clean the mount board**

*Remove the mounted print from the press, place it face down on clean paper, and cover it with a weight while it cools. This will help it to remain flat. After the print has cooled, use a gum eraser to remove any smudges from the mount board.*

## *Window-Mat Mounting*

**A** window mat eliminates two problems. A print in a window mat cannot be marred by scuffing, which happens when one mounted print is slid across another. A print in a window mat, when framed, cannot stick to the glass and be torn during removal (especially a problem with color prints). The thickness of the board used for the window mat helps to protect the surface of the photograph when it is being framed, handled, or stored. The space it creates between the photograph and the glass helps to prevent any traces of moisture that may condense on the glass from being absorbed by the photograph. If acid-free mount board—such as Conservation or 100% Rag Museum board—is used, it forms a barrier around the photograph to protect it from acid conditions that cause a photograph to deteriorate.

The window mat is, however, the most expensive and time-consuming presentation method. It is recommended for archival prints (see page 244) and at other times when you want to be sure the image will be permanent.

**window-mat mounting**

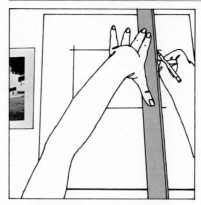

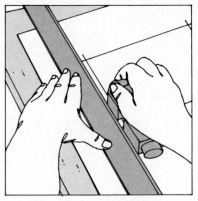

**1 mark off the image area on the top mount board**

*Measure very accurately the image size of the photograph. Place the top mount board face down on a clean, smooth surface and use a hard-lead pencil (3H or 4H) to mark off the image area. Draw cutting guidelines about $\frac{1}{16}$ inch (2mm) smaller than the image area to allow some leeway in cutting and in placing the photograph. Do not use a soft pencil, for it may dirty the beveled edges being cut. Double-check the measurements before cutting.*

**2 cut the window with a mat cutter**

*Place the mat cutter on the edge of the mount board being cut and adjust the blade so that it penetrates the cutting board slightly. With the mount board on the cutting board, gently push the blade of the mat cutter through the board about $\frac{3}{16}$ inch (6mm) beyond a crossing of horizontal and vertical guidelines. When using a hand cutter, such as the Dexter, be sure the straightedge is always on the border area, not in the window area. If it isn't, the mat will be undercut instead of beveled, and the board will be ruined. (When using an expensive professional mat cutter, such as the Keeton, placement is different. Consult the manufacturer's instructions or make some tests on a piece of scrap board.) Make sure the straightedge is parallel to the edge of the board to ensure a straight cut. Hold the straightedge down with one hand and push the mat cutter along the straightedge with the other.*

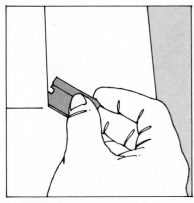

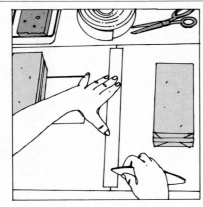

**3 finish the cut with a razor blade**

*Without experience, it is hard to know when to stop cutting because there is no way to tell where the blade is. Some cutters, such as the Dexter, are marked on one side with a line indicating the location of the blade. Cut to about 3/16 inch (6mm) beyond the crossing of the lines. Often the cuts do not overlap at the corner and the cut-out part is still attached to the rest of the board. Do not pull at it because the edge will tear, leaving a frayed edge. Cut them apart with a razor blade or an X-Acto knife. Examine the edges of the window for neatness. Use fine sandpaper wrapped around a wooden block to smooth any roughness. Use a burnishing bone to help smooth cut marks that went too far or rough edges in corners.*

**4 hinge the window mat to the bottom mount board**

*Place the window mat face down on a clean, smooth surface with the bottom mount board placed next to it in the correct position for hinging. Two bricks or other weights covered with several layers of paper will help to keep both boards flat and touching each other. Measure a length of acid-free linen tape and cut it a fraction shorter than the length of the edge where the two boards touch. Moisten the tape with a sponge so that it is thoroughly wet but not dripping wet. Partially dry tape or excessively wet tape will not stick well. Apply the tape to the edges of the two boards and use the burnishing bone to smooth it out and ensure that it is sticking. Close the hinged boards and place the window side down on a clean surface. After making sure they are correctly positioned, gently burnish the back of the mount board at the hinge.*

**5 insert the photograph**

*Turn the mat over and insert the photograph, adjusting it for proper placement. Carefully open the window mat without moving the photograph. Some photographers use positioning clips or place a weight on the border of the print to hold it in place while attaching the photo corners.*

**6 attach the photograph to the mount board**

*Being careful not to move the photograph, place a photo corner on one corner of it. Hold down this corner with a piece of acid-free linen tape. Smooth it with a burnishing bone. Repeat for the other three corners. Swing the window mat down over the photograph.*

241

## linen tape mount

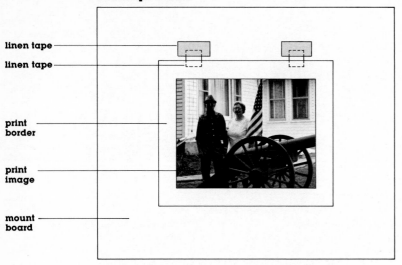

linen tape

linen tape

print
border

print
image

mount
board

*The virtue of the tape and photo corner methods of attaching
a print to the mount board in a window-mat mounting is
that the image side of the print is not marred in any way.
Above: In the tape method, strips of water-soluble linen tape
are fixed to the back of the print border and then held down
to the mount board by other pieces of tape to form a hinge
for the print.*

## photo corner mount

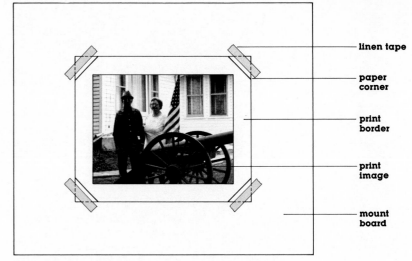

linen tape

paper
corner

print
border

print
image

mount
board

*In the photo corner method, paper corners are slipped over the
corners of the print and then held down to the mount board
by strips of water-soluble linen tape. The print can easily be
removed from the mount and reinserted without being damaged.*

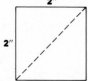
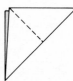
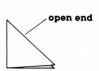

2″

2″

open end

*To make your own photo corners, cut paper into 2-inch (5-cm)
squares, then fold each square diagonally into a triangle (left).
Fold this triangle into a smaller triangle (center) and use
scissors to cut off a small portion of the open end to make it neat.
Either of the two pockets created at the open end (right)
will serve to cover the corner of the print. For greatest permanence,
the corners should be of acid-free Permalife paper.*

The photograph may be attached to the bottom mount board by several different methods. Some photographers use heat- or pressure-activated adhesives to ensure maximum flatness. For archival mounting, the method used in the guidelines on pages 240–241, the print is mounted with acid-free, water-soluble linen tape or with photo corners made from acid-free Permalife paper; corners may be bought or made, as shown opposite. Acid-free linen tape is used to hold the corners in place. Prints mounted in this way have nothing actually sticking to them. A border of at least $\frac{1}{2}$ to 1 inch (12–25mm) is needed to hold the photo corners.

A window mat may be cut with a regular mat knife, but a mat cutter is recommended because it cuts a professional-looking 45° angle to make a bevel. Mat cutters are available at prices from about $6 to more than $500. The more expensive ones have a guide system for making straight lines quickly and easily. Inexpensive, hand-held types are slid along a metal straightedge, which makes it somewhat harder to maintain a straight line. With patience and practice, however, high-quality mats may be cut with an inexpensive cutter. Whatever tool you use, change the blade often; a dull blade tears the edge being cut. (Some cutters are designed for right-handed people and may be awkward for you if you are left-handed.)

When you are cutting the window, you must slide the mat cutter against a thick, nonmovable edge. A thin metal or wood ruler slips too easily. A non-skid metal straightedge, held down firmly, is better.

Some photographers prefer to use a metal T-square because it has less tendency to move when the cutter is held against an edge. The cutting board placed between the mat and the table can be mount board, corrugated cardboard, or foam-core board, but mount board tends to dull the blade and makes cutting more difficult because of its thickness. When corrugated cardboard is used with the corrugations running parallel to the cutting direction, the cutter blades will not dull as fast. If the corrugated channels of the cardboard are at a 90° angle to the cutting, the blade will hit thin paper, then thick paper, and produce an uneven cut. Some photographers prefer foam-core board, which consists of flat sheets of cardboard with a styrofoam core.

Acid-free linen tape for hinging the window mat is the kind that is commonly used for book bindings. It is not generally available in ordinary art-supply stores, but it can be obtained from book-binding suppliers. Do not use pressure-sensitive tapes, such as masking tape, because they will dry and crack with age, and they have a tendency to ooze, which may harm the print.

When it is matted, the photograph may be covered with a sheet of interleaving tissue, acid-free for the greatest permanence during storage. Some photographers place the tissue between the top and bottom mats, while others who do not want anything to touch the surface of the photograph place the tissue on top of the mat.

Step-by-step guidelines for window-mat mounting begin on page 240.   □

*243*

Normal film-and print-processing procedures described in this book produce prints that will last many years without fading or staining. Modifications in print processing must be made, however, to produce *archival prints*—prints that have the greatest possible permanence and are considered to be of "museum quality." Archival processing is an advanced technique—one not usually used by beginning photography students.

Recent research into conservation of photographs has shown that the following factors affect the safety and permanency of prints:

- choice of printing paper
- processing of the print
- type of mount board
- type of mounting material
- mounting method
- storage container for the print
- storage environment for the print

Fiber-based paper should be used for an archival print. With fiber-based paper, unlike RC paper, there is a problem in removing the chemicals because the paper is porous. However, RC paper is unacceptable for an archival print because its plastic coating has been found to deteriorate. When making the enlargement, set your easel to allow a 1-inch (2.5-cm) border on all four sides of the print. This is because some types of staining start at the edges of the print and extend inward; the wide border helps to contain these stains.

The next concern is processing. For an archival print, be sure the amount of developer in the tray is adequate for the size of the print; it should be between ½ inch (12mm) and ¾ inch (18mm) deep. Discard the developer often. *Do not leave the print in developer for more than 3 minutes,* because it will become saturated with more developer than the stop bath can completely neutralize and will be almost impossible to fix completely.

Since the stop bath's sole function is to neutralize the developer so the fixer can work on the silver halides, *the stop bath must be fresh and the prints must be constantly agitated in it.* Recommended time in the stop bath is 30 seconds at a temperature between 65° and 75° F (18°–21° C). Change the stop bath often.

If a print is not thoroughly fixed, unexposed and undeveloped silver halides remain in it. Eventually, these halides cause the image to deteriorate. However, all traces of fixer must then be removed because the fixer contains sulfur, which, during fixing, forms compounds with the silver that makes up the image; these compounds, which are not easily removed by washing, eventually cause discoloration and fading. Therefore, archival processing emphasizes complete fixing and washing. *Always use two fixing baths* (page 205). Place the print in the first fixing bath to remove the bulk of the unexposed and undeveloped silver. Agitate it constantly for from 3 to 5 minutes—depending on the manufacturer's instructions for the fixer you are using.

Some photographers prefer to put a number of prints in a tray of water (65°–75° F or 18°–24° C) between the first and second fix and use this as a "holding" tray so as to finish processing all of them as a batch. The danger in this method is that if the "holding" tray does not have constantly running water, the water will become so fixer-laden that the prints actually continue to fix. If you prefer this method and running water is not available, change the water in this tray after every four to five prints.

In archival processing, *always use a washing aid* (hypo clearing agent) *and follow it up with a hypo eliminator* for 6 minutes at 68° F (19° C). The hypo eliminator reduces the fixer to sodium sulfate, which is harmless to the silver image and easily washed away during the final wash.

Mix the hypo eliminator with caution. Since it produces a gas, store it in an *open* container, because the accumulated gas can break a capped container. This solution decomposes quickly and must be used within an hour at most after mixing. Following is the formula for Kodak's Hypo Eliminator HE-1 solution:

| | |
|---|---|
| water | 16 oz (500 ml) |
| 3% hydrogen peroxide solution | 4 oz (125 ml) |
| ammonia solution (1 part 28% concentrated ammonia, 9 parts water) | 3½ oz (100 ml) |
| water to make | 1 quart (1 liter) |

To protect the silver image in the print from oxidation over the years, *the print may be toned in selenium toner or treated with a gold protective solution.* These produce a protective layer around the silver in the print. The gold protective solution gives the

## testing a print for residual fixer

*You can check the effectiveness of your washing technique with a residual hypo (fixer) test. The sample print to be tested should have at least a ¼-inch (6mm) white border. You will need a test solution that you can buy readymade or make yourself, according to the following formula:*

| | |
|---|---|
| *water* | *24 oz (750 ml)* |
| *acetic acid (28% solution)* | *4 oz (125 ml)* |
| *silver nitrate* | *¼ oz (7.5 g)* |
| *water to make* | *1 quart (1 liter)* |

*This solution is light-sensitive and should be prepared in low light and stored in a dark glass capped bottle. Handle it carefully because it causes black stains.*

*To make the test, place one drop of the solution on the white (unexposed) border of a washed, squeegeed print. Cover the area of the drop with a lighttight container, such as a can, to prevent its exposure to light. After exactly 2 minutes, remove the can and wipe off the drop. Examine the spot for discoloration. The paler the yellowish stain, the less fixer is left in the print. The Eastman Kodak Darkroom Dataguide has a color chart for comparison. A print with no remaining fixer will not have a yellowish stain. If there is a yellow stain, continue to wash the print and check it again to determine the necessary washing time for your facilities. This test may be used for fiber-based or RC papers (although RC papers are not used for archival prints).*

## formula for gold protective solution

### Solution A

| | |
|---|---|
| *distilled water* | *750 ml* |
| *gold chloride** | *10 ml* |

*\*1% stock solution: dissolve 1 g to 100 ml distilled water*

### Solution B

| | |
|---|---|
| *distilled water* | *125 ml* |
| *Kodak Sodium Thiocyanate* | *15 ml* |
| *distilled water to make* | *1 liter* |

*Pour the gold chloride solution into the 750 ml distilled water to make Solution A. Then pour the Kodak Sodium Thiocyanate into the 125 ml distilled water to make Solution B. Add Solution B to Solution A while stirring quickly. Then add enough distilled water to make 1 liter.*

greatest permanence, but selenium is less expensive. Do not use both in combination.

Adding selenium toner to the washing aid increases the permanence of the image and makes it possible to combine the washing-aid procedure with toning. If you add toner to the washing aid, it is important to go directly from the second fix to the washing aid-toner solution with no rinse in between in order to prevent stains. To add toner to the washing aid, use 1½ oz (43 ml) Kodak Rapid Selenium toner stock solution to 1 gallon (4 liters) washing aid solution and agitate the print constantly in it for 5 minutes. Selenium toner at this dilution increases the richness of the blacks of the print without changing the overall tonalities.

You may buy gold protective solution ready to use or make it yourself by the formula given separately. Place the prints in the gold protective solution for 10 minutes at 68° F (19° C). Do not expect to see drastic changes in the color of the print. Although gold solution is a toner, it only makes the dark tones slightly cooler.

The Ilford Company offers a printing paper (Galerie) and also a set of chemicals (Ilfobrom Archival Chemistry Kit) that is faster than the processing system just described. According to Ilford, its kit leaves only one-quarter the amount of residual fixer as when using two fixing baths and a 60-minute final wash—an amount of fixer too low to be detected with the Kodak Hypo Test Solution. If you add selenium toner diluted 1:9 to the washing aid in the Ilford kit, you even further increase permanence. Recommended procedures for using selenium

toner, gold protective solution, and the Ilford kit are listed in the separate table.

The major difference between the Ilfobrom kit method and the other methods is the amount of time in the fixer. Ilford believes that 30 seconds is enough time for fixing the image and that this short time prevents the fixer from forming compounds that are difficult to remove and cause stains and fading.

Whether or not prints are toned, the final wash should be 65°–75° F (18°–24° C) and of sufficient volume to change the water in the tray every 5 minutes (for the selenium and gold methods). Many print washers are not suitable because they do not separate the prints from one another; an archival print washer with individual compartments is recommended (see page 186). The best duration for the final wash is debated among photographers, but an hour is usually suggested.

After washing, archival prints should be squeegeed and placed on a plastic-screen drying rack in a drying environment that is lint-free and dust-free.

Archival prints should be placed in window mats, with only acid-free materials used for attaching them to acid-free boards (see page 240). They should be framed in anodized aluminum frames only.

Archival prints should not be stored for long periods of time in photographic paper boxes because these boxes are not acid-free. They should be stored in acid-free boxes in a cool, dry environment. Prints should not be exposed to harmful vapors (such as sulfur dioxide) or to excessive dryness. □

245

## procedures for selenium toning, gold protective solution, Ilfobrom Archival Chemistry Kit

| | selenium toning | gold protective solution | Ilfobrom kit |
|---|---|---|---|
| **developer** | *2 min* | *2 min* | *2 min* |
| **stop bath** | *30 sec* | *30 sec* | *5–10 sec* |
| **first fix** | *3–5 min* | *3–5 min* | *30 sec* |
| **rinse** | *(optional)* | *(none)* | *5 min* |
| **second fix** | *3–5 min* | *3–5 min* | *(none)* |
| **rinse** | *(none)* | *30 sec* | *(none)* |
| **washing aid** | *with selenium toner: depends on brand: about 5 min* | *depends on brand: about 5 min* | *selenium toner optional: 10 min* |
| **hypo eliminator** | *6 min* | *6 min* | *(none)* |
| **wash** | *60 min* | *10 min*<br>*gold protective solution: 10 min*<br>*wash: 60 min* | *5 min* |

Early photographers could make photographs only on bright, sunny days because of the slow speed of their plates and films. As the sensitivity of films increased, photographers could use artificial light produced by burning flash powder, a compound of magnesium, potassium chlorate, and antimony sulfide. This crude and often dangerous source of light was eventually replaced by more dependable and safer sources of light using electricity.

Artificial electric light can provide steady illumination—light bulbs—or a burst of intense light for a short duration—flashbulbs and electronic flash. With artificial light, photographs can be made when there is no sunlight or not enough. With artificial light, photographs can also be made by means of light that is controlled in direction and character. In other words, artificial light can closely imitate sunlight or it can produce illumination not found in nature.

Artificial light has unique properties that distinguish it from sunlight. It radiates in all directions from its source; it loses its intensity as it travels away from its source; it is either specular or diffused. These properties are described on page 248.

*The exposure for this electronic flash photograph*
*was 1/2,000,000 of a second.*

HAROLD EDGERTON.    *Cutting the Playing Card Quickly.*    c. 1965.

# Studio Lights

Electric light bulbs of one form or another that are plugged into conventional electrical outlets and give continuous illumination are one of the two major categories of artificial lights. Depending on their size and weight, they have varying degrees of portability. As a group they are called *studio lights* here, though some can easily be used outside a photographic studio. (The other major category of artificial lights is flash photography, discussed beginning on page 255.)

## Studio Lights and Their Characteristics

**T**here are four types of studio lights: flood, spot, umbrella, and pan reflector. There are subtypes within each of these types and even some subtypes within subtypes, but the four main types are distinct from each other.

A *floodlight* is either a high-wattage tungsten frosted bulb, commonly called a *photo-*

*flood,* or a tungsten-halogen bulb, commonly called a *quartz light,* in a mat reflector. Quartz lights are more expensive than photofloods, but they are brighter. They are excellent for color photography because their color balance does not change as they age with use. (Photofloods tend to give off more yellow light with age.)

At times, photographers attach metal flaps—called "barn doors" because they swing out like a door—to a quartz light to control the direction of the light. They also sometimes place a diffusion screen made of translucent fiberglass in front of a floodlight to soften the light (see page 253).

A *spotlight* contains a bare tungsten bulb—not frosted like the photoflood—a polished reflector, and a lens that condenses light and projects it as a narrow, intensely focused beam. The beam can be further narrowed by adjusting the focus and by means of a "snoot," a tube of sheet metal placed over

### properties of artificial light

*Artificial light has three unique properties that distinguish it from sunlight. It radiates in all directions from its source, not just in one direction, as sunlight seems to do, because the sun is so far from the earth. Thus photographers use special lamp housings to direct light where they want it.*

*Artificial light also loses its intensity as it travels away from its source. This phenomenon is described by the* inverse square law: *the amount of illumination on a subject is inversely proportional to the square of the distance between the source and the subject. Thus when the distance between light source and subject is doubled, the subject receives only one quarter as much light (not half as much), and so on. The inverse square law does not apply to sunlight because it is impossible to change the distance to the light source. The sun is 93 million miles (149 million kilometers) away, no matter where you stand.*

*Artificial light also is either specular or diffused. Sunlight is both. Specular light comes from a single source; its rays travel in straight, nearly parallel lines and strike the subject from one direction; it appears as a beam of light. Diffused light comes from many different points; its rays travel in many directions; it usually originates from a broad area. Sunlight is specular because it comes from one source; it is also diffused because its rays are scattered when they pass through atmospheric moisture and dust particles.*

*Left to right: quartz light with barn doors; umbrella light; photoflood; pan-reflector light; spotlight with snoot.*

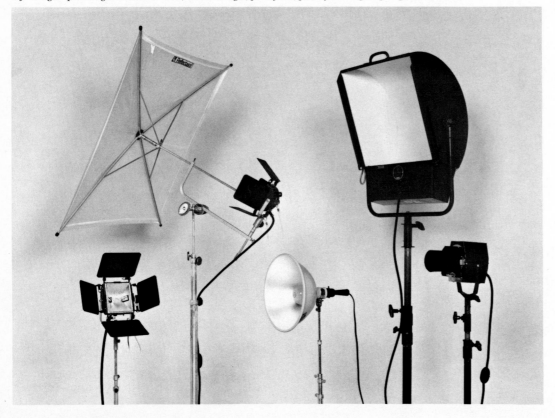

**floodlight as main light**
*Floodlights usually provide the main source of lighting in portraiture. A floodlight casts a soft-edged shadow.*

**spotlight as main light**
*The highly directional spotlight is often used as a main light in product photography. It is used to produce strong shadows, emphasize texture, or create highlights on the subject. A spotlight gives a hard-edged shadow.*

**umbrella or pan reflector as main light**
*Both pan reflectors and umbrellas are used when a broad, even area of light is needed, as when photographing products or people (portraits), when the environment around the subject is important. These lights are ideal main lights, especially when softness and gentle modeling are needed. This type of lighting gives the softest edge to the shadows. (An umbrella is not well suited for subjects with polished metal surfaces because the umbrella's ribs may be reflected.) A pan reflector was used for this photo.*

249

the spotlight that transmits the light only through a small circular opening. The spotlight may also have barn doors to control the light—that is, keep the light from "spilling" over into unwanted areas of the picture or into the camera's lens. Spotlights are available in many sizes, ranging from one that uses a tiny 200-watt bulb with a lens typically 3 inches (75mm) in diameter to a 750-watt spotlight with a lens that is usually 6 inches (150mm) in diameter.

An *umbrella light* is actually a combination of an umbrella reflector and a light. It is a lighting method that is quite popular. The umbrella (often the size of a conventional rain umbrella or larger) is usually made of a mat or reflective silver cloth. It is attached to a light stand with a bracket that also holds a quartz light or electronic flash unit. The light is aimed at the inside concave portion of the opened umbrella, producing a broad and even distribution of light.

A *pan-reflector light* takes its name from its rather large, bulky reflector. It is an expensive light that uses either a quartz light or groups of them. The light or lights are reflected off a curved white metal surface that looks like a pan. This light is bright, has some direction, produces very soft shadows, and gives broad, even coverage. Barn doors and a diffusion screen may be added to a pan reflector.

The differences in the quality of light produced by the various types of studio lights are shown here. For the three photographs, light placement and distance from light to subject were kept the same. The photos are somewhat contrasty because no attempt was made to fill in the shadow areas with another light or a reflector. (How reflectors fill in shadows is shown in two photographs on page 252.)

## How Distance of a Light Affects Exposure

**B**ecause of the property of artificial light described by the inverse square law (page 248), the farther a subject is from an artificial light source, the greater the exposure must be. The light diminishes in intensity rapidly because the amount of illumination on a subject is inversely proportional to the *square* of the distance between the source and the subject. In practice, this means that if a certain amount of light illuminates an area at a distance of 2 feet (60 cm) from the light source, the same amount of light is distributed over *four* times that area at 4 feet (1.2 m) and *sixteen* times that area at 8 feet (2.4 m). Because of this reduction in light intensity, each time you double the distance between the light source and the subject, you need to increase the aperture size by *two* f-stops. Or you can decrease the shutter speed by two speeds. The law works in reverse, naturally: when you halve the distance between light source and sub-ject, you need to decrease the aperture size or increase the shutter speed correspondingly.

## How Direction of a Light Affects Rendition of Subject

**T**he direction from which light strikes a subject affects the way the subject is rendered by the camera. This is true for natural as well as artificial light (see Chapter 5). Studio lights, however, enable you to illuminate a subject from any of a number of different directions at a given time. The six photographs opposite show how different *positions* of the light apparently change the texture, color, and quantity of the subject's hair and alter the shape of the subject's face. The photos were made with a photoflood (the results would be similar with flashbulbs or electronic flash) at the same distance from the subject for consistent brightness. Again some are rather contrasty because no attempt was made to fill in shadow areas.

250

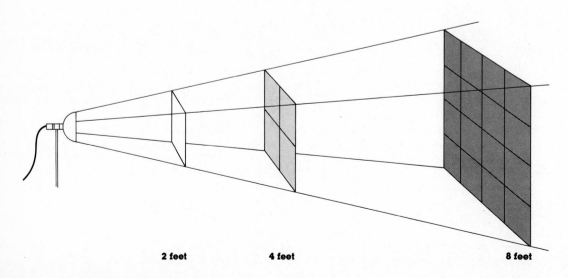

2 feet      4 feet                          8 feet

*Assume that a subject at 2 feet (60 cm) from the light can be exposed at f/16. Because the amount of light is inversely proportional to the square of the distance, for a subject at 4 feet (1.2 m), open the aperture by two stops to f/8. For a subject at 8 feet (2.4 m), open the aperture another two stops to f/4.*

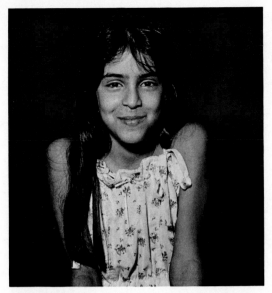

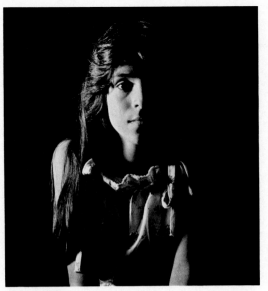

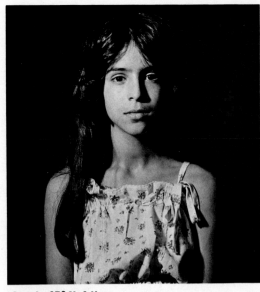

### front lighting

*Front lighting, also called "flat" lighting, results when the floodlight is placed directly above or directly to the side of the camera. It is not usually a pleasing type of lighting for portraiture because it eliminates small local shadows and makes the face look two-dimensional—flat. Some photographers use front lighting intentionally, however, to get the flat effect. Front lighting often results in pictures taken with a flash unit attached to the camera.*

### side lighting

*Side lighting results when the floodlight is placed level with the subject's head and at a 90° angle to the subject—directly at the ear of a subject looking into the camera. Here it changes the shape of the subject's face, making it appear longer and thinner than with front lighting. Portions of the face are now distinctly separated, giving roundness to the planes of the cheeks and forehead, and the illuminated hair is strikingly set off from the background.*

### classic 45° lighting

*Classic lighting results when the floodlight is placed somewhat higher than the subject's head and then aimed down at the subject at a 45° angle—typically midway between the ear and the camera when the subject is looking into the camera. This type of lighting is popular because of the three-dimensional effect it produces in the face.*

251

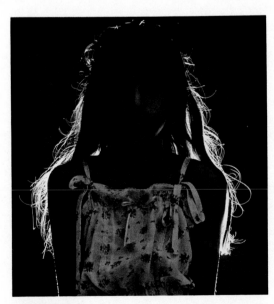

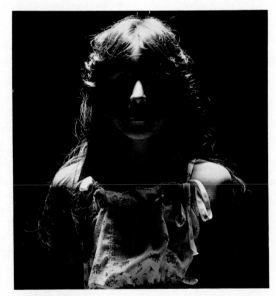

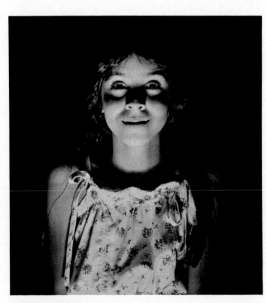

### backlighting

*Backlighting results when the floodlight is placed directly behind the subject in such a way that it does not shine into the camera lens. It should not be placed too close to the subject or it may give the ears a strange look. Because the face is not lit, backlighting is seldom used alone but with other lights to separate the head from the background. It can give a halo effect for portraits or light transparent objects to give a glowing quality.*

### top lighting

*Top lighting results when the floodlight is aimed down at the top of the subject's head. Top lighting creates shadows that so dominate the subject that all identity is lost. It is often used with other lights to create highlights on the hair. Barn doors should be used to confine the light to the top of the head, so it will not spill over onto the face, where it will interfere with the main light or shine into the camera lens.*

### bottom lighting

*Bottom lighting results when the floodlight is placed near the floor in front of the camera and aimed directly up at the subject's face. The results are dramatically unnatural, exaggerating both form and texture. This kind of lighting is often used to suggest horror or evil.*

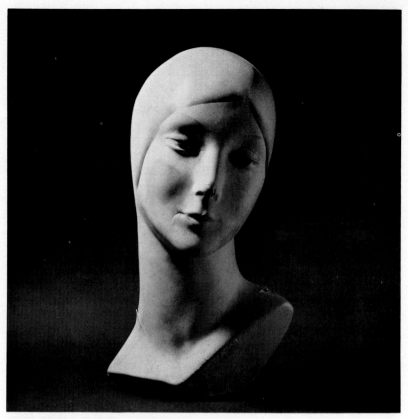

252

**single light—no reflector**
*The subject is lit from the side with a single floodlight. Only part of the subject is illuminated, and the shadowed side blends in with the background.*

**single light—smooth reflector**
*The subject is lit in the same way, but a smooth reflector has been added on the shadow side. The smooth white surface reflects some of the light back into the shadows, softening their quality and separating the subject somewhat from the background. When more reflectance is wanted, cardboard covered with crumpled aluminum foil can be used instead of a smooth reflector.*

## How Reflectors Assist Studio Lights

**W**hen a single photoflood is used to photograph a scene, the resulting picture is usually extremely contrasty, as in the first photograph here. If a pan reflector or umbrella is used alone, this contrast is reduced somewhat, but the results may still be more contrasty than desired. The contrast is caused by the single light brightly illuminating the area it hits directly, while at the same time leaving the nonilluminated part of the scene in deep, dark shadows. Except when you want to make a scene look stark and somewhat dramatic, you will generally have to "fill in" those dark shadows to lessen the contrast and "open up" the shadow area to reveal some details. Use a reflector for subtle filling in, as in the second photograph of the bust, or another light for more filling in.

## Softening the Quality of Light by Diffusion

**L**ight from floodlights is sometimes too harsh. To soften its impact, photographers often place a diffusion screen containing a sheet of translucent material (paper, plastic, fiberglass, or white muslin cloth) directly in front of a floodlight. The diffusion material scatters the light, reducing its intensity and widening its direction. When you want maximum diffusion, place the screen closer to the subject than to the light. Screen placement near the subject can be used with pan-reflector lights also, but not with umbrella lights. Be careful when placing flammable diffusion material not to let it come in close contact with the light.

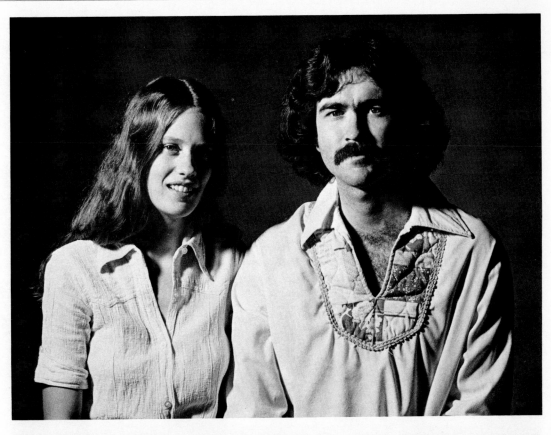

**floodlight without diffusion**
*This picture is contrasty because the shadows are dark and have little visible detail, the result of lighting with an undiffused floodlight.*

253

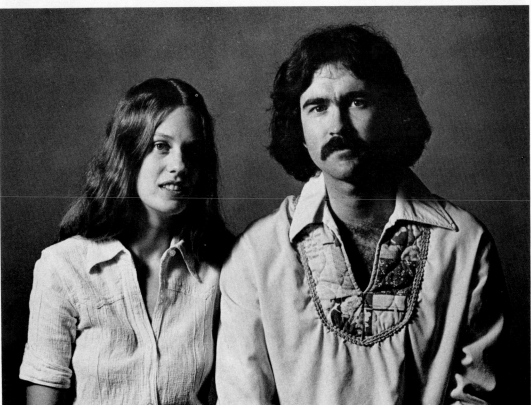

**floodlight with maximum diffusion**
*Here a diffusion screen has been placed close to the subjects. The shadows have been softened and there is detail visible in these areas.*

254

**single light**
*The sculpture is illuminated by a single source of light placed above and to one side of it—as though lighted by the sun. The tonal character of the form is contrasty because there are no other objects to act as reflectors to help lighten the shadows. The light is a floodlight. A spotlight would have produced a still harsher rendition.*

**diffused lighting**
*For complete diffusion (perhaps desirable because of the polished metal), a tent of white translucent paper is placed around the sculpture. A small hole is cut in it for the camera lens. The tent diffuses the light beamed on it, making the surface of the sculpture gleam with reflections from the luminous white paper and, at the top, from the dark ceiling overhead. A small black reflection like this one is sometimes undesirable in photographs of polished metal, but here it helps to define the elongation of the form. This lighting effect has no real direction; its source is nearly impossible to distinguish.*

**silhouetting**
*Illuminating a white background and allowing no light to fall on the subject itself produces a silhouette. Here all surface differentiation is lost, making it impossible to determine what the subject is made of. Only its basic shape is revealed.*

**edge lighting**
*Lights on each side create outline highlights along the edges of the sculpture. Barn doors prevent the light from striking the camera lens. This type of lighting emphasizes any imperfections in shape, such as the sculpture's blunt tip. Here floodlights produce the effect wanted because of the polished surface. For materials with less reflectance, spotlights might be necessary.*

**cast-shadow lighting**
*The horizontal lines of a patterned screen placed between the sculpture and a spotlight cast shadows that give the appearance of a changed form. The spotlight focuses the shadows. A less shiny surface would be even more changed.*

## Ways to Light Objects in the Studio

There is no one best way to arrange artificial lights for photographing a subject in a studio. The lighting arrangement you choose depends on the results you want. Five types of arrangements are shown here with their results. These are basic ap-proaches, but there are many other possible ones. These five examples are simply points of departure. A small sculpture of polished metal was used as the subject because of its simple shape and reflective surface. Note how its appearance changes when the direction and quality of the light are changed. □

# Flash Photography

The word "flash" refers to two special types of illumination: flashbulbs—in many cases as large as electric light bulbs—and electronic flash units. These, the second major category of artificial lights, give off intense illumination for a very brief period of time.

Flashbulbs were introduced in the early 1930s; very large and cumbersome electronic flash units were introduced soon after the end of World War II. Although many simple, inexpensive cameras use miniature flashbulbs in cubes or bars, serious photographers now almost never use flashbulbs. The reason for this is the overwhelming growth in popularity of electronic flash units, some of which are now as small as a pack of cigarettes.

Photographers use electronic flash for a variety of reasons. It is a cooler light source than studio lights and is therefore more comfortable for a person being photographed. It eliminates squinting at bright floodlights and thus produces more natural portraits. It is very consistent in the amount and quality of light produced and allows fast action to be stopped. It is frequently used outside the studio (outdoors or in temporary "studios" on location) because it is lighter and more easily taken apart for packing and transportation than the larger studio lights. The smaller, lighter electronic flash equipment that works on battery power enables the photographer to photograph anywhere with no need for electrical outlets.

## Electronic Flash

An electronic flash unit releases a powerful burst of light as a result of electrical energy built up from a household electrical outlet or from batteries and stored in the unit's capacitor. The stored energy leaps between electrodes inside a glass tube filled with a mixed selection of gases; when the gases are fired by the electrical discharge, they glow brilliantly for very brief durations. (Durations vary from unit to unit; speeds range from as fast as 1/10,000 of a second to a minimum of about 1/1000 of a second.) The electronic flash gives thousands of flashes throughout its lifetime, making its per-flash cost quite low.

## flash synchronization

*The length of time (milliseconds) that a flashbulb stays illuminated is considerably longer than the time for electronic flash. Flash synchronization describes the ability of the camera shutter to be open as the flashbulb burns throughout its peak of brilliance—or when the electronic flash goes off. If the shutter and the flash unit are "out of synch," no pictures will result. There are two types of synchronization: M and X. Most cameras today offer both modes.*

*M synchronization is the mode used when taking pictures with flashbulbs. Electronic flash units will not synchronize at the M setting. M synchronization delays the shutter's opening by about 12 milliseconds, thereby permitting the shutter to be open when a flashbulb attains its maximum brilliance. Without that delay, a shutter speed faster than 1/30 would be impossible because of the time it takes some flashbulbs to reach their maximum. Consequently, M synchronization allows you to choose among a wide selection of shutter speeds, greatly increasing the versatility of the camera when flashbulbs are used.*

*X synchronization is the mode for electronic flash, but with this caution: when X synchronization is used with a focal-plane shutter, you must use the shutter speed designated by the camera's manufacturer for electronic flash. All other shutter speeds will result in blank or partially exposed film. Manufacturers of cameras with focal-plane shutters always indicate the proper shutter speed for electronic flash in a camera's operations manual. They also stamp a red X next to this required shutter speed or mark it in red on the shutter-speed dial. Cameras equipped with leaf shutters have no such problem; they may be set at any shutter speed.*

## electronic flash units

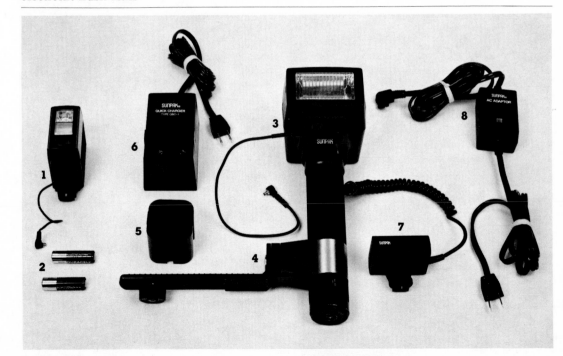

**1** small unit
**2** batteries for small unit
**3** large unit, usually part of a "system"
**4** bracket to hold unit on camera
**5** rechargeable batteries
**6** battery recharger
**7** exposure sensor
**8** AC adaptor

The electronic flash unit's short duration of light enables it to stop action even if the camera is waved up and down as the shutter is depressed or if the subject is moving extremely fast. Photographers working with electronic flash have extended our vision with astounding images impossible to attain in any other photographic way. Harold Edgerton's photograph of a bullet cutting through a playing card, reproduced at the beginning of this chapter, is an example. Electronic flash photography is unlike all other picture-taking situations in that it is the electronic flash of light that stops the action—*not* the shutter. This is because the exposures are *always* based on the strength of the electronic light and not on the existing illumination. Electronic light is usually brighter *indoors* than any existing light; thus the scene is recorded on the film only when it is illuminated by that light. For the rest of the time that the lens is open (and it is usually open for 1/60 of a second—a very long time relative to the 1/1000 of a second or faster burst of light) the existing light in the scene is usually not strong enough to register on the film. But because the exposure is based on the light from the flash, it is sometimes difficult to use electronic flash as the main light in bright situations outdoors. In such cases a dual image—a ghost image—is likely to be recorded on the film because the existing light is bright enough to produce an image in addition to the one produced by the flash.

The light from an electronic flash is ideal for color photography, and no corrective filters are required. (The color temperature of most electronic flash units is 6000° K; daylight temperature ranges between 5000° K and 6500° K. See Chapter 13.)

Electronic flash units come in a variety of sizes. Many clip on top of the camera; others are mounted on a bracket alongside the camera. Commercial studios use large units, some of them not very portable. Within recent years, many new features have been added to these electronic units, giving the photographer greater flexibility than ever before. Sensors, for example, have been incorporated to control the light's output and thereby ensure that the exposure will automatically be correct, as long as the subject stays within a specific range of the camera. (The greater the range, the larger and more powerful the electronic flash unit must be.) Ordinarily, when you take flash pictures with flashbulbs or an electronic unit, you must adjust the exposure each time the subject moves somewhat closer or farther away. Automatic exposure is especially helpful when photographing fast-moving events, for once you have selected a particular range (along with its designated f-stop), you need make no further adjustments.

Some units have swivel "heads" (the portion that flashes) that are capable of being aimed up at the ceiling (for bounce photography, see page 259), down at the floor, and to the left and right, as well as straight ahead, without moving the unit from its bracket. Some flash units have sensors that stay pointed at the subject even when the light itself is directed upward, which ensures correct exposure. These units are easier to use than the units that have sensors that point in the same direction as the light. The sensors reduce the exposure by shortening the duration of the flash. As a result, when doing extreme closeups, it is possible to have exposures of about 1/40,000 of a second, which can freeze action normally not even seen by the human eye. Some flash units have a way to control the output of light by a high/low switch or by even finer adjustments to use for closeups or controlling depth of field. Attachments are also available that broaden the area of the flash for use with wide-angle lenses. Some units have built-in provisions for "photo eye" sensors (slave units), an electric-eye device that when sensing the light from one unit fires another unit. This permits multiple units to be used without tangling connecting wires. Filters and diffusers may also be attached to the heads to change the color or quality of the light

and bring still greater flexibility to flash photography.

A number of camera manufacturers now market a new type of electronic flash called the "dedicated-exposure flash unit." Each one is compatible only with its maker's camera because each company has a different design for its electrical components. This also prevents the independent electronic-flash manufacturing companies, who usually offer less expensive units, from competing. The "dedicated-exposure flash unit" fits directly on the camera, which provides the electrical source, eliminating cords. It automatically sets the camera at the proper X synchronization and adjusts the aperture. A light in the viewfinder indicates when the flash is ready for firing. These units offer convenience, but the harsh directional light produced by a flash mounted directly on the camera is not satisfactory for everyone. For harsh light used intentionally, see Cal Kowal's photograph on page 258.

### Determining Flash Exposures

**E**xposure for flash photography—whether flashbulbs or electronic flash without sensors—is based on a system called "guide numbers," a simple formula that takes into consideration the inverse square law, described on pages 248 and 250. Each flashbulb has its own set of guide numbers—one guide number for each of the frequently used ASA ratings. Each electronic flash manufacturer issues suggested guide numbers for specific ASA ratings for its units.

To determine the correct flash exposure, divide the distance the flash (*not* the camera) is from the subject into the guide number indicated by the manufacturer of the flashbulb or electronic flash unit for the film you are using. The answer you get is the f-stop required for proper exposure. For example, if the electronic flash unit attached to your camera has a guide number of 160 when you use a film with an ASA rating of 400, and you are about to photograph a person seated in an armchair 10 feet away, divide the distance—10 feet—into the guide number of 160 and you get 16. Your exposure is thus f/16. The shutter speed will be the one demanded by your camera for X synchronization—provided you are using a focal-plane shutter. If you are using a leaf shutter, you may choose any shutter speed. A relatively fast one is advisable so as not to pick up ghost images caused by the available light when the shutter is open.

You can compute your personal guide number. Seat a person in a chair in a normal-size room—one roughly 15 × 20 feet (4.5 × 6m)—with light-colored walls and set up your camera and flash unit or separate flash unit exactly 10 feet from the person. Photograph the person at f/22, f/16, f/11, f/8, and f/5.6. (To make the test simpler, have the person hold a large card with the f-stop you are then using clearly marked on it.) When the film has been processed, study the negatives to decide which one has the density that pleases you. If you choose the negative with the person holding the f/11 card, multiply 11 by 10—the distance your light was from the subject. Your guide number will be 110—as long as you use that film and that flash equipment and follow the same procedures for developing the negatives.

Guide numbers are simply that—*guide* numbers. Not even your personal guide number can be considered absolute. *Where* you take your pictures will also influence the exposure. If you are in a very large room where large reflective surfaces such as walls and ceiling are far away, you will need to open up one or two f-stops beyond the indicated guide-number exposure. On the other hand, if you are in a small room where the light can bounce off the walls or ceiling back to the subject, you may need to stop down one or two f-numbers below the guide-number exposure. Only experience with your flash equipment and your method of developing negatives will enable you to arrive at satisfactory exposures each time.

CAL KOWAL. *Untitled* (from *T-Shirts Are Tacky*). 1976.

### off-the-camera lighting

*Off-the-camera lighting can be used to create directional lighting similar to the lighting produced by flash on the camera. This light flattens the subject and casts big black shadows, correctly exposing the subject while underexposing the background. Cal Kowal sought this quality intentionally in his series* T-Shirts Are Tacky, *made with a handheld flash. Head-on lighting can produce glare problems when a subject is in front of a smooth reflective surface.*

### ▶ bounce and umbrella lighting

*For bounce lighting, the flash is aimed at the ceiling at a 45° angle; the light "bounces" back, filling the room with nondirectional light, resulting in soft shadows. Bounce lighting works best in normal-size and smaller rooms with light-colored walls and normal-height ceilings. In large or high-ceiling rooms, an alternative is to bounce the flash off an opened umbrella reflector. In either case, the exposure is increased by about two f-stops over the exposure that would have been used with a flash aimed directly at the subject. Exposure adjustments are unnecessary with a flash unit with a sensor that remains pointed at the subject.*

## Ways to Light by Flash

**V**isualizing the way the subject will be rendered by flash is often rather difficult because you see the results only after having made the exposure. The large commercial flash units have built-in "modeling" lights, which enable the photographer to see the direction and quality of light that the flash will produce. The discussions on pages 250 and 253 of how direction and quality of light with diffusion affect the rendition of a subject apply to flash photography as well as studio lights.

Off-the-camera lighting comes closest to the classic 45° lighting used in studios. The flash is held high up and well out from the photographer's body. The light is then aimed down and *in* toward the subject. This lighting effect pushes the possibly objectionable shadows into the bottom of the scene and out of camera range. Off-the-camera lighting also gives pleasant modeling to the face. In color photography it also helps prevent *red eye,* which can happen when the flash hits the subject directly in the eyes and their red inside surfaces are reflected back, making the eyes have a strange red look in the resulting photograph.

The photographs here clarify some other considerations that apply particularly to flash photography.

NEAL SLAVIN. *Society for Photographic Education* (from *When Two or More Are Gathered Together*). 1974.

**outdoor lighting**
*The sun directly overhead casts harsh shadows about the eyes.*

**outdoor lighting with fill-in flash**
*Fill-in flash adjusted to supplement the main light source (the sun) has opened up the shadows around the eyes but has kept the modeling of the face.*

## How to Use Fill-In Flash Outdoors

There are times when a subject is harshly lighted outdoors and flash may be used to fill in the shadows. Set the shutter of your camera at the X synchronization setting if you are using electronic flash. (Follow the manufacturer's instructions when using flash-bulbs.) Read the scene with a light meter and select the f-stop—assume f/11. Next, using your flash unit's guide number for your film—assume 160—determine how far away your *flash* (not necessarily the camera) must be from the subject to eliminate shadows. To find this distance, divide the guide number by the selected f-stop number. In this case, 160 divided by 11 gives 14.54—or 15 feet. But this distance would eliminate the sunlight shadows entirely, and the purpose of the flash is to *fill in* shadows and not override the daylight illumination. You must therefore move the flash back by half the distance *more* to dim its power—in this case, another 7½ feet. (You need a long "PC" cord—the cord that connects flash unit and camera—and a stand to hold the flash.) Your flash unit is now placed for fill-in flash photographs of that subject. In some situations, you may want more or less fill in, so you adjust the flash accordingly.

A more convenient method of dimming a flash is to reduce the amount of light from it, rather than moving it back. By experimenting, you may find that you can do this by placing one or two layers of a handkerchief over the reflector. Another solution is to change the light output of the electronic flash, if it has such an adjustment. □

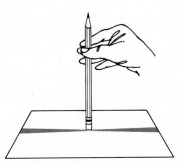

For copying, place the camera, lights, and copy as shown. The copy here could be on either a table or a wall.

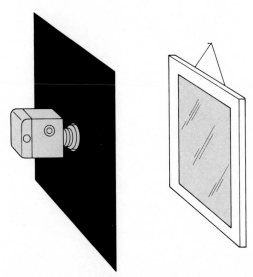

To check the evenness of the distribution of light without a meter, examine the shadows cast by a pencil held upright at the center of the copy. Two equal shadows show balanced illumination.

To eliminate reflections from glass covering copy, photograph through a hole cut in black cloth.

## Basic Procedures

Copying means photographing in black and white or color another photograph, a painting, a line drawing, a magazine or book page, or any other two-dimensional surface. The resulting photograph, when made with care, reveals all of the fine detail and tones of the original. Copying is most easily done with a single-lens reflex camera or a view camera, neither of which has any parallax-error problem because it shows you exactly what you are photographing as you look through the picture-taking lens. The special equipment you need is a tripod for holding the camera, a cable release for making exposures without risk of moving the camera, and two photoflood or quartz lights to illuminate the copy (four lights if the copy is large).

When you are copying, you have to secure the copy as firmly as the camera, and you need to calculate the camera-subject angle precisely. Fix the copy absolutely flat to a wall or a horizontal surface with something other than pins, which may cast undesirable shadows on the copy. A copyboard designed specifically to hold the copy can be used. To avoid distortion, carefully position the camera so that it is centered on the copy and parallel to it. That is, center the copy on the axis of the lens. Surround the copy with black paper or place black paper over the copyboard before attaching the copy to it to reduce the possibility of glare.

The best lighting for copying is usually even and diffused. Thus place the floods or quartz lights symmetrically, one at a 45° angle on each side of the copy. Keep the lights near enough to the copy to flood the surface with strong light, yet far enough away so as not to illuminate the edges of the copy more than its center. You have to check the evenness of the light distribution with an exposure meter. When using a reflected-light meter, hold a gray or white card near the left-hand side of the copy and take a reading from it. Repeat the readings for the middle, right-hand side, top, and bottom. If one side is brighter than the other, slightly change the position of the light on that side to even out the distribution. When using an incident-light meter, simply place it on different areas of the copy.

Some copy, such as heavily-textured oil paintings, may need lighting arranged *irregularly* to dramatize through highlights and shadows the textures of the brush strokes. Bring one of the floods slightly closer or reduce the angle slightly so as to rake the raised portions of the surface with strong light and cause those portions to cast small shadows. Adjust the other light so it fills in the shadows sufficiently to keep them from appearing too dark.

When copying paintings with varnished surfaces, you may have to change the angle of the light source to eliminate glare. If that does not work well, attach polarizing filters to the floods or quartz lights and add one to the camera lens also. (A pola filter on the camera alone is *not* enough.)

The Kodak Polalight, Model 2, is designed specifically for copying. It consists of a light baffle, a bracket to hold the pola filter, and a socket for the bulb. Two of these lights are used at once. The pola filters on the two must be rotated to synchronize the angle of polarization between them. Another pola filter is used over the camera lens and is rotated until the glare disappears. This method, which requires through-the-lens viewing, eliminates the glare from a glossy photo or the glossy varnish on a painting; it also helps minimize cracks or wrinkles in a photograph or painting.

Glass over a framed picture can produce troublesome reflections; it may even "mirror" the image of the camera, the photographer, and the surrounding area. Unfortunately, a polarizing filter cannot eliminate such reflections because of the 90° angle between camera and copy. Stretch a sheet of black cotton cloth from one light stand to the other across the front of the camera. Then insert the camera lens into a hole cut in this black "wall."

To determine exposure when copying, use either an incident- or reflected-light meter. To use an incident-light meter, just place it on the copy to get an average reading. To use a reflected-light meter, take a reading off an 18 percent gray card held in front of the copy. However, if the copy is darker or lighter than average, you may have to open up or stop down slightly with either meter. If you are still in doubt about the exposure, bracket the exposures. With color transparency film, bracket the exposures by opening up one-half of an f-stop beyond the metered exposure and then stopping down one-half of an f-stop below the metered exposure. With black-and-white film, bracket with one full f-stop each way.

261

Use only panchromatic films such as Super XX or Tri-X to photograph colored subjects in black and white so as to render all tones accurately.

When you copy subtle works such as pencil drawings, you need a film that is more contrasty than regular black-and-white film. Tri-X Ortho for sheet-film cameras or High Contrast Copy for 35mm cameras would be good.

When you are copying high-contrast work, such as ink drawings, mechanical drawings, maps, charts, typography, you will probably want to reproduce the copy as black lines on a stark white background. In such cases, use extremely contrasty film like Kodalith. Because this film is very sensitive to exposure and development variations, it is more easily handled with sheet-film processing, though it is available in 35mm. With 35mm cameras, High Contrast Copy is often used. Though it is not quite so contrasty as Kodalith, it is easier to use with the smaller format.

Large paintings, photographs, drawings, maps, and the like require temporary individual copying setups. But you can make copies of small pictures or book or magazine pages with either a temporary or a permanent installation. If you use a temporary setup, keep exact records of the exposure level produced by the lights so you can place them the same way for your next copying session. You are more likely to get consistent results with a permanent setup.

A permanent copying installation consists of a copy stand, two photofloods in reflectors and on stands, a table to hold the copy stand, and a single-lens reflex camera. Copy stands are available in a wide range of prices. They hold the camera parallel to the copy—a faster, more efficient method than using a tripod. The lights are placed at each side of the copy stand at a 45° angle. Be sure to check light distribution over the baseboard with a light meter.

A carpenter's level is useful when you place the camera on the copy stand to help

you be sure the camera is parallel to the baseboard.

To center the copy quickly under the lens, lay on the baseboard a ¾-inch (18mm) piece of plywood, a little bigger than the baseboard itself. Then place the copy on the plywood and move the plywood around while centering the copy as you look through the camera. If the copy starts to curl, use a clean sheet of 11 × 14-inch (28 × 35-cm) or 16 × 20-inch (40 × 50-cm) ¼-inch (6mm) thick glass to hold it down.

You need to use a different method when copying pages out of a book to prevent damage to the binding of the book. Make a wood stand that holds up one side of the book while letting the other side lie flat. A smaller piece of ¼-inch thick glass may be used to hold the page flat. However, you may find that when the copy is horizontal on a vertical page, it may be impossible (with most equipment) to fill the entire frame properly because the bracket holding the book obstructs the light.

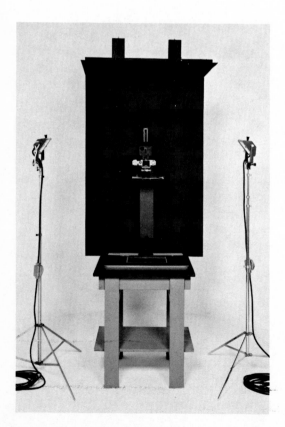

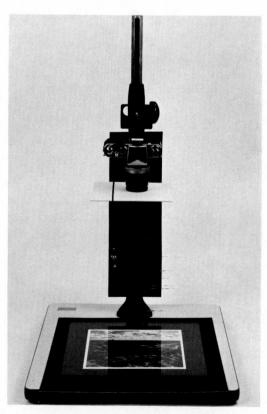

Far left: *A permanent copying installation includes a black shield for the camera, a black cloth on the vertical pole of the copy stand, a black wall in back of the stand, and a black false ceiling over the stand to help eliminate reflections from the camera, the stand, and other items in the room.* Left: *The camera and copy stand are shown against a white background for clarity.*

## Copying with Color Transparencies

When copying with color transparencies, you may use either photofloods or quartz lights. Photofloods are cheaper, but their color balance falls off as the bulbs age. Quartz lights remain stable throughout their life. When considering lights, be sure the lights and the color film agree. For example, if you use Kodachrome Type A, you need 3400° K bulbs, or you will have to place an appropriate color-balance filter over the lens. On the other hand, if you use Ektachrome Type B, you need 3200° K bulbs. See Chapter 13. (With black-and-white film, the temperature does not matter.)

The choice of color film is a matter of taste. Some photographers who prefer a slightly more contrasty rendition use Kodachrome for copying in color; others who prefer a flatter rendition use Ektachrome. No matter what film you use, test it to be sure of accurate results. Make tests of a gray card, a gray scale, and color samples—all with one-half of an f-stop differences. The tests will tell whether the particular batch of film is normal speed or slightly faster or slower. Such tests will also show the film's color balance. See Chapter 13.

Finally, if you plan to do much critical copying in color, buy a quantity of film with the same emulsion number and store it in a refrigerator—after having made the tests for film speed and color balance.

## Duplicating Color Transparencies

To make identical-size duplicates of color transparencies, you need a single-lens reflex 35mm camera, the proper equipment for extreme closeup photography, some way to diffuse the light that strikes the color transparency to be duplicated, and a light source. The simplest method is to use a macro lens with its short extension tube that permits one-to-one (1:1) copying. If other lenses are used, a bellows unit with a transparency holder is needed. To distribute the

*263*

*Right: A stand for use when copying pages from books is made by nailing together two pieces of wood, as shown. A thick elastic or rubber bands hold one side of the book up and a sheet of glass holds the other side flat for copying. Far right: The book-copying installation is shown against a white background for clarity.*

light, place a piece of translucent white plexiglass in back of the color transparency. Most of the tube copiers or bellows that have a transparency holder have a diffusion sheet built into the unit.

If tungsten light is used for the light source, it must be 3200° K to match the film's color balance (see Chapter 13). However, additional filtration to "fine-tune" the color balance is often needed. There are commercial units that consist of a dichroic light source and a bellows unit, but they are quite expensive. Photographers who have dichroic color heads on their enlargers can remove them and use them for color correction (see Chapter 13). The dichroic head is very convenient and produces a wide range of filtration. When electronic flash is used as the light source, you must work out some way to hold the flash unit in an upright position facing the bellows unit, as shown. Keep the distance between the electronic flash and the bellows unit constant. Either measure the distance each time or build a simple wood platform to hold the bellows unit and the electronic flash. The electronic flash makes color correction more difficult than the dichroic system because you have to buy color-correction filters and possibly neutral-density filters and place them in front of the

diffusion sheet for the color-balance tests (see Chapter 13). This takes time, money, and patience.

When you have solved the equipment and lighting problems, you must concentrate on the quality of the duplicated color transparency. Generally, such a transparency will have more contrast than the original. In some cases, this will be what you want, but most often not. There are several ways to reduce this excessive contrast: flashing (see page 218); masking (see page 366); and the use of special film for duplicating. The first two methods are complicated and usually not necessary simply because duplicating film gives adequate results. One of these films, Kodak Ektachrome Slide Duplicating Film, is made low in contrast to reduce the contrast of copy. It is available for either tungsten or daylight; it is processed normally.

At times when duplicating a color transparency you may wish to change the composition of the original. You may do that by cropping. You may also—while copying—correct for overexposure and underexposure in the original. Finally, you may change the color balance of the original with the help of filters. Thus you can add warmth to a scene that needs warmth but lacks it in the original transparency.

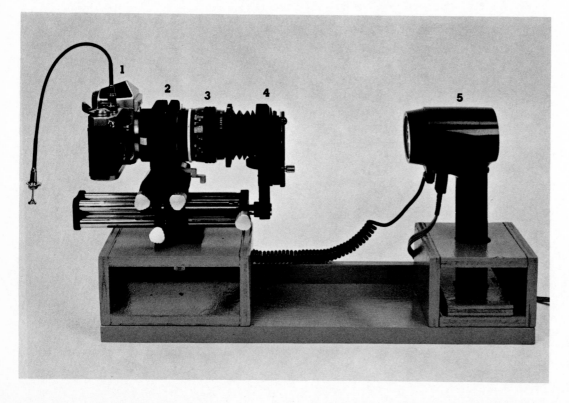

*This setup can be used for copying transparencies or film strips. In addition to copying 1 to 1, the bellows permits sections of an original to be enlarged. This particular setup permits moving the transparency vertically or laterally.*

**1** 35mm SLR camera
**2** bellows unit (closed up)
**3** lens
**4** transparency holder (with second bellows unit to eliminate reflections)
**5** electronic flash unit

## Copying with Black-and-White Transparencies

**I**f you need a transparency when copying black-and-white material, you should use Panatomic-X or Direct Positive Panchromatic Film. When copying something black and white (a photograph) with color transparency film, it is very hard not to get some hint of color. For example, a small discrepancy in color balance may give you a bluish-green black. Furthermore, Kodachrome usually gives excessive contrast to black-and-white material. Direct Positive Panchromatic film is available only in 100-foot (30-m) rolls and therefore requires bulk-loading (page 109).

Both Panatomic-X and Direct Positive film require a special process to produce positive transparencies rather than negatives. If you plan to use only a few rolls of film, buy Kodak's kit, called the Direct Positive Developing Outfit. It will process eight rolls.

If you plan to do much black-and-white transparency copying, buy bulk chemicals:

- 1-gallon package of Kodak's D-19 developer with four drams of Kodak Sodium Thiocyanate (liquid) added
- 1-gallon package of Kodak Direct Positive Bleach
- 1 gallon of Kodak Direct Positive Clearing Bath
- individual packets of Kodak Direct Positive Film Redeveloper
- regular film fixer

At times photographers add some selenium toner (30 ml to 1 quart) to the washing aid to clean the highlights, make the blacks richer, and add permanence.

Since black-and-white transparencies are a reversal process and are thus quite sensitive to exposure and development variations, you need to take just as much care with them as with color transparencies.

One final word of caution: It is perfectly permissible to photograph any copyrighted magazine page, book page, photograph, picture, or painting for private display or reference. However, it is a violation of the copyright laws of the United States to photograph any copyrighted image or passage of text in order to reproduce many copies for distribution, either free or for sale, unless you have specific written permission from the copyright holder. Written permission from the creator and/or owner is also necessary for any such use of photographs of photographs and other works of art, whether or not they are copyrighted. □

265

The Zone System, as originally introduced by Ansel Adams and Fred Archer, and as it is practiced today in various versions, is a method that a photographer may use to determine accurately and consistently how the tonal values in a scene will be rendered in the print. It consists of relating the various tonal values in a scene to the exposure, development, and printing of the film, in order to produce the rendition of the scene that the photographer wants. That rendition need not be limited to a factual depiction but may be a personal interpretation.

The Zone System is, in addition, a systematic and logical means for understanding the exposure and processing characteristics of photographic materials and equipment. Photographers who are not getting the results they want with their exposing, developing, and/or printing procedures often find that the system is a good way to analyze what is going wrong and decide how to correct it. Some of the refinements of the system are more easily handled with sheet-film cameras because each sheet of film may be exposed and developed individually, giving the maximum amount of control. Roll film does not give this degree of control because all the exposures on one roll must be given the same development. This works well if all the exposures are of similar situations. If they are not similar, the Zone System enables the photographer to tell how each different exposure will be affected by a common development.

There is an inherent danger in any such mechanical system. Photographers occasionally become so involved with the mechanics of the Zone System that the content of their pictures suffers, diminishing the visual strength of their work. The Zone System does offer greater technical proficiency, but it is important to remember that proficiency is a means, not an end.

▶ *Minor White was an early practitioner of the Zone System who taught it during his many years as a teacher, leader of workshops, and author. He also introduced the idea that grew into density parameters.*

As soon as film and paper were no longer sensitized by individuals (often inconsistently) and became consistent products from manufacturers, the need for a way to evaluate them became evident. This need is filled by *sensitometry,* the scientific study and evaluation of the sensitivity of photographic materials to exposure and development.

One important tool used to present information visually with sensitometry is the *characteristic curve.* A characteristic curve that illustrates the differences between exposure and density has already been shown in this book (see page 106).

The characteristic curve can also be used to show how various types of film differ inherently in contrast, as in the first of three graphs here. It also can show how exposure controls density, as in the second graph. And it can show how development controls density primarily in highlight areas, as in the third graph. The information derived from the second and third graphs provides the basic concepts of the Zone System: Exposure controls all densities, but development controls mainly highlight density. These concepts lead to the corresponding principle of the Zone System: *Expose for the shadows and develop for the highlights.*

The characteristic curve is often used to show differences in contrast, but it is not very precise. In order to describe numerically the difference in these density curves, the *gamma* and *contrast index* systems were developed. The specifics of these systems are beyond the introductory level of this book; if you are interested, see the bibliography for a list of more advanced technical publications that deal with these systems. Briefly, the gamma system consists of a formula that produces a number to describe the slope (the straight portion) of the characteristic curve. A curve with a steep slope has a high gamma number; a more shallow curve has a lower number. The higher the gamma number, the higher the contrast. Many photographers and technicians feel that the gamma system is limited because it uses only the straight line section of the characteristic curve, ignoring the toe and shoulder. The contrast index system, more recently introduced, takes into account the usable portions of the toe and shoulder, as well as the straight line, producing a system that is somewhat more useful.

*268*

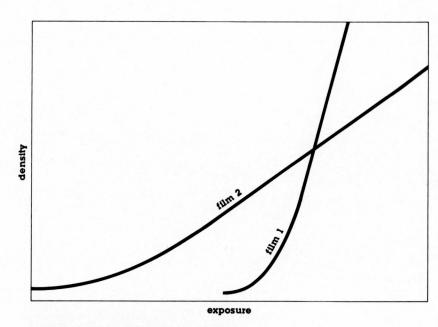

**inherent contrast differences of film**
*These characteristic curves show inherent differences in contrast between two types of film. Each was given the normal exposure and development for its type. Values of negative density increase from bottom to top of the vertical scale. Since film 1 has the steepest slope, it has the greatest difference between low density and high density at a given exposure range (density range) and is therefore more contrasty. The graph also shows that film 1 is a slower film, since it needed considerably more exposure before any density at all was recorded.*

The major problem with the gamma and contrast index systems is that they are more helpful to photographic engineers designing new materials and to technicians comparing or monitoring quality from one film sample to another than to photographers in the field.

The Zone System offers a solution that is more practical for the photographer. Ansel Adams combined technical aspects of the characteristic curve with visual ideas important to photographers in the field and integrated them into a logical, unified system with practical applications. This system, called the Zone System, enables the photographer to analyze the brightness range of a scene and to manipulate exposure and development in specific ways to produce the rendition desired in the print.

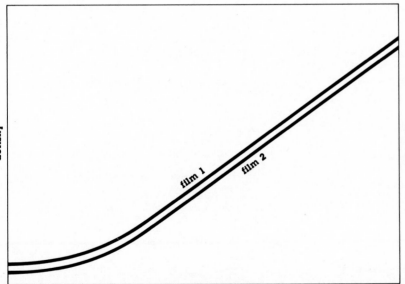

### exposure controls density

*These characteristic curves show how exposure affects density. The subject photographed was the same—a gray scale—signified by subject brightness values on the horizontal scale. Values of negative density increase from bottom to top of the vertical scale. The two films of the same type received the same development, but film 1 received more exposure, producing more density in each of the steps on the gray scale. Note that the shadow and highlight densities of both curves changed to the same degree, showing that there was no change in contrast (density range). (If these curves were extended to include the shoulder portions, they would compress together, since both would have achieved maximum density.)*

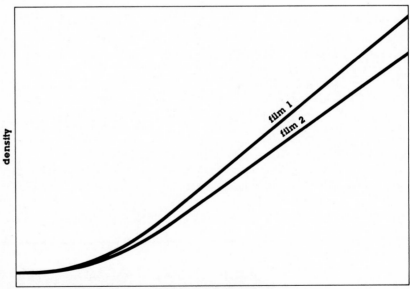

### development controls contrast

*These characteristic curves show how development affects negative density in highlight areas. This graph is set up like the preceding one: both films record a gray scale which has each step plotted to show negative density changes. The two films of the same type received the same exposure, but film 1 received considerably more development. Film 1 has more density in the highlights, with little effect in the shadow areas, showing that development controls primarily highlight density. Thus development caused a change in contrast in film 1, shown by its much steeper curve (greater density range) at a given exposure range.*

## Previsualization

**A** scene usually has a great variety of tonalities that range from black through gray to white. A photograph cannot record all of the tonalities in a scene and produce an exact "copy" of it. At best, it is only an approximation. Photographers acknowledge this and the variables inherent in their materials, procedures, and techniques when they express doubts about how their pictures will look. The purpose of the Zone System is to help eliminate such implied lack of control.

Even more important, the Zone System encourages the idea that a photograph is not merely a copy, but an entity with life of its own. This life of its own is a mental and conceptual idea resulting from the photographer's feeling about how the photograph should look. In some cases the photographer may want to produce a near factual image of the scene; in other cases the photographer may want a more exaggerated or impressionistic rendition. The photographer needs a great deal of sensitivity and understanding in order to make decisions about methods of interpretation.

These decisions are made easier by the Zone System because it permits *previsualization*. This means that when looking at a scene, the photographer mentally translates the various tonalities of the subject into the tonal values that will represent them in the final print. Previsualization consists of, first, reading and evaluating the tonal values in the original scene; then deciding how the tones should be rendered in the print; and, finally, planning a method of exposure and development that will produce a negative with the appropriate densities to achieve the desired rendition.

In order to provide some means of describing a particular tone or be able to compare it to another whether it is in the subject (subject brightness value), the negative (negative density value), or the photograph (print tonal value), Ansel Adams introduced the concept of the "zone" in his book *The Negative* in 1948.

The term "zone" may be used during all three stages (subject, negative, print) of making a photograph. In the *print,* there are ten value zones, as shown on the Zone Scale, ranging from black to white. Zone 0 is the darkest of all tonal values; Zone IX is the lightest. Each zone represents a particular tone; for example, Zone V is the same as an 18 percent gray card.

In the *subject,* there are exposure zones. Unlike print zones, exposure zones have no upper limit in number. The meter is set up to read a middle-gray value, 18 percent reflectance, and successive exposure zones are one f-stop apart. For example, if you wanted to give a subject value a Zone IV exposure, you would stop down one f-stop from the meter reading. If you wanted to give it a Zone III exposure, you would stop down one more f-stop or two f-stops from the meter reading, and so on.

In the *negative,* the term "zone" refers to specific negative densities needed to represent their corresponding values in the print. These densities vary according to the paper used.

A thorough understanding of the zones and how they relate to real objects in a scene is very important. You should be so familiar with them that the correlation becomes intuitive. Understanding this relationship is crucial to applying the principles and methods of the Zone System.

### the Zone Scale

**low values**

**Zone 0**   *In the print Zone 0 represents the most absolute black possible with the printing paper; it lacks all detail or texture.*
**Zone I**   *In the print this is the threshold, the first perceptible change from absolute black; it lacks all detail or texture.*
**Zone II**   *In the print this is lighter than Zone I, but it is still a definite black with only a hint of detail or texture.*

**middle values**

**Zone III**   *In the print this is a dark value. This is an important zone because it is the first one that has substantial information. It is used as the tone of a shadow area that is to contain detail or texture.*
**Zone IV**   *In the print this is a dark gray such as in a shadow in a landscape photograph (dark foliage). It is often used also as the tone for the shadow of a portrait done in sunlight.*
**Zone V**   *In the print this is the same tone as an 18 percent gray card or sunlit grass.*
**Zone VI**   *In the print this is a medium light gray similar to old wood or shadows on snow in a landscape.*

**high values**

**Zone VII**   *In the print this is a light gray similar to sand or snow that is sidelit with full texture.*
**Zone VIII**   *In the print this is a very light gray. This is an important zone because it is the last one that contains information. It is often used as the tone of highlight areas that contain subtle detail and texture.*
**Zone IX**   *In the print this is a white area that contains no detail or texture. It represents the white of the printing paper.*

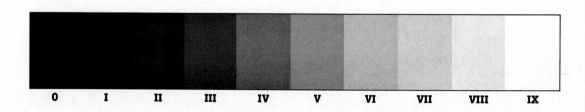

0   I   II   III   IV   V   VI   VII   VIII   IX

271

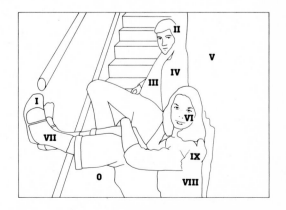

## How to Use the Zone System

**B**ecause the Zone System is based on exposing for the shadows and developing for the highlights, the first step in previsualization is to evaluate the dark subject values (the shadows) of a scene. Since these values are usually small areas, you need to know how to use your particular exposure meter to accomplish this. A spot meter (either handheld or built into the camera) is very convenient. A reflected-light meter is pointed at the value being read. If you are using a through-the-lens meter, you need to understand exactly what area of the scene is being read; it may be hard to get a closeup reading with an averaging meter. (Obviously, an incident-light meter is unsuitable for this purpose.) With previsualization you use the light meter to read the darkest subject value of interest. Then you decide which value zone you prefer that area to be in the print. This is called *placing*. When you have placed this subject value in a print zone, you affect the rendition of all the other tones in the scene accordingly.

Often the darkest subject value is placed in Zone III in the print because that is the darkest print value that holds detail. However, depending on your intent for a particular photograph, Zone II or Zone IV may be more appropriate. You would then use the appropriate exposure, as already explained, to produce the desired zone (print value) in this shadow area of the print.

The next step is to evaluate the bright subject values in the scene with the light meter and to determine from them what development time or dilution is appropriate. In the traditional Zone System, the testing procedures allow only one choice for highlight placement, Zone VIII, because that is the lightest zone in the print that holds detail. Thus you must find the area of the subject that you want to be reproduced as Zone VIII and take a meter reading from it. The exposure of that reading is determined by taking the difference in f-stops between the shadow reading and the highlight reading and adding the resulting number to the placement of the shadow area. For example, if you place the shadow values in Zone III and there are five f-stops between the shadow and highlight readings, the highlights will receive a Zone VIII exposure (III + V = VIII). If there are six f-stops between, the highlights will receive a Zone IX exposure, and so on.

In order to translate this exposure range into a specific development, you need to know that in the Zone System, normal development, signified by N, is defined as the development needed for a Zone VIII exposure to yield a negative density value that will produce a Zone VIII in the print. At this development all exposure zones will yield corresponding zones in the print. Any development that reduces contrast (N −) is called a *compaction* (or contraction); any development that increases contrast (N +) is called an *expansion*. N − 1, for example, is the development needed for a Zone IX exposure to yield a negative density that will produce a Zone VIII in the print.

To determine the proper development for a highlight exposure, find the area in the scene (subject value) that you want to have a Zone VIII value in the print and then use the table below.

Basing development on achieving Zone VIII in the print gives you very little information about the other highlight area zones and little ability to vary the placement of the highlights accurately. This is important because the Zone VIII placement may not always be appropriate. Your interpretation may require detail in the highlights or it may require paper-white highlights or it may require a highlight value that is closer to a middle gray. You make this decision during previsualization. Because of this limitation of only supplying information about one zone in the highlights, many photographers have chosen to use a more flexible version of the Zone System called the *density parameter system*. □

**highlight exposures and development to produce Zone VIII in the print**

| exposure zone | print zone | development |
|---|---|---|
| X | VIII | N − 2 |
| IX | VIII | N − 1 |
| VIII | VIII | N |
| VII | VIII | N + 1 |
| VI | VIII | N + 2 |

The density parameter system was introduced by Minor White and expanded by Arnold Gassan (see the bibliography). It is a very versatile and accurate system because it provides more complete information about placement and development than the traditional Zone System. It gives information for doing expansions and compactions based on *any* highlight zone rather than only for Zone VIII. The parameters allow you to see graphically what is happening to all the zones. Since the density parameter system is based on the Zone System and is a refinement and extension of it, the tests in this chapter are geared to the density parameter system.

The density parameter system uses the idea of the characteristic curve but reorganizes the presentation of the information. Instead of exposure or subject brightness values being the horizontal scale, as with characteristic curve diagrams, development is placed there; there is no change in the vertical density scale. This simple alteration enables density parameter curves to give accurate information about each exposure zone as development changes. The information is convenient and easy to use because all of it may be found on a single graph. Also, the testing procedures for the information necessary to produce the curves are considerably easier and faster than for the Zone System.

A density parameter diagram looks different from a characteristic curve diagram but is easily understood. It is a series of curves, each representing a particular zone exposure and the corresponding density yielded by various developing dilutions (or times). See Density Parameter Curve A.

The first thing to examine on this graph is how the various exposure zones are shown. Look first at Zones I, II, and III at the bottom of the graph. Note that the Zone I line increases very little in density with added development, while Zone II increases somewhat, but not as much as Zone III. Zone III is an important zone because it usually has a considerable amount of detail in the shadow area. Also note that the distances between the lower zones, from fb+f (film base + fog, see page 277) to Zone II, are not as great as between the next zones. This means there will be less tonal separation in the shadow areas of the print. These lower zones correspond to the toe on a characteristic curve.

Next, look at the curves marked Zones IV, V, VI, VII, VIII. Note how these increase more in density with added development but basically retain equal spacing. These exposure zones are comparable to the straight line of a characteristic curve.

The bright areas of the subject are shown as Zones IX, X, XI, and XII. These exposure

zones react most dramatically to development changes, as shown. It is through a rapid increase in density in these high exposure zones compared to the minimal change of density in the lower exposure zones that you control the contrast of the negative. Also notice that the spacing between Zones IX, X, XI, and XII is slightly less than that between the middle zones. This area corresponds to the shoulder of the characteristic curve and tonal separation is reduced.

The next information to look for in the density parameter diagram is the location of normal development, defined here, as in the Zone System, as the development dilution (or time) that a Zone VIII exposure requires to yield the suitable density in a negative to produce Zone VIII tone in the photograph. The normal development time is indicated on the development scale by the vertical line drawn from the point where a horizontal line representing the density needed to produce Zone VIII on your printing paper (determined by the test described on page 278) intersects the curve for Zone VIII.

When the normal development is known, the graph can easily be used to determine the correct development for other situations. Density Parameter Curve B shows how to find compactions and expansions. To the left of the line for normal development are compaction dilutions (or times); to the right,

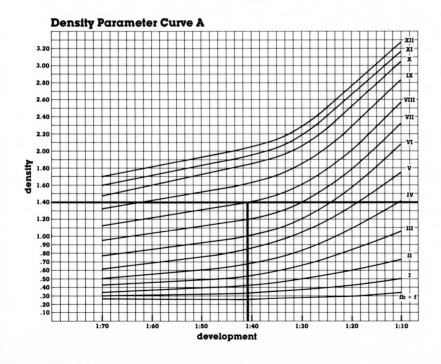

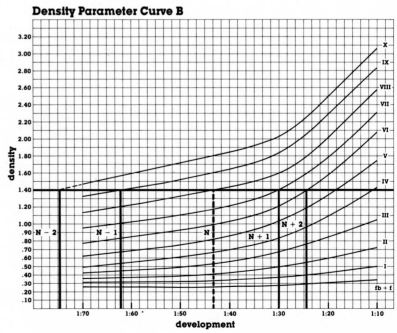

expansion dilutions (or times). In this case assume you had taken a meter reading of the shadow area and placed it in Zone III. When you read the highlight area, you found that the meter reading taken from the area you wished to be a Zone VIII in the print was actually six f-stops from Zone III instead of five. This meant that the highlight area would appear as a Zone IX if the film were developed "normally." Since compaction of one zone (N − 1) would produce a Zone VIII, you look to the left of the normal development line and find the point where the Zone VIII density line intersects the Zone IX curve. This indicates a one-zone compaction (N − 1). A line drawn down from this intersection to the bottom of the chart indicates the proper development dilution (or time) for an N − 1 compaction.

When a more drastic compaction such as N − 2 is needed, note what happens to Zone I and Zone II on the curve. There is very little separation between them, and they may blend into only one tone. Exposures should be increased by 1/4 or 1/3 an f-stop to help separate them. If, in another situation, the photographer finds the highlight reading falls in Zone VII and a Zone VIII is wanted, the same procedure is followed, but to the right side of normal development to obtain an expansion (N + 1). This is found where the Zone VIII density line crosses the Zone VII curve. A line dropped down from this intersection will give the proper development for this expansion. To find an N + 2 expansion (your exposure zone is VI and you want an VIII in the print), continue over to where the Zone VIII density line hits the Zone VI curve. (See the two photographs of a young woman, opposite.)

The amount of compaction and expansion possible depends on the type of film and the developer. Usually with a regular developer, a two-zone compaction and a two-zone expansion are possible. However, with special developers (two-bath, see page 171) or special developing procedures (water bath, see page 171), the range may be extended.

One advantage of the density parameter system over other systems is that high zones other than Zone VIII can be placed. For example, if you want to place a certain highlight value in Zone VII and it has an exposure value of Zone VI, you draw a horizontal line from the intersection of Zone VII and the normal development dilution or

274

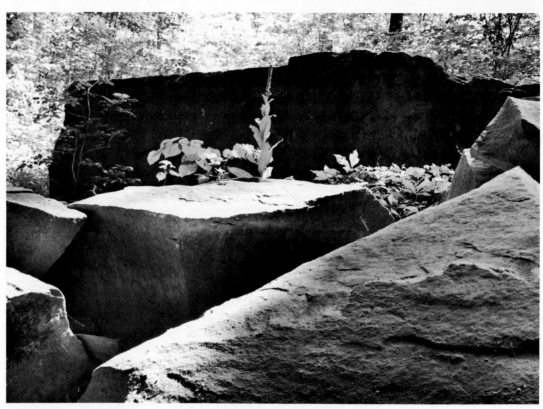

*While previsualizing this scene, the photographer took a meter reading off the rocks in the shadow area and placed them in Zone III. When taking a reading off the highlight areas—the rocks in bright sunlight—he found that they fell in Zone IX. Zone IX does not have the textural quality he felt would be right for the photograph he wanted to produce. He consulted his density parameter curve to find the development that would produce a one-zone compaction. The resulting photograph has the desired textural quality in both shadow and highlight areas.*

**Density Parameter Curve C**

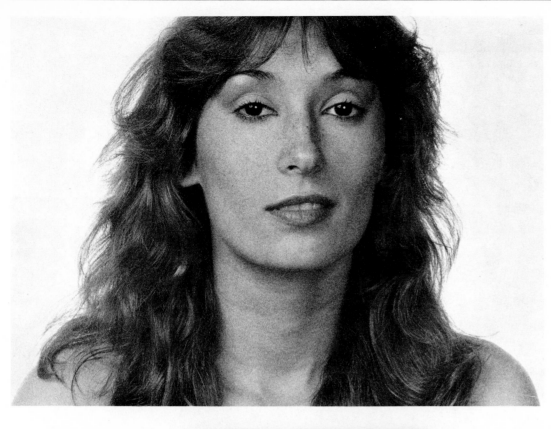

time (representing the needed density to produce Zone VII in the print), find where th Zone VI exposure crosses that horizontal line, and drop a line to find the development, as indicated in Density Parameter Curve C. That development will raise a Zone VI exposure to a Zone VII in the print. The ability to place any zone makes the density parameter system far more valuable than the traditional Zone System.

It is important to understand that both the density parameter system and the Zone System are ways to help you control the print values in a photograph. Often photographers impose a limitation on the Zone System, using it only to create a "normal" print. However, the density parameter system should be thought of as a total means of control, giving you the ability to make an interpretation beyond a "normal" print. The two photographs shown here indicate why there is no such thing as underdevelopment or overdevelopment when using the density parameter system, but merely the *appropriate* development to produce the desired print values in a photograph.  □

275

*The lighting was the same for both photographs.* Left above: *The photographer placed the shadow areas in Zone III and with the meter found that the skin tone fell in Zone VI. Using his N development, he produced a rather natural rendition, with a delicate roundness in the face and a soft, tactile quality in the hair.* Left: *To produce a more exotic or glamorous rendition of the young woman, the photographer again placed the shadow areas in Zone III, but he consulted his density parameter curve to find the development that would produce a Zone VIII in the left side of the face (N + 2). He found where the Zone VI exposure curve crossed the Zone VIII density line and dropped a vertical line from that point to the development scale to get the proper dilution (or time). Here the face looks less rounded, almost angular, and the hair has a shiny, almost metallic glow.*

Successful use of the Zone System and its more flexible counterpart, the density parameter system, depends on your attitude. You need to be willing to buy some additional supplies and equipment, and you need to perform a series of tests to obtain the information required to plot density parameters. You need to recognize, respect, and adhere to standards of careful and consistent technique because precise control over materials leaves little tolerance for errors in exposing, developing, and printing.

In order to use density parameter curves effectively, you need to buy supplies such as film in larger quantities. For example, you should buy at least twenty rolls of 120 or 35mm film or a 100-sheet box of sheet film, *all with the same emulsion number.* You also need to decide on the type of film, method of development (one-shot or replenishment), and the brand and type of printing paper you intend to use and then stay with them.

For the various tests you need a Kodak 18 percent gray card as a photographic subject. A spot meter is very helpful but not es-sential, as any reflected-light meter may be used. For tests with fast film, such as Tri-X, you usually need a 1.20 neutral-density filter, which reduces exposure by four f-stops. For tests with sheet film, you need three specially prepared film-holder slides (see below) to enable you to make the tests faster and with fewer sheets of film and a smaller quantity of developing solutions.

The tests for density parameters use density as a unit measurement. Therefore you need to use a densitometer, a very precise but expensive piece of equipment that even college laboratories often do not have. If you have no access to a densitometer, there is an effective alternative, described on page 277.

The graph paper sheets you use to plot density parameters should have rules of 10 millimeters to the centimeter, such as National's 12-188. These are three-hole punched and thus easily incorporated into a record-keeping notebook.

The processing equipment you use for the tests should be the equipment you usually use—the same type of enlarger, etc.

276

## how to make exposure slides for tests with sheet film

*To make the exposure slides used to conduct tests with sheet film, drill a hole in each of three slides for a sheet-film holder. If you are using 4 × 5-inch (10 × 12.5-cm) film, make each hole 1 inch (25mm) in diameter; if you are using 8 × 10-inch (20 × 25-cm) film, make each hole 2½ inches (63mm) in diameter. To cut the holes, use a power drill equipped with a sawtoothed bit.*

*To place the holes correctly, begin by inserting the three slides one by one into the sheet-film holder. With a felt-tip pen rule the boundary made by the frame of the holder on each slide. This boundary marks off the image area. Placing each slide in a horizontal position, divide the image area of each in half with a perpendicular line on each slide.*

*Drill a hole in the first slide at the top left of the image area. Put this slide over the second slide and rule the boundary of the hole onto the second slide to indicate the position of the hole. Drill a hole in the second slide in the top middle portion of the image area, making sure that it does not overlap the position of the hole in the first slide. Drill a hole in the third slide in the top right portion of the image area, again making sure it does not overlap the positions of the holes in the other two slides. Your three slides will look like the ones in the photograph.*

*The three "exposure" slides allow you to make six test pictures on one sheet of film. Adjust your camera for the horizontal format. Then insert the completed slides into the loaded sheet-film holder top side up, one at a time, to make three exposures through the three holes you have drilled. Then insert them one at a time top side down to make three additional exposures on the bottom of the film. When it has been developed, the resulting sheet of exposed film will look like the one shown here.*

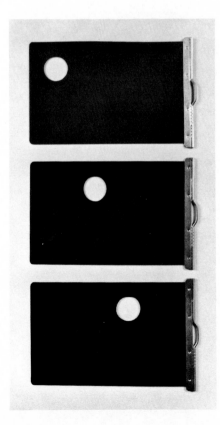

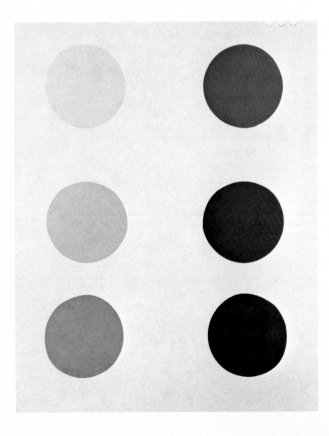

## an alternative to the densitometer

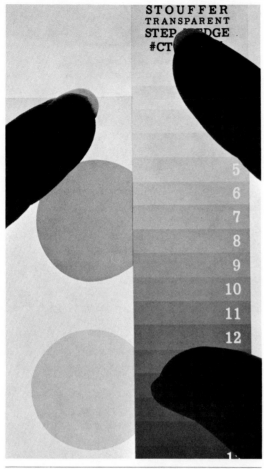

*This way to determine density is not as accurate as using a densitometer, but, with patience, it is adequate. You need a photographic step tablet (transmission gray scale), a piece of film that has either twenty-one, thirty-one, or forty-one different densities. These are available from Eastman Kodak or Stouffer. Both companies offer calibrated and uncalibrated (less expensive) step tablets. The Stouffer Step Tablet is the only one available with forty-one steps with a .05 difference between densities. This permits more accurate judgment than is possible with a twenty-one-step tablet, which has a .15 difference between steps. The Stouffer Step Tablet is also convenient to use because a reference number for each step is incorporated in the film.*

*If you can find a way to use a densitometer just once, you can easily calibrate an uncalibrated tablet by reading the various densities and recording them for each area. If you cannot arrange this, buy the more expensive calibrated tablet.*

*Place the step tablet on a light table next to a section of a negative of unknown density and move it back and forth until one of the steps on the tablet is equal to the unknown density, as shown in the photograph. To make comparisons easier, cut off the edge of the negative so the step tablet can be held next to the unknown density (do not overlap them). Often, it is difficult to find an exact match, but with some interpolating, you can determine the density quite accurately. (Step tablets are also used for the paper density range test; see page 278.)*

## How to Determine Your Personal Exposure Index

The manufacturer's suggested exposure index (ASA) for a film is not accurate enough for effective use of the Zone System because of the many variables in both the manufacturing and storage of the film and your own equipment and techniques. Thus you need to determine your own individual exposure index. To do this, you use the *threshold test,* which determines the ASA for a film that will take a Zone I exposure and yield a density of .10 above the density on an unexposed, developed piece of the film. This unexposed and developed area is called *film base + fog* (fb + f).

A density of .10 above fb + f in a negative is necessary to produce the first perceptible tone change from absolute black (that is, Zone I) on most printing papers. Therefore, you need to find the correct exposure index for your film that will yield this density when you underexpose four f-stops from a regular meter reading. For roll film, perform the threshold test as follows:

1. Place an 18 percent gray card in sunlight or tungsten light, whichever you use most.
2. Put the camera on a tripod, set the focus at infinity, and make certain the gray card fills the entire frame. The fact that the card is out of focus does not matter; you are photographing a tone, not a subject. The camera is set at infinity to ensure accuracy at the lens opening you select. If you are doing the test outdoors, tilt the gray card up slightly, being careful not to get any glare on it.
3. Set the light meter at the manufacturer's recommended ASA rating for the film.
4. Take a reading off the gray card. Avoid casting a shadow on the card.
5. Make an exposure with that reading to use as a reference point. This Zone V exposure will be used just to show where the test begins on the roll. To prevent reciprocity failure, use at least a ⅛ second exposure.
6. Make one exposure *with the lens cap on* to produce an area of film that will not be exposed, but will be developed (fb + f).
7. Remove the lens cap and make an exposure *five stops less* than the meter reading for Zone V. Often, you will need a 1.20 neutral density filter, especially if you are testing a fast film outdoors.

8. Make *five* additional exposures, giving each exposure *one-third of an f-stop more light* than the one before it.

The procedure for testing sheet film is similar to that for roll film. You can usually do it with a single sheet of film if prepared special film-holder slides are used. (See page 276 for instructions for making these slides.) If you do not use special slides, you need seven sheets of film. With special slides, the area around the circular exposed areas may be used for the fb + f reading, so the six test exposures are possible on one sheet of film. The first circle is at an exposure five stops less than the meter reading for Zone V and the five remaining circles are exposed as in step 8.

When you have developed your film at the dilution or time and temperature suggested by the manufacturer, you are ready to judge the results of the test exposures.

Use a densitometer or the alternative method explained on this page to read the various densities of the test negatives. Begin with the blank frame (the one made with the lens cap over the lens) or the area of the sheet film not exposed by the holes in the exposure slides. Either has the fb + f density. Read this fb + f density and record the figure on a chart that you have set up with columns for exposure number, ASA rating, and density reading. (Readings vary with different types of film.)

Next, jot down your six test exposures one under the other. (The Zone V exposure on roll film was just a reference point, not a test exposure, and fb + f should not be a numbered exposure.) Place the manufacturer's suggested ASA in the ASA column opposite your fourth test exposure, which was four stops below the meter reading (theoretically, Zone I). Then write the standard ASA increments above and below the suggested ASA rating so that the higher ASA numbers ascend and the lower ASA numbers descend from that suggested ASA. Next, take individual readings of the six test exposures in the sequence you made them, recording the density reading and the number and description of each exposure in the appropriate columns below your record for fb + f. Your next step is to find the exposure in the sequence that is .10 above the fb + f. For example, if the fb + f density is .25, you are looking for a reading of .35. This .35 frame—or circle on the sheet film—is the

277

correct density for Zone I. If, to continue the example, you find the .35 reading in your fifth numbered exposure (you do not count the blank fb + f as an exposure), this exposure is your own Zone I exposure. The ASA rating (in this case the 320 rating shown on the sample chart at the fifth exposure) is your *personal* ASA for that emulsion number of film when used with your equipment and developing practices. If your fourth rather than your fifth exposure had been .10 above fb + f, then your personal ASA rating would have been the same as the manufacturer's suggested ASA. On the other hand, if your third exposure had been .10 above fb + f, then your personal ASA rating would have been ASA 500. See the Sample Exposure Index Record below.

### How to Determine the Density Range of Your Printing Paper

**J**ust as you need to determine your personal exposure index (ASA) for your film, you need to find the density range of your own printing paper. This is so that you may match the density range of your film with the paper's density range.

There are a number of different ways to determine the density range of printing paper, and they differ from one Zone System book to another. Some photographers use the density range provided by the manufacturer, but these numbers are usually not very practical because they do not take into account the many variables introduced by individual equipment and

techniques. The following method is easy, fast, and integrates your own equipment and techniques:

1. Place a step tablet (transmission gray scale; see page 277) into a glass negative carrier, masking the scale around the edges to prevent flare. Insert the carrier into the enlarger.
2. Expose the step tablet to the printing paper. The exposure must produce a solid black at one end and a solid white at the other.
3. Develop, fix, wash, and dry the print.
4. Study the dried print under normal lighting conditions:
   a. determine which step represents Zone I—that is, the first perceptible tone lighter than black; record the appropriate step and its corresponding density
   b. determine which step represents Zone VIII—that is, the lightest value that holds detail in the print; remember that Zone VIII is slightly darker than the first perceptible break from pure white; record the appropriate step and its corresponding density
5. Subtract the density reading of Zone I from the reading of Zone VIII to get the density *range* of the paper, and record it.
6. Repeat this test for each grade of paper you use. If you use variable-contrast paper, you need to test for each filter. The information gained by this enlarging method will differ from contact printing with the same materials. A separate series of tests is needed for contact printing.

*In this printing paper test, step 8 represents Zone I, and step 13 represents Zone VIII.*

278

### sample exposure index record*

| exposure number | ASA rating† | density reading |
|---|---|---|
| *no exposure—fb + f* | — | *.25* |
| *1. five stops below meter reading* | *800* | *.25* |
| *2. ¹/₃ f-stop more exposure* | *650* | *.26* |
| *3. ¹/₃ f-stop more exposure* | *500* | *.28* |
| *4. ¹/₃ f-stop more exposure = 4 stops below meter reading = manufacturer's theoretical Zone I* | *400* | *.31* |
| *5. ¹/₃ f-stop more exposure* | *320* | *.35 = Zone I* |
| *6. ¹/₃ f-stop more exposure* | *250* | *.40* |

*\*The manufacturer's suggested ASA for the film used in this record was 400. Readings vary with the type of film.*

*†The standard sequence of ASA increments is 5, 6, 8, 10, 12, 16, 20, 25, 32, 40, 50, 64, 80, 100, 125, 160, 200, 250, 320, 400, 500, 650, 800, 1000.*

*How to Determine Development*

This test provides information about the densities produced with varying development in all the exposure zones so you will know what development dilution (or time) will make the appropriate density in the negative to produce the tones you want in the print. The test will require exposing five rolls or ten sheets of film. (If the special slides for sheet film are not used, you need fifty sheets for a complete series of tests!) It is extremely important to expose the rolls or sheets identically. Any inconsistencies in exposure will ruin the results of the tests. For roll film, expose each of five rolls as follows:

1. Set up your camera and an 18 percent gray card as in the exposure index test on page 277.
2. Set your light meter to the personal ASA rating for your film, which you found in the exposure index test.
3. Make one exposure with the lens cap on (for fb + f).
4. Remove the lens cap and make one exposure at Zone I. To do this, read the card with the meter to get a Zone V exposure again, and then stop down four f-stops to arrive at Zone I.
5. Make one exposure each for Zones II through X. Allow one f-stop more exposure for each zone. Use the aperture instead of the shutter to change the exposure because it is more accurate. Thus, if Zone I is f/16, Zone II is f/11, Zone III is f/8, and so on to Zone X. If

you want to, you can make one or more additional exposures for Zones XI and XII (more conveniently done with roll film), which will give you more flexibility for compaction (see pages 273–274) later on when you are plotting a graph. In Density Parameter Curve A (see page 273) exposures were made to include these additional zones.
7. Finish off the roll with Zone V exposures. You must expose the *entire* roll so that your tests will duplicate the actual situation when you have an entire roll to develop. If you do not, you will distort the tests because the developer will be more active working on only a few frames than on an entire roll.

The procedure for sheet film (using the special slides) is similar to the roll-film procedures, but you will need two sheets of film to equal the exposures on one roll of film. You will not have to make an exposure with the lens cap on, since your fb + f will be the area surrounding the circle exposures. Mark the sheet-film holders in order to keep each set (two sheets) identified, preventing confusion when processing them.

You must now alter the development of each of the five rolls or five sets of sheet film. Develop one with the manufacturer's suggested development and the other four at different stages of more or less development. How you vary the development—whether by altering the time the film is developed or by changing the strength of the developer—depends on your choice of developer,

279

because some developers are not suitable for the dilution method. (Kodak's HC-110 or Agfa's Rodinal are concentrated liquid developers that do lend themselves to the dilution method.)

Photographers who prefer the dilution method feel that liquid developers are easier to use, more consistent, and produce finer quality, especially when compacting. A concentrated liquid developer, when diluted a great deal, becomes a semi-compensating developer (see page 147). This is very desirable because the delicate separation of tones in the shadow area is maintained, yet the highlight areas do not become excessively contrasty. Shortening the development time, on the other hand, often tends to reduce the already slight separation in the shadow areas, compounding the problem.

If you prefer to vary development by changing the length of time the film is developed, first develop one roll or set of sheet film at the time given in the manufacturer's technical sheet accompanying the film (X). Then develop another roll or set of sheet film at one-half ($\frac{1}{2}$ X), another three-quarters ($\frac{3}{4}$ X), another at one and one half (1 $\frac{1}{2}$ X), and finally one at two (2X) times the manufacturer's indicated time.

It is somewhat more difficult to suggest dilutions than it is to advise time changes in development because dilution rates vary greatly with the type and brand of film, the brand of developer, and the way you agitate during development. Therefore, if you elect to vary development by changing the strength of the developer you will have to establish your own dilutions by the following procedure. Develop one roll or set of sheet film according to the instructions on the developer bottle. Then develop two rolls or sets at two different strengths that are greater than (less diluted) the manufacturer suggests and two rolls or sets at different strengths that are less than (greater dilution) recommended. In Density Parameter Curve A (page

273), dilutions were made with Kodak's HC-110.

Whichever your preference—time or dilution—be sure to:

1. Use fresh developer for each roll or set of sheet film.
2. Develop each roll or sheet-film set at the same temperature.
3. Use consistent agitation techniques throughout all test development.

Now that you have developed your film at varying degrees of development, you are ready to chart on graph paper the changes in the film's density. When you have done that, you will be able to determine what developing time will make the appropriate densities on the negative produce the ones you want in the print.

When you have completed your tests, you must carry over into your future working methods those standards of temperature, agitation, and fresh chemicals. If you do not, the results will not conform to the information you found in the tests.

### How to Plot a Density Parameter Curve

**W**hen plotting density parameters turn the graph paper (see page 276 for recommendations) horizontally so that the ring holes, if any, run across the top of the sheet. Label the top of the graph paper to indicate the method of varying development you are using (dilution or time), the type of film, and the developer.

Use the vertical line at the far left of the sheet and the horizontal line at the very bottom of the sheet of graph paper to indicate your two scales. Label the vertical line *density,* and the horizontal line *development.* Since each millimeter rule on the density scale represents .02 density, mark each centimeter rule—starting at the bottom of the graph—.20, .40, .60, and so on up to 3.20. To improve clarity at the lower levels of the

density scale, add the density calibrations for every half-centimeter up to 1.00 density.

When the dilution method is used for developing, mark off a point approximately midway on the development scale and record here the manufacturer's recommended dilution ratio. Record the more diluted development ratios to the left of this point and the less diluted development ratios to the right. Use suitable and consistent spacing.

When the time method is used for development, each centimeter rule along the horizontal line represents a 1-minute increment. For example, on the graph paper shown here, developing times from 1 to 24 minutes could be recorded.

The graph is now ready to receive the information from the film developing tests. Begin with the roll or set of sheet film that was developed according to the manufacturer's recommendation. Take a densitometer reading (or use the alternate method described on page 277) to find the density of the unexposed area of the film (fb + f). Mark this density with a small dot or × on the graph directly above the mark for the manufacturer's recommended development.

Next, obtain density readings of Zones I through X (and of Zones XI and XII if these exposure zones were included in the test) on that roll or set of film and mark these readings also on the graph along the same vertical rule that indicates the manufacturer's recommended development. After this roll or set of sheet film has been noted, repeat the procedure for the other four rolls or four sets of film, marking the density of each exposure zone above its appropriate development mark.

At this point your graph will look like the sample shown. Now use a flexible or french curve to connect all the dots in one exposure zone for each development. Label the curves with fb + f and the zone numbers on the right-hand side of the paper, as shown on Density Parameter Curve A (page 273).

*280*

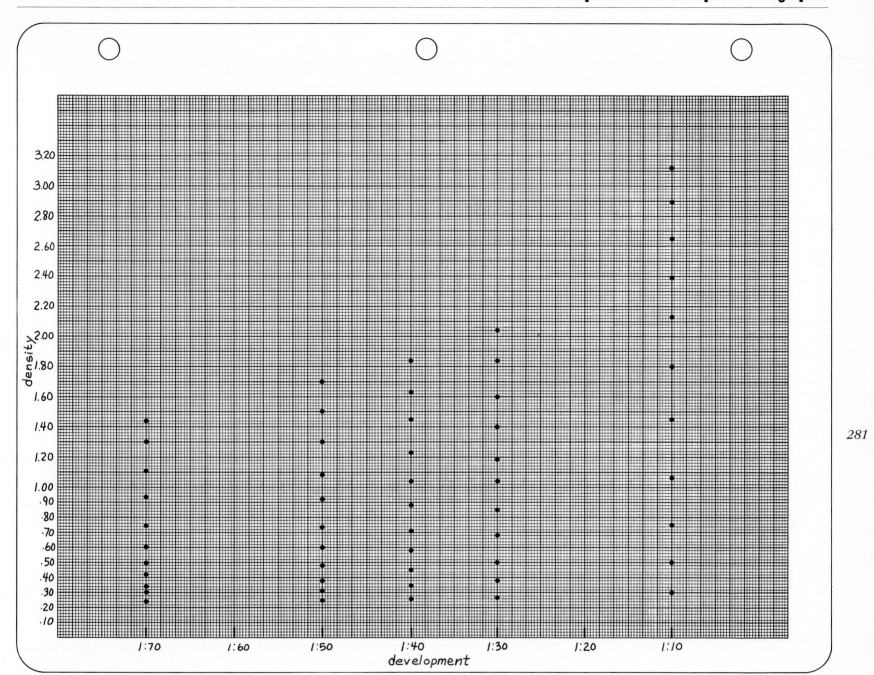

**sample graph: dilution method**

*The manufacturer's recommended dilution ratio of 1:40 is near the middle of the development scale, with greater dilutions to the left and lesser dilutions to the right. The dots in each of the five columns represent the density of each exposure zone on a particular roll or set of film developed by the dilution ratio specified. When the dots in any one exposure on all five rolls or sets of film are connected, they produce a curve, which should then be labeled at the right with the appropriate zone number.*

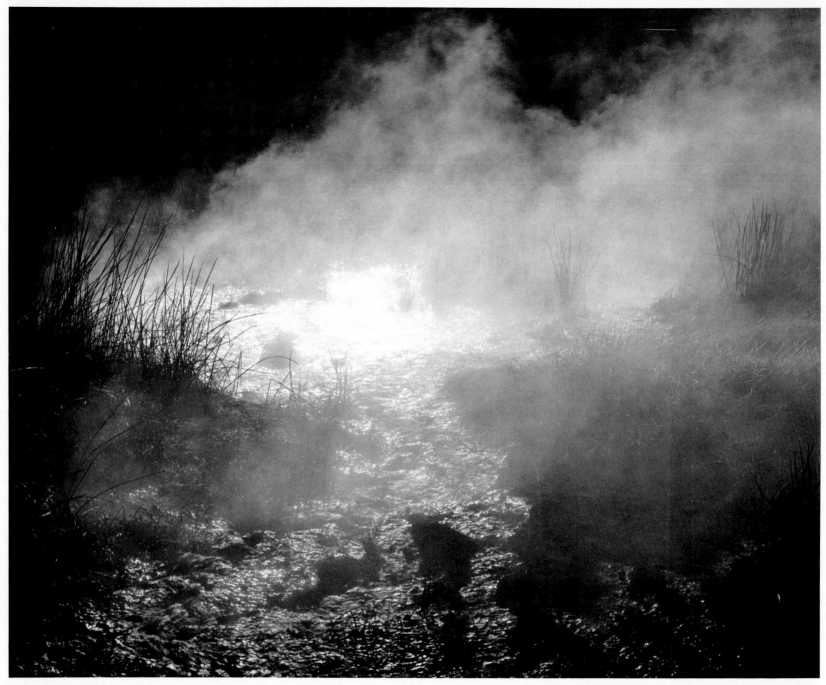

OLIVER L. GAGLIANI.  *Print No. 271, Grover Hot Springs State Park, Calif., 1962.*

*Oliver Gagliani (b. 1917) combined his sensitive feeling for light with his skill in using the Zone System to transform the reality of the hot springs into a dreamlike experience. The highlights fell in Zone XII but were brought down to Zone VII by reducing the development time. The negative was developed in D-23 for about 1 minute, then placed in a 1 percent solution of Kodalk for 3 minutes. The negative was agitated continuously in both solutions. This method of development was used to control the inherent high contrast and also to maintain the soft mood. The print was developed in Beers developer for about 3 minutes. The negative size is 4 × 5 inches (10 × 12.5 cm).*

The next information to put on the graph is computed from the density range test for the printing paper on page 278. Determine the proper density that the negative must have to produce a Zone VIII tone in the print. To do this, add the Zone I density (fb + f + .10, determined by your personal exposure index test—exposure 5 in the Sample Exposure Index Record on page 278) to the density of the printing paper being used. If, as in the Sample Exposure Index Record, the Zone I density was .35 (.25 + .10) and the paper's density range was 1.05, the Zone VIII density is 1.40.

Now that you have found the proper density for your highlights—Zone VIII—you need to determine how much development of the negative is necessary to achieve that density. To do this, locate the proper density on the density scale—1.40 in this case—and at this point draw a horizontal line across the graph. Find where this line intersects the curve for Zone VIII and at that point draw a perpendicular line to the development scale.

Where the perpendicular line hits the scale marks the degree of dilution or length of time the film should be developed for normal (N). Density Parameter Curve A shows exactly where this would be in the present case if you were using the dilution method. Follow the same procedure to find N + 1 (where Zone VII crosses the Zone VIII density line), N + 2, N − 1, N − 2. See Curve B, page 273.

This normal development is usually different from the manufacturer's recommendation. The reason is that it is your own personal development, the result of your equipment and techniques. The information is not transferable to another person because each has to do personal tests.

The information from the tests should now be used for a "field test" in actual situations. Often, some slight adjustments may be necessary to fine-tune your system. The final step is to use the system and become comfortable with it in order to produce the desired tonalities in your photographs.

The earliest camera was a view camera. It is still the camera that offers the most flexibility and the most control of the photographic image. Because view cameras are large and heavy, they must be used on a tripod. The various types of view cameras and a field camera and press camera are described and illustrated on pages 59–60.

Large-format photography is done with any of the types of cameras mentioned above. "Format" here means the size of the negative. Common film sizes for view cameras are 4 × 5, 5 × 7, and 8 × 10 inches (10 × 12.5, 12.5 × 17.7, and 20 × 25 cm). An 8 × 10-inch print produced by contact-printing an 8 × 10-inch negative offers the best possible photographic quality because nothing is lost in enlargement.

View camera lenses are interchangeable; such a camera accepts long-, short-, and normal-focal-length lenses, as well as lenses for special effects. Through-the-lens viewing and ground-glass focusing (see pages 38–41) enable you to see exactly what the photograph will include and examine the focus of the image. Movements of the front and back of the camera, made possible by its flexible bellows, give greater control over perspective and depth of field than any other type of camera. Added to these features is the control given by processing each negative individually. In other words, the view camera is extremely versatile.

This chapter discusses how to load, expose, and process large-format film and also the special movements.

CLARENCE JOHN LAUGHLIN. *The Iron Shell, 1949* (Old Louisiana State Capitol).

# The View Camera

Except for its greater variety of controls, the view camera is similar to all other cameras. Light enters through the *lens* and falls on the *ground-glass focusing screen. Aperture* and *shutter* adjustments are the same as on other cameras.

The film and the method of loading it are different for a view camera. Sheet film is used. And not until the image has been composed and focused is a film holder containing the film inserted between the ground glass and the *camera back.* Thus the image exposed onto the sheet of film is exactly the same as the image on the ground glass.

A flexible *bellows* links the *camera front* to the camera back. The back and front of the camera can be moved independently of each other. These movements are accomplished by loosening and then tightening into the desired position the movement controls of the camera: the *front adjustment knob,* the *front standard adjustment knob,* the *lens board adjustment knob,* the *back adjustment knob,* and the *back standard adjustment knob.*

The shutter mechanism of the view camera is normally operated with a *shutter cable release.* □

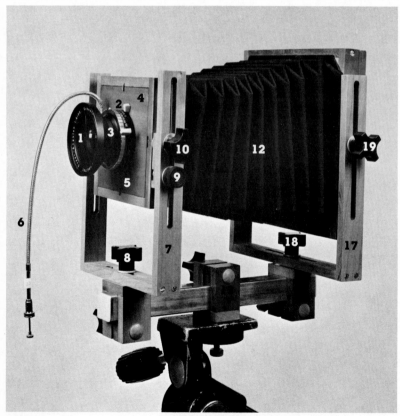 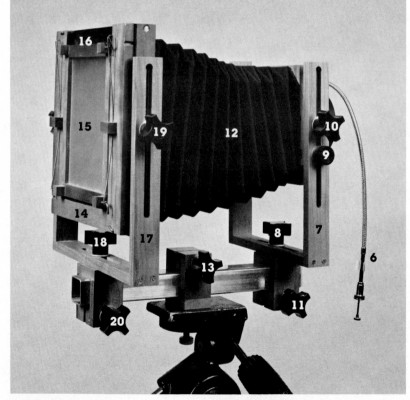

| 1 lens | 6 shutter cable release | 11 front focusing knob | 16 entrance for film holder |
| 2 aperture setting | 7 front standard | 12 bellows | 17 back standard |
| 3 shutter setting | 8 front adjustment knob | 13 tripod mounting bracket | 18 back adjustment knob |
| 4 lens board | 9 front standard adjustment knob | 14 camera back | 19 back standard adjustment knob |
| 5 camera front | 10 lens board adjustment knob | 15 ground-glass focusing screen | 20 back focusing knob |

# Sheet Film

There are many kinds of sheet film, including some special-purpose graphic arts films made only in sheet form. Some of the more readily available sheet films are listed below.

Each type of sheet film has one or more differently shaped notches in one corner so that you can identify the emulsion side in total darkness by feeling the location of the notches. Two notch patterns are shown here.

Sheet film comes in boxes of usually twenty-five or more sheets. The sheets are sealed in an envelope, which must be opened in total darkness. Unused sheets may be safely stored in the box after that and removed, again in darkness, for insertion in a film holder.

Sheet film also comes in *film packs* of sixteen 4 × 5-inch (10 × 12.5-cm) sheets of film. The price per exposure is higher than for regular sheet film, but a pack has several advantages. First, though it is only the same thickness and about the same weight as a film holder, it permits sixteen exposures. It thus gives more exposures in a more portable form and helps prevent running out of film. A film pack is less susceptible to the tiny light leaks that sometimes occur around the hinges of a film holder. Also, there is no problem of maintaining cleanliness, as there is with a film holder. Some photographers prefer the quality of the film in packs, but because it is thinner than regular sheet film, it takes more practice to process it properly. Film-pack negatives may need trimming to fit the negative carriers of some enlargers, and they are more likely to pop during long exposures, though a glass negative carrier can prevent this (see page 184). An accessory adapter must be bought separately to accommodate film packs. (Some view cameras can be adapted to use roll film with a special back, but sheet film is most commonly used.)  □

## common varieties of black-and-white sheet film

| film type | ASA |
| --- | --- |
| **Kodak** | |
| *Plus-X Pan Professional 4147* | *125* |
| *Tri-X Pan Professional 4141* | *320* |
| *Super-XX 4142* | *200* |
| *Commercial 4127* | *varies* |
| *Fine-Grain Positive 2302* | *varies* |
| *Professional Copy Film 4125* | *12–25* |
| *Tri-X Ortho 4163* | *320* |
| *Ektapan 4162* | *100* |
| *Royal Pan 4141* | *2100* |
| *Royal-X Pan* | *1250* |
| *High-Speed Infrared* | *varies* |
| **Ilford** | |
| *FP4* | *125* |
| **Agfa** | |
| *Agfapan* | *25* |
| *Agfapan* | *100* |
| *Agfapan* | *200* |
| **Luminos Lumipan Portrait Press** | *125* |

**Plus-X Pan film**

**infrared film**

Sheet film must be loaded into a *film holder* for exposure. The film holder accepts two sheets of film, one on each side, separated by an opaque barrier. An opaque slide with a metal or plastic tab, black on one side and white on the other for identification, fits over each sheet of film to prevent accidental exposure. When it is loaded, the holder is inserted in the back of the view camera to make the exposure.

Loading a sheet-film holder is relatively simple, especially as sheet film is stiffer than roll film, but it must be done in complete darkness. Thus it is a good idea to practice loading a holder with unwanted film first.

See the step-by-step guidelines, opposite.

A film pack must be loaded into an *adapter* for exposure. To load an adapter, first remove the film pack from its package, being careful to hold it only by the edges. Do not press on the open side because this would let in light, which would fog the film. Place the pack in the adapter and close it. Make sure the adapter slide is pushed in all the way. Insert the adapter in the back of the camera. Then pull out the paper safety cover as far as it will go and tear it off. This uncovers the first sheet of film, in position for exposure. Pull out the adapter slide before making an exposure. □

**film holder**

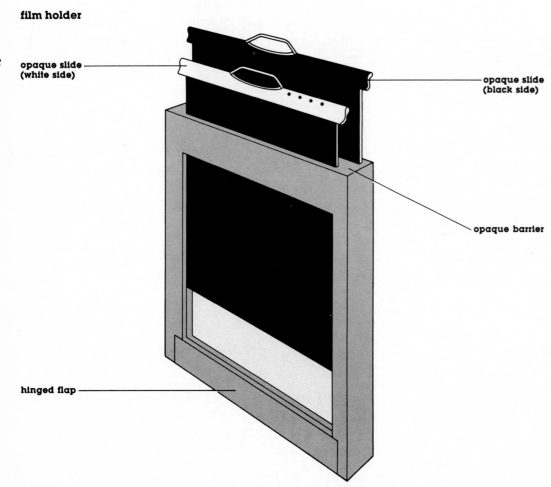

opaque slide
(white side)

opaque slide
(black side)

opaque barrier

hinged flap

## loading a sheet-film holder

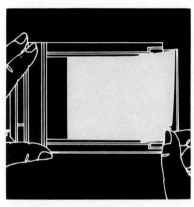

**1 clean the holder**

*Remove the two slides from the holder and place them, white sides up, on a clean table. Clean the holder and slides with a wide, soft paintbrush or compressed air to remove all dirt, lint, and dust. Do not blow on them, as your breath may deposit moisture. (Because either paintbrush or compressed air may stir up dust in the loading area, some photographers prefer to use a vacuum cleaner to remove dust completely rather than simply relocating it.)*

**2 remove a sheet of film from the box**

*When the holder and slides are clean, be sure the film box is easily accessible. Then turn off the lights for complete darkness. The lights must be left off until loading is finished. Open the box of film and take out a sheet, holding it by the edges only.*

**3 find the notches and emulsion side**

*With your index finger, feel for the notches in one corner of the film. When the notches are at the upper-right corner, the emulsion side of the film is facing up. Film must be loaded emulsion side up or it will not be exposed. (The notches also identify the film type.)*

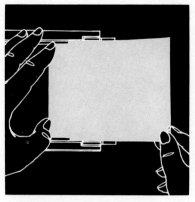

**4 guide the film into the film holder**

*Open the hinged flap. Then with your left hand, guide the film under both retainers on the film holder. Keeping your index finger on the notches, use your right hand to push the film gently under the retainers.*

*289*

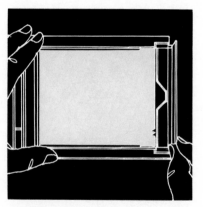

**5 check for proper loading**

*Check the loading by making sure the film is firmly held under both retainers. If it can be lifted on either side, it is being held by one retainer only. Remove it completely and reload. An inadequately secured sheet of film can fall out of the holder and into the bellows and ruin the next exposures if you do not look through the camera before the next exposures.*

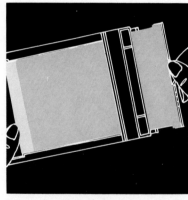

**6 close the film holder**

*Close the hinged flap. If the flap does not close easily, the film has probably not been pushed all the way into the holder. Never try to force the holder closed.*

**7 insert the opaque slide into the holder**

*Insert the opaque slide with the white tab facing outward from the holder. In the dark, you can identify the white side by a notch or several bumps on the edge around the tab of the slide. The white tab shows that the film on that side of the holder is unexposed. Then load the other side of the holder and insert the other slide in the same way. After closing the box of film, you may turn on the lights. Write the type of film in the holder on the small white area provided on the holder or on a small piece of masking tape and attach it to the holder. This is especially important if you will be exposing different types of film on the same occasion.*

The view camera has special movements (see pages 299–309) that give it an enormous amount of flexibility; these movements usually take some practice to master. However, you do not need much experience to use a view camera in simple photographic situations. In these cases keep the front and back standards parallel, move them backward or forward for focusing, and then lock them into place.

First, mount the view camera on a tripod. For the best support mount the camera close to the apex of the tripod. Extending the central column of the tripod much above the apex may cause the heavy camera to vibrate when the exposure is made. Therefore, adjust the tripod height by lengthening or shortening its legs rather than by moving the central column.

Because the image that appears on the ground glass is rather dim, you must cover your head and the back of the camera with a black cloth or use a focusing hood while composing and focusing to eliminate all light except the light that comes through the lens. A dark cloth tends to be awkward on a windy day, since light can get in around it and dim the image. Many photographers prefer a focusing hood, which eliminates nearly all extraneous light and will not blow off. It also contains a mirror and a magnifier. The mirror rights the upside-down image on the ground glass (though it is still laterally reversed).

Step-by-step guidelines for operating a view camera with a film holder are given. As you acquire more experience with the view camera and learn to use its movements, you will be able to make more extensive adjustments in step 4.

Operating a view camera with a film pack is basically the same as operating it with a film holder, except that you pull out a paper tab as each picture is exposed. Pulling the tab replaces exposed film with unexposed film. Each sheet of film in the pack has a number printed on one edge; the same number is on the paper tab, so you can write information about the exposure on the tab and correlate this with the sheet of film to which it applies.  □

290

## operating a view camera

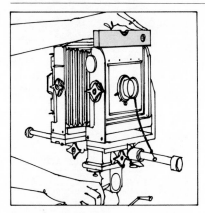

**1 lock the adjustments and level the camera**

*Check to be sure all the camera's movement adjustment controls are locked in their neutral or normal position. Next, level the camera horizontally and be sure it is vertically parallel to the subject. Some view cameras have built-in levels, but if yours does not, you can use a small separate level (obtainable from a hardware store).*

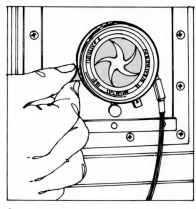

**2 open the shutter**

*Most view camera lenses have a special lever (shown here) or button that keeps the shutter open regardless of the set shutter speed. If the view camera you are using does not have such a lever, either set the shutter at T or attach a locking cable release and set it at B. (The shutter is shown partially open.)*

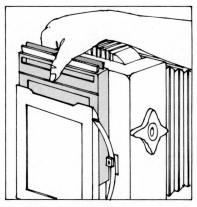

**7 insert the film holder**

*As gently as possible, in order to avoid changing the camera position, insert the loaded film holder in the back of the camera by sliding it between the camera back and the ground-glass frame. Make sure it is pushed all the way in to prevent light leaks from fogging the film.*

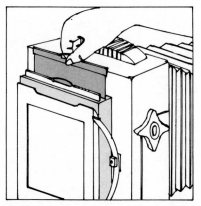

**8 pull out the front slide**

*Double check to be sure the shutter is closed. Then pull out the front slide, closest to the lens. Pulling out the back slide would ruin the back sheet of film by exposing it to light passing through the ground glass.*

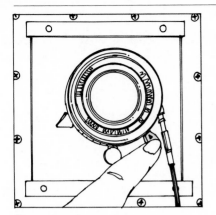

**3 open the aperture**

*To get the brightest possible image for viewing, open the aperture to its maximum opening.*

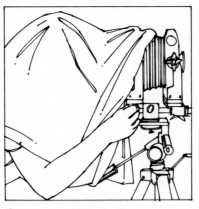

**4 compose and focus the image**

*With a focusing hood or a black cloth (shown here) over your head, look at the image on the ground glass. Adjust the front and/or back standard controls until the image is sharp. For extremely critical focusing, examine the ground-glass image with a magnifying glass. Lock the controls when the image is focused.*

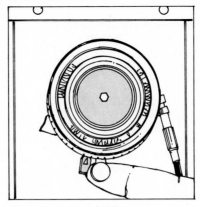

**5 close down the aperture**

*Close the aperture to the desired f-stop and observe the depth of field.*

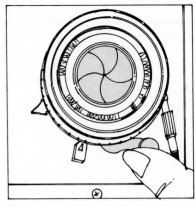

**6 close and cock the shutter**

*Close the shutter in whatever way is applicable (depending on the method you used to open it), set the shutter speed you want, and cock the shutter (if necessary), as shown.*

291

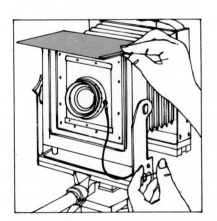

**9 expose the film**

*Press the cable release to make the exposure. Do not pull the cable release line taut, as this could cause the camera to vibrate during the exposure. In outdoor photography, many photographers use the slide from the film holder to help shield the lens from glare during the exposure.*

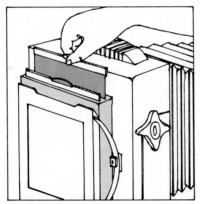

**10 reinsert the slide**

*After the exposure, reinsert the slide with the black tab (indicating exposed film) facing outward, that is, toward the lens.*

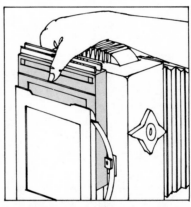

**11 remove the film holder**

*Pull slightly on the back of the camera in order to remove the film holder. Mark the holder with any information you want to record about the exposure. You can then turn the holder around for another exposure, repeating steps 7 through 11. After both exposures, the black sides of both tabs should be facing outward from the holder. An empty holder also has the black tabs showing. You can always tell, therefore, whether the film in a holder is exposed or partially exposed or if the holder is empty. Thus there is almost no possibility of a double exposure or of making exposures with an empty holder.*

Film must be taken out of the film holder or the film pack in total darkness before it can be processed. If you are unloading the one exposed sheet from a film holder, place the holder so that the side with the exposed film—the side with the black tab outward—is facing you. Then turn off the lights and follow the step-by-step guidelines.

You do not have to expose all the film in a film pack before removing exposed sheets for development. However, reclosing the film pack to protect the remaining unexposed sheets requires more care than opening it because the notches in the case and tabs in the light lock must be perfectly aligned for the pack to close properly. The notch system is diagrammed here. When the light lock is removed, the top of the case is raised slightly by a spring inside that maintains pressure to hold the film flat during exposure. Notches in the case join with tabs in the light lock to hold the two sections together. Understanding this notch system will help you to follow steps 4 through 6 of the guidelines for unloading and reclosing a film pack. □

**film pack**

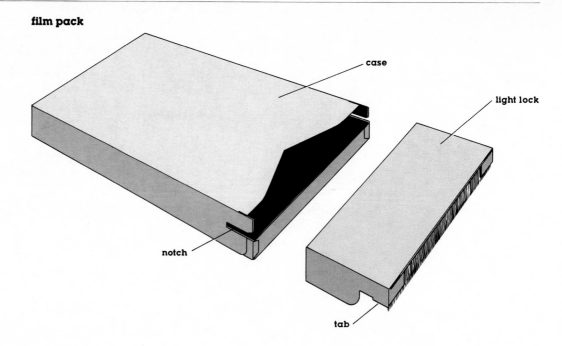

case

light lock

notch

tab

292

**unloading a film holder**

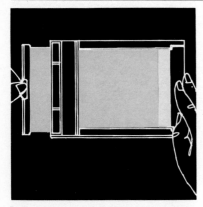

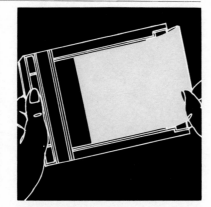

**1** check for the exposed film

*After you have turned out the lights, double check to be sure the side of the holder with the exposed film is facing you by feeling the slide tab. The exposed side (black tab outward) is smooth (the white side has a notch or bumps).*

**2** remove the exposed film

*Pull the slide out. Then open the flap and remove the exposed film from the holder by sliding it out from under the retainers.*

## unloading a film pack

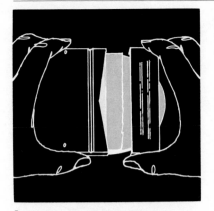

**1 pull the light lock off the film pack**

*Hold the case with one hand and pull the light lock in the opposite direction. Sometimes a light twisting action helps.*

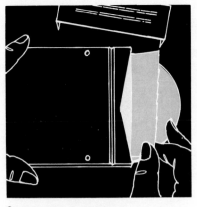

**2 remove the exposed sheets**

*You can remove all sixteen sheets from the pack at once or you can take out just a few sheets without disturbing the others. If you have made only ten exposures and want to develop them immediately, feel for the exposed sheets on the top of the pile. Each exposed sheet has a ragged edge of paper where the pulled tab was ripped off; unexposed sheets still have their paper tabs. Take all the exposed sheets out as a group and set them in a pile.*

**3 separate the film from the paper backing**

*Pick up each sheet individually by the edges and buckle it slightly, so that the film begins to separate from the paper backing. Pull the film apart from the paper where the two are taped together. Discard the paper. Be careful not to confuse the thin film with the paper and discard the wrong one. If you are not going to develop the film immediately, place it in a lighttight box—an empty 5 × 7 or 8 × 10 film box will do—and close the box.*

293

**4 begin to replace the light lock**

*If unexposed film remains in the pack, replace the light lock. To close the case, hold the top down over the bottom with your left hand. This will depress the spring inside so that when you guide the light lock over the top of the case, the light lock tabs will mesh with the case notches, as further shown in steps 5 and 6.*

**5 set the light lock in position**

*While the middle finger of your right hand holds down the paper tabs attached to the unexposed film, use your right thumb and index finger to set the light lock in position and move it from side to side, so that it is just over the top of the case.*

**6 finish replacing the light lock**

*If the edges of the light lock enter the space between the two portions of the case, it will move no farther and will not fit properly. Hold the case flat with two fingers of your left hand while sliding the light lock into place with a slight twisting action of your right hand. When the light lock is in its proper position, it cannot be lifted. The remaining exposures in the pack can now be used.*

The basic chemical principles and procedures for processing sheet film are the same as for roll film (see Chapter 6). However, most sheet films require a different developer solution. One reason is that most sheet film is thicker than roll film; thus some of the fine-grain roll-film developers are unsuitable for sheet film because they are formulated for thin-emulsion films. Another reason is that the roll-film developers that require longer developing times of from 10 to 15 minutes are inconvenient for processing sheet film by the recommended method, in trays.

Many of the general-purpose developers, such as Kodak D-76, can be used for sheet film with the replenishment system. The one-shot system may be financially impractical because of the dilution ratios, especially when developing 8 × 10-inch (20 × 25-cm) film, which requires a fairly large volume of solution. Kodak HC 110 developer is recommended for large volumes, because it is inexpensive and readily available. In commercial studios, when fast processing is needed, a more vigorous developer, such as DK 60 or DK 50, is often used.

Several methods may be used to process sheet film. The method that gives the most even development and the greatest degree of control is the tray method, using regular photographic trays. Another method is to load film into a plastic developing tank in total darkness, then develop it with the room lights on. This method is not recommended because it is hard to give the film enough agitation. For photographers who must process a lot of film quickly, the film hanger method is suitable. The tray and film hanger methods are discussed further below.

## The Tray Method of Development

The tray method of developing sheet film from holders or packs is generally accepted as the best way to get even and precise development. Each sheet can be processed individually. This gives maximum control over quality and the chance to alter contrast during development. The number of sheets that can be developed at once depends on experience. A beginner should develop only two or three at a time, but, with practice, six or eight can be handled.

Sheet film is highly light-sensitive and must be developed in total darkness until it is fixed. Before beginning processing arrange four developing trays in a row. The first tray, at the left, contains *water* to wet the film before development. If you are developing only a sheet or two of film, this tray may be omitted. The purpose of the water presoak is to soften the emulsion enough so that the sheets will not stick to each other during the other processing steps. The water soak is particularly recommended for pack film, which is thinner than regular sheet film and has a greater tendency to stick together. The second tray contains *developer*. The third contains *stop bath*. The fourth contains *fixer*.

As with roll film, the temperature of all solutions should be between 68° F (20° C) and 75° F (24° C); the recommended temperature is 68° F. Developing time depends on the specific film and developer; consult the information packaged with the film and developer.

Before turning out the darkroom lights, set the timer for the necessary developing time. Then follow the step-by-step guidelines for the tray method of development.

## the tray method of development

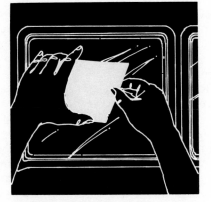

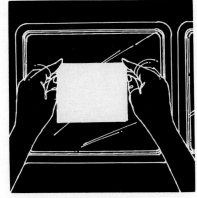

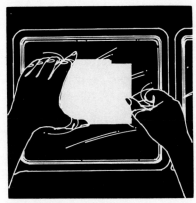

**1 turn out the lights and arrange the film**

*After you have assembled the four trays with water and chemicals at the proper temperature and set the timer for the necessary developing time,* turn out the lights. *Then take the film out of the holder or pack (following the instructions given earlier in this chapter) or out of the lighttight box if it has already been removed from the holder or pack. Arrange the film so each sheet can easily be picked up. A good way is to lift the pile of film and place it in a box so the ends overlap the edge of the box.*

**2 submerge the sheets in water for the presoak**

*Pick up a sheet of film with your left hand and transfer it to your right hand (as shown here). With your right hand, submerge the film in the water tray, making sure it is totally immersed. Repeat this operation for each sheet. Changing hands keeps the left hand dry. Never get a wet hand near film not yet processed, because it may splash water on the sheets, which may cause them to stick together. Film stuck together can seldom be separated without destroying the images.*

**3 arrange the sheets in a pile**

*When all the sheets are immersed in the water, use both hands to arrange them in a neat pile under water.*

**4 pull out the bottom sheet and place it on top**

*Agitation of sheet film in trays is done by continuously and smoothly interleaving the sheets until each sheet has been handled twice. To begin, pull out the bottom sheet and place it on top of the pile.*

295

**5 push the entire pile down**

*Push the entire pile down into the water each time you place a sheet on top. Repeat steps 4 and 5 until you are sure all the sheets are thoroughly wet and none are sticking together.*

**6 drain excess water from each sheet**

*With your left hand, pick a sheet out of the water and drain the water briefly. Then transfer the sheet to your right hand.*

**7 submerge the sheets in developer and agitate**

*With your right hand, submerge each sheet in the developer. Perform steps 6 and 7 smoothly and quickly. When all the sheets have been drained and transferred to the developer, start the timer for the developing period. If you are using a short developing time or processing a number of sheets, the time between immersion of the first and last sheet should be taken into consideration in determining the overall developing time. Agitate the film smoothly and continuously in the developer by repeating steps 4 and 5.*

**8 drain sheets and transfer first to stop bath and then to fixer**

*When development is completed, with your left hand, lift a sheet from the tray and drain excess developer briefly. Transfer the sheet to your right hand (as shown here) for insertion in the stop bath. Changing hands eliminates the chance of contaminating the developer with stop bath. When all the sheets are in the stop bath, agitate them by interleaving (as in steps 4 and 5) until each sheet has been handled twice. Transfer the film to the fixer by the changing hands method and agitate it for 1 or 2 minutes. You may now turn on the room lights to examine the film. After the fixing time has elapsed, transfer the film to a tray for washing.*

### the tray method of development (continued)

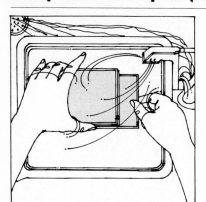

**9** wash the film

*The simplest way to wash sheet film is: run water continuously into a photo tray placed in a sink and agitate the film by the method described in steps 4 and 5. This washing technique ensures enough agitation and enough water, but it requires time and constant attention. Never leave sheet film unattended in a tray of swirling water, since its corners are sharp, and if the sheets are left to move around against each other the emulsion of some may be scratched.*

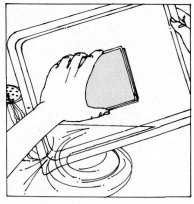

**10** drain the water

*After you have washed the film for 2 or 3 minutes, hold the pile of film against the bottom of the tray and drain the water.*

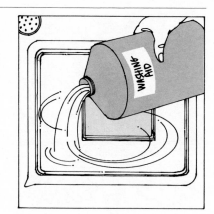

**11** fill the tray with washing aid

*Fill the tray with washing aid and agitate the film by interleaving (as in steps 4 and 5). The length of time film should remain in the washing aid depends on the brand, but it is usually about 2 minutes. When the time has elapsed, drain the washing aid from the tray.*

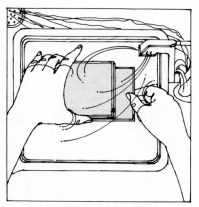

**12** give the film a final wash

*Give the film a final wash (as in step 9) for 10 to 15 minutes and then drain the water (as in step 10).*

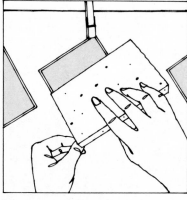

**13** add the wetting agent

*Add the wetting agent to the tray and leave the film in it for less than 1 minute.*

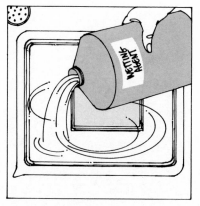

**14** wipe and dry the film

*Hang up each sheet of film separately and wipe it gently with a wiping aid (photographic sponge) thoroughly moistened with wetting agent. This removes excess water. Let the sheets hang until they are dry.*

296

## *Developing by Inspection*

**W**hen developing sheet film a few sheets at a time in trays, some photographers develop by inspection to determine the best time for each sheet of film. When half the normal developing period has passed, it is possible to view the negative very briefly by the light reflected from a specific colored safelight suitable for the particular film being processed. The film is not held toward the safelight in an attempt to see through it, for it is still opaque at this point; only the *surface* can be inspected.

Successful developing by inspection requires much practice in learning to correlate the appearance of negatives at this stage with how much more development is needed. Adding a desensitizer to the developer solution makes the process of inspection somewhat easier because it makes film partially nonreactive to light. As a result, even a fairly bright safelight will not harm the negative. However, to use a desensitizer, film must have received more exposure initially, so it is seldom practical, and practice with a dim safelight is necessary.

### The Film Hanger Method of Development

**T**he tray method gives high-quality processing, but it is not practical for many commercial photographers because of the large volume of film they must process. They use the quicker film hanger method.

Film hangers are made of stainless steel or plastic. They are available in a 4 × 5-inch (10 × 12.5-cm) size, for use with tanks that range in size from 40 ounces to 1 gallon (1–4 liters), or in an 8 × 10-inch (20 × 25-cm) size, for use with tanks that range in size from 1 to 3½ gallons (4–13 liters). The 8 × 10-inch size comes in different styles to hold one sheet of 8 × 10-inch film or two sheets of 5 × 7-inch (12.5 × 17.7-cm) film or four sheets of 4 × 5-inch film. These hangers are placed on a rack that holds fourteen hangers, so that when the rack is filled as many as fifty-six sheets of 4 × 5-inch film may be processed at once. Special hangers are available to hold film from film packs.

Some photographers develop their film with the tray method but prefer to use film hangers for washing. The hangers eliminate the risk of the film being scratched during washing. Also, the photographer's hands do not have to be immersed in water during the entire washing time. After the film has been removed from the fixer, it is loaded on hangers for the first wash.

Before turning out the lights to begin processing by the hanger method, arrange three tanks in the following order in a temperature-control pan: developer, stop bath, fixer; fill them with solutions. Keep a fourth empty tank on the dry side of the darkroom. This holding tank is used for carrying loaded hangers to the developer and is later used for the wash.

Set the timer before turning out the lights. Then follow the step-by-step guidelines for the film hanger method of development on page 298 (where 4 × 5-inch hangers and 40-ounce tanks are used).  □

*Front: 40-ounce tank and 4 × 5-inch film hanger.*
*Back left: 3¹/₂-gallon tank. Center: 8 × 10-inch film hanger.*
*Right: rack for 8 × 10 film hangers.*

297

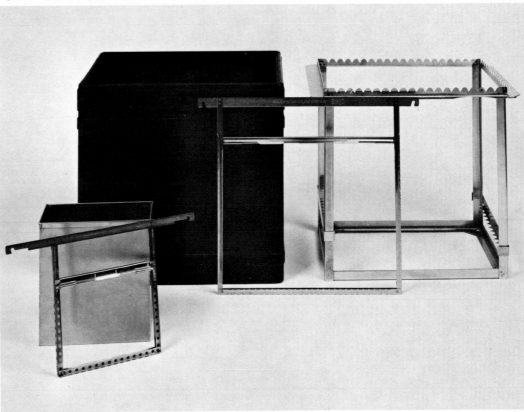

## the film hanger method of development

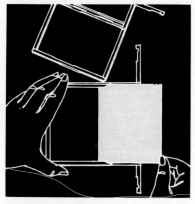

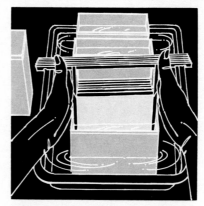

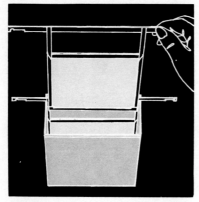

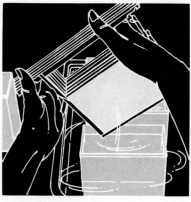

**1 turn out the lights
and insert the film in hangers**

*After arranging the four tanks—one empty
and three with the chemicals—turn out the
lights. Open a film hanger by unfolding its
top edge. Insert the film and refold the edge
to hold it in place.*

**2 place each loaded hanger
in the empty tank**

*After each hanger is loaded, place it immedi-
ately and very carefully in the empty tank
before loading the next hanger. This prevents
film on the hangers from getting scratched.*

**3 lower the hangers into the developer**

*When all the hangers are loaded, take the
holding tank to the tanks of chemicals
(shown here arranged front to back), care-
fully lift the hangers all together out of the
holding tank, and lower them into the devel-
oper. Tap them up and down a few times to
remove possible air bubbles. Then leave
them motionless for the first minute.*

**4 lift the hangers to agitate the film**

*To agitate, lift the entire batch of hangers all
the way out of the developer and turn them
to one side at a 45° angle.*

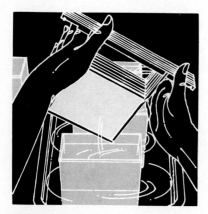

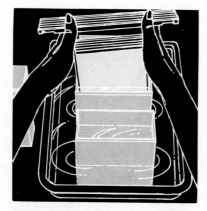

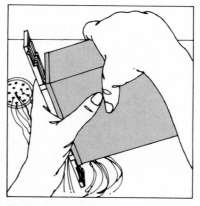

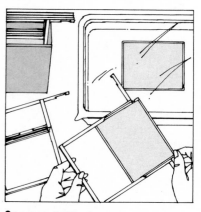

**5 continue agitation**

*Quickly put the hangers back in the tank;
then remove them again, turning them to-
ward the opposite side of the tank. This agi-
tation cycle should be completed in about 6
seconds and repeated every minute. Too vig-
orous agitation can produce uneven develop-
ment or mottling along the film edges,
because of turbulence around the hanging
mechanism.*

**6 lower the hangers first into the stop bath
and then into the fixer**

*At the end of the developing time, lift and
drain the hangers for a few seconds before
lowering them into the stop bath. Repeat the
agitation method as in steps 4 and 5. Then
drain the hangers and lower them into the
fixer. Repeat the agitation method as in steps
4 and 5.*

**7 wash the film**

*Put the hangers in the holding tank and run
water continuously into it. Agitation is also
needed in the washing cycle to eliminate air
bubbles. Do this by tapping the hangers up
and down. Periodically drain the tank com-
pletely by carefully tilting it while holding
the hangers in. After this first wash, drain
the tank, pour in washing aid, and agitate
in the same way for the required time.
Empty the washing aid from the tank and
give the film a final wash.*

**8 immerse the film in a tray
of wetting agent**

*After the final wash, remove the film from
the hangers and place it in a tray of wetting
agent. Then hang, wipe, and dry the film, as
in step 14 of the tray method.*

298

**vertical shifts**

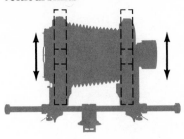

**horizontal shifts**

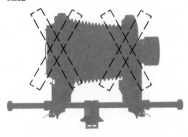

**tilts**

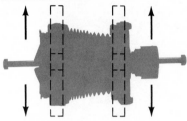

**swings**

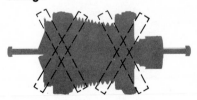

CHARLES SWEDLUND. *Untitled.* 1962.

299

*The movements of view cameras, shown above, give very exact control. The multiple-exposure photograph was made with only 1mm movements between exposures. The result was gradations of tones and variations in the apparent roundness of the form. The view camera is the only camera that offers such subtle control.*

The front standard and back standard of a view camera (see page 286) can be moved independently of each other because of the camera's bellows. The front and back may be shifted horizontally and vertically. They may also be tilted forward and backward or swung clockwise and counterclockwise. Therefore, the view camera's movements are classified as *shifts, tilts,* and *swings.* Moving the back standard by swinging it horizontally or tilting it vertically determines the perspective of the image on the ground glass. *The guiding principle of view camera movement is that the back of the camera controls perspective and the front controls depth of field.*

The lens on a view camera must have a coverage area that is adequate for the movements of the camera. Most view camera lenses offer a coverage area considerably

larger than the camera film size in order to prevent vignetting caused by the camera movements. The three diagrams here show the effect of lens coverage. Adequate coverage must be considered with lenses of all focal lengths, though there is usually no problem with long-focal-length lenses (except telephoto lenses). Therefore, when buying a lens for a view camera, consult the manufacturer's literature and/or the salesperson to be sure the lens is designed to give adequate coverage with the camera movements you plan to use.

The bellows must also be adequate for the movements. For some movements a regular bellows may be too tightly compressed. View camera "system" manufacturers offer interchangeable bellows, including a "bag bellows," which is more flexible than the standard bellows and is used primarily for wide-angle lenses (see page 59). In some view cameras, the front and back standards cannot be brought close enough to each other for adequate focusing with a wide-angle lens even with a bag bellows. A special recessed lens board for wide-angle lenses helps overcome this problem.

*300*

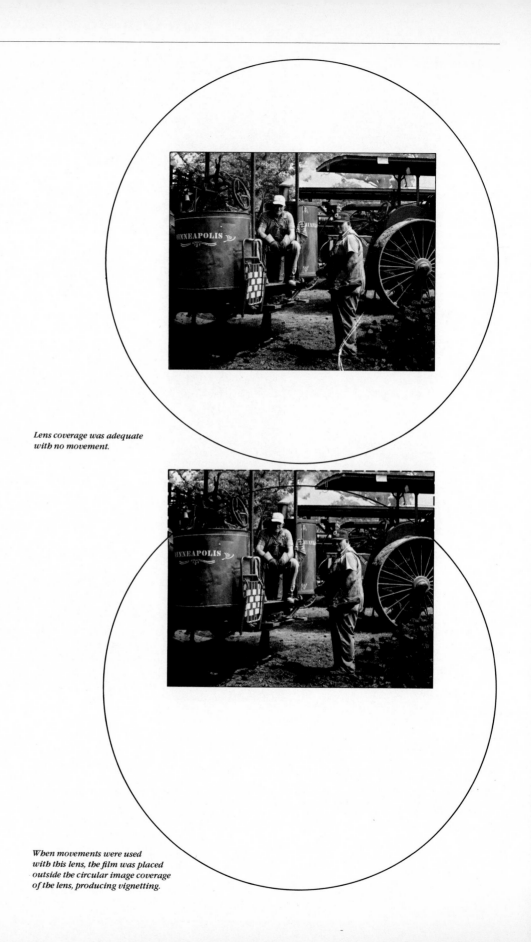

*Lens coverage was adequate with no movement.*

*When movements were used with this lens, the film was placed outside the circular image coverage of the lens, producing vignetting.*

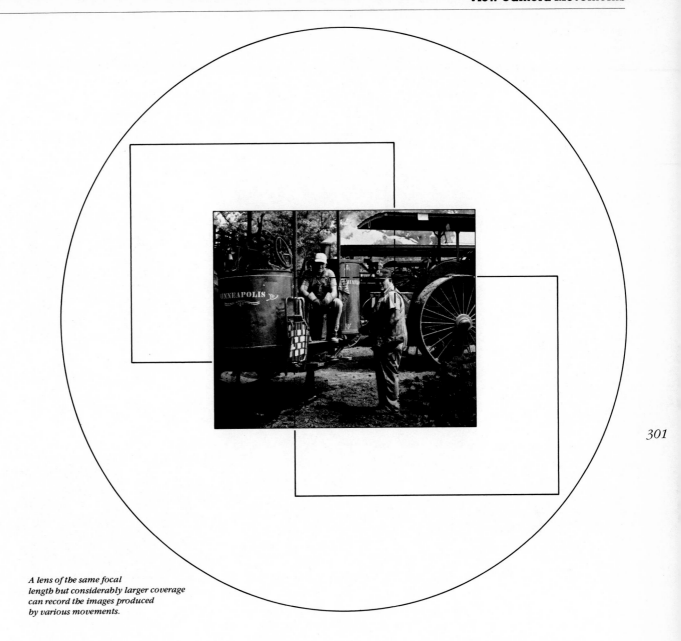

*301*

*A lens of the same focal
length but considerably larger coverage
can record the images produced
by various movements.*

**vertical shifts**

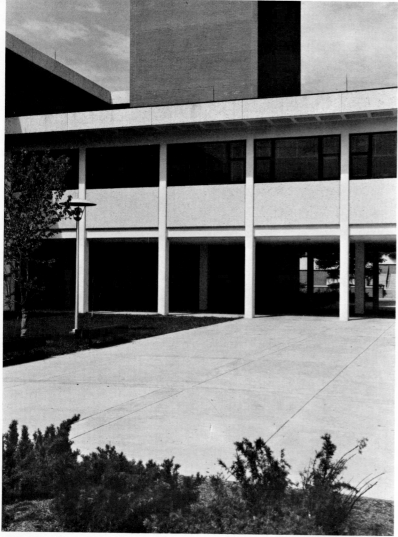

no shift

vertical front shift

## Vertical Shifts

**W**hen the view camera is parallel to the subject, the front may be shifted up or down to center the subject vertically on the ground glass. This can also be achieved by shifting the back up or down. In the first photograph here the camera was parallel to the building, but the image included too much of the courtyard and too little of the tower. To bring the building entirely into the picture, the photographer raised the camera front. Often, this movement solves such a problem. But here the lens coverage was not large enough, and vignetting in the top corners resulted. This type of lack of coverage unfortunately is often difficult to see on the ground glass. However, some view cameras have the corners cut off the ground glass. You look through these toward the camera lens. When you see a perfect circle of light, there will be no vignetting. If the shape is an ellipse, there will be vignetting; it will change back to a circle when the amount of shift is reduced. Vertical shifts like the one in the second photograph can be used to make moderate changes in composition, but for more extreme changes tilts and swings are needed (see page 304).

## Horizontal Shifts

**S**hifting the front of the camera to the left or right helps to center the subject horizontally. This is important when street traffic or other obstructions prevent you from placing the camera directly in front of the subject. With horizontal shifts, the camera can be at the side and the subject can still be moved into the center of the picture. The three photographs here show different view-points of the same scene with no shift and left and right front shifts. For extreme horizontal shifts, you may also need to shift the camera's back.

**left front shift**

**no shift**

**horizontal shifts**
*The camera remained in the same place for these three pictures.*

**right front shift**

303

**camera parallel to ground**

*304*

**camera angled up**

**tilts**
*The camera remained in the same place for these four pictures.*

## Tilts and Swings

**T**ilts and swings are the movements that enable the view camera to photograph a subject, usually architectural, without distortion of its parallel lines. Rarely can we get far enough away from a tall building to see it all without looking up. The angle of vision created by looking up with our eyes or with a regular camera results in a perspective that causes the building's vertical parallels, the orthogonals, to seem to con-verge toward a single point. Though our eyes register this distortion, we psychologically correct it, so that we see the lines as parallel. In a two-dimensional photograph optical correction is needed. Tilting and swinging a view camera makes this correction.

Four photographs here show the effect of tilts. First, with the front and back of the camera parallel to the building's vertical lines, only the lower part of the building was included in the image. Next, the entire

**camera back tilted**

**camera front also tilted**

camera was pointed up, with front and back still parallel to each other. This rendered the building in steep perspective, making it seem to fall backward. For the third photograph, the back of the camera was tilted until it was parallel to the building's vertical lines. (A level was used to be sure the back was exactly vertical.) The orthogonals are now parallel, but even though the aperture was stopped down all the way, the top half of the building was out of focus. This problem was solved by tilting the camera's front until it

also was parallel to the building's vertical lines. This fourth photograph made the building look straight and clearly defined.

In these examples the camera was pointing up at the subject. In other situations, such as photographing smaller objects, the camera is pointed down, especially when the top of an object has to be included in the photograph. In such a case, the camera should be raised high and pointed down, with the back straightened to correct the perspective and with the front tilted.

## tilts
*The aperture was wide open for both photographs.*

306

**camera angled down**

Usually, correcting perspective and controlling depth of field are done together. However, when perspective correction is not needed but a great deal of depth of field is, you can tilt or swing the front of the camera to increase depth of field on the horizontal or vertical plane. In either case you try to get the lens more nearly parallel to the subject. The photographs of the railroad tracks were both made with the aperture wide open, but in the second photograph tilting the camera's front produced much greater depth of field. This technique works well for many other subjects with lines that run parallel to the ground, such as ploughed fields and roads.

camera front tilted

307

To achieve enough depth of field for vertical subjects, swing the camera's front. The photographs of the fence were both made with the aperture wide open, but in the second photograph swinging the camera's front significantly extended the depth of field. □

**swings**
*The aperture was wide open for both photographs.*

308

**camera focused on first round-topped post**

309

**camera front swung left**

# Beyond Basics

Throughout the history of photography, most photographers have been interested primarily in capturing the "real" appearance of their subject matter—true perspective and proportion, accurate color or tonal range, and so on. Still, a factual rendition does not always produce the effect a photographer hopes to achieve. In recent years, therefore, many photographers have become intrigued by the special kinds of images made possible by manipulating the exposing, developing, and printing processes beyond what is necessary to produce an accurate representation—beyond basics.

The techniques and processes discussed in this chapter do not guarantee "better" or "more creative" pictures. A bad idea presented in a factual rendition cannot be saved by any of these techniques. In fact, some basically good images can be spoiled if they do not relate well with the unique visual quality of a particular technique or process.

The purpose of this chapter is simply to introduce some of the more accessible of these methods and to suggest ways that they might be sensitively used to produce photographs.

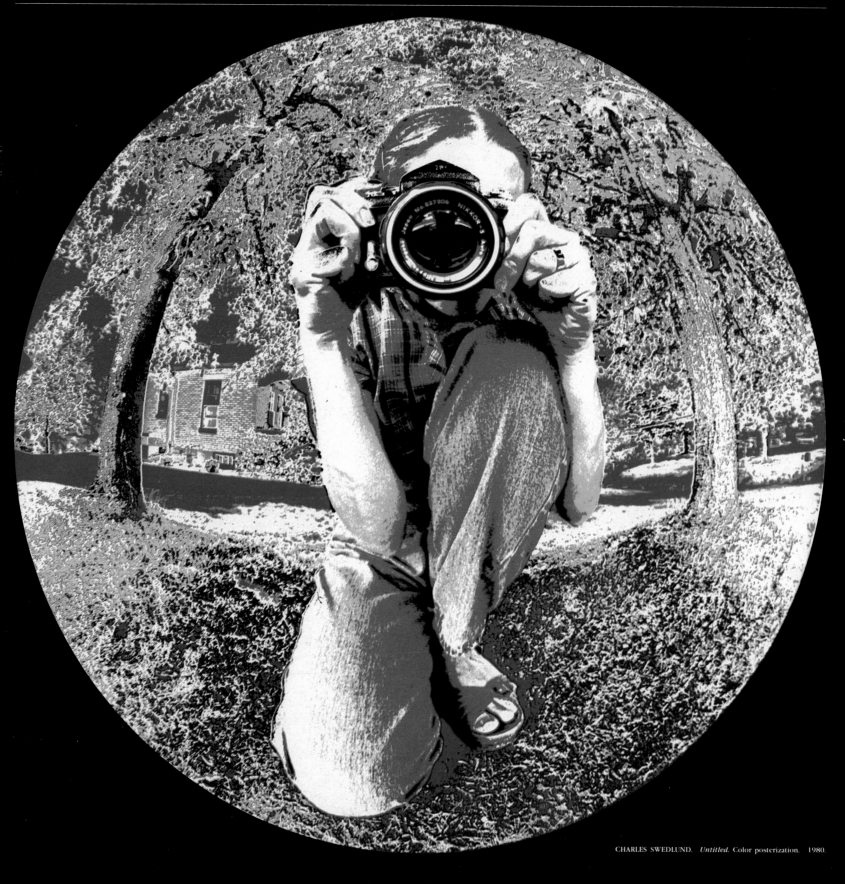

311

CHARLES SWEDLUND. *Untitled.* Color posterization. 1980.

# Pinhole Photography

The pinhole camera is not a replica of an obsolete device used by photographers who like to experiment with historical curiosities. It is actually a custom-made tool. When you make your own pinhole camera, you are creating a *picture-making system* that simply cannot be duplicated by any existing camera. A number of contemporary photographers use the pinhole because of its great depth of field, soft rendition of detail, and delicate tonalities and also because of the way it can incorporate the elements of time and motion by long exposures.

The pinhole camera consists of the pinhole (the lens), a lighttight container to hold the film (the camera body, ideally painted black on the inside), and a flap to cover and uncover the pinhole (the shutter). The pinhole, functioning as a lens, is the controlling point for light coming from the subject; its size is directly related to the sharpness of the resulting photographic image. One of the two photographs here was made with a small pinhole, requiring a 20-second exposure. This small pinhole allowed the film to be struck by only a selection of the total num-

ber of light rays reflected from each point of the subject. With a small opening, light rays strike the film in clusters (circles of confusion) that are small and tightly bunched and thus reasonably sharp. When the pinhole was enlarged to shorten the exposure, the image became more fuzzy, as in the second photograph, because the larger hole let more light rays in. With a larger opening, light rays make larger circles of confusion that not only group into large clusters but also are forced to overlap. The overlapping of the clusters causes the image to blur.

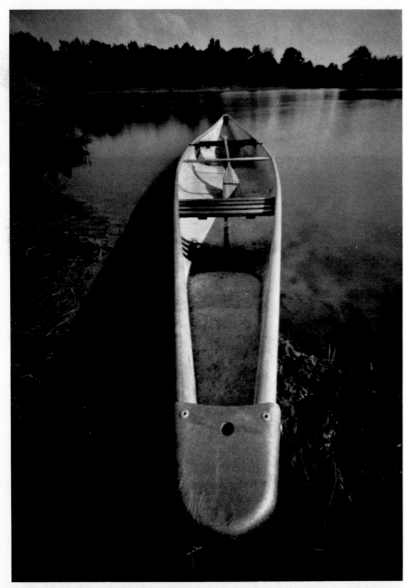

**small pinhole, exposure 20 seconds**

**same camera; larger pinhole, exposure 5 seconds**

*This photograph was made with a pinhole "lens" on a 35mm camera. An electronic flash was used to stop subject and camera movement. Note the great depth of field.*

## pinhole camera tips

- *The pinhole camera requires longer exposures than a standard camera. Long-focal-length pinhole cameras need longer exposures than shorter focal-length ones.*
- *A pinhole lens is best made with a 1-inch (2.5-cm) square piece of .002-inch (.05mm) brass shim stock, available at auto supply stores. Tape the brass square to a piece of cardboard.*
- *To make a pinhole, insert a needle into an X-Acto blade holder and place it on the sheet of brass. Slowly turn it, allowing the needle gently to penetrate the brass by the weight of the blade holder. Do not press down! When the needle has gone through, remove it and the cardboard and carefully sand the hole with fine sandpaper or emery cloth to remove any burrs. Replace the needle in the hole to be sure the hole is clean. Blacken the area around the hole to prevent flare.*
- *Each camera focal length has an optimum pinhole size. For example, a No. 10 needle produces the optimum size hole for a 6½-inch (165mm) focal length; a No. 4 needle for a 20-inch (500mm) focal length; and a No. 13 for a 2½-inch (60mm) focal-length.*
- *Each size needle produces a different f-stop: a No. 10 needle produces f/300; a No. 4 needle, f/550; and a No. 13 needle, f/190.*
- *To keep the camera steady during exposures, glue a T-nut to the bottom, so it can be used on a tripod.*
- *A small piece of black electrical tape stuck over the pinhole makes an effective shutter. Fold three-fourths of the tape back on itself, sticky sides touching, to form a flap with one sticky end to attach to the camera.*
- *Insert sheet film in total darkness. Tape it in place or insert it in the slot in a U-shaped cardboard frame glued to the back of the container. Close the camera and seal it in some way to make it lighttight.*

JAY BENDER. *Untitled.* 1978.

313

Because the small pinhole gives a reasonably sharp image—at least compared with the image given by a larger pinhole—it might seem logical that the smaller the pinhole, the sharper the photograph. This is not the case, however. There is an *optimum* pinhole size for each camera focal length (see Pinhole Camera Tips). If the pinhole is smaller than it should be for the focal length, the picture is fuzzy.

The makers of early pinhole cameras usually concentrated on craftsmanship, aiming merely to prove that they would work. They gave practically no thought to the influence of design on imagery, and even less did they explore the unique visual qualities pinhole cameras can produce. Today, however, photographers often go beyond boxes and make their pinhole cameras in a variety of shapes and sizes. Containers have ranged from spice-boxes to watermelons to bulk-film containers.

Still other photographers have modified their existing cameras by removing the lens and mounting a pinhole in its place, leaving the body and film transport system untouched. Jay Bender, for example replaced the lens of his 35mm camera with a pinhole made to provide wide-angle coverage—see his photograph.

Even the notion of a single pinhole is being challenged. Frank Salmoiraghi made a pinhole camera with several pinholes, producing multiple images that would otherwise have required a series of lenses. He also went a step further and attached the film to a curved plane.

The images produced by such unique cameras suggest the expanding possibilities of pinhole photography. □

*This photograph was taken through three pinholes. The multiple images are further distorted by the curved film.*

FRANK SALMOIRAGHI. *Self-Portrait.* 1969.

*Normal panchromatic film was used.*

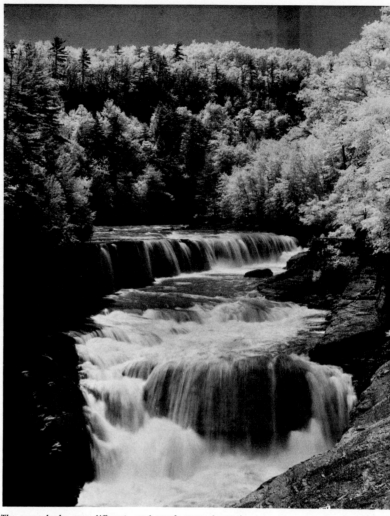

*The scene looks very different—and much more dramatic—when photographed with infrared film through a Wratten 25 (red) filter.*

315

Infrared photography enables you to take pictures with lightwaves that are invisible to the naked eye—lightwaves with absorption and reflection qualities that are so different from visible light that they produce strange and wonderful photographic effects. For example, ordinary sunlit scenes look like surreal landscapes. Joseph D. Jachna's photograph in the Portfolio (page 388) is an example of an infrared photograph.

Technically speaking, infrared radiation consists of lightwaves that are just slightly longer than the waves of red in the visible spectrum. Thus infrared waves are invisible to human eyes. Infrared *film,* however, records these infrared wavelengths, as well as the visible wavelengths. Infrared energy—that is, light—is found in sunlight and also

in the light from incandescent bulbs and electronic flashes.

The two photographs here give an idea of what infrared photography can do. In the picture made with infrared film the trees look white because the subsurfaces of the leaves strongly reflected infrared wavelengths. This picture was made with a red filter, which blocked out the green and blue lightwaves and thus also caused the sky to be recorded quite dark.

You always need to use a filter with infrared film. Without one, your pictures will look as though you had taken them with regular panchromatic film. This is because infrared film is sensitive to *all visible light*—not just infrared light—and you need to limit the visible light striking the film to get the full

infrared effects. For example, if you use a Wratten 15 (dark yellow) filter, the tones of green foliage will be only *slightly* distorted, making it somewhat whiter than normal; and blue skies will be darker than normal, but not black. That is because a yellow filter allows some visible light to strike the film. For dramatic infrared effects, use either a Wratten 25 (red) or a 29 (red) filter. If you are using a single-lens reflex camera, you will have no difficulty in seeing through your lens with either of these red filters. For the most dramatic effects, use the still darker Wratten 87 (red) filter. With an SLR, however, it is impossible to compose and focus a scene with such a dark filter. Either use a camera with a viewfinder or compose and focus *before* putting the filter on the lens of an SLR.

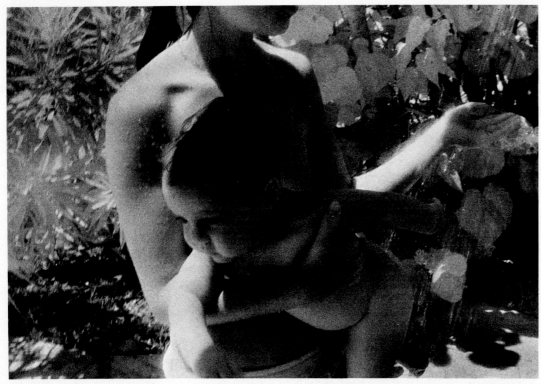

ABIGAIL PERLMUTTER. *Eliza Showering with Andrea.* Infrared photograph. 1977.

316

When you photograph people you will discover still another interesting characteristic of infrared photography. Flesh tones look very soft, and many details such as light body hair and small wrinkles disappear, making body shapes into smooth forms. Also, light seems to glow from the subject's skin rather than being reflected from it (see Abigail Perlmutter's photograph).

Ideally, infrared film should be stored in a refrigerator at 55° F (13° C)—preferably lower—until you are almost ready to use it. You will need to remove the film from the refrigerator a couple of hours in advance.

The 35mm cartridge containing the infrared film is not lighttight enough at the film entrance to block out infrared radiation. So you must load and unload infrared film in *total* darkness. Many photographers carry a changing bag for this purpose. In total darkness, put the exposed film in the metal container in which it was packaged and store it there before development.

Because infrared light does not focus in the same way as visible light, you will have to adjust your normal focusing habits. Ordinarily, you focus on a subject and then take the picture. With infrared film, however, focus as usual but then *change* that focus by

pretending the subject is slightly *closer* to you than it actually is. If your lens has an infrared index mark (check your owner's manual), you have no problem. For example, if the distance scale shows 10 feet (3 m) after you have focused on the subject, line up the 10-foot indicator on the lens barrel with the infrared index mark. If you do not have an index mark, focus on the near side of your subject. (If you stop down to f/11 or f/16 and use a normal or wide-angle lens, you will have no focusing problem even if you focus normally and then take the picture, because of the greater depth of field.)

It is difficult to determine the correct exposure for infrared film because exposure meters are not designed to react to infrared radiation. In any case, there is no established ASA rating for infrared film. Also, the amount of radiation reflected from objects in a scene produces an exposure variable that is hard to estimate because it differs in overcast or sunny conditions. The best solution is to use a light meter, assume as a guide that the film has an ASA rating of 50, and bracket your exposures (page 139). Because bracketing will give you some negatives that are overexposed and some that are underexposed, you will also have a choice of renderings. *Over-*

*exposure* produces a very soft, rather misty quality. Foliage glows and seems almost without substance because of the dominance of light tones. The sky usually has some gradation of tones and looks "smoky." The shadow areas are lightened. *Underexposure* typically produces large areas of darkness; the photo is usually not as exciting as an overexposed one. An average, or *normal,* exposure produces a more normal range of tones. But many of the mysterious effects seen in an overexposed negative are lost. Obviously, these are generalities, and results vary with specific photographic situations. With experience, you will eventually be able to produce satisfactory infrared photographs with a minimum of exposures.

Not all developing tanks are suitable for developing infrared film because their pouring lids do not always prevent infrared radiation from entering and fogging the film. Try one test roll. If it is fogged, develop all other rolls in the tank in total darkness. Some photographers prefer to accentuate the grainy quality and contrast of infrared film by using a contrasty developer, such as Kodak's D-19 or DK-50 (1 part developer to 1 part water). Others who prefer a finer grain with softer tonalities use D-76.  ☐

# Closeup Photography

*This extreme closeup is so sharp that each eyelash and pore can be counted individually.*

NATHAN LERNER. *The Closed Eye.* Chicago, 1940.

Closeup photography on the scale of one-to-one (for example, a 1-inch—2.5-cm—subject is 1 inch on the negative) and more reveals textures and surface details that can never be recorded at conventional distances. Closeup photography of commonplace materials and objects often produces extraordinarily pleasing—and surprising—results, in both black and white and color.

A popular camera for extreme closeups is a 35mm single-lens reflex equipped with a macro lens—an optically corrected lens specifically designed for closeup photography as well as normal-range work. The first macro lenses were limited to the 50mm size. Now they are available in longer focal lengths, such as 100mm, and in some zoom lenses as well. The main advantage of the single-lens reflex for closeup photography is its viewing system. When you compose and focus through the picture-taking lens, you can preview the exact image area and see exactly which elements will be sharp and which will be out of focus.

A large-format (at least 4 × 5-inch—10 × 12.5-cm) view camera, which also enables you to view through the camera's lens, may be used for closeup photography. The large film size is often desirable because enlargements can be sharper than enlargements from the smaller 35mm format. However, the accessories needed for extreme closeup photographs (an extra bellows with view cameras that have the system concept) are rather expensive.

To prevent the blurring that even the slightest movement would cause, you must stabilize the camera with a tripod and use a cable release for the exposure. If the exposures are long, lock the mirror on a single-lens reflex camera in the up position to prevent possible vibrations. Many photographers prefer to use electronic flash to eliminate both subject and camera movement.

If you do not have a single-lens reflex camera and a macro lens or a large view camera, there are other possibilities of varying degrees of effectiveness.

*Closeup lenses* are a low-cost way to do closeup photography. They come in various magnifications designated by diopters (+1, +2, +3, and so on). They may be combined for more magnification. However, since these inexpensive lenses—screwed on *over* the camera's lens—are not nearly as good as the lenses they cover, they greatly reduce image

sharpness. (To overcome the lack of sharpness as much as possible, stop down to f/11 or f/16 when using a closeup lens.) Closeup lenses have other drawbacks. They do not permit anywhere near one-to-one photography, and on cameras with viewfinders independent of the lens they do not work well at distances closer than 3 *feet* (1 m)—well beyond any definition of closeup photography—because at closer distances, parallax (see page 38) becomes a problem.

*Extension tubes* are another solution. They are designed for cameras with interchangeable lenses, such as 35mm single-lens reflex, 35mm rangefinder (Leica), and 120/220 single-lens reflex cameras, and can be used with a macro lens for further magnification. These tubes are sold separately or in sets of three, each tube a different length. The tubes enlarge the image of the object being photographed by *lengthening* the distance between lens and film. Remove the lens and attach one or more tubes to the

camera, depending on the degree of magnification you want. Then attach the normal lens or, preferably, a macro lens to the outer end. Another kind of extension device, a *bellows unit,* has advantages because, unlike rigid tubes, it can be collapsed or expanded like an accordion, giving continuous and more precise adjustments.

Some cameras with through-the-lens metering systems compensate automatically for the necessary increase in exposure with extension devices. If your camera does not do this, follow the instructions with the tubes or bellows unit.

A *reversing ring* lets you use your interchangeable lens *backwards*. This seemingly odd arrangement of the lens—the front of the lens screwed into the camera—produces a sharper picture than when the lens is used normally at magnifications greater than one-to-one. However, there is some risk of damaging the front element of the lens when you screw it into the reversing ring. □

318

*A bellows unit in use with a 35mm single-lens reflex camera. Three extension tubes are shown in the foreground.*

# Solarization (Sabattier Effect)

When an exposed photographic emulsion is reexposed to an intense light during processing, the result is a reversal of tonalities. Earlier photographers, such as Francis Bruguière (see page 20), produced tonal reversals with film. Contemporary photographers work with the print, exposing it to a less intense light, producing a more subtle effect. This technique with the print is actually the *Sabattier effect,* though it is often incorrectly called *solarization.*

The Sabattier effect is produced by exposing the print for a slightly less than normal time, developing it for a brief period, reexposing it to a dim light, and then developing it again. The resulting photograph is both positive and negative in tonality. Separating the positive and negative areas is a white line called a *Mackie line,* which is often an interesting visual element in the photograph. Exhaustion of the developer between areas of extreme contrast produces the Mackie line. The choice of subject matter affects the final quality of the print. Some photographers who prefer the complex textures produced by Mackie lines intentionally photograph subjects with much detail. Others who prefer soft tonalities photograph subjects that are simpler and more formal.

Not all printing papers are suitable for the Sabattier effect; generally, a contrasty paper such as Agfa #6 is preferable. The developer is very important. Fresh developer is not suitable because it produces only dark and muddy tones. Some photographers try to prevent this by using very-high-contrast litho negatives (see pages 320–322) to expose the paper. A more effective way is to use a developer like Dektol that has been used to process many prints and then left in a tray for 10 to 12 hours. This exhausted developer produces softer tonalities and more intense Mackie lines. "Ripening" the developer like this is not very convenient. A special developer, Solarol, may be used instead.

To produce a print with the Sabattier effect, first make a test strip (without reexposure) to determine the shortest exposure time necessary to produce a solid black in the shadow area of the print. Then use about one-third of this time for the actual exposure of the print. Develop the print face up for about 35 seconds. Make sure the developer is close to 70° F (21° C). Then reexpose the print for about 1 second to a 40-watt bulb 3 feet (1 m) away. This is the exposure that produces changes in the tones of the print. After about 1 minute more in the developer, remove the print, place it in the stop bath, and continue to process it normally.

The length of time the print is in the developer before the reexposure is very important. If it has not been developed long enough, the second exposure (reexposure) will turn the image very dark. The image will also turn dark if the reexposure occurs after the developer has lessened its activity (usually after 1 minute).

The method used for the reexposure will depend on whether you use a "ripened" developer or Solarol. Because of the discoloration of the "ripened" developer, the print may have to be removed from it and squeegeed off. Solarol is clear, and the print may be reexposed while it is still in the tray.

The first exposure of the print, producing the image, is the most important one, but it must be related to the reexposure. The relationships between these exposures and the development times give a wide choice of tonalities. □

*This "solarization" (Sabattier effect) was produced by Rainwalker, actually Clarence Rainwater and Sandy Walker, who together worked out the formula for Solarol. The exposure was f/5.6 with two bounced lights. The print was solarized on Agfa Brovira BEH 1 #6 in Solarol.*

CLARENCE RAINWATER. *Hourglass.* 1970.

High contrast is a field of photography that redefines the role of the darkroom. The darkroom is usually used to refine tonalities, correct minor discrepancies, and clarify visual ideas photographed outside its walls. High-contrast photography, however, transforms it into an area where different visual elements are brought together to create new visual entities—see the photograph on the opposite page. High-contrast photography thus involves extending your visual ideas in the darkroom. It is also used as a basis for printmaking (silkscreen, direct-plate and offset lithography, letterpress) and for many of the nonsilver processes.

High-contrast photography centers around high-contrast film, called *litho film*. Litho film is an extremely high-contrast film designed chiefly for the printing industry, where it is used to photograph type and pictures to make printing plates. For photographers, litho film is available from Kodak, DuPont, Ilford, and Agfa.

There are three types of litho film: ortho, pan, and Autoscreen. Ortho film is the most common. It and Autoscreen film may be used under a Kodak 1-A red safelight. Pan litho film is sensitive to all colors and must be handled in total darkness. It is usually used when the original is a color negative or a color transparency.

Litho film comes in sheets. It may be contact-printed or enlarged. Or it may be put in holders for use in view and press cameras. Exposure is critical with this film because too much causes the loss of fine detail. Pan litho film has notched codes for identifying the emulsion side when using the film in sheet-film holders. Ortho and Autoscreen films, used under a safelight, need no notches; they must be gently folded over to compare the two sides. The emulsion side is slightly lighter.

The first consideration in working with any of the following high-contrast techniques is relating the tonalities and organization of the picture to the qualities produced by the technique. Not all pictures are suitable. Generally a picture with large masses has a tendency to hold together better than one with tiny elements, which often seem to be unconnected, floating around the area of the picture. You might try a variety of negatives first, observe the different visual qualities, and then use your experience to produce pictures that have a visual harmony between imagery and technique.

320

## supplies for high-contrast work

*You will need the following materials to use the high contrast techniques described in this chapter:*

- *Litho film: ortho, pan, Autoscreen*
- *Litho film developer: Regular A and B, for most purposes Kodak Fine Line for fine detail and granulation (see page 328)*
- *Stop bath*
- *Film fixer*
- *Kodak 1-A red safelights for ortho and Autoscreen film*
- *Red litho tape to mark off areas on litho film to block light*
- *Opaque, a water-soluble paint (red or black) used to block light produced by pinholes in litho film (tiny clear dots in opaque areas)*
- *Brush (fine) for opaquing*
- *X-Acto knife for removing black spots from negatives*
- *Extra safelight with an OA filter and a 15-watt bulb for flashing (see page 328)*
- *Light box to examine density of negatives*
- *Lazy Susan turntable*
- *Contact-printing frame*
- *Enlarger*
- *Timer*
- *Filters*
- *Trays*

## how to develop litho film

*Litho films require special litho-type developers available in powder and in liquid form. The developer comes in two solutions: A and B. Each solution has a long shelf life when stored separately. When the two solutions are mixed for developing, however, they must be used within 30 minutes. The proper developing temperature is 68° F (20° C) for two reasons: (1) In colder solutions some of the developer's components are not active. (2) In warmer solutions, the film will be adversely affected by a chemical fog that builds up and produces a yellowish stain on the film. Developing time also is critical since litho films developed in their special developers reach maximum density rapidly. Overdevelopment causes fine detail to be lost.*

*Here are the processing steps in developing litho film:*

1. *Mix solutions A and B according to manufacturer's directions. Bring the developer to 68° F (20° C) and hold at that temperature.*
2. *Pour the developer into a photographic tray only slightly larger than the size of the negative to be developed.*
3. *With a fast movement, place the exposed sheet of litho film in the tray, emulsion side up.*
4. *Unless you are using either the Fine-Line (see page 328) or still method, agitate the film for the 2 to 3 minutes it is developing. Time development precisely.*
5. *Remove film quickly and place it in stop bath for 15 seconds.*
6. *Fix for 4 to 5 minutes. (Turn on white light after 1 minute.)*
7. *Inspect the wet negative for contrast, details, and so on by placing it on an electrically safe light box. (Water and electricity are potentially dangerous together, so use a light box designed for this function.) If satisfactory, proceed to step 8. If not, start again with a new sheet of film.*
8. *Wash film for 10 minutes in a tray of running water at 68° F (20° C).*
9. *Squeegee film to remove excess water.*
10. *Hang film up to dry or dry with an electric hair dryer.*
11. *Examine film over light box for pinholes. Using a small brush, cover film with opaque to block light from pinholes.*

*This high-contrast photograph was originally made on Tri-X at EI 800, on a 6 × 7-inch (15.2 × 17.7-cm) negative. The negative was then enlarged onto 16 × 20-inch (40 × 50-cm) litho film and contact-printed.*

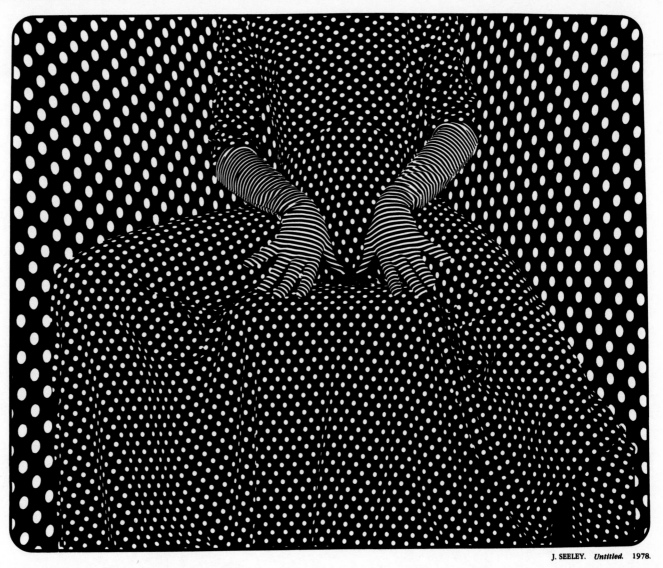

J. SEELEY. *Untitled.* 1978.

321

## Tonal Deletion

**W**ith the high-contrast process of tonal deletion (or tone dropout), you can transform a continuous-tone negative (one with a full range of tones from black to white) or a color transparency into a picture consisting of nothing but blacks and whites. A high-contrast photograph, such as the one by J. Seeley on this page, usually looks quite graphic because of the hard, definite edges between the forms or areas in the picture and because all gray tones have been de-

leted. There is an attractive abstract quality about such photographs.

To make a high-contrast print, start with either a black-and-white negative or a color or black-and-white transparency and enlarge it onto a sheet of litho film. When you enlarge a black-and-white *negative,* you turn the litho film into a high-contrast black-and-white *positive transparency.* Contact-print that positive transparency onto another sheet of litho film to make a high-contrast *negative.* (This exposure should simply translate the tones and not exaggerate them.) Use this

negative to contact-print a high-contrast black-and-white *print.* By varying the exposure, you determine how many of the tones in the final print will record as black and how many as white. If the initial exposure of the black-and-white negative to the litho film is long, you will emphasize the highlight (white) areas in the resulting print. If the initial exposure is short, you will emphasize detail in the shadow (black) areas. Finally, an exposure between these two extremes will balance the middle tones (black and white equally distributed) of the picture.

When you enlarge a color or black-and-white transparency or contact-print a large transparency onto litho film, you skip one step and immediately produce a high-contrast black-and-white *negative.* Use this negative to contact-print a high-contrast black-and-white *print.* In this case, because you start with a positive, a long initial exposure will emphasize the shadow areas in the resulting print, while a short exposure will emphasize the highlights. Again, an exposure in between will balance.

In either case, the high-contrast negative is called a *one-tone* negative—that is, a negative that, by virtue of exposure, concentrates on either the shadows, middle tones, or highlights of the original.

322

## Posterization

**W**hen you have seen how the one-tone negative can transform a continuous-tone picture into pure blacks and whites, you may wish to expand your possibilities with the posterization process, actually a continuation of tonal deletion. Posterization in its simplest form involves *three* one-tone negatives, or tonal separations. Instead of making a single one-tone negative as you did for tonal deletion, you make three one-tone negatives—one for shadows, one for highlights, and one for the middle tones. Each of these one-tone negatives is contact-printed one by one in register (see Registration System, page 324) or out of register (preferred by some) on a single sheet of contact paper to produce a posterization print.

The contact-printing process varies considerably from normal contact printing: Run a test using any one of the three one-tone negatives to arrive at an exposure that gives you a print consisting of middle grays, as shown here. When you know the exposure, follow this procedure. Assume the exposure

**tonal deletion**

Right to far right: *Prints from one-tone negatives made by long, short, and medium exposures of the same continuous-tone negative onto high-contrast litho film.*

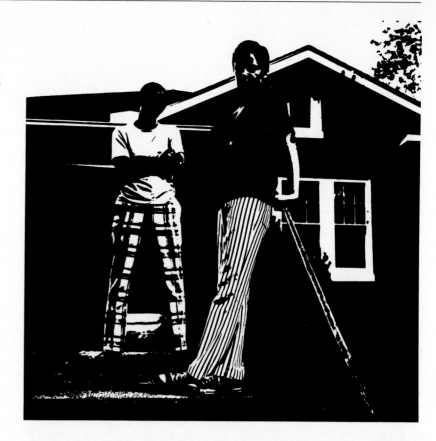

**posterization**

Right: *Exposure of one one-tone negative adjusted to produce a middle-gray tone (the middle-tone negative was used here).* Center: *Final print produced by giving the three negatives the exposure that produced the first middle-gray print.* Far right: *Final print with lighter tonality and more delicate effect produced by using a different exposure time for each negative. With black-and-white posterization three or perhaps four negatives are usually enough because additional ones do not add significant tonal information.*

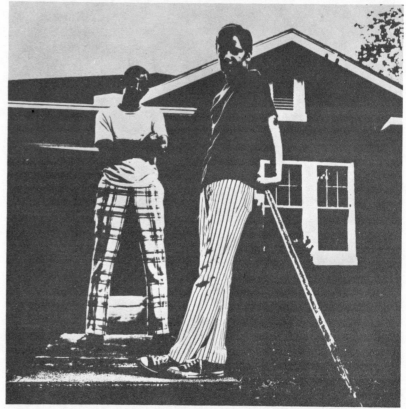

was 10 seconds. Expose any one of the one-tone negatives for 10 seconds. Next, expose another one-tone negative for 10 seconds. Finally, expose the third one-tone negative for 10 seconds. Develop and process the print in the normal manner.

In effect, the three exposures on the one sheet of contact paper build up gray area on gray area, resulting in a photograph consisting of light gray, dark gray, and black, as in the second photograph made from the three negatives shown printed in the tonal deletion series. The first exposure produces a middle gray in some areas of the picture. The second exposure produces a brand-new gray in different areas of the picture, plus a darker area where the two grays overlap. The third exposure produces yet another new area of gray where the two grays overlap and a black area where all three gray areas overlap. By altering the exposures of the negatives, so that each receives more or less exposure than the others, you can achieve quite different effects, as in the third photo.

Posterization can involve more than three negatives. In fact, many positives and negatives can be used together. In the following example, five sets of positives and negatives are used, but the number could have been increased to nine or more.

To begin, make five negatives or positives at various exposures from the original positive color transparency or black-and-white negative.

Then contact-print these to another piece of film, to produce the opposites, being careful with the exposure to avoid exaggeration. You will now have five positives and five negatives.

Then contact-print the negatives to produce five one-tone positives. For the sake of simplicity, consider each negative and its accompanying contact as a set with the *same* density. Number each set 1 through 5, assigning number 1 to the set with the shortest exposure, number 2 to the set with the next longer exposure, and so on to number 5, the set with the longest exposure.

Now rearrange these sets so that a negative of one density is "sandwiched" with a positive of a *different* density, thereby letting some light pass through to the paper. If a positive and a negative of the *same* density (same set) were placed in registration, the transparent area of the negative would cancel out the transparent area of the positive, making it impossible to pass light through them.

There are many ways to rearrange these sets. Use the following arrangement of negative-positive "sandwiches" as a starting point:

| | |
|---|---|
| negative 1 | no positive |
| positive 1 | negative 2 |
| positive 2 | negative 3 |
| positive 3 | negative 4 |
| positive 4 | negative 5 |
| positive 5 | no negative |

Contact-print on a single sheet of paper each group (new set) of negatives and positives, plus the single negative and the single positive. This complex posterization is generally used with color processes (see page 330).

## registration system

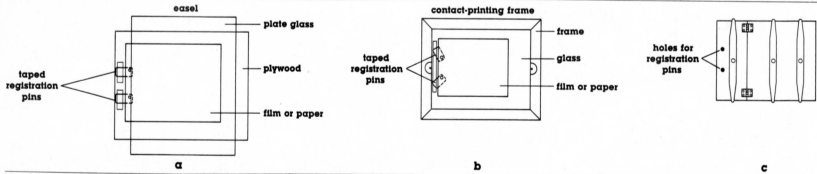

*Commercial registration systems are quite expensive. The following system is inexpensive, readily available, easy to use, and very accurate; it is suitable for both enlarging and contact printing. The following materials are needed:*

- *4 ¼-inch (6mm) registration pins (available from graphic arts suppliers)*
- *11 × 14-inch (28 × 35-cm) piece of ¼-inch plate glass with edges smoothed*
- *11 × 14-inch piece of ¾-inch (18mm) plywood*
- *11 × 14-inch contact-printing frame (takes prints up to 8 × 10 inches—20 × 25 cm)*
- *¼-inch 2-hole punch (available in office supply stores) with about a 3-inch (8-cm) space between the holes*

*a To prepare the easel for registration, punch holes along one side of a sheet of scrap film. Place a registration pin in each of the two holes and lay this combination down on the sheet of plywood, which will be the enlarging registration easel. Tape the registration pins to the plywood and carefully remove the scrap film.*

*b To prepare the contact-printing frame for registration, place the other two registration pins in the holes in the scrap film and place the film on the glass in the frame. Tape the pins to the glass and carefully remove the scrap film.*

*c Drill holes in the back of the contact-printing frame to fit the pins. These holes let the pins stick through them; thus there is no danger of breaking the glass when you close the contact-printing frame.*

*To enlarge, place the plywood registration easel under the enlarger. Scale and focus the projected image and then tape down the easel to prevent any possible movement when you are attaching or removing the film. Punch holes in the unexposed film, place it over the registration pins emulsion side up, and cover it with the plate glass, as shown in* **a.**

*To contact-print, remove the back of the contact-printing frame and place the negative or positive on the registration pins. Punch holes in the unexposed film or paper, place it over the registration pins with the emulsion side toward the glass, and close the contact-printing frame.*

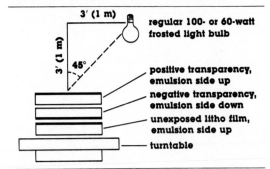
tone line:
**Fine-Grain Positive film used in initial stages**

325

tone line: **litho film used throughout**

## contact-printing a tone-line "sandwich"

3' (1 m)

3' (1 m)

45°

regular 100- or 60-watt frosted light bulb

positive transparency, emulsion side up
negative transparency, emulsion side down
unexposed litho film, emulsion side up
turntable

*Place the film sandwich—the positive and negative transparencies with their emulsion sides away from each other—in a contact-printing frame on a sheet of litho film, emulsion side up, as shown. Be sure all three films are in registration. Place the frame on a Lazy Susan turntable. Rotate the turntable during the exposure so that all areas of the film are exposed. The exposing light must be on an angle, for if it hits the films from straight above, the positive and negative areas, being in register, will cancel each other out. Light on an angle passes between the positive and negative areas on the film to expose a line on the unexposed litho film. You may alter the width of the line by spacers (sheets of thin glass or frosted acetate) between the negative and positive transparencies and by changing the angle of the exposing light. The quality of the line will change if the negative is on top.*

## Tone Line

The tone-line process enables you to convert a photographic image into a line drawing with either thin or thick lines. First, enlarge your negative onto litho film, using an exposure appropriate for the middle tones. Next, contact-print the resulting positive transparency onto another sheet of litho film, making certain the resulting negative transparency has the same contrast as the positive. Sandwich positive and negative with their emulsion sides *away* from each other. See Contact-Printing a Tone-Line "Sandwich" for how to contact-print this "sandwich" onto another sheet of litho film.

When you have contact-printed the sandwich, you will have a litho transparency with black lines against a clear background. Contact-printed on a piece of paper, it will produce a print with white lines on a black background. If you want black lines against a white background, contact-print the litho transparency used for the print onto another litho sheet to produce a transparency that has clear lines on a black background; then contact-print this to produce your print.

Some photographers use Kodak's Fine-Grain Positive film—a continuous-tone film with all the qualities of enlarging paper, built on a film support—to make the initial positive and negative. They then expose these two in a sandwich onto *litho* film. This method gives a less graphic rendition than the one just described, with more delicate lines and finer detail.

326

**bas-relief**
*The church was a rewarding subject because the three-dimensional effect emphasized the linear patterns of roof tiles and wall siding and gave an appealing textural quality to them.*

## Bas-Relief

The bas-relief (low-relief) technique produces a photograph that seems to be three-dimensional. The shapes are outlined with either black or white lines that separate the various elements, thus producing an illusion of depth.

You may enlarge a negative (or positive) onto either litho film or Kodak Fine-Grain Positive film. The Fine-Grain film is relatively inexpensive and usually easier to work with. The steps are much the same as for the techniques already described. Enlarge the negative (or positive) onto a sheet of film to get a positive (or negative). Then contact-print the positive (or negative) onto another sheet of the *same* film to produce a negative (or positive). Sandwich both positive and negative slightly out of register and contact-print onto a sheet of contact paper, using a higher than normal contrast grade for best results.

The degree to which the positive and negative are out of registration determines the width of the line: the more out of register, the thicker the line. Generally, a scene with complex detail looks best with a delicate line—that is, the positive and negative very *slightly* out of register. A scene with bold shapes looks better with a wider line.

## Halftone Prints

A normal photograph is composed of continuous tones ranging from white through many tones of gray to black. When such a photograph is to be reproduced in any of various graphic arts and printing processes, it must be converted to a form that will enable one density of ink to reproduce varying densities of tones—the halftone print. A halftone print consists of high-contrast black-and-white areas that optically combine to re-create the continuous tones of the original. These prints are often used in lithographs, etchings, and silkscreen prints, when photographic images with a full range of tones are wanted.

Technically, the halftone method transforms a continuous-tone negative into a photograph consisting of dots of varying sizes. All the photographs in this book are reproduced as halftones; they were converted to halftone negatives before the printing plates were made. Look closely at any one photograph in the book with a magnifying glass and you will see groupings of dots similar to those in the enlargements shown here. Middle-gray flesh tones have roughly an even balance of dots and white areas around them. Black areas are black with only tiny

*327*

**black**       **gray**       **white**

*Enlargements of halftone dot patterns showing distribution and size of dots in black, middle-gray, and white areas.*

white dots. Areas that look white actually contain tiny black dots. Our eyes interpret the variations in the size and spacing of the dots as tones of gray or as black or white.

You can make your own halftone photographs relatively inexpensively with a special film: Kodak's Autoscreen ortho film. This film, which must be developed in a litho developer, has a halftone screen containing the dots built into it. Contrast is controlled by a technique called *flashing* (see Flashing: A Way to Control Autoscreen Contrast).

To make the halftone print, enlarge a normal negative onto a sheet of Autoscreen film to produce a positive. Then contact-print the positive onto an ordinary sheet of litho film—*not* another sheet of Autoscreen film. (The use of two sheets of Autoscreen film causes the dots from one sheet to overlap the dots on the other sheet, producing patterns and shapes that alter the original imagery—an effect called *moiré.*) Use the resulting litho negative to make the halftone contact print. Halftone negatives can also be made with a contact screen, used by many printers. Contact screens are more versatile than Autoscreen film, since they come in various patterns and types of dots. However, they are quite expensive and for best results require complex equipment, such as a vacuum holder and vacuum pump.

## Granulation

**I**nstead of using Autoscreen film (or a contact screen) to produce a halftone photograph, you can make a "random" halftone by the granulation process. In a normal halftone, the dots are well-proportioned and arranged in a precise, systematic order; in a random halftone, they are shaped like small, ragged-edged rocks and "arranged" as though dropped helter-skelter on the picture.

To achieve this result, preferably begin by photographing a flat scene—one with low value contrasts—with a grainy film such as Tri-X or Ilford HP-5. Expose the film at about 400 ASA. Next, develop the film in Rodinal diluted 1 part developer to 75 parts water for 13 minutes at 68° F (20° C), with intermittent agitation. (Rodinal works well; results with other developers vary.) You should produce a negative so flat that it would be unsuitable for normal enlarging—even on a contrasty grade of paper.

Enlarge this extremely flat Tri-X or Ilford HP-5 negative onto a sheet of litho film. Flashing is usually used to control contrast. Next, develop the litho film in Kodak's Fine-Line Litho developer (see How to Use Fine-Line Litho Developer).

The processed litho film will be a granulated positive. It must be contact-printed on another sheet of litho film to get a granulated *negative,* which is then used to make the granulation contact print. Many photographers and graphic artists prefer this method because the halftone is produced during processing, instead of being added to the negative. There is another advantage: because the dots are random, there is no possibility of a moiré pattern. (See Bill Branson's photograph.)

### flashing: a way to control Autoscreen contrast

*The contrast of a halftone may be reduced by flashing the Autoscreen film. Flashing is a nonimage exposure of the Autoscreen film to light in order to produce a dot pattern in the shadow areas. It is done either before or after the normal exposure of the negative.*

*To flash, aim a Kodak darkroom lamp fitted with an OA filter and a 15-watt bulb at the Autoscreen film, emulsion side up, from a distance of 6 feet (2 m). You need to make tests to determine how long the light should stay on. As a guide, start with exposures of 5, 10, and 15 seconds. If the flash exposure is too long, the overall contrast of the Autoscreen positive will be reduced to the point where it is too flat.*

### how to use Fine-Line Litho developer

*Because the developer used in the granulation process demands close control over both time and temperature, the following one-shot method is advised.*

*To develop an 8 × 10-inch (20 × 25-cm) sheet of litho film, mix in a container 3 ounces (100 ml) each of the two solutions (A and B) making up Kodak's Fine-Line Litho developer. Place the container in a tray of 68° F (20° C) water to control its temperature.*

*Next, place the exposed sheet of litho film in a flat-bottom photo tray—one with no ridges or grooves, which would cause developing streaks. Pour 68° F (20° C) water (not developer) over the film to presoak it. Lift out the film, discard the water, and place the litho film back in the damp tray, emulsion side up. (If the emulsion side is down, the film will not develop.) Set a timer for 2 minutes and 45 seconds. Pour the already prepared fine-line developer on top of the film. Immediately start the timer and agitate the tray for 45 seconds. At the end of 45 seconds, do not touch the tray and do not disturb the developer for the remaining 2 minutes. Any disturbance will cause developing streaks.*

*When the timer signals that the time is up, quickly remove the film from the developer and immerse it in the stop bath for from 10 to 15 seconds. Fix, wash, and dry the film in the normal manner.*

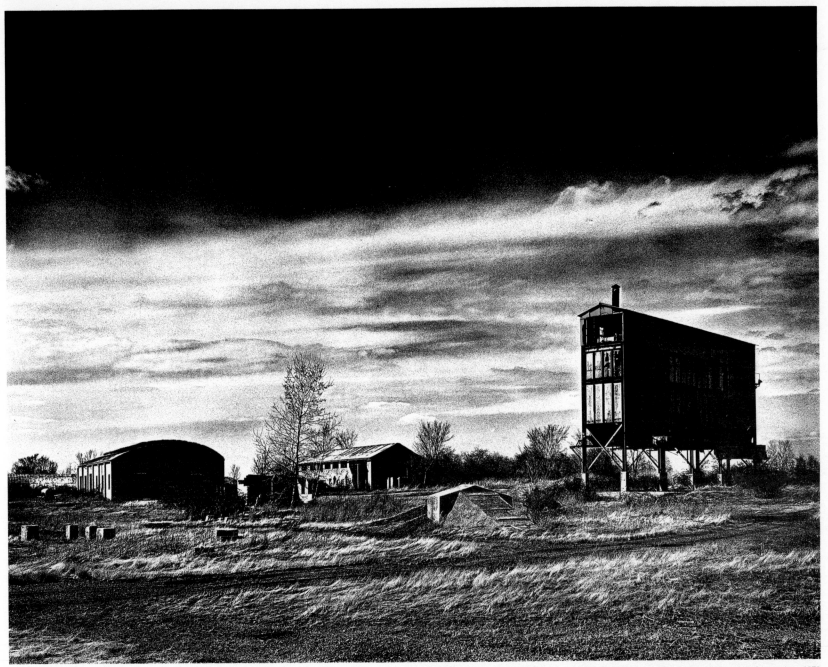

329

BILL BRANSON. *Ziegler No. 2 Coal Mine.* Granulation print. 1979.

## The Addition of Color to High Contrast

**B**y adding color to high-contrast techniques, you can create more complex photographs because you can expand the limited variety of tones produced in black and white.

The methods used to produce the different colors for these techniques depend on the process by which prints are produced from the negatives (and/or positive transparencies). With gum bichromate or Kwik-Print (nonsilver printing processes discussed next), you mix or overlap the inks or pigments. With color printing processes such as Ektaprint, the colors are produced with color filtration. The light from an enlarger is filtered and then used to expose the sandwiched negative-positive combinations to the Ektaprint paper in the contact-printing frame. The color posterization shown here was made in this way. See also the color posterization at the beginning of this chapter.

There are three different ways, each relatively easy, to filter the enlarger light. Each way ideally requires that the color of the Ektaprint paper be balanced to produce a neutral rendition of an 18 percent gray card (see pages 360–361).

One way is to buy six gelatin filters to place in the enlarger housing. The table lists the filters you need to reproduce specific colors in Ektaprint paper. Another way, similar to the first, is to make your own filters. Simply photograph with color negative film sheets of colored construction paper, choosing colors that match the gelatin filters (red, green, and so on). Color Aid paper available in art supply stores is a good choice. The processed colored negatives then substitute for the filters. Place the negative of each color you want to use in the enlarger.

In the third way to filter the enlarger light, you use just three filters: Wratten 29 (red), Wratten 61 (green), and Wratten 47B (blue). The red filter will make the print cyan, the green one will make it magenta, and the blue one will make it yellow. By making separate exposures through the filters, one at a time, in various combinations, you can produce all colors (or black). For example, an exposure through the blue filter (yellow) plus an exposure through the green filter (magenta) will produce red in the print. See Chapter 13 on color for explanations of the effect of these filters and why they produce certain colors. □

### filters for adding color to high-contrast prints

| Wratten filter | color produced |
|---|---|
| 29 (red) | cyan |
| 61 (green) | magenta |
| 47B (blue) | yellow |
| 44 (cyan) | red |
| 32 (magenta) | green |
| 12 (yellow) | blue |

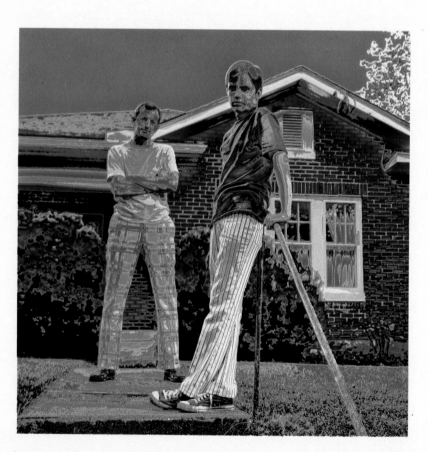

### color posterization

*This color posterization was made from the continuous-tone negative used for the black-and-white posterizations on pages 322–323. Nine different color exposures through a red, green, or blue filter with various combinations of positives and negatives were used.*

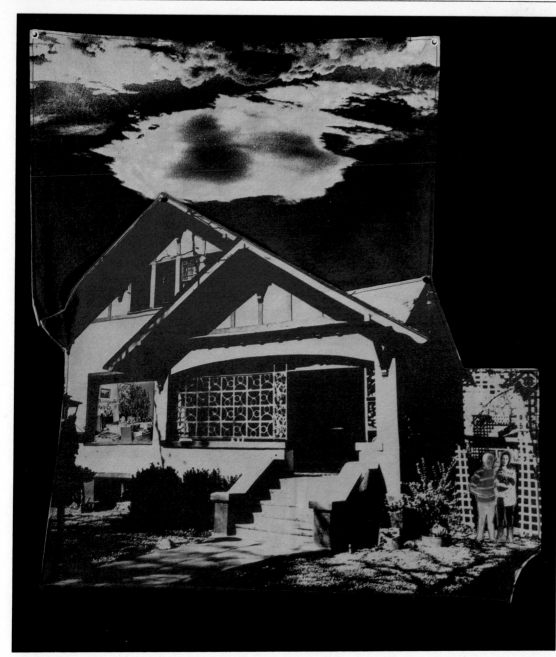

TOM PETRILLO. *Untitled.* 1973.

*Cyanotype with attached brownprint
on bleached muslin.
Original: 19⅜ × 20 inches (49 × 50 cm).*

There are two good reasons why you may want to explore in depth the nonsilver processes capable of producing images that cannot be produced with conventional silver materials. First, since these processes are nonsilver and use 100 percent rag paper as a support, there is no risk of damage by chemical actions over time, as there is with supports used in the silver-based techniques (see pages 244–245 for archival practices that can be used to preserve silver-based papers). Second, some of the nonsilver processes (two of those discussed here) involve coatings that may be applied with a brush, giving you a chance to use a great deal of hand manipulation. Thus you can produce pictures with a handmade quality.

This is merely an introduction to help you familiarize yourself with the broad aspects of some of the nonsilver techniques. Later, as you gain more technical experience and confidence, you can delve into this field and explore the techniques that appeal to you with the help of the many books on them. Use this book's bibliography as a guide. Five of the most popular nonsilver processes are discussed here. They are: cyanotype, gum bichromate, Kwik-Print, carbon and carbro, and platinum.

331

## Cyanotype

Cyanotype is a very early process produced with compounds of light-sensitive iron—as opposed to light-sensitive silver compounds that can fade and stain. When exposed to light high in ultraviolet radiation the light-sensitive irons produce a compound that is cyan—bluish—in color and insoluble in water. Only two chemicals are needed: ferric ammonium citrate and potassium ferricyanide. (Both are poisonous; rubber gloves are essential.)

The picture is made—basically—by coating 100 percent rag paper with a mixture of the chemicals to make it light-sensitive; then, when the paper has dried, a negative is placed on it and exposed to light. The exposed print is placed in water for development.

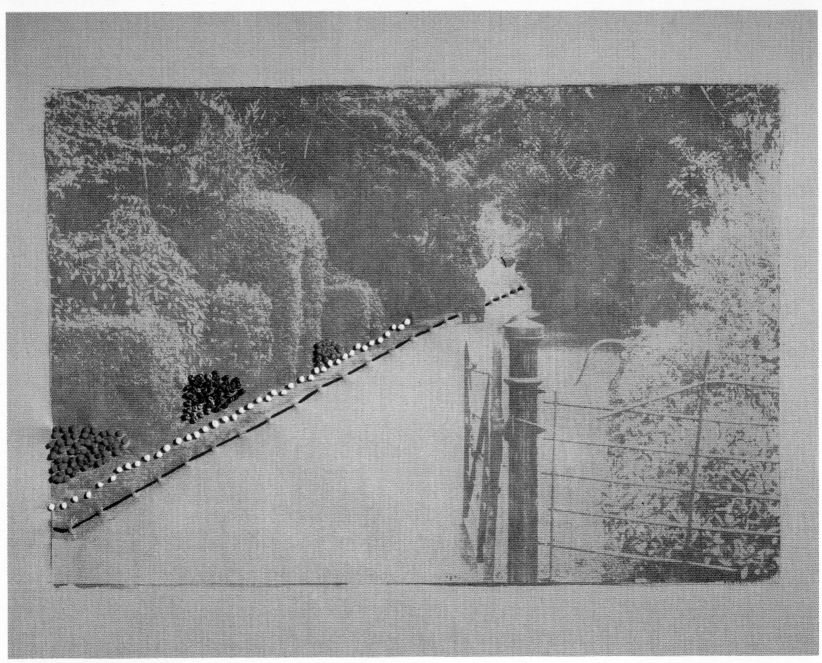

*332*

*Green gum bichromate on tan cotton fabric*
*with white, blue, and purple French knots.*
*Original: 11 × 14 inches (28 × 35 cm).*

BETTY HAHN.  *English Garden.*  1973.

## Gum Bichromate

Gum bichromate is a pigment process based on the hardening principle rather than on the latent image and development principle. Certain compounds become insoluble in water when exposed to light. These insoluble compounds are mixed with pigments and are then coated onto a piece of thick 100 percent rag paper or other support. The paper—now light-sensitive—is exposed to a negative by an ultraviolet light. The exposed paper is then placed in warm water where the unexposed (nonhardened) areas gradually wash away, leaving the exposed (hardened) areas.

## Kwik-Print

Originally, Kwik-Print was a commercial process introduced for printers for pre-press color proofing. Later, it was improved, and it is now bought by artists and photographers. It is quite similar to the gum bichromate process in that the image is produced by light-sensitive compounds containing pigments which, when exposed to light, become insoluble in water. These exposed areas remain while the unexposed areas and accompanying pigments wash away. Bea Nettles' photograph in the Portfolio (page 379) is an example of a Kwik-Print.

Kwik-Print, though more expensive, is faster and more convenient than the gum bichromate process in that it is purchased as a "package," while you must spend time preparing the gum bichromate materials. Also, the Kwik-Print pigments are more light-sensitive, reducing exposure times. Kwik-Print is available in black, brown, gray, a variety of blues, green, yellow, and a clear tone to which you add your own pigments. (It is distributed by Light Impressions, 131 Gould Street, Rochester, New York 14610.)

## Carbon and Carbro

Carbon and carbro processes were used by many early photographers for high-quality portraits. Prints produced by these two techniques were—and still are—admired for their unique surface. The dark areas on the print have a thick deposit of pigment, but the white areas have none. This arrangement produces a very beautiful tactile quality that gives a strong feeling of dimension (difficult to reproduce by photo-offset lithography).

Both processes are similar to the gum bichromate process in that they are based on the principle that certain compounds become insoluble in water after exposure. The difference is in the application and method used to produce the picture.

The carbon and carbro processes use a type of paper called "tissue" (sometimes called "carbon tissue" because the early tissues used carbon for the pigment) that contains a thick gelatin layer that includes pigment. At one time there were more than fifty different shades and colors available from four different manufacturers. A few years ago, the last remaining company considered stopping the manufacture of the tissue. Dr. Robert Green, who is deeply interested in carbon and carbro printing, persuaded the company's officials to continue to make it. Today, the tissue is available only from Dr. Green (Gallery 614, 614 West Berry Street, Fort Wayne, Indiana 46802). The tissue is sensitized and exposed to the negative. It is then transferred to the final support sheet (100 percent rag paper) and placed in warm water to allow the nonhardened areas to wash away.

The difference between carbon and carbro is that the carbon process is a contact technique and the carbro process allows both contact and enlarging. The carbon method was the first, but carbro eventually became more popular.

## Platinum

Generations ago some photographic paper had a platinum base because platinum produced a greater range of tones and was considerably more stable than silver. A platinum photograph is very elegant, with its soft, cool gray-black tonality, and it has beautiful middle tones (also difficult to reproduce in a printed book). The middle tones are caused by the self-masking quality of the process: the shadow areas actually turn dark in the print during exposure, which reduces the exposure to these areas. In effect, this self-masking provides automatic dodging and helps balance out the tones.

Unfortunately, platinum became considerably more expensive than silver, and the manufacture of platinum-base paper was discontinued. (Silver is now also high in price!) If cost is not a factor for you, however, you can still buy the materials to make your own platinum paper. Photographer's Formulary, Inc. (P.O. Box 5150, Missoula, Montana 59806) specializes in these otherwise hard-to-find chemicals.

In addition to exploring the purely photographic processes that may be used to produce permanent pictures, many contemporary photographers are exploring printing processes. These include silkscreen (seriography), photogravure, and direct-plate lithography. Each of these processes reproduces the photographic image with a special visual quality. None of them should be thought of as an exact facsimile but rather as an interpretation. For example, the silkscreen process is not capable of reproducing extremely fine detail. The quality achieved is roughly equivalent to that in a newspaper; as a result, a photograph with extremely fine detail is not usually suitable. The photogravure process converts the photographic image into a pattern of very small random dots, which produces very rich tones. The direct-plate lithograph requires some form of a halftone to expose onto the plate. All of these processes involve equipment not generally found in regular photographic facilities because they relate very strongly to printmaking and printing. The inks are permanent, and when they are used on 100 percent rag paper, the resulting prints are quite permanent. □

# Color

In the last few years color photography as an art has been increasingly explored by serious photographers. At the same time color processing—chemicals, number of steps, time and temperature tolerances, equipment and facilities—has been much simplified. In fact, the technology for color processing is continually being changed and improved. Though these changes make it practical for even beginning students to start to explore color, they also make it impractical to include specific step-by-step procedures in a text that cannot be updated constantly. To process your own color film or prints, then, consult the technical literature that comes with the process you buy. This chapter concentrates instead on giving an overview of color photography.

Whichever color process you choose to work with, it is important to buy your film and paper in quantities of the same emulsion number and store them properly. This will help standardize your procedures and eliminate retesting for color balance and exposure to achieve satisfactory pictures each time you expose film or print.

335

# Color: A Function of Light

In 1666 Isaac Newton (1642–1727) demonstrated that color is a function of the interaction between light and whatever it illuminates. By directing a ray of sunlight through a glass prism, Newton produced a rainbow array of the various components of the visible spectrum (see Chapter 3, page 70). Then by returning the spectrum through another prism, he produced the original "white" or visible light. Thus Newton proved that sunlight contains the elements of all colors.

An object has a certain color because it reflects the elements of white light that produce the color and absorbs the others. An apple, for instance, looks red because it reflects the red element in the spectrum and absorbs all remaining color elements.

The term *color* refers to a combination of hue, saturation, and value. *Hue* is the property of a color that gives it a name, distinguishing it from other colors. The many elements of the visible spectrum can be divided, for convenience, into the hues of red, orange, yellow, green, blue, and violet.

*Saturation* is the relative purity, vividness, or intensity of a color. A brilliant red is said to be of high saturation; a soft yellow is said to be of low saturation. Saturation is dependent on hue. The black, white, and grays of black-and-white photographs do not convey color saturation.

The technical term for shading is *value*; this is the property of a color that makes it seem light or dark. Light colors are said to be high in value; dark colors are said to be low in value. Colors are conveyed in black-and-white photographs only in terms of their values.

In color photography, the components of white light must be separated and then recombined. There are two ways to do this: the additive method and the subtractive method. The additive method was used in the 19th century for the first successful color reproductions. Today it is the subtractive method that underlies color photography (see page 339).

336

*A beam of light breaks down into a spectrum when it passes through a prism. The beam enters horizontally from the left. (Light traveling up and down, angled to the left, is irrelevant reflected and scattered light.)*

The wavelengths of electromagnetic energy radiating from the sun range from .00000000004 inch (.000000001016mm) for X rays and gamma rays to as much as 6 miles (9.6 kilometers) for radio waves. About halfway between fall the wavelengths that are visible to the human eye—the wavelengths called light, or "white" light. Photographic film can register all wavelengths from the shortest to some in the infrared group just longer than the visible wavelengths. The visible light-waves can be grouped by their lengths into the hues violet, blue, green, yellow, orange, and red. Mixed together, these colors appear to the eye as white light.

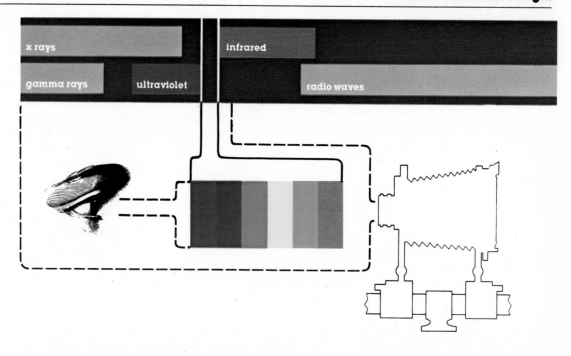

This scale shows that saturation is diminished by adding the opposite hue on the color wheel (see page 338). The scale ranges from pure magenta to pure green. Saturation is sometimes called intensity.

337

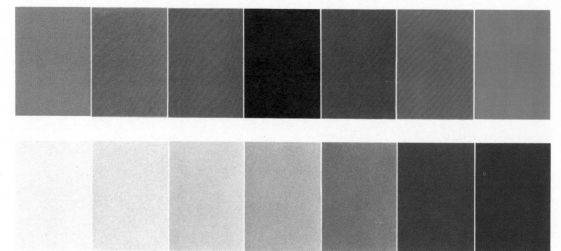

This scale shows the values of blue. Value distinguishes the relative lightness or darkness of a hue.

### The Additive Color Principle

The additive principle of combining colors is: When they have been separated, the primary color components of light—red, green, and blue—can be recombined to produce all other colors or white, and the total absence of color is black. Called *additive primaries* because they introduce color where none exists (black), each of these colors transmits about one-third of the spectrum's wavelengths; the addition of any one of these colors to the other when projected in separated beams of light can produce other colors. Overlapped in beams of light, all three appear to the eye as white. This may be shown by setting up three slide projectors. Place a number 25 red filter over the first projector lens, a number 58 green filter over the second, and a number 47 blue filter over the third. Now turn out the lights, turn on the projectors, and overlap their beams of light on a screen. By combining the colors from the three projectors, you can produce:

$$\text{red} + \text{green} = \text{yellow}$$
$$\text{green} + \text{blue} = \text{cyan (bluish green)}$$
$$\text{blue} + \text{red} = \text{magenta (purplish red)}$$
$$\text{red} + \text{green} + \text{blue} = \text{white}$$

The colors produced by combining two additive primaries are called *secondary colors*. A primary and a secondary color whose light (in similar situations) combines to make white light are called *complementary colors*. On the color wheel complements are opposite each other—such as blue and its complementary color yellow.

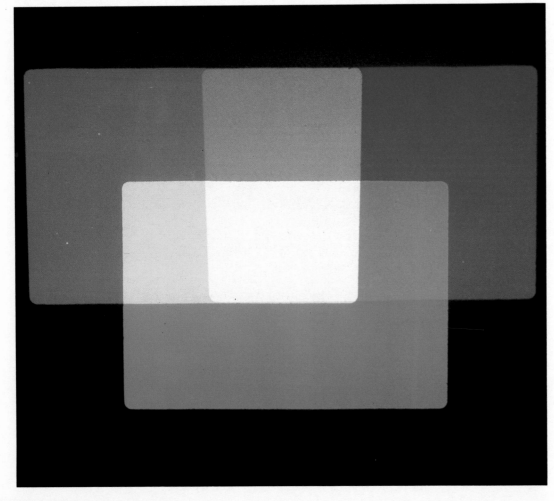

338

▲ *The hues making up white light are shown on the color wheel as the primaries red, green, blue (black triangle) and the secondaries cyan, magenta, yellow (gray triangle), which are opposite the primaries. A primary color and the secondary color opposite it are called the complements of each other.*

◄ *When separated, the additive primaries—red, green, and blue— can be recombined, only in darkness, to make all other colors or white. These colors add up to other colors only when projected separately.*

*The subtractive primaries are actually the secondary colors cyan, magenta, and yellow. Overlapped, two subtractive primaries create an additive primary by subtracting from white light the wavelengths for all colors but the specific color made visible. When all three subtractive primaries overlap, they create black.*

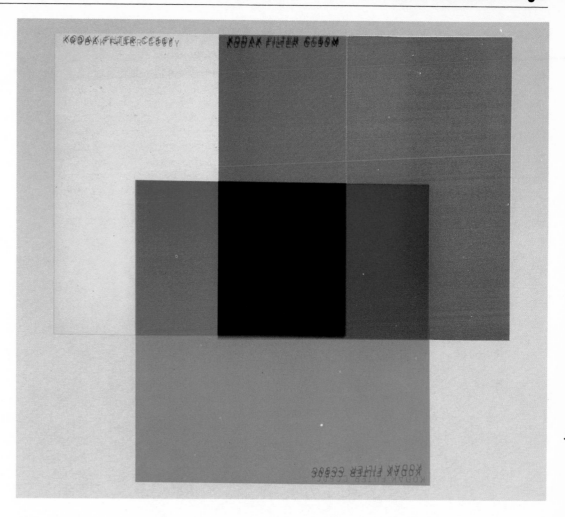

339

## The Subtractive Color Principle

The absorption characteristics of the additive primary colors—red, green, and blue—are such that they can be combined to make white only when projected separately as colored light beamed into a darkened environment. Also, for the same reason, any two additive primaries can be combined to make a secondary color only when projected into a darkened environment. When additive primaries are placed on a white background, such as a sheet of white paper or a light table, in an illuminated environment, the situation is very different. In that case, when two additive primaries overlap, they produce not a secondary color but black. This is because each additive primary can transmit only one-third of the total spectrum, while absorbing two-thirds. Therefore, when filters for two additive primary colors are superimposed, they absorb all light and transmit none, producing black.

The subtractive method of combining colors starts with white light and subtracts from it the wavelengths of the three additive primaries. This process makes use of the secondary colors, which are the complements of the additive primaries. The complements, in combination, absorb or subtract the wavelengths of the additive primaries, leaving black. These complements—cyan, magenta, and yellow—are thus called the *subtractive primaries*.

Each subtractive primary absorbs the wavelengths of its complement, an additive primary, and transmits or reflects the wavelengths for the other two additive primaries. And because each subtractive primary is the result of the mixture of two additive primaries, each shares the reflection and absorption characteristics of the two additive primaries. Thus when filters for two subtractive primaries are overlapped on a light table, they do not cancel each other into blackness (as two additive primaries do), but they create a third color—an additive primary:

yellow ($-$ blue) + magenta ($-$ green) = red
cyan ($-$ red) + yellow ($-$ blue) = green
magenta ($-$ green) + cyan ($-$ red) = blue
yellow + cyan + magenta = black

Only when all three subtractive primaries overlap is the result black because all three additive primaries are then absorbed.

To sum up, the additive primaries produce colors only in darkness, as inside a camera or in a darkroom. The subtractive primaries produce colors in an illuminated environment against a white or light background, as paper or a light table. ☐

When early photographers had succeeded in producing black-and-white images, they soon began to want pictures in color. Many early photographers experimented. Daguerreotypes were often painstakingly hand-tinted with powders to soften the cold, silvery tones of the originals. Eventually, ambrotypes, tintypes, and even paper prints were hand-painted, often in a crude way that destroyed the quality of the original. These unsatisfactory results reinforced the desire for a real color process—one that would begin while the picture was being taken, rather than after the image had been formed.

The future success of color photography derived from a technique British physicist James Clerk Maxwell (1831–1879) devised in 1861 for illustrating a lecture on the nature of color vision. Maxwell made three separate exposures of the same subject on three pieces of black-and-white film through blue, green, and red filters, respectively. Each black-and-white negative gave a reasonably accurate record of the blue, green, or red tones in the subject. As the next step, Maxwell converted the negatives into black-and-white positive images, called transparencies. Maxwell used three projectors to project

the three transparencies onto a screen simultaneously. He placed in front of each projector light a filter of the same color as the filter used to take that particular picture. When the three images were projected, precisely superimposed on a screen in total darkness, they produced a full-color photographic reproduction of the subject. This was the additive principle of color (page 338).

The full-color picture Maxwell projected was formed by a mixture of colored light and therefore was rather complicated to produce and present. Many researchers worked to evolve simpler methods.

340

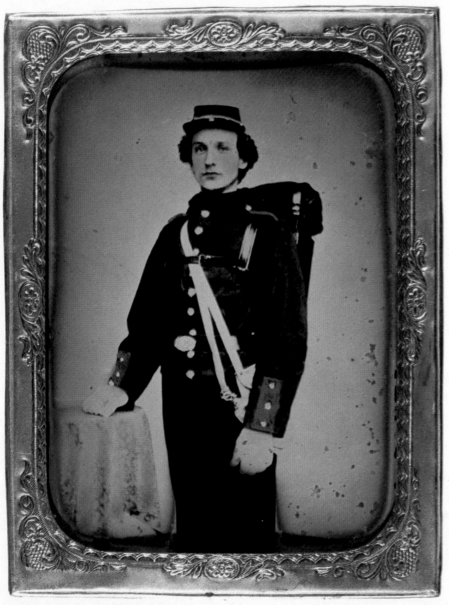

Civil War soldier. Hand-tinted ambrotype. 1860s.

In 1893, John Joly (1857–1933) succeeded in combining all of the elements of the additive color process in a single glass plate that could be used in standard cameras. Still later, in 1907, Auguste and Louis Lumière (1862–1954; 1864–1948) developed the Autochrome process, which simplified color photography enough to make it more practical for commercial purposes.

The major drawback to all such approaches to color photography was that they all produced positive transparencies and not color prints. Two French researchers who tried to solve the problem were Louis Ducos

341

*An Autochrome is a glass plate coated on one side with an even layer of tiny transparent starch particles dyed red, green, or blue, as in this magnified reproduction. Over this layer a panchromatic emulsion is applied. Facing the lens during exposure, the grains function as tiny color filters, recording the image as a mosaic of colored dots. When the negative is developed and then reversed into a positive, its image can be seen in full color. The Stieglitz photograph is an example.*

ALFRED STIEGLITZ. *Mrs. Selma Schubart in a Yellow Dress* (Stieglitz' sister). Lumière Autochrome (image reversed), 5 × 7 inches. 1907.

LOUIS DUCOS DU HAURON. *Leaves and Flower Petals.* 1869.

342

du Hauron (1837–1920) and Charles Cros (1842–1888), working independently. Both men applied the *subtractive* principle (see page 339) of complementary colors to produce color prints. After years of research, they announced their virtually identical findings in 1869. As Maxwell had done earlier, Hauron and Cros made separation negatives by exposing black-and-white film through blue, green, and red filters. They then converted the negatives to black-and-white positives. However, instead of projecting the positives through filters, they dyed each positive the complementary color of its original filter. The positive made through the red filter was dyed cyan; the positive made through the blue filter was dyed yellow; the positive made through the green filter was dyed magenta. When these transparencies were overlapped on white paper, the three colored layers with their various densities of color came together (as a result of the sub-

tractive principle) and produced a full-color reproduction of the original subject.

Thus the subtractive principle is the basis for most of the color photographic processes in use today. Yet color photography remained cumbersome and difficult for many years. Color processes—whether additive or subtractive—for a long time continued to use the separation-negative technique initiated by Maxwell. This method was of limited practicality because it was complex and slow. For example, any alteration, no matter how slight, in the subject being photographed or any movement of the camera between the necessary three individual exposures produced differences among the negatives and upset the color balance. Eventually cameras were built with prism or mirror systems so that all three negatives could be exposed simultaneously, thus simplifying the process considerably. The color-separation negatives produced with these "one-shot" cameras

were used to produce carbon, carbro, and, later, dye-transfer prints.

Shortly before World War I, a German chemist, Rudolf Fischer (1881–1957), patented the principle of dye coupling, which laid the foundation for many present-day color processes. Basically, Fischer proposed that dye-producing elements called dye couplers be incorporated into the emulsion right along with the light-sensitive silver compounds. These chemicals would then generate color by turning into dyes when activated by the color developer.

Multilayer films were the next innovation in color photography. These films consisted of very thin, individually color-sensitized layers of black-and-white emulsion sandwiched to form an integral unit. The emulsions, sensitized to the primary colors (blue, green, and red), recorded wavelengths at the appropriate levels as light penetrated the film. Thus the entire process of color separation

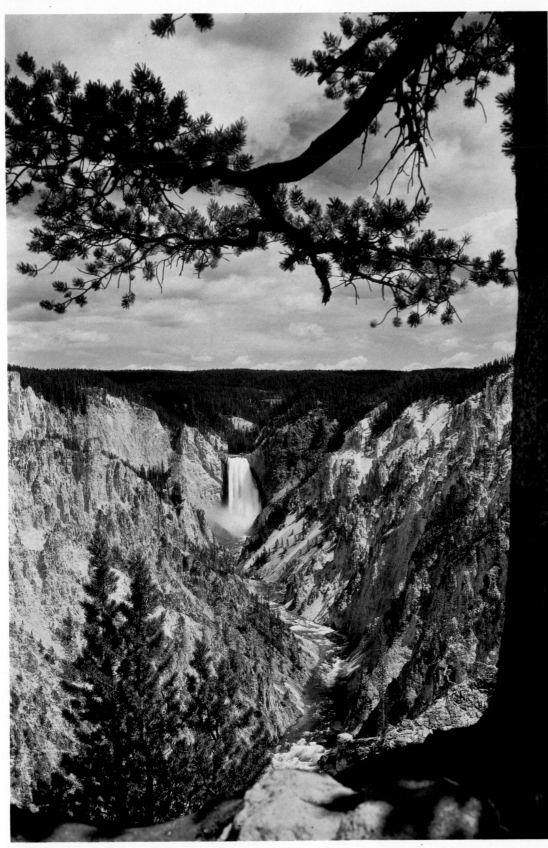

View of Yellowstone Falls, Wyoming. Kodachrome color (photographic reproduction). 1936.

was compressed onto a single piece of intricately fashioned film.

Foremost among experimenters with this multilayer approach were Leopold Mannes (1889–1964) and Leopold Godowsky, Jr. (b. 1900), both professional musicians whose avocation was serious photography. When Mannes and Godowsky learned of Fischer's ideas on dye coupling, they temporarily abandoned their complicated developing procedures and began experimenting with dye couplers in triple-layer or integral tripack films. However, after a short period of time, they went back to their original research. Five years of collaboration between Mannes, Godowsky, and Eastman Kodak in Rochester, New York, followed. Their work eventually resulted in the first commercially feasible color positive film. In 1935, Kodachrome film went on the market for use in home movie cameras and 35mm cameras and some sheet-film cameras. The techniques and the necessary equipment required for developing Kodachrome remain so complicated that even today photographers send their exposed film to either Kodak or a large independent processor.

In spite of its complex developing processes, Kodachrome represented the culmination of research in color theory and technique. The integral tripack film was combined with selected characteristics of earlier color processes for a practical system that made color photography available to the public.

Shortly after the advent of Kodachrome, German researchers at the Agfa Company managed to adapt dye couplers to a multilayer film. Then, in 1942, Ansco marketed a film called Ansco-Color, later called Anscochrome. Soon afterwards, Kodak introduced Ektachrome. Both Ektachrome and Anscochrome contain dye couplers, which simplify developing procedures, making it possible for individuals to develop their own film. Dye-coupler color transparency film is the dominant type of color transparency film today. However, Kodachrome is still available for both motion-picture and 35mm cameras. Kodak discontinued Kodachrome in sheet-film sizes when Ektachrome was introduced.

In 1941, Kodak introduced Kodacolor, the first color negative film, initially marketed for amateurs who wanted color prints instead of color transparencies. It was followed in 1947 by Ektacolor, a color negative film in sheet-film sizes. Both types are still available in various sizes. □

*343*
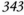

# The Characteristics of Modern Color Film

Modern color film contains in a single sheet stratified layers of three different emulsions, each sensitive to wavelengths of one of the additive primary colors in light; these layers alternate with separating material and rest on a supportive base. As shown in the diagram, a *hard gelatin* layer coats the top of the film to protect the emulsion from scratches. Next is the *blue-sensitive emulsion* layer, which records the image during exposure in values of blue. Next is a *yellow filter* made of colloidal silver; it does not record an image but absorbs any blue light rays that may have passed beyond the blue layer. Thus the yellow filter permits green and red wavelengths to penetrate to the *green-sensitive* and *red-sensitive emulsion* layers below, which record the image in values of green and red, respectively. Below these two layers, which are separated by a layer of *gelatin,* is the *subbing,* a special gluelike gelatin that bonds the emulsion to its *support* layer below. The final layer, the *antihalation backing,* prevents reflections that could create halos around bright areas of the image. These nine layers together measure about .0065 inch (.1651mm) in thickness, only slightly more than black-and-white film, which is less complex in structure.

There are two principal kinds of color film: color negative and color reversal. *Color negative film* is used primarily to make color prints. It produces a negative transparent image in which all the colors are the complements of the colors that will be in the print. For example, the additive primaries blue, green, and red would appear on the negative as yellow, magenta, and cyan, their opposites on the color wheel. *Color reversal film* produces a positive color transparency, a color slide in which all the colors appear as they did in the original subject. The slides can either be projected on a screen or used to make color prints. The basic process for producing a print from color negative film is diagrammed and explained on pages 356–357; the process for producing a slide from color reversal film is diagrammed and explained on pages 354–355. Color films are further distinguished by their color sensitivity to a specific light source, either daylight or tungsten illumination. Color negative film is easier to work with than color reversal film because it has a very wide exposure latitude, which means that slight errors in exposure—especially overexposure—are not as crucial as they are with color reversal film.

Color negative film and color reversal film are available with fast ASA ratings of 400; thus color photography can be done with as little light as black-and-white photography. Both types of color film are also available in fine-grain versions with appreciably lower ASA ratings.

Color negative films come in most sizes, from tiny 110 film to 11 × 14-inch (28 × 35-cm) sheet film; they are made by a number of companies. Color transparency film comes in a somewhat smaller range of sizes. Companies that manufacture both color negative and color reversal film include Kodak, Agfa, and Fuji.

344

**color film: cross section**

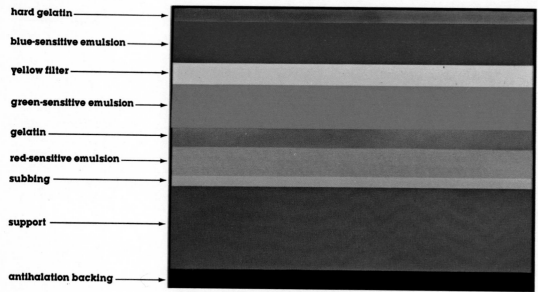

hard gelatin

blue-sensitive emulsion

yellow filter

green-sensitive emulsion

gelatin

red-sensitive emulsion

subbing

support

antihalation backing

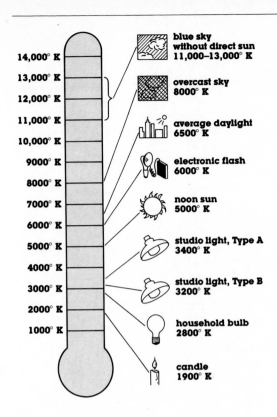

*The Kelvin scale expresses color temperature as Celsius plus 273. Degrees Kelvin (°K) represents the extent to which a black radiator (which could reflect no light) would have to be heated for it to emit light of the same color as the source being measured. Light sources low on the Kelvin scale—below 5000° K—are stronger in red light rays than sources higher on the scale, which are strong in blue light rays.*

## Color Sensitivity

**E**ach color film is designed to function in light with a particular *color temperature*. Color temperature is a way to describe the quality of light resulting from a specific balance among the different wavelengths. It is usually measured by the Kelvin scale. The *lower* the color temperature of a light source, the richer it is in the shorter wavelengths for red and yellow. The *higher* the color temperature of a light source, the richer it is in the longer wavelengths for blue. (Note that colors usually called warm have lower color temperatures, while colors usually called cool have higher color temperatures.)

Color films are sensitized to match the colors of the light sources most typically available for exposing film—daylight and tungsten. The sensitivities of the emulsions in each film are balanced to reproduce colors as human vision is prepared by experience to see them. Daylight films are designed for taking photographs in daylight or by electronic flash. They are balanced for the color temperature of midday light, about 5500° K. Tungsten films are further divided into Type A, balanced for photoflood illumination at 3400° K, and Type B, balanced for professional studio lighting lamps at 3200° K. Color reversal film is available in all three varieties. Most color negative films are balanced for daylight.

When you use a specific color film under the lighting conditions for which it is intended, your pictures wll have proper *color balance*. That is, the scenes you photograph will appear natural, with a faithful rendition of the colors as you saw them. When you use the film under different lighting conditions, however, the colors will look unnatural and there will be an unusual color cast. To avoid these effects, use the right film or compensate for the mismatch of film and light source with the appropriate filter. Conversion filters for both color negative and color reversal film are listed below.

### conversion filters for color film

| | Wratten filter required for daylight | Wratten filter required for 3400° K lights | Wratten filter required for 3200° K lights |
|---|---|---|---|
| **color negative film** | none | 80B | 80A |
| **color reversal film** | | | |
| Type A | 85 | none | 82A |
| Type B | 85B | 81A | none |
| daylight | none | 80B | 80A |

*When conversion filters are used, they require a different ASA, always noted in the film manufacturer's literature. The change may not be necessary with cameras that have through-the-lens meters.*

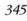

If you use Type B film in daylight, the transparencies will have an overall bluish cast. If you use daylight color reversal film under artificial light, the transparencies will have an orange cast. The closer the color temperature of the light source to the specific color balance of the film, the more factual will be the resulting rendition of color. For extremely critical work, the two factors should not differ by more than 100° K. In these situations, a color temperature meter, though expensive, is very helpful because it permits an accurate analysis of the color temperature of the light source and indicates the filtration needed to correct the film for it.

Trying to print a color negative or color transparency that was not exposed with the appropriate filter usually does not work very well, in spite of the leeway for altering color balance during printing.

Changing the color balance with filters based on the Kelvin scale is not the most accurate method because it does not take into consideration the actual temperature of the existing light. With light sources not commonly used (such as household lights, which are not on conversion tables), the *mired system* may be used to determine what filter will be needed. A filter that produces a 200° K change will produce a greater change at higher Kelvin numbers than at lower ones. The mired system (for *microreciprocal*—the reciprocal of degrees Kelvin multiplied by 1,000,000) produces a change that is consistent throughout the spectrum because the warming and cooling effect of a filter is expressed as a single number. The system relates the degrees Kelvin for which the film is balanced and the Kelvin temperature of the existing light source.

The procedure for finding the correct filter is: First, determine the mireds of both the film and the desired light source by dividing 1,000,000 by the degrees Kelvin. For example, you want to use film balanced for 3200° K with regular household light bulbs (2800° K as listed on the Kelvin scale on page 345 or as determined by consulting a color temperature meter). Compute the mired for each as follows:

$$\frac{1,000,000}{3200} = 312.5 \qquad \frac{1,000,000}{2800} = 357.1$$

After finding both mireds, subtract the mired for the film you are using from the mired of the existing light to determine the *mired shift*:

$$357.1 - 312.5 = 44.6$$

Finally, by consulting the table of filters for mired shift (below) for the closest corresponding number, you learn that the most appropriate filter is 81D.

Some manufacturers produce sets of decamired filters, which are calibrated in units of 10 mireds (1 decamired), since it takes a 10-mired change to see any perceptible change in color. These filters are used singly or in combinations to create the desired change. Complete instructions come with the filters.

### filters for mired shift

| mired shift | Wratten filter number | filter factor | color |
|---|---|---|---|
| +242 | 86 | 1 | ↑ |
| +131 | 85B | 2/3 | |
| +112 | 85 | 2/3 | |
| +81 | 85C | 1/3 | |
| +67 | 86B | 1/3 | |
| +52 | 81EF | 2/3 | |
| +42 | 81D | 2/3 | |
| +35 | 81C | 1/3 | |
| +27 | 81B | 1/3 | |
| +24 | 86C | 1/3 | |
| +18 | 81A | 1/3 | |
| +9 | 81 | 1/3 | red |
| −10 | 82 | 1/3 | blue |
| −21 | 82A | 1/3 | |
| −24 | 78C | 1/2 | |
| −32 | 82B | 2/3 | |
| −45 | 82C | 2/3 | |
| −56 | 80D | 1 | |
| −67 | 78B | 1 | |
| −81 | 80C | 1 | |
| −112 | 80B | 2 | |
| −131 | 80A | 2 1/3 | |
| −196 | 78AA | 2 2/3 | |
| −242 | 78 | 3 1/3 | ↓ |

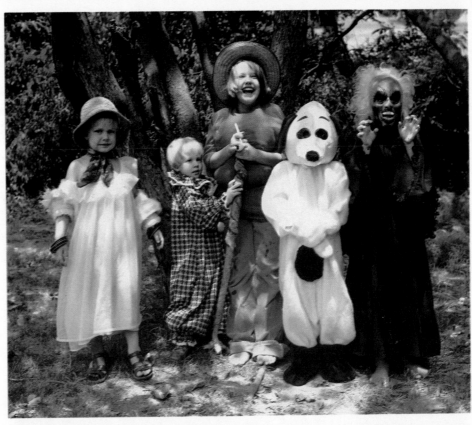

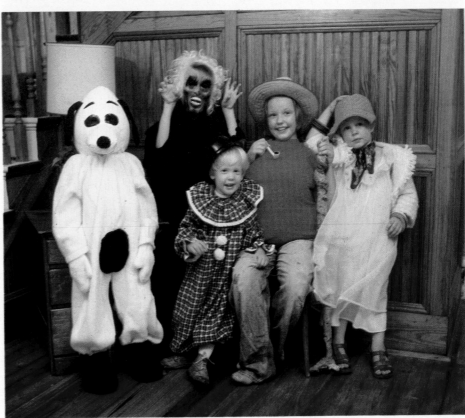

Right above: *A photograph taken in daylight with tungsten (Type B) film.* Right: *A photograph taken indoors with daylight film. These effects usually are not intentional.*

## The Problem of Fluorescent Light

**C**olor temperature theory does not apply to fluorescent lighting. Both daylight and tungsten light transmit a full, though unbalanced, range of wavelengths, but fluorescent light transmits a discontinuous spectrum; in other words, some wavelengths are omitted and there are heavy concentrations of blue and green. This makes it difficult to get a natural color-balanced transparency with fluorescent lighting, no matter what filters are used. If prints are wanted, it is easier to obtain a more natural color rendition because the color balance can be changed with less difficulty during printing.

Another factor that compounds the difficulties in taking pictures under fluorescent illumination is that there are three principal types of fluorescent lighting, each characterized by a slight, but nevertheless significant, difference in color emphasis: daylight, deluxe warm white, deluxe cool white. Often it is impossible to find out which type is in use where you plan to take your pictures.

Complicating the issue still further is the fact that fluorescent color changes as the tubes age and many areas in factories and offices are illuminated with tubes of different ages—perhaps even by different types of fluorescent light.

Work by fluorescent lighting only when you cannot use more dependable and accurate illumination from a tungsten source. If you must use fluorescent light, use the filtration and exposure suggestions on the next page as a point of departure. Commercial photographers who have to work with fluorescent lighting use very expensive color temperature meters to help determine the proper filtration for more accurate renditions.

348

*A photograph taken in fluorescent light with tungsten (Type B) film has a blue cast.*

*A photograph taken in fluorescent light with daylight film has a green cast.*

## filters and exposure compensation for fluorescent illumination

| film | daylight | | deluxe warm white | | deluxe cool white | |
|------|----------|--|-------------------|--|-------------------|--|
| | *Wratten filter* | *f-number increase* | *Wratten filter* | *f-number increase* | *Wratten filter* | *f-number increase* |
| **daylight** | *40M + 30Y* | *1 stop* | *60C + 30M* | *1⅔ stop* | *30C + 20M* | *1 stop* |
| **Type B** | *85B + 30M + 10Y* | *1⅔ stops* | *10Y* | *⅓ stop* | *10M + 30Y* | *⅔ stop* |
| **Type A** | *85 + 30M + 10Y* | *1⅔ stops* | *none* | *none* | *10M + 20Y* | *⅔ stop* |

## The Effect of Environment

The color we see is often quite different from the color that color film records. Our brains compensate for variations in color, but film records color objectively (within the limits it was designed for). See the photograph of the shack in the snowy field at sunset. At the scene, you would see the snow on the roof and the shadows in the snow on the ground as white because you "know" snow is white. The film records what actually is there—pink snow on the roof and blue snow in the shadows.

349

*Color-sensitized film registers colors objectively.*

**noon**

**sunset**

350

**late evening**

These three photographs were made with color reversal film. Each transparency registered the color of the light that illuminated the subject. The photograph taken at noon, when daylight is at its whitest, shows the exposure conditions most favorable to color balance in daylight color film.

## care of color film

Color film is far more sensitive to high relative humidity and high temperature than black-and-white film and therefore requires more care. Both high relative humidity and high temperature can affect one color-sensitive layer of emulsion differently from another, thus causing a shift in color. This will result in pictures much more red or green or blue than normal.

Do not open the package until you are ready to use the film, which is sealed in a water-vapor-tight package to protect it from relative humidity of 70 percent or higher. (Relative humidity—not absolute humidity—determines how much moisture is in the air to affect the film.) Because the packaging is not designed to protect the film against high temperature, be sure to keep the film in a cool place. For best results, put it on the bottom shelf of a refrigerator if you plan to use it within a few weeks. This slows down the aging process of the film considerably.

Do not take the film out of the refrigerator and immediately put it into your camera. Allow the film to reach room temperature while still packaged to prevent condensation from ruining it. It takes about 30 minutes for 120 film to reach room temperature, 1 hour for 35mm film and 10-sheet boxes of cut film, and 2 hours for 50-sheet boxes.

If you do not intend to use the film within a few weeks, put it in the freezer section of the refrigerator to bring its aging process to almost a complete halt. However, you must allow twice as long for film kept in a freezer to reach room temperature as for film kept in the refrigerator. Again, allow the film to reach room temperature in its original packaging.

Keep the film and the camera containing film out of the sun, out of a parked car, and out of the trunk or glove compartment of a car. You can also take the precaution in the summer of carrying your film in a "cooler" used for iced drinks. Be sure to prevent the film from getting wet from melted ice. One solution is to use ice packs. Have the exposed film processed immediately.

The time of day color photographs are taken influences color balance, because the color temperature of daylight differs throughout the day. From 10 A.M. to 2 P.M., daylight is at its "whitest" because at those hours lightwaves from the sun strike the earth at a relatively perpendicular angle. At that angle all of the sun's rays enter the atmosphere more or less simultaneously and in the generally balanced mixture that makes white light. Before 10 A.M. and after 2 P.M., however, the color temperature is quite different. At sunrise and sunset, the color temperature is lower, resulting in a much redder color. Moreover, the intensity of the hue in a sunrise or sunset is affected by additional factors such as the amount of water vapor, dust, dirt, smoke, and smog in the air. Before sunrise or after sunset, on the other hand, the color temperature is higher, and thus pictures taken then have a cool bluish look. There is also a bluish cast to pictures taken on cloudy days, though a less drastic one.

The shadows cast by objects are also seen by our eyes in colors different from the colors recorded by film. We interpret such shadows as black or a dark shade of gray; color film records shadows as blue. Further,

Right above: *Shadows cast by objects are almost always recorded as blue on color film.* Right: *An ultraviolet filter removes the blue tint if it is not wanted.*

351

any individual or object photographed in shadow picks up the blue tint in the finished photograph. An ultraviolet filter (Kodak 1A) helps offset the blue domination when the effect is not wanted. Light filtering through semitranslucent colored material also tints a scene with the hue of that material more distinctly than human vision perceives. The greenish tones of leaves often find their way into a photograph. Finally, light bouncing off a colored surface illuminates a subject with that hue.

Another environmental factor that affects color film is *glare,* or polarized light, produced by smooth, light-reflecting surfaces such as water and glass. Glare dulls the color and reduces the detail recorded by film. A polarizing filter can be used to reduce the glare, enhancing the color and sharpening details. A polarizing filter can also darken the sky in a scene without changing the color in the photograph. □

352

*Green leaves filtered the light and tinted this photograph green.*

*Reflective material that seems unobtrusive can affect color in a photograph.*

*353*

*Glare from the light reflected from the surface of the pond reduced detail and paled all color.*

*A pola filter revealed clarity and detail and even the bottom of the shallow pond, which could not have been seen with the naked eye.*

# Color Reversal Film from Exposure to Transparency

Exposure of color reversal film causes the film layers sensitive to blue, green, and red light to record as latent images the wavelengths for those colors reflected from the subject. Where the subject is black, no exposure occurs at any layer; where it is white, all three layers are exposed.

When it has been exposed, the film must be handled in total darkness until the processing has advanced through the reversal bath.

The developer causes the light-sensitive silver crystals in the three emulsion layers to blacken in proportion to their exposure. The result is three black-and-white (metallic silver) separation negatives sandwiched into a single sheet of film. After this first development, this integral tripack negative must be given a water rinse to stop the developer's action. At that point, the film consists of three black-and-white negatives, each reproducing the value record of one of the additive primaries. The next step is to reverse these value images to produce the positive transparency.

The chemical action of the reversal bath, a second development process, causes the previously unaffected silver crystals in the light or thin passages of the transparency to turn black (to become metallic silver) and assume the image. This makes the film completely black and opaque.

For the image to appear in color, the positive latent images in the three emulsion layers must be dyed and the whole transparency relieved of its blackness. The color developer oxidizes and then activates the dye couplers in the positive portions of the three emulsions. The dye couplers release in each of the emulsion layers the color that is the complement, or subtractive primary, of the additive primary that created the latent image at the time the film was exposed. Thus the dye couplers dye the positive black-and-white images yellow, magenta, and cyan. The result is a film composed of three positive black-and-white images combined with three color images.

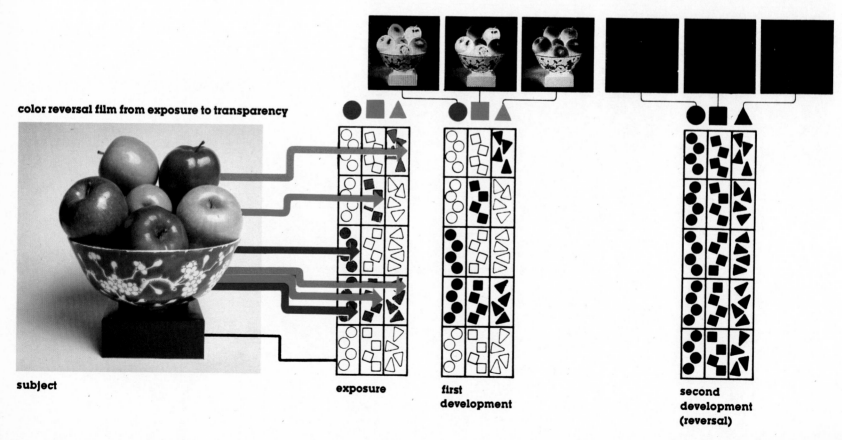

**color reversal film from exposure to transparency**

**subject**

**exposure**

**first development**

**second development (reversal)**

To make the color image visible, black must be removed from the film by a bleaching solution, which weakens the silver compounds and makes them soluble. A fixing bath then dissolves not only all metallic silver formed during the two developments but also the yellow filter between the blue-sensitive and green-sensitive emulsions (see page 344). It also bleaches away any dye not already solidified by exposure and development.

After a final rinse, the film is placed in a stabilizer to help fix the permanence of its hues. Remaining are three positive images formed of hardened gelatin whose colors are, respectively, yellow, magenta, and cyan.

Because they were exposed and processed simultaneously in a single piece of tripack film, the three images overlap in perfect registration.

A beam of white light projected through the three images, united as a single positive transparency, causes their colors to combine in various mixtures and re-create the original colors of the light reflected from the subject whose image the camera recorded on film. Since the transparency's colors function by the subtractive principle (see page 339), each color subtracts or absorbs from white light the wavelengths of its complement and allows the others to pass through. Thus, where red should appear, images have formed on

the yellow and magenta layers to subtract their complementaries blue and green from the white light. This blocks the passage of all but the wavelengths of red light, thus permitting the eye to perceive the image as red. Other combinations occur to re-create by subtraction of their opposites all the colors present in the subject. Where the image should appear white, no color has formed at any level of the tripack positive and thus the clear, featureless film transmits all wavelengths of white light. Black, on the other hand, is reconstituted by an image appearing at all three layers, which together subtract all light and result in the eye perceiving black. □

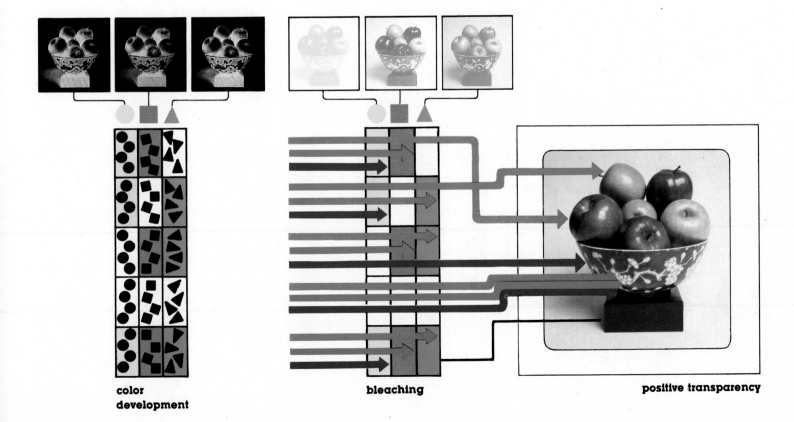

**color
development**

**bleaching**

**positive transparency**

Color negative film works in essentially the same way as the reversal films made for transparencies (see page 354) except that the color negative must be developed as a negative transparent image rather than a positive one. When color negative film is exposed, it also separates and records as latent images light reflected from a subject on three layers of emulsion that individually are sensitive to blue, green, or red wavelengths. Where the subject is black, it reflects no light to expose the film; where it is white, light rays expose all emulsion layers.

During the development, the latent image in each emulsion emerges as a black-and-white negative representing values in blue, green, or red. As the developer oxidizes, it activates dye couplers to color the negative images the hues of their complements—yellow for blue, magenta for green, and cyan for red. It also produces an orange cast that remains in the fully processed negative as a mask to compensate for color distortions that otherwise would occur in printing tripack color negatives.

Next, the metallic silver must be bleached from the film, leaving the tripack a composite of superimposed images in yellow, magenta, and cyan—the "negative" colors of the original blue, green, and red separated from the light bouncing off the subject at the time of exposure.

The negative is printed on paper coated with three layers of emulsion whose light sensitivity corresponds to the three colors in the film. The colors of the negative are the complements yellow, magenta, and cyan; white light beamed through the negative causes it to convey the wavelengths for specific additive primary colors to the paper by the subtractive principle.

The negative subtracts from the white light the wavelengths for the complements of the additive primaries, allowing the additive primaries to pass through.

356

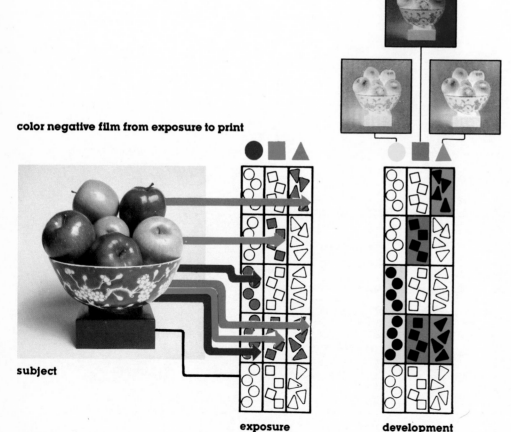

**color negative film from exposure to print**

subject

exposure

development

**fully processed negative**

Where the negative is clear, it transmits red, green, and blue light to expose all three emulsions on the paper. Where the negative is magenta, it subtracts green (the complement of magenta), while transmitting red and blue lightwaves to expose the emulsion layers sensitive to those colors, and so on. Where yellow, magenta, and cyan are superimposed in the negative, all light is absorbed and the paper remains unexposed.

The process for developing the print resembles that for the negative. Each layer of the emulsion emerges as a black-and-white positive image of the values of the blue, green, or red light that exposed it.

Development also causes dye couplers to color the images with the complements of the additive primaries that exposed them. Thus, where red, green, and blue light exposed all three layers, the three images become dyed, respectively, cyan, magenta, and yellow. The overlapped layers exposed by red and blue lightwaves turn cyan and yellow. That part of the image left unexposed—owing to the presence in the negative of superimposed layers of yellow, magenta, and cyan—has the whiteness of the paper support for the emulsion.

When the metallic silver deposits have been bleached out of the print, only the three color images remain. Perceived in full light, these complements once again mix and function by the subtractive principle to reconstitute the original colors present in the subject photographed. Overlapped yellow, magenta, and cyan subtract all of white light and reflect none. Thus, where that overlapping occurs, human vision perceives black. Yellow and cyan absorb all but the wavelengths for green, which causes the image to reflect green. The white passages reflect all colors, which are perceived as paper white. □

357

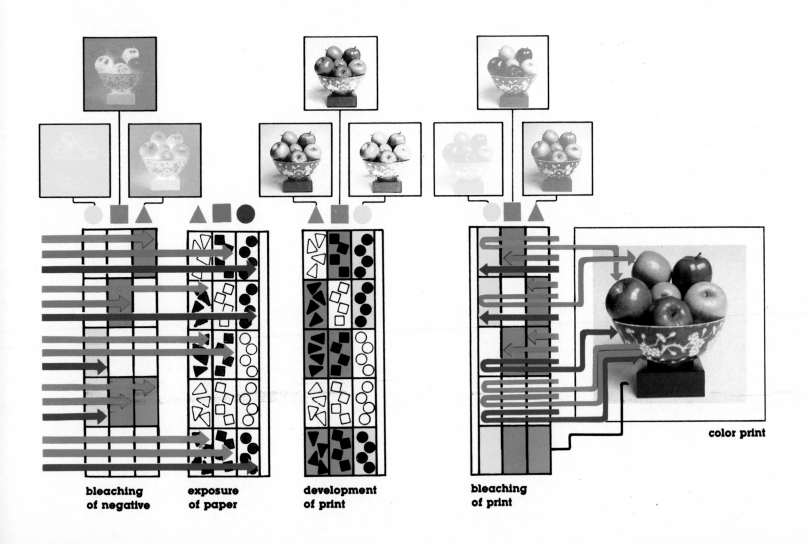

**bleaching of negative**  **exposure of paper**  **development of print**  **bleaching of print**

**color print**

**narrow exposure
latitude
of color
reversal film**

**underexposure: 1 stop**

358

## Color Reversal Film

**T**he time to control color balance when using color reversal film is during exposure, especially if the end product will be a transparency. You need to evaluate carefully the quality of light being used and the amount of light necessary for correct exposure. When the end product is not a transparency but a print made from it, color balance is less critical, since it is possible to alter the color balance slightly by filtration while making the print.

You can control the first critical condition for proper exposure of color reversal film by making sure that the light you are using is the appropriate quality for your film. Match the color temperature of the light source to the sensitivity of your film by choosing a film to match the light source or by choosing a light source to match your film or by using the appropriate filter to change the color balance in the light so it will not adversely affect the film (see page 361).

The proper exposure for color reversal film is critical, since the exposure latitude for

this film is considerably narrower than for black-and-white or color negative film. An apparent change in color occurs with an alteration in exposure of no more than a single f-stop or even half that. In other words, it is easy to underexpose or overexpose a scene badly and thereby ruin a slide under conditions that would give you an excellent black-and-white print if printed on flat or contrasty paper. Three photographs show how narrow the latitude of color reversal film is.

The most obvious way to get the amount of light necessary for correct exposure

normal exposure

overexposure: 1 stop

**exposure latitudes**

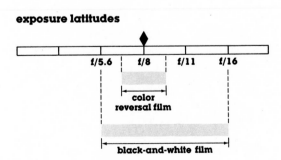

would be to use a light meter and *bracket* your exposures. However, color reversal film varies somewhat in its ASA rating and color balance from one emulsion batch to another. This and other variables—your camera's shutter, your light meter, and inconsistency in processing—as well as the limited exposure latitude of the film, mean that even bracketed exposures based on the ASA rating can be off enough to yield transparencies of poor quality. You have to learn the speed of your reversal film in terms of your own equipment and light-metering techniques. Similarly, although the color balance of color reversal film is controlled within exact tolerances, it nonetheless varies *slightly* from emulsion batch to emulsion batch. Moreover, not only do emulsion batches of the *same* brand of film differ; there also are variations in color balance from one manufacturer's film to another's.

A suggested approach to making exposures for color transparencies is to conduct your own ASA test for color film and then bracket your exposures, making one exposure according to the meter and then two additional exposures, one a half-stop under and the other a half-stop over the metered reading. Since there are times when slight overexposure or slight underexposure can produce an interesting picture—more dramatic than one made at the "correct" exposure—some photographers choose to extend their bracketing. Such an approach, though expensive (only a few scenes can be photographed in this way on a single 36-exposure roll of 35mm film), allows the photographer a wide choice of color renditions and sufficient protection against possible inconsistency in the processing.

To test color reversal film for speed and color balance, photograph a colorfully dressed person holding an 18 percent gray card with the type of lighting suitable for the

360

**reciprocity failure with color materials**

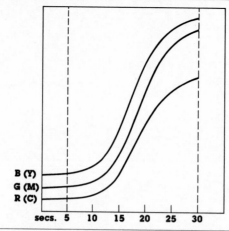

*All color materials—color reversal and color negative films and color printing paper—have been formulated for exposures within specified durations of time. Exposures exceeding these specified durations result in reciprocity failure (see page 140), critical with color films because it alters the sensitivity of the color-producing layers. The graph plots the exposure pattern of the color components in color reversal film. From 5 seconds to about 25 seconds, the three emulsions are equally sensitive. However, after about 25 seconds and especially after 30 seconds, the red-sensitive emulsion fails to keep the desired equilibrium. The developed transparency in this particular example would reveal a dominance of red because of inadequate cyan. In many situations the exaggerated color resulting from reciprocity failure is not undesirable. However, if a less dramatic rendition is wanted, tests may be conducted with corrective filtration when exposing color reversal film. Yet a filter lengthens the exposure even more because of the density of the filter, thus compounding the problem. With color negative film or when making prints from color transparencies the color may be altered somewhat by using filters when printing.*

film. (This test is practical only if a quantity of film with the same emulsion number is bought and stored correctly—see page 350.) Make certain the gray card receives the same light as the subject by having the subject point the card slightly up toward the sky, since the card needs to be fully illuminated, with no shadows and no glare. Take the light meter reading from the gray card with the meter set at the manufacturer's suggested ASA. Make one exposure as indicated and then several others, bracketing a half-stop apart above and below that exposure.

When the film has been processed, study the various transparencies over a light table, looking for the exposure that reproduces the subject and gray card accurately. If the transparency exposed at the manufacturer's suggested ASA looks correctly exposed, your personal ASA agrees with that ASA. If, on the other hand, the transparency that looks correct received a half-stop less light than the supposedly "normal" one, your personal ASA is slightly higher than the one suggested by the manufacturer and should be used for future exposures.

Next, study the correctly exposed gray card to see whether it looks gray or has a tint of color in it. If it looks gray, the color balance is perfect. If it has, on the other hand, a hint of blue or a shade of red in it, you know that the color balance is off. The gray card picks up even the slightest hint of a color shift in a transparency far more effectively than a white card or a black card. The gray card, which is objective, along with the subjective colors like the flesh tone and other colors in the scene, gives you an accurate way to find the color balance and speed of a particular batch of reversal film.

The color balance of color reversal film may be altered with color compensating (CC) filters produced by Kodak. These filters are available in red, green, blue, yellow,

magenta, and cyan and in concentrations ranging from extremely pale (CC.05) to rather dark (CC.50). A .05 or .10 filter, which produces subtle changes, is usually enough for correcting color balance. The .30 to .50 filters, which are very dark, may be used to produce exaggerated or drastic effects. If the color transparency is dominated by one color, using a filter of the complementary color over the camera lens for succeeding exposures will result in more natural slides. If the test transparency is too blue, for instance, a yellow filter will improve other exposures made with the same film batch. Filters can be used not only to correct color for a factual rendition, but also to exaggerate or control the color in a scene. For example, you may want to use a cyan filter to reduce the redness of objects illuminated by a sunset or use a red or yellow filter to exaggerate the warmth of the scene.

## Color Negative Film

**C**olor quality considerations are less important when exposing color negative film because corrections can be made in printing. Also, color negative film is much *easier* to expose than color reversal film. It has a much wider latitude, especially for overexposure, since even the darkest areas of a color negative (the overexposed portions) can be made to render at least some detail in the printing. Underexposure, however, is more of a problem because the inadequate density of an underexposed negative does not produce a full range of color.

Because of its wide exposure latitude, color negative film is especially attractive to photographers working with multiple exposures, slow shutter speeds, and such abnormal situations as fluorescent lighting (see page 348), which makes accurate exposure calculations almost impossible. □

361

Over the past few years, the manufacturers of color film have improved and simplified their color processes to a point where you yourself can develop both color transparencies and color negatives and then produce prints from both without special facilities or extremely expensive equipment. The differences between processing black-and-white film and color film are significant. However, basic black-and-white darkroom experience makes the transition fairly easily.

Unlike black-and-white enlarging paper, which is used under a reasonably bright safelight, color printing papers require a very dark safelight or total darkness. But the processing of color prints may be done in room light when using a lighttight developing drum. Many students use a completely darkened spare room or bedroom for enlarging; then, after exposing the paper, they load it into the lighttight drum and take it to the kitchen sink for developing.

Apart from the ordinary darkroom items used in black-and-white enlarging—items such as a timer, dodging and burning-in tools, thermometer, and so on—you need the following *additional* supplies to transform your black-and-white darkroom into a darkroom for color processing:

- Enlarging bulb—to prevent variations caused by the color of the bulb, many photographers use one bulb just for color printing; in school situations, each student may have a personal bulb
- Enlarger—one with either a filter drawer or a dichroic color head
- Enlarging lens—color-corrected; more expensive than a lens for black-and-white printing
- Color printing filters—magenta, yellow, and cyan of varying densities and ultraviolet; if the enlarger head takes filters between lamp and negative, the relatively less costly acetate color printing (CP) filters can be used; when filters must be attached below the enlarging lens, only color-compensating (CC) gelatin filters can be used because, unlike CP filters, they are optically corrected to prevent distortion when used in this position; because of their critical location, CC filters must be absolutely clean and scratch-free; minor blemishes on CP filters, because they are above the negative, do not alter the image or its color; therefore CP filters are preferred
- Heat absorbing glass—to protect color negatives and transparencies
- Voltage regulator for enlarger lamp—to prevent fluctuations in electrical current that would affect color rendition in prints
- Modified printing easel—with a black surface to prevent color distortions
- Fluorescent tape—for finding essentials in totally dark darkroom

- Processing drum—a lighttight unit that is one of the most popular devices to aid color print processing; open-tray processing is *not* recommended because of fumes
- Motor base—used with processing drum; reduces agitation to a standard that can be duplicated each time
- Temperature-control system—since the temperatures used for color processing are higher and more critical than for black-and-white materials, a system for temperature maintenance is necessary; it can be as simple as a temperature-control pan for the chemicals or as elaborate as a water heater with a pump to recirculate the water around the chemicals (these systems are frequently modified by manufacturers; assess current models in your price range)
- Printing calculator (optional)—speeds up determining which filter and exposure to use when color balancing a gray card in the test print; complete instructions come with the calculator
- Gray card—see page 124
- Refrigerator—for storage of color paper for printing color negatives
- Hair dryer—to dry RC paper quickly for accurate evaluation of color balance
- Miscellaneous—rubber gloves; cotton (film-editing) gloves for handling color printing papers; small plastic bucket for mixing chemicals; notebook for records

362

*A processing drum for prints, on a motor base. Drums of different sizes take 8 × 10, 11 × 14, and 16 × 20-inch (20 × 25, 28 × 35, and 40 × 50-cm) prints. A 16 × 20 drum takes four 8 × 10 prints.*

## Developing Color Reversal Film

**P**rocessing color reversal film is similar to processing black-and-white film—but considerably more critical. (Kodachrome, however, must be processed by Kodak or a commercial laboratory.)

Processing requires accurate temperature measurement and control at a relatively high temperature, 100° F (38° C), which may be difficult to maintain. The processing times are often short and must be accurately controlled. Furthermore, you must be consistent in the way you agitate so you can ensure repeatable results. Even *minor* deviations can alter a film's representation of color.

The mixing of the chemicals and the subsequent processing require a high level of cleanliness to prevent contamination of one solution by another, and all solutions should be placed in clean bottles labeled clearly to prevent possible mistakes. The storage of the developer is especially critical because a half-filled bottle will oxidize even though tightly capped. Use an oxidation retardant or squeeze a plastic bottle to raise the solution to the top to eliminate the air space before recapping it. Most companies now provide the one-shot system—each solution can be used once and then discarded, ensuring consistency.

Rubber gloves are recommended throughout mixing and processing, since some of the solutions may cause skin irritations. Adequate ventilation, especially when mixing the chemicals, is very important.

The chemistry has been simplified and so different brands of color film can be processed with the same kit. For example, both Ektachrome and Fujichrome may be developed in E-6 chemistry. In addition to Kodak's E-6 chemistry, there are now Beseler's E-6, Unicolor's E-6, and Photocolor's Chrome-Six.

There are three ways to process color reversal film. With roll films you may use regular stainless-steel or plastic tanks and reels or the recently introduced processing drums (such as the Unicolor Film Drum II, shown here) with accompanying plastic reels. Sheet film requires hangers and tanks (page 297) because the tray method may scratch the film.

Two good reasons for processing your own color reversal film rather than sending it to a commercial lab are that you can see the results immediately and that you can then alter the processing times to accommodate specific situations. For example, knowing that you can extend the developing time enables you to increase the ASA of a film, permitting photographs to be made at night with only available light. However, there will be a loss of exposure latitude, an increase in contrast, and usually a shift in the color rendition.

## Developing Color Negatives

**T**he processing of color negative film has been simplified to the point where it, too, may be done in a home darkroom. Although more complex than processing black-and-white film, it is considerably simpler than processing color reversal film. There are fewer solutions and the total processing time is shorter. The procedure has been standardized so that the available kits can be used with more than one brand of film.

Altering the processing procedure—such as lengthening development time—for a color negative does *not* increase its ASA (unlike color reversal film), but very slightly increases the contrast.

The following kits are available for color negative processing; complete instructions come with each kit.

Acucolor 2 (Paterson/Braun North America)
Beseler CN2 (Beseler Photo Marketing Company)
Dignan NCF-41-8 (Dignan Photographic, Inc.)
Kodak Flexicolor C-41 (Eastman Kodak Company)
N-16 Color Negative Kit (Zone V, Inc.)
Opticolor C-41 (Optimum Foto Products)
Photocolor II (Satter Distributing Company)
Unicolor K-2 (Unicolor)  □

363

*The Unicolor Film Drum II, with its plastic developing reels, on a motor base. This drum takes six 35mm reels or four 120/220 reels.*

Filtration is always used in making properly balanced color prints from color transparencies or color negatives, for these reasons: variations in the color sensitivity of color film, variations in qualities of light to which the film is exposed, slight variations in processing, variations in each batch of color printing paper. There are two filtration methods: tricolor and white light.

The *tricolor method* consists of exposing the color printing paper three separate times. One exposure is made with a blue filter, another with a green filter, and a third with a red filter. If color corrections need to be made, the exposure time for the appropriate filter is either shortened or lengthened. The tricolor method, although capable of providing sensitive and subtle filtration, has certain disadvantages. Changing filters for serial exposures through the additive primary colors is tedious and time-consuming, and even a slight dislocation of the enlarging equipment between exposures could result in a print with its color images poorly registered. The tricolor method can only be used for printing color negatives.

The *white-light method* of filtration may be used for both color transparencies and color negatives. It uses the subtractive primaries. Because cyan, magenta, and yellow create some colors by subtracting others from white light, these colors can be combined in a filter pack for simultaneous projection—a single exposure instead of three separate ones. The subtractive primaries thus eliminate the possibility of poor registration and, overall, they give the photographer more opportunity to work flexibly toward a subtle and refined balance of color. Subtractive filters are manufactured in graduated densities (see page 361); the filtration process entails adding densities of the same color to produce a total density. For example, 1.20M designates magenta filtration that could be composed of filters with densities of .30M, .40M, and .50M. *The densities remain the same when a red, green, or blue filter is converted into its subtractive counterparts.* For example, a .10 red is composed of .10M and .10Y (not .05M and .05Y).

With the white-light method, whenever large amounts of filtration are needed, it is best to use high-density filters rather than many low-density ones. Low-density filters present more filter surfaces because of the large number of filters needed and thus require longer exposure. Each filter, because of its color and density, has a *filter factor*. These filter factors are used to calculate a corrected exposure whenever filters are added or removed from the filter pack. The exception is yellow filtration, because the filter factor is so low that it is generally not even considered. However, if a filter pack consisting of high densities of yellow is needed, the many filters do require exposure corrections because of the number of surfaces.

Do not use a filter pack that has all three colors in it—yellow, magenta, and cyan—because of *neutral density*. Neutral density is filtration that absorbs all colors equally, does nothing to alter color balance, and requires additional exposure. When a filter pack has all three colors, look for the lowest filtration. For example, in a filter pack of .90M, .40Y, and .20C, the .20 of the .20C is the lowest. Subtract this .20 from all three colors:

$$
\begin{array}{r}
.90M + .40Y + .20C \\
- .20 \quad - .20 \quad - .20 \\
\hline
.70M + .20Y + .00
\end{array}
$$

The new pack is .70M + .20Y. It produces the same color correction as the first, but requires a shorter exposure.

An important consideration when viewing and judging the color balance of a color print is the type of illumination under which you view it. A print made to appear neutral under tungsten illumination does not appear neutral when evaluated under fluorescent light but looks slightly bluish.

The principles for using filtration are different for prints from color transparencies (positive to positive) and prints from color negatives (negative to positive). Each set of principles is covered under the specific process. □

# Making Prints from Color Transparencies

Today there are a number of processes for making your own color prints from color transparencies with a minimum of darkroom facilities. In addition to Kodak's Ektaprint R-1000, there are Beseler's RP1000, Unicolor's RP1000, and Ilford's Cibachrome. Each process has its own chemistry. However, the Beseler and Unicolor processes use Kodak's Ektachrome RC paper, type 2203, which contains dye couplers in the emulsion that form organic dyes when exposed and processed. This method is called chromogenic.

The Cibachrome process is entirely different from the others because it has its own chemistry and its own paper. It also is unique in its method for producing color. Cibachrome is not chromogenic. Instead of dye couplers, actual colored layers of yellow, magenta, and cyan dye are incorporated in the paper's emulsion. The color in the finished Cibachrome picture is produced by *bleaching out color* from the various layers instead of producing color, as with the chromogenic method.

Whether you choose the chromogenic or Cibachrome process depends on a number of personal considerations. Here are some of the pros and cons:

- Kodak paper used with the Kodak, Beseler, and Unicolor chemistry is less expensive than Cibachrome paper and chemicals.

- Cibachrome is less demanding in its temperature requirements than Kodak. (Beseler and Unicolor also are flexible.)
- The colors in a Cibachrome print are intense; the colors in Kodak paper are softer.
- Cibachrome prints are more contrasty than prints on Kodak paper.
- The Cibachrome colors consist of Azo dyes, considered quite permanent. When these colors do fade, they all do so at the same rate, making the fading less obvious than when one color fades and throws off the color balance of a print.
- The images in the Cibachrome prints are sharper than those in Kodak paper prints because the Azo dye layers help to reduce halation and minimize the scattering of light.
- Kodak paper should be stored in a refrigerator; refrigeration is not needed for Cibachrome paper.
- The Cibachrome emulsion is more delicate than Kodak's when wet and may peel off.
- The storage life of the Cibachrome developer is longer than for Kodak's.
- The surface of "glossy" Cibachrome paper, which is actually plastic, looks too slick to some photographers. However, there is now a regular Cibachrome type paper, which has a "pearl" surface that is still brilliant but less shiny.

- Used Cibachrome bleach *must be neutralized* with tablets or powder supplied by the manufacturer before it is dumped down the drain to prevent damaging the plumbing system.
- Excessively long or short exposures are much more likely to produce reciprocity failure with Cibachrome paper, affecting the overall exposure level and the color balance of the resulting print unless the exposure is adjusted to account for it.

The color transparency used to make color prints should be normally exposed or slightly underexposed. Many photographers intentionally underexpose by $\frac{1}{3}$ to $\frac{1}{2}$ an f-stop. A slightly underexposed color transparency has more detail in the highlights, which helps to prevent these areas from being pale or washed out in the prints. The colors also tend to be richer and more saturated, which is desirable in some situations (though not necessarily in others where a soft, delicate rendition is appropriate). Another consideration when slightly underexposing is the contrast range of the scene—a contrasty scene is usually more suitable than a very flat one. Bracketing the exposures is recommended in order to give a choice of renditions. An overexposed transparency combined with the inherent contrast of the process produces washed-out, featureless prints.

With this positive-to-positive process, a long exposure produces *lighter* prints, not darker ones; short exposures *darken* prints. Burning in and dodging may be used to change the tonalities of local areas. Again, because you are using a positive-to-positive process, burning in *lightens* an area that is too dark; dodging *darkens* a light area. The photographs of the snow scene show how careful and sensitive burning in and dodging can reduce the high contrast that is inherent in the process.

Another way to reduce the contrast that positive-to-positive prints, especially Cibachrome, often have is to use *masking*. Make an underexposed positive transparency on pan masking film from the original color transparency and then place the mask on the transparency, in register, when the transparency is exposed to the paper. Masking adds density to the shadow areas and as a result decreases contrast. The two photographs of the trucks, produced from the same transparency, show this.

Rubber gloves should be worn when mixing the chemicals and during processing. The room should be well ventilated. Cotton (film-editing) gloves should be worn while exposing to prevent fingerprints on the paper.

Above: *Unaltered Cibachrome print.*
Right: *The dark background was burned in to show more detail, and the headlights and snow in front of the car were dodged to darken them.*

*Cibachrome print from an unmasked transparency. There is no detail in the white wall or in the hubcaps of the trucks.*

*Print made from masked transparency. Now there is detail in the wall and hubcaps, and the print more accurately renders the colors in the original transparency.*

*Evaluating the Print*

**W**hen evaluating a print made from a color transparency, it is best to look at a gray area to judge color balance and exposure. This gray area could be a gray card in a test print (made from the color transparency and used to test the speed and color balance; see pages 360–361) or a concrete sidewalk or some other neutral-tone object in the scene. In the series of prints of the chairs, the gray house would do. If the gray

card or area is not too dark or too light, the print may then be used to judge the color balance. If the print looks too dark or too light, as the underexposed and overexposed prints in the series do, do not try to determine color balance, but correct the exposure first by making a new print.

When making color corrections of prints from color transparencies, which requires the white-light method of filtration (page 364), the rule to remember is: *to remove the dominant color, remove that color from the*

*filter pack whenever possible or add its complementary color.* For example, if the print is too red, remove red (yellow + magenta) or add cyan. When red is removed , the blue- and green-sensitive layers receive more exposure, and during *reversal* development they produce less yellow and magenta, respectively (red). When cyan is added, the red-sensitive layer receives less exposure and during *reversal* development produces more cyan dye, which counterbalances the excessive red. See the table on the next page.  □

**underexposure**

**overexposure**

**normal exposure**

## white-light filtration for correcting prints made from color transparencies

| color judged excessive in print | add | filtration change needed or | subtract |
|---|---|---|---|
| blue | yellow | | blue (magenta + cyan) |
| green | magenta | | green (yellow + cyan) |
| red | cyan | | red (yellow + magenta) |
| cyan | red (yellow + magenta) | | cyan |
| magenta | green (yellow + cyan) | | magenta |
| yellow | blue (magenta + cyan) | | yellow |

*With Cibachrome positive-to-positive prints from transparencies, only drastic changes in exposure and filtration produce visible differences in prints. The underexposed, normally exposed, and overexposed prints here were made with one-stop differences in exposure. The normally exposed print is also balanced for color. The color changes in the other prints were achieved with .30 changes in filtration. Changes of .05 in filtration would not have affected the prints significantly.*

369

**too much blue**

**too much green**

**too much red**

**too much yellow**

**too much magenta**

**too much cyan**

# Making Prints from Color Negatives

There are various chemistries and some choice of printing papers for making color prints from color negatives. The paper varies slightly in contrast among manufacturers; also, Kodak makes a higher-contrast paper in addition to its regular stock. Handling and mixing of chemicals and handling paper are the same as when making prints from color transparencies (see page 365).

Making color prints from color negatives is a negative-to-positive process. Thus the exposing procedures are the same as for normal black-and-white printing: the longer the exposure, the darker the print. Burning in and dodging are also the same; they can be used in the same way to enhance a color print. Filters may be used also as burning-in or dodging tools to change color in local areas of prints, as shown in the prints of the flag.

*The trees and foreground grass were burned in with a reexposure. The result is a stronger, more natural print.*

*The color in these two prints was produced by multiple exposure. Opposite: The foreground had too much magenta, though the other areas were satisfactory. Left: Dodging the foreground with a magenta filter changed the area without affecting the rest of the print.*

373

## Evaluating the Print

As with a print made from a color transparency, examine a print made from a color negative for correct exposure and then for color balance by using a gray area in the scene. Usually the photographer makes a *standard negative*. This is a correctly exposed and developed negative that includes a gray card, a flesh tone, and a number of colors, much like a scene used for testing color transparency film (see pages 360–361). The filtration and exposure found to produce a color-balanced print from this negative are then used as a point of departure for future negatives. Examine the gray card in the print (or a natural gray occurring in the scene), first for value and then for color balance. If a print is excessively dark or light, you cannot judge color balance accurately, so if the exposure is considerably off, you must make a print with the proper (or close to proper) exposure. Then look at the gray area (or entire picture) to deter-

mine the color that seems to dominate the scene—the color that causes the neutral gray to have a tint of a color.

When using the white-light method of filtration for prints from color negatives, the rule to remember is: *to remove the dominant color, remove its complementary color from the filter pack whenever possible or add the dominant color itself.* For example, if the print is too red, remove the complementary color, cyan, or add red (yellow + magenta). When cyan is removed, the red-sensitive layer receives more exposure, which during development produces more cyan dye, counterbalancing the excessive red produced by the other two layers. When red (yellow + magenta) is added, the blue- and green-sensitive layers receive less exposure and when developed produce less yellow and magenta, respectively (red). Usually only yellow and magenta filtration is needed. When using the tricolor method of filtration, a compensation with the proper filter(s) is necessary. See the tables on the next page.

When a print correctly balanced for color has been achieved with the standard negative, use the information on exposure and filtration to make a "proof sheet" of all the exposures on one roll of film. The proof sheet enables you to see what the pictures look like for selection purposes and to compare exposure and filtration among the various pictures. Proof sheets are also an ideal way to file and retrieve negatives. Proof sheets can be helpful when making prints from color transparencies, but they are even more useful with color negatives because of the orange cast and "negative" complementary colors of color negatives, which make it difficult to visualize the final prints.

White spots on a print may be covered with Kodak's Retouching Colors, Dr. Martin Dyes, and Webster's Photocolors. These colors can also be used to alter area colors. Retouching colors are versatile materials. Detailed instructions and guidance are in the Eastman Kodak Handbook *Printing Color Negatives.* □

374

**underexposure**

**overexposure**

**normal exposure**

## white-light filtration for correcting prints made from color negatives

| color judged excessive in print | subtract | filtration change needed or | add |
|---|---|---|---|
| blue | yellow | | magenta + cyan (blue) |
| green | magenta | | cyan + yellow (green) |
| red | cyan | | yellow + magenta (red) |
| cyan | magenta + yellow (red) | | cyan |
| magenta | cyan + yellow (green) | | magenta |
| yellow | magenta + cyan (blue) | | yellow |

## tricolor filtration for correcting prints made from color negatives

| color judged excessive in print | exposure change necessary in filter |
|---|---|
| blue | increase blue exposure |
| green | increase green exposure |
| red | decrease green and blue exposure equally |
| cyan | decrease red exposure |
| magenta | decrease green exposure |
| yellow | decrease blue exposure |

*With prints made from color negatives, considerably smaller changes in filtration and exposure produce visible differences than with prints made from color transparencies. The underexposed, normally exposed, and overexposed prints here were made with one-stop differences in exposure, as were the three similar Cibachrome prints on page 368. The normally exposed print is also balanced for color here. The differences between these three prints are quite subtle compared to those between the three Cibachrome prints. Filter changes of .10 in the other prints are noticeable here, whereas .30 changes in filtration were necessary to affect the Cibachrome prints significantly.*

375

**too much blue**

**too much green**

**too much red**

**too much yellow**

**too much magenta**

**too much cyan**

The dye-transfer process produces a color photograph of very high quality from a color transparency, a color negative, or color separations made directly at the scene by photographing it three times.

Dye-transfer prints have a very rich color range, clean whites, neutral black tones, and excellent retention of clarity. The color balance is easily manipulated, areas of color can be changed locally, and contrast is easily increased or decreased.

Making a dye-transfer print from a color transparency is especially difficult, but the process is reasonably easy when using a color negative or color separation negatives made directly from the scene. The process and all information and supplies—including paper and developers—are available only from Kodak.

Unless the *original* used to produce a dye-transfer print is a color negative, the dye-transfer process begins by photographing the subject itself or a color transparency of the subject three times on three pieces of black-and-white film through blue, green, and red filters. The result is three *color separation negatives*.

If the original is a color transparency, *masks* for contrast and color correction are placed in register with the transparency when the separations are made. This step is not needed if the separations are made directly from the subject.

376

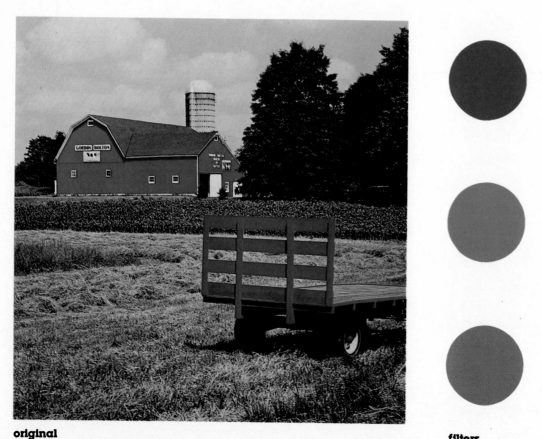

**original**

**filters**

**separation negatives**

**matrices**

Next, the three color separation negatives are used to expose *matrices*—special film consisting of a thick, light-sensitive gelatin coating on an Estar support—which are developed as positive relief images corresponding inversely to the values in the negatives. The color separation negative images can be enlarged onto the matrix film, but the size of the image on the matrix determines the size of the print. If the original is a color negative, color separations are not necessary. Instead, three pieces of a special matrix film—pan matrix—are exposed to the color negative through blue, green, and red filters.

The developed matrices, no matter what the original, are next *dyed* with the subtractive primaries. The blue record is dyed yellow, the green record is dyed magenta, and the red record is dyed cyan. The matrices absorb the dye proportional to the varying volumes of gelatin in their relief surfaces.

The dye-laden matrices are then registered one by one on dye-transfer paper, a double-weight paper heavily coated with gelatin to absorb the dye. Gentle pressure with a roller when putting the matrix in contact with the paper assures maximum contact. The cyan matrix is transferred first, then removed from the paper, and the magenta matrix is transferred; the yellow is then transferred, resulting in the *final dye-transfer image*. The matrices can be redyed and used repeatedly to transfer the dyes for additional prints. □

377

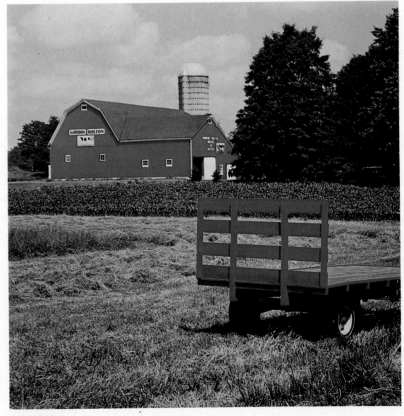

**dyed matrices**

**print with cyan and magenta**

**final print**

# Portfolio

A photograph is not created by nature and found. It is an object conceived and produced by a human act. There are no accidents; there is no such thing as luck. Being at the right place at the right time has nothing to do with making an effective photographic statement. The strength of the photographer's vision, not the subject, makes the photograph.

Any photograph represents a series of choices from among thousands—perhaps millions—of variables: camera, film, filters, subject, time, lighting, viewpoint, exposure, processing, to name but a few. Some photographers follow a very logical and methodical procedure for making the numerous decisions from their first encounter with the subject or idea to the final image; others respond to more intuitive impulses. There is no one correct approach. With experience, most of these decisions become automatic, so automatic that the photographer may not even remember making them.

The images in this portfolio, chosen by the photographers themselves to represent their work, are accompanied by statements that help identify a few of the variables of greatest concern to specific contemporary photographers. These statements were made by the photographers themselves or by others they thought responded effectively to their work.

We hope that the variety of technical and stylistic choices reflected in the images and statements will raise questions, stimulate discussion, and spark your curiosity to explore further.

BEA NETTLES. *Florida Moonrise.* Kwik-Print on vinyl; 20 × 26 inches (50 × 65 cm). 1976.

### Bea Nettles / b. 1946

Since 1975 I have been working exclusively with Kwik-Print, premixed light-sensitive colors that are applied in layers onto vinyl sheets. This enables me to build up an image with a combination of negatives with full control of color over an extended period in time. Because of my background in painting, this is a natural and exciting way to work. *Florida Moonrise* is a portrait of myself as a full moon rising . . . the image of a woman in her prime floating through the skies of the landscape of her remembered youth. Like most of my images, it is a sharing of my life, my fantasies and dreams.

EIKOH HOSOE. *Untitled* (from *Man and Woman*, No. 33). 1961.

*380*

## Eikoh Hosoe / b. 1933

The negative shows everything, you know, which means it's too raw. You have to cook it. However, like Japanese cooking, it shouldn't be overcooked. I respect the raw material . . . what you must do is cook very carefully so that you may not destroy the value of its raw material.

The darkroom is a place to think, a sort of workshop. It is a resting place. I think back to the image I photographed, and I work to create something out of that remembered image. Sometimes my effort is to match the image I photographed. Sometimes, something new is created. I make discoveries in the darkroom. While printing, I may get an unexpected effect. If it seems right to me, I make it mine. I think about my photographs while I am in the darkness.

## Judy Dater / b. 1941

Judy Dater's photographs record the mysteries of human personality. Selecting her sitters from the floating population of San Francisco's Bohemia, she photographs them in their own, often fantastic, costumes. Sometimes she suggests a costume that she has seen the sitter wearing before or the sitters may spread out their wardrobe for the photographer's selection. The people are often exotic, the poses carefully contrived, but the photographic procedures are for the most part traditional, classic. Judy Dater's prints with their intensity of detail and richness of tone continue the West Coast tradition of Edward Weston and Imogen Cunningham.

These portraits stimulate thoughts about human diversity, about costume as self-expression, about role-playing. They also raise the question of to what degree the photographic portrait is a record of the sitter's personality or a projection of the photographer's fantasy.

*Clifford S. Ackley*
"Private Realities:
Recent American Photography,"
Catalogue, Museum of Fine Arts,
Boston, 1974

*381*

JUDY DATER. *Consuelo Cloos.* 1980.

382

LINDA CONNOR. *Shirt, Benares, India.* Gold-toned print. 1979.

## Linda Connor / b. 1944

My work has never been about temporal situations. I had always gravitated toward images that reveal the "essence" of something, the apparition of a form or idea, rather than any particular fact. Recently, I've switched from using a soft-focus lens to a sharp-focus lens, and I find that the challenge of using a system that so clearly reveals the specific and factual reality of things is to respond somehow to the balance between that which is recognized and understood and that which remains unknown and mysterious. I want the subject matter of these pictures to signify my receptiveness to the intricate patterns of the natural world, and to reflect my own interior perceptions and growth.

# Stephen Shore

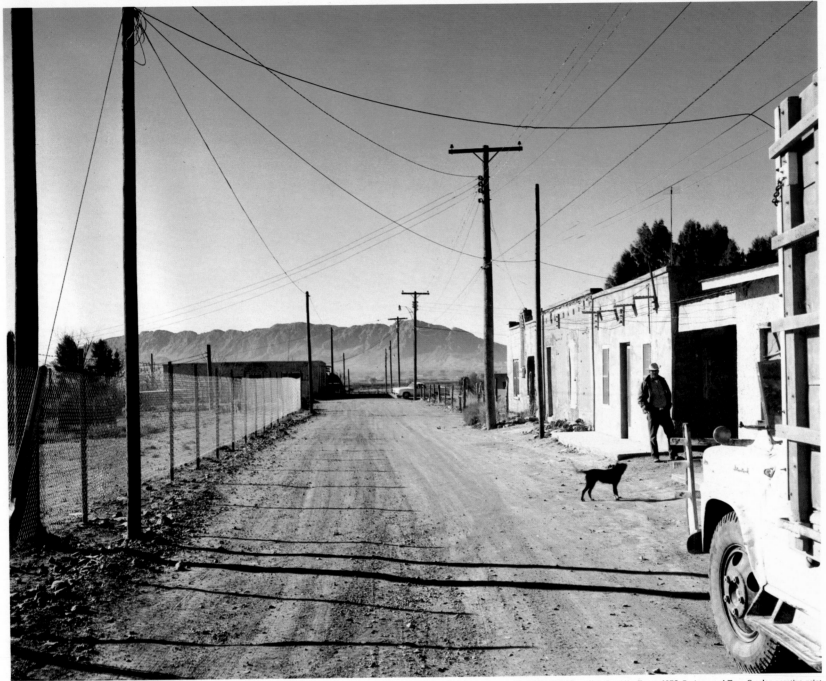

STEPHEN SHORE. *Alley, Presidio, Texas, 1975.* Resin-coated Type C color negative print.

## Stephen Shore / b. 1947

There are limitations imposed on any photographer using a camera that big [8 × 10 view camera], but there is nothing, or very little, in Stephen's pictures that reminds you of the artifice, of the method of making the picture. There is no grain in the film to establish the surface of the picture, no visible lighting to set a plane a certain number of feet away from the photographer. . . .
Type C prints are so *immaterial*—you don't have the sense of a body of dye, of any physical deposit. It's just colored light—like a transparency.

Shore is a very interesting photographer. . . . His pictures, for all their complexity, for all their coolness, have a very distinctive, personal character. A Shore picture is very classical in spirit, very quiet, very poised, very much at rest, very much having to do with the moments between events, and yet very potential. Not boring, not empty—but suspended.

*John Szarkowski*
*American Photographer,*
Feb. 1979

EVE SONNEMAN.  *Water Vision, Paris.* Two Cibachrome prints.  1977.

### 384 *Eve Sonneman / b. 1950*

Sonneman discovered something: the beauty of adjacent frames. Her two-part photographs recall the montage of Godard and also the formalism of Eisenstein. Unlike the English language, these photographs may be read right to left and vice versa. Sonneman sees herself as preoccupied with the human content of her images, but she always has an extreme tact toward form. Her work sometimes resembles a parody of detective fiction in which the viewer is given the problem of dealing with puzzling deletions and suspenseful sequences. Her deletion of any easy solution invites strenuous participation. Ezra Pound had this economy when, instead of writing about melancholy birds that had sported away, he wrote, "The phoenix are on the terrace / The phoenix are gone." In other words, Sonneman, like the brilliant imagist, gives us the pleasure of reading and seeing both presence and absence, with the minimum of explanatory connection.

*David Shapiro*
"Eve Sonneman's Photography:
Splitting and Integrity,"
Catalogue, Minneapolis Institute of Arts,
Minneapolis, 1980

## Ralph Gibson / b. 1939

For the past few years I have been working with longer lenses on a Leica. I want to learn how they function and what effects their magnification has on the picture plane. In this image of the Art Deco Doorway, I discovered that the left side of the image, in reality farther away from the camera than the right side, was pulled forward to the surface of the picture plane and tended to produce a kind of mood that perhaps would not have occurred otherwise. I realize also that the properties of contrast are involved here and contribute to the spatial change. Usually I photograph things that are inherently black and white in themselves, thereby gaining my tones from the subject rather than entirely from the contrast grade of the paper, etc. Bright sun awakens a sense of tropism in me, which I rarely resist. I seldom photograph in the shade, finding the light less stimulating. Ho-hum. . . .

RALPH GIBSON. *Art Deco Doorway* (from *The Black Series*). 1979.

*Todd Walker / b. 1917*

How the frame is designed, how things fit together in that frame, the gesture, the way the linear structure of that print works, the way it is lighted, the sensuality of the surface . . . all these are very important to make someone look at whatever you've done long enough to find out if you have anything to say.

386

TODD WALKER. *Portfolio III, No. 9.* Tone-line print. 1969.

RAY METZKER. *Greece.* 1976.

387

*Ray Metzker / b. 1931*

Metzker's problem was to find a way to explore the character of the medium in order to define photography and then to make a photograph conform to this definition. His fundamental interest was to isolate the unique formal aspects of the medium and to see if they could embody an expressive statement—a statement rather far removed from the psychological humanism of much of the work surrounding him. All of Metzker's work since has been a continuous step-by-step articulation of this desire. It has been a challenging of himself to make the picture be of something and simultaneously exist independently as a photograph.

*Peter Bunnell*
*The Print Collector's Newsletter,*
Jan.–Feb. 1979

JOSEPH D. JACHNA. *Colorado, 1975.* Infrared photograph.

## Joseph D. Jachna / b. 1935

Joe Jachna's aim has always been to communicate the spiritual quality of his forms and of the natural elements. How fascinating it is . . . to witness the inner change, the growth of a soul whose increasing at-oneness with his world is made visible by the softening of the edges, the melting down of the lines that reason says divide one thing from another.

*Gretchen Garner*
Review in *The New Art Examiner,* June 2, 1977,
of an exhibit at the University of Illinois, Chicago

Perhaps this statement speaks about the ability of a photograph to reveal something profound about the photographer as well. My earliest photographs were concerned with making that line which divides things clear, and now I can't help wonder about—even anticipate—what will be revealed next.

*Joseph D. Jachna*
10 Jun 80

# Bruce Davidson

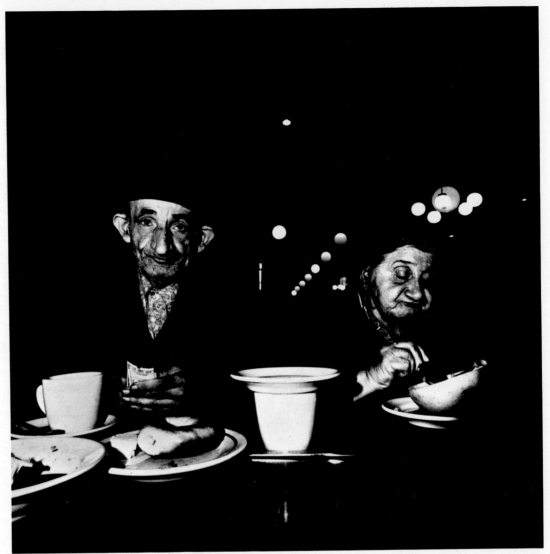

BRUCE DAVIDSON. *The Cafeteria.* 1976.

*Bruce Davidson / b. 1933*

Few contemporary photographers give us their observations so unembellished—so free of apparent craft or artifice. . . . The presence that fills these pictures seems the presence of the life that is described, scarcely changed by its transmutation into art.

*John Szarkowski*

I went each day to the cafeteria and sat at the tables with my small camera on a tripod, or hand held it with a strobe. The direct flash caused the background to go black, isolating the people from the environment and conveying that sense of silent waiting that permeated the endless rattle of dishes, the fragile movements of the aged and the slow, the careful swallowing of food.

*Bruce Davidson*

390

She: Are you happy with me?
He: Usually.
She: What makes you happy?
He: Not being asked about it.

© Heinecken '75-'78

ROBERT HEINECKEN. *Untitled.* Three SX-70 prints on white board with pencil; 11 × 14 inches (28 × 35 cm). 1978.

## Robert Heinecken / b. 1931

Ray Birdwhistell, a pioneer investigator of nonverbal communication, said:

Communication isn't like a sending set and a receiver. It's a negotiation between two people, a creative act. It's not measured by the fact that you get precisely what I say, but that you contribute your part to it, that both of us change by the act. And then when we do communicate, we're an interacting and reacting, beautifully integrated system.

This points to an interesting difference in the structure and experience between the conversations and the photographs [that comprise Heinecken's latest works]. The talks enforce a social system where there are two active participants while the images document only Heinecken's observations. The photographs involve far less negotiation; they are *taken*. One might argue that since this is Heinecken's dream, all the characters are parts of himself. In a sense, since the women are anonymous, they function as extensions of himself rather than as separate beings. However, the conversations are enacted by two people and are about the interchange between them, while the intent of the pictures is literally to show us Heinecken's point of view.

*Irene Borger*
"Relations: Some Work by Robert Heinecken,"
*Exposure,* Summer, 1979
(Society for Photographic Education)

# Bill Owens

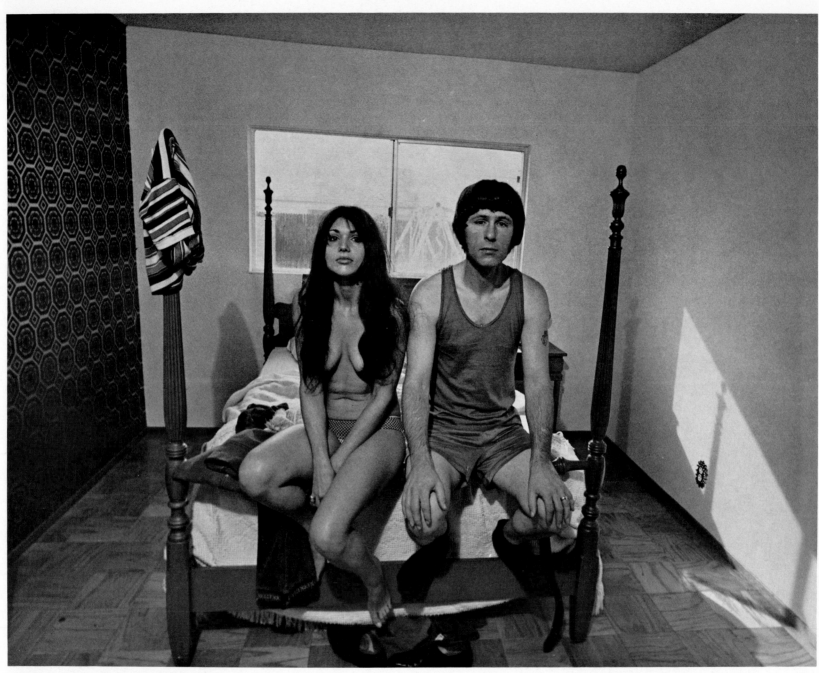

BILL OWENS. *"We feel most people have the wrong attitude towards sex, that it's nasty and to be done only in the dark. With us sex takes care of itself"* (from *Suburbia*). Taken with a 2¼ × 3¼-inch (5.7 × 8.2-cm) Superwide camera. 1972.

*Bill Owens / b. 1938*

The heart of photography is the documentary image, as it is a record of people, places, and events. The challenge to the documentary photographer is the highest as the photograph must be technically perfect and show how people live. The documentary photograph contains the symbols of our society and tells about ourselves. This type of photography if properly done will stand the test of time.

# Kenneth Josephson

KENNETH JOSEPHSON. *Stockholm.* 6 × 9 inches (15 × 23 cm). 1967.

## *Kenneth Josephson / b. 1932*

Much of my work is intuitive and spontaneous and I wish to have it function purely on a visual level. The following statement about this photograph is afterthought. This image is concerned with three of my interests: photographs containing images within images, allusions to the photographic medium and the vicarious experience of the sense of touch. The light "shadow" shape of the car was created by the warmth of the sun and the coldness of the air within the shadow. The scene was a natural event and very "photographic" with the suggestion of a negative element formed by sunlight. The viewer may also experience the sensation of hot and cold in a vicarious manner.

Ice Table Shattered on Fieldstone    West Suffield, Connecticut.    17 February, 1979.

ROBERT CUMMING. *Ice Table Shattered on Fieldstone.* Composite photograph. 1979.

## Robert Cumming / b. 1943

My production of photographs (mostly of objects) over the last 10 to 12 years has been co-existent with the production of sculpture and a quantity of writing. Within those brackets, there seems to have been a wide-ranging field of concerns that coaxes a narrative potential out of things inanimate . . . the absurdity when the good sense of proper cause and effect malfunctions (objectified in form and function), the multiple meaning of metaphoric language, pictorial perceptual tests, human reason, and natural phenomena, etc. My photographs have paid attention to the regularities of the medium and have dealt with the nature of documentation and evidence, arresting time and setting it back in motion (in sequences), "enlivened" still-lifes of sorts (theatre of objects), etc. I think they've been looking for blind spots.

The following bibliography is intended to be only an introduction to the vast literature on the art and science of photography.

Because they provide comprehensive coverage of the major categories of photographic information, the volumes comprising the *Life Library of Photography* (New York: Time-Life Books, 1970–1975) are listed here: *The Camera, Light and Film, The Print, Color, Photography as a Tool, The Great Themes, Photojournalism, Special Problems, The Studio, The Art of Photography, The Great Photographers, Photographing Nature, Photographing Children, Documentary Photography, Frontiers of Photography, Travel Photography, Caring for Photographs.* Supplements: *Series Index, A Photographer's Handbook, Camera Buyer's Guide, Buyer's Guide to Darkroom Equipment.*

## History

Beaton, Cecil, and Gail Buckland. *The Magic Image.* Boston: Little, Brown, 1975.

Braive, Michel F. *The Photograph: A Social History.* New York: McGraw-Hill, 1966.

Buckland, Gail. *Reality Recorded: Early Documentary Photography.* New York: New York Graphic Society, 1974.

Coe, Brian. *The Birth of Photography.* London: Ash & Grant, Ltd., 1976.

————. *Cameras.* New York: Crown, 1978.

————. *Colour Photography.* London: Ash & Grant, Ltd., 1978.

Coke, Van Deren. *One Hundred Years of Photography.* Albuquerque: University of New Mexico Press, 1975.

————. *The Painter and the Photograph: From Delacroix to Warhol.* Albuquerque: University of New Mexico Press, 1964.

Darrah, William Culp. *Stereo Views: A History of Stereographs in America and Their Collection.* Gettysburg, PA: Times and News, 1964.

————. *The World of Stereographs.* Gettysburg, PA: private press, 1977.

Dennis, Landt, and List Dennis. *Collecting Photography.* New York: Dutton, 1977.

Doty, Robert. *Photo-Secession: Photography as a Fine Art.* New York: Dover, 1978.

Eder, Maria Josef. *History of Photography.* Trans. Edward Epstean. New York: Dover, 1978.

*French Primitive Photography.* Intro. by Minor White. New York: Aperture, 1970.

Freund, Gisèle. *Photography and Society.* Boston: David R. Godine, 1980.

Gassan, Arnold. *A Chronology of Photography.* Rev. Ed. Athens, OH: Handbook, 1972.

Gernsheim, Helmut. *Creative Photography: Aesthetic Trends, 1839–1960.* London: Faber & Faber, 1962.

————. *The History of Photography.* New York: McGraw-Hill, 1970.

————, and Alison Gernsheim. *A Concise History of Photography.* New York: Grosset & Dunlap, 1965.

Green, Jonathan, ed. *Camera Work: A Critical Anthology.* Millerton, NY: Aperture, 1973.

Jones, John. *Wonders of the Stereoscope.* New York: Random House, 1976.

*Literature of Photography, The.* New York: Arno Press, 1973. A series: 62 facsimile editions of old and rare out-of-print books.

MacDonald, Gus. *Camera: Victorian Eyewitness.* New York: Viking Press, 1979.

Newhall, Beaumont. *The Daguerreotype in America.* Rev. ed. New York: Dover, 1976.

————. *The History of Photography from 1839 to the Present Day.* Rev. ed. New York: New York Graphic Society, 1978.

Pfister, Harold Francis. *Facing the Light: Historic American Portrait Daguerreotypes.* Washington: Smithsonian Institution, 1978.

Pollack, Peter. *The Picture History of Photography.* Rev. ed. New York: Abrams, 1970.

Rinhart, Floyd, and Marion Rinhart. *American Daguerreian Art.* New York: Clarkson N. Potter, 1967.

Rudisill, Richard C. *Mirror Image: The Influence of the Daguerreotype on American Society.* Albuquerque: University of New Mexico Press, 1971.

Sandler, Martin. *The Story of American Photography.* Boston: Little, Brown, 1979.

Scharf, Aaron. *Art and Photography.* Baltimore: Viking Press, 1974.

————. *Creative Photography.* London: Studio Vista and New York: Van Nostrand Reinhold, 1965.

Sobieszek, Robert, and Odette M. Appel. *The Spirit of Fact: The Daguerreotypes of Southworth & Hawes, 1843–1862.* Boston: David R. Godine and Rochester, NY: International Museum of Photography, 1976.

Stoff, William. *Documentary Expression and the Thirties America.* London and New York: Oxford University Press, 1976.

Taft, Robert. *Photography and the American Scene: A Social History.* New York: Dover, 1964 (reprint of 1938 ed.).

Wall, E. J. *E. J. Wall's The History of Three-Color Photography.* New York: Amphoto, 1970.

Welling, William. *Collector's Guide to Nineteenth-Century Photographs.* New York: Macmillan, 1976.

Willsberger, Johann. *The History of Photography.* New York: Doubleday, 1977.

Witkin, Lee, and Barbara London. *The Photograph Collector's Guide.* Boston: New York Graphic Society/Little, Brown, 1979.

## Technique

Adams, Ansel. *Artificial-Light Photography, Basic Photo Series.* Boston: New York Graphic Society, 1971.

————. *Camera and Lens, Basic Photo Series.* Boston: New York Graphic Society, 1973.

————. *Natural-Light Photography, Basic Photo Series.* Boston: New York Graphic Society, 1971.

————. *The Negative, Basic Photo Series.* Boston: New York Graphic Society, 1971.

————. *Polaroid-Land Photography.* Boston: New York Graphic Society, 1978.

Bunnell, Peter, ed. *Nonsilver Processes.* New York: Da Capo, 1973.

Carroll, John S. *Photographic Lab Handbook.* New York: Amphoto, 1976.

Cravin, George. *Object and Image: An Introduction to Photography.* Englewood Cliffs, NJ: Prentice-Hall, 1975.

Crawford, William. *The Keepers of Light.* Dobbs Ferry, NY: Morgan & Morgan, 1979.

Curtin, Dennis, and Joe DeMaio. *The Darkroom Handbook.* Marblehead, MA: Curtin & London, 1979.

Davis, Phil. *Photography.* 3rd ed. Dubuque, IA: Wm. C. Brown, 1979.

Denison, Herbert. *A Treatise on Photogravure.* Rochester, NY: Visual Studies Workshop, 1974.

Dowdell, John J., III, and Richard Zakia. *Zone Systemizer.* Dobbs Ferry, NY: Morgan & Morgan, 1973.

Eaton, George T. *Photo Chemistry in Black-and-White and Color Photography.* Dobbs Ferry, NY: Morgan & Morgan, 1965.

Gassan, Arnold. *Handbook for Contemporary Phtography.* 4th ed. Rochester, NY: Light Impressions, 1977.

Hattersley, Ralph. *Photographic Lighting: Learning to See.* Englewood Cliffs, NJ: Prentice-Hall, 1979.

————. *Photographic Printing.* Englewood Cliffs, NJ: Prentice-Hall, 1977.

Hedgecoe, John. *The Photographer's Handbook.* New York: Random House, 1978.

Horenstein, Henry. *Beyond Basic Photography: A Technical Manual.* Boston: Little, Brown, 1977.

————. *Black-and-White Photography: A Basic Manual.* Boston: Little, Brown, 1974.

Howell-Koehler, Nancy. *Photo Art Process.* Rochester, NY: Visual Studies Workshop, 1980.

Kelly, Jain, ed. *Darkroom 2.* New York: Lustrum Press, 1978.

*Kodak Black & White Darkroom Dataguide.* Rochester, NY: Eastman Kodak, 1979.

*Kodak Color Darkroom Dataguide.* Rochester, NY: Eastman Kodak, 1980.

Langford, Michael J. *Advanced Photography.* New York: Amphoto and London: Focal, 1972.

————. *Basic Photography.* New York: Amphoto and London: Focal, 1965.

Lewis, Eleanor. *Darkroom.* New York: Lustrum Press, 1976.

Nadler, Bob. *The Color Printing Manual.* New York: Amphoto, 1978.

Neblette, C. B. *Fundamentals of Photography.* New York: Van Nostrand Reinhold, 1970.

Nettles, Bea. *Breaking the Rules: A Photo Media Cookbook.* Rochester, NY: Inky Press, 1977.

Newman, Thelma R. *Innovative Printmaking: The Making of Two- and Three-Dimensional Prints and Multiples.* New York: Crown, 1978.

Picker, Fred. *The Fine Print.* New York: Amphoto, 1978.

————. *The Zone VI Workshop: The Fine Print in Black-and-White Photography.* New York: Amphoto, 1974.

Pittaro, Ernest, ed. *Photo-Lab-Index: Compact Edition.* Dobbs Ferry, NY: Morgan & Morgan.

————. *Photo-Lab-Index: Lifetime Edition.* Dobbs Ferry, NY: Morgan & Morgan.

*Preservation of Photographs.* Rochester, NY: Eastman Kodak, 1979.

*Recovering Silver from Photographic Materials.* Rochester, NY: Eastman Kodak, 1979.

Reilly, James. *The Albumen and Salted Paper Book.* Rochester, NY: Light Impressions, 1980.

Rexroth, Nancy. *The Platinotype, 1977.* Albany, OH: Violet Press, 1977.

Saff, Donald, and Deli Sacilotto. *Printmaking: History and Process.* New York: Holt, Rinehart and Winston, 1978.

Saltzer, Joseph. *A Zone System for All Formats.* New York: Amphoto, 1979.

Sanders, Norman. *Photographic Tone Control.* Dobbs Ferry, NY: Morgan & Morgan, 1977.

Scopick, David. *The Gum Bichromate Book.* Rochester, NY: Light Impressions, 1978.

Shaman, Harvey. *The View Camera.* New York: Amphoto, 1979.

Shull, Jim. *The Hole Thing: A Manual of Pinhole Photography.* Dobbs Ferry, NY: Morgan & Morgan, 1974.

Simon, Michael, and Dennis Moore. *First Lessons in Black-and-White Photography.* New York: Holt, Rinehart and Winston, 1978.

Spencer, D. A. *Colour Photography in Practice.* New York: Focal Press, 1977.

Stone, Jim. *Darkroom Dynamics.* Marblehead, MA: Curtin & London, 1979.

Stroebel, Leslie. *View Camera Techniques.* New York: Hastings House, 1976.

————, and Hollis N. Todd. *Dictionary of Contemporary Photography*. Dobbs Ferry, NY: Morgan & Morgan, 1974.

Sturge, John M., ed. *Neblette's Handbook of Photography and Reprography*. 7th ed. New York: Van Nostrand Reinhold, 1977.

Swedlund, Charles, and Elizabeth Swedlund. *Kwik-Print*. Cobden, IL: Anna Press, 1978.

Todd, Hollis N., and Richard D. Zakia. *Photographic Sensitometry*. Dobbs Ferry, NY: Morgan & Morgan, 1969.

Upton, Barbara, and John Upton. *Photography*. Boston: Little, Brown, 1976.

Vestal, David. *The Craft of Photography*. New York: Harper & Row, 1975.

Wade, Kent E. *Alternative Photographic Processes*. Dobbs Ferry, NY: Morgan & Morgan, 1978.

Walker, Sandy, and Clarence Rainwater. *Solarization*. New York: Amphoto, 1974.

Wall, E. J., and Franklin I. Jordan. *Photographic Facts and Formulas*. New York: Amphoto, 1976.

White, Minor. *The Zone System Manual*. Dobbs Ferry, NY: Morgan & Morgan, 1968.

————, Richard Zakia, and Peter Lorenz. *The New Zone System Manual*. Dobbs Ferry, NY: Morgan & Morgan, 1976.

Zakia, Richard D., and Hollis N. Todd. *101 Experiments in Photography*. Dobbs Ferry, NY: Morgan & Morgan, 1969.

## Photographers

### Berenice Abbott

Abbott, Berenice, and Elizabeth McCausland. *Changing New York*. New York: Dutton, 1939.

*Berenice Abbott: Photographs*. New York: Horizon, 1970.

McCausland, Elizabeth. *New York in the Thirties: As Photographed by Berenice Abbott*. New York: Dover, 1973 (reprint of *Changing New York*).

### Ansel Adams

Adams, Ansel. *Photographs of the Southwest*. Boston: New York Graphic Society, 1976.

————. *Yosemite and the Range of Light*. New York: New York Graphic Society, 1979.

DeCock, Liliane, ed. *Ansel Adams*. Hastings-on-Hudson, NY: New York Graphic Society, 1972.

### Harold Allen

Allen, Harold. *Father Ravalli's Missions*. Chicago: Goodlion, 1971.

### George Alpert

Alpert, George. *The Queens*. New York: Da Capo, 1975.

### Diane Arbus

*Diane Arbus*. Millertown, NY: Aperture, 1972.

### Eugène Atget

Adams, William Howard. *Atget's Gardens*. Garden City, NY: Doubleday, 1979.

*Atget*. The Aperture History of Photography Series. Millerton, NY: Aperture, 1979.

### Alice Austen

Novotny, Ann. *Alice's World*. Old Greenwich, CT: Chatham Press, 1976.

### Richard Avedon

*Avedon: Photographs, 1947–1977*. Essay by Harold Brodkey. New York: Farrar, Straus & Giroux, 1978.

### Lewis Baltz

Baltz, Lewis. *The New Industrial Parks near Irvine, California*. New York: Castelli Graphics, 1974.

### Cecil Beaton

Beaton, Cecil. *The Best of Beaton*. New York: Macmillan, 1968.

Danziger, James, ed. *Beaton*. New York: Viking Press, 1980.

### E. J. Bellocq

Szarkowski, John, ed. *E. J. Bellocq: Storyville Portraits*. New York: New York Graphic Society, 1978.

### Barbara Blondeau

Lebe, David, Joan Redmond, and Ron Walker, eds. *Barbara Blondeau, 1938–1974*. Rochester, NY: Visual Studies Workshop, 1976.

### Margaret Bourke-White

Bourke-White, Margaret, with Erskine Caldwell. *Say, Is This the U.S.A.?* New York: Da Capo, 1977.

Brown, Theodore M., and Sean Callahan. *The Photographs of Margaret Bourke-White*. Greenwich, CT: New York Graphic Society, 1972.

### Mathew Brady

Kunhardt, Dorothy Meserve, and Philip B. Kunhardt, Jr. *Mathew Brady and His World*. New York: Time-Life Books, 1977.

Meredith, Roy. *Mathew B. Brady: Mr. Lincoln's Camera Man*. New York: Dover, 1974.

### Bill Brandt

*Shadow of Light*. Intro. by Cyril Connolly and Mark Haworth-Booth. New York: Da Capo, 1977.

### Brassaï

Brassaï. *The Secret Paris of the 30's*. New York: Pantheon Books, 1976.

### Manuel Alvarez Bravo

Parker, Fred R. *Manuel Alvarez Bravo*. Pasadena, CA: Pasadena Art Museum, 1971.

### John Brook

Brook, John. *Along the Riverrun*. 1970. Available from Light Impressions, Rochester, NY.

### Francis Joseph Bruguière

Enyeart, James. *Bruguière*. New York: Random House, 1977.

### Wynn Bullock

Bullock, Barbara. *Wynn Bullock*. San Francisco: Scrimshaw Press, 1971.

DeCock, Liliane, ed. *Wynn Bullock: Photography: A Way of Life*. Dobbs Ferry, NY: Morgan & Morgan, 1973.

*Wynn Bullock*. The Aperture History of Photography Series. Millerton, NY: Aperture, 1976.

### Harry Callahan

Szarkowski, John, ed. *Callahan*. Millerton, NY: Aperture, 1977.

### Julia Margaret Cameron

Gernsheim, Helmut. *Julia Margaret Cameron: Her Life Photographic Work*. Millerton, NY: Aperture, 1975.

Ovenden, Graham, ed. *A Victorian Album: Julia Margaret Cameron and Her Circle*. New York: Da Capo, 1975.

### Paul Caponigro

Caponigro, Paul. *Landscape*. New York: McGraw-Hill, 1975.

————. *Sunflower*. New York: Filmhaus, Inc., 1974.

### Lewis Carroll

Gernsheim, Helmut. *Lewis Carroll, Photographer*. New York: Dover, 1967 (reprint of 1949 ed.).

### Henri Cartier-Bresson

*Bresson*. New York: Viking Press, 1952.

Cartier-Bresson, Henri. *The Decisive Moment*. New York: Simon & Schuster, 1952.

————, and Yves Bonnefoy. *Henri Cartier-Bresson: Photographer*. Boston: New York Graphic Society, 1979.

*Henri Cartier-Bresson*. The Aperture History of Photography Series. Millerton, NY: Aperture, 1976.

### Alvin Langdon Coburn

Gernsheim, Helmut, and Alison Gernsheim, eds. *Alvin Langdon Coburn: An Autobiography*. New York: Dover, 1978.

### Linda Connor

Connor, Linda. *Solos*. Millerton, NY: Apeiron, 1979.

### Marie Cosindas

*Marie Cosindas: Color Photographs*. Essay by Tom Wolfe. New York: New York Graphic Society, 1978.

### Robert Cumming

Cumming, Robert. *Picture Fictions*. Fullerton, CA: private press, 1972.

————. *Untitled 18: Cumming Photographs*. Carmel, CA: Friends of Photography, 1979.

### Imogen Cunningham

Dater, Judy, ed. *Imogen Cunningham: A Portrait*. Boston: New York Graphic Society, 1979.

*Imogen! Imogen Cunningham Photographs, 1910–1973*. Intro. by Margery Mann. London: Henry Art Gallery and Seattle: University of Washington Press, 1974.

### Edward S. Curtis

Curtis, Edward S. *The North American Indians*. Millerton, NY: Aperture, 1972.

### Louis Jacques Mandé Daguerre

*Daguerre*. Intro. by Beaumont Newhall. New York: Winter House, 1971.

Gernsheim, Helmut, and Alison Gernsheim. *L. J. M. Daguerre: The History of the Diorama and the Daguerreotype*. New York: Dover, 1969 (reprint of 1956 ed.).

### Judy Dater and Jack Welpott

Dater, Judy, and Jack Welpott. *Women and Other Visions*. Dobbs Ferry, NY: Morgan & Morgan, 1975.

### Bruce Davidson

*Bruce Davidson Photographs*. New York: Simon & Schuster, 1979.

Davidson, Bruce. *East 100th Street*. Cambridge, MA: Harvard University Press, 1970.

————. *Subsistence U.S.A.* Text by Carol Hill. New York: Holt, Rinehart and Winston, 1973.

### Liliane DeCock

*Liliane DeCock Photographs*. Dobbs Ferry, NY: Morgan & Morgan, 1973.

### DeMeyer

*DeMeyer*. New York: Random House, 1976.

### David Douglas Duncan

Duncan, David Douglas. *Self-Portrait U.S.A.* New York: Abrams, 1969.

————. *This Is War!* New York: Bantam, 1967 (reprint of 1951 ed.).

————. *War Without Heroes*. New York: Harper & Row, 1970.

### Thomas Eakins

Hendriks, Gordon. *The Photographs of Thomas Eakins*. New York: Grossman, 1972.

**Harold Edgerton**

Edgerton, Harold, and James R. Killian, Jr. *Moments of Vision: The Stroboscopic Revolution in Photography.* Cambridge, MA: M.I.T. Press, 1979.

**William Eggleston**

*William Eggleston's Guide.* Essay by John Szarkowski. New York: Museum of Modern Art, 1976.

**Alfred Eisenstaedt**

Eisenstaedt, Alfred. *The Eye of Eisenstaedt.* New York: Viking Press, 1969.

**Peter Henry Emerson**

Newhall, Nancy. *P. H. Emerson: The Fight for Photography as a Fine Art.* Millerton, NY: Aperture, 1975.

**Elliot Erwitt**

Erwitt, Elliott. *Photographs and Anti-Photographs.* Greenwich, CT: New York Graphic Society, 1972.

**Frederick H. Evans**

Newhall, Beaumont. *Frederick H. Evans.* Millerton, NY: Aperture, 1973.

**Walker Evans**

Evans, Walker, and James Agee. *Let Us Now Praise Famous Men.* Boston: Houghton Mifflin, 1960 (expanded version of 1941 ed.).

*Walker Evans.* The Aperture History of Photography Series. Millerton. NY: Aperture, 1978.

*Walker Evans: American Photographs.* New York: East River Press, 1975.

*Walker Evans: First and Last.* New York: Harper & Row, 1978.

*Walker Evans: Photographs for the Farm Security Administration, 1935–1938.* Intro. by Jerald C. Maddox. New York: Da Capo, 1975.

**Andreas Feininger**

Feininger, Andreas. *Experimental Work.* New York: Amphoto, 1978.

———. *Forms of Nature and Life.* New York: Viking Press, 1966.

**Benedict J. Fernandez**

Fernandez, Benedict J. *In Opposition: Images of American Dissent in the Sixties.* New York: Da Capo, 1968.

**Robert Frank**

Frank, Robert. *The Americans.* Intro. by Jack Kerouac. New York: Aperture, 1969.

———. *The Lines of My Hand.* Los Angeles: Lustrum, 1972.

*Robert Frank.* The Aperture History of Photography Series. Millerton, NY: Aperture, 1976.

**Jill Freedman**

Freedman, Jill. *Circus Days.* New York: Harmony Books, 1975.

**Lee Friedlander**

Friedlander, Lee. *The American Monument.* New York: Eakins, 1976.

———. *Self-Portrait.* New York: Haywire Press, 1970.

*Lee Friedlander Photographs.* New York: Haywire Press, 1978.

**Oliver Gagliani**

*Oliver Gagliani.* San Francisco: Ideograph Publications, 1975.

**Alexander Gardner**

*Gardner's Photographic Sketch Book of the Civil War.* New York: Dover, 1959 (reprint of 1866 ed.).

**Charles Gatewood**

Burroughs, William S. *Sidetripping.* New York: Strawberry Hill Publishing Company, 1975.

**Ralph Gibson**

Gibson, Ralph. *Déjà-vu.* New York: Lustrum, 1973.

———. *The Somnambulist.* New York: Lustrum, 1970.

**Emmet Gowin**

*Emmet Gowin Photographs.* New York: Alfred A. Knopf, 1976.

**Ernst Haas**

Haas, Ernst. *The Creation.* New York: Viking Press, 1971.

**Charles Harbutt**

Harbutt, Charles. *Travelog.* Cambridge, MA: M.I.T. Press, 1973.

**Chauncey Hare**

Hare, Chauncey. *Interior America.* Millerton, NY: Aperture, 1978.

**John Heartfield**

*John Heartfield.* London: Institute of Contemporary Arts, 1969.

**Robert F. Heinecken**

Heinecken, Robert F. *Are You Real? 1964–1968.* A portfolio. Rochester, NY: George Eastman House, n.d.

———. *The Photograph: Not a picture of, but an object about.* Los Angeles: U.C.L.A. Press, n.d.

**David Octavius Hill and Robert Adamson**

Bruce, David. *Sun Pictures: The Hill-Adamson Calotypes.* Greenwich, CT: New York Graphic Society, 1973.

**Paul Himmel**

Himmel, Paul, and Walter Terry. *Ballet in Action.* New York: Putnam, 1954.

**Lewis W. Hine**

Hine, Lewis W. *America and Lewis Hine: Photographs, 1904–1940.* Millerton, NY: Aperture, 1977.

———. *Men at Work: Lewis W. Hine Photographic Studies of Modern Men and Machines.* New York: Dover and Rochester, NY: International Museum of Photography, 1977.

**L. A. Huffman**

Brown, Mark H., and W. R. Felton. *Before Barbed Wire: L. A. Huffman, Photographer on Horseback.* New York: Bramhall House, 1955.

**William Henry Jackson**

Newhall, Beaumont, and Diana E. Edkins. *William H. Jackson.* Dobbs Ferry, NY: Morgan & Morgan, 1974.

**Lotte Jacobi**

*Lotte Jacobi.* Danbury, NH: Addison, 1978.

**Ken Josephson**

Josephson, Ken. *The Bread Book.* Chicago: private press, 1974.

**Dan Jury and Mark Jury**

Jury, Dan, and Mark Jury. *Gramp.* New York: Grossman, 1976.

**André Kertész**

*André Kertész.* The Aperture History of Photography Series. Millerton, NY: Aperture, 1976.

Ducrot, Nicolas, ed. *Distortions.* New York: Random House, 1976.

———. *André Kertész: Sixty Years of Photography, 1912–1972.* New York: Viking Press, 1972.

**William Klein**

*William Klein.* Millerton, NY: Aperture, 1980.

**Josef Koudelka**

Koudelka, Josef. *Gypsies: Josef Koudelka.* Millerton, NY: Aperture, 1975.

**Cal Kowal**

Kowal, Cal. *A Book Full of Spoons.* Cincinnati: private press, 1975.

———. *T-Shirts Are Tacky.* Cincinnati: private press, 1976.

**George Krause**

*George Krause-1.* Haverford, PA: Toll & Armstrong, 1972.

**Leslie Krims**

Krims, Leslie. *Fictocryptokrimsographs.* Buffalo: Humpy Press, Inc., 1975.

———. *Four Limited Edition Folios: The Deerslayers; The Incredible Case of the Stack O'Wheats Murders; The Little People of America; Roadside Deaths.* Buffalo: private press, 1972.

———. *Making Chicken Soup.* New York: private press, 1972.

**Syl Labrot**

Labrot, Syl. *Pleasure Beach.* New York: Eclipse, 1976.

**Dorothea Lange**

Heyman, Theresa Thau. *Celebrating a Collection: The Work of Dorothea Lange.* Oakland, CA: Oakland Museum, 1978.

Lange, Dorothea, and Paul S. Taylor. *An American Exodus.* New Haven and New York: Yale University Press, 1969.

Meltzer, Milton. *Dorothea Lange: A Photographer's Life.* New York: Farrar, Straus & Giroux, 1978.

**William Larson**

Larson, William. *Fire Flies.* Philadelphia: Gravity Press, 1976.

**Jacques-Henri Lartigue**

*Jacques-Henri Lartigue.* The Aperture History of Photography Series. Millerton, NY: Aperture, 1976.

Lartigue, Jacques Henri. *Diary of a Century.* New York: Viking Press, 1970.

**Clarence John Laughlin**

*Clarence John Laughlin: The Personal Eye.* Intro. by Jonathan Williams. Millerton, NY: Aperture, 1974.

Laughlin, Clarence John. *Ghosts Along the Mississippi.* New York: Scribner, 1948.

**Russell Lee**

*Russell Lee, Photographer.* Dobbs Ferry, NY: Morgan & Morgan, 1978.

**Danny Lyon**

Lyon, Danny. *Conversations with the Dead.* New York: Holt, Rinehart and Winston, 1969.

**Nathan Lyons**

Lyons, Nathan. *Notations in Passing.* Cambridge, MA: M.I.T. Press, 1974.

**Mike Mandel**

Mandel, Mike. *How to Read Music in One Evening.* San Francisco: private press, 1974.

———. *Myself: Time Exposures.* Los Angeles: private press, 1971.

———, and Larry Sultan. *Evidence.* Santa Cruz, CA: private press, 1977.

**Man Ray**

*Man Ray.* The Aperture History of Photography Series, Millerton, NY: Aperture, 1979.

Man Ray. *Photographs, 1920–1934.* New York: Dover, 1979.

**Mary Ellen Mark**

Mark, Mary Ellen. *Ward 81.* New York: Simon & Schuster, 1979.

**Paul Martin**

Flukinger, Roy, Larry Schaaf, and Standish Meacham. *Paul Martin: Victorian Photographer.* Austin: University of Texas Press, 1977.

**Ralph Eugene Meatyard**

Meatyard, Ralph Eugene. *Emblem and*

*Rites.* Millerton, NY: Aperture, 1974.
———. *Lucybelle Crater.* Frankfort, KY: The Jargon Society, 1974.

**Ray Metzker**
Metzker, Ray. *Sand Creatures.* Millerton, NY: Aperture, 1979.

**Joel Meyerowitz**
Meyerowitz, Joel. *Cape Light.* Boston: New York Graphic Society, 1978.
———. *St. Louis and the Arch.* Boston: Little, Brown, 1980.

**Duane Michals**
Michals, Duane. *Real Dreams, Photo-stories.* Danbury, NH: Addison House, 1977.
———. *Sequences.* Garden City, NY: Doubleday, 1972.

**Arno Rafael Minkkinen**
Minkkinen, Arno Rafael. *Frostbite.* Dobbs Ferry, NY: Morgan & Morgan, 1978.

**Richard Misrach**
Misrach, Richard. *Telegraph 3 A.M.* San Francisco: Cornucopia Press, 1974.

**Lisette Model**
*Lisette Model.* Millerton, NY: Aperture, 1979.

**László Moholy-Nagy**
Haus, Andreas. *Moholy-Nagy: Photographs and Photograms.* Trans. Frederic Samson. New York: Pantheon Books, 1980.
Moholy-Nagy, László. *Photographs of Moholy-Nagy, from the Collection of William Larson.* Claremont, CA: Pomona College, 1975.
———. *Vision in Motion.* Chicago: Paul Theobald, 1965 (reprint of 1947 ed.).

**Barbara Morgan**
*Barbara Morgan.* Dobbs Ferry, NY: Morgan & Morgan, 1972.
*Barbara Morgan Photomontage.* Dobbs Ferry, NY: Morgan & Morgan, 1980.

**Wright Morris**
Morris, Wright. *The Inhabitants.* New York: Da Capo, 1972.

**Eadweard Muybridge**
Muybridge, Eadweard. *Animals in Motion.* New York: Dover, 1957 (reprint of 1899 ed.).
———. *Human and Animal Locomotion.* New York: Dover, 1980 (reprint).
———. *The Human Figure in Motion.* New York: Dover, 1957 (reprint of 1901 ed.).

**Nadar (Gaspard Félix Tournachon)**
Gosling, Nigel. *Nadar.* New York: Random House, 1976.

**Charles Nègre**
Borcomon, James. *Charles Nègre.* Ottawa: National Museum of Canada, 1976.

**Bea Nettles**
Nettles, Bea. *The Elsewhere Bird.* Rochester, NY: Light Impressions, 1974.
———. *Flamingo in The Dark.* Rochester, NY: Light Impressions, 1979.

**Arnold Newman**
*One Mind's Eye.* Boston: David R. Godine, 1974.

**Timothy O'Sullivan**
Horan, James D. *Timothy O'Sullivan: America's Forgotten Photographer.* New York: Doubleday, 1966.

**Bill Owens**
Owens, Bill. *Documentary Photography.* Danbury, NH: Addison House, 1978.
———. *Our Kind of People: American Groups and Rituals.* San Francisco: Straight Arrow Books, 1975.
———. *Suburbia.* San Francisco: Straight Arrow Books, 1973.

**Olivia Parker**
Parker, Olivia. *Signs of Life.* Boston: David R. Godine, 1978.

**Irving Penn**
Penn, Irving. *Moments Preserved.* Intro. by Alexander Liberman. New York: Simon & Schuster, 1960.

**Eliot Porter**
Porter, Eliot. *Intimate Landscapes.* Afterword by Weston J. Naef. New York: The Metropolitan Museum of Art and Dutton, 1979.

**Nancy Rexroth**
Rexroth, Nancy. *Iowa.* Rochester, NY: Violet Press, 1977 (dist. by Light Impressions).

**Jacob A. Riis**
Alland, Alexander, Sr., ed. *Jacob A. Riis: Photographer and Citizen.* Millerton, NY: Aperture, 1974.
Riis, Jacob A. *How the Other Half Lives.* New York: Dover, 1971 (reprint of 1890 ed.).

**Arthur Rothstein**
Rothstein, Arthur. *The Depression Years as Photographed by Arthur Rothstein.* New York: Dover, 1978.

**Eva Rubenstein**
*Eva Rubenstein.* Preface by Sean Dernan. Dobbs Ferry, NY: Morgan & Morgan, 1974.

**Edward Ruscha**
Ruscha, Edward. *Crackers.* New York: Wittenborn, 1969.

———. *Hard Light.* Los Angeles: private press, 1978.
———. *Nine Swimming Pools and a Broken Glass.* New York: Wittenborn, 1968.

**Erich Salomon**
*Erich Salomon.* The Aperture History of Photography Series. Millerton, NY: Aperture, 1978.

**Lucas Samaras**
Samaras, Lucas. *Photo-Transformations.* Long Beach: California State University and New York: Dutton, 1975.

**August Sander**
*August Sander.* The Aperture History of Photography Series. Millerton, NY: Aperture, 1977.
Sander, August. *Men Without Masks: Faces of Germany, 1910–1930.* Greenwich, CT: New York Graphic Society, 1973.

**Napoleon Sarony**
Bassham, Ben L. *The Theatrical Photographs of Napoleon Sarony.* Kent, OH: Kent State University Press, 1978.

**Ben Shawn**
*Ben Shawn, Photographer.* Intro. by Margaret R. Weiss. New York: Da Capo, 1972.

**Aaron Siskind**
Siskind, Aaron. *Bucks County: Photographs of Early Architecture.* New York: Horizon, 1974.
———. *Places.* New York: Farrar, Straus & Giroux, 1976.

**Victor Skrebneski**
*Skrebneski Portraits: A Matter of Record.* Garden City, NY: Doubleday, 1978.

**Neal Slavin**
Slavin, Neal. *When Two or More Are Gathered Together.* New York: Farrar, Straus & Giroux, 1976.

**Eugene W. Smith**
Smith, W. Eugene, and Aileen M. Smith. *Minamata.* New York: Holt, Rinehart and Winston, 1975.
*W. Eugene Smith: His Photographs and Notes.* Aperture Monograph. New York: Aperture, 1969.

**Edward Steichen**
*Edward Steichen.* The Aperture History of Photography Series. Millerton, NY: Aperture, 1978.
*Steichen: The Mater Prints, 1895–1914: The Symbolist Period.* Intro. by Dennis Longwell. New York: New York Graphic Society, 1978.

**Alfred Stieglitz**
*Alfred Stieglitz.* The Aperture History of Photography Series. Millerton, NY: Aperture, 1976.
Bry, Doris. *Alfred Stieglitz: Photographer.* Boston: New York Graphic Society, 1978.
Frank, Waldo, et al., eds. *America and Alfred Stieglitz: A Collective Portrait.* Millerton, NY: Aperture, 1979.
Norman, Dorothy. *Alfred Stieglitz: An American Seer.* Millerton, NY: Aperture, 1978.

**Paul Strand**
*Paul Strand: Sixty Years of Photographs.* Millerton, NY: Aperture, 1976.
Strand, Paul, and Basil Davidson. *Ghana: An African Portrait.* Millerton, NY: Aperture, 1976.

**Josef Sudek**
Bullaty, Sonja. *Josef Sudek.* New York: Crown, 1978.

**Frank Sutcliffe**
*Frank Meadow Sutcliffe.* The Aperture History of Photography Series. Millerton, NY: Aperture, 1979.
Hiley, Michael. *Frank Sutcliffe, Photographer of Whitby.* Boston: David R. Godine, 1974.

**Charles Swedlund**
*Charles Swedlund Photographs.* Cobden, IL: Anna Press, 1973.
Swedlund, Charles. *Stereo Photographs.* A portfolio. Cobden, IL: Anna Press, 1973.

**Joseph Szabo**
Szabo, Joseph. *Almost Grown.* Foreword by Cornell Capa. New York: Harmony Books, 1978.

**William Henry Fox Talbot**
Buckland, Gail. *Fox Talbot and the Invention of Photography.* Boston: David R. Godine, 1980.
Jammes, André. *William H. Fox Talbot.* New York: Collier, 1973.
Talbot, William Henry Fox. *The Pencil of Nature.* Intro. by Beaumont Newhall. New York: Da Capo, 1969 (facsimile of 1864 ed.).

**George A. Tice**
*George A. Tice Photographs: 1953–1973.* New Brunswick, NJ: Rutgers University Press, 1975.
Tice, George A. *Paterson.* New Brunswick, NJ: Rutgers University Press, 1972.

**Charles Traub**
*Charles Traub: Beach.* New York: Horizon, 1978.

**Arthur Tress**
Tress, Arthur, *The Dream Collector.* New York: Avon, 1973.

397

————. *Theatre of the Mind.* Intro. by A. D. Coleman. Dobbs Ferry, NY: Morgan & Morgan, 1976.

**Jerry N. Uelsmann**
*Jerry N. Uelsmann.* Millerton, NY: Aperture, 1973.
Uelsmann, Jerry N. *Silver Meditations.* Dobbs Ferry, NY: Morgan & Morgan, 1975.

**Doris Ulmann**
Ulmann, Doris. *The Appalachian Photographs of Doris Ulmann.* Penland, NC: The Jargon Society, 1971.
————. *The Darkness and The Light.* Millerton, NY: Aperture, 1974.

**James Van der Zee**
*James Van der Zee.* Dobbs Ferry, NY: Morgan & Morgan, 1973.
Van der Zee, James. *The Harlem Book of the Dead.* Dobbs Ferry, NY: Morgan & Morgan, 1979.

**Todd Walker**
Walker, Todd. *A Few Notes.* Gainesville, FL: private press, 1976.
————. *For Nothing Changes . . .* Tucson, AZ: private press, 1976.
————. *See.* Tucson, AZ: private press, 1978.
————. *Three Soliloquies.* Tucson, AZ: private press, 1977.

**Carleton Watkins**
Watkins, Carleton. *Photographs of the Columbia River and Oregon.* Carmel, CA: Friends of Photography, 1979.

**Weegee (Arthur Fellig)**
*Weegee.* The Aperture History of Photography Series. Millerton, NY: Aperture, 1978.
Weegee. *Naked City.* New York: Da Capo, 1975 (reprint of 1945 ed.).

**Brett Weston**
Weston, Brett. *Voyage of the Eye.* Millerton, NY: Aperture, 1975.

**Edward Weston**
*Edward Weston: His Life and Photographs.* Millerton, NY: Aperture, 1979.
*Edward Weston: Nudes.* Millerton, NY: Aperture, 1977.
*Edward Weston: Seventy Photographs.* New York: New York Graphic Society, 1978.
Newhall, Nancy, ed. *The Daybooks of Edward Weston, Vol. I and Vol. II.* Millerton, NY: Aperture, 1973.
Weston, Edward. *California and the West.* Millerton, NY: Aperture, 1978.

**Clarence H. White**
*Clarence H. White.* The Aperture History of Photography Series. Millerton, NY: Aperture, 1979.

**Minor White**
*Minor White: Rites and Passages.* Millerton, NY: Aperture, 1978.

**Geoff Winningham**
Winningham, Geoff. *Friday Night in the Coliseum.* Houston: Allison, 1972.
————. *Going Texan.* Houston: Maris P. Kelsey Jr., 1972.

**Garry Winogrand**
Winogrand, Garry. *Public Relations.* New York: New York Graphic Society, 1977.
————. *Women Are Beautiful.* New York: Farrar, Straus & Giroux, 1975.

**Kelly Wise**
Wise, Kelly. *Still Points.* Danbury, NH: Addison House, 1978.

## Anthologies

Coleman, A. D. *The Grotesque in Photography.* New York: Simon & Schuster, 1977.
Doty, Robert. *Photography in America.* New York: Ridge Press-Random House, 1974.
*Faces and Facades.* Intro. by Peter C. Bunnell, foreword by L. Fritz Gruber. Cambridge, MA: Polaroid Corporation, 1977.
Gibson, Ralph, ed. *SX-70.* New York: Lustrum, 1980.
Green, Jonathan. *The Snapshot.* Millerton, NY: Aperture, 1974.
Kelly, Jain. *Nude: Theory.* New York: Lustrum, 1979.
Leekley, Sheryle, and John Leekley. *Moments: The Pulitzer Prize Photographs.* New York: Crown, 1978.
Lyons, Nathan. *Photography in the Twentieth Century.* New York: Horizon and Rochester, NY: George Eastman House, 1967.
————, ed. *Contemporary Photographers: The Persistence of Vision.* New York: Horizon and Rochester, NY: George Eastman House, 1967.
————, ed. *Comtemporary Photographers: Toward a Social Landscape.* New York: Horizon and Rochester, NY: George Eastman House, 1966.
————, ed. *Vision and Expression.* New York: Horizon, 1969.
Newhall, Beaumont. *Airborne Camera.* New York: Hastings House, 1969.
Norfleet, Barbara. *Wedding.* New York: Simon & Schuster, 1979.
Pare, Richard. *Court House: A Photographic Document.* New York: Horizon, 1978.
Rathbone, Belinda. *One of a Kind.* Boston: David R. Godine, 1979.
Steichen, Edward. *The Family of Man.* New York: Museum of Modern Art and Simon & Schuster, 1955.
Szarkowski, John. *From the Picture Press.* New York: Museum of Modern Art, 1973.
————. *Looking at Photographs.* New York: Museum of Modern Art and Greenwich, CT: New York Graphic Society, 1973.
————. *Mirrors and Windows.* New York: New York Graphic Society, 1978.
————. *The Photographer and the American Landscape.* New York: Museum of Modern Art, 1963.
————. *The Photographer's Eye.* New York: Museum of Modern Art and Garden City, NY: Doubleday, 1966.
Trachtenbury, Alan. *The American Image: Photographs from the National Archives, 1860–1960.* New York: Random House, 1979.
Tucker, Anne, ed. *The Woman's Eye.* New York: Random House, 1973.
White, Minor, *Octave of Prayer.* Millerton, NY: Aperture, 1972.
Wiesenfeld , Cheryl, et al., eds. *Women See Women.* New York: Thomas Y. Crowell, 1976.
Wise, Kelley, ed. *The Photographer's Choice.* Danbury, NH: Addison House, 1975.

## Related Books

Albers, Josef. *Interaction of Color.* New Haven, CT: Yale University Press, 1975.
Arnheim, Rudolph. *Art and Visual Perception.* Berkeley and Los Angeles: University of California Press, 1971.
————. *Visual Thinking.* Berkeley and Los Angeles: University of California Press, 1972.
Cavallo, Robert M., and Stuart Kahan. *Photography: What's the Law?* 2nd ed. New York: Crown, 1979.
Coffin, Charles. *Photography as a Fine Art.* Intro. by Thomas Barrow. Dobbs Ferry, NY: Morgan & Morgan, 1971.
Coleman, A. D. *Light Readings: A Photography Critic's Writings, 1968–1978.* New York: Oxford University Press, 1979.
Collier, John, Jr. *Visual Anthropology: Photography as a Research Method.* New York: Holt, Rinehart and Winston, 1967.
Hattersley, Ralph. *Discover Your Self Through Photography.* Dobbs Ferry, NY: Morgan & Morgan, 1970.
Ivins, William M. *Prints and Visual Communications.* Cambridge, MA: M.I.T. Press, 1969.
Jussim, Estelle. *Visual Communications and the Graphic Arts.* Rochester, NY: Light Impressions, 1974.
LaPlante, Jerry, ed. *Photographers on Photography.* New York: Sterling, 1979.
Liebling, Jerome. *Photography: Current Perspectives.* Rochester, NY: Light Impressions, 1979.
Lyons, Nathan, ed. *Photographers on Photography.* Englewood Cliffs, NJ: Prentice-Hall, 1966.
Malcolm, Janet. *Diana and the Nikon, Essays on the Aesthetic of Photography.* Boston: David R. Godine, 1980.
McLuhan, Marshall. *Understanding Media.* New York: McGraw-Hall, 1971.
Sontag, Susan. *On Photography.* New York: Farrar, Straus & Giroux, 1977.
Ward, John L. *The Criticism of Photography as Art: The Photographs of Jerry Uelsmann.* Gainesville: University of Florida Press, 1970.
Zakia, Richard. *Perception and Photography.* Rochester, NY: Light Impressions, 1979.

## Periodicals

*Afterimage.* Visual Studies Workshop, Inc., 31 Prince Street, Rochester, NY 14607.
*American Photographer.* 1515 Broadway, New York, NY 10036.
*Aperture.* Aperture Inc., Elm Street, Millerton NY 12546.
*Artforum.* California Artforum, Inc., 667 Madison Avenue, New York, NY 10021.
*ARTnews.* 122 East 42nd Street, New York, NY 10017.
*Camera.* C. J. Bucher, Ltd., Lucerne, Switzerland.
*Camera 35.* Popular Publications, 150 East 58th Street, New York, NY 10022.
*Creative Camera.* International Federation of Amateur Photographers, 19 Doughty Street, London, England.
*History of Photography.* Dr. Heinz K. Henisch, ed. 249 Materials Research Laboratory, University Park, PA 16802.
*Image.* International Museum of Photography (George Eastman House), 900 East Avenue, Rochester, NY 14607.
*Modern Photography.* ABC Leisure Magazine, Inc., 130 East 59th Street, New York, NY 10022.
*Petersen's Photographic Magazine.* 8490 Sunset Boulevard, Los Angeles, CA 90069.
*Popular Photography.* Ziff-Davis Publishing Co., Inc., 1 Park Avenue, New York, NY 10016.
*Portfolio.* Box 61, Dannemora, NY 12929.

# Glossary

Terms *italicized* within the definitions are themselves defined in the glossary.

**aberration**  Optical defect in a *lens* that causes it to render subject matter in *images* that are marred by blurring or some other type of distortion. Types are *astigmatism, barrel distortion, pincushion distortion, chromatic aberration, coma, spherical distortion, curvature of field*.

**absorption**  In photography, the assimilation of *light* rays by the medium they strike, the effect of which is to block light so that it travels no farther. The complete absorption of light results in black. The opposite of *reflection*.

**accelerator**  *Alkali* that in *developer* increases the *speed* of chemical action.

**acetic acid**  The *acid* used in diluted form for stop bath, which neutralizes the action of *developer* in the *processing* of *film* and *prints*. Also used in *fixing baths* as an *emulsion hardener* and in the *dye-transfer* process to prevent bleeding between dyes.

**achromat**  A lens designed to reduce *chromatic aberrations* of two colors.

**acid**  A solution with a ph below 7.0.

**activator**  A component of a *print*-stabilizing developing system which alters the ph of the developer, causing the developer contained in the emulsion to be activated. See *stabilization*.

**acutance**  *Film sharpness* as distinguished by the degree of tonal gradation separating light and dark areas in a photographic *image*.

**adapter ring**  A device attached to the front of a *camera lens* to enable the camera to accept *filters* and *closeup lenses*.

**additive colors**  In *light,* those *hues* known as the *primaries*—red, green, and blue—that when blended in a dark environment can, theoretically, add up to *white light* (all light), since each contains approximately one-third of the total number of *wavelengths* in the visible portion of the electromagnetic *spectrum*. On this principle is based the additive system of simulating full color in photographic *images*. See also *subtractive colors*.

**additive principle** or **system**  See *additive colors*.

**agitation**  The technique of causing the *processing* liquids to flow freely and continuously over all surfaces of *film* and paper throughout their immersion.

**air bells**  Clear areas on the *film* which produce black spots in the resulting *print* caused by bubbles of air between two surfaces of film during development.

**albumen**  The white of eggs used for many years in the *emulsion* for printing paper; it was eventually replaced with *gelatin*.

**alkali**  A solution with a ph above 7.0; a base solution.

**ambrotype**  An early *wet-plate* photographic *process* that produced a faint *negative image* upon a glass *plate* coated with *collodion*. When backed with black, it appeared as a *positive*.

**analyzer**  An electronic device for determining the *filtration* needed to obtain a *print* of good color balance from a specific *negative* projected by *light* from a specific *enlarger*.

**anhydrous**  A term describing powdered chemical compounds that are free of water and especially the water of crystallization. In mixing formulas by weight, the amount of anhydrous chemicals necessary is smaller when compared to *crystalline* chemicals.

**ANSI**  For American National Standards Institute, now the name of the *ASA*.

**antihalation backing**  A coat of dye or pigment on the back of the *film* support to *absorb* extraneous *light* rays passing through the *emulsion* and thus prevent their *reflecting* back onto and affecting the light-sensitive material.

**aperture**  The *lens* opening that admits controlled amounts of *light* into a *camera*, its size variable but regulated by an iris *diaphragm* and expressed as an *f-number*.

**apochromat**  A very expensive type of *lens* that is highly corrected for *chromatic aberrations* because it is corrected for three colors, not just two, as the *achromat* is. Often manufacturers use "Apo" as a prefix to the name of such a lens. These lenses are used on process cameras for photomechanical reproduction.

**archival**  The quality of permanence or durability.

**artificial light**  The light produced by manufactured devices such as electric light bulbs, *flashbulbs,* or *electronic flash* units.

**ASA**  For American Standards Association, which evolved a system designed to rate the *speed* or *light* sensitivity of photographic materials. Used to mean the system.

**astigmatism**  A *lens aberration* that prevents equal *focus* for lines that lie at right angles to each other on the same plane.

**available light**  The light illuminating a scene that is not controlled or added by the photographer. It usually refers to a low level of light such as that found in dark interiors or at night. Other names are ambient light, existing light.

**back focus**  The distance from the rear of the *lens* to the focal point when focused at *infinity*.

**back lighting**  *Light* that comes from behind the subject and toward the *camera*. It has a tendency to emphasize the shape of the subject.

**barrel distortion**  A *lens aberration* that causes magnification of an *image* at its center.

**baryta coating**  A coating of barium sulfate on photographic paper under the *emulsion* to help improve the whiteness of the support.

**bas relief**  A picture with a lineal relief quality produced by printing a continuous-tone positive and negative of the same image slightly out of register.

**base**  See *alkali*.

**base plus fog density**  The *density* of an unexposed area of *film* which has been developed. Also called film base + fog.

**bellows extension**  The maximum extension of a *bellows*; useful for *closeup* photography.

**bellows**  An accordion-pleated, *light-tight,* collapsible unit—made of leather, cloth, or plastic—that in certain *cameras* connects the *lens* to the back of the camera. Its back-and-forth movement permits the lens to be *focused*.

**between-the-lens shutter**  See *leaf shutter*.

**bichromate**  Also called dichromate, it consists of chromium salts such as potassium and ammonium used to produce photographic *images* by the hardening action of light. They are used with the *gum bichromate* and pigment processes *carbon/carbro*. These chemicals are poisonous.

**bleach**  A chemical solution that removes silver photographic *images*; used in producing color *transparencies* and color prints.

**bleed**  In color *processing,* the seeping of dyes beyond *image* boundaries. Also, an image trimmed at the edge of the page or mount board supporting it.

**blocked up**  Describes an extremely *dense* area in an *overexposed* and possibly overdeveloped *negative* so *opaque* that it prevents the passage of *light*. See *burned out*.

**blowup**  Photographic vernacular for enlargement or *projection print*.

**blue sensitive**  An *emulsion* sensitive only to blue and *ultraviolet light* and not sensitive to red or green.

**bounce light**  *Light* that does not come directly from the source but is *reflected* off a surface, producing a soft, diffused, less directional quality.

**box camera**  The first handheld *roll film camera,* introduced in 1888 by George Eastman, consisting of a *light-tight* box fitted with *lens, shutter,* and *viewfinder,* as well as rollers for advancing and registering the *film*.

**bracketing**  As a margin for error, the technique of making, in addition to a "normal" *exposure,* several exposures both over and under the normal.

**built-in meter**  A light meter that is built into the *camera* which enables the *exposure* to be determined while holding the camera.

**bulb**  A *camera exposure* setting (B)

allowing the *shutter* to remain open as long as its release is depressed.

**burned out**  Describes a white area in a *print* that has no detail because the *negative* was *overexposed,* producing excessive *density*. See *blocked up*.

**burning in**  A printing technique for allowing restricted areas of an *image* to receive longer *exposure* while the rest of the *print* is shielded from the *enlarger light*. See also *dodging* and *vignetting*.

**cable release**  A long, flexible, cable-like plunger, an accessory that permits the photographer to release the *shutter* without touching the *camera*.

**cadmium sulfide (CdS) cell**  A receptive agent of *available light* that, by resisting a battery-generated electrical current, functions as a light indicator in some *exposure meters*. See also *selenium*.

**calotype**  A paper *negative process* introduced by W. H. Fox Talbot in 1840 and later called a "talbotype."

**camera**  From the Latin for "room," a *lighttight* box fitted with a *lens* to admit, by the action of a released *shutter,* a selection of *light* rays so as to cause them to form an *image* on a field of light-sensitive material.

**camera obscura**  From the Latin for "dark room," a *lighttight* box or room with a tiny hole or *lens* in one wall that *projects light* rays upon the opposite wall to form there an upside down and reversed *image* of the scene outside. Long used by artists for viewing and sketching, the camera obscura developed into the modern *camera* when materials of suitable light sensitivity had been invented.

**carbon/carbro processes**  Early printing processes that used *light*-sensitive sheets of *gelatin* (tissue) that contained carbon or other pigments, to produce very beautiful and permanent *images*.

**carte-de-visite**  An *albumen* photograph mounted on a card (visiting card) $2\frac{1}{2} \times 4$ inches (6 × 10 cm). These were very popular from the 1860s until the 1880s. They were mass-produced; often pictures of famous people were collected and stored in albums.

**cartridge**  A roll-*film* carrier, sometimes called cassette, that completely encloses the *light*-sensitive material.

**cassette**  See *cartridge*.

**CC filters**  Color Compensation *filters* made of *gelatin*, optically corrected and produced in six colors of various intensities for use in balancing the color of the *light* available for *exposing* color *film* and photographic paper.

**changing bag**  A *lighttight* bag for loading film into developing tanks or *sheet-film holders* without a darkroom.

**characteristic curve**  A graph to show the relationship between the *density* of *film* and *exposure* or *development*. It is also called the D log E curve, the H & D curve, and the sensitometric curve.

**chloride paper** A contact-printing paper that uses silver chloride instead of silver bromide or silver chlorobromide as the *light*-sensitive ingredient in its emulsion. This makes it less sensitive to light than *enlarging paper*. See also *halide*.

**chromatic aberration** A defect of simple *lenses* that causes the *light* rays of different colors to *focus* at different planes, resulting in blurred black-and-white *images* and color images that are fringed or haloed with extraneous color.

**circle of confusion** A tiny, round cluster of *light* rays projected on a *focal plane* by a point of light *reflected* from a subject outside the *camera*. The tighter such clusters are, the sharper the *image*.

**clearing time** The length of time required for *fixer* to clear the cloudy appearance of *film*. Generally it is suggested that film be fixed for twice the time it takes to clear the film.

**closeup** A photograph in which *focus* has occurred, by optical or mechanical means, at a distance of no more than 1½ to 3 or 4 feet (45–90 or 120 cm) in front of the *camera*.

**closeup lens** A supplementary positive *lens* which may be attached in front of a *camera* lens to shorten its *focal length*, thus enabling it to *focus* closer for *closeup* photography.

**coating** A thin, *transparent* film of magnesium fluoride, or other material, applied to *lens elements* to *absorb* extraneous *light*, reduce *flare*, and brighten the *image*.

**cold (cool) tones** A term used to describe the greenish or bluish tones in black-and-white printing papers.

**cold-light enlarger** An *enlarger* that uses a circular fluorescent tube or a tightly wound grid lamp for its light.

**collodion** A *transparent* and glutinous solution consisting of pyroxyl, alcohol, and ether, used as a vehicle for *light*-sensitive *silver* particles and coated onto *emulsion* supports in the 19th-century *wet-plate* process. See *tintype*.

**collotype process** An early printing *process* that used a relief *gelatin plate* to produce a very beautiful and rich ink *image* on paper. It is still being done but on a very limited basis because of the great expense.

**color head** In an *enlarger*, a drawer or slot above the *condenser lenses* designed to contain the *filters* that affect the color of the *exposing light*.

**color sensitivity** The effective response of a photographic *emulsion* to different *wavelengths* of *light*.

**color temperature** A means of describing the color of *light* in terms of its relative warmth (dominance of blue *wavelengths*) or coolness (dominance of red *wavelengths*), which can be measured in degrees *Kelvin*. Applicable only to light sources, such as the sun or a *tungsten* lamp, that emit a *continuous spectrum*.

**coma** A *lens aberration* that causes *light* rays passing diagonally through a lens to form unsymmetrical *image* points on the *film*.

**compaction** A *Zone System* term referring to the decrease of separation of tones (*contrast*) in a *negative* with reduced *development*. Also called contraction.

**compensating developer** A *developer* for *film* which is usually a liquid concentrate that has the characteristic of exhausting itself quickly in a *highlight* area. This permits it to continue to develop in the *shadow* areas while not developing the highlight areas, which reduces excessive *contrast*.

**complementary colors** Any two *hues* of *light* that when combined in the *additive system* reflect all *wavelengths* to produce white; in the *subtractive system*, any two hues that combine to *absorb* all wavelengths and yield black or neutral gray.

**composite** The photographic *image* created when two or more *negatives*, or parts of negatives, are *printed* as one.

**concave lens** See *negative lens*.

**condenser system** In an *enlarger*, a pair of *convex* (positive) lenses whose interfaced relationship enables them to gather rays beamed from the *light* source and spread them uniformly over the *negative* for *projection* through it.

**contact paper** See *chloride paper*.

**contact print** A *print* made by interfacing the *emulsion* sides of a *negative* and a sheet of photographic paper and by *exposing* the paper with *light* beamed through the *negative*.

**contact-printing frame** A wooden frame with a sheet of glass on the front and a removable back with springs. It is used to *contact print negatives* to printing paper.

**contact screen** A device used to convert *continuous-tone* imagery into *halftone* dots for the photomechanical reproduction of photographs.

**contaminate** The accidental mixture of chemicals that produces an undesirable result. For example, if a small amount of *fixer* is mixed into a *developer* solution, *film* developed in this solution will be perfectly clear, a total loss.

**continuous spectrum** *Light* containing measurable quantities of all *wavelengths*, such as the light emitted by the sun or a *tungsten* filament.

**continuous tone** The gradual change of *value* from white through grays to black, as in a photograph.

**contraction** See *compaction*.

**contrast** In black-and-white photography, the differences in the brilliance or *density* from one passage to another that make possible the visibility of an *image*. A contrasty *negative* or *print* is characterized by drastic differences in brilliance or density.

**contrast grade** A number or letter assigned to printing paper by the manufacturer indicating its *contrast*. Number 1 is *flat*, number 5 is *contrasty*, number 2 is normal. S (soft) paper is flat, H (hard) paper is contrasty, M (medium) paper is normal.

**contrast index** A method to describe the minimum and maximum *densities* in film to produce a quality negative. It differs from the *gamma* method in that it considers both the *toe* and *shoulder* portions of the *characteristic curve*, making it more representative of actual situations.

**conversion filters** *Filters* designed to help correct *film* sensitized to one type of *light* (e.g., daylight) for use in a different type of light (e.g., *tungsten*).

**converter** A supplemental *lens* placed between the lens and the *camera* which increases the effective *focal length* of the lens by a factor of 2× or 3×. Additional *exposure* is required and often there is some loss in *sharpness*.

**convertible lens** A lens designed for large-format cameras that enables the front *element* and the rear element to be removed. This changes the *focal length* of the lens.

**covering power** The capability of a *lens* to give, at the largest *aperture*, a sharply defined *image* out to the edges of the *film* it is designed to cover.

**convex lens** A *lens* that is thicker at the center than at the edges; it curves outward. A positive lens. See *real image*.

**Copal Square shutter** The latest type of *focal-plane shutter*; metal leaves create a slit that moves from bottom to top of the *focal plane*. Modular in design, it is more compatible with *cameras* that have built-in electronic *light meters*.

**correction** A word used to describe the design of a *lens* to reduce *aberrations*; also the appropriate color *filter* with color films when photographing under different lighting conditions; also, the use of tilts and swings on a *view camera* to produce a more pleasing rendition of objects.

**CP filters** Color Printing *filters* used to balance, in relation to the *negative* or color *transparency*, the color of the *light exposing* the photographic paper. Because they are made of acetate, CP filters are not optically corrected and must therefore be inserted above rather than below the *enlarger lens*.

**crop** To change the borders of a *print* to exclude extraneous information.

**crystalline** A term describing the physical form of chemicals composed of tiny crystals rather than powder. See also *anhydrous*.

**curtain shutter** Opaque flexible curtains that make a slit when passing the *film* at the *focal plane* to produce the *exposure*.

**curvature of field** A *lens aberration*

causing the plane of *focus* to be curved so that the center and edges of an *image* cannot be focused simultaneously.

**cut film** See *sheet film*.

**cyanotype** An early permanent printing process that uses a light-sensitive compound of iron rather than silver. The resulting prints have an intense blue color and thus are also called blueprints.

**daguerreotype** The first successful photographic *process* and its product (1839), which employed vapors from heated mercury to form an *image* on a copper plate coated with polished silver.

**decamired filter** A series of colored *filters* used when photographing with color films under different lighting situations. See also *mired*.

**definition** The fineness and clarity of detail in an *image* or the capability of a *lens* or an *emulsion* to yield fine detail.

**densitometer** An instrument for measuring the silver deposits in any portion of a *developed* photographic *image*.

**density** In a *negative*, the *light*-stopping power of a blackened silver deposit relative to the light beamed through the negative.

**density range** The numerical difference when the *density* of the *shadow* area is subtracted from the *density* of the *highlight* area.

**depth of field** The zone extending in front of and behind the point of sharpest *focus* throughout which focus seems acceptably sharp and unblurred.

**depth of focus** The small zone in which the *focal plane* (*film*) can be moved away from a focused *lens* without incurring a perceptible loss of *focus* in the *image*.

**desiccated** A term describing chemicals with water removed. See *anhydrous*.

**developer** A chemical solution that acts to change silver *halides* affected by *light* to black metallic silver, thereby converting an invisible *latent image* on *film* into a visible image.

**diaphragm** In a *camera*, a device for regulating the size of the *light*-admitting *aperture* by means of leaves that overlap to expand and contract in circular order; usually placed in the *lens* barrel or *shutter* mechanism.

**dichroic filter** A glass *filter* coated with a thin layer that reflects *light*. Commonly used on color *enlargers* because of the wide range of filtration possible and the resistance of the filters to changing color (fading).

**diffraction** The optical phenomenon of *light* rays bending around the edge of an *opaque* object.

**diffusion** The scattering of *light* rays in all directions, as a result of their *reflecting* off a rough surface or passing through a *translucent* medium.

**diffusion system** In an *enlarger*, a sheet of frosted glass that diffuses rays beamed from the *light* source to spread

them generally over the *negative* for *projection* through it.

**DIN** For Deutches Industrie Norm (German Standards Organization), which evolved a system common in Europe for measuring the *speed* or *light*-sensitivity of photographic materials. Used to mean the system.

**diopter** A unit of measure employed in optics to express the power of a *lens*; usually applied to supplementary *closeup* lenses to indicate their capability for magnification.

**discontinuous spectrum** *Light* in which certain *wavelengths* are not present, such as fluorescent light, in which blue and green wavelengths predominate.

**distortion** A *lens* defect that produces an inaccurate rendition of the shapes in a scene. See *barrel distortion, pincushion distortion.*

**dodging** A technique for lightening part of the *image* in a photographic *print* by briefly shielding that part during the *exposure* of the photographic paper. See also *burning in* and *vignetting.*

**double exposure** Two or more *images* recorded on one *film* or sheet of photographic paper, the record made either deliberately or inadvertently.

**drop out** A high-*contrast image* without grays, usually produced with extreme high contrast *(litho) film,* bleaching, or *opaquing.*

**dry down** This term refers to the *tonalities* of a *print* becoming a little darker and less *contrasty* when it dries.

**dry mounting** A technique of mounting a *print* by applying heat to a sandwich of thin tissue of thermoplastic material interleaved with the print and its mount board or by using a pressure-sensitive adhesive.

**dye couplers** Chemicals present in the three *emulsions* of color *film* that react with *developer* to release dyes and thus color the developed *images.*

**dye transfer** See *matrix.*

**easel** A flat board at the base of an *enlarger* designed to support paper during *exposure,* usually fitted with masking slides to hold the paper flat and in proper position and to frame the *image* inside white borders.

**electromagnetic spectrum** See *spectrum.*

**electronic flash** An *artificial light* produced by storing electricity in a capacitor and then discharging it through a glass tube filled with an inert gas (xenon). This intense flash is repeatable, has a very short duration ($\frac{1}{1000}$ of a second or less), and is the same color as daylight.

**element** A single piece of glass in a complex *lens.*

**Elon** A chemical (Eastman Kodak brand name) used as a developing agent in many developers.

**emulsion** A coating of *gelatin* in

which are suspended the *silver* salts that make *film* and paper *photosensitive.*

**enlargement** See *projection print.*

**enlarger** An apparatus for *projecting light* through a *negative* so as to *expose* light-sensitive paper and *print* the *image* at a *scale* either larger or smaller than the negative.

**enlarging paper** A printing paper that uses silver bromide or silver chlorobromide as the light-sensitive ingredient. This type of paper is more sensitive to light than contact-printing paper and is used for making enlargements (in *projection printing*). See also *halide.*

**EVS** A system (which never became very popular) to integrate the *ASA* of the *film,* the *aperture,* and *shutter speed* into one operation.

**existing light** See *available light.*

**expansion** A *Zone System* term referring to the increased separation of tones *(contrast)* in a *negative* with extended *development.*

**exposure** The effect that *light* has on *photosensitive* material; also the product of the intensity of light and the time during which it affected the *photosensitive* material.

**exposure factor** The number to multiply the indicated *exposure* by to compensate for a change in exposure such as when using a *filter* or *bellows* unit.

**exposure index** The number *(ASA* or *DIN)* suggested by a film manufacturer to use for setting a light meter in order to determine the proper camera adjustments to produce correctly exposed film.

**exposure latitude** The degree of *exposure* variance possible without detriment to *image* quality. See *reciprocity law.*

**exposure meter** See *light meter.*

**extension tubes** *Lighttight* tubular rings designed to extend the distance between the *lens* and the *focal plane* and produce *image* magnification.

**F** The symbol for *flash synchronization* on *shutters* on older cameras. No longer applicable because the *flashbulbs* it was designed for are no longer available.

**Farmer's reducer** A solution that lowers the *density* of the *silver image* in a *negative* or *print.*

**fast** *Film* or paper that is highly sensitive to *light;* also a *lens* with a small *f-number,* one capable of admitting a great deal of light into the *camera.*

**ferrotype** The *tintype* process, so named for the iron in the plates used (1860s); now the technique of giving a glossy finish to the *emulsion* surfaces of photographic *prints* by squeegeeing them to dry with the emulsion side flat against a polished metal surface, often stainless steel.

**fiber-based paper** A term often used to describe photographic paper with a *baryta coating* as opposed to *resin-coated* (RC) papers.

**field camera** A large-format *sheet-film camera* ($4 \times 5$, $5 \times 7$, $8 \times 10$ inches; $10 \times 12.5$, $12.5 \times 17.7$, $20 \times 25$ cm) which folds up into a neat, compact package suitable for easy transportation.

**fill light** A *light* or *reflector* used to fill in the shadows produced by the *main light* to reduce the *contrast* of lighting.

**film** A sheet or strip of thin, flexible, *transparent* material (acetate or polyester plastic) coated on one side with a *light*-sensitive *emulsion* capable of recording an *image* as a result of *exposure* in a *camera.*

**film base + fog (fb + f)** See *base plus fog density.*

**film holder** A *lighttight* device to hold two sheets of film for exposing in a view or press *camera.*

**film pack** A metal device that fits into a special adapter for a $4 \times 5$ *view camera.* The packet holds sixteen pieces of *film* with paper tabs which pull out to move the next sheet of unexposed film into position for *exposure.*

**filter** A piece of *transparent* material, *gelatin,* glass, or acetate, that when placed in front of the *light* source can, through its color or structure, affect the *exposure* of *photosensitive* materials by *absorbing* some *wavelengths* while passing others.

**filter factor** The number by which correct *exposure* without filtration must be multiplied in order to maintain the same effective exposure with a *filter.* The factor increases exposure to compensate for the *light* withheld by the filter.

**fisheye** An extremely *wide-angle lens,* covering a field of about 180° and reproducing a circular *image* with pronounced *barrel distortion.*

**fix** In *film* and *print processing,* to render a photographic *image* stable by desensitizing the *emulsion* in a fixing bath or *hypo,* which dissolves all *silver halides* not converted by the *developer* to black metallic silver.

**fixer** or **fixing bath** See *fix.*

**flare** Halos around photographic *images* and other types of bright patches caused by extraneous *light reflections* inside the *lens* or along the edge of the *lens hood* or mount.

**flash** A light source that is coordinated with the camera's *shutter* mechanism to provide, for purposes of *exposure,* a brief intense flash of light.

**flash bar** or **cube** These are multiple *flashbulbs* in one unit—the bar has ten, the cube has four. Each bulb has its own *reflector,* and they fire sequentially.

**flashbulb** A special bulb that contains a combustible material that is ignited by electricity. It produces a single flash of intense *light.*

**flashing** The *exposure* of *film* or printing paper before or after the *image* exposure to a dim light for a very short period of time to reduce its *contrast.*

**flash synchronization** The ability of the *shutter* timing to be adjusted in order to be open when the *flashbulb* is at its peak of brilliance or when the *electronic flash* occurs.

**flat** A term describing a photographic *print* image with low *value contrasts.*

**f-number** The numerical expression of the relative size of the *light*-admission opening in the *lens,* an expression derived from the lens' *focal length* divided by the effective diameter of the lens. Each lens is capable of a series of *apertures,* often termed f-stops.

**focal distance** The distance from the *lens* to the plane where the *image* is *focused.*

**focal length** The distance from the *lens* to the plane of *focus* when the lens is focused at *infinity.*

**focal plane** The surface where *light* rays fall and come together to form an *image;* the *film* inside the *camera.*

**focal-plane shutter** A *light*-controlling mechanism installed along and just foward of the *focal plane* of the *camera* that allows *film* to be *exposed* progressively through a slit of adjustable size formed by one or more roller blinds moving parallel to the focal plane.

**focus** The point inside the *camera* where *light* rays converge to form a clear and sharply defined *image* of the subject in front of the camera. To adjust the camera to achieve this result.

**focusing cloth** A piece of black cloth used to cover the *ground-glass* area when focusing and composing with large-format cameras.

**focusing hood** A hood attached to the rear of some brands of *view cameras* that contains a mirror and magnifier that permit the *image* on the *ground glass* to be seen magnified, right side up, and more clearly and conveniently than when a *focusing cloth* is used.

**fog** A veil-like *density* in the *negative* or *print* deriving from extraneous *light* or chemical action.

**frilling** The release of the *gelatin emulsion* around the edges of *film* or paper generally caused by too hot solutions or prolonged immersion in water.

**f-stop** See *f-number.*

**gamma** A method using the slope of the *straight-line* portion of the *characteristic curve* to calculate a number (gamma) that relates the *exposure* of *film* to its *development (contrast).*

**gelatin** A jelly-like protein substance isolated by boiling the hides, horns, bones, and hooves of animals and used as a binder for the *halides* contained in *light-sensitive emulsions.* Its transparent and flexible nature, plus its ability to absorb water, makes it ideal for other purposes as well, including the top protective layer of *film,* the support for the dyes in *filters,* and for many of the nonsilver processes such as *carbon/carbro processes.*

401

**glacial acetic acid**  A concentrated form of *acetic acid.*

**glare**  See *polarized light.*

**glossy**  A term referring to the shiny mirror-like surface of printing papers.

**goo**  Slang for an alkaline chemical used in the diffusion process by which *developer* is activated in Polacolor *film.*

**gradation**  A range of *values* or *tones* from the white through gray to black.

**gradient**  Refers to the slope of the *characteristic curve.*

**grain**  Particles and clumps of black metallic silver that form a *developed* photographic *image* and become visible under a microscope or in an enlargement.

**gray card**  The Kodak Neutral Test Card prepared to offer a standard in the form of an average gray (one with 18 percent *reflectance*) by which reflected *light* can be measured or color balance compared for the purpose of controlling the tonal or color quality of photographic *images.*

**gray scale**  A printed rendition of a standardized *scale* of *tonal values* arranged in a *gradation* of ten steps representing the degrees of *reflectance* possible in nature, from lighter to darker around a median or average gray. See *gray card.*

**ground glass**  In *view* and reflex *cameras,* a plate of glass frosted on one side to provide a *translucent screen* capable of stopping *light* rays to reveal the *image* formed on the *focal plane.*

**guide number**  A number used to determine the *exposure* when using *flashbulbs* or *electronic flash.* The guide number is divided by the distance from the *light* to the subject to arrive at the appropriate *f-number.*

**gum bichromate**  An early nonsilver process in which the *image* is formed by a hardening process rather than *development.* An *emulsion* consisting of gum arabic and colored pigments is sensitized with a *bichromate* (potassium bichromate) and applied to paper. The *exposure* to *light* hardens some areas while the nonexposed areas wash off in water, producing the image.

**halation**  Blurring or halos around *images* produced by excess *light* passing through the *film* and *reflecting* back from the film support. See *antihalation backing.*

**halftone**  A term used by engravers and printers for a process that simulates the *continuous tone* or tonal *gradation* characteristic of photographic *images* (and actual subjects) by means of a regularly patterned *screen* of dots whose size is proportional to the *density* of the original image. Also often used as a synonym for "photograph."

**halide**  A compound of one of the halogens, such as bromine, chlorine, and iodine, with silver that provides the

*light*-sensitive material fundamental to photographic processes.

**hanger**  A metal or plastic device to hold *sheet film* during *processing* in tanks.

**hardener**  A chemical such as potassium or chrome alum, used in one of the *processing* solutions, or separately, to firm and toughen the *gelatin* of a photographic *emulsion* after it has been *developed.*

**H & D curve**  Another name for the *characteristic curve;* named for Hurter and Driffield, who introduced this curve.

**highlights**  The brightest portions of a photographic *image,* which appear *dense* or dark in the negative and light gray or white in the *positive.*

**hotspot**  A term referring to the uneven distribution of *light,* as when light is brighter at the center.

**hue**  The property of a color that distinguishes it from another color, as red, green, blue, etc.

**hydroquinone**  A chemical used as a *developing* agent.

**hyperfocal distance**  The distance in front of the *camera* from the *lens* to the nearest limit of *depth of field* when the lens has been *focused* on *infinity.*

**hyperfocal focusing**  A technique for extending *depth of field* by *focusing* on the *hyperfocal distance,* which enlarges the scope of focus to an area extending from one-half the hyperfocal distance to *infinity.*

**hypo**  Photographic slang for sodium thiosulfate (discovered in 1819 by Sir John Herschel), a chemical compound used in *fixing baths* to dissolve the undeveloped silver salts remaining in an *emulsion* after *development.*

**hypo eliminator**  A Kodak formula which removes residual *hypo* from *film* or paper.

**hypo neutralizer**  A solution that helps to change residual *hypo* in a *negative* or *print* into a compound that is less likely to react with the silver *image* and is also more easily washed out (clearing bath).

**image**  A two-dimensional representation of an object or subject in nature realized by photographic means.

**incandescent light**  Illumination generated by a heated substance, such as the glowing filament of a *light* bulb, which derives its energy from electric current.

**incident light**  *Light* falling on a subject before it has been *reflected* by the subject.

**incident-light meter**  A light meter that reads the light falling on the subject. See *incident light.*

**indoor film**  A color *film* made to be exposed with either 3200° K or 3400° K bulbs, not daylight.

**infinity (∞)**  In photography, the area farthest from the *camera* in which objects are rendered by the *lens* in sharp *focus.* This usually begins at 40 or 50 feet (12 or 15 m) in front of the camera

and continues into the distance as far as 300 yards (275 m). Infinity focusing derives from the phenomenon of *light* rays seeming to travel parallel to each other over great distances rather than at angles to one another, as over short distances.

**infrared**  A band of *wavelengths* in the electromagnetic *spectrum* next to and longer than those for red and too long to be visible, but detectable by specially sensitized photographic materials.

**inspection**  A method, which requires experience, by which black-and-white *film* may be inspected with a very dim *safelight* for very short periods of time during *development.*

**intensification**  A "last-resort" chemical means of increasing *density* or *contrast* in *negatives.*

**intensifier**  A chemical solution used in *intensification.*

**interval timer**  A *timer* that may be preset for periods of time and produces an audible sound at the end of each period. It is used when developing *film* in total darkness.

**inverse square law**  A physics law that applies to the distribution of *artificial light* when using photofloods, *flashbulbs,* or *electronic flash.* It states that the intensity of the light is inversely proportional to the square of the distance from the light source to the subject. (When the distance doubles, the amount of light is one fourth.)

**Kelvin**  For W. T. Kelvin (1824–1907), who devised a system now used for measuring the *color temperature* of *light* sources. Its units, called degrees Kelvin, are numerically equal to degrees Celsius plus 273.

**key light**  A term for the *main light.*

**lamp**  *Artificial-light* source, usually powered by electric current.

**lamp housing**  The *lighttight* and ventilated chamber containing the *light* source in an *enlarger* or projector.

**latent**  The invisible state of the *image* formed in *light-sensitive emulsion* by *exposure* until such time as it has been acted upon by *developer.*

**leader**  A strip of *film* or paper used for threading film in a *camera.*

**leaf shutter**  A mechanism for controlling *exposure,* usually located in the *lens* or just behind it, whose assembly is a concentric arrangement of overlapping metal leaves that, when activated, rotate toward the outer rim of the circle, thus admitting *light,* and then close.

**lens**  A solid, shaped piece of transparent material, or an assembly of such pieces, that can gather and select *light* rays *reflected* from a subject and modify their behavior so that they enter the *camera* and travel toward the *focal plane* to form there an *image* of the subject from which they came.

**lens hood**  A detachable accessory for the *camera* designed to shield the *lens*

from the extraneous *light* capable of creating the problem of *flare.*

**lens mount**  The part of the *camera* housing the *lens* and all its *elements.*

**light**  Energy emitted in wave-like pulsations from the sun that forms the visible part of the electromagnetic *spectrum.* Illumination.

**light meter**  An instrument for measuring the intensity of the *light* falling on or *reflecting* from a subject and for indicating this in terms of *camera exposure* settings for the *speed* of the *film* used.

**lighttight**  Capable of excluding all light.

**light trap**  A device such as a baffle or double doors to permit entrance to and exit from a darkroom without disturbing the illumination in the room.

**litho film**  A high-*contrast* (maximum-contrast) *film* available in sheets for large-format cameras; primarily used for the photomechanical reproduction of type or photographs.

**long lens**  A *lens* whose *focal length* is at least twice that of the *normal lens* for a particular *camera.* It produces a larger *image* on the *negative* than a normal lens and optically reduces the depth of space separating objects located in the field before the camera. Such a lens can render a clear and large image of subjects relatively distant from the camera. A long-focal-length lens.

**luminance meter**  A term for a reflected-*light meter.*

**M**  The symbol used for *flashbulb synchronization* on a *shutter.*

**Mackie line**  The light line produced between extreme light and dark areas when *solarizing* a *negative* or *print.*

**macro lens**  A *lens* capable of extending *focal distance* so as to achieve the *image* magnification required for *closeup* photography.

**macrophotography**  The photographing of objects *closeup* when the *image* size in the *camera* is the same size (1:1) or larger than the actual object.

**main light**  A term used when arranging studio lighting to describe the brightest and most dominant light that casts shadows to produce modeling.

**masking**  A means to delete or alter areas in a photographic image. It may consist of an *opaque* material that blocks out areas for printing or it may be a silver *image (film)* that when placed in register with a color *transparency* or color *negative* alters the color or *contrast* of the resulting prints.

**mat**  A cardboard frame serving to border, isolate, enhance, present, and protect a photographic *image.* In photographic paper, an *emulsion* surface textured to be dull and not *reflective.*

**mat knife**  A knife with a large handle and interchangeable blades for cutting *mat* board.

**matrix**  In the dye-transfer process, a

402

relief *image* in *gelatin* corresponding to the *values* of red, green, or blue light *reflected* from the subject. Each is dyed the color *complementary* (yellow, magenta, or cyan) of the exposing *filter* and then transferred separately in *registration* to a suitable paper base that absorbs the dye. Each matrix is removed before the next one is placed down. All three dye layers superimposed create a full-color photographic image of high quality.

**Metol** A chemical used as a developing agent with hydroquinone in MQ developers.

**microprism** A device in the viewing screen in some *single-lens reflex* cameras that enables the method of focusing to be similar to that of a *rangefinder.* In the center of the viewing screen is a circle with an image split when out of *focus* that comes together when the camera is in focus.

**midtone** A term referring to the middle-gray areas of a *negative* or *print.*

**mired** A unit of measurment used when evaluating the *filter* needed with color *film* balanced for one light source when using it with another light source. See also *decamired filter.*

**mirror optics** An optical system employing curved mirrors, rather than glass elements, to form *images.* Converging *light* by internal *reflection,* rather than through *refraction,* mirrors eliminate *chromatic aberrations.*

**monobath** A single solution containing both *developer* and *fixer* for rapid *processing.*

**monochrome** A single color.

**motor drive** An electric motor available as an accessory or built in on some 35mm and 120 *single-lens reflex* cameras which makes possible rapid sequences of *exposures.*

**mottling** A nonuniform distribution of tones in a *negative* or *print* caused largely by improper agitation during development.

**MQ** The abbreviation for developers which have Metol and hydroquinone.

**negative** A *developed* photographic *image* in which the subject's *value tonalities* have been reversed from light to dark and dark to light. Usually, the image on *transparent film* from which a *print* is made. In optics, a concave lens. See *negative lens.*

**negative carrier** A frame for holding the *negative* inside an *enlarger* so that it can be *printed.*

**negative lens** A *lens* that is thinner in the center than at the edges, causing the light to diverge instead of converge, preventing it from forming an *image* on a piece of *ground glass.* See *virtual image.*

**neutral-density filter** A colorless *filter* toned a uniform gray and designed to reduce the brilliance of the *exposing* light without altering its color.

**normal lens** A *lens* that produces basically the same coverage of a scene as our eyes when at the same distance from the subject. The *focal length* varies for different *film* sizes.

**one-shot developer** A developer for *film* that is usually prepared by diluting a *stock* solution into a *working solution;* it is used once and then discarded.

**opal bulb** A type of bulb specifically for *enlargers.*

**opaque** The characteristic of matter that makes it resist the passage of *light.* Also, a tempera paint that when applied to a *negative* can block the passage of light.

**open flash** A method for using *flashbulbs* or *electronic flash* when *shutter synchronization* is not possible. It consists of opening the shutter (assuming the level of the *light* is too low to produce an independent exposure and the subject is not in motion) and then firing the flash.

**orthochromatic** Sensitive to the *wavelengths* for all colors but red.

**overexposure** Too much *light* striking *photosensitive* material.

**oxidation** A chemical reaction in which a compound reacts with oxygen, as when silver *halides* combine with oxygen during the *development process* to produce silver. The loss of a developer's activity due to exposure to oxygen in the atmosphere (why the developer turns brown sitting in a tray). It also is the reason for capping and removing all air from a developer storage bottle.

**pan** To swing the *camera* during *exposure* to follow a moving subject.

**panchromatic** Sensitive to the *wavelengths* for all colors in the visible *spectrum.*

**parallax** The discrepancy between the view presented to the eye through a *camera's* sighting device and that recorded by the camera's *lens.*

**perspective** The representation of a three-dimensional subject in the two dimensions of a flat surface.

**perspective-control lens** A *wide-angle lens* made for 35mm *single-lens reflex* cameras that may be moved slightly off the lens axis, producing the same movement as the *rising front* or sliding front on a *view camera.* It is useful for photographing architecture.

**photogram** A photograph made without any *film* or *camera* by placing an object directly on the printing paper and then exposing it. The areas blocked by the *opaque* object will be white and the exposed areas will be black or shades of gray depending on the exposure.

**photogravure** A printing process that through mechanical and chemical means converts the *image* to be reproduced into tiny depressed dots (intaglio) on a zinc or copper printing *plate.* These pits are then filled with ink and a scraper or wiper mechanism removes all of the ink from the surface of the plate. When the plate is placed in contact with paper under extreme pressure, the ink transfers to the paper, producing a richly printed image. This process is still used today for high-quality printing (rotogravure), as well as on a smaller scale (sheet-fed gravure) or by printmakers who use etching printing presses.

**photomontage** Multiple imagery made by combining the imagery of one negative or transparency with another. A photomontage may be assembled by cutting out pieces of one print and pasting them together with another in collage fashion or by combining them with numerous exposures on one piece of printing paper.

**photosensitive** Chemically responsive to the action of *light.*

**pincushion distortion** An optical *aberration* that reproduces squares as if the sides were curving in. The opposite of *barrel distortion.*

**pinhole camera** A *camera* whose *aperture* is not a *lens* but a tiny hole in an *opaque* material.

**plate** A term used to refer to glass photographic *negatives.* Also a metal plate used in the printing industry with a light-sensitive *emulsion* on it.

**platinotype (platinum paper)** An early and very permanent printing paper that produces a very long and delicate *tonal scale.* It uses a compound of platinum rather than silver, making it considerably more expensive than regular printing paper. Although it is no longer manufactured, some contemporary photographers make their own.

**pola filter** A *filter* that by means of its structure, not its color, can block *polarized light* to prevent its entering the *camera* or can actually polarize light before admitting it into the *lens.*

**polarized light** The phenomenon of glare or *light* whose vibrations emanate from highly *reflective* surfaces and occur in a single plane, instead of in several.

**portrait attachment** Another name for *closeup lens.*

**positive** A photographic *image* whose colors and/or *tonal values* correspond to those in the original subject. The opposite of a *negative.* Also, a *convex lens.*

**posterization** A technique used in the darkroom in which a *negative* or *positive* is exposed to several sheets of *litho film* at different *exposures* to produce high-contrast records of the different tones. These litho records are then *contact-printed* to produce reversals. The negative and positive litho films are used in *register* or out of register to produce black-and-white or color prints that have the visual quality of a poster.

**preservative** A chemical—often sodium sulfate—used in a *developer* formula to slow down the rate of *oxidation;* also added to some *fixer* formulas.

**presoak** A water bath before *development* used to reduce the possibility of air bubbles and to produce more even development in *film.*

**press-focus** A lever or button on the *lens* for *view cameras* that opens the *shutter* for *focusing* and composing no matter what shutter speed it is set for. This eliminates constant changing of the shutter speed to B or T.

**primary colors** In *light,* red, green, and blue, or the *hues* that together add up to create *white light* (all color) in darkness, where no light existed, and that in various combinations are capable of creating any other hue.

**print** The photographic *image* in its final, *positive* state when it has been reproduced on sensitized paper by means of *light projected* through a *negative.* Also, the photographic *process* of making such a print.

**printing-out paper** A term referring to special printing paper which produces an image without *development.*

**prism** A solid triangular form made of *transparent* material and bounded on two sides by polished surfaces whose straight planes are inclined toward one another so that a beam of *white light* entering from one side is *refracted* or bent by the angle of the second side to exit as an array of the component *wavelengths* or colors of white light. The capability of shaped transparent material to affect the behavior of light constitutes one of the principles fundamental to the photographic *process.*

**process** In photography, the sequence of steps by which *light* and light-sensitive materials can be caused to reproduce an *image* of a subject.

**process lens** See *apochromat.*

**projection** Controlling *light* so as to shape its beam and direct it toward a specific target, the *focal plane,* to which are conveyed the colors and/or forms present in any *transparent* medium introduced into the beam.

**projection print** A print made by projecting the *image* from a *negative* onto the printing paper; an enlargement is a projection print that is larger than the negative.

**proofing** The procedure for making *contact prints* of all the *negatives* from one roll of *film.*

**push** A term referring to overdeveloping *film* that was *underexposed.*

**pyro** A chemical *(reducing agent)* used in many early *film developers;* it is still used by some photographers who prepare their own developers.

**racked out** A term referring to a *bellows* on a *view camera* or a bellows unit that is extended to its maximum.

**rangefinder** A device used in a *viewfinder* that consists of an optical system in which two views of the subject can be made to coincide for finding the distance to the subject. See *superimposed rangefinder.*

**real image** An *image* capable of being *projected,* as by a *positive lens,* on a surface, such as the *ground-glass screen* at the back of a *view camera,* and there made visible to the naked eye. See *virtual image.*

**reciprocity failure** See *reciprocity law.*

**reciprocity law** The principle holding that *exposure* is the product of *light* intensity and time, which means that exposure changes in proportion to changes in either intensity or time. Thus, if in the second of two exposures intensity is doubled and time halved, the black metallic silver produced on *development* should be the same in both *negatives.* However, reciprocity failure occurs in disproportionate combinations, such as the long times required for low light or the high intensities needed for exposures of very brief duration.

**reducer** A chemical solution capable of reducing the *density* of a *negative* or *print* by dissolving some of the silver forming its *image.*

**reducing agent** A *developer* ingredient that converts a *latent image* in *film* or paper by supplying additional electrons to the ions of exposed *halides* in the *emulsion* to lessen their positive charge.

**reel** A plastic or metal device that has parallel spirals and grooves onto which *roll film* is wound before being placed in a *tank* for processing. The design of the reel keeps any one surface of the film from touching another.

**reflect, reflectance,** and **reflective** See *reflection.*

**reflected-light meter** A type of *light meter* that measures the *light* being *reflected* from the scene.

**reflection** The rebounding of *light* rays as a result of their having struck a surface. Also, the *image* seen by reflection in such gleaming surfaces as those on mirrors and water.

**reflector** A surface used to control rays from a *light* source and direct them with minimum loss to fall on the subject to be illuminated.

**refraction** The bending of *light* rays caused by their passing obliquely from one *transparent* medium through another of different density.

**register** In photography, to superimpose *images* so that they coincide and align perfectly either as a single image or in whatever way may be desired.

**replenisher** A relatively concentrated chemical solution added to *developer* to restore the strength exhausted by *processing.*

**resin-coated (RC) paper** A printing paper with a plastic coating that reduces the amount of liquid chemicals the paper absorbs, enabling *prints* to be washed and dried quickly.

**resolving power** The ability of a *lens* to record or of an *emulsion* to reproduce fine detail.

**restrainer** A chemical such as potassium bromide which is added to *film developer* to help prevent it from developing the unexposed silver *halides.*

**reticulation** A wrinkled surface of processed *emulsion* resulting from the expansion and contraction that drastic temperature changes or strong chemical action can cause.

**retro-focus lens** A *lens* (usually a *wide-angle lens* for a *single-lens reflex camera*) designed to keep its *elements* out of the way of the moving mirror.

**reversal** The process of converting a *negative image* to a *positive* one, as well as the other way; this principle is basic to all photography, but especially to color photography.

**rim light** Refers to the *light* outlining a subject with *back lighting.*

**rising front** A movement on a *view camera* which allows the *lens* to be raised; often used in architectural photography to include more of a building.

**roll film** Generally refers to film that comes in roll form rather than sheets.

**Sabatier effect** See *solarization.*

**safelight** Darkroom illumination of a color and intensity that are not likely to affect, within an allowable period, the *sensitivity* of the photographic materials being *processed.*

**saturation** The intensity and/or purity of a color, its relative brilliance (high saturation) or softness (low saturation).

**scale** A sequential arrangement of *values* from light to dark or small to large; the relative size of an object or *image.* Also, to make an image larger or smaller than its *negative* by adjusting the distance between the *light* source in an *enlarger* and the *focal plane* where the image is *projected.*

**scale focusing** Focusing a *camera* by setting the distance from the subject on the distance scale by estimating or actually measuring the distance from the camera to the subject.

**scattering** The *diffusion* of *light* rays by water vapor and atmospheric haze, producing the blue light of the sky and the reds and oranges of a sunset.

**screen** A sheet of glass or plastic bearing a regular pattern of dots or lines designed to break up an *image* for photomechanical reproduction as a *halftone;* the *ground glass* at the back of a *view camera* on which *focusing* and viewing occur; a surface on which images can be *projected* for viewing.

**secondary colors** In *light,* yellow, magenta, and cyan, or the *complementaries* of the *primary colors* blue, green, and red; distinct *hues* each containing equal portions of two primaries; and hues that themselves are primary in the *subtractive system* of color reproduction.

**selenium** Like *cadmium sulfide,* an agent in some *light* meters for providing an electrical measure of *available light.*

**sensitivity** The description of the ability of a *light*-sensitive *emulsion* to react to *exposure.*

**separation** The *process* of analyzing the colors of a subject into three black-and-white records, one each for the *values* of red, green, and blue, made by photographing the subject through *filters* of those colors. Also, the qualities that differentiate elements in an *image,* such as dark forms against a light ground.

**sharpness** The quality of an *image* as seen in a *camera,* in a *negative,* or in a *print* that shows the rendition of the scene clearly defined.

**shadow** The darkest portions of a photographic *image* that appear clear on a *negative* and black on a *print.*

**sheet film** A type of *film* in sheet form for large-format cameras.

**sheet-film holder** A device to hold two sheets of *sheet film* for *exposure.*

**shifts and swings** The movements possible with a *view camera* to control *perspective* and *depth of field.*

**short lens** A term for a short-focal-length (wide-angle) lens. See *wide-angle lens.*

**short stop (acid stop bath)** See *acetic acid.*

**shoulder** The upper portion (high *density*) of a *characteristic curve* that begins to flatten out, representing the *highlight* area of a *negative.*

**shutter** A mechanical system for controlling the time variable of the *exposure* of *film.*

**shutter release** The button or lever which operates the *shutter.*

**shutter speed** The length of time the *shutter* is open, producing *exposure.* The numbers on a shutter speed dial indicating the various shutter speeds.

**silicon photo-diode** A type of light sensor used in some *built-in light meters* on *SLR* cameras.

**silver halide** See *halide.*

**single-lens reflex (SLR)** A *camera* that has a built-in movable mirror at an angle to reflect the *light* from the scene through the *taking lens* and a pentaprism to a viewing screen. When the *shutter release* is pressed, the mirror flips up, allowing the light to pass through and *expose* the *film.*

**slide (dark slide)** A piece of black *opaque* material used to protect *sheet film* from *exposure* while in the *film holder.* A term for a 35mm *transparency.*

**slow** *Film* or paper that has relatively low sensitivity to *light.* Also, a *lens* with a large *f-number,* one relatively incapable of admitting a great deal of light into the *camera.*

**SLR** The abbreviation for *single-lens reflex* cameras.

**sodium thiosulfate** See *hypo.*

**soft** A term for *prints* and *negatives* low in *contrast* or for printing papers made to yield low-contrast *images.*

**soft focus** A blurred or slightly out-of-*focus* photographic *image,* often a quality deliberately sought.

**solarization** The *reversal* of *tones* that occurs as a result of extreme *overexposure.* More often used to mean the Sabatier effect, the partial reversal produced when a *negative* or *print* is exposed briefly to a dim light in the darkroom during *development.*

**spectrum** The systematic arrangement of electromagnetic *wavelengths* from short X and gamma rays to radio waves measuring as much as 6 miles in length; more specifically, the array of colored bands composing the visible portion of the electromagnetic spectrum known as *light.*

**speed** A term for the relative *light sensitivity* of photographic materials; also for the light-admitting capabilities of *lenses.*

**spherical aberration** An *aberration* in a simple *lens* that produces a rather sharp *image* in the center of the picture that becomes progressively *soft* toward the edges. *Stopping down* a lens or using a lens with more than one *element* helps to reduce the problem. Some lenses specifically for portraiture are not corrected for this aberration because this type of softness is desired.

**spot meter** A special-purpose *light meter* for measuring *light* as it is *reflected* from a small part of the subject.

**spotting** Painting over and bleaching out defects in a photographic *print* so as to improve its appearance.

**spotting colors** Water-soluble dyes used to eliminate spots on a print.

**spring back** The device that includes a *ground-glass* viewing screen and springs that hold the *film holder* securely in place on a large-format *camera.*

**stabilization** A system that enables *prints* to be made quickly and conveniently which requires a special type of printing paper, a special machine, an *activator,* and stabilizer solution. The exposed print is put in a machine that uses the activator solution to produce the image and then a stabilizer to make the image less sensitive to light. The resulting print is not permanent because it is contaminated with chemicals.

**stain** Usually a yellow or tan area on a *print* caused by exhausted or contaminated *developer* or insufficient *fixing* and washing.

**step tablet** A piece of *film* that has a series of graduated *densities* of approximately equal increments, or a paper *print* with areas ranging from white to black.

**stock** Chemical *processing* solution in concentrated form intended to be diluted for use. Also, the material, such as paper or plastic, used as the support for photographic *emulsion.*

**stop bath** See *acetic acid.*

**stop down** To reduce *exposure* by ad-

404

justing the *camera* to a smaller *aperture.*

**straight-line portion** The part of a *characteristic curve* between the *toe* and *shoulder* that is straight and represents *densities* in direct proportion to *exposure.*

**strobe** For stroboscopic, an *electronic flash* whose capability to fire repeatedly and rapidly, for the purpose of producing a high-intensity *exposure light,* derives from energy stored in a charged condenser.

**subbing** In a sheet of *film,* an adhesive *gelatin* securing the *emulsion* to its backing.

**subtractive colors** In light, those *hues* known as the *secondaries*—cyan, magenta, and yellow, or the *complementaries* of the *primary colors* red, green, and blue—that give the effect of specific color by subtracting from the totality of *white light* all *wavelengths* but those for the color revealed. Because they function in white light—unlike the *additive colors,* which create color only in darkness where no color existed—the subtractive "primaries" are the basis for modern processes of color reproduction.

**subtractive principle** or **system** See *subtractive colors.*

**superimposed rangefinder** The type of *rangefinder* with two images that overlap in the center area of the *viewfinder.* The *camera* is properly *focused* when the two images are made to coincide because the viewfinder is coupled to the focusing mount.

**supplementary lens** See *closeup lens.*

**synch cord** A short piece of insulated wire that connects a flash unit with a *camera* so that the flash operates with the *shutter.*

**synchronization** See *flash synchronization.*

**synchro-sun** Using *flashbulbs* or *electronic flash* to fill in the shadows of a subject being photographed in sunlight.

**tacking iron** A small electric iron used for attaching dry-mount tissue to a *print* when *dry mounting.*

**talbotype** See *calotype.*

**taking lens** The *lens* on the *camera* that is used for *exposing* the *film.*

**tank** The container to *develop film* in; it is usually designed so that solutions may be poured in or out with the room lights on.

**telephoto lens** A *long lens* exceeding 200mm that is specially designed to be physically shorter in length than the indicated *focal length* in order to reduce the size and weight of the lens.

**test print** A *print* exposed segmentally so that each succeeding strip-like section receives a constant multiple of the *exposure* allowed the immediately preceding one. From the visual evidence this provides, the photographer can determine the desired exposure and *contrast* for the final print.

**thin** A term referring to an *underexposed* area (with less *density*) in a *negative* which lets a lot of light go through to expose the paper.

**thin-emulsion film** A special group of *slow films* for 35mm *cameras* that are extremely fine *grain,* but have a tendency to be *contrasty.*

**time exposure (T)** *Exposure* made with the *shutter* set at T, which causes the shutter to remain open after it has been pressed for release until it is pressed a second time. This permits exposures of durations longer than those made by the automatic settings.

**time and temperature** The two variables by which it is possible to control the results obtained in the *film-development process.* Manufacturers distribute charts indicating time-temperature relationships for given materials. Photographers can themselves make charts based on their own experience and objectives.

**timer** A mechanical or electronic type of clock that makes a sound or turns off electricity at a preset interval.

**tintype** A photographic process (ferrotype) introduced in 1852 that recorded *images,* usually portraits, on wet *collodion emulsion* coated on a japanned metal plate.

**TLR** The abbreviation for *twin-lens-reflex* cameras.

**toe** The *shadow (underexposed)* area of the *characteristic curve* that is between *fb + f* and the *straight-line portion* of the curve.

**tonal scale** The range of tonalities in a photographic *print.*

**tonality** The overall quality of gray in a photograph, its range of *values,* or the quality of its color.

**tone, tonal** See *tonality* and *toning.*

**toner** A chemical bath used in *toning.*

**tone-line** A technique involving *positives* and *negatives* (either *continuous tone* or *high contrast*) of the same *image* superimposed on each other and used to *expose* a piece of high-contrast light-sensitive material with a light source at a 45° angle. In another method, a regular light source (90° angle) is used by having the two images slightly out of *register.* The result of both methods is a print with a line-drawing feeling.

**toning** Using a *toner* to enhance the tonalities of a *print,* make its *image* more permanent, or change its color.

**translucent** The character of a medium that makes it neither clear nor *transparent* nor altogether *opaque,* the quality that permits the material to pass *light* but to scatter its rays and create a *diffusion* of light.

**transmission** The passage of *light* through a *transparent* or *translucent* medium.

**transparency** A photographic *image*

in a medium, such as *film,* whose transparency permits it to be *projected* by means of *light* beamed through it.

**transparent** Capable of transmitting *light* without scattering its rays.

**tripod** A three-legged support for stabilizing a *camera* while permitting it to be tilted, turned, raised, or lowered.

**TTL** The abbreviation for "through-the-lens" type *light meters* which are usually on 35mm or 120 *single-lens reflex* cameras.

**tungsten** In photography, a general term for artificial illumination; specifically, the material in the filament that heats to *incandescence* the bulbs familiar from everyday use.

**twin-lens reflex (TLR)** A *camera* that has two lenses—one for *focusing* and composing the *image* and the other the *taking lens.*

**Type A film** A color *transparency film* (Kodachrome) balanced for 3400° K bulbs. See *color temperature.*

**Type B film** Most color *transparency* and color *negative* films, balanced for 3200° K bulbs. See *color temperature.*

**ultraviolet** A band of *wavelengths* in the electromagnetic *spectrum* next to and shorter than those for blue-violet and too short to be visible, but detectable by specially sensitized photographic materials.

**underexposed** Too little *light* admitted to the *camera* to form a sufficiently bright *image,* resulting in a *thin,* pale *negative* and a *dense,* dark *print.*

**value** The presence of black, in whatever degree or relative amount. Values can be rated on a *scale* ranging from white (the absence of black, or the *reflection* of all *light*) through gray to black (the *absorption* of all light).

**variable-contrast paper** A special black-and-white paper that has two *emulsions:* one for high *contrast* and one for low contrast. Each emulsion is sensitive to a different color and *filters* are used to obtain the different contrasts when exposing the paper, permitting a wide range of contrast on a single piece of paper.

**view camera** A large *camera* so-called for the *ground-glass* viewing *screen* whose location on the same plane as the *film* permits it to receive *light* directly from the *taking lens,* thus showing the photographer precisely what the film will record.

**viewfinder** A device on or in a *camera* for sighting and framing the *image* to be photographed.

**viewing lens** The lens on a *twin-lens reflex* camera which produces the image on the *ground-glass* viewing *screen* that is used for focusing and composing the *image.*

**vignetting** A technique for isolating an *image* detail inside *soft* borders by a gradual change of tone from the center of a picture to its edges, causing the

image to appear to float; often used in portraiture. It may also occur if a wrong-size filter is placed on a lens, cutting off the edges of the image.

**virtual image** The *image* formed in a *negative lens* which, though clearly visible, perfectly *focused,* and oriented like the original subject, cannot be registered on a flat surface. See *real image.*

**visible spectrum** See *spectrum.*

**warm tones** Refers to the brownish (warm) color of some printing papers in contrast to the bluish (cold) tones of other types of paper.

**washed out** A term referring to the pale tones in a print, especially the highlights caused by insufficient *exposure.*

**wavelength** The characteristic that distinguishes each type of energy within the electromagnetic *spectrum.* The varying lengths of their waves cause light rays to appear red, green, or blue, etc.

**weak** A term referring to the lack of detail and *contrast* in a *negative* or *print* caused by *underexposure* or too little *development.*

**wet plate** The *collodion* processes of the *ambrotype* and *tintype* in which the *light*-sensitive chemical had to be coated onto the plate and then both *exposed* and *developed* while still wet.

**wetting agent** A chemical used to soak *film* before drying to help it dry uniformly and prevent water spots.

**white light** In general, illumination, such as daylight and *tungsten incandescence,* in which all *wavelengths* of the visible *spectrum* are present and by which normal *exposure* of photographic materials can occur.

**wide-angle lens** A *lens* of short *focal length* that allows broad viewing coverage and, in addition, great *depth of field.*

**working solution** Photographic chemicals appropriately mixed, diluted, and ready for use.

**X** Symbol for the *electronic flash* shutter setting on a *camera.*

**zone** A term used in the *Zone System* to describe a *tone.* In a subject it describes a certain brightness *value* one stop from the next one. In a *print* it describes a certain tonal value ranging from pure black (Zone O) to paper white (Zone IX). In a negative, it refers to a specific *density* value that will produce a specific zone in the print.

**zone focus** Setting the *focus* and *aperture* of a *camera* at certain settings to establish an area in the scene which will be in sharp focus and waiting until the subject enters the area before making the *exposure.*

**Zone System** A method by which a photographer can examine a scene and plan the *exposure* and *development* of the *film* to produce a *print* with the tonalities desired.

**zoom lens** An adjustable *lens* capable of continuously variable *focal lengths.*

405

# Index

406

# Photograph Acknowledgments and Credits

Picture credits are grouped by chapters. Photographs taken by the author are listed at the end. The International Museum of Photography at George Eastman House, Rochester, NY, is identified as IMP/GEH.

## Chapter 1
### A Visual Heritage

**1**—The Staten Island Historical Society, NYC. **2**—IMP/GEH. **3** (top)—Gernsheim Collection, Humanities Research Center, University of Texas, Austin; (bottom)—Société Française de Photographie, Paris. **4**—Bayerisches Nationalmuseum, Munich. **5**—Author's collection. **6** (top)—IMP/GEH; (bottom, both)—Science Museum, London. **7** (both)—Author's collection. **8** (left)—IMP/GEH; (right)—Author's collection. **9** (top)—IMP/GEH; (bottom left)—Art Institute of Chicago, Alfred Stieglitz Collection; (bottom right)—Gernsheim Collection, Humanities Research Center, University of Texas, Austin. **10** (both)—The Royal Photographic Society of Great Britain, London. **11** (top)—IMP/GEH; (bottom)—Gernsheim Collection, Humanities Research Center, University of Texas, Austin. **12** (both) IMP/GEH. **13**—Author's collection. **14**—IMP/GEH. **15** (left)—IMP/GEH; (right)—San Francisco Museum of Art, Alfred Stieglitz Collection. **16**—Philadelphia Museum of Art: Given by Carl Zigrosser. **17** (top left and bottom)—IMP/GEH; (top right)—Collection, The Museum of Modern Art, NY, Gift of the Photographer. **18** (top)—The Imogen Cunningham Trust, Berkeley, CA; (bottom left)—Copyright 1971, The Paul Strand Foundation, as published in *Paul Strand: A Retrospective Monograph,* Aperture, 1971; (bottom right)—Collection, The Museum of Modern Art, NY, Gift of Edward Steichen. **19** (left)—Collection Cole Weston; (right)—Ansel Adams. **20** (top left and bottom)—IMP/GEH; (top right)—© William Larson. **21** (left)—IMP/GEH; (right)—Museum of the City of New York, Jacob A. Riis Collection. **22** (top)—The Oakland Museum, CA; (bottom)—Library of Congress, Farm Security Administration photo. **23** (both)—Magnum Photos, NYC. **24** (top)—W. Eugene Smith © 1972; (bottom left)—Alfred Eisenstaedt, Life Magazine, © 1945, Time Inc.; (bottom right)—Photograph by Irving Penn; Copyright © 1952, 1980 by the Condé Nast Publications Inc. **25**—Reprinted from *Camera 35,* March 1979. **26** (top)—Lennart Nilsson, Life Magazine, © 1965, Time Inc.; (bottom)—NASA. **27** (left)—Copyright 1932 by Brassai, Marlborough Gallery, NYC; (right)—Courtesy Sonja Bullaty and Angelo Lomeo, NYC. **28** (top left and right)—Photo Researchers, NYC; (bottom

left)—Copyright © Robert Frank 1979, Zebra Corporation. **29**—Harry Callahan. **30**—Aaron Siskind. **31** (top)—Center for Creative Photography, Tucson, Wynn Bullock Archives; (bottom)—Krannert Art Museum, University of Illinois, Urbana-Champaign. **32**—Courtesy Castelli Graphics, NYC. **33** (top)—Courtesy Robert Freidus Gallery, NYC; (bottom)—Doon Arbus. **34** (top)—Courtesy Witkin Gallery, NYC; (bottom)—Naomi Savage. **35**—Charles A. Arnold.

## Chapter 2
### The Camera

**44**—Photos of M. Monroe billboard by Gloria Karlson. **45**—Paul Himmel. **46** (both)—Oscar Bailey. **47** (all) and **48** (top and bottom right)—Rhoda Galyn. **50**—Photos of woman at gate by Gloria Karlson. **52** (center)—Heather Swedlund. **53** (top)—E. Leitz, Inc., Rockleigh, NJ; (bottom)—John Wm. Nagel. **54** (center)—E. Leitz, Inc., Rockleigh, NJ. **55**—Garry Winogrand. **56** (left center)—Nikon, NYC; (bottom)—E. Leitz, Inc., Rockleigh, NJ. **57**—Ray K. Metzker. **58** (bottom)—Berkey Manufacturing Co., Woodside, NY. **59** (top center and right, bottom left and right)—Courtesy Horst R. Schmidt, Sinar Bron, Inc., Carle Place, NY. **60** (bottom left)—Courtesy Calumet Photographic, Inc., Elk Grove Village, IL; (bottom right)—Jay Bender. **62** (top)—HRW photo by Russell Dian, camera supplied by Ken Hansen Photographic, NYC. **63** (top and bottom left)—David Avison; (bottom right)—Courtesy Charles A. Hulcher Company, Inc., Hampton, VA. **64** (bottom left)—H. P. Marketing Corp., Cedar Grove, NJ; (bottom right)—Nikon, NYC.

## Chapter 3
### Light and the Lens

**74**—David Cavagnaro. **82** (all)—HRW photos by Russell Dian. **83** (left)—HRW photo by Russell Dian; (all others)—Dan Bailey. **88**—Ezra Stoller, © ESTO. **89**—Geoff Winningham. **91**—Robert Riger. **94**—IMP/GEH.

## Chapter 4
### Film and Filters

**97**—Ansel Adams. **101**—J. Seeley. **112** (both)—Gloria Karlson.

## Chapter 5
### Exposure

**119**—Harry Callahan. **121** (bottom)—Author's collection. **126**—Dorothea Lange Collection, The Oakland Museum, CA. **127**—Harry Callahan. **130**—The Imogen Cunningham Trust, Berkeley, CA. **135**—Courtesy The Minor White Ar-

chive, Princeton University. Copyright © The Trustees of Princeton University. **141**—George A. Tice.

## Chapter 6
### Film Processing

**143**—The Wynn and Edna Bullock Trust. **174** (both) and **175** (both)—Herbert R. Nelson.

## Chapter 7
### The Darkroom

**177**—Jerry N. Uelsmann. **193**—Timothy A. Wilbers.

## Chapter 8
### The Print

**211** (all)—Oscar Bailey. **213** (all)—Jay Bender. **216, 217, 221** (all)—Oscar Bailey.

## Chapter 9
### Artificial Light

**247**—Dr. Harold E. Edgerton, M.I.T., Cambridge, MA. **258**—Cal Kowal. **259**—Neal Slavin. **260** (both)—Herbert R. Nelson.

## Chapter 10
### The Zone System

**267**—Courtesy The Minor White Archive, Princeton University. Copyright © The Trustees of Princeton University. **271**—Paul Elledge. **274**—Herbert R. Nelson. **275** (both)—David Gilmore. **282**—Oliver L. Gagliani.

## Chapter 11
### Large-Format Photography

**285**—Philadelphia Museum of Art: Purchased with Funds given by Dorothy Norman.

## Chapter 12
### Beyond Basics

**312, 313** (all)—Jay Bender. **314**—Frank Salmoiraghi. **315** (both)—© Eastman Kodak Company, 1980. **316**—Abigail Perlmutter. **317**—Nathan Lerner. **319**—Photograph by Clarence Rainwater of the Solarol Corporation. **321**—J. Seeley. **329**—Bill Branson. **331**—Tom Petrillo. **332**—Betty Hahn.

## Chapter 13
### Color

**335**—Joel Meyerowitz. **340**—Author's collection. **341** (right)—The Alfred Stieglitz Collection, The Metropolitan Museum of Art, 1955. **342**—Société Française de Photographie, Paris.

**354–357**—Photograph of bowl of fruit by David Vine.

## Chapter 14
### Portfolio

**379**—Bea Nettles. **380**—Light Gallery, NYC. **381**—Judy Dater. **382**—Linda Connor. **383**—Stephen Shore. **384**—Eve Sonneman. **385**—Courtesy Castelli Graphics, NYC. **386**—Todd Walker. **387**—Ray K. Metzker. **388**—Joseph D. Jachna. **389**—From *Bruce Davidson Photographs* by Bruce Davidson, an Agrinde Book. **390**—Light Gallery, NYC. **391**—© Bill Owens. **392**—Kenneth Josephson. **393**—Robert Cumming.

## Charles Swedlund

*Chapter 2:* **37. 38–41** (antique stereoscope). **43** (all). **48** (top). **50** (diaphragms and lens mount). **51** (all). **52** (top, bottom). **54** (top, bottom). **56** (top right). **58** (top left, top center, top right). **59** (top left). **60** (top). **61** (both). **62** (center, bottom). **64** (top). **66.**

*Chapter 3:* **69, 71, 73** (all). **75** (all). **76. 78** (all). **79** (all). **80–81** (all). **85** (both). **87** (both). **90** (all). **92. 93** (all).

*Chapter 4:* **99** (all). **100** (both). **103** (all). **104** (all). **105. 107** (all). **108. 109** (both). **110. 111. 113** (both). **114** (both). **115** (both). **116** (both).

*Chapter 5:* **120–121** (top left and right). **124** (both). **125** (all). **128** (both). **129** (all). **131** (all). **132. 133** (both). **134. 137** (all).

*Chapter 6:* **144** (all). **148. 164** (all). **166–167** (all). **168–169** (all). **172–173** (both).

*Chapter 7:* **179. 183** (both). **186. 188** (both). **189–191** (all).

*Chapter 8:* **195** (both). **196** (both). **198. 206. 207** (both). **208** (both). **210. 212, 214–215** (all). **219** (both). **220. 222. 223** (both). **224. 225** (all). **226. 228** (all). **229. 230–231** (both). **233. 234** (both).

*Chapter 9:* **248. 249** (all). **251** (all). **252** (both). **253** (both). **254** (all). **255. 262** (both). **263** (both). **264.**

*Chapter 10:* **276** (both). **277. 278.**

*Chapter 11:* **286** (both). **297. 299. 300–301** (all). **302–305** (all). **306–307** (both). **308–309** (both).

*Chapter 12:* **311. 318. 322–323** (all). **325** (both). **326. 330. 332–323** (all).

*Chapter 13:* **336. 338** (bottom). **339. 341** (left). **347** (both). **348** (both). **349. 350** (all). **351** (both). **352** (both). **353** (both). **358–359** (all). **362–363** (both). **366** (both). **367** (both). **368–369** (all). **370–371** (both). **372–373** (both). **374–375** (all). **376–377.**

410

623